FLORA & FAUNA

"There is something about the grand waves, the amazing orchid, the leaves with fresh rain, the sudden breeze, or the impossible designs of animals of all kinds that deepens your kindness and sense of awe."

Laura Méndez

Creative Directress

FOREWORD
by Menta

There are flowers for those who want to see them.
— Henri Matisse

When I was asked to write the foreword for Victionary's Flora & Fauna, I was flattered to dedicate the first words of such a curated collection of projects from around the globe – like a blooming flower in the deep forest. I recognised some of the selected projects, and instantly observed how flora and fauna could be interpreted in so many rich ways; never dull. I was curious to imagine the type of surroundings or personal memories related to nature that inspired the studio members or designers when creating a specific branding or artwork.

From flamboyance and lushness to subtle hues and naive patterns, every single case study in this book brings to life a contemporary vision on a theme that has always been the source of inspiration for man and womankind. Nature is all around us and at the same time, is us. We are part of a bigger living system than just human beings living in eco-systems. Nature always makes you reconnect with your inner self. There is something about the grand waves, the amazing orchid, the leaves with fresh rain, the sudden breeze, or the impossible designs of animals of all kinds that deepens your kindness and sense of awe. It is fascinating to look at nature as an abundant source of magic and curiosity.

Since I founded Menta in the summer of 2008, I have been strongly guided by intuition, especially when it comes to decision-making as a Creative Directress. An enlightening intelligence — maybe Mother Nature's voice? — that is actually very necessary in the creative process. Isn't it funny how you just know when a piece of work is right?

We feel very fortunate to be able to select purposeful people behind great projects to work with. It was certainly the result of many long summers and winters. These paced seasons enabled us to specialise in working for brands that offer natural products and processes. Perhaps it was because I grew up in a tropical beach town by the Pacific, that I was immediately attracted to work with nature as an inspiration; integrating bits of it into our work without noticing it. In the end, we like to think of it as one of our signature features as a studio. Paired with a sip of nostalgia typography-wise, our work aims to create timeless identities that balance classic and contemporary aesthetics.

While there have been a lot of ways to create boards of graphic references digitally, I have found that a printed image allows for more intimate thought; a closer feel. Hopefully, this book will be a picnic basket for picking up bits from nature's playground.

For the younglings in design, I recommend that you fetch a nice cup of tea or coffee, grab your favourite sketchbook, and get lost in the several languages that the most talented studios in the world offer as a feast. Sometimes, a vast universe is the starting point to defining the core of a new project. It can be overwhelming at first, not knowing where a creative direction is heading, and although it is normal to feel lost in the thunderstorm of ideas that come to mind, it is very rewarding when the first rays of light start to appear. Exciting things happen when you explore and let yourself think-write-draw, inspired by other minds. Think of a cloudy sky with light slowly peeping through!

I hope that emerging creatives find visual inspiration not only in nature, but also in the patterns, slow timing, and rhythm found anywhere – from the wild outdoors to the humble flower between the cracks on a sidewalk.

FOREWORD
by IWANT Design

Nature and design have always been, and will always be, entwined like the famous Fibonacci sequence's or Golden Ratio's ubiquitous functionality in nature; in that their fundamental purpose in creating naturally pleasing design compositions lies in feeding humankind's simple desire for bringing the natural world into all aspects of our lives so that we can feel close to, and in touch with, the outside.

Nature enhances surface design in many ways. Applying flora and fauna onto cold and flat man-made materials can instantly create a joyous sense of authenticity, calm, and trust. It can feel natural, organic, beautiful, ethereal, and even innocent. We trust nature: it is real, neutral, and both safe and dangerous at the same time – yet, it can also evoke so much in many different ways.

Besides emanating aesthetic beauty, messages can be disseminated through the symbolisms that surround many natural things. A red rose, an apple, or a dove, for example, has a clear and universal meaning. As such, it is important to select what goes into each project carefully, because when used correctly, these elements can send messages that leave a big impact.

As a designer, it has never been my philosophy to use flora and fauna in our studio work even though it is something we have always been drawn to. Our mark-making and illustration style tend to always begin with an organic process. We create in many ways: sometimes collaging vintage botanical drawings, sometimes illustrating our own, sometimes creating abstract marks using natural materials. The computer is a cold and lifeless box, which is probably why these natural elements and the process of physically touching them allow us to sit at our screens without imploding.

The biggest questions for creatives going forward – including ourselves – are how long can the use of flora and fauna in design remain relevant, and how can we continue to use nature in fresh, interesting, and innovative ways? How do we keep the trust and belief that what we are creating is authentic if it is so widely exhausted? It is important to consider why and when it is okay to use nature to sell something, as using it too often may end up hiding what is inside it rather than bring out its essence. It will erode the trust, beauty, and impact that nature can truly bring to our designs.

For now, we will continue to work with flora and fauna when it has relevance in our projects. We look forward to enjoying the journey of discovering new and wonderful ways to bring nature to life in our work, no matter what the future holds.

"Applying flora and fauna onto cold and flat man-made materials can instantly create a joyous sense of authenticity, calm, and trust. It can feel natural, organic, beautiful, ethereal, and even innocent."

John Gilsenan

Founder

2TIGERS design studio	Ignas Senteris	Maniackers Design	Salih Kucukaga
Alexey Boychenko	In-hyuk Jo	Matthieu Martigny	Sandro Laliashvili
B&B studio	Ivan Voznyak	Midnight Design	Saturna Studio
Beetroot Design Group	Iyo Yamaura	Minimalexa	Slavisa Dujkovic
Bratus	Jessica Benhar	MisterShot	Stand & Marvel
Cardumen \| 467	Jody Worthington	Mykola Striletc	Steve Wolf Designs
Carpenter Collective	JU&KE design studio	Oddds	Studio Pros
Courier Design	Kobra Agency	oniguili	Suisei
DOCK 57	Kreatank	otto design lab	surmometer inc.
Doublenaut	Latente.	Patryk Hardziej	tegusu
Fieldwork Facility	Lewis Moberly	Peck Design Associates	Triangler Co., Ltd.
Gaëlle Faure	LOOLAA Designs	Peltan-Brosz	Tricota Agency
Gardner Design	Luca Fontana	Peter Komierowski	vacaliebres
Hyoung-joon Jahng	Manasteriotti DS	SAFARI inc.	Yumi Asakura

—

Field Specimens:

Symbolic Representations

Discover how a simplified rendering of nature can communicate a complex idea and leave a lasting impression through the selection of logos and icons in this section. These featured creative specimens perfectly exemplify how one small illustration can encapsulate the identity, philosophy, and personality of a brand in its entirety. Through a seamless blend of lines, shapes, and forms both authentic and familiar, they convey concepts and emotions without words to create a whole new language of visual representation and meaning that anyone can appreciate.

— 01 —

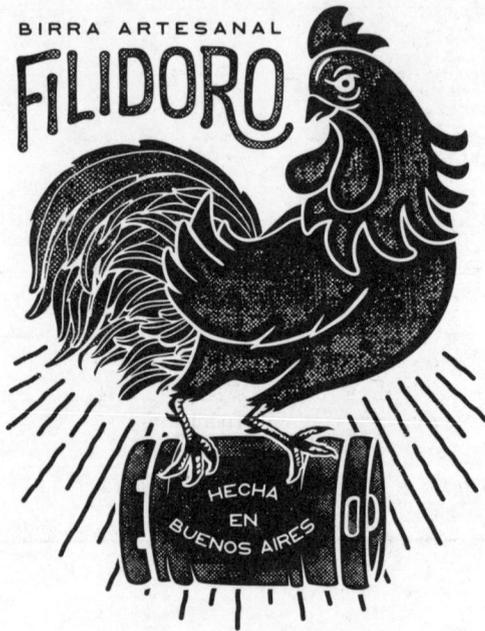

— 02 —

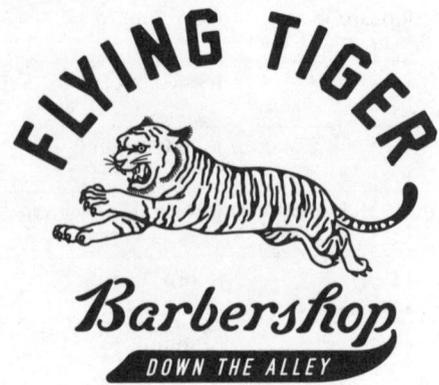

— 03 —

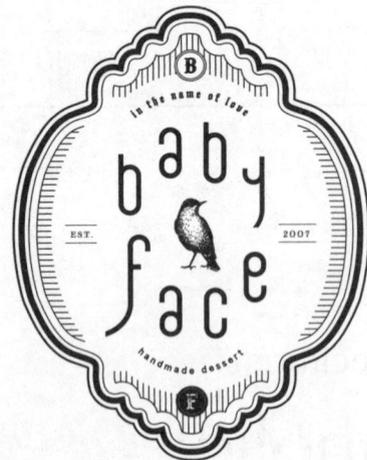

01. FILIDORO – Argentinian Brewery | TRICOTA AGENCY

The stamp-textured logo for Filidoro, an Argentinian brewery, features a rooster that represents the brand's commitment to craft and attention to detail.

02. Flying Tiger | DOCK 57

Australian barbershop Flying Tiger's logo literally reflects the brand's name with a dynamic illustration that is reminiscent of vintage pins and varsity jacket lettering.

03. babyface handmade dessert | 2TIGERS DESIGN STUDIO

babyface handmade dessert shop's logo exudes happiness and timeless sophistication through a bluebird and classic-looking type within a vintage frame.

— 04 —

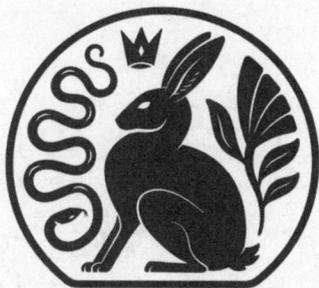

ARTÌDOTE

— 05 —

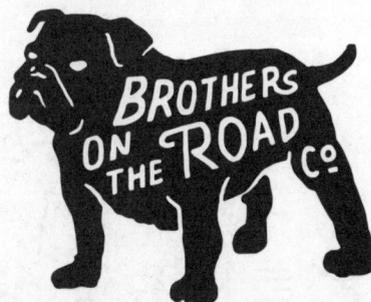

BROTHERS ON THE ROAD
— QUALITY MADE —

— 06 —

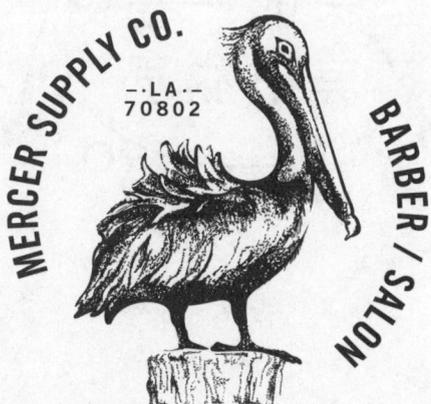

— 07 —

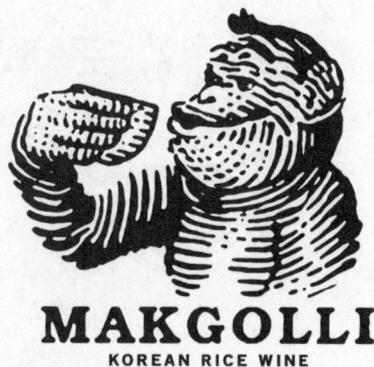

MAKGOLLI
KOREAN RICE WINE

04. Artidote Scented Candles | JESSICA BENHAR

Inspired by artist Joseph Beuys' famous hare, Artidote Scented Candles' logo combines elements of nature and art into one luxurious brand identity wrought with meaning.

06. Mercer Supply Co. | PECK DESIGN ASSOCIATES

Mercer Supply Co.'s logo merges a vintage-looking pelican illustration with a polished, contemporary typeface to symbolise the authentic nature of the salon itself.

05. B.O.T.R. | IN-HYUK JO

Through the effective use of negative space and the simple silhouette of a bulldog, B.O.T.R.'s logo captures the rebellious spirit of modern skate culture.

07. Makgolli | IN-HYUK JO

By combining the caricature of a monkey with a vintage stamp-textured style, the logo for rice wine company Makgolli unites pop and traditional culture.

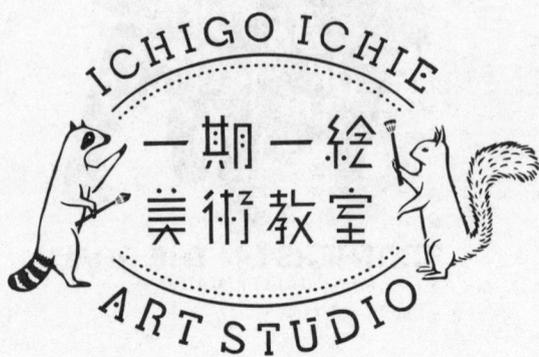

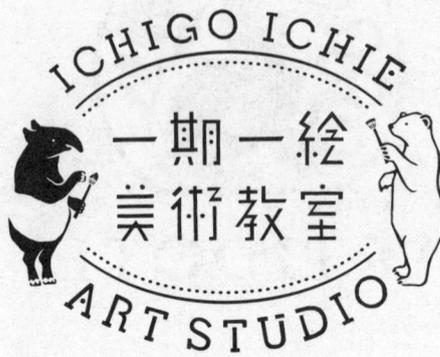

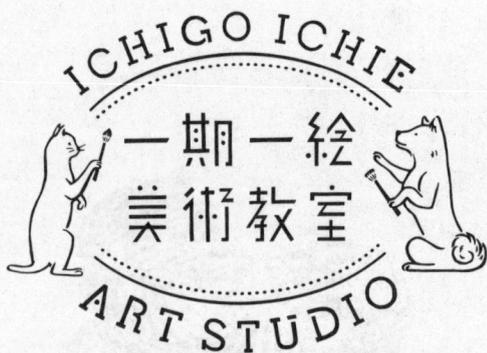

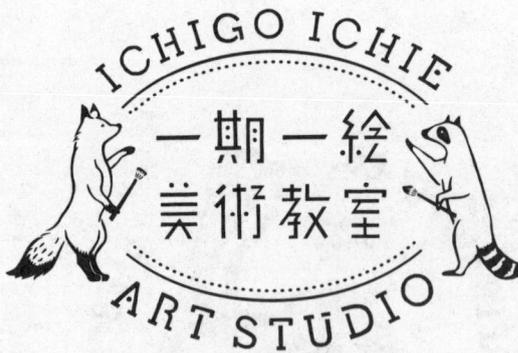

08. Ichigo Ichie Art Studio | TEGUSU

Ichigo Ichie Art Studio is a children's art school that aims to provide a supportive environment for attendees to freely create art. It encourages both teachers and students to be united in sincerity as well as their shared love of and passion for creativity.

Using different combinations of animal illustrations, tegusu developed a set of logos that communicates the fun and lively atmosphere of the classrooms, as well as the ideology of sincerity that the school hopes to embody. In each iteration of the design, two animals stand across each other holding paintbrushes in outstretched arms. Their open postures and friendly faces represent the ways with which different students in the school can meet like-minded peers and enjoy creativity together.

— 09 —

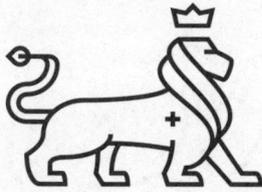

V.V.K. SCHWEIZ

VERSICHERUNGEN. VERMITTLUNG. KOORDINIERUNG.

— 10 —

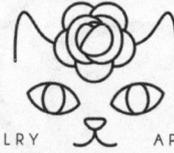

JEWELRY APPAREL

CHANDRA

ESTD. 2015

— 11 —

· ITALIAN BAR ·

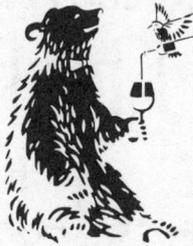

ALLEGREZZA

············· ITALIAN FOOD & WINE ·············

◆ ◆ ◆ ◆ ◆ ◆ PRESENTED BY AVANZARE ◆ ◆ ◆ ◆ ◆ ◆

— 12 —

CIRCUITO·PRE

—

CABALLOS
PURA RAZA ESPAÑOLA

09. V.V.K. Schweiz | MINIMALEXA

Using the king of the jungle to symbolise stability, trust, and power, V.V.K. Schweiz's logo embodies luxury with a contemporary edge through simple and striking linework.

10. CHANDRA | ODDDS

Inspired by feminine sensibility and style, Chandra's logo was brought to life through modern and minimalistic lines to communicate simplicity, elegance, as well as playfulness.

11. ALLEGREZZA | TEGUSU

In many circuses, the bear is the star of the show. tegusu featured it in Allegrezza's logo design to reflect the bar's lively atmosphere, while preserving its sense of refinement.

12. Circuito PRE | SATURNA STUDIO, ISRO BRIONES

Featuring a fresh take on the company's past visual identity, Circuito's new logo design incorporates elements of the Andalucían shield, where the purebred horses that it deals with are born.

— 13 —

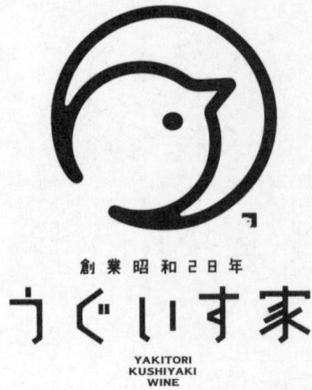

創業昭和2日年

うぐいす家

YAKITORI
KUSHIYAKI
WINE

— 15 —

SPECIALTY COFFEE ROASTER

BUNDY
BEANS

— 14 —

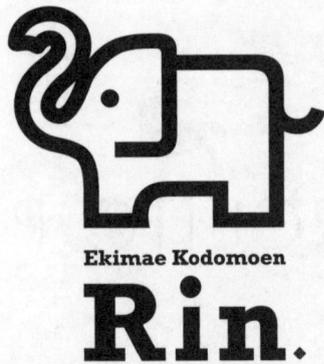

Ekimae Kodomoen
Rin.

13. uguisu-ya | ONIGUILI

To reflect the 'uguisu' or the Japanese nightingale in the store's visual identity, oniguili designed a meaningful logo that depicts a bird as well as a moon.

14. Ekimae Kodomoen Rin | ONIGUILI

For Ekimae Kodomoen Rin nursery school's logo, oniguili featured an animal that they knew would be popular with children, and portrayed it in a refreshing way.

15. BUNDY BEANS | SAFARI INC.

Inspired by the way that its name sounds similar to that of the famous young deer Bambi, SAFARI inc. used the motif of a fawn to represent this coffee roaster and store in Hyogo, Japan.

— 16 —

H U S K I

— 17 —

—18 —

— 19 —

16. Huski | STAND & MARVEL

Besides reflecting the animal in its name, the illustration in Huski's logo also resembles ski trails and the paths of mountain deliveries that the company operates along.

17. Gdańsk Book Fairs | PATRYK HARDZIEJ

Combining elements in the Gdańsk coat of arms with the purpose of the book fairs itself, this impactful logo serves to promote reading and literature published in Poland.

18. Förlaget | KOBRA AGENCY

Commonly associated with literature and wisdom, this simple yet striking logo for the publishing house features the traditional owl icon with a modern and graphic twist.

19. Books for Life | GARDNER DESIGN

Books for Life's bold logo features a bird that embodies how closely life is tied with literature, as well as a stack of books that represents the joy of reading.

— 20 —

もりした♪
音楽教室
Morishita Music School

— 21 —

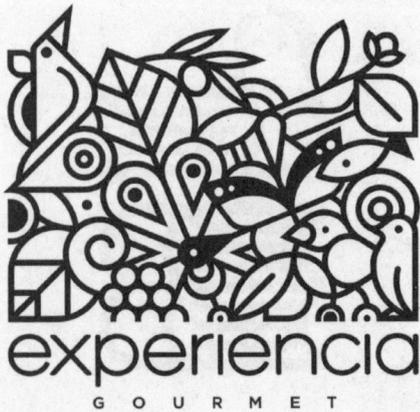

experiencia
G O U R M E T

— 22 —

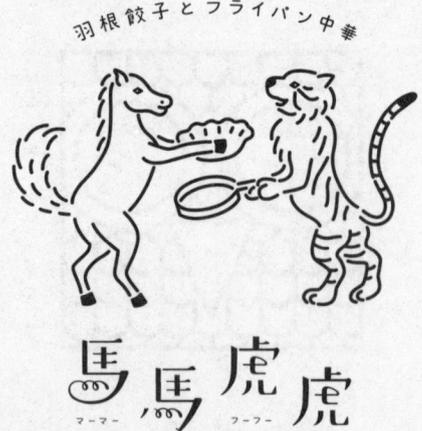

羽根餃子とフライパン中華

馬馬虎虎
マーマー　フーフー

20. Morishita Music School | TEGUSU

The logo for Morishita Music School was inspired by the German folk song 'Ich bin ein Musikant', and represents the different personalities or talents of the school students.

21. Experiencia Gourmet | LEWIS MOBERLY

Experiencia Gourmet's logo with a visually impactful collage of various animal and plant illustrations showcases the diversity of flavours available at the foodhall itself.

22. mamafufu | SURMOMETER INC.

In depicting the characters of the restaurant's Chinese name ('ma' = horse, and 'fu' = tiger), mamafufu's playful logo personifies its eccentric yet easy-going character.

— 23 —

— 24 —

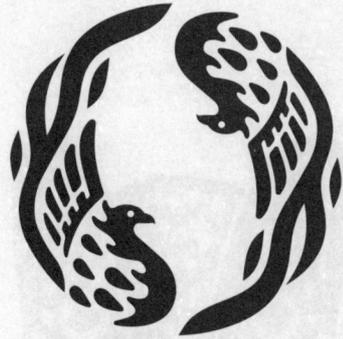

— 25 —

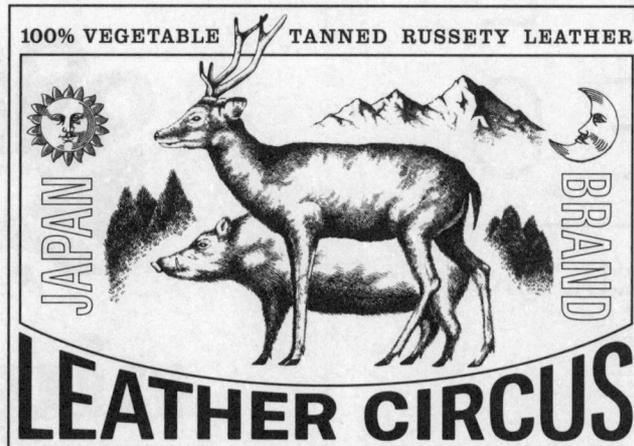

100% VEGETABLE TANNED RUSSETY LEATHER
JAPAN BRAND
LEATHER CIRCUS

23. SHI FENG SHIANG Taiwan Pastry | 2TIGERS DESIGN STUDIO

The magpies in this pastry store's logo represent good luck and blessings, while the bold linework of the cords as well as the hibiscus and osmanthus flowers create a perfect balance between Chinese tradition and modern innovation.

25. LEATHER CIRCUS | SUISEI

Resembling an idyllic, retro-style postcard, LEATHER CIRCUS's logo represents the source of leather that its products are made from. The animals appear calm to showcase the brand's dedication to environmental protection and lawful hunting only.

24. Ito tenrei | SUISEI

In Chinese culture, the phoenix represents solemnity, serenity, and peace; while in the Japanese tradition, it symbolises paradise. The two in this logo form a circle that resembles 'i' (い), the first letter of the funerary company's name in Japanese, while also depicting the cycle of life.

— 26 —

ATE
NEO

COCINA Y CULTURA

— 27 —

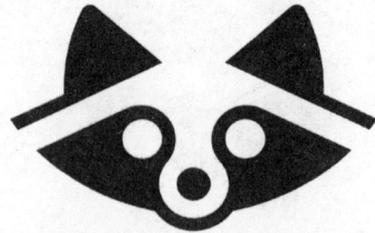

l'accoon

— 28 —

niyab

26. Ateneo | CARDUMEN | 467

To reflect the values of the modern generation and Latin America
at large, the logo for Ateneo is a symbol of freedom of movement,
thought, and life – presented in a versatile and unique way.

28. Niyab | MYKOLA STRILETC

The logo for Niyab, a traditional clothing production company in India,
features a stylised image of a peafowl, which is an iconic animal within
the culture.

27. MICHAEL D°ONOFRIO HISTORICAL RESTORATION |
VACALIEBRES

MDHR's logo was inspired by a family of mummified raccoon skeletons.
The one with the most irreverent gaze was immortalised as the 'Raccoon
Mummy': a playful, resourceful, and protective trickster figure that
tragically entombs itself within the historical architecture projects that
MDHR works on.

— 29 —

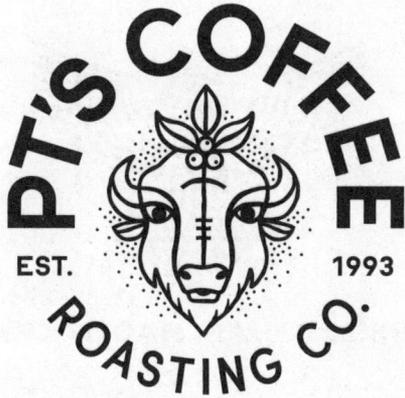

— 30 —

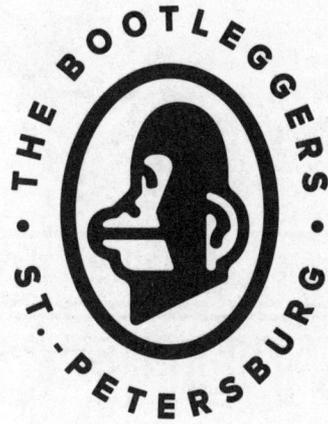

—31—

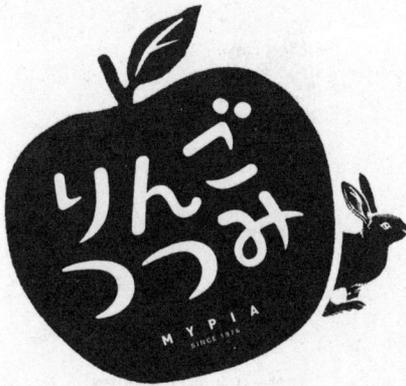

— 32 —

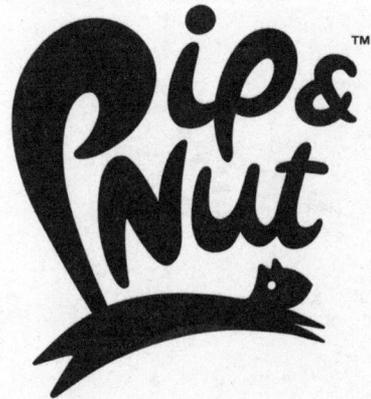

29. PT's Coffee Co. | CARPENTER COLLECTIVE

The friendly face of a bison, which is a symbol of strength, unity, and abundance, references PT's Coffee Co.'s roots in the Midwest to form a logo that is not only warm and welcoming, but also symbolic and meaningful.

31. Ringo Tsutsumi | MANIACKERS DESIGN

Ringo Tsutsumi's logo combines the bakery's mascot with the main ingredient of its pies: the famous Aomori apples. The bright, graphic interpretation of the fruit complements the more realistic rabbit illustration perfectly.

30. The Bootleggers | DOCK 57

The logo for The Bootleggers shoe store harmoniously combines the retro yet timeless, fan-favourite character of Jolly Chimp with a refreshingly modern, graphic style.

32. Pip & Nut | B&B STUDIO

Featuring a friendly leaping squirrel and a playful typeface, Pip & Nut's logo radiates with the sense of motion, positivity, and dynamism one can expect from an on-the-go energy snack.

— 33 —

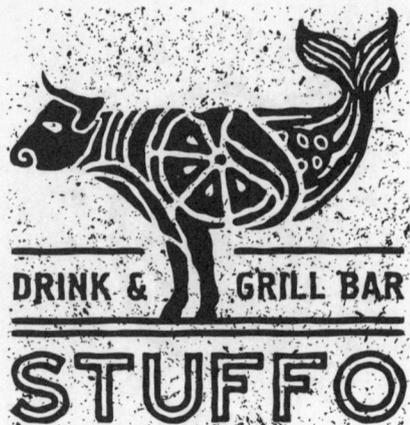

— 34 —

ИНЖЕНЕРНАЯ МАСТЕРСКАЯ

—35—

B A L M O R I

R O O F B A R

— 36 —

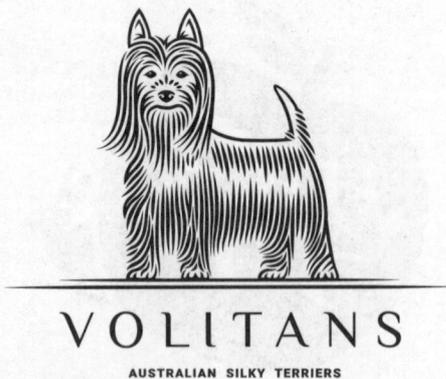

V O L I T A N S

AUSTRALIAN SILKY TERRIERS

33. STUFFO | IVAN VOZNYAK

Stuffo's logo, featuring a bull with a fish's tail and an abdomen made out of various fruits and vegetables, aptly represents the fusion of flavours offered by the innovative grill-bar.

35. Balmori Rooftop Bar | LATENTE.

Throughout the construction of the Balmori Rooftop Bar, the site received frequent visits from friendly little birds, whose form was immortalised in its simple yet striking logo design.

34. Engineering Workshop | IVAN VOZNYAK

Engineering Workshop's logo brings the image of a falcon – the bird with the most accurate vision– to life by symbolising efficiency and strength, which are both values that are essential to effective engineering design.

36. Volitans | IVAN VOZNYAK

The logo design for Volitans, an Australian Silky Terriers kennel, features a detailed illustration that showcases the animal's graceful character and appealing aesthetic features.

— 37 —

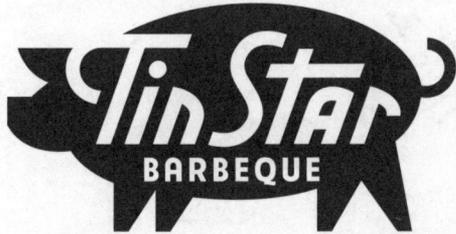

— 38 —

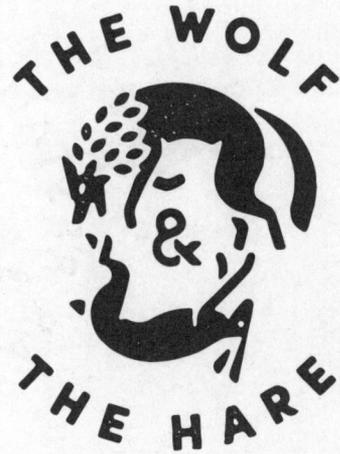

— 39 —

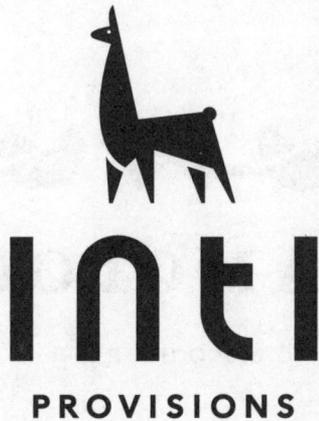

— 40 —

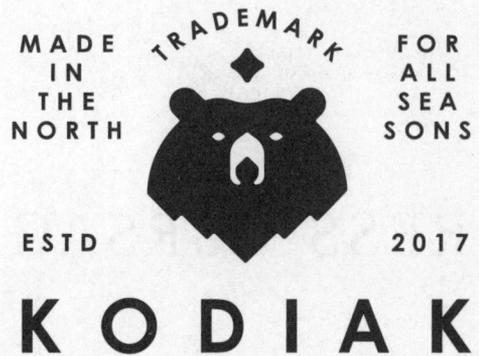

37. Tin Star BARBEQUE | STEVE WOLF DESIGNS

The robust silhouette of a pig, a fan-favourite ingredient/dish on Tin Star BARBEQUE's menu, forms the basis of the southern-style outlet's modern and playful logo.

39. Inti Provisions | STEVE WOLF DESIGNS

In honour of the company's Peruvian roots, Inti Provisions' logo features a friendly llama that represents how the brand's foods are both naturally nutritious and environmentally conscious.

38. The Wolf & The Hare | PETER KOMIEROWSKI

Representing the relationship between predator and prey in a visually appealing way, The Wolf & The Hare's logo features strong typography, striking geometry, and minimal complexity for maximum legibility.

40. Kodiak | PETER KOMIEROWSKI

Through the unique silhouette of a Kodiak bear's head and typography inspired by vintage clothing labels, the footwear brand's logo effectively captures the durable quality of its products.

— 41 —

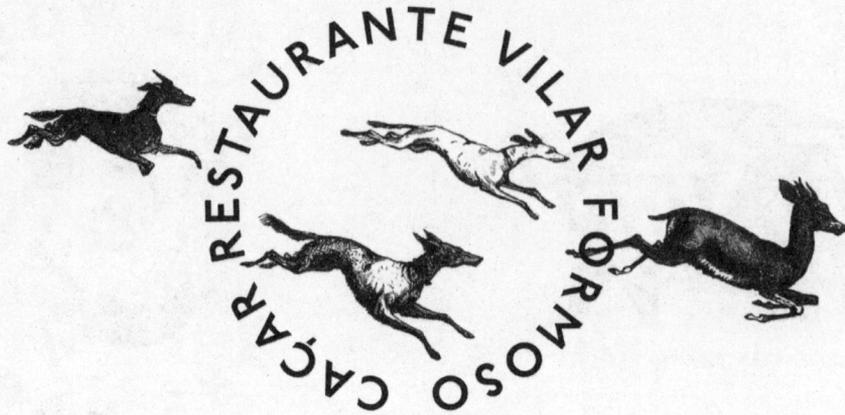

— 42 —

DRESS CORSAGE

— 43 —

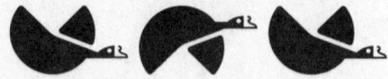

ХОЛМОГОРЫ

• СЫРОВАРНЯ •

41. Caçar Restaurante Vilar Formoso | PELTAN-BROSZ

The dynamic movement of hunter dogs in Cacar Restaurante Vilar Formoso's visual identity successfully captures the contemporary-yet-retro feel of the fusion restaurant.

42. DRESS CORSAGE | YUMI ASAKURA

Dress Corsage's logo features a delicate butterfly that looks as though it was captured mid-flight. Illustrated using intricate lines, it encapsulates the elegance of the brand perfectly.

43. Kholmogory | DOCK 57

Kholmogory's logo of three flying geese playfully reflects its products' origins: a Russian region known for the birds. The geese's wings resemble cheese rounds, symbolising the company's use of natural ingredients from local farms in its production process.

— 44 —

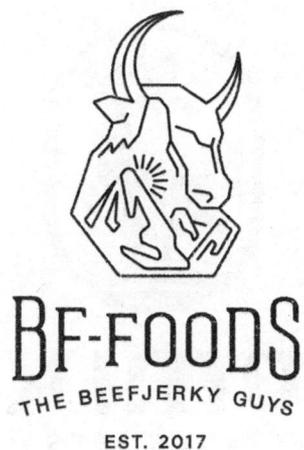

BF-FOODS

THE BEEFJERKY GUYS

EST. 2017

— 45 —

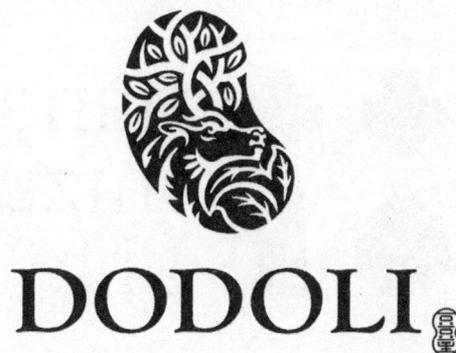

DODOLI

— 46 —

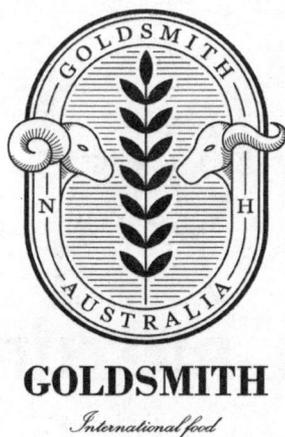

GOLDSMITH

International food

— 47 —

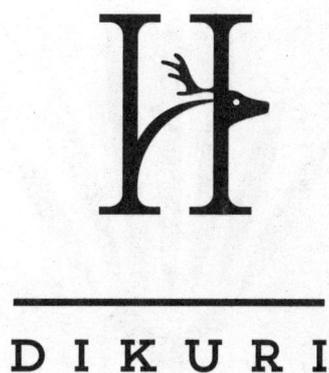

D I K U R I

44. BF-FOODS | MIDNIGHT DESIGN

BF-FOODS' refined yet slightly rugged logo depicts both a bull and a mountain to refer to the brand's product of dried beef strips, as well as its consumer base of mountaineers and travellers.

46. GOLDSMITH | MIDNIGHT DESIGN

Midnight Design's timeless logo design for the Australian lamb and beef supplier resembles a badge of honour or championship, referring to the brand's award-worthy calibre of meat.

45. DODOLI | MIDNIGHT DESIGN

DODOLI's logo of a majestic deer refers to its product – soft bean stew – as well as its namesake, the Korean god of wood. The leaves growing around and out of the deer's antlers give the design an enchanted feel.

47. Dikuri | LATENTE.

Dikuri is a footwear brand that collaborates with the Huichol community of Mexico, where deers are esteemed sacred animals. The logo interweaves the letter 'H' with a deer's head to symbolise how important the community is to the brand.

— 48 —

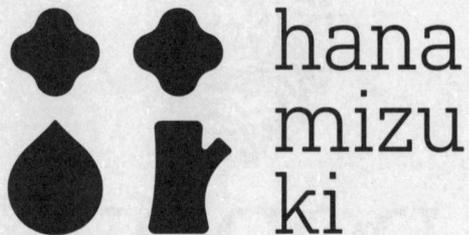

— 49 —

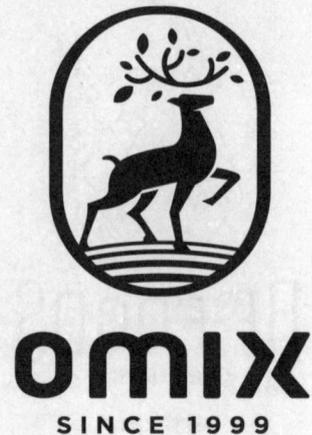

— 50 —

— 51 —

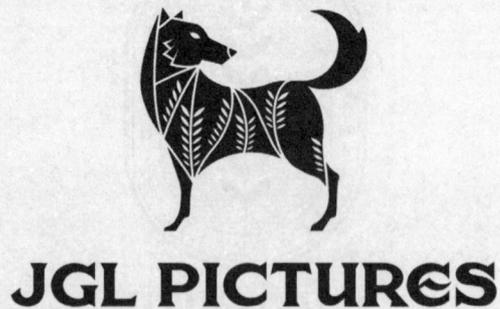

48. Hanamizuki | TRIANGLER CO., LTD.

Hanamizuki's multilayered logo represents the cleaning company's practice of natural cleaning through plant-based detergents, while depicting the components of its Japanese name ('hana' = flower, 'mizu' = water, and 'ki' = tree).

50. Hedge New York | VACALIEBRES

Besides portraying a hedge plant and a hedgehog, the tennis and golf clothing brand's logo also resembles a tennis skirt fanning out from the waist. The flexible design reflects the versatility of its products, which can be for sport or leisure.

49. Omix | BRATUS

Bratus' visual identity work for Omix, an organic fertiliser company based in Dong Nai – a place historically known for its deer, features a modern interpretation of the animal with antlers made of branches and leaves to represent luck, prosperity, and growth.

51. JGL PICTURES | MIDNIGHT DESIGN

To symbolise the advertising and photography company's journey in the industry, which resembles the travel patterns of a nomadic wolf, JGL PICTURES' logo features trailing leaves on a wolf's body to represent how far the firm has come.

— 52 —

— 53 —

OTORI MATERNAL
APOTHECARY

— 54 —

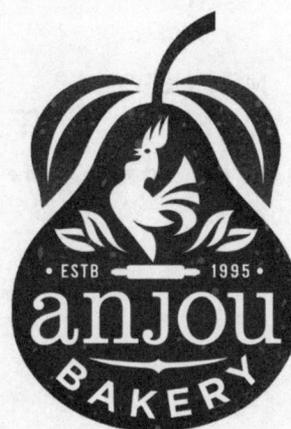

52. Goodwill Cholula | LATENTE.

For a Mexican organisation revolving around the culture of giving, Goodwill Cholula's logo represents the universal symbol of a helping hand that embodies supporting and uplifting one another.

54. Anjou Bakery | GARDNER DESIGN

Anjou Bakery's logo showcases its heritage as a former fruit warehouse in a region of pear orchards through its vintage style. The rooster – a symbol of France, farm life, and nature – refers to the bakery's countryside location and its preference for fresh local ingredients.

53. OTORI MATERNAL APOTHECARY | OTTO DESIGN LAB

Otori Maternal Apothecary's logo represents the letter 'O' in its name, as well as the cycle of life. All the details in the illustration stand for elements that are essential for future mothers, such as the stork for good luck, feet for exercise and health, kampo for nature, sun for energy, heart for love, hands for kindness, angel for new life and hope, moon for good sleep, and cutleries for nutrients.

— 55 —

MAISON
BŪCHETTE
• ALCHIMIES BOTANIQUES •

— 56 —

REFINE SKIN TEXTURE

pure drops

NNNEURON
原 田 製 研

— 57 —

Acupuncture &
Massage Clinic

FOR
mente

55. Maison Bûchette | GAËLLE FAURE

The natural ingredients used by this artisanal manufacturer of candles
and beauty serums are reflected in its visual identity. The logo features
a minimalistic collage of leaves growing together on the same twig,
embodying a sense of unity and cohesion.

57. FORmente | TEGUSU, SHOKO FURUDATE

The blossoming flower in FORmente's logo represents the blossoming
patients of this clinic as they regain their healthy bodies through natural
treatment. The four circular petals symbolise the four pillars of their
treatment method, and the flower pistils represent acupuncture needles.

56. NNNEURON Cosmetics | STUDIO PROS

To reflect the innovative spirit of the brand that is based in nature
and science for beauty and well-being, NNNEURON's flexible logo
contains elements that can be disassembled without losing its sense of
professionalism.

— 58 —

越後ハーブ香園

UONUMA・IRIHIROSE

— 59 —

RENEWAL

CHURCH

— 60 —

NINSARE

— 61 —

IVONA
GASTAVO

FLOWERS

58. Echigo Herb Park | SAFARI INC.

Based on the three key words 'wind', 'sky', and 'incense', Echigo Herb Park's logo features visually distinct thematic sections of nature silhouetted by the shape of a tree to represent the fullness of life.

60. Ninsare | JU&KE DESIGN STUDIO

Stemming from the brand's desire to promote Chinese yew extract skincare products all over the world, Ninsare's logo celebrates imperfections, quality, and the spirit of craftmanship.

59. Renewal Church | MINIMALEXA

Using traditional symbols of Christianity, Renewal Church's logo contains a modern reinterpretation of the iconic fish to showcase the mental and spiritual growth that people can gain through church.

61. Ivona Gastavo | LOOLAA DESIGNS

Ivona Gastavo's design work is a mix of neo-classical and contemporary elements to create a nostalgic mood with a twist. The visuals fit the brand's goal to transform everyday objects into visual inspiration.

— 62—

akinire shop
harunire café

— 63 —

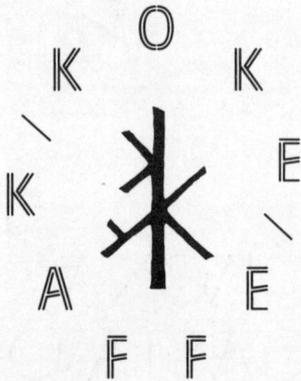

—64 —

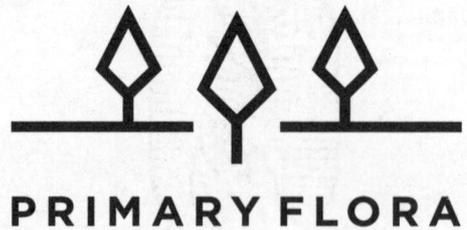

PRIMARY FLORA

62. harunire café & akinire shop logotype |
MANIACKERS DESIGN

The harunire and akinire logotypes feature letters that look like tree branches with curious little birds. Both designs emphasise the natural and organic focus of the café and shop.

64. Primary Flora | MINIMALEXA

Referring to the pharmaceutical company's priobiotic nutritional supplements, its logo comprises three simple trees with a single close-up to demonstrate the 'primary' element in the brand name.

63. KOKEKAFFE | 2TIGERS DESIGN STUDIO

KOKEKAFFE's logo consists of three letter 'K's arranged to look like firewood, which references the shop's signature coffee-making technique of direct heating with firewood.

— 65 —

FEVER-TREE

PREMIUM NATURAL MIXERS

— 66 —

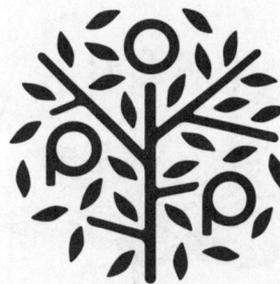

POWER OF PLANT

— 67 —

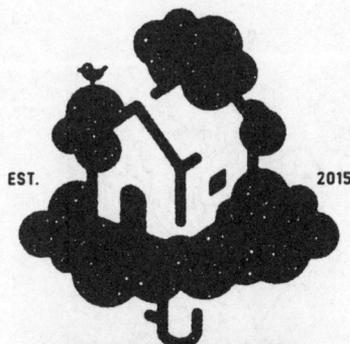

65. Fever-Tree | B&B STUDIO

Fever-Tree's logo features a cinchona tree, from which the key ingredient of the brand's tonics is derived. The brand's meticulous attention to detail is revealed through the repetition of the leaf motif.

66. Power of Plant | MANASTERIOTTI DS

The logo for Power of Plant, a hemp and aromatic oil business, represents the harmony between man and nature through the human figure hidden within the outstretched branches, as well as the round fruits that form the letters 'P.O.P.' – the brand's initials.

67. GUNMA TREEHOUSE PROJECT | MANIACKERS DESIGN

Gunma's two different logo designs represent treehouses in unique ways — one features the silhouette of a tree filled with the distinctive texture of a tree trunk, while the other is brought to life through a modern and playful illustration style.

— 68 —

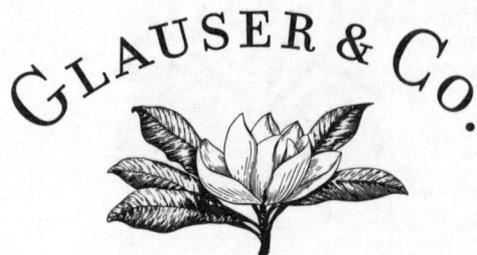

LANDSCAPING

est. 2012

— 69 —

HERBACEOUS
DRINKS

— 70 —

Handmade Candle

— 71 —

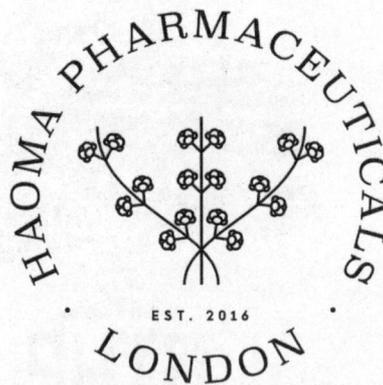

68. Glauser & Co. | JODY WORTHINGTON

Inspired by letterpress prints, vintage seed packets, as well as botanical etchings, Glauser & Co.'s logo serves as an elegant and timeless representation of William Glauser's upscale landscaping business.

70. Ballare | IYO YAMAURA

The logo for Ballare, a candle shop, embodies the spirit of the shop name – which means 'to dance' in Italian. The illustration abstracts and conflates the forms of flowers and flames to create a delicate yet dynamic combination of things that colour everyday life.

69. Herbaceous Drinks | VACALIEBRES

Herbaceous Drinks' logo of a flower in a glass fuses modern typography with classic-looking illustrations and icons to represent a mixture of innovation and nature.

71. Haoma Pharmaceuticals London | PELTAN-BROSZ

Haoma Pharmaceuticals' minimalistic and symmetrical logo represents the Haoma plant, which is a divine herb that grants strength, vigilance, fertility, spiritual power, and knowledge in Persian mythology.

— 72 —

Mark Spencer
Botanist

— 73 —

VIVAIO & GREEN DESIGN

— V.COI — N.113 —

GARDENIA®

32020
LIMANA (BL)

— 74 —

BeRUNA
living foods

— 75 —

MARY ANN CORP.

72. Mark Spencer Botanist | FIELDWORK FACILITY

Using an eye to symbolise the skills of observation needed for Mark Spencer's work as a forensic botanist, Fieldwork Facility cleverly incorporated a skeletonised leaf into his logo.

73. Gardenia | LUCA FONTANA

For Gardenia plant nursery's visual identity, Luca Fontana designed a minimalistic logo combining two leaves and a shovel to convey the organic nature of plants in a modern and geometric way.

74. BeRuna | MINIMALEXA

BeRuna's edible healthy-seed product range is aptly represented in its logo design. The strong, clean, and lively combination of linework and typography conveys the brand's idea of 'living food'.

75. MARY ANN CORP. | MIDNIGHT DESIGN

The logo for Mary Ann Corp., an upscale women's shoe brand, features a fluttering hummingbird and leaves to represent the comfort and joy wearers can derive from its products.

— 76 —

HOMEWARE

— 77 —

Artisan Fleur

école & atelier de haute couture

— 78 —

TRADE | MARK

Shinoda

篠田紙加工場

KYOTO 1915

76. Ferguson-Phillips | GARDNER DESIGN

Using the familiar shape and structure of a crest as well as intricate type, the logo for Ferguson-Phillips, a homeware and interior design furnishing company, communicates luxury in a modern way.

78. Shinoda Kami-kakouba | YUMI ASAKURA

Shinoda Kami-kakouba's detailed logo of a tree growing out of a scroll with a bird perched on top represents the respect that this stationery brand has for the trees with which its products are made.

77. Artisan Fleur | YUMI ASAKURA

Inspired by the beautiful and delicate shape of the camellia flower, Yumi Asakura's logo design for Artisan Fleur, an haute couture corsage school, is modern and minimalistic yet impactful.



— 79 —

— 80 —

— 81 —

— 82 —

79. Le Puju | YUMI ASAKURA

Inspired by the brand's desire to help children bloom and grow, Le Puju's logo exudes warmth. The varying angles of the circular flowers also create interest and diversity in the design.

80. ANDELINA | OTTO DESIGN LAB

ANDELINA's logo is as sweet and delicate as the red-bean paste desserts that the brand sells. Its modern illustration style redefines the traditional image of Japanese red bean paste, also known as 'anko'.

81. Garden Party | DOUBLENAUT

The thoughtful selection of plants and careful organic methods with which Garden Party constructs beautiful gardens is reflected in its delicate and symmetrical logo.

82. Homus | LUCA FONTANA

The logo for Homus, a social co-operative and non-profit organisation, references the work that it does with men in prison, which includes uniting people through the theme of gardening.

Birds

001

002

003

004

005

006

007

008

009

010

011

012

013

014

001 LATENTE. / 002 SLAVISA DUJKOVIC / 003.010.011 MATTHIEU MARTIGNY / 004.006.007 VACALIEBRES / 005 HYOUNG-JOON JAHNG / 008 PELTAN-BROSZ / 009.013 COURIER DESIGN / 012 BEETROOT DESIGN GROUP / 014 KREATANK

015

016

017

018

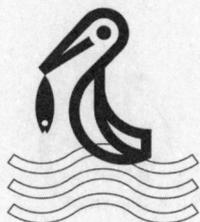

019

020

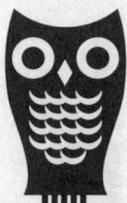

021

022

023

024

025

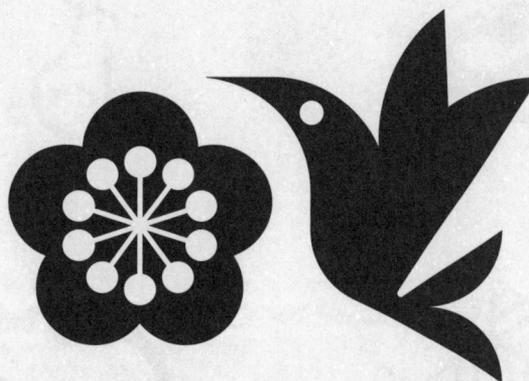

026

015.026 COURIER DESIGN / 016 LATENTE. / 017 SLAVISA DUJKOVIC / 018.020 MATTHIEU MARTIGNY / 019.023.024 VACALIEBRES /
021 BEETROOT DESIGN GROUP / 022 ALEXEY BOYCHENKO / 025 IGNAS SENTERIS

Mammals

027

028

029

030

031

032

033

034

035

036

037

038

039

040

027 SLAVISA DUJKOVIC / 028.030.031.035.036 VACALIEBRES / 029.032.034.038 COURIER DESIGN /
033.037 BEETROOT DESIGN GROUP / 039 SANDRO LALIASHVILI / 040 MATTHIEU MARTIGNY

041

042

043

044

045

046

047

048

049

050

051

052

041.042.045.046.051 VACALIEBRES / 043 IGNAS SENTERIS / 044.049 SANDRO LALIASHVILI /
047 ALEXEY BOYCHENKO / 048 COURIER DESIGN / 050.052 BEETROOT DESIGN GROUP

053

054

055

056

057

058

059

060

061

062

063

064

065

066

067

053.060.066 ALEXEY BOYCHENKO / 054.055.067 KREATANK / 056.057.061 SANDRO LALIASHVILI /
058.059.062.063 MATTHIEU MARTIGNY / 064 VACALIEBRES / 065 MISTERSHOT

068

070

069

071

072

073

074

075

076

077

078

079

068.071.078 KREATANK / 069.072 HYOUNG-JOON JAHNG / 070.074 IGNAS SENTERIS /
073.077 MISTERSHOT / 075 COURIER DESIGN / 076 MATTHIEU MARTIGNY / 079 ALEXEY BOYCHENKO

080

081

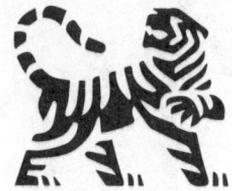

082

083

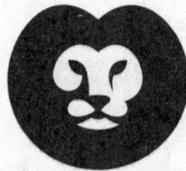

084

085

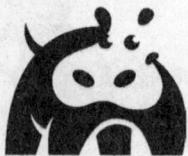

086

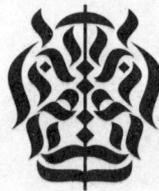

087

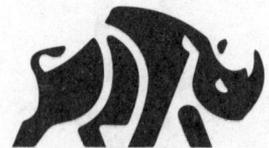

088

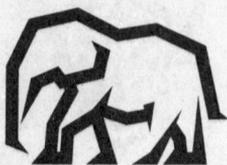

089

090

091

080 LATENTE. / 081.085.087 ALEXEY BOYCHENKO / 082.088.091 MATTHIEU MARTIGNY /
083 VACALIEBRES / 084.089.090 MISTERSHOT / 086 KREATANK

Reptiles &
Insects

092

093

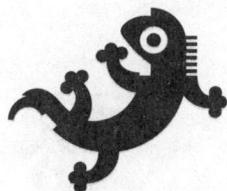
094

095

096

097

098

099

100

101

102

092 SANDRO LALIASHVILI / 093 MATTHIEU MARTIGNY / 094 BEETROOT DESIGN GROUP /
095.100.101.102 COURIER DESIGN / 096 ALEXEY BOYCHENKO / 097-099 SLAVISA DUJKOVIC

Aquatic
Creatures

103

104

105

106

107

108

109

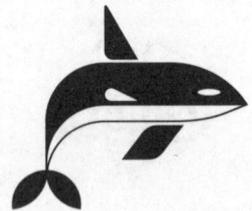

110

111

112

113

103.106.108.113 BEETROOT DESIGN GROUP / 104.105.107 HYOUNG-JOON JAHNG /
109.112 KREATANK / 110 COURIER DESIGN / 111 VACALIEBRES

114

115

116

117

118

119

120

121

122

123

124

125

114.122-124 BEETROOT DESIGN GROUP / 115.117.119.125 MATTHIEU MARTIGNY /
116 KREATANK / 118.120 SLAVISA DUJKOVIC / 121 COURIER DESIGN

Plants

126

127

128

129

130

131

132

133

134

135

136

126-128.130-132.135.136 COURIER DESIGN / 129.134 IGNAS SENTERIS / 133 SALIH KUCUKAGA

137

138

139

140

141

142

143

144

145

146

147

148

149

150

151

137.139.143.144 IGNAS SENTERIS / 138.140-142.147.149 SALIH KUCUKAGA /
145 VACALIEBRES / 146.148.150.151 COURIER DESIGN

152

153

154

155

156

157

158

159

160

161

162

163

152-154.156.160-163 COURIER DESIGN / 155 LATENTE. / 157 VACALIEBRES / 158.159 SALIH KUCUKAGA

164

165

166

167

168

169

170

171

172

173

174

175

164.167 LATENTE. / 165.168.169.171.172.175 COURIER DESIGN / 166.174 PELTAN-BROSZ / 170.173 VACALIEBRES

Field Study Showcase:
Creative Applications

The curated design projects in this section reveal the creative diversity with which nature can be interpreted, transformed, and expressed. Explore how comprehensive brand identities have been built around various elements in the natural world using distinctive illustration styles, original colour palettes, clever compositions, custom typography, experimental finishes, and innovative concepts. Learn about the ideating processes, production techniques, and strategic symbolism behind each piece of work from the talented designers who draw their inspiration from flora and fauna to depict them in inspiring ways.

2TIGERS design studio

A Work of Substance

Angelina Pischikova

Anomaly Brands

arithmetic

artless Inc.

asatte design office

Atelier Olschinsky

Backbone Branding

Baillat. Studio

Bardo Industries

Beetroot Design Group

Candid Brands®

Carpenter Collective

Carter Hales Design Lab Inc.

Caterina Bianchini Studio

CIRCLE Design + Direction

Constantin Bolimond

Darling Visual Communications

Davide Parere

Design Studio B.O.B.

Estudio Maba

Fieldwork Facility

FormNation LLC

Happycentro

HOUTH

Hula Estudio

Impact BBDO

IWANT Design

Janar Siniloo

Karla Heredia Martínez

kissmiklos

Kobra Agency

Le Billyclub

LOCO Studio

Magdalene Wong

Makers and Allies

MAROG Creative Agency

Marta Gawin

Masquespacio

Matt Ellis

Menta

Monograph&Co.

Motyf Studio

Mucho

Mundial

Natalia Elichirigoity

Natasha Nikulina

Nick Liefhebber

O.OO Design & Risograph ROOM

Oddds

OlssønBarbieri

One Design

Pata Studio

Pavement

Pop & Pac

Projet Noir

SanYe design Associates

Sean Huang

Shine Visual Lab

Shunsuke Satake

Studio Blackburn

studio NUR

Studio Pros

studiowmw

SUBMACHINE

Suisei

The Bakery design studio

Twentyfive™

UnderConsideration

UVMW

Xfacta

Yao-ming Yan

anflor*

To reflect anflor*'s philosophy in which 'bouquets are more than words', Angeliana Pischikova designed a fitting visual identity that celebrates the natural beauty of flowers. Her creative work features bright colour combinations, abstract patterns, and delicate typography that revolves around the stylised asterisk in the studio's logotype – exuding vibrance across a modern and sophisticated branding suite.

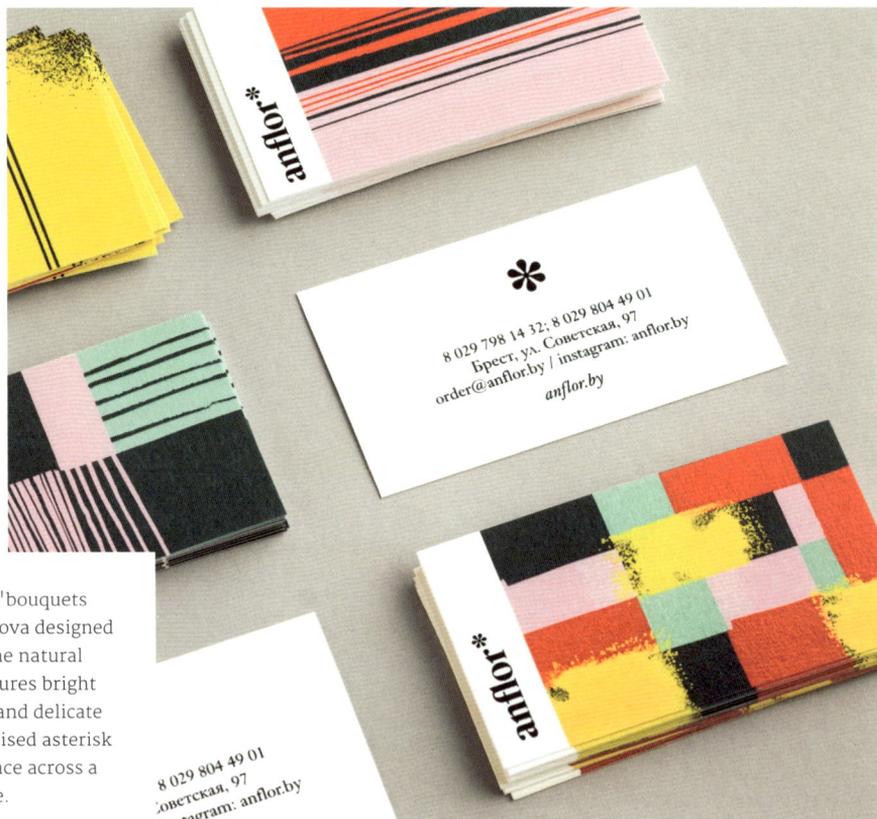

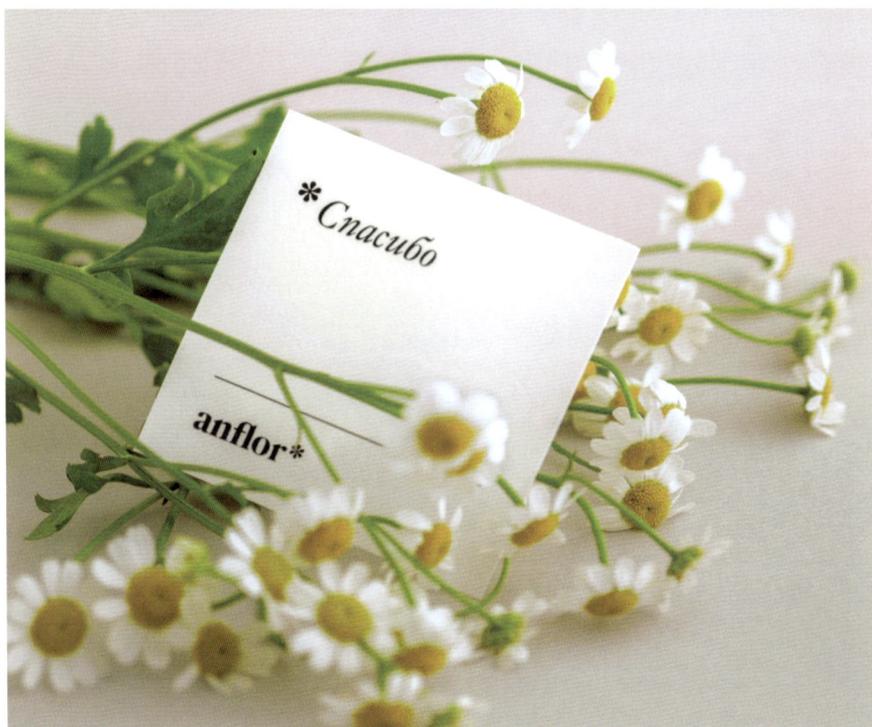

Design
Angelina Pischikova

Client
anflor*

Photography
Karina Zhukovskaya

共に育つ、
めぐる庭。

aila
LIVING WITH GARDEN
[神戸・芦屋・西宮]
TEL / FAX 0798-00-0000
ailaweb.jp

庭の設計 植栽プラン
季節のメンテナンス

aila

To portray its purpose as an interior design and gardening store, asatte design office rooted aila's visual identity design in the essence of a garden. The size of its logotype increases from left to right, representing the growth process as well as the growing relationship between aila and its customers. Minimalistic photos of simple natural wonders are the key features in collaterals, drawing the viewer's attention to the stark beauty of nature.

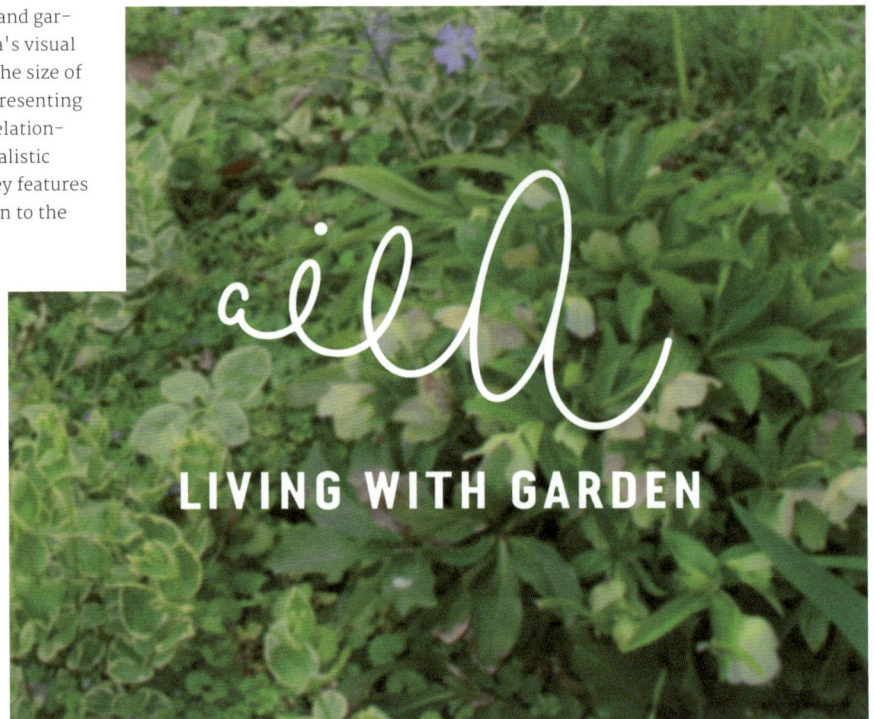

aila
LIVING WITH GARDEN

Design
asatte design office

Client
aila

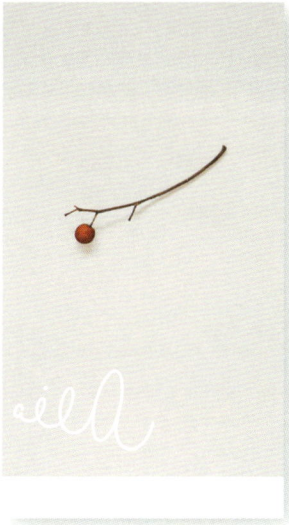

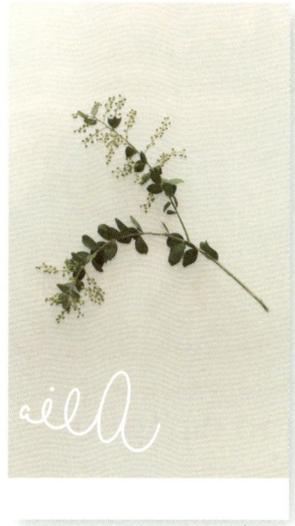

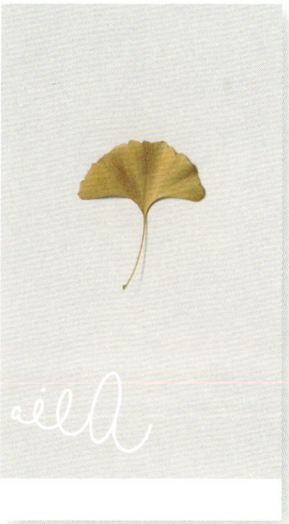

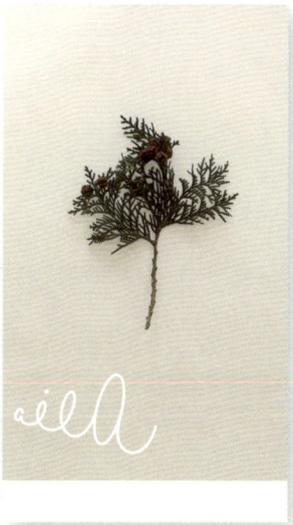

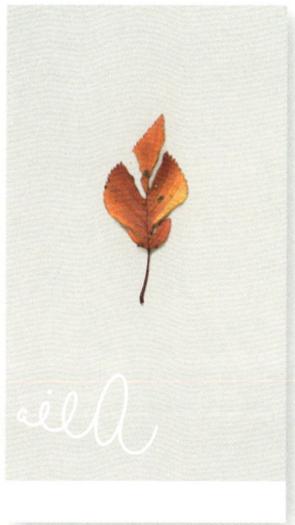

Design
artless Inc.

Client
Maison de Taka

Maison de Taka

Inspired by the authentic character of Maison de Taka, artless Inc. applied subtle leaf illustrations onto grainy recycled papers to design a meaningful visual identity for the French restaurant. Besides thoughtfully embodying the outlet's warm and welcoming nature, the delicate motif and material combination offers an alluring glimpse of its lush gardens.

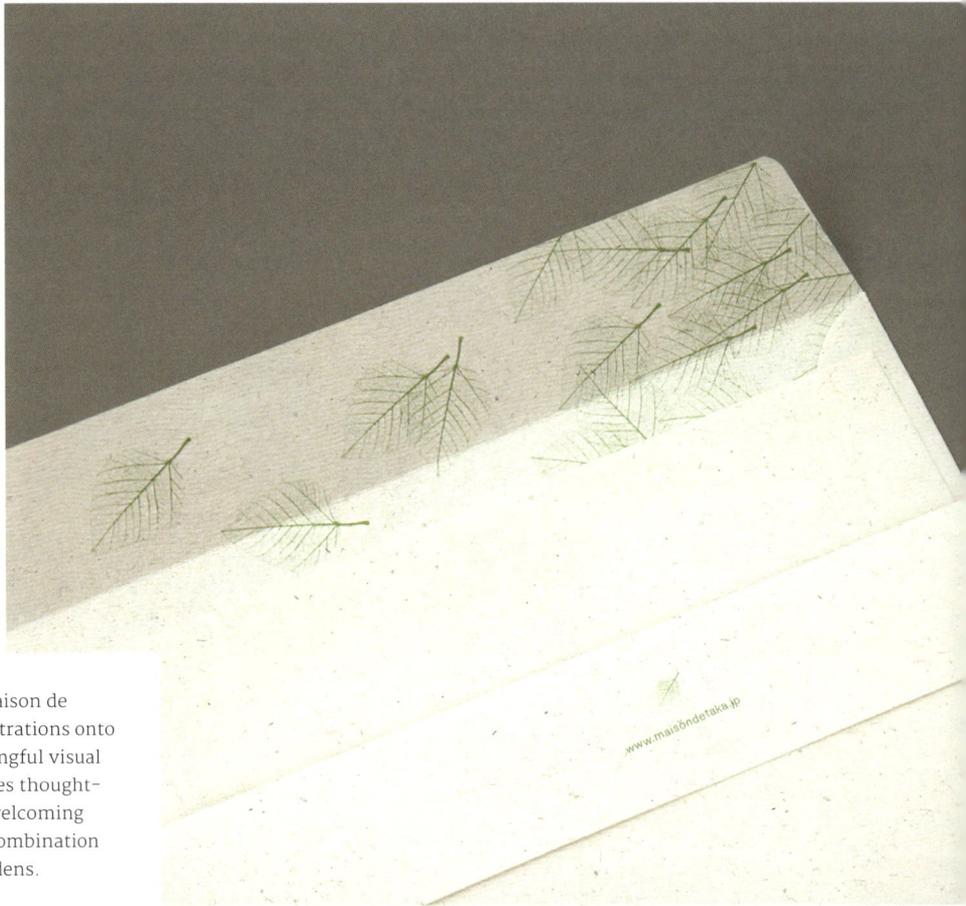

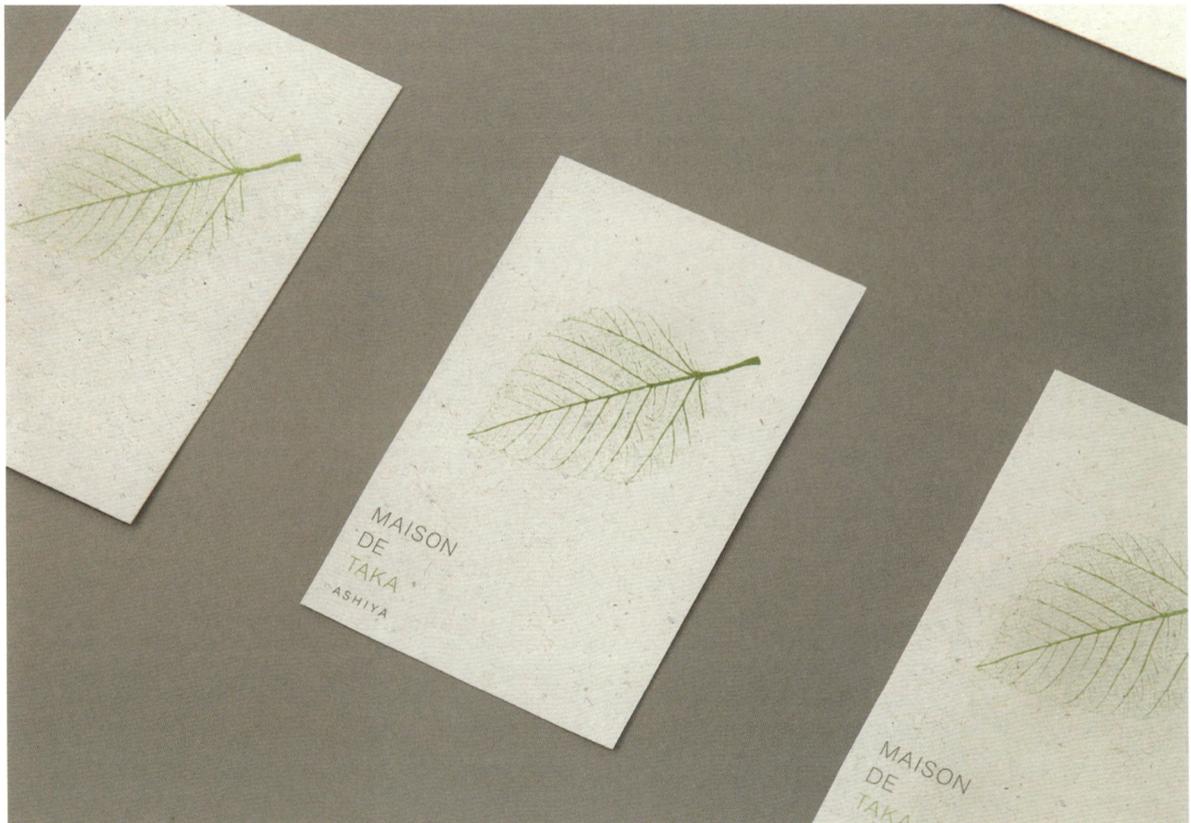

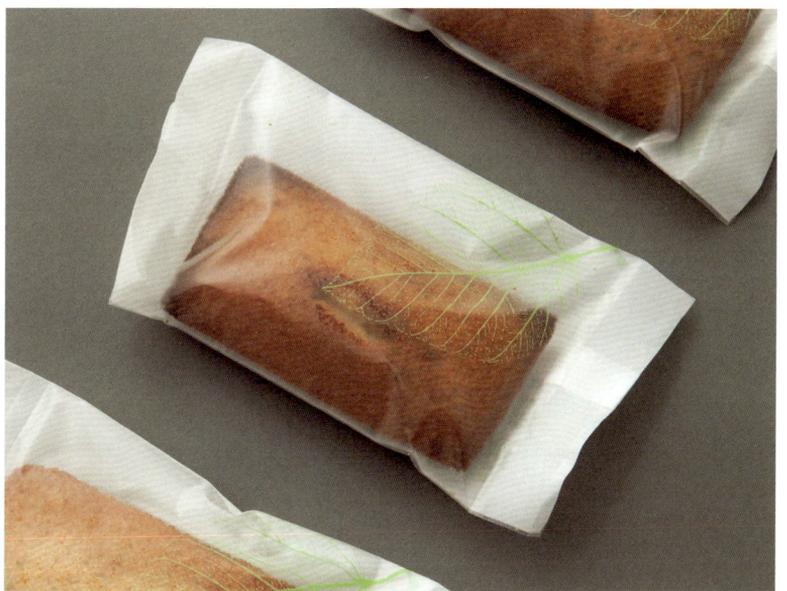

Tea Charlie Floral Scented Tea

Drawn to the image of a delicate bud folding and unfolding in water, Yao-ming Yan froze key moments of the flower-brewing process to capture the beauty in the art of floral tea-making for Tea Charlie's packaging design. The illustrations adorning the tea boxes paint a subtle yet striking picture of life, which is full of meaningful little moments. Different colour treatments were used to highlight two of the flavours in its Floral Scented Tea product line.

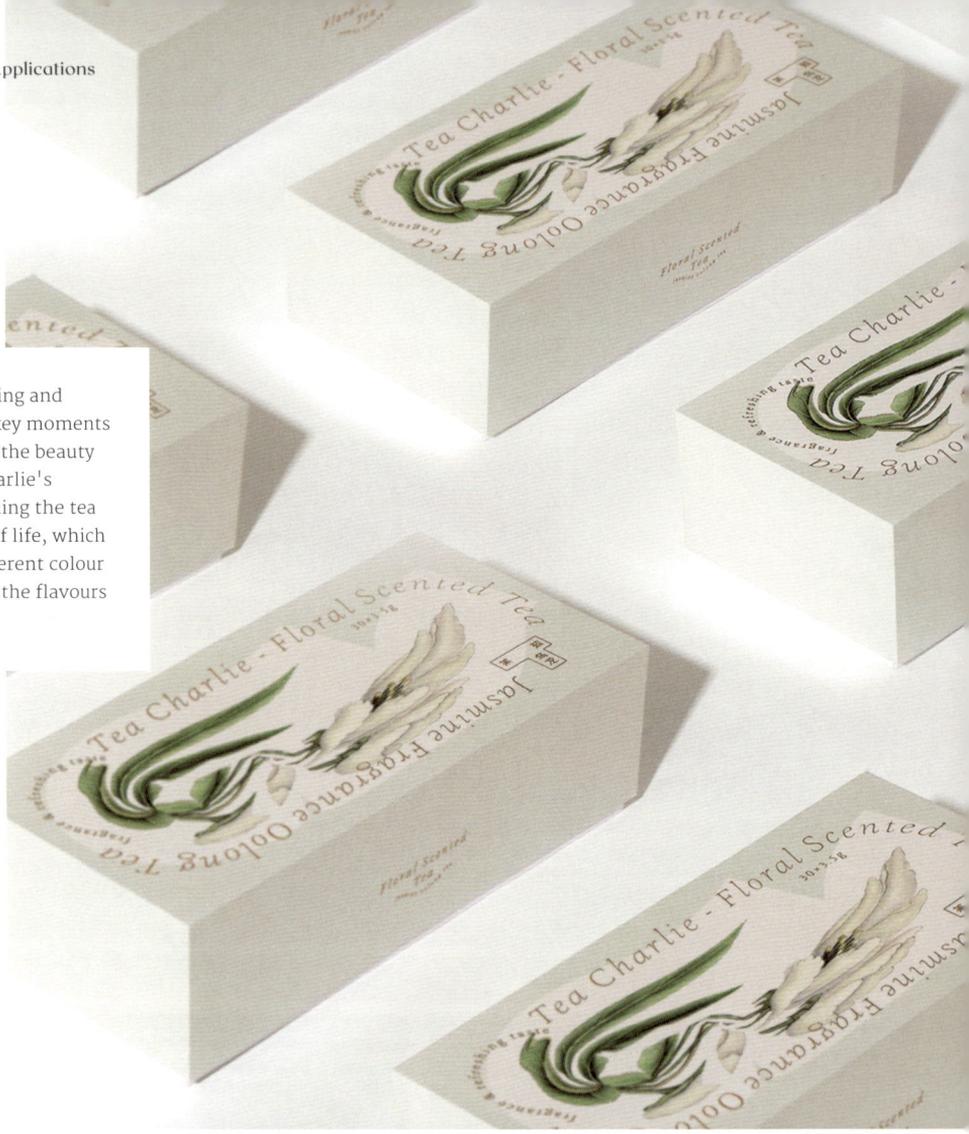

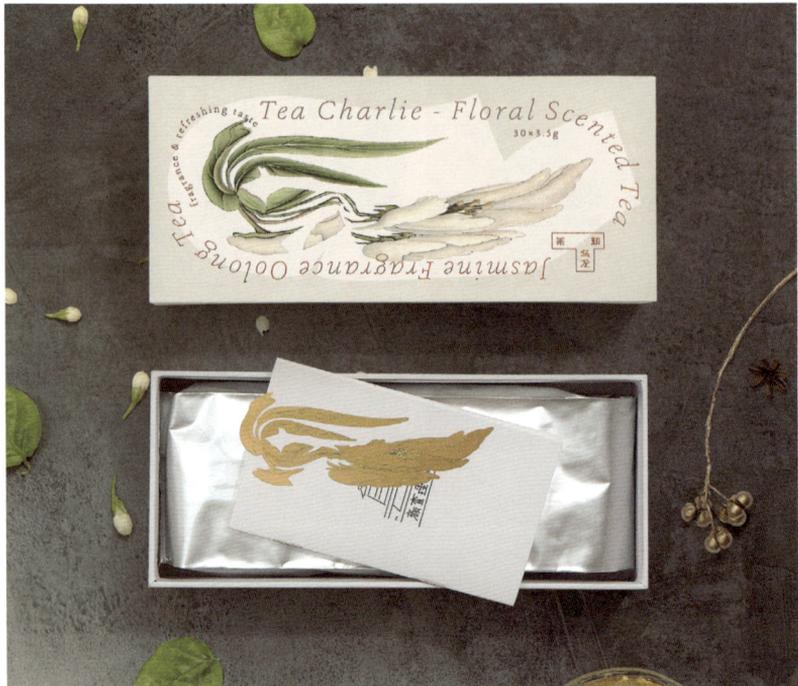

Design
Yao-ming Yan

Client
Tea Charlie

Photography
Xingyun

Illustration
Yuan-hao Liu

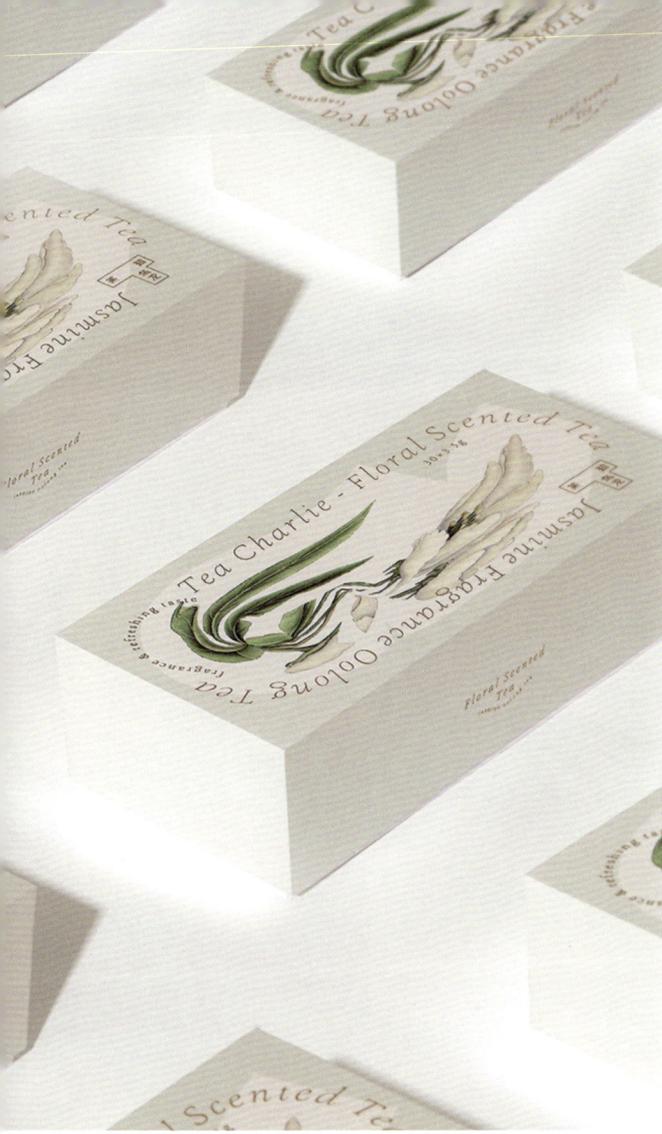

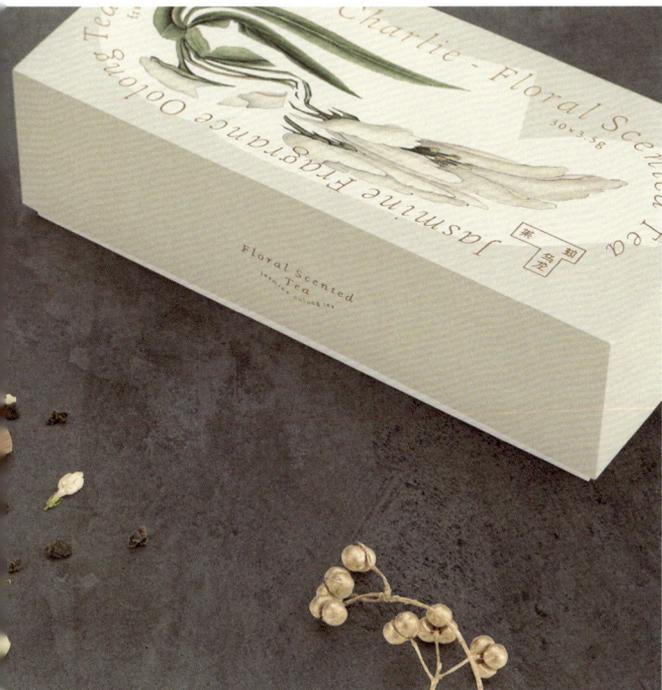

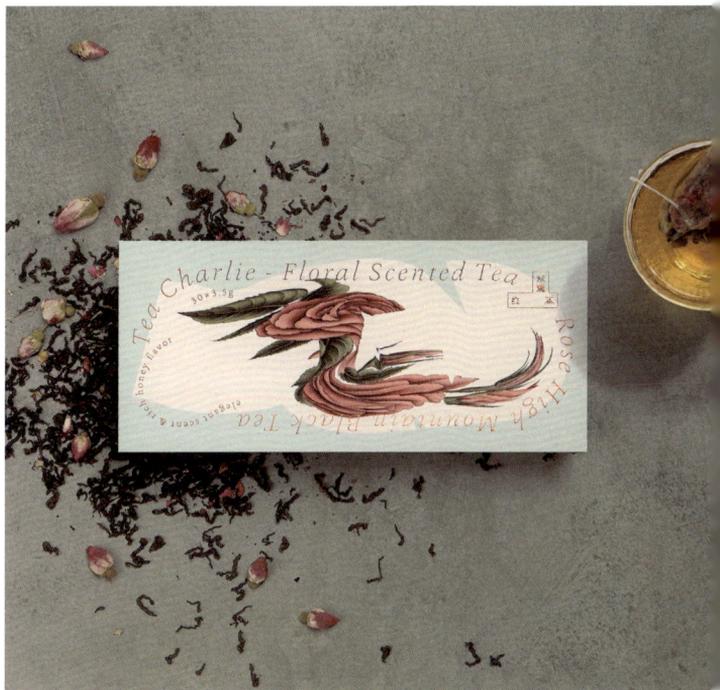

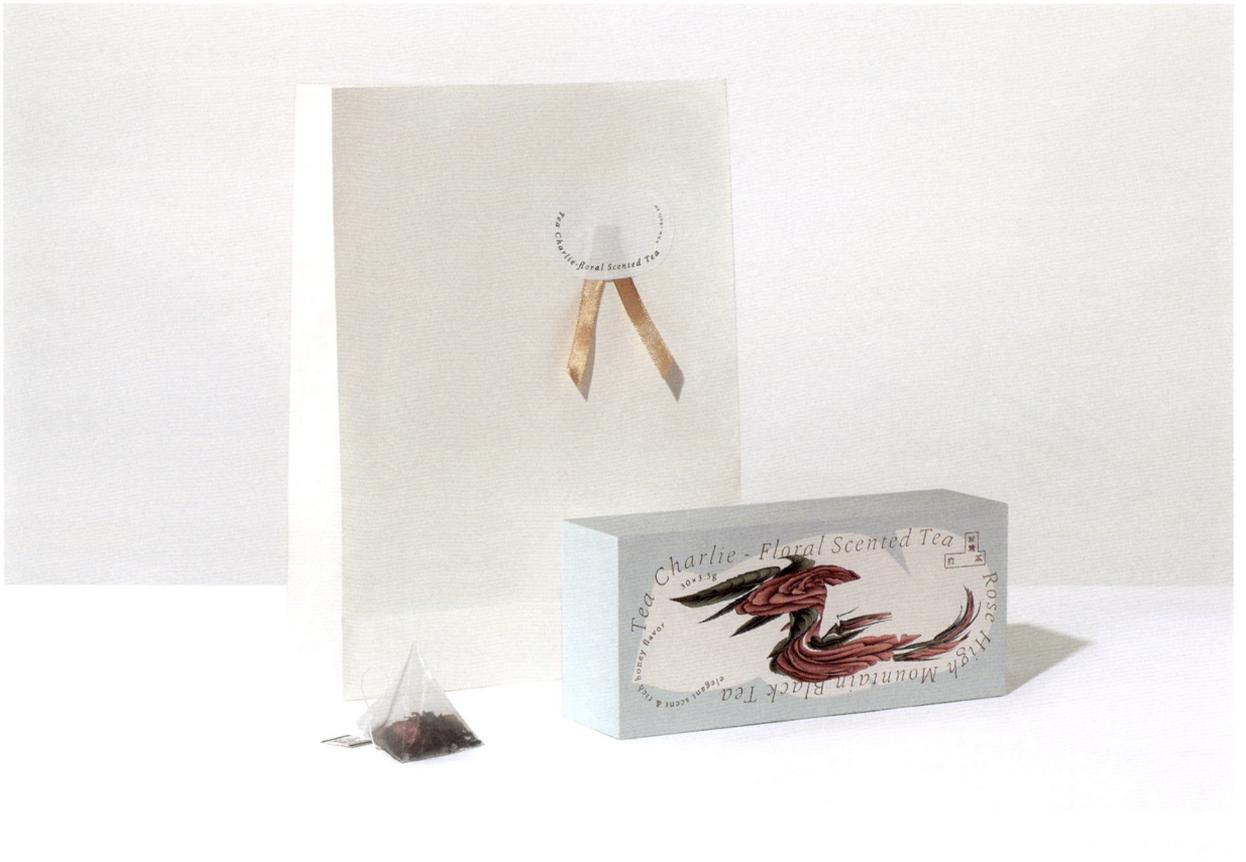

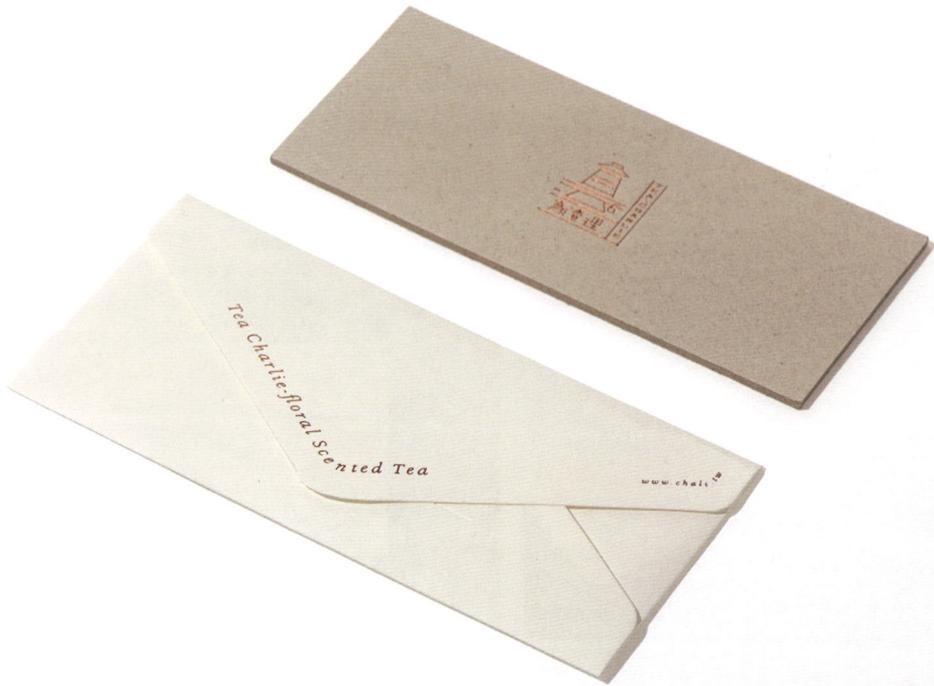

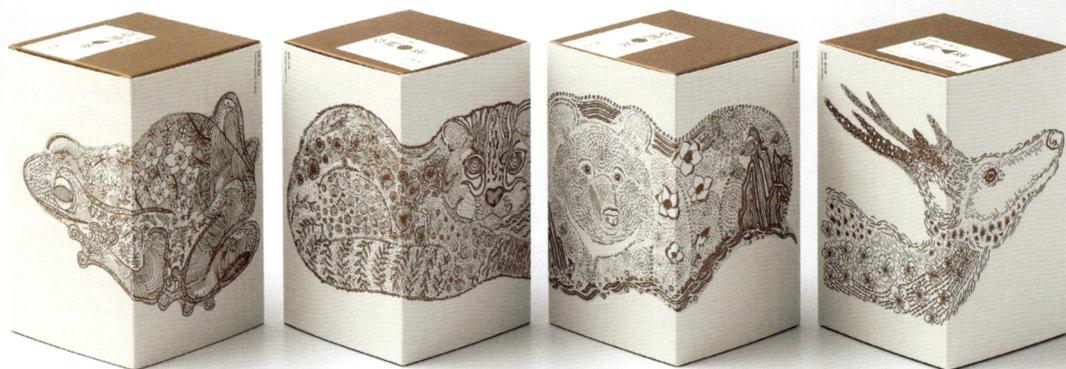

Tse-Xin Organic Tea Carrying Case

Embodying its devotion to organic cultivation, the Taiwan Tea Series of Conserved Animals' packaging design features delicate handmade illustrations in a golden-brown tea hue. When placed next to each other, the four different boxes form a complete map of Taiwan, while revealing different animals and natural habitats when separated. Altogether, SanYe Design Associates' creative work encapsulates the brand's eco-friendly mission to truly cherish the Earth.

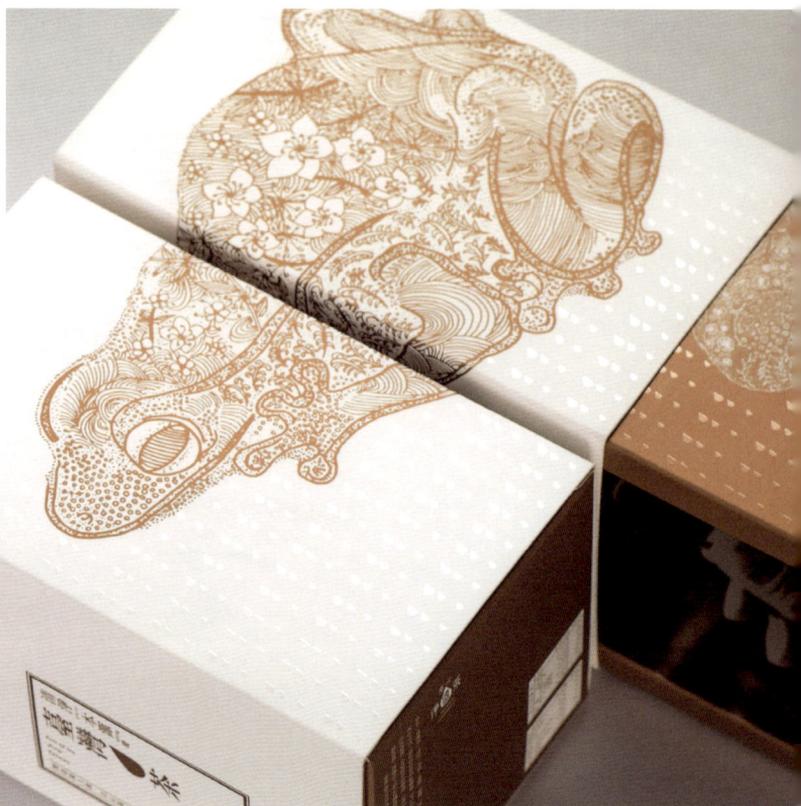

Design
SanYe Design Associates

Client
Tse-Xin Organic
Agriculture Foundation

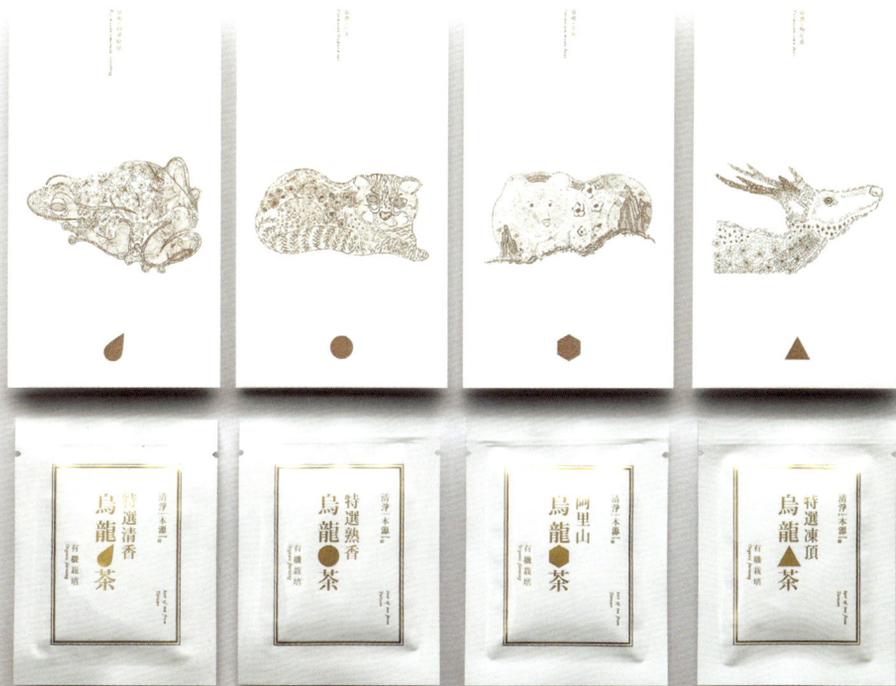

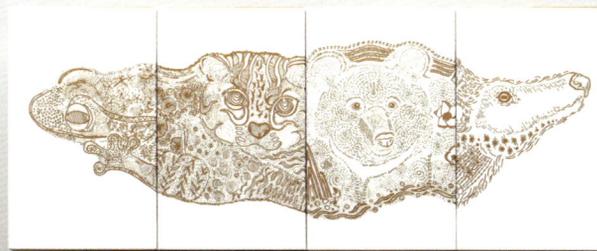

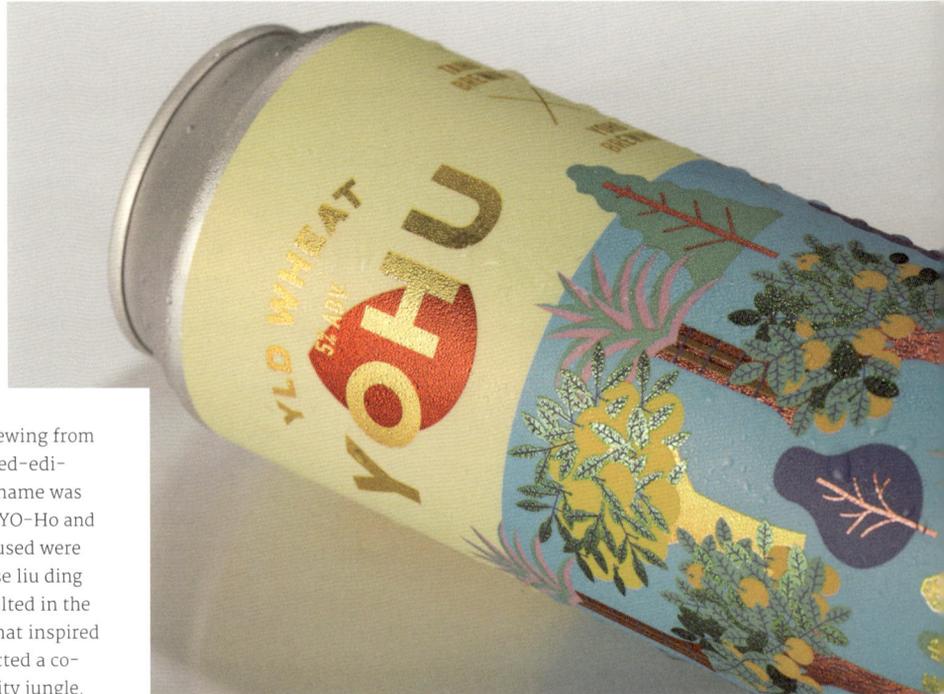

YOHU YLD
WHEAT

Yo-Ho Brewing from Japan and Taihu Brewing from
Taiwan worked together to create a limited-edi-
tion, seasonal beer called YOHU. Its full name was
a combination of their company names (YO-Ho and
TaiHU), while the two main ingredients used were
the Japanese yuzu fruit and the Taiwanese liu ding
fruit. The first letters of these fruits resulted in the
acronym YLD or 'wild' — the key word that inspired
HOUTH to design its tin can, which depicted a co-
lourful adventure through a wild and fruity jungle.

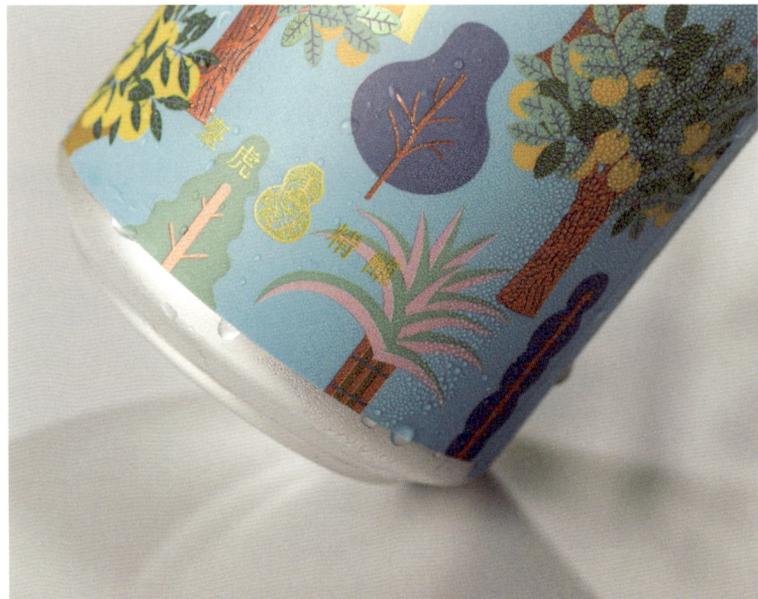

Design
HOUTH

Client
Taihu Brewing
Yo-Ho Brewing

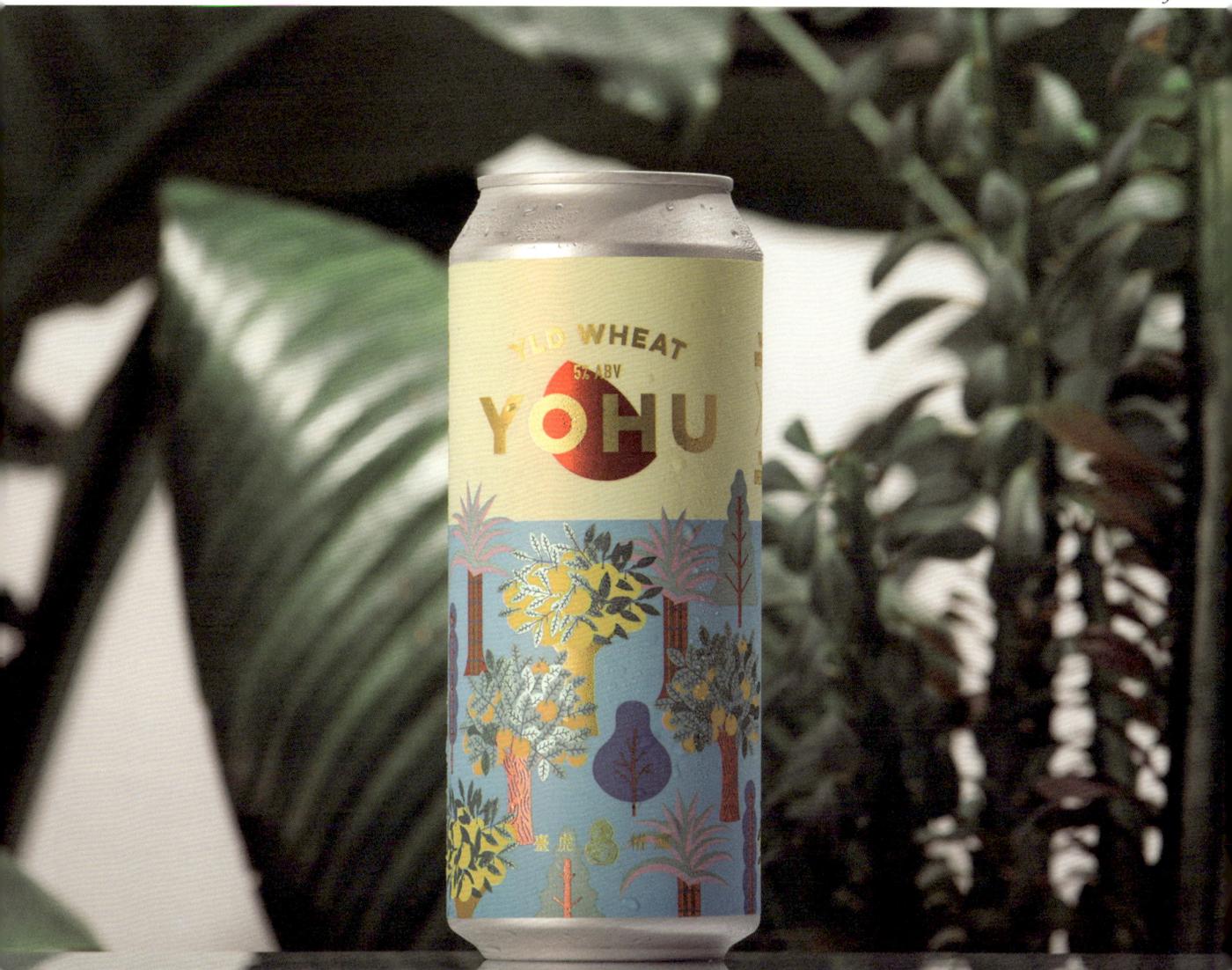

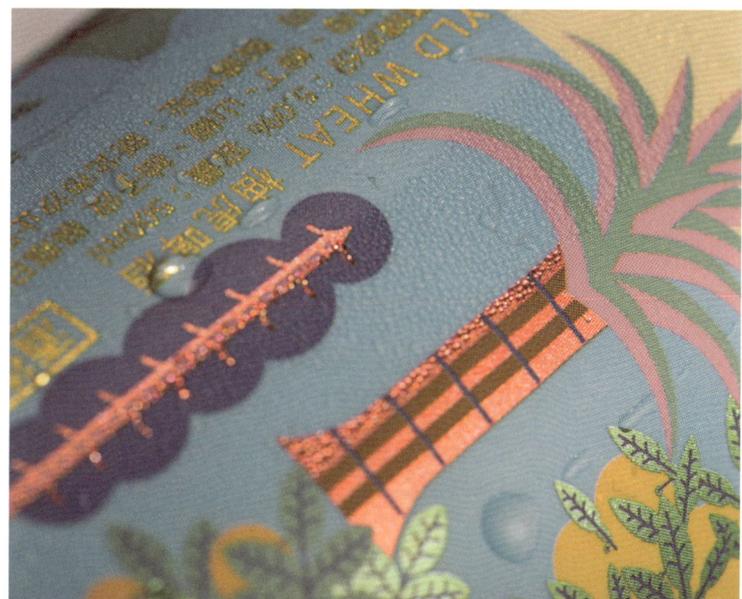

Design
IWANT Design

Client
Wölffer Estate

Wölffer Gin

Inspired by the Wölffer Estate 'Pink' Gin's signature aesthetic quality, IWANT Design sought to feature and complement the drink's unique hue in their label design work. While the glass bottle allows for light to shine through and reflect off the pink liquid, the label features an inverted scalloped edge and an intricate illustration of a butterfly to embody both the luxurious nature of the brand, as well as the natural origins of the product.

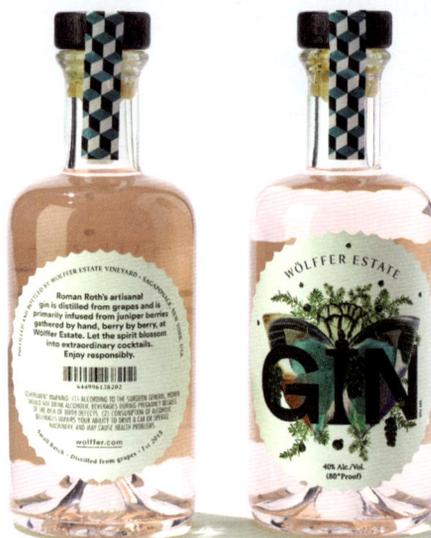

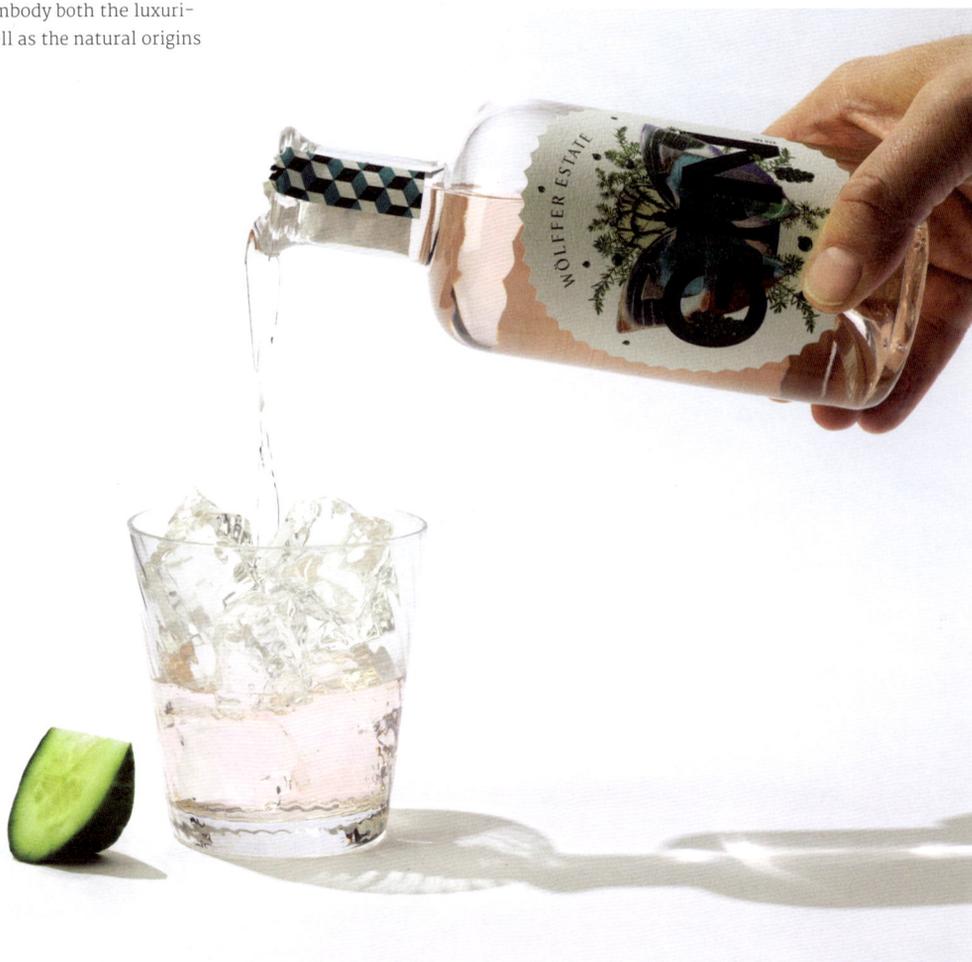

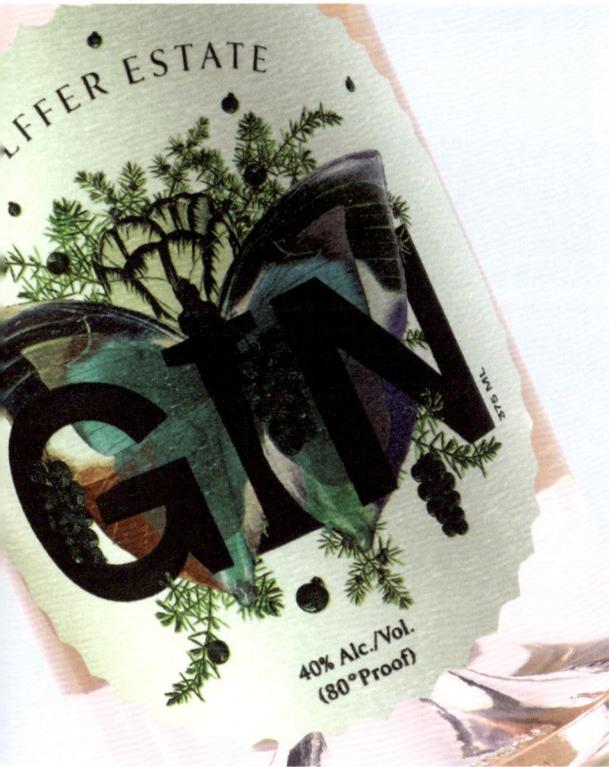

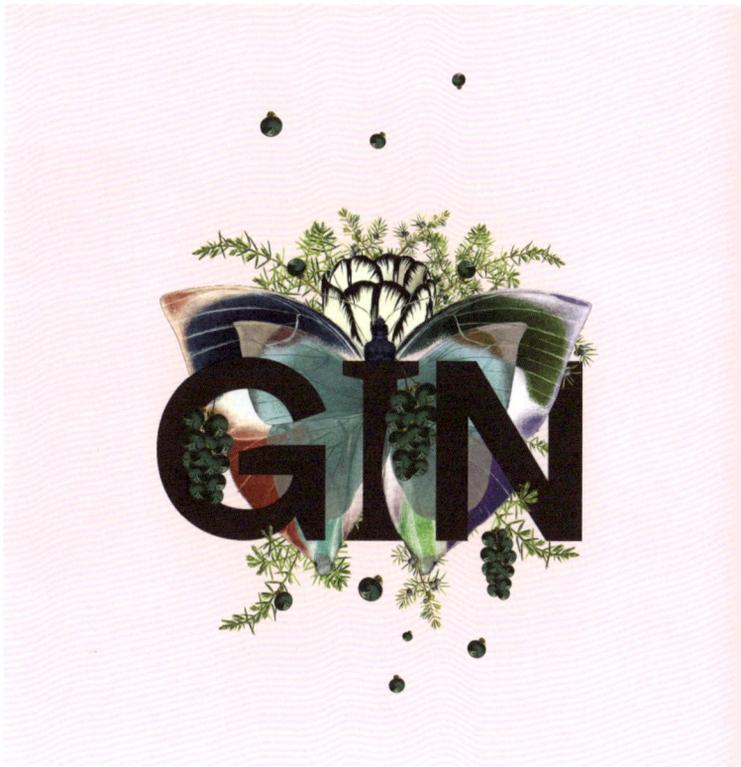

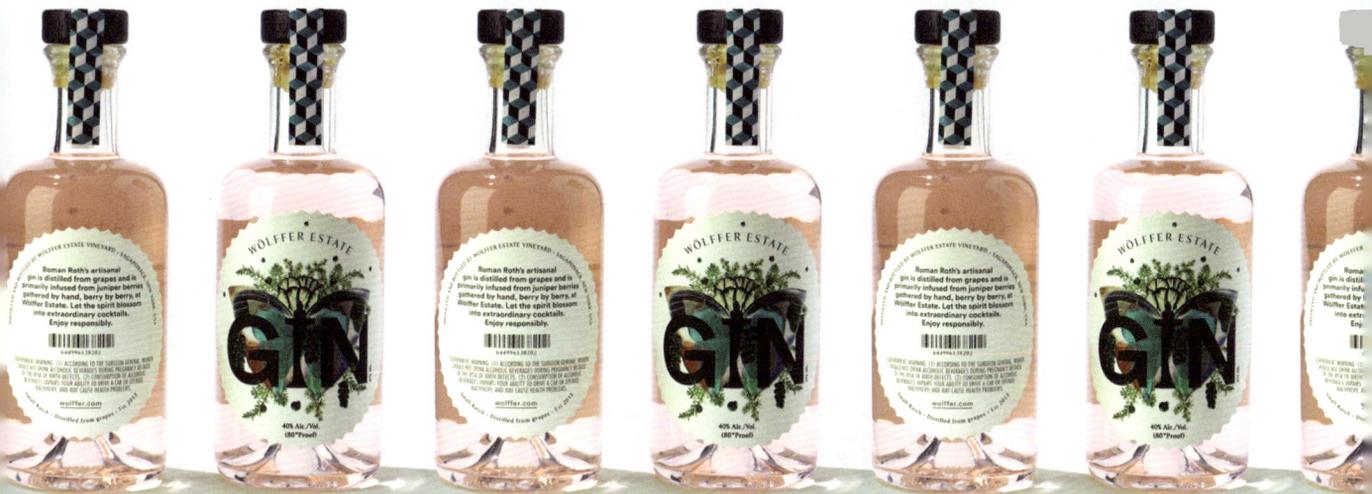

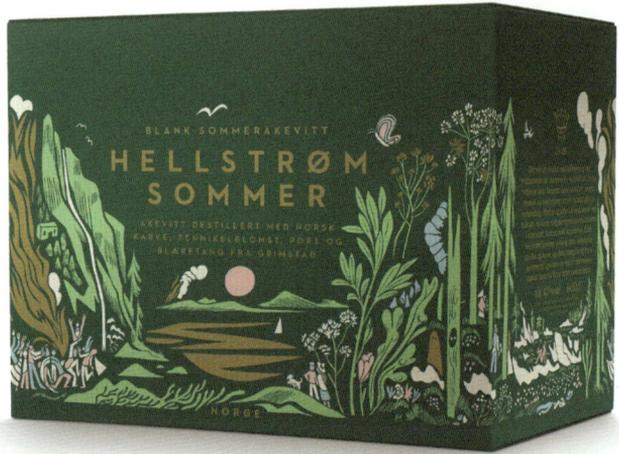

Hellstrøm
Sommer Aquavit

OlssønBarbieri's refreshing visual work for Hellstrøm Sommer – a spirit made from Norwegian seaweed and wild herbs that were handpicked along the coast – was inspired by ephemeral Norwegian summers. The emerald-green bottle forms the perfect backdrop for the label illustrations depicting a visual narrative of the summer solstice or mid-summer, which is the shortest night of the year. It is said that the power of medicinal herbs and flowers are strongest on this night, and if an unmarried woman were to pick nine kinds of flowers, she would be able to see the man she would marry in the reflection of pond water. To that end, the illustrations include nine kinds of flowers and herbs according to this folklore, as well as a caterpillar and butterfly, which are both natural symbols of rebirth.

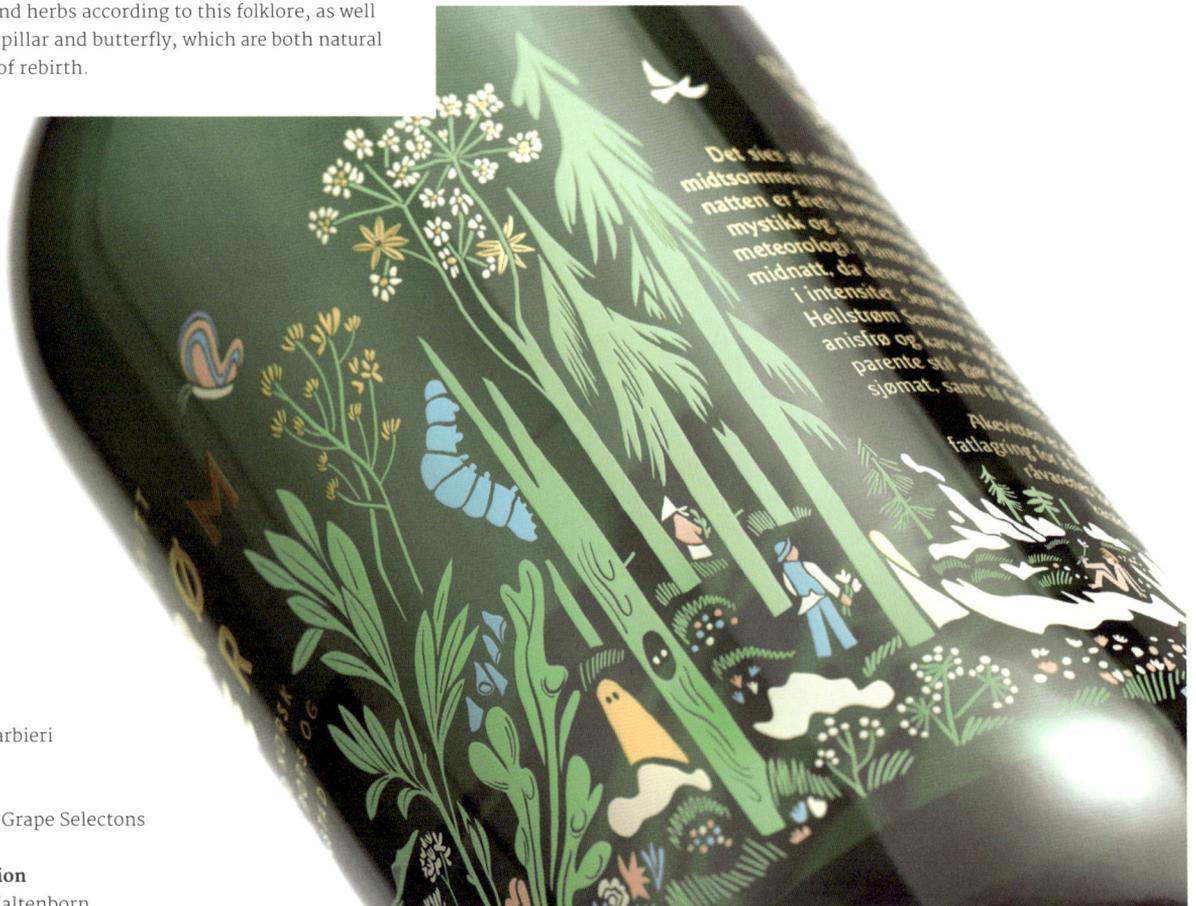

Design
OlssønBarbieri

Client
Moestue Grape Selectons

Illustration
Bendik Kaltenborn

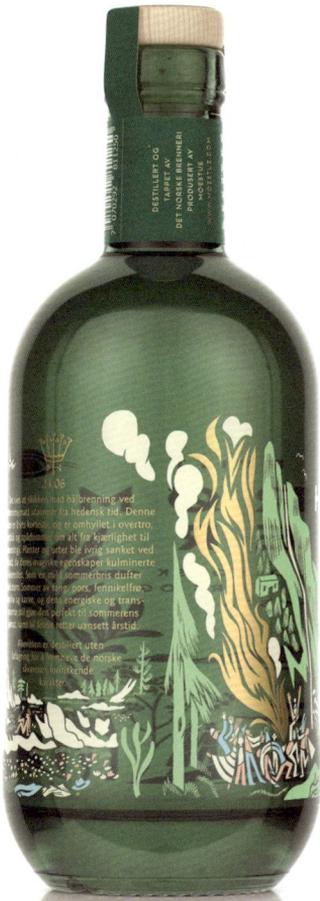

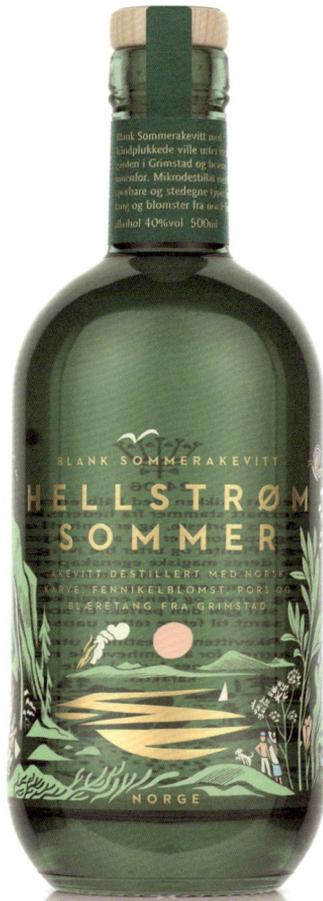

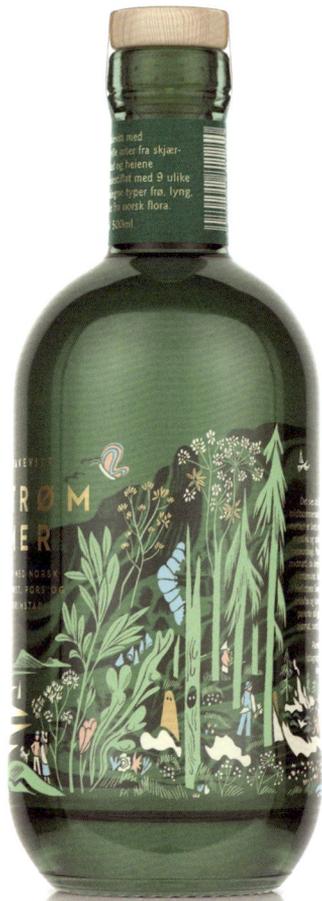

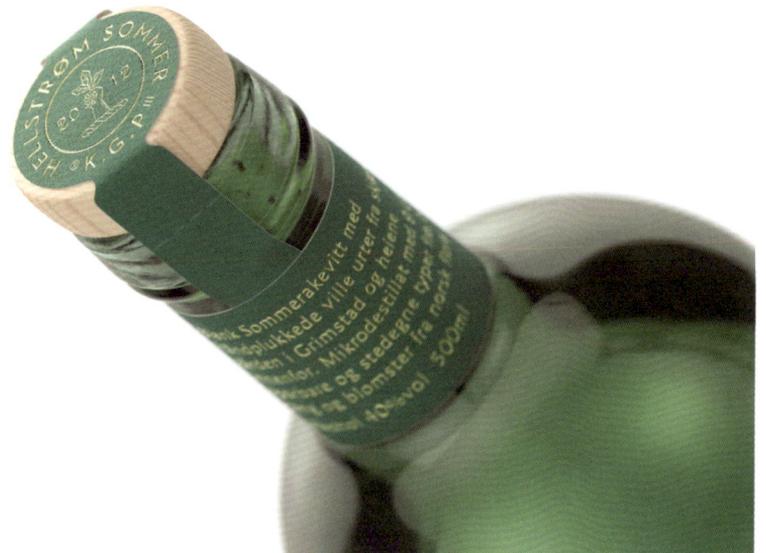

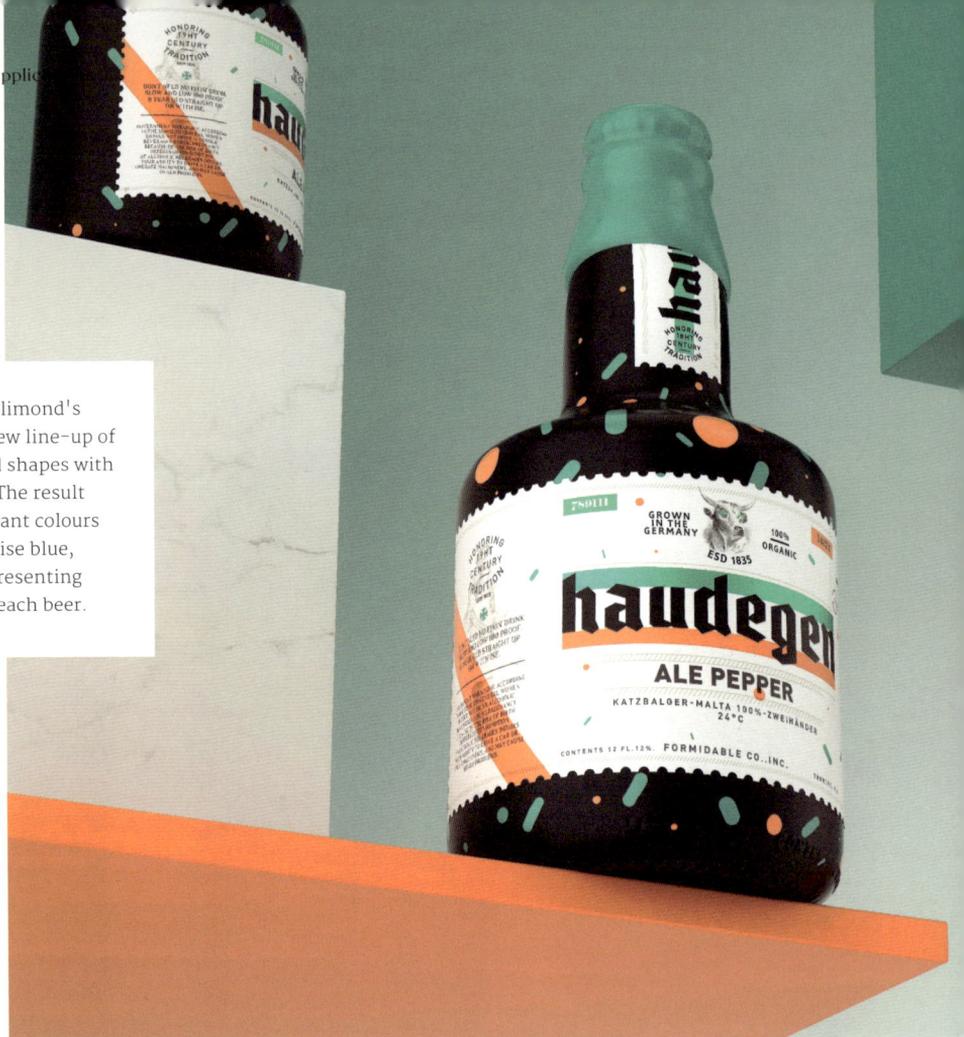

Haudegen Beer

In a collision of opposites, Constantin Bolimond's packaging design work for Haudegen's new line-up of beers combine contemporary colours and shapes with the brand's traditional craft of brewing. The result is a creative visual identity featuring vibrant colours like leaf green, lemon yellow, and turquoise blue, alongside fun details like coca leaves representing confetti to capture the unique flavour of each beer.

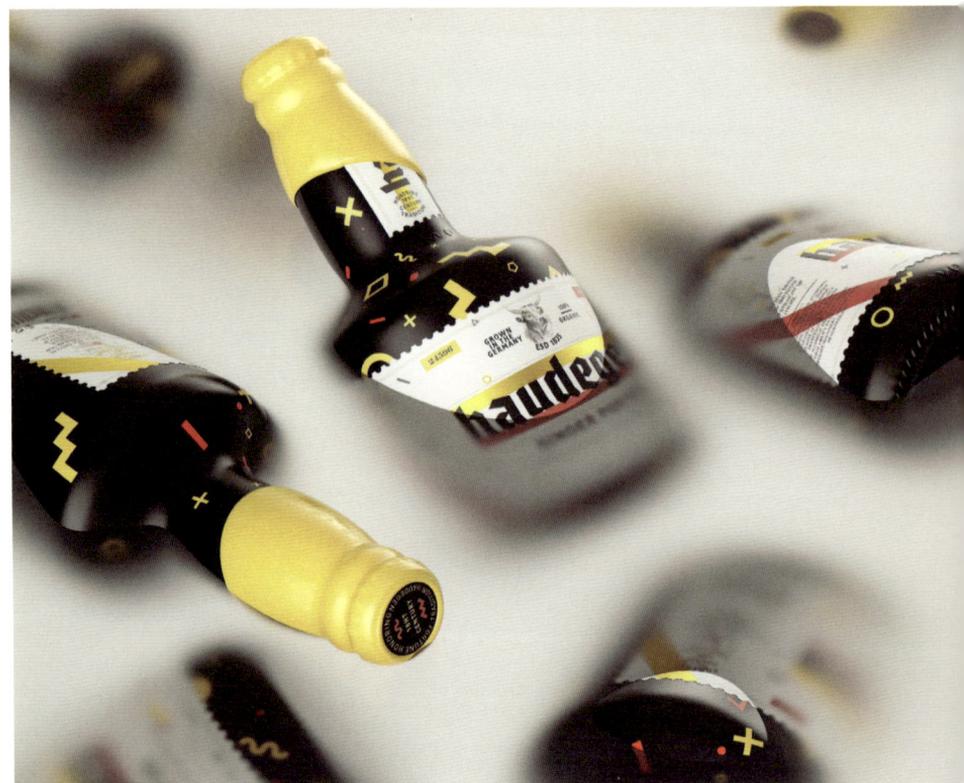

Design
Constantin Bolimond

Client
Haudegen Beer

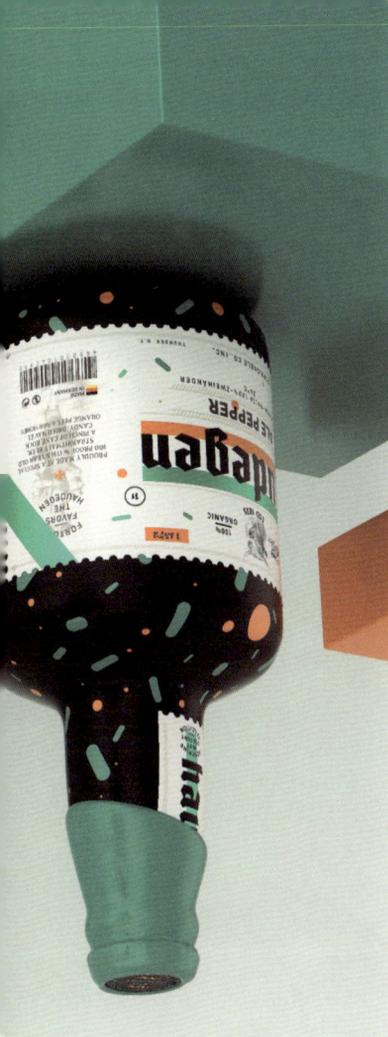

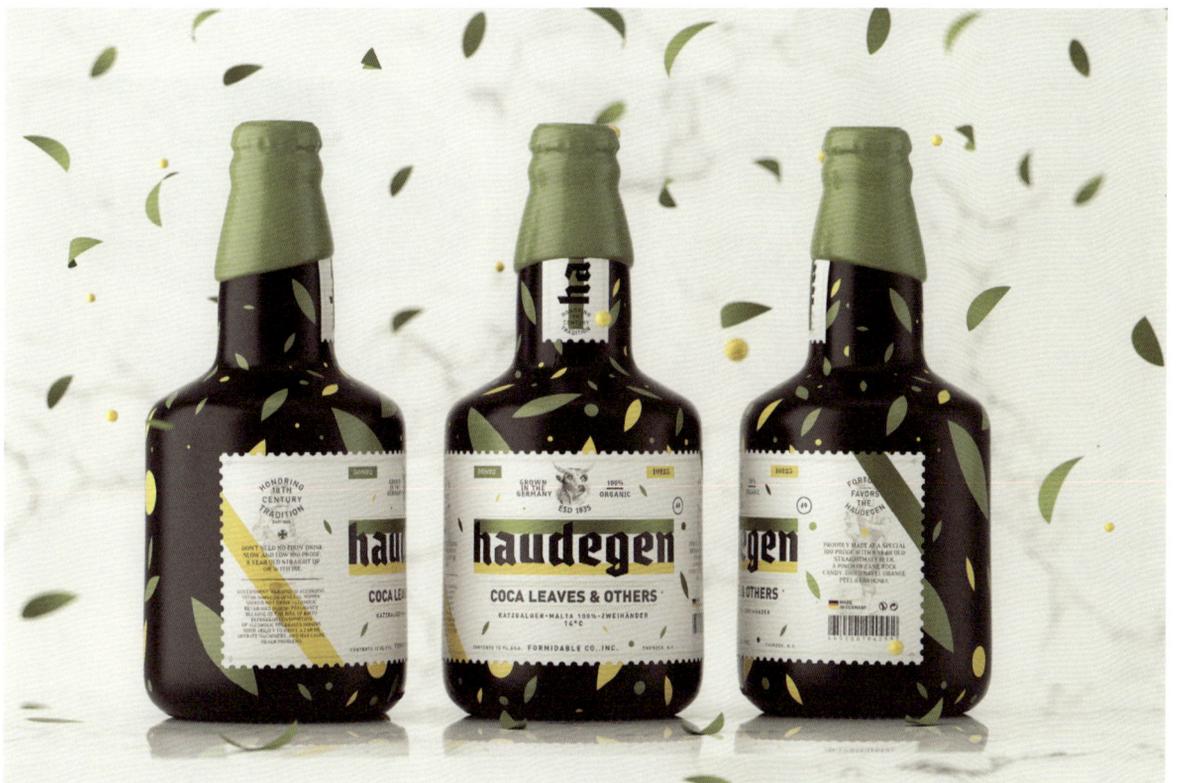

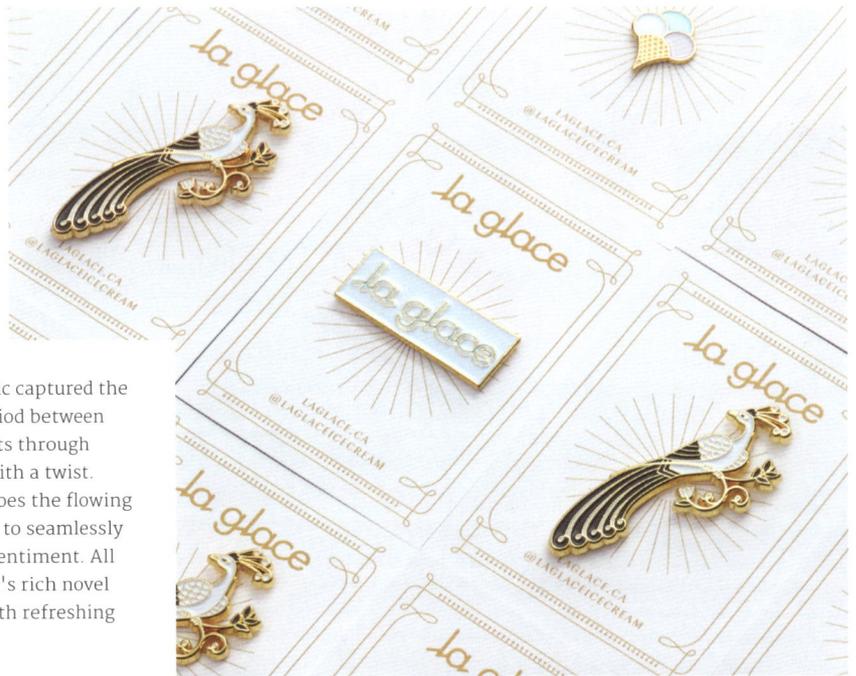

La Glace

For La Glace ice cream parlour, arithmetic captured the timeless elegance of the transitional period between the Art Nouveau and Art Deco movements through vintage Chinoiserie-style illustrations with a twist. The geometric-yet-cursive logotype echoes the flowing curves of the peacock feathers and vines to seamlessly merge modern nuances with historical sentiment. All in all, the design work reflects the brand's rich novel flavours and nostalgic charm that are both refreshing and familiar to today's consumers.

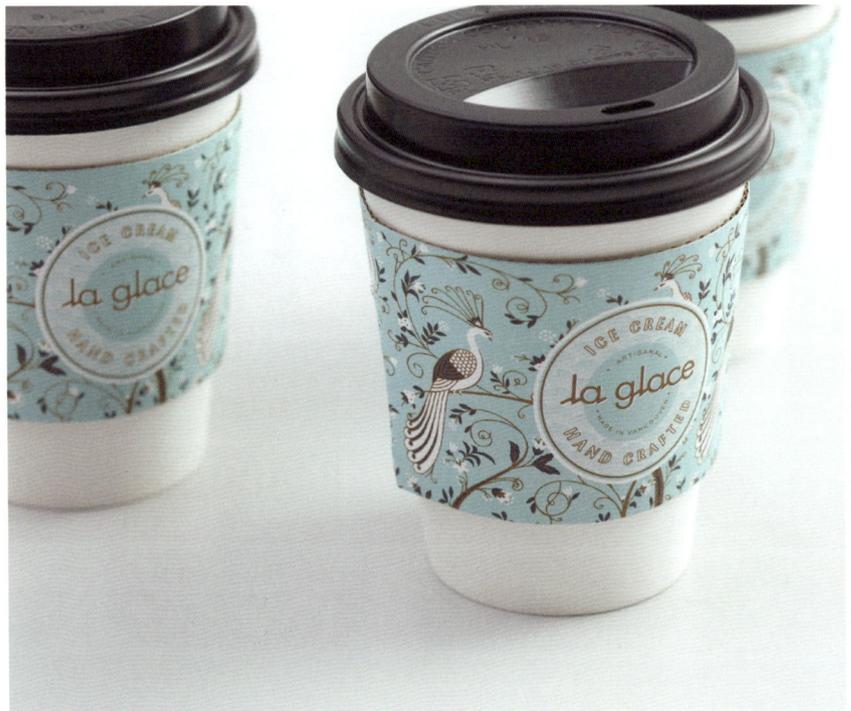

Design
arithmetic

Client
La Glace

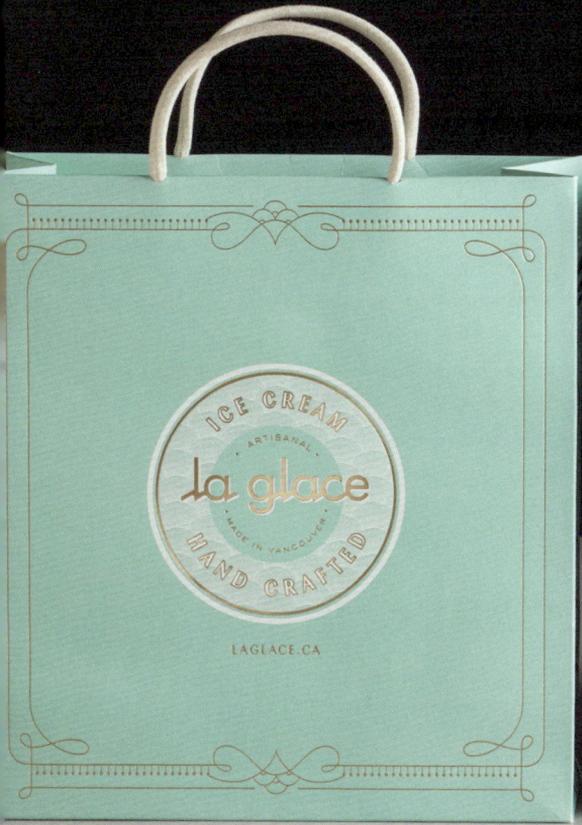
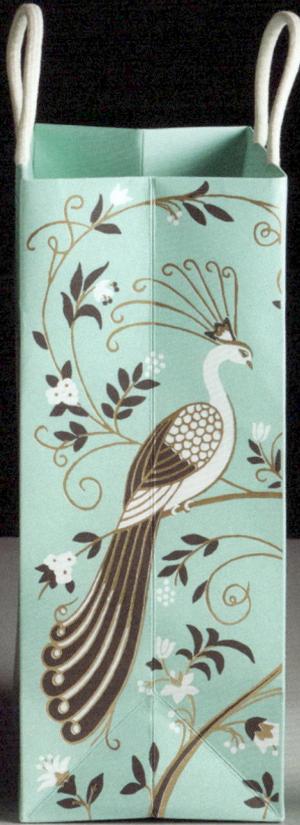

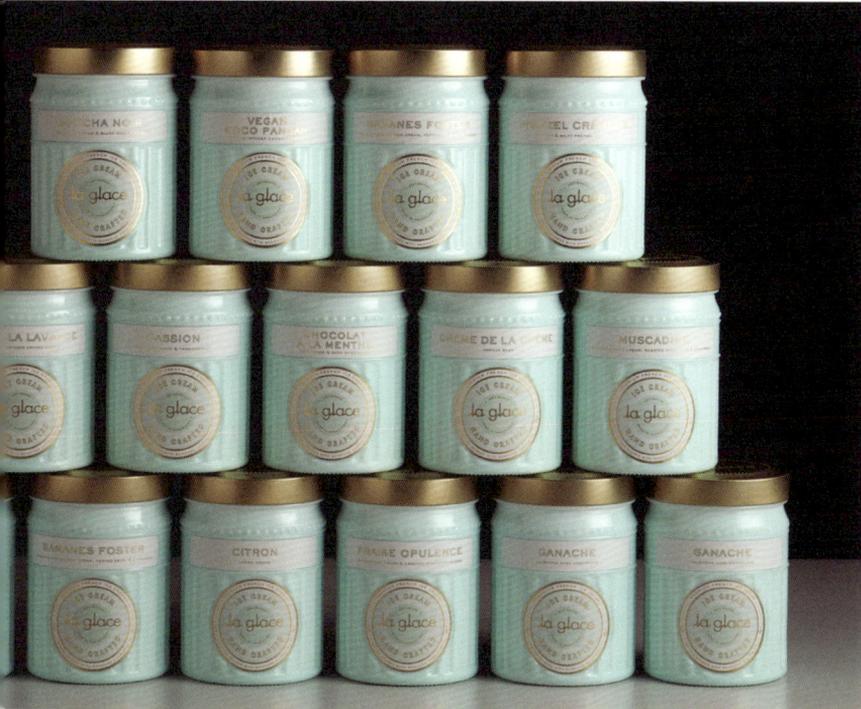

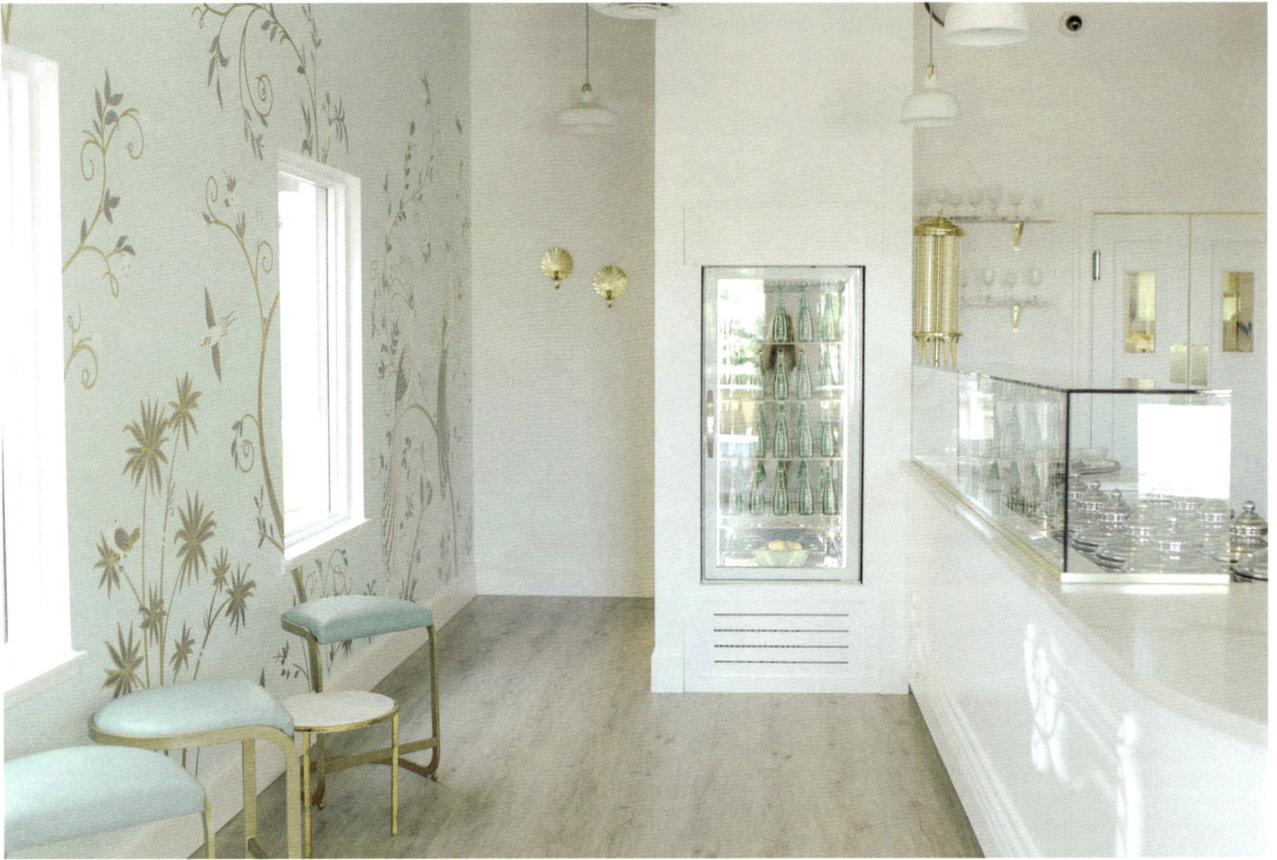

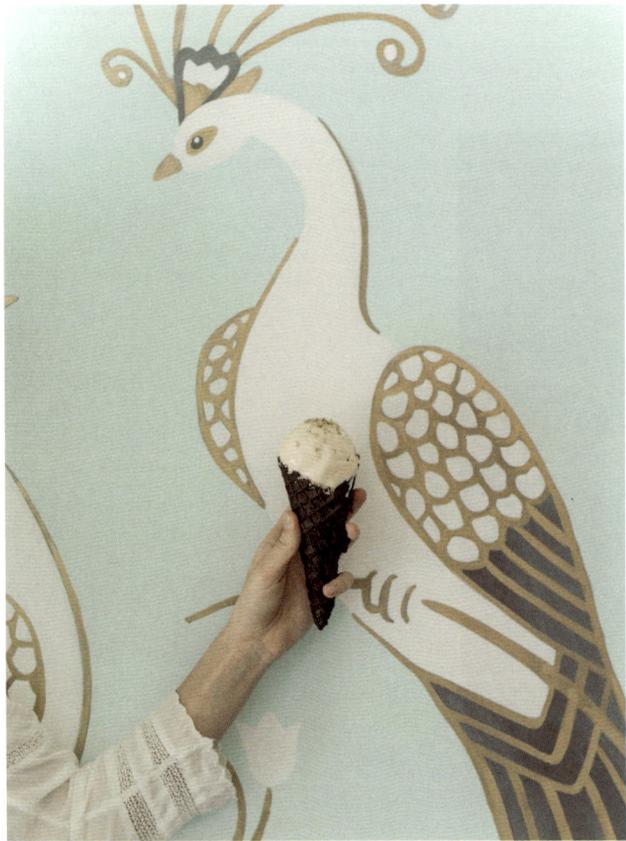

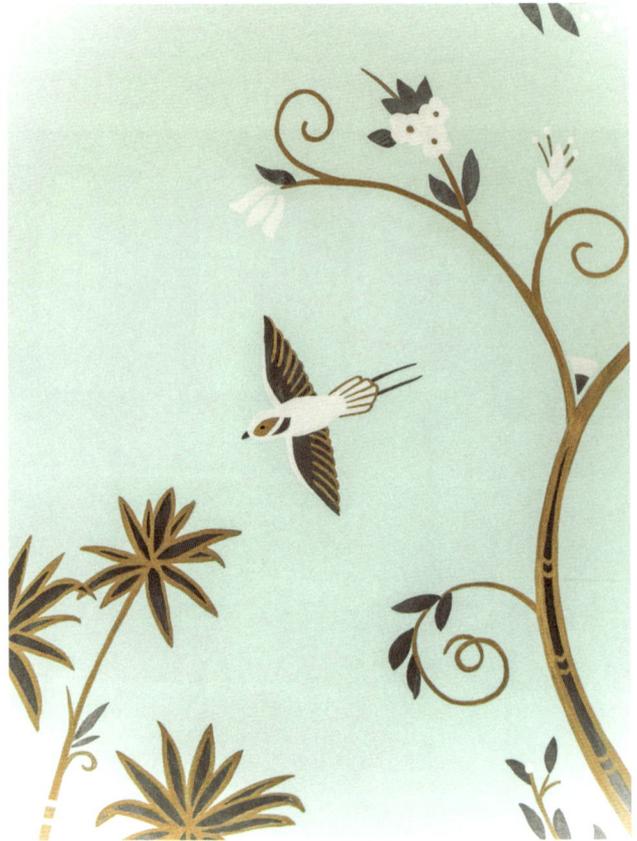

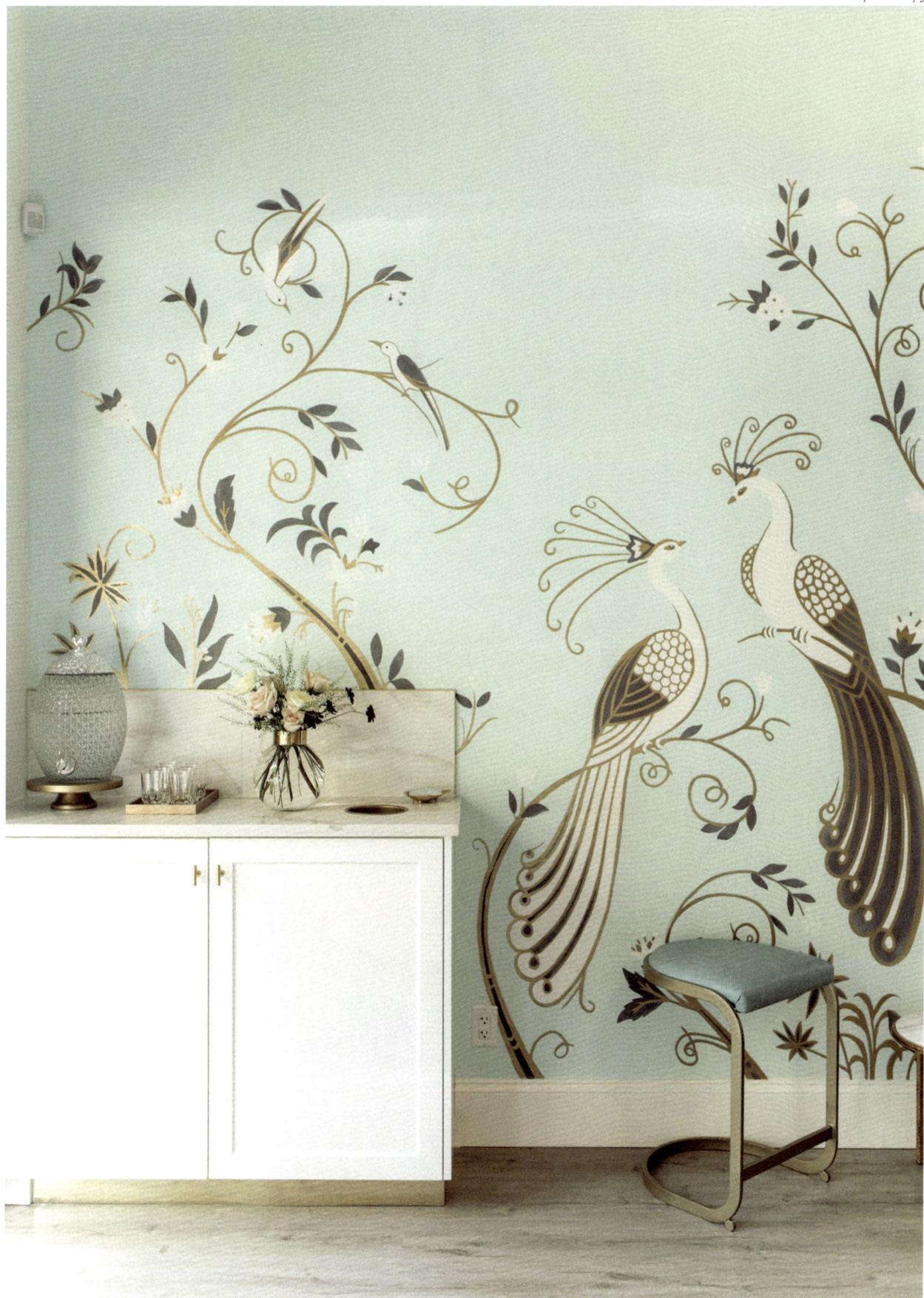

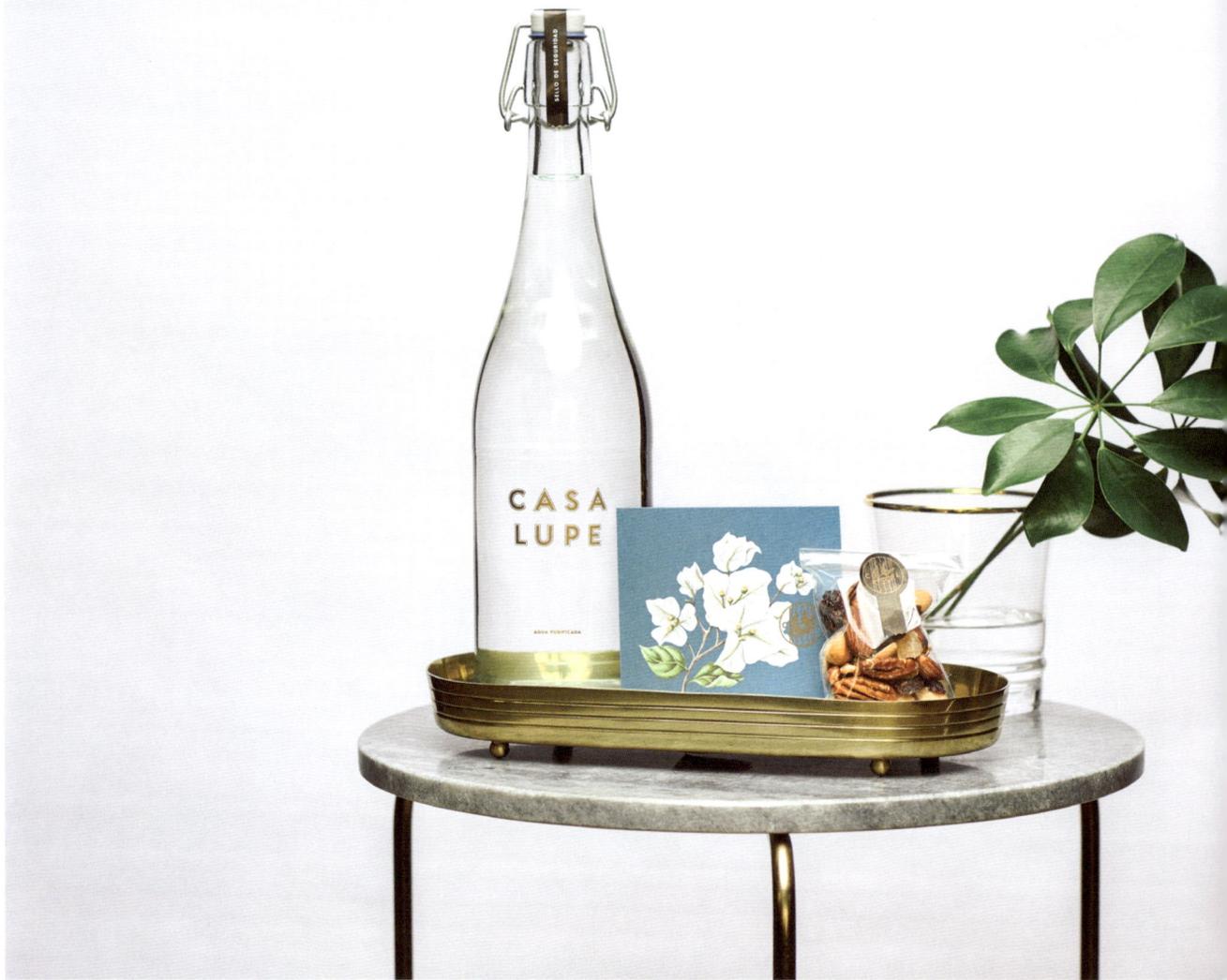

Casa Lupe

To express the feeling of nostalgia from echoes of recent travels, Menta's visual identity for Casa Lupe revolves around a sparrow design that was brought to life by the spirit of Art Deco that still lingers around the area surrounding the AirBnB. Its stylised logo is accompanied by a series of botanical illustrations inspired by the local plants that are found nearby, such as the bougainvillea, jacaranda, and geranium flowers that brighten up the city of Guadalajara.

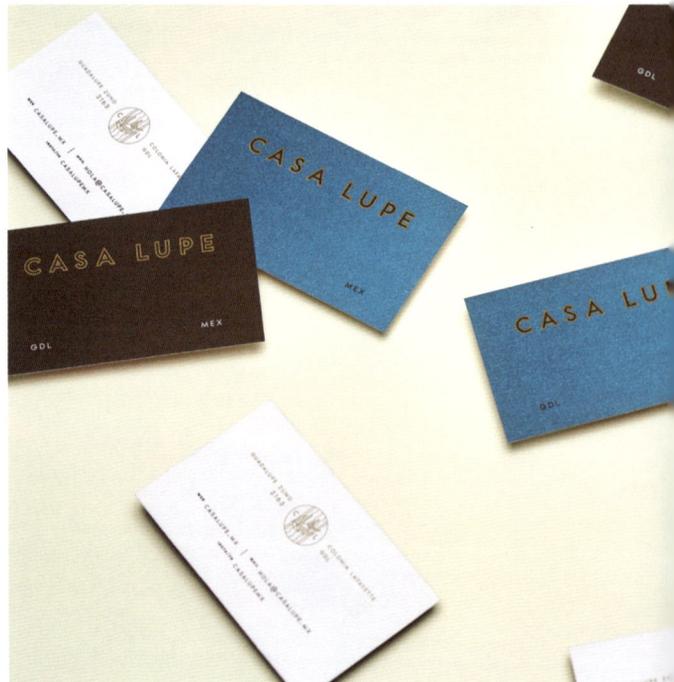

Design
Menta

Client
Casa Lupe

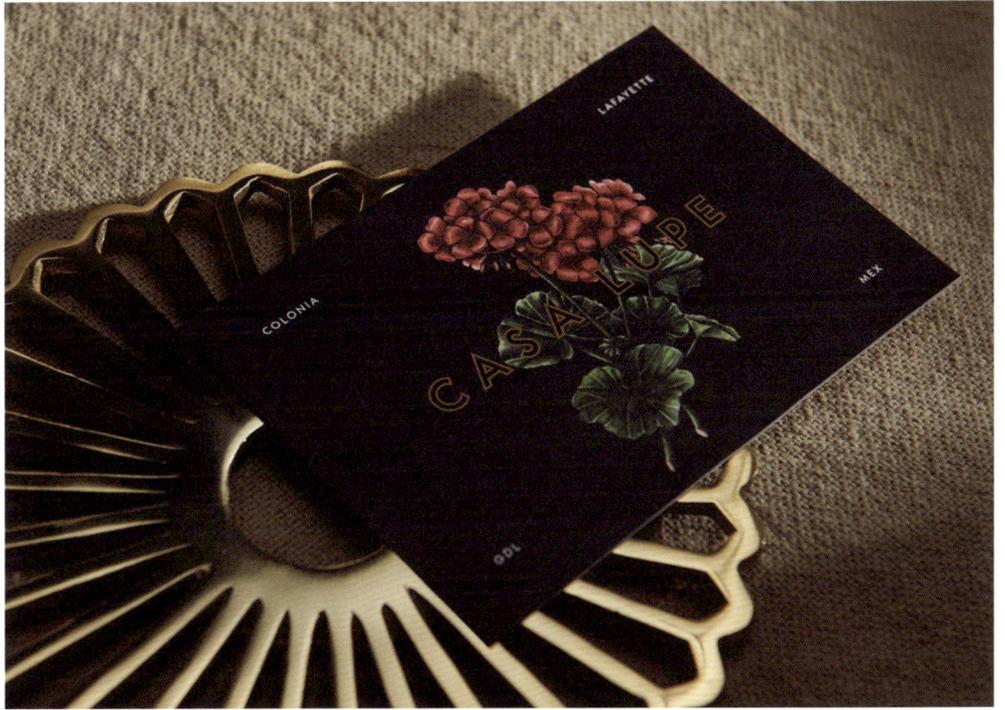

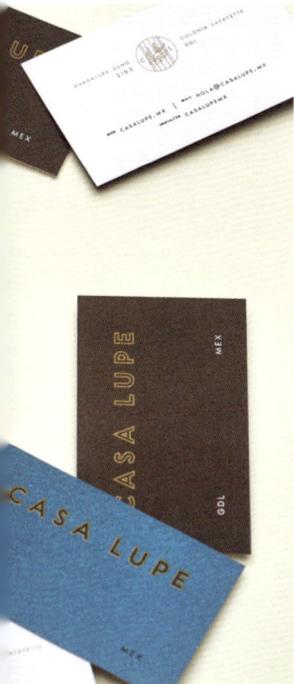

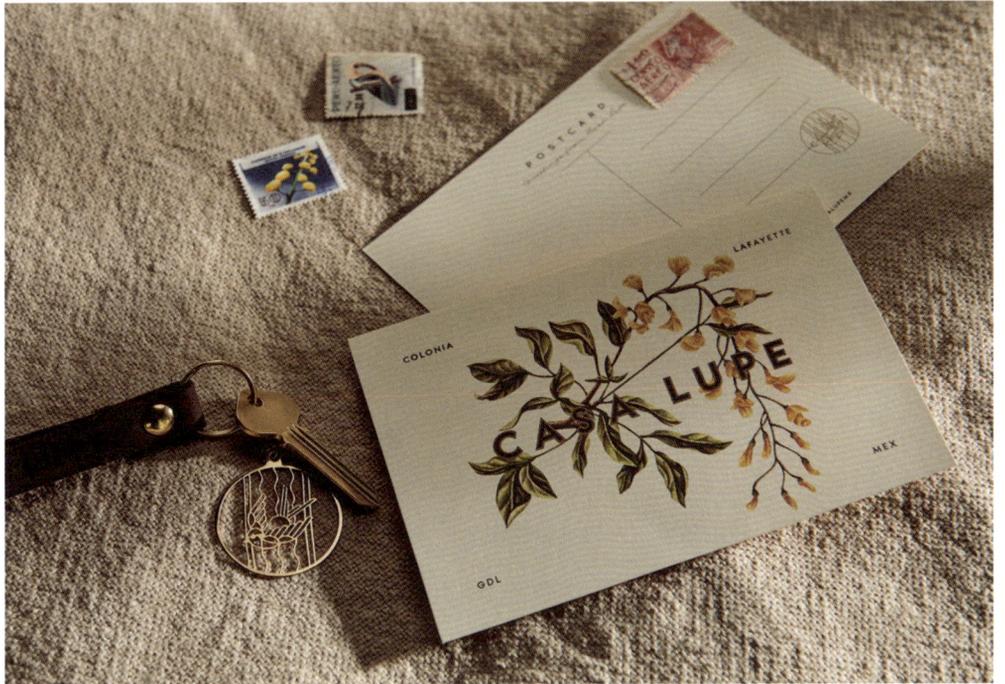

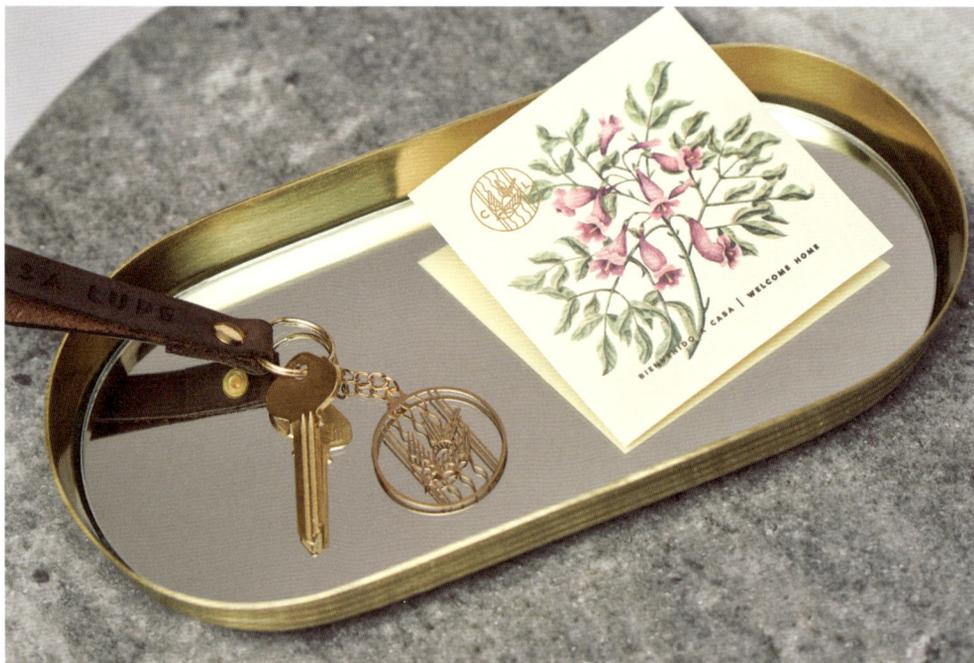

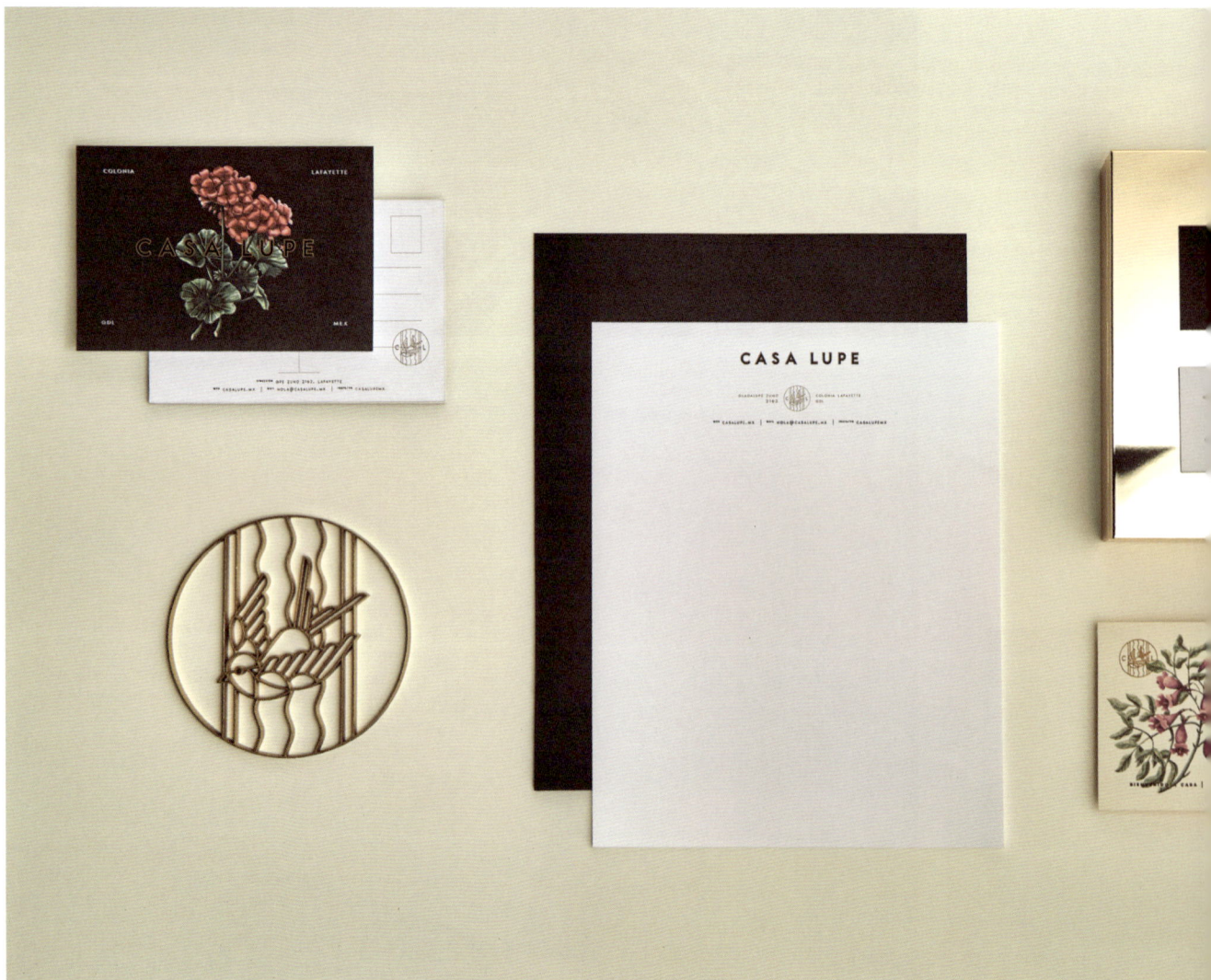

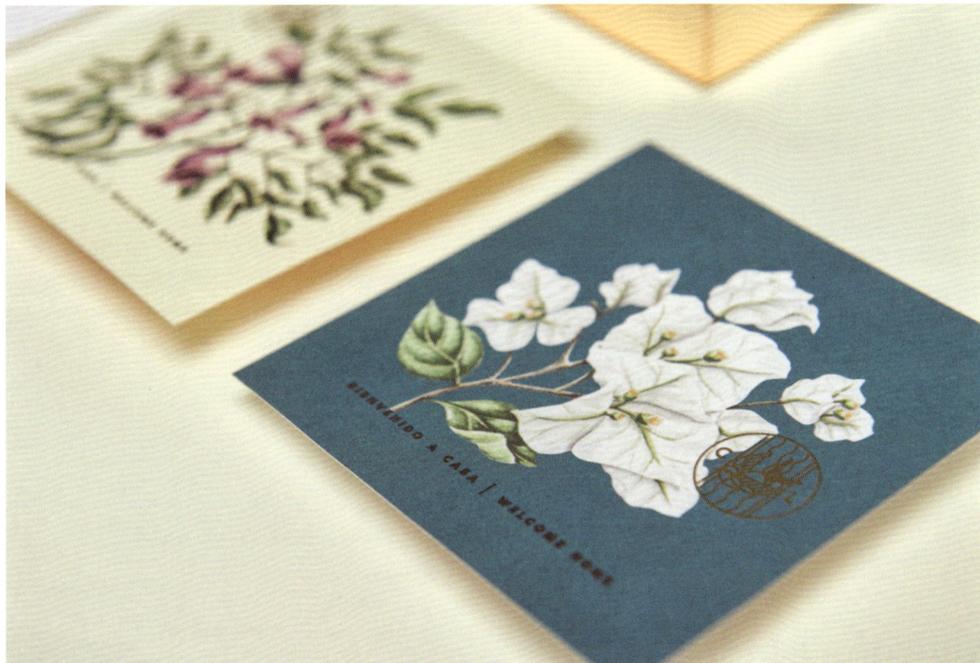

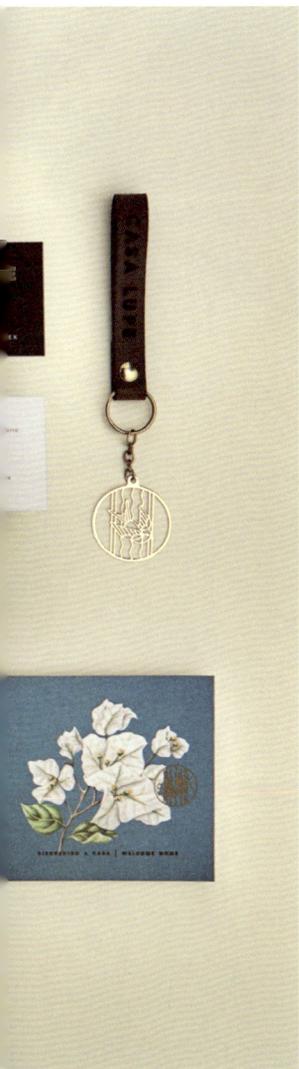

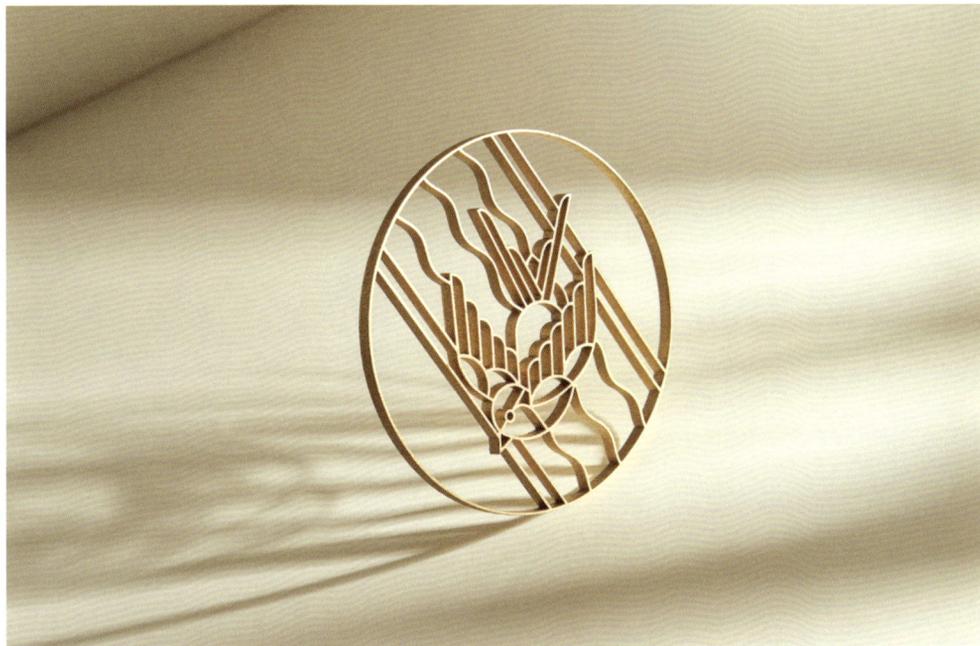

Miavana Island Sanctuary

For an exclusive, eco-friendly luxury resort off the coast of the Madagascar mainland, Xfacta sought to capture the beauty and balance of Mother Nature through its name Miavana, which means 'to reconcile' in Malagasy. The logotype was inspired by the rippling waves of the Indian Ocean meeting the pristine beaches near the resort, while the rich copper and turquoise palette draws from the colours around the island. To reflect Madagascar's French heritage and culture, the visual identity also features Breton stripes with illustrations of local flora and fauna in traditional Madagascan woodcut-style.

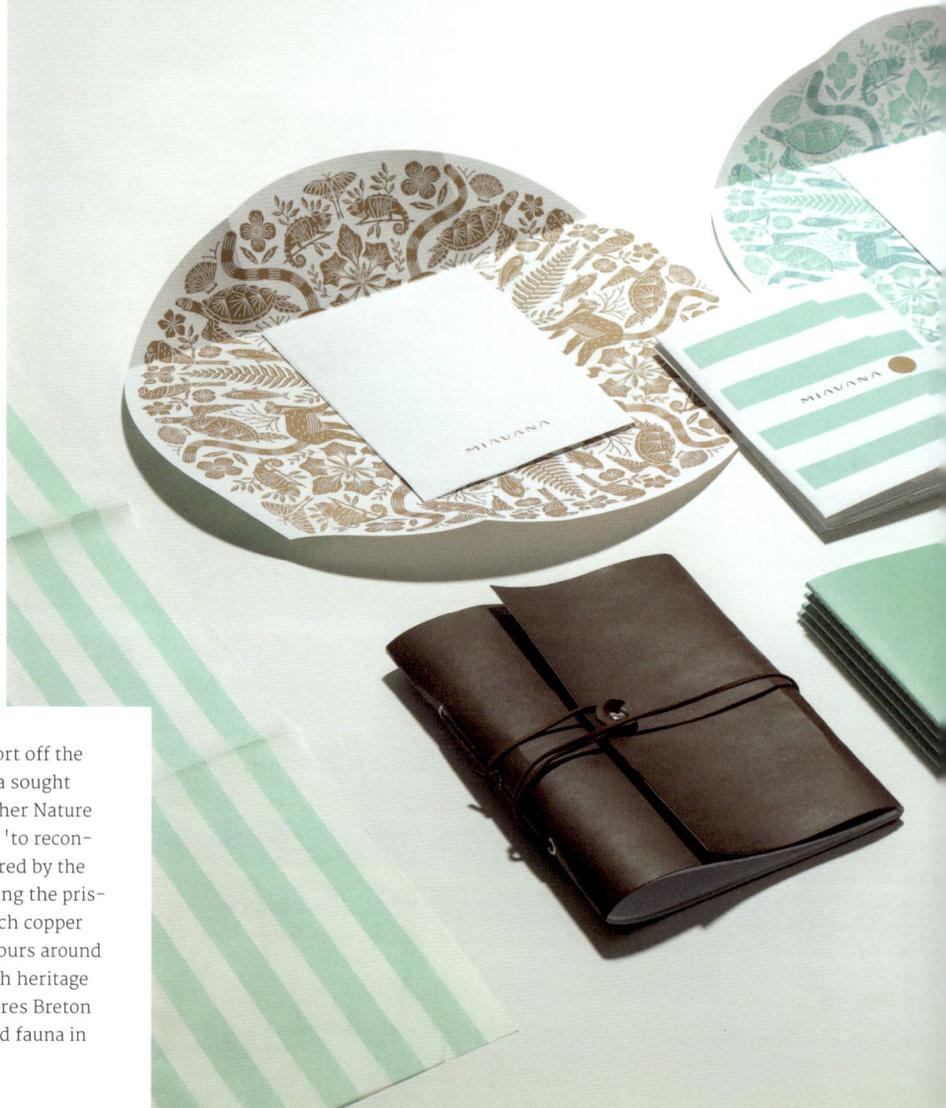

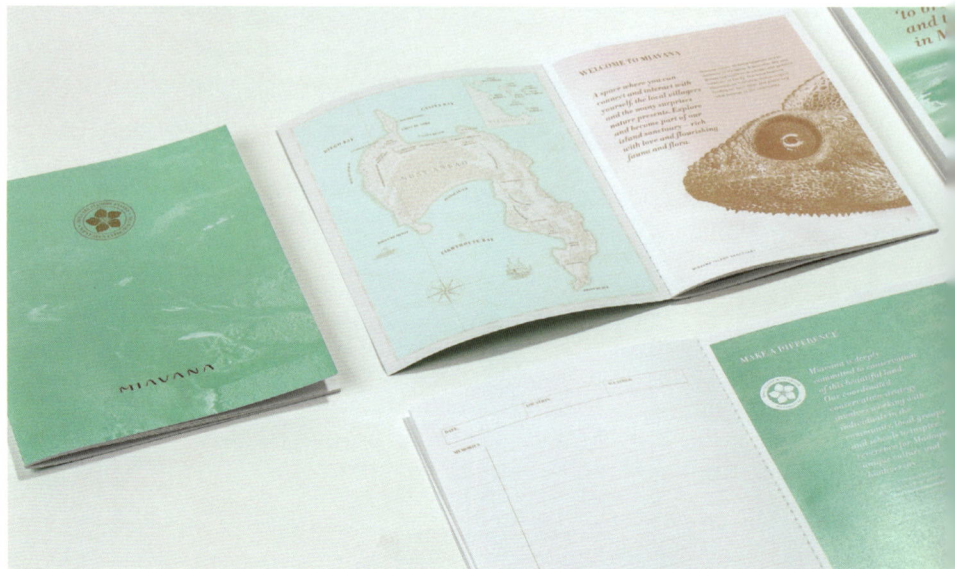

Design
Xfacta

Client
Time + Tide

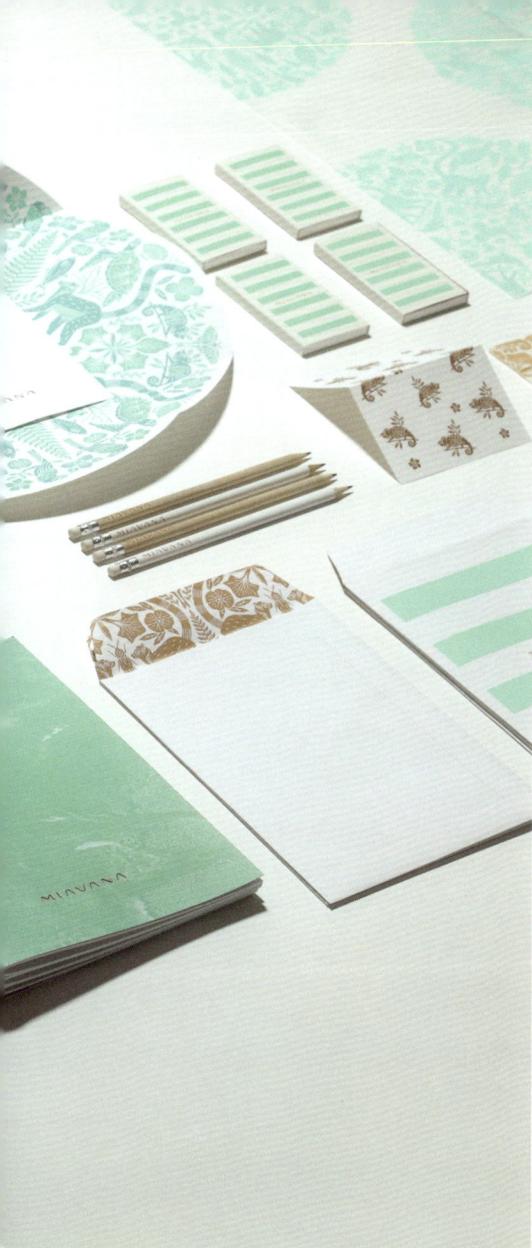

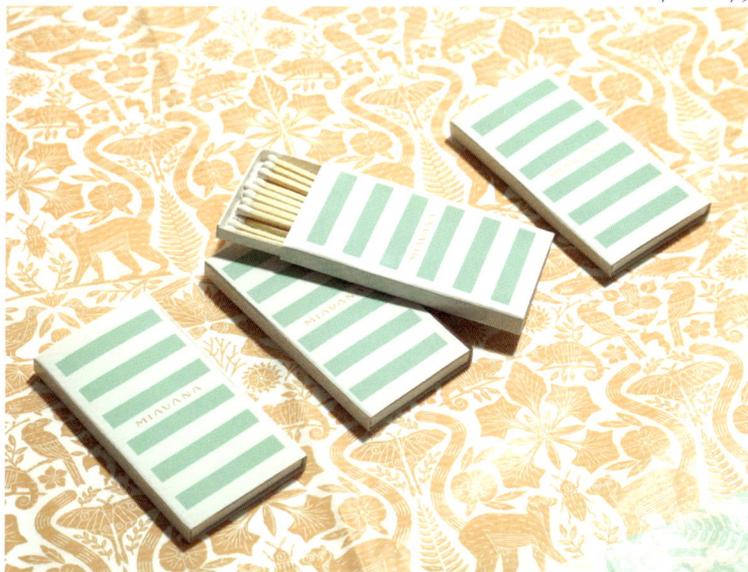

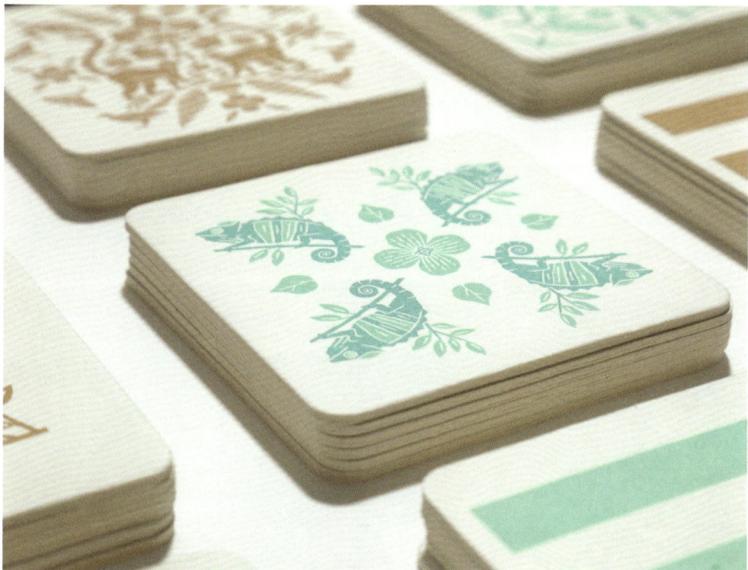

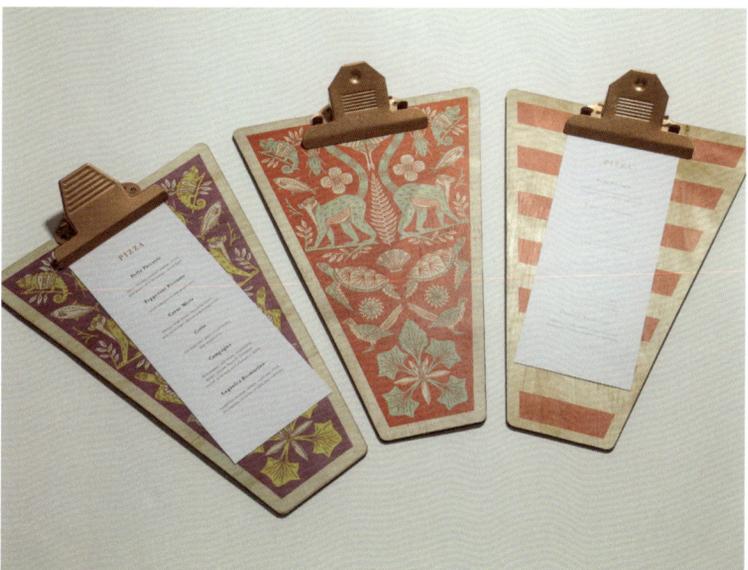

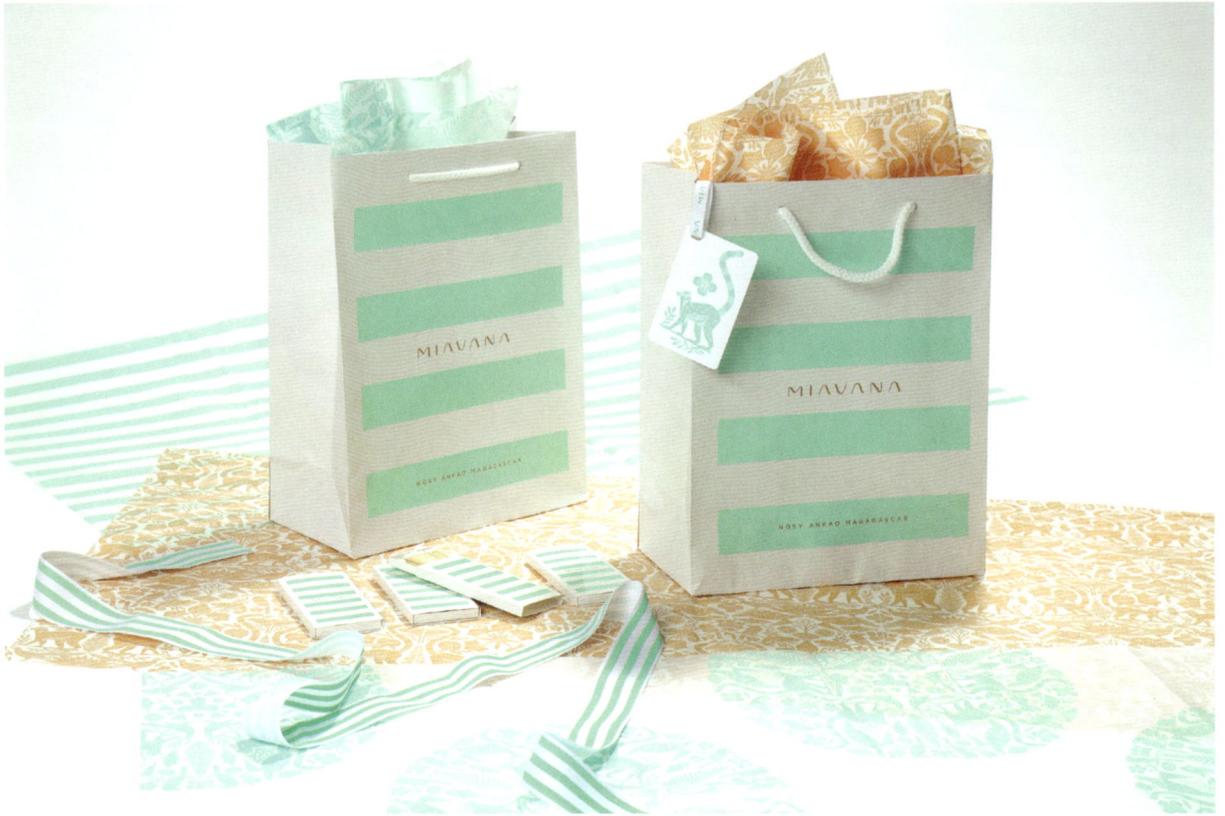

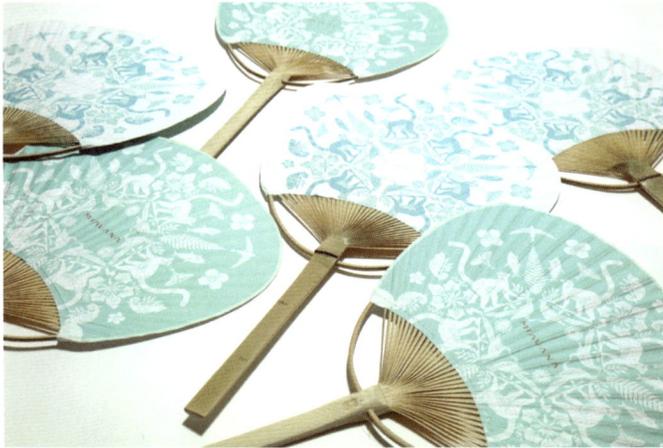

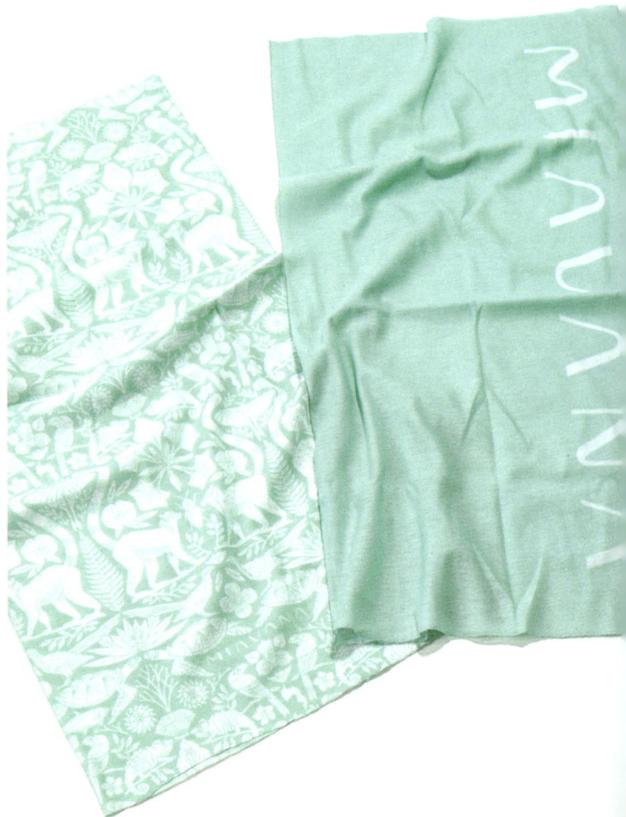

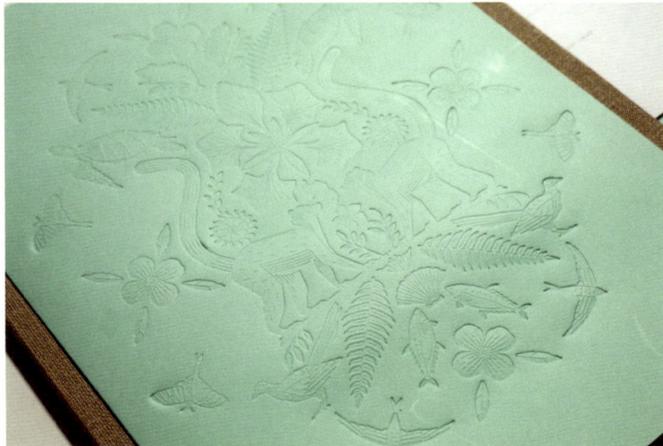

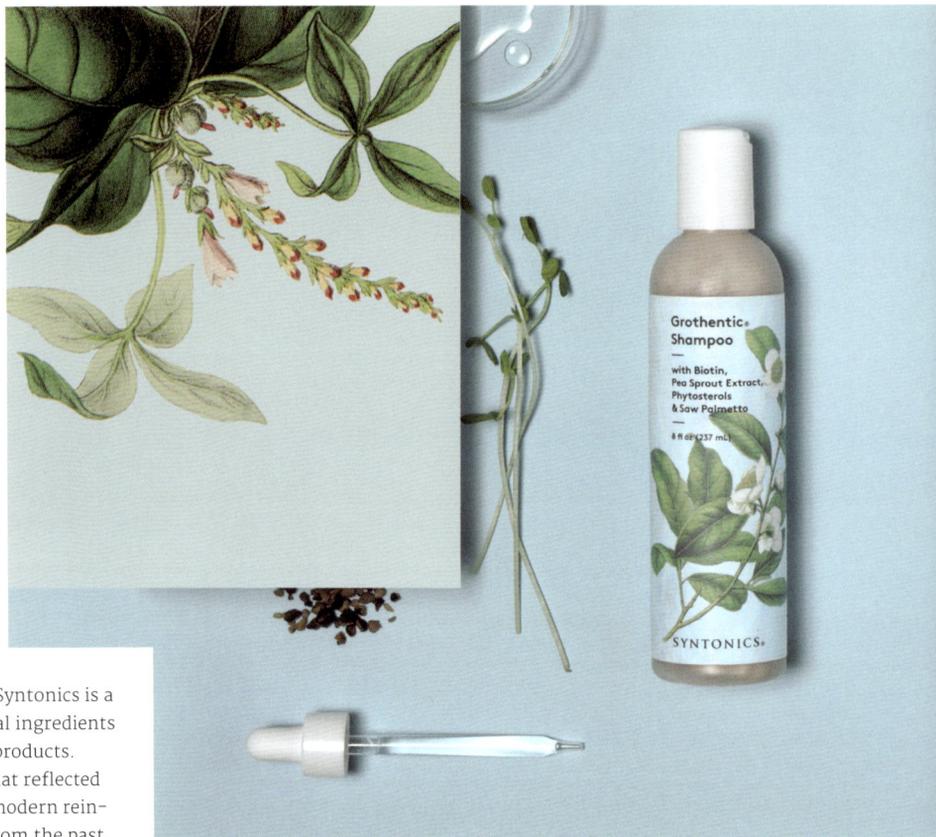

Syntonics

A balanced blend of nature and science, Syntonics is a holistic hair care system that uses natural ingredients and scientific research to create quality products. FormNation designed a visual identity that reflected the brand's dual approach by featuring modern rein-terpretations of botanical illustrations from the past. The juxtaposition of the watercoloured plants with the bold, sans-serif typeface on the labels seamlessly merge the delicate physical attributes of the ingredients with their potency.

Design
FormNation LLC

Client
Syntonics

Photography
Lisa Klappe

Styling
byAMT

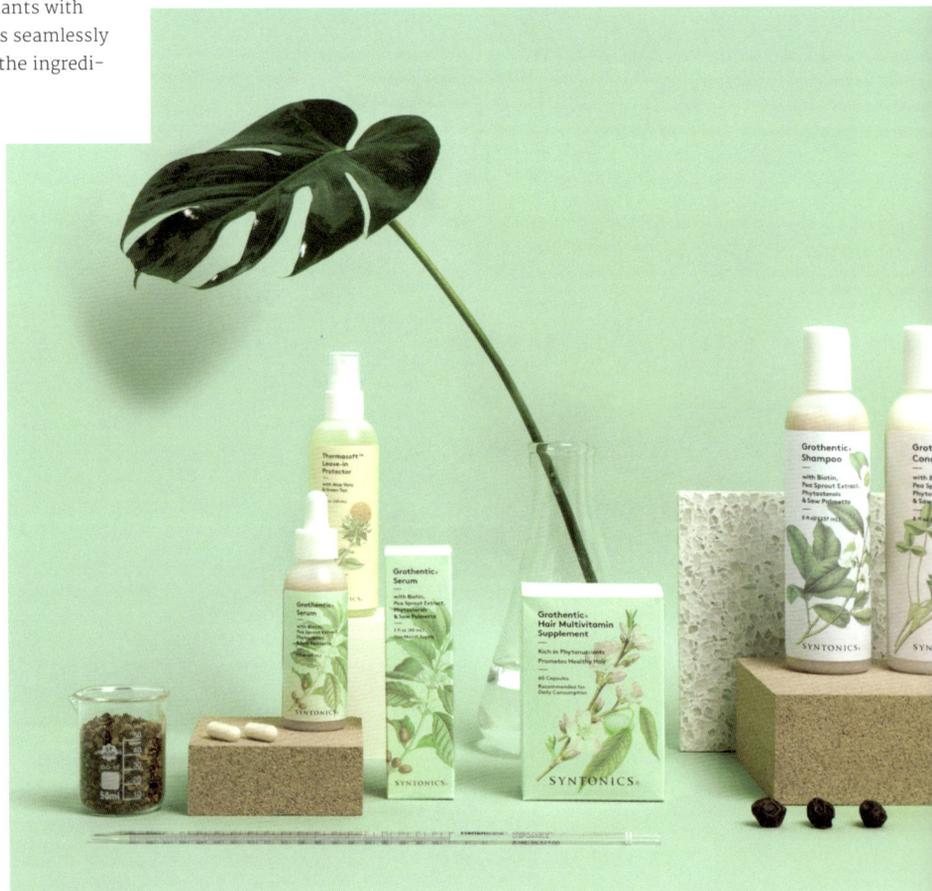

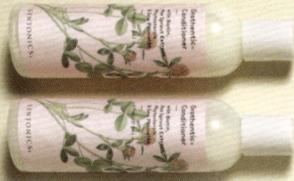

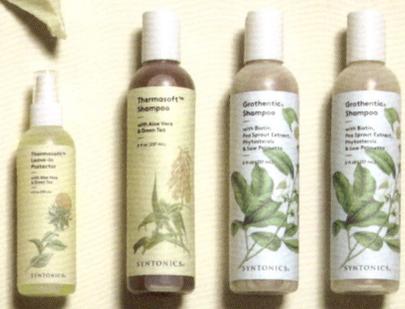
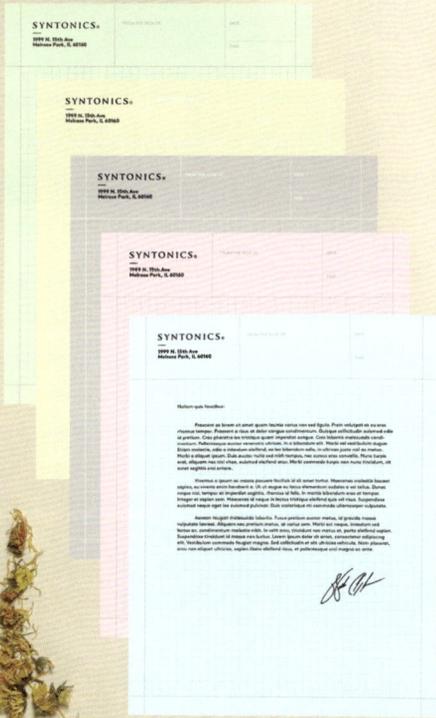

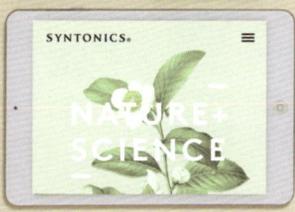

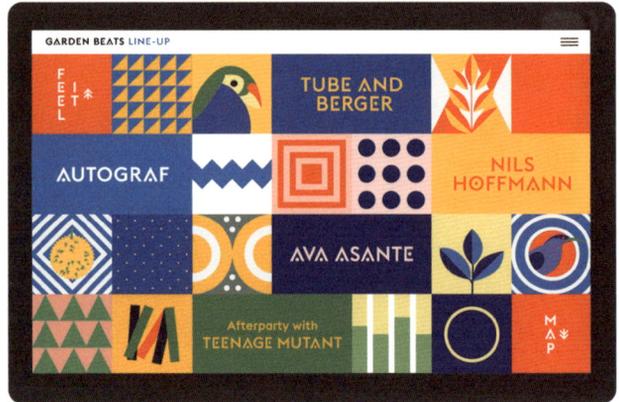

Garden Beats Festival

Garden Beats is an annual live music event with a focus on sustainability. It takes place in the botanically diverse Fort Canning Park in Singapore, where visitors from all over the world converge to watch an impressive line-up of international performers on stage. To create a visual identity that reflects its new carbon-neutral status, CIRCLE were inspired by the venue's tropical ambience to develop a colourful and versatile design scheme with vibrant illustrations rooted in nature.

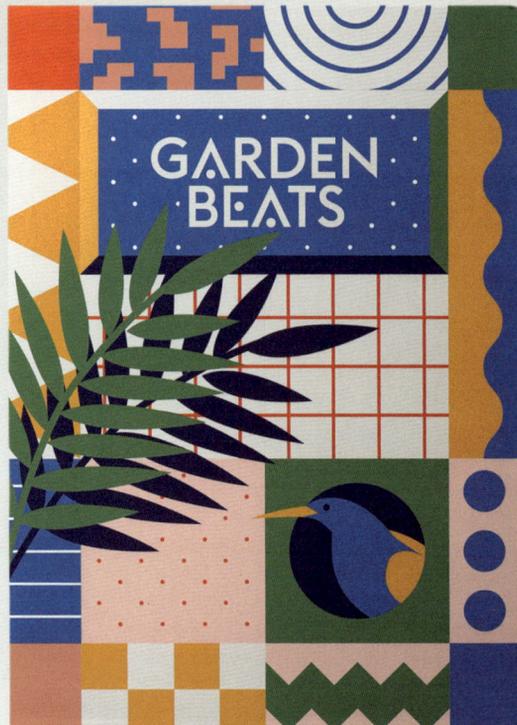

Design
CIRCLE Design + Direction

Client
Sunshine Nation Pte Ltd

Photography
Colossal

Illustration
Daniel Triendl

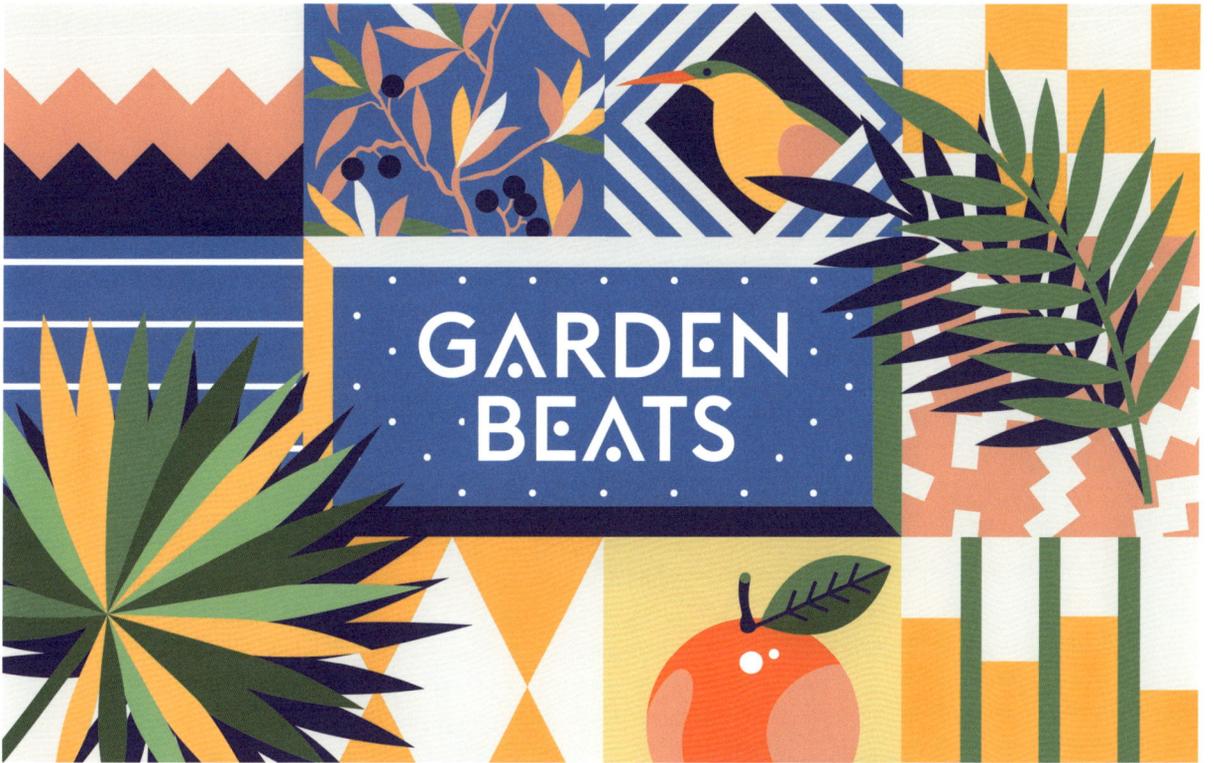

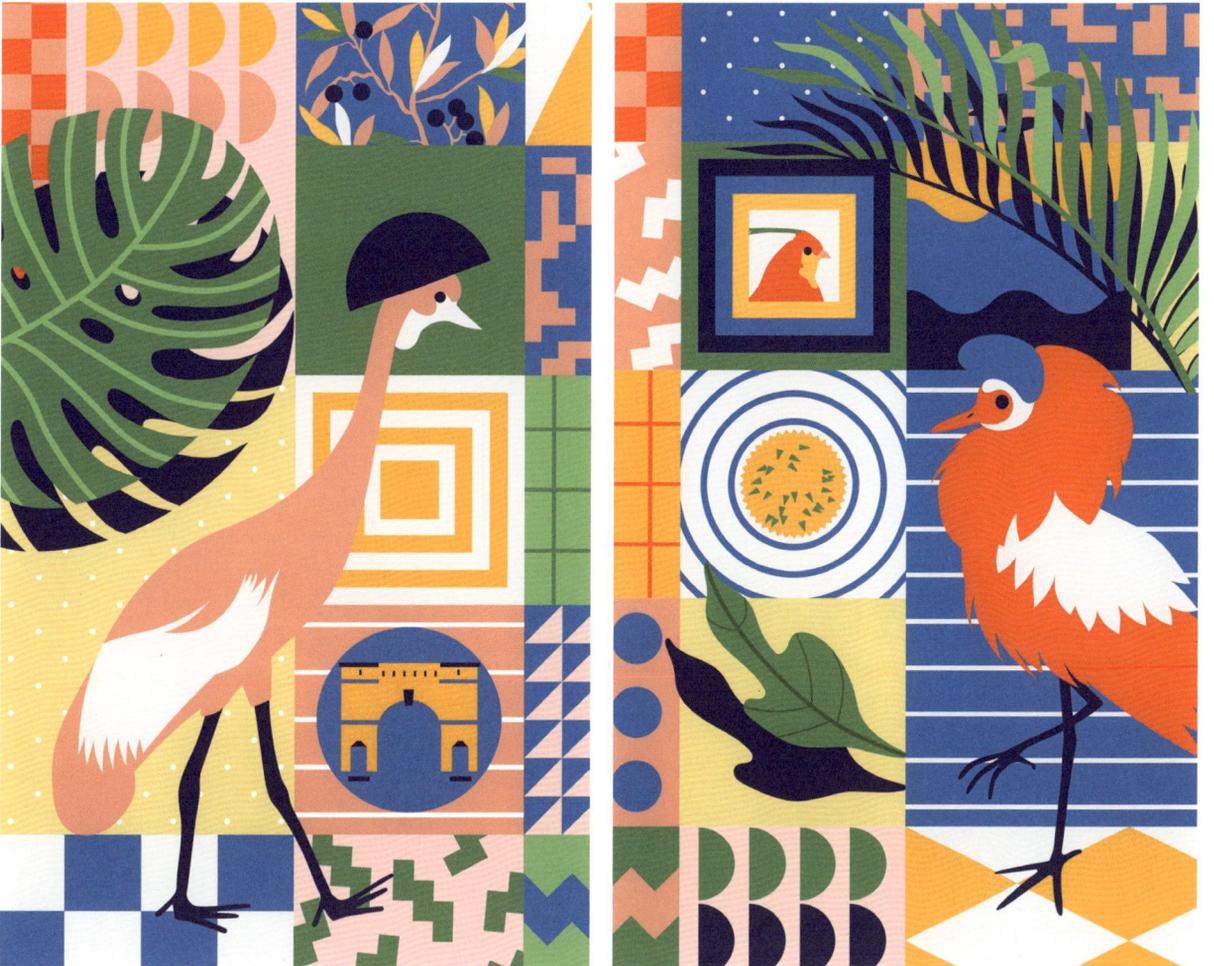

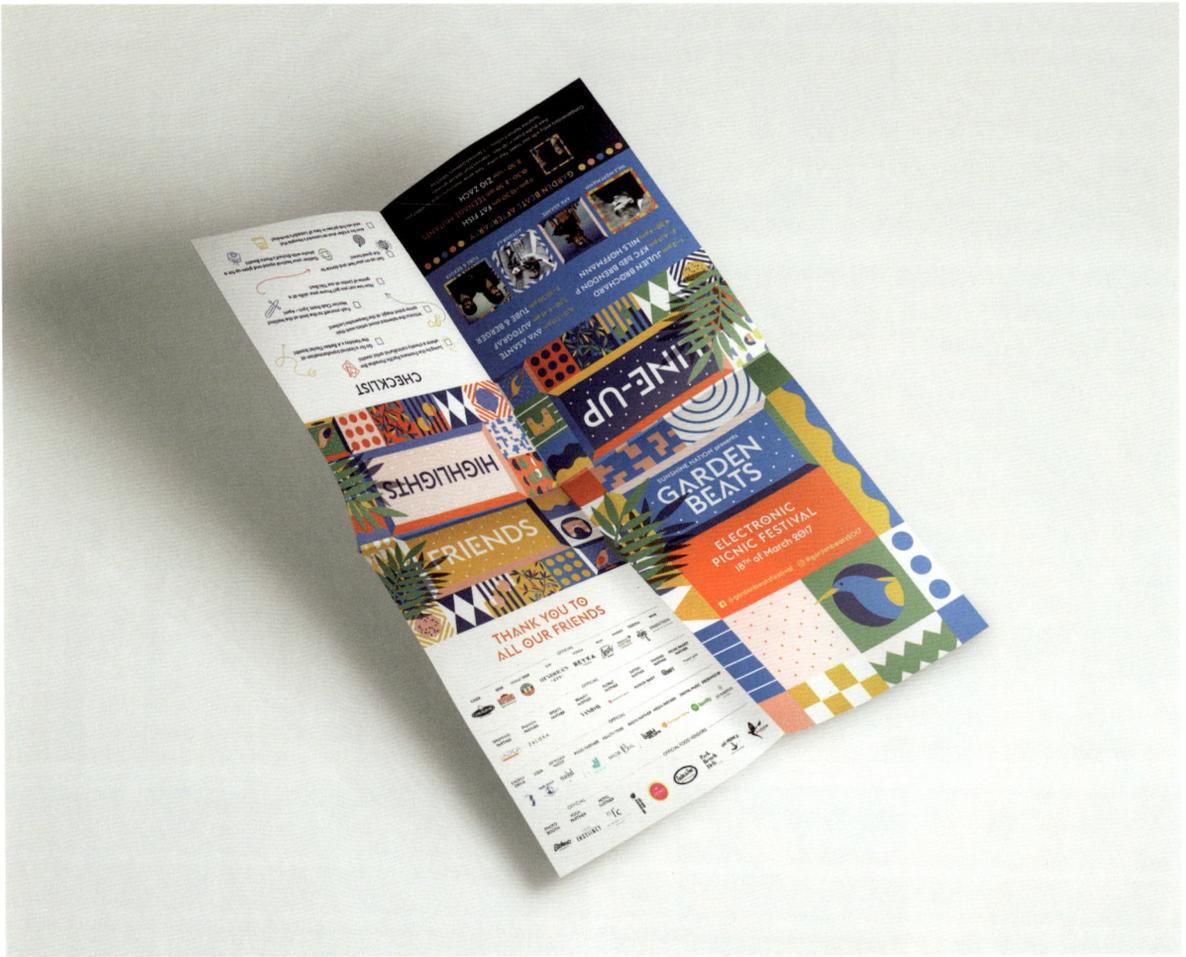

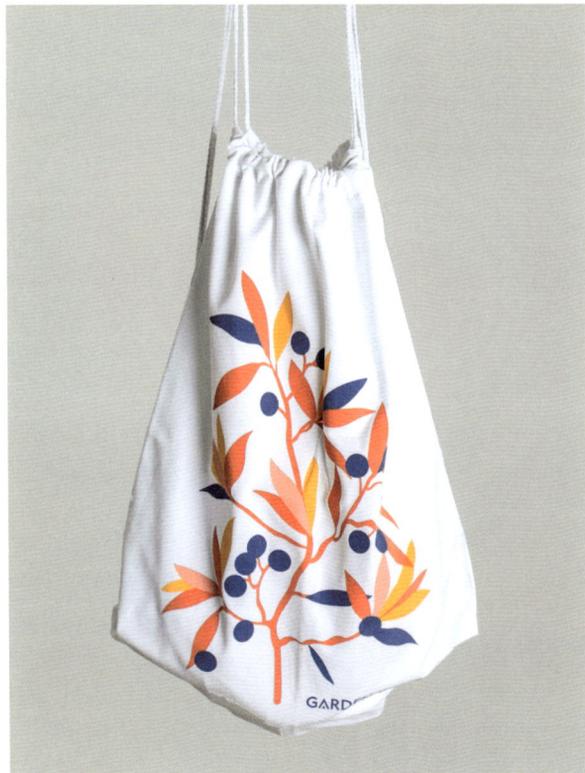

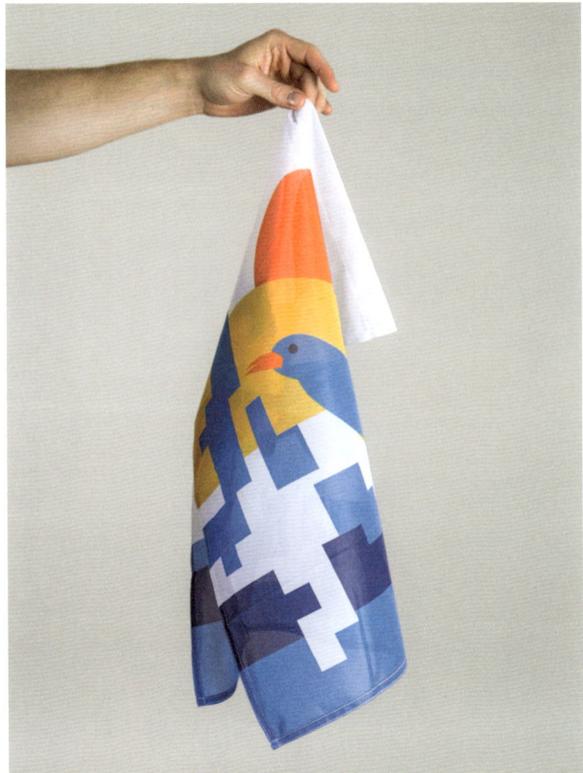

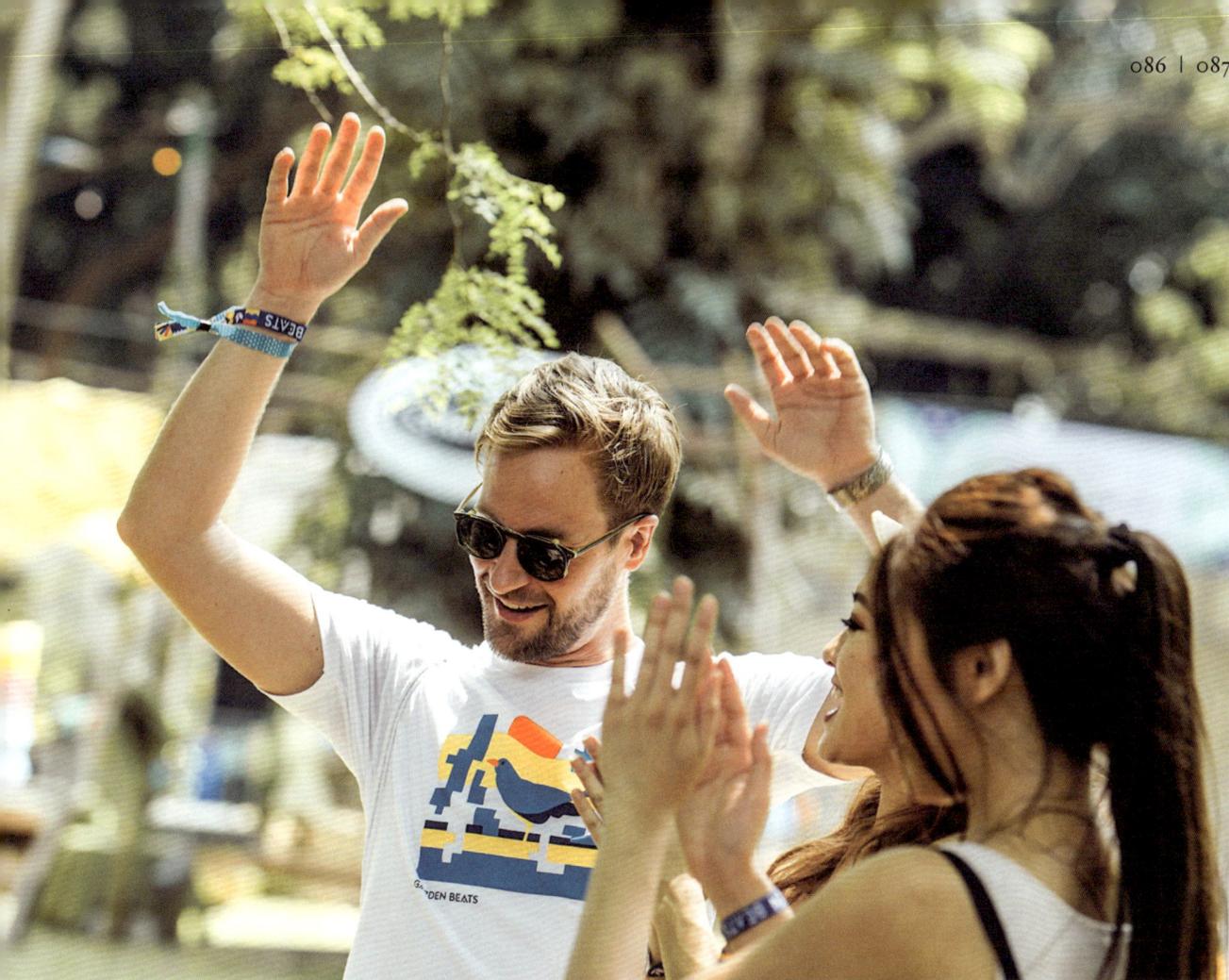

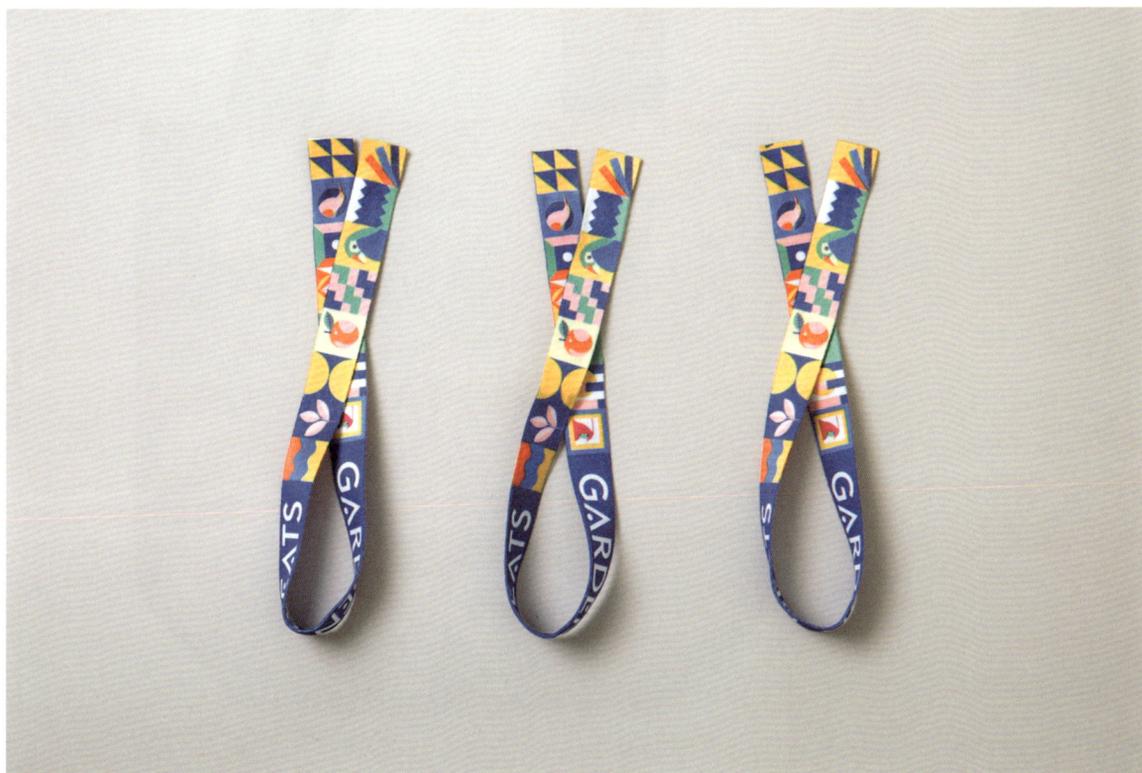

Battersea
Flower Station

Brimming with bold shapes and silhouettes, the Battersea Flower Station's vibrant visual identity was inspired by the bright colours found at the 2018 Royal Chelsea Flower Show. Besides creating striking visual effects with collages of abstract plant forms, Caterina Bianchini Studio designed a unique logotype that reflected the iconic chimneys of the Battersea Power Station, the flower station pop-up's venue.

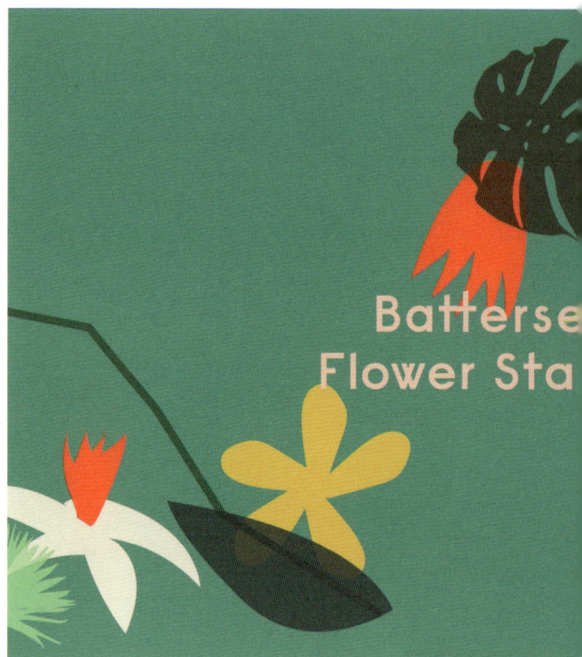

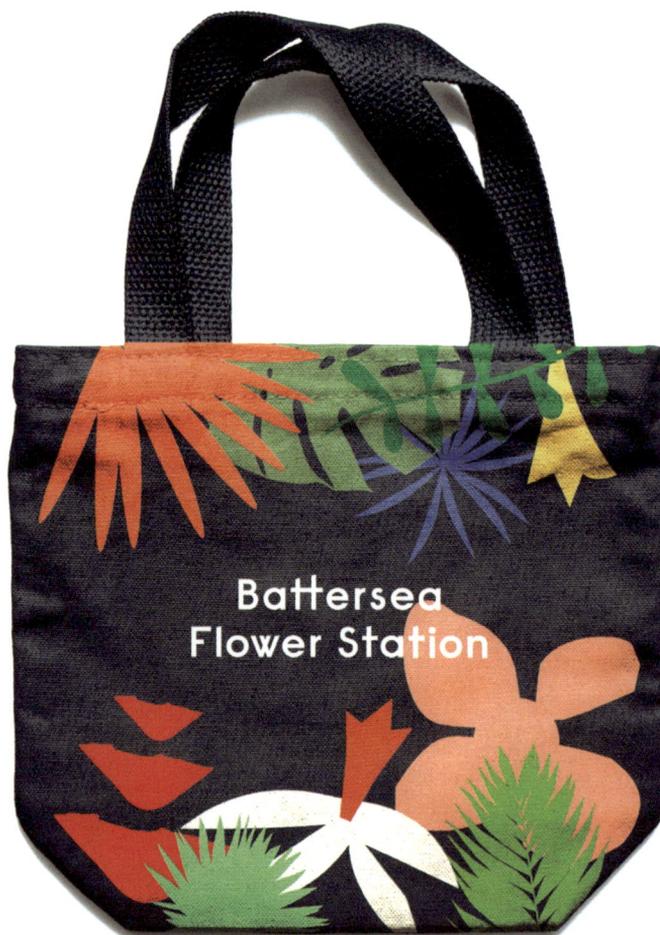

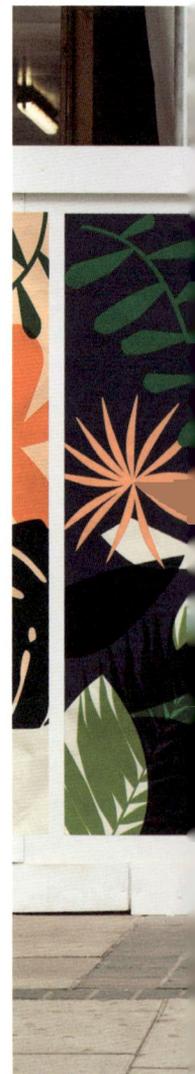

Design
Caterina Bianchini Studio

Client
Battersea Power Station

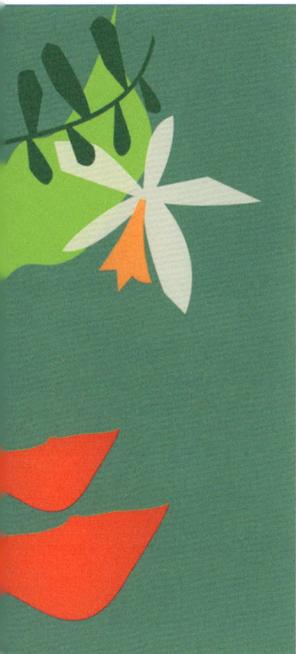

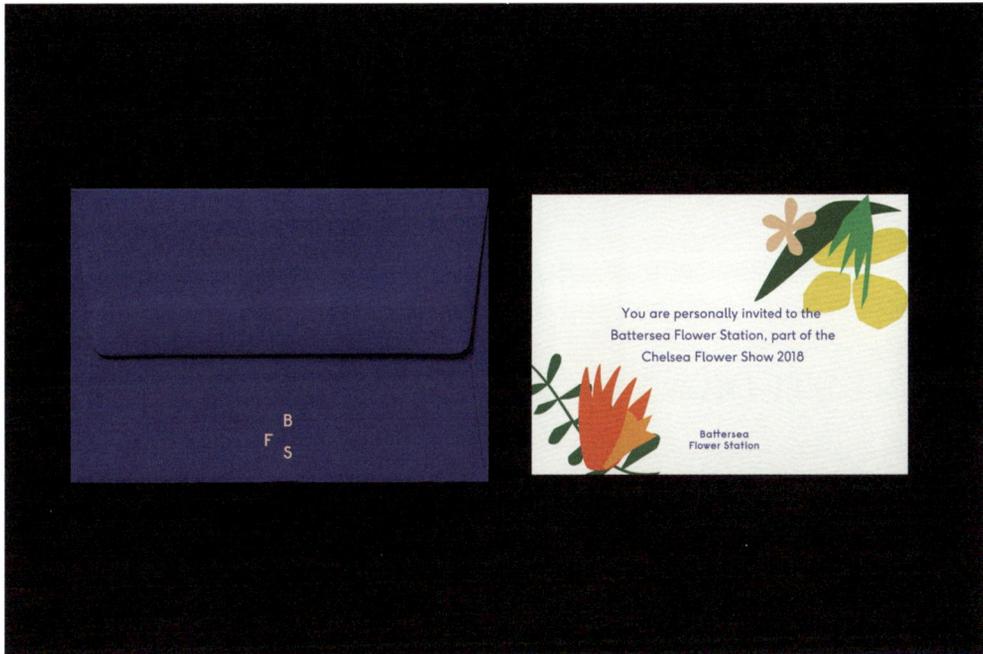

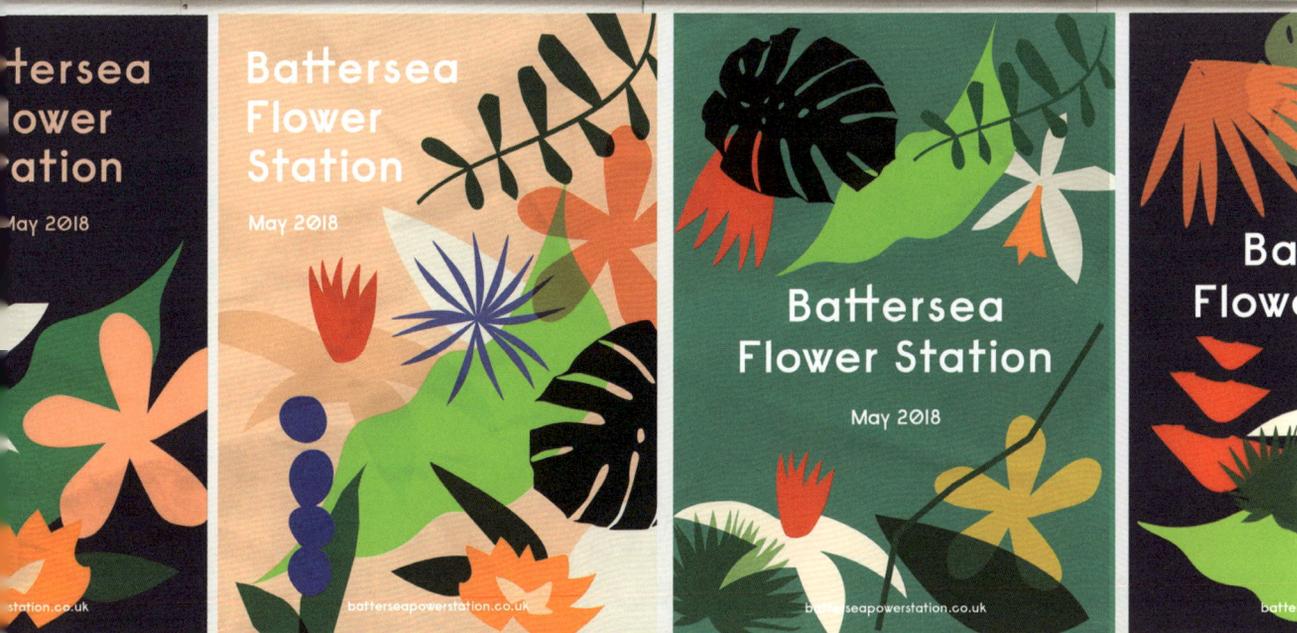

Design
Bardo Industries

Client
Adobe Live

verde,
PLANT STUDIO

verde was a fictional project that Bardo Industries developed over three days of live streaming for Adobe Live's Graphic & Packaging Design Series in 2018. Besides reflecting the functional side of the imaginary shop through the tagline 'PLANT STUDIO', they captured its fun and free spirit in their Henri Matisse-inspired designs by translating the natural form of leaves into lively graphic representations that were both organised and organic.

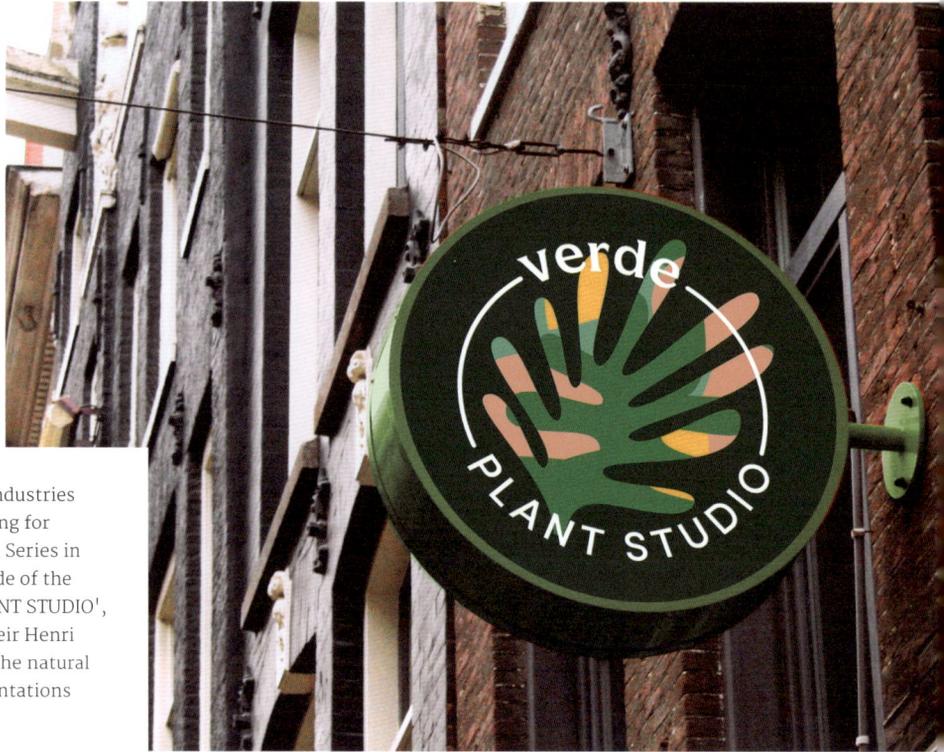

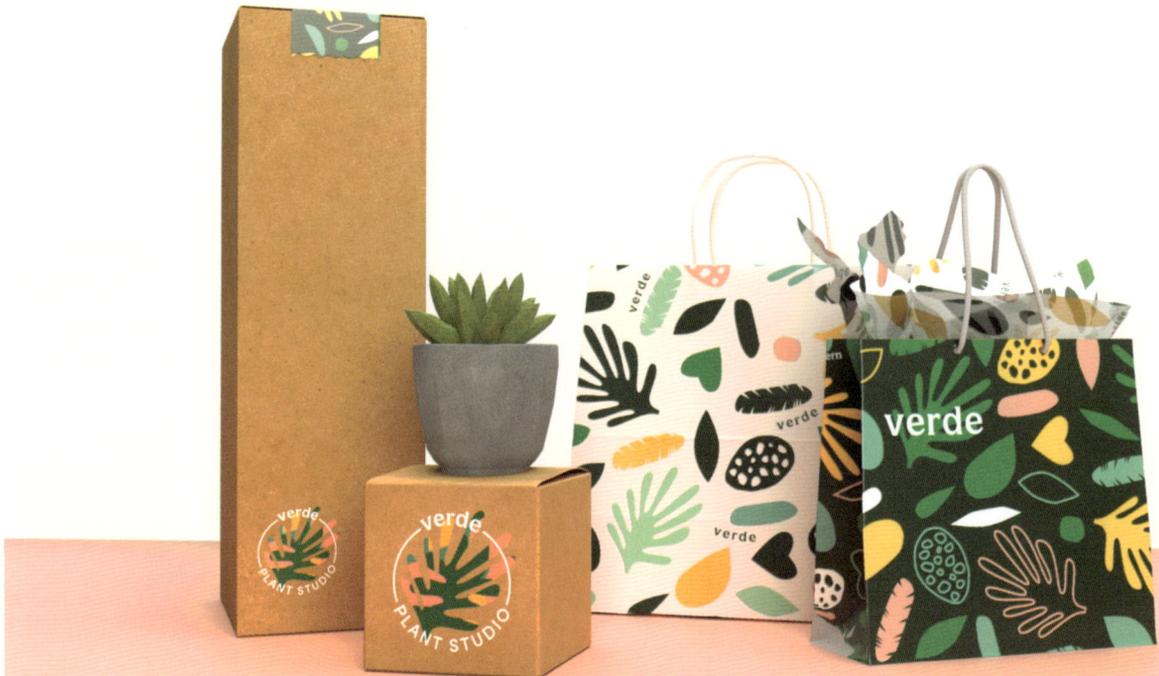

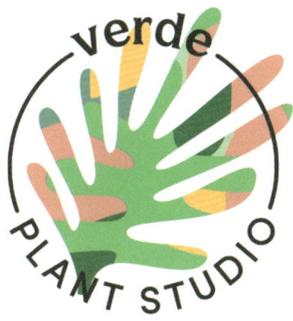
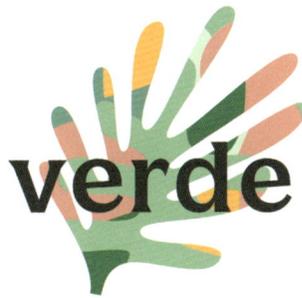
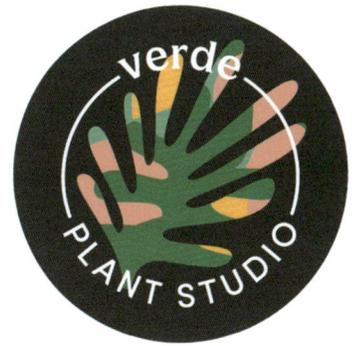

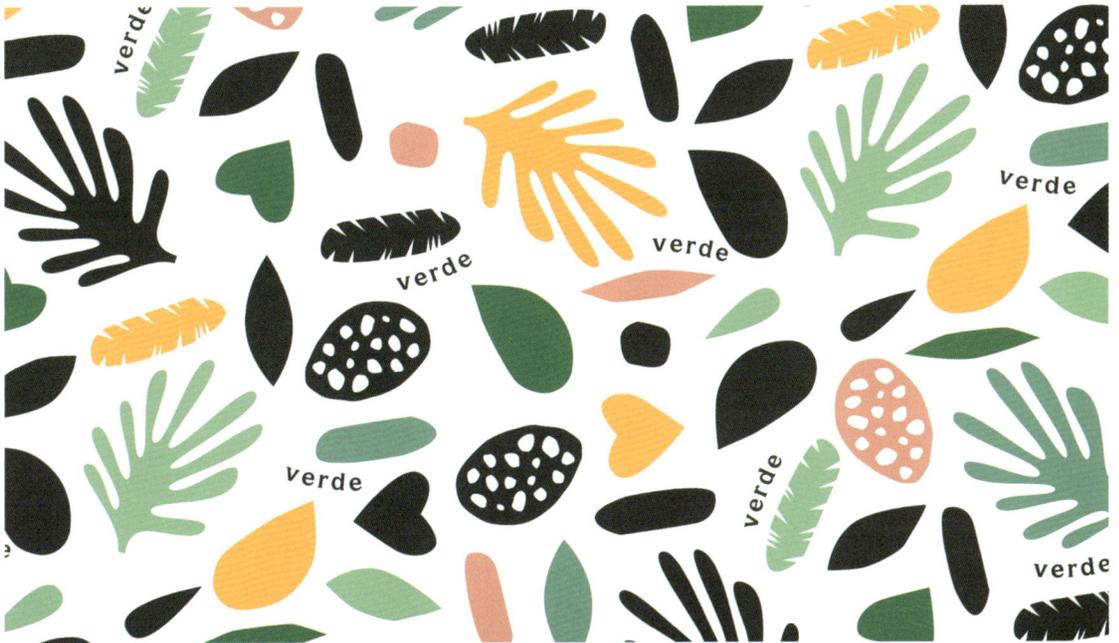

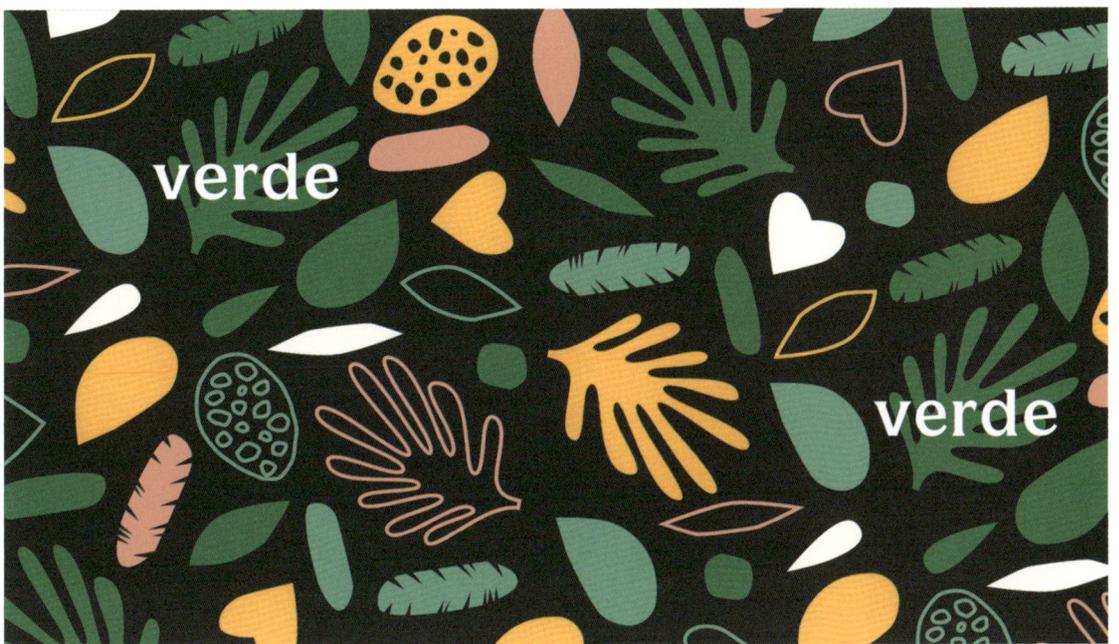

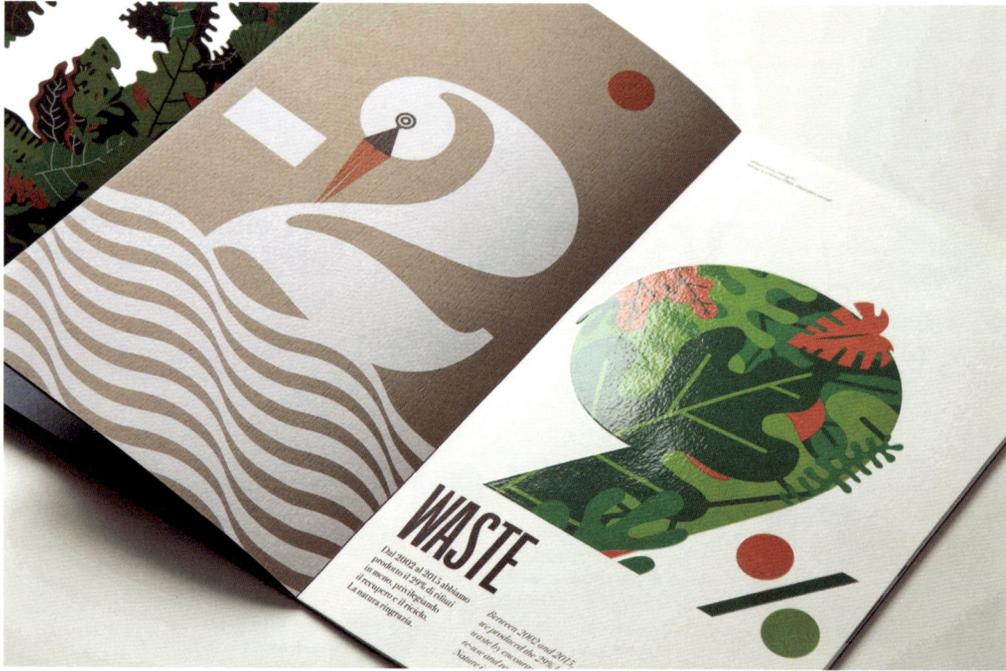

Freelife Visual Book

Happycentro's compelling catalogue for Fedrigoni, a paper manufacturer in Italy, featured stunning colour palettes, striking visuals, inventive 3D printing, and clever layering techniques. The Freelife book served as a testament to the company's devotion to sustainable paper production by explaining the ways with which it minimises the environmental impacts of its production processes in a thoughtful manner. Through the intricacy of their designs, Happycentro were able to effectively convey Fedrigoni's genuine concern for the future.

Design
Happycentro

Client
Fedrigoni

Print
Intergrafica Verona

Many thanks to Marta Franceschi by Fedrigoni.

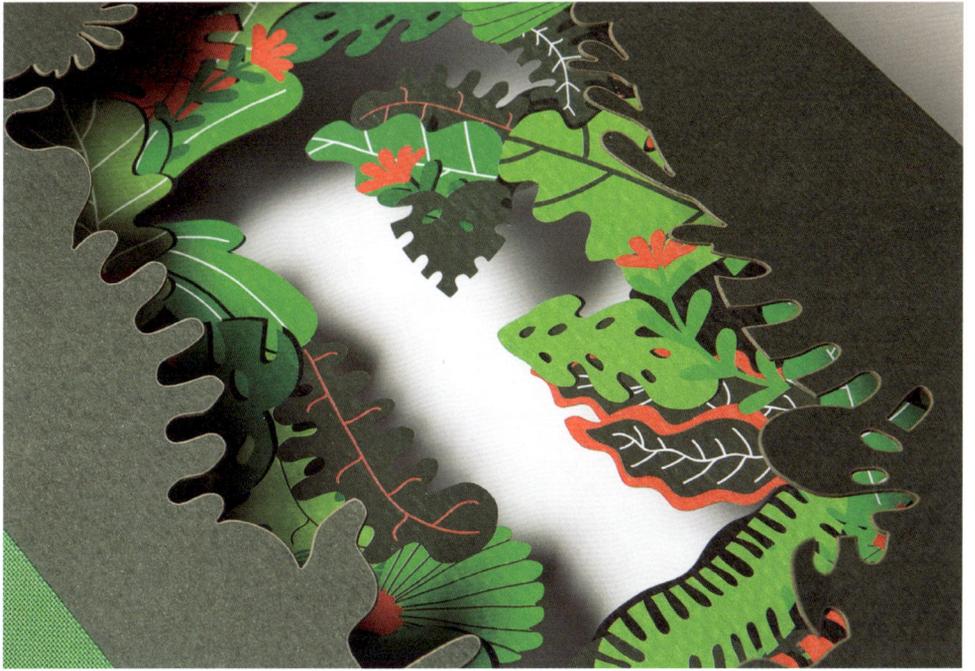

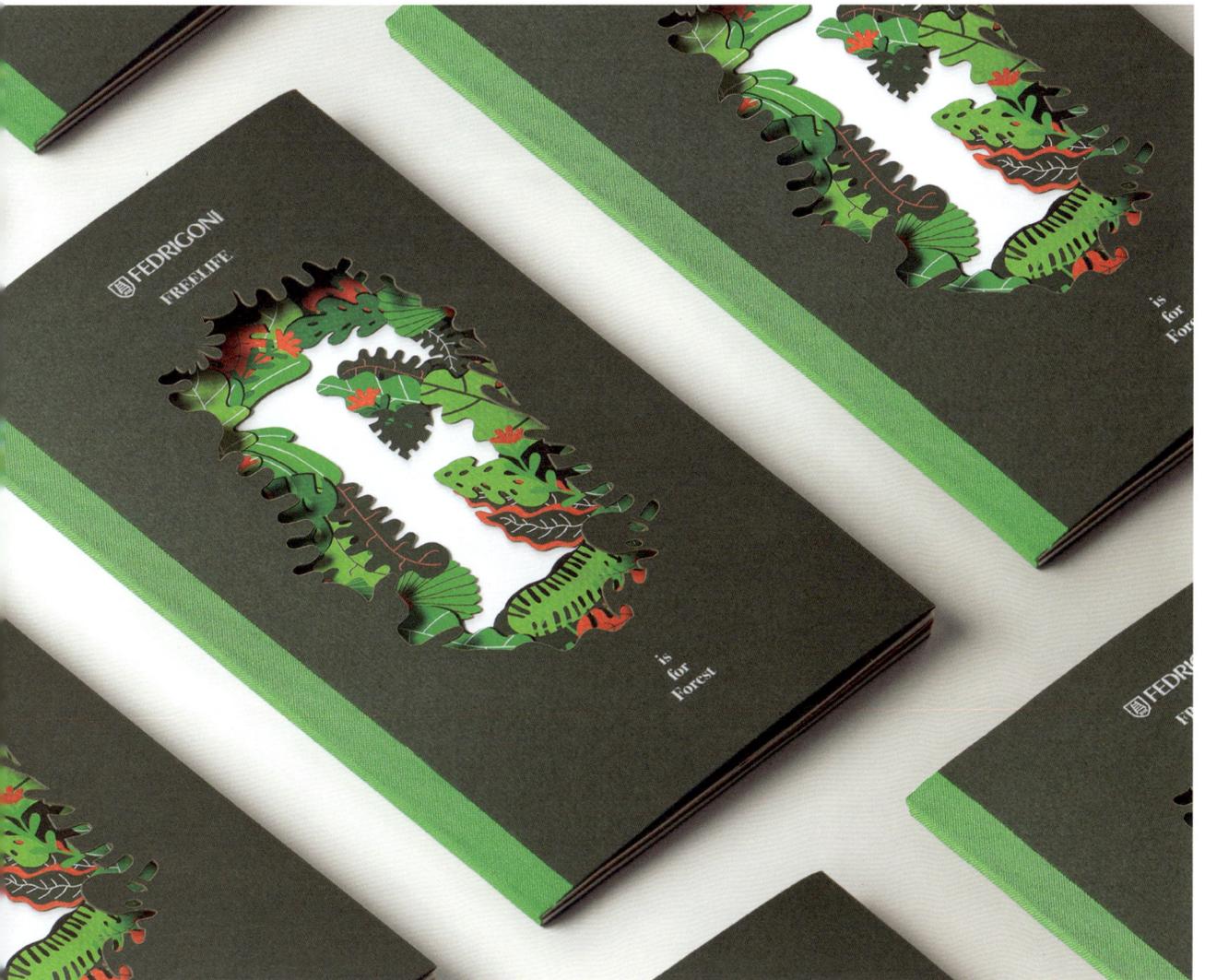

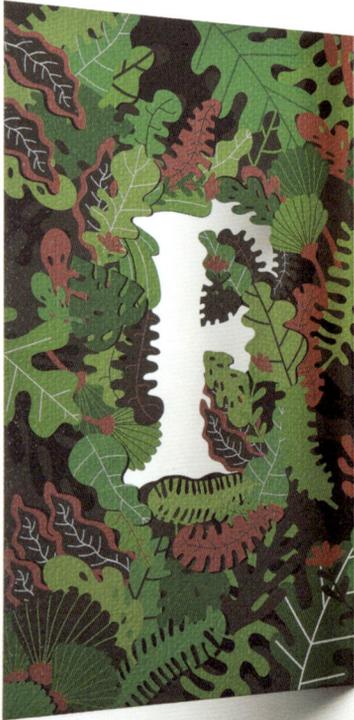

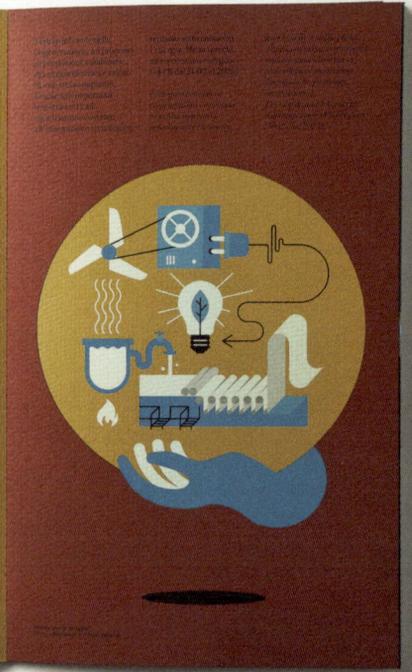

SAFE
ENERGY

72% FSC
CHAIN OF CUSTODY

28% FSC
CONTROLLED WOOD

Supportiamo la gestione
forestale sostenibile.

Nel 2015 abbiamo acquistato
il 72% di cellulosa certificata
FSC® Chain of Custody,
e il 28% di cellulosa FSC®
Controlled Wood.

1. Grazie allo standard di
Catena di Custodia, la
certificazione FSC® viene
garantita lungo tutta la filiera
legno/carta, che ha origine
nella foresta certificata sino ad
arrivare ai prodotti finali che da
essa derivano.

2. Il **Legno Controllato**,
utilizzato nei prodotti
etichettati "FSC Misto", è
un materiale che può essere
mescolato con quello
certificato, derivante da fonti
FSC®.

Nello specifico si escludono le
seguenti categorie:

• Legno tagliato
illegalmente
• Legno tagliato in
violazione dei diritti
tradizionali e civili
• Legno tagliato in foreste
dove sono presenti Alti
Valori di Conservazione
• Legno che deriva de
foreste convertite in
piantagioni o altro uso
non forestale
• Legno da foreste
dove si fa uso di alberi
geneticamente modificati

We support sustainable
forestry management.

In 2015, we purchased 72%
of pulp with FSC® Chain
of Custody certification,
and 28% of FSC® Controlled
Wood pulp.

1. With the **Chain of Custody**
standard, the FSC® certifica-
tion is guaranteed through
the entire supply chain, which
starts in the certified forest
and reaches up to the final pro-
ducts that follow from it.

2. **Controlled Wood** is
material that can be mixed
with certified material during
manufacturing "FSC Mix"
products. Only materials from
FSC® acceptable sources can
be used as controlled. In parti-
cular the following categories
are excluded:

• Illegally harvested wood
• Wood harvested in
violation of traditional and
civil rights
• Wood harvested in
forests in which High
Conservation Values
are threatened by
management activities
• Wood harvested in forests
being converted to
plantations or non-forest
use
• Wood from forests
in which genetically
modified trees are
planted.

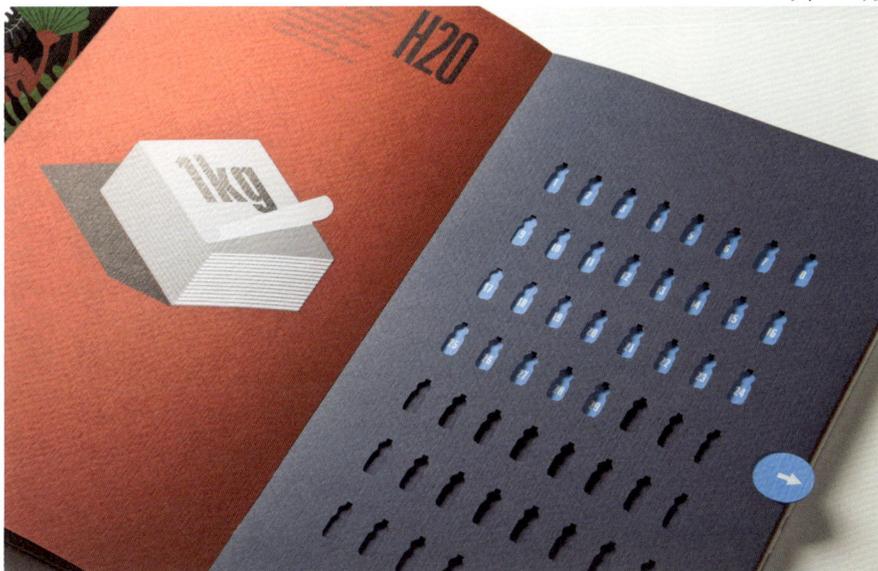

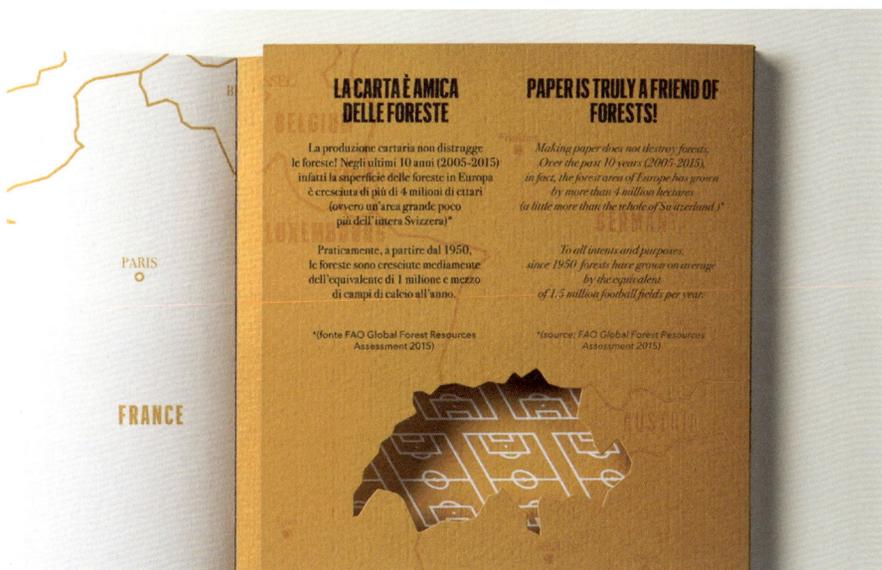

LA CARTA È AMICA DELLE FORESTE

La produzione cartaria non distrugge le foreste! Negli ultimi 10 anni (2005-2015) infatti la superficie delle foreste in Europa è cresciuta di più di 4 milioni di ettari (ovvero un'area grande poco più dell'intera Svizzera)*

Praticamente, a partire dal 1950, le foreste sono cresciute mediamente dell'equivalente di 1 milione e mezzo di campi di calcio all'anno.

*(fonte FAO Global Forest Resources Assessment 2015)

PAPER IS TRULY A FRIEND OF FORESTS!

Making paper does not destroy forests. Over the past 10 years (2005-2015), in fact, the forest area of Europe has grown by more than 4 million hectares (a little more than the whole of Switzerland.)*

To all intents and purposes, since 1950 forests have grown on average by the equivalent of 1.5 million football fields per year.

*(source: FAO Global Forest Resources Assessment 2015)

Sargs IPA

To reflect the attention to detail with which Sargs IPA, a craft Indian Pale Ale-style beer, is made, Hula Estudio designed an apt label demonstrating similar finesse. The key visual of the colourful jungle cut-out encapsulates both the pleasant personality of the beer as well as the layers of fruity flavours that drinkers will enjoy – revealing the beauty in the process.

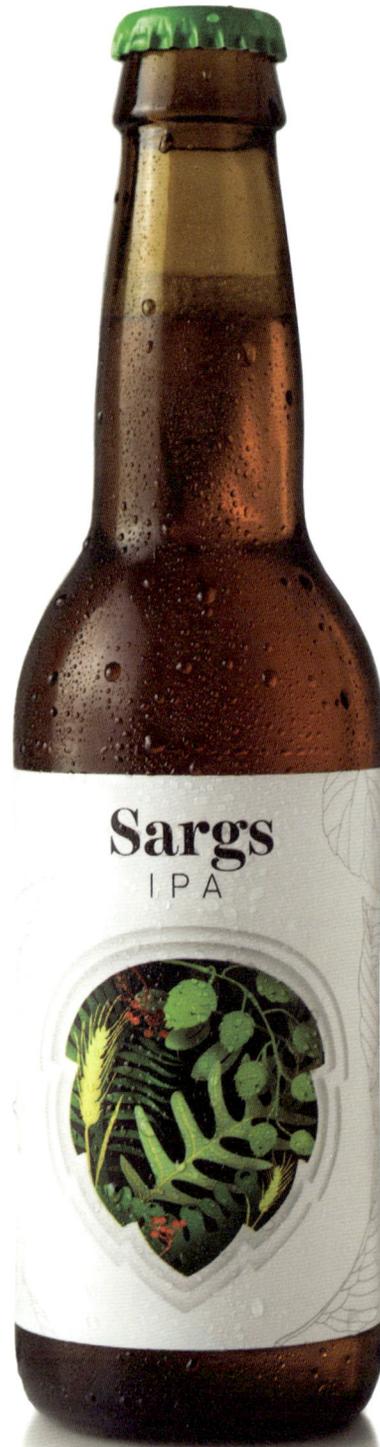

Design
Hula Estudio

Client
Cerveza Sargs

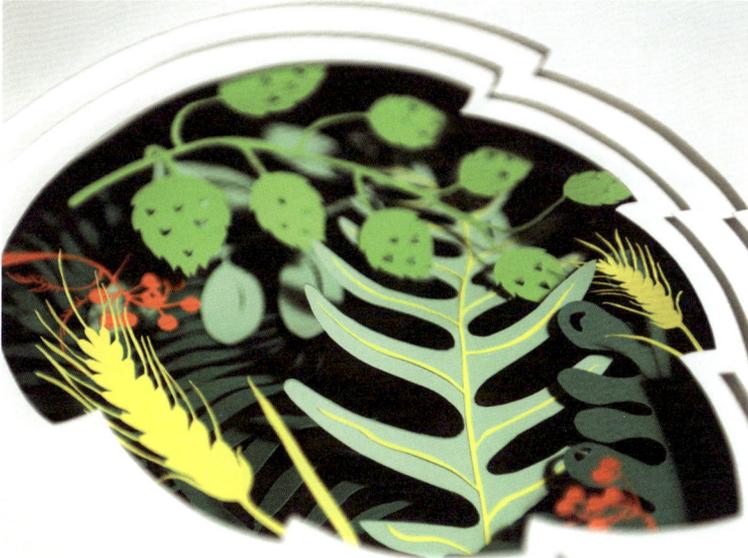

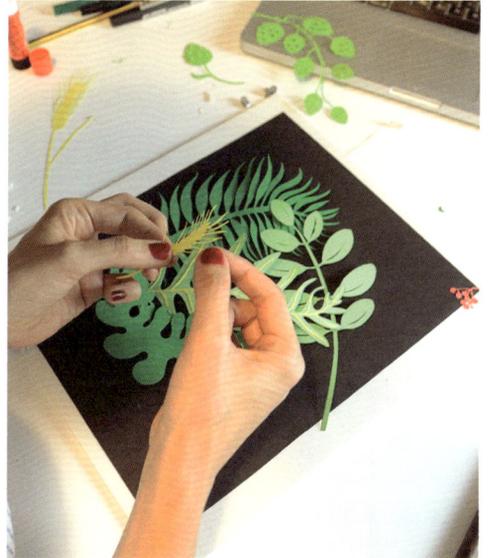

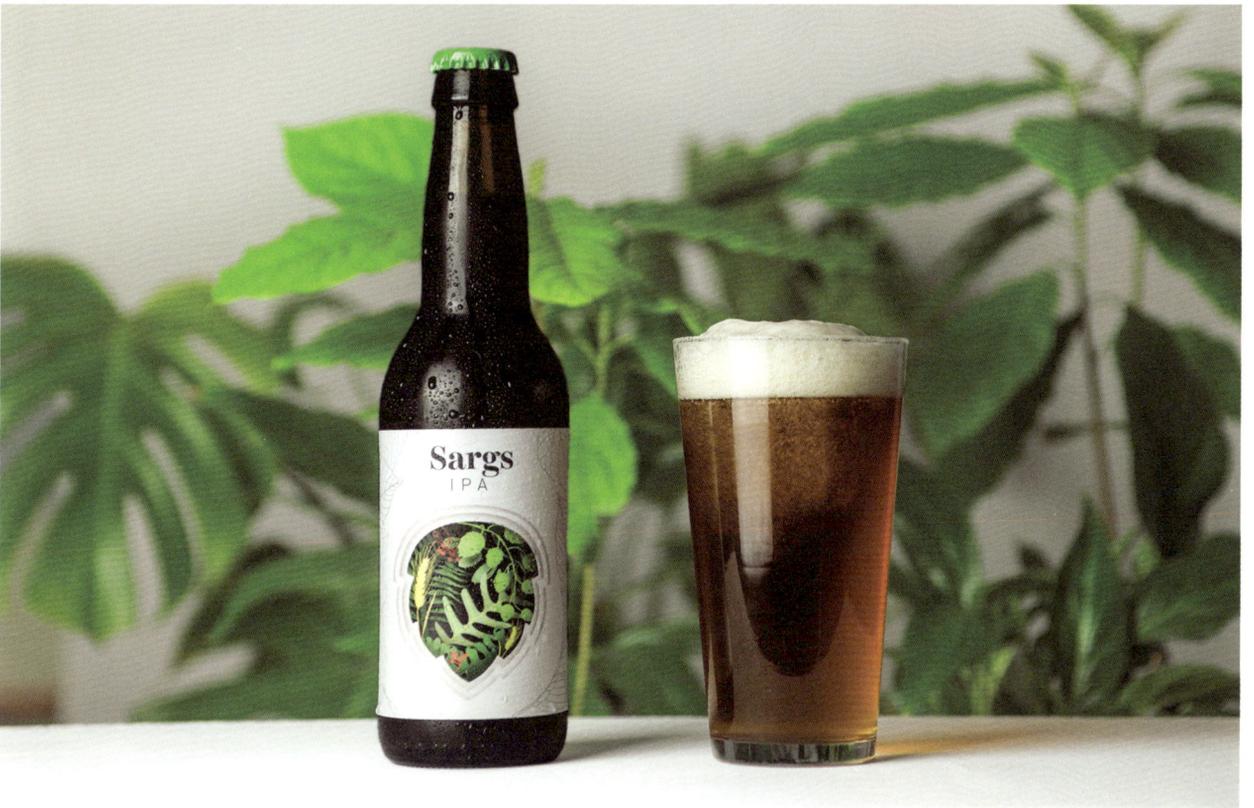

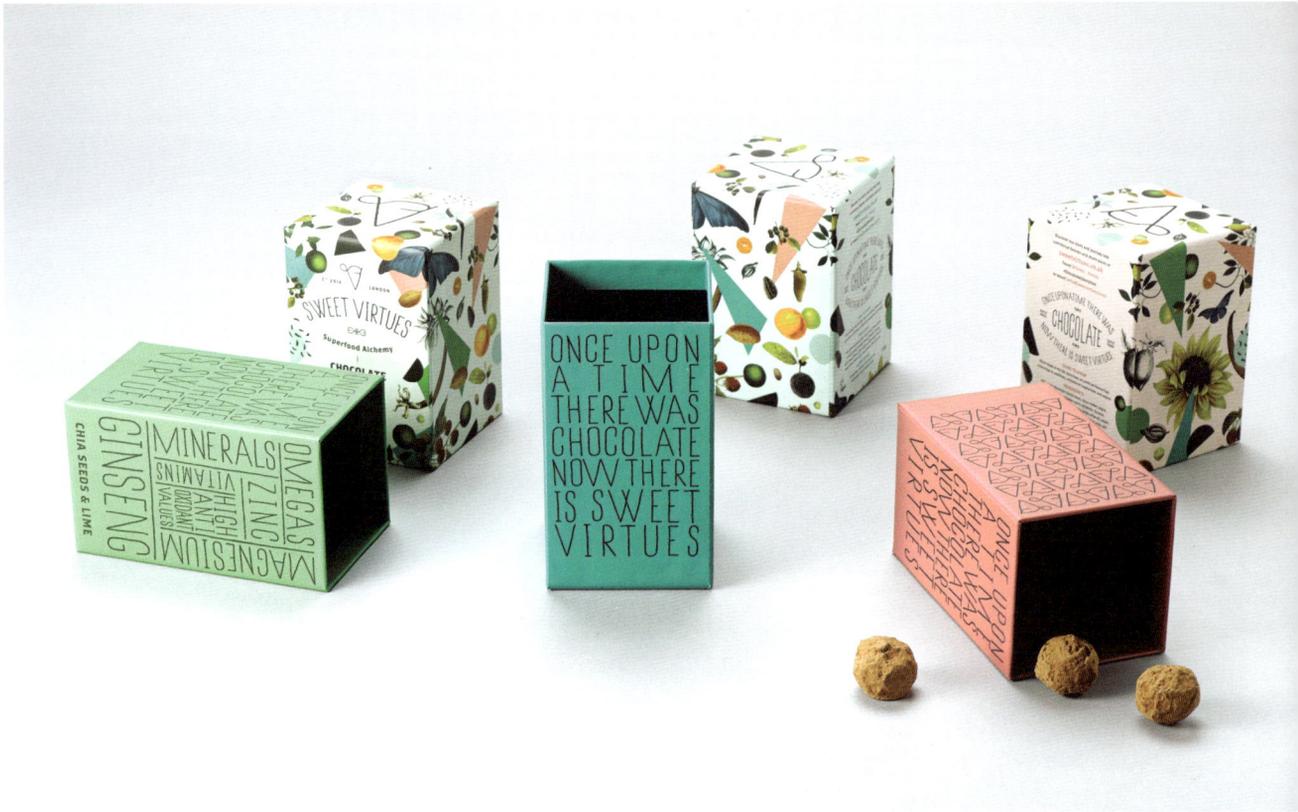

Sweet Virtues

To develop Sweet Virtues' innovative, forward-think-
ing, and health-conscious persona, IWANT Design
created an eye-catching visual identity that seamlessly
blends style, credibility, and accessibility. Combining a
minimalistic logo and typographic approach with clever
colour combinations and playful collages across key
communication materials, they designed a unique and
holistic graphic treatment that embodies the brand's
philosophy perfectly.

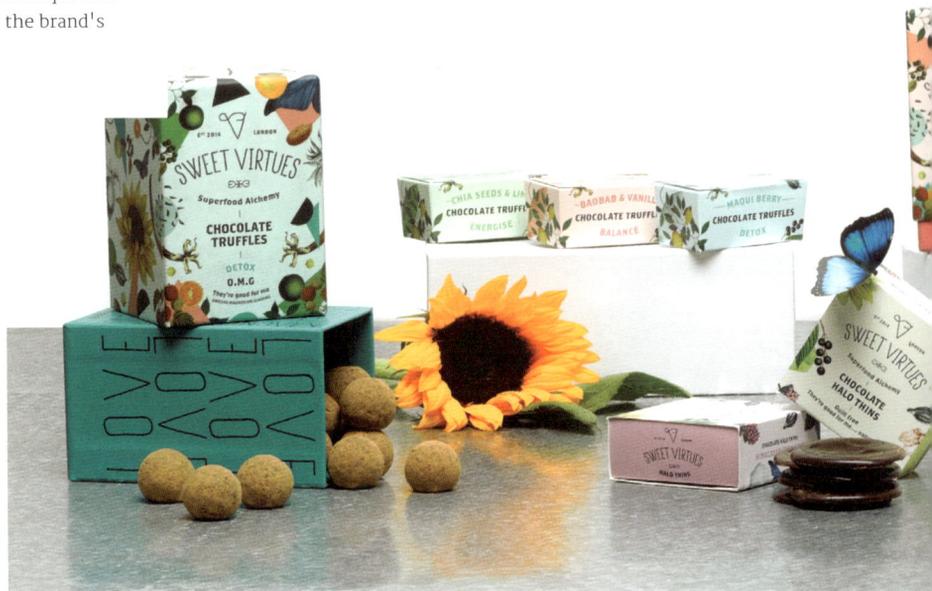

Design
IWANT Design

Client
Sweet Virtues

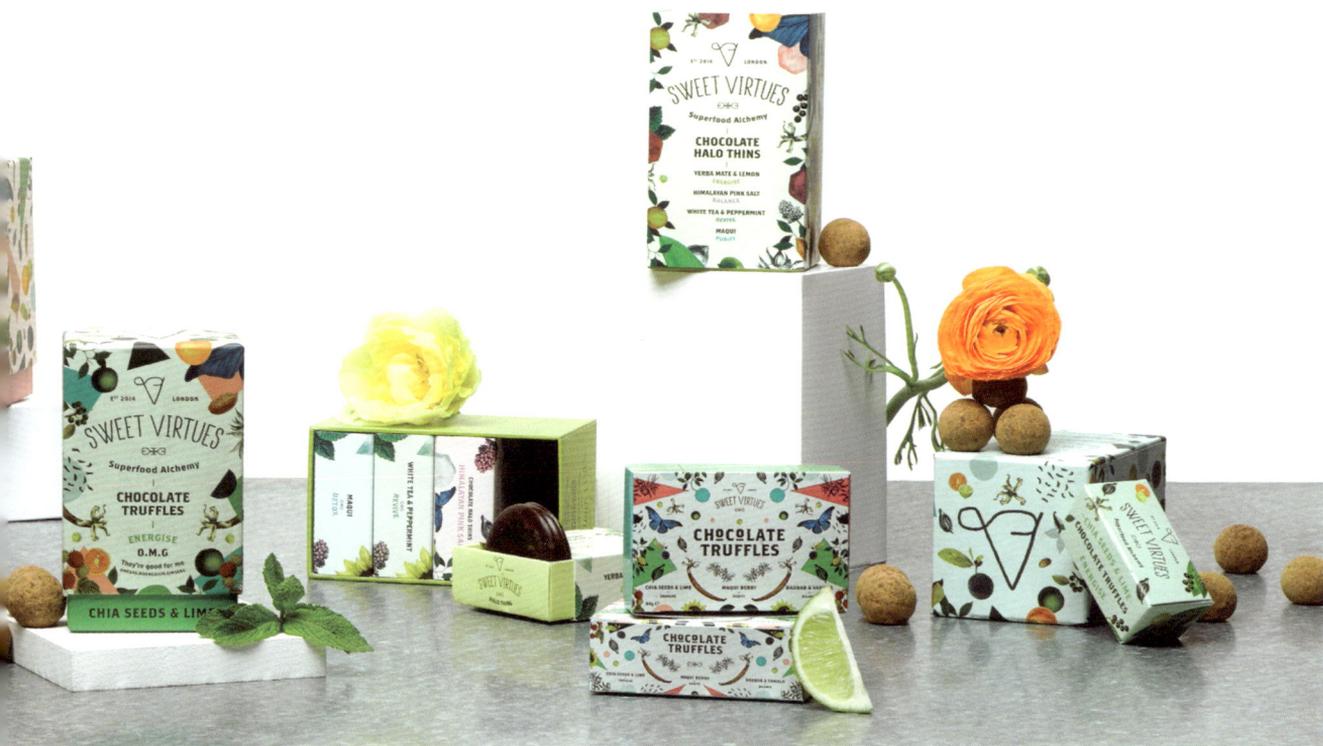

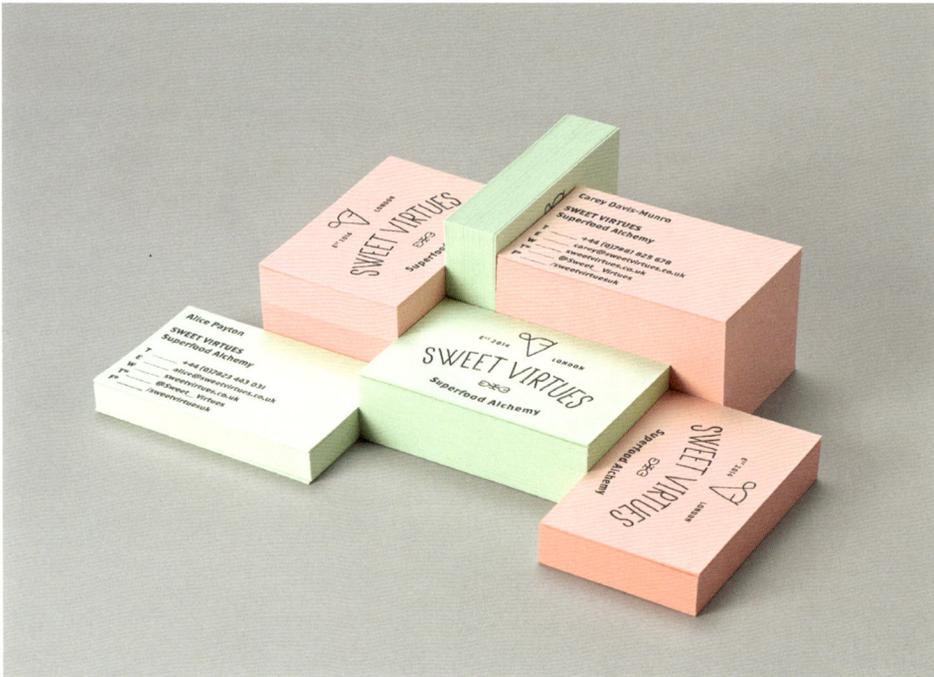

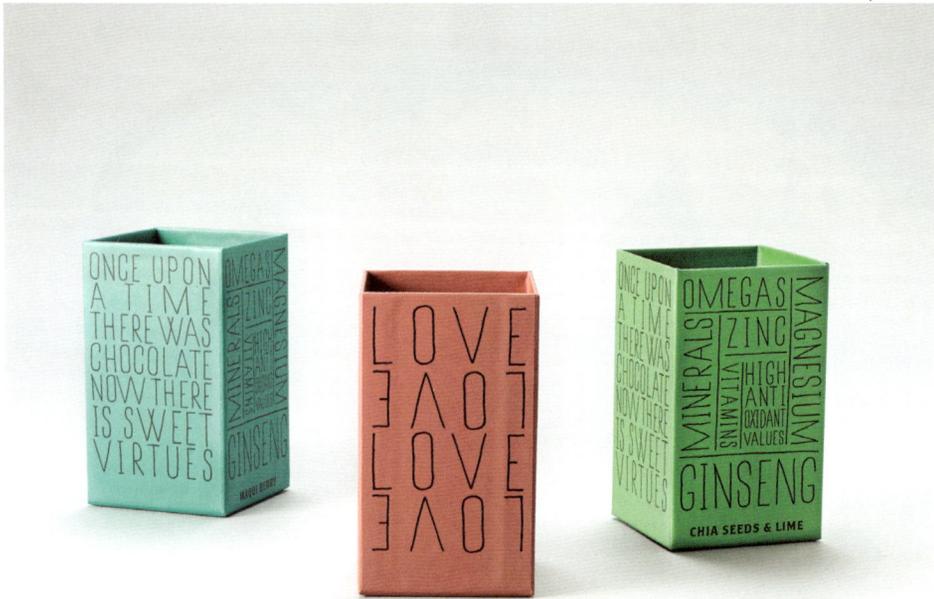

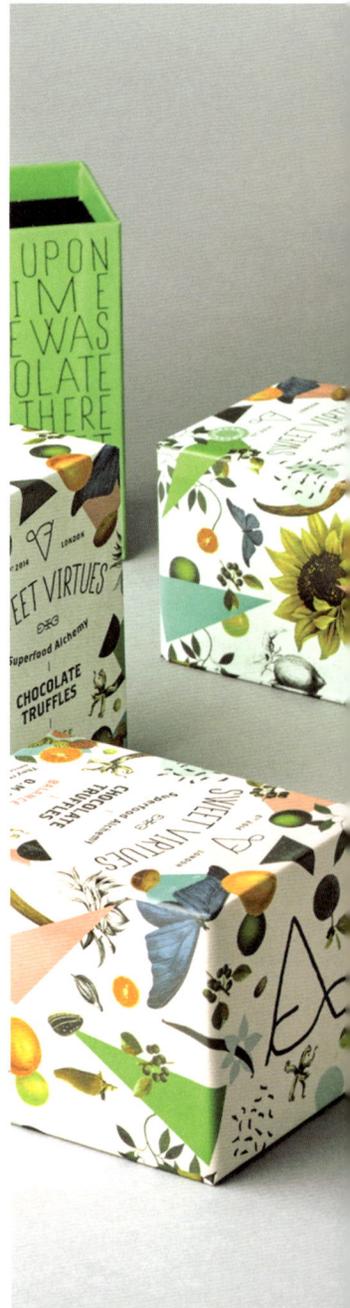

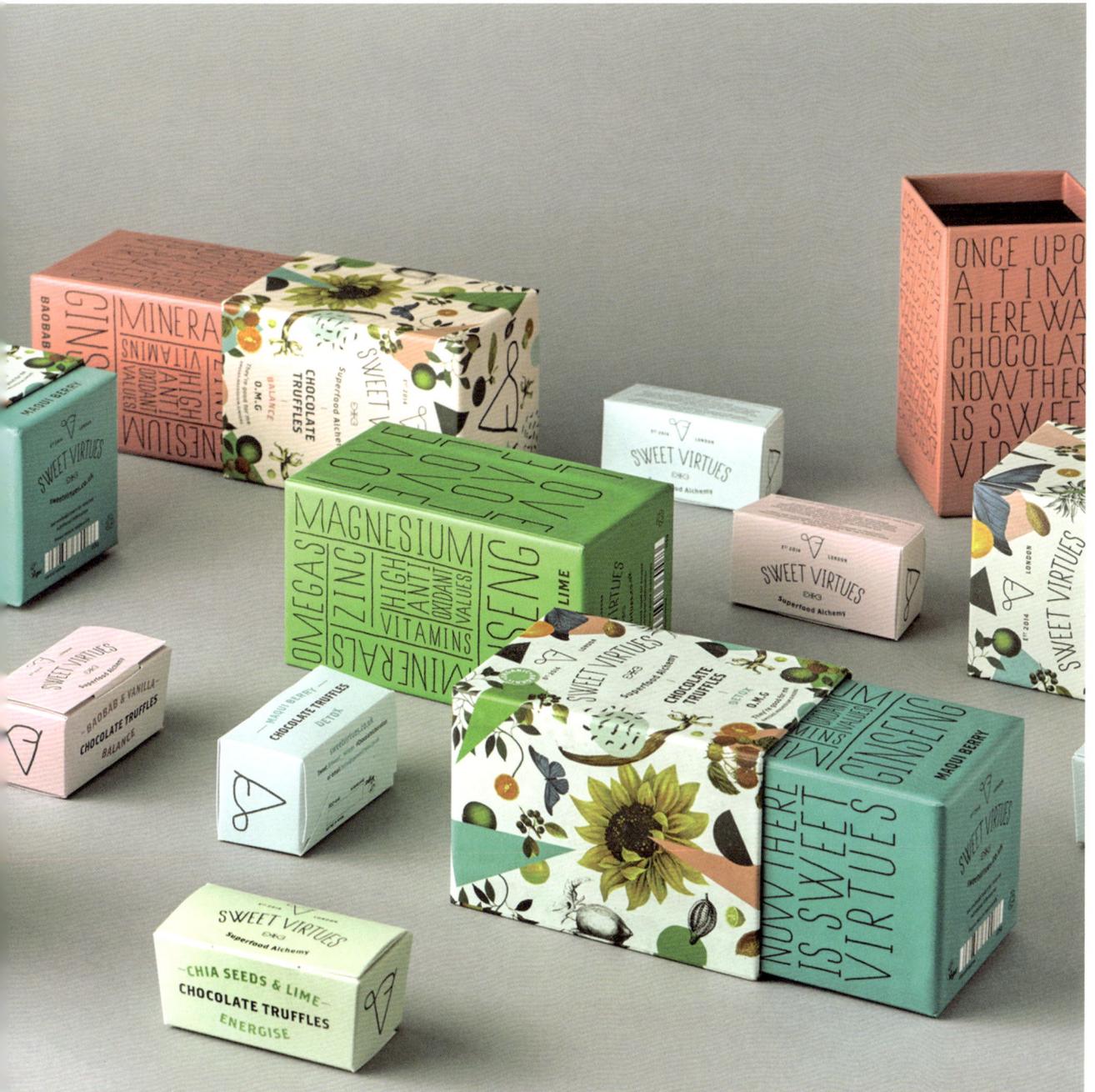

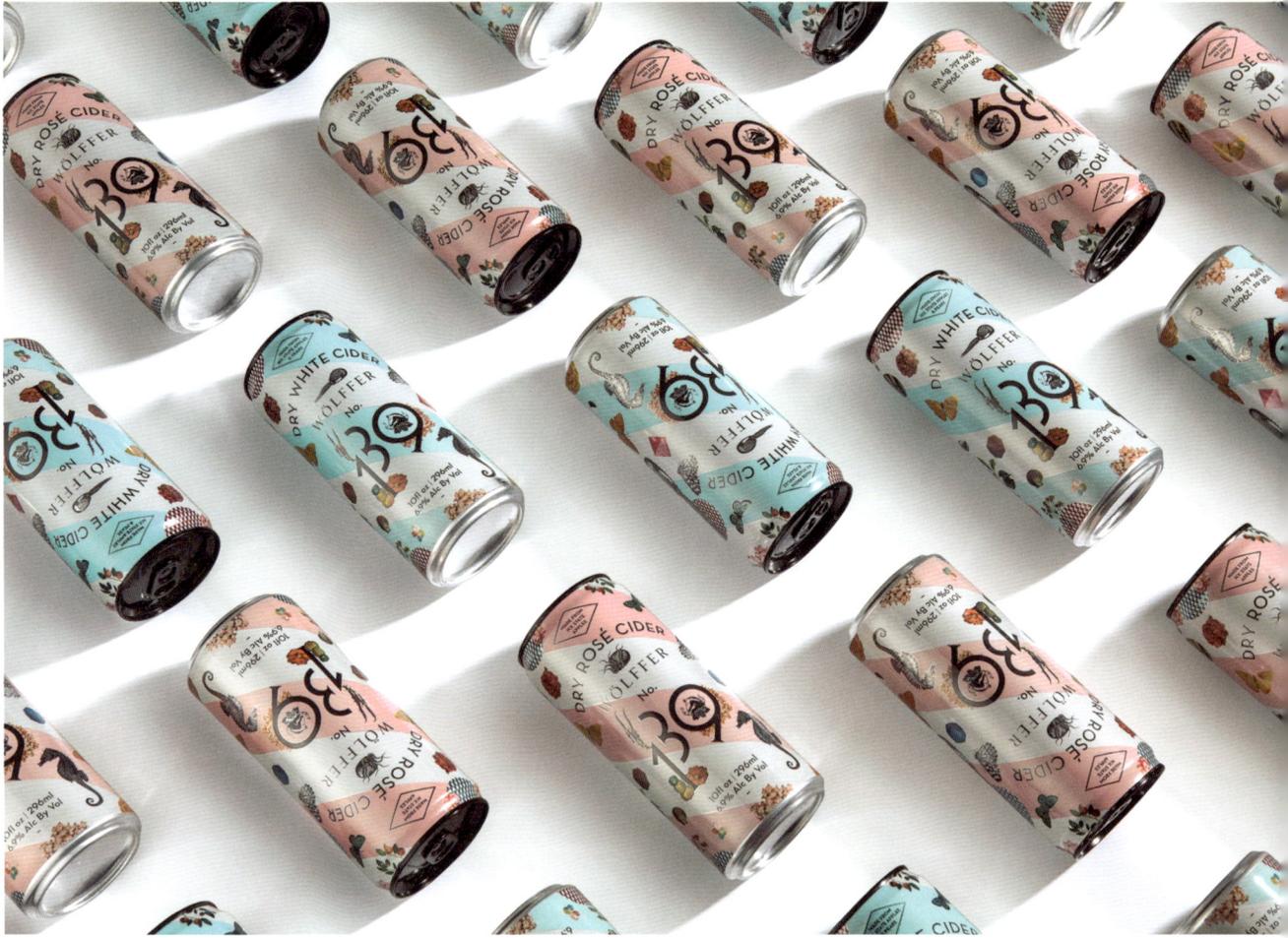

Wölffer 139
Cider Cans

IWANT Design sought to feature the contents of Wölffer 139's rosé and white variants in a modern and refreshing way. For each tin can design, they applied an aptly-coloured stripe pattern overlaid with images of plants and animals that corresponded with the variant. The resulting creative work exemplified 'sprinkles of nature' that helped the brand's unique products visually stand out on the shelves.

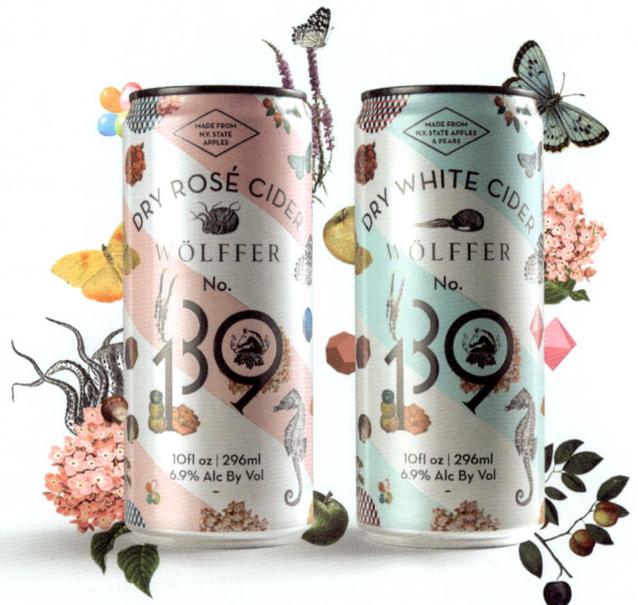

Design
IWANT Design

Client
Wölffer Estate

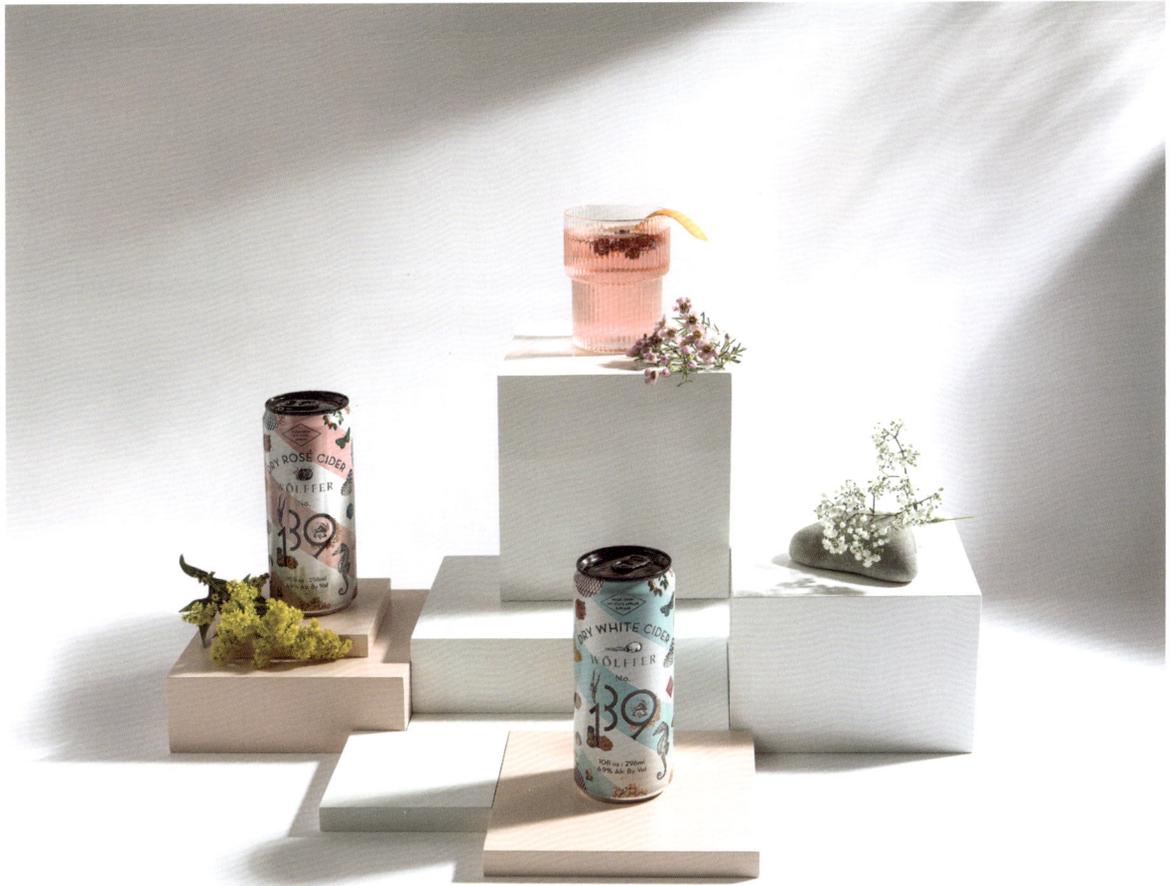

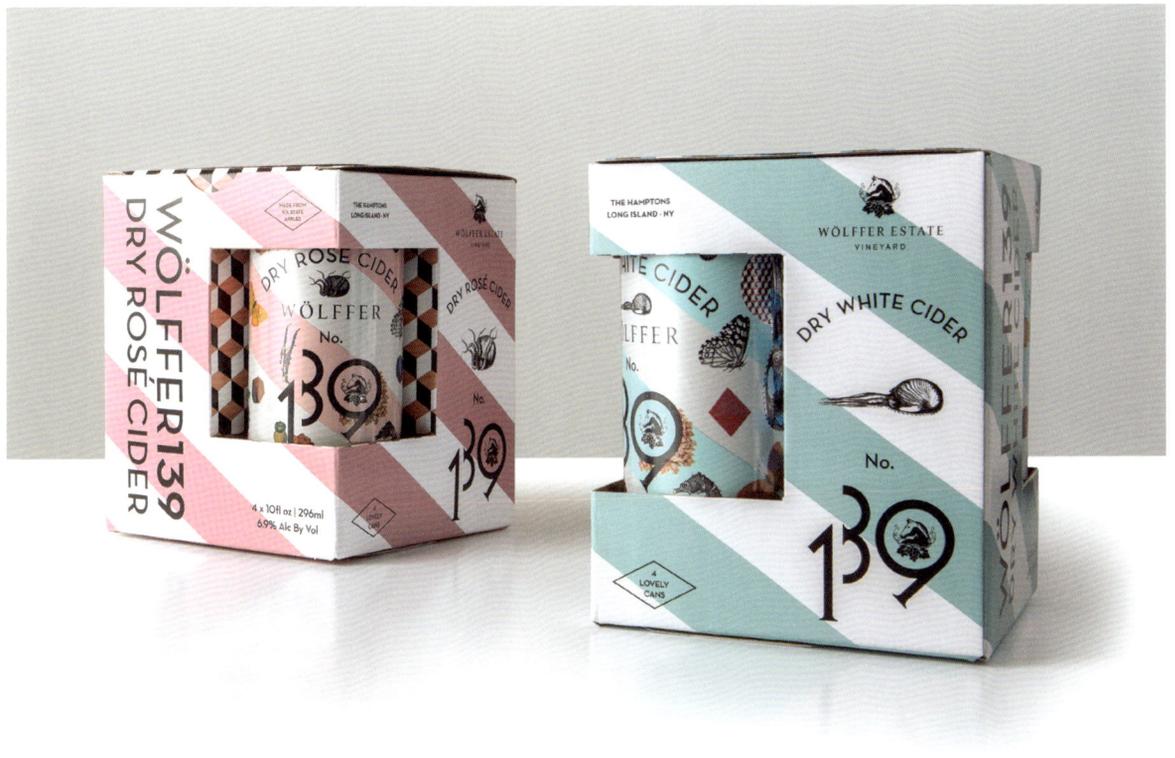

Mum

Mum is an organic chocolate manufacturer that uses environmentally sustainable production methods. To communicate its philosophy effectively, Design Studio B.O.B. combined colourful illustrations of various plants with traditional printing methods and embossed gold-foil finishes. The raw texture from printing represented the handmade quality of the chocolate while the gold embossing exuded elegance to embody the carefully-crafted nature of the premium products effectively.

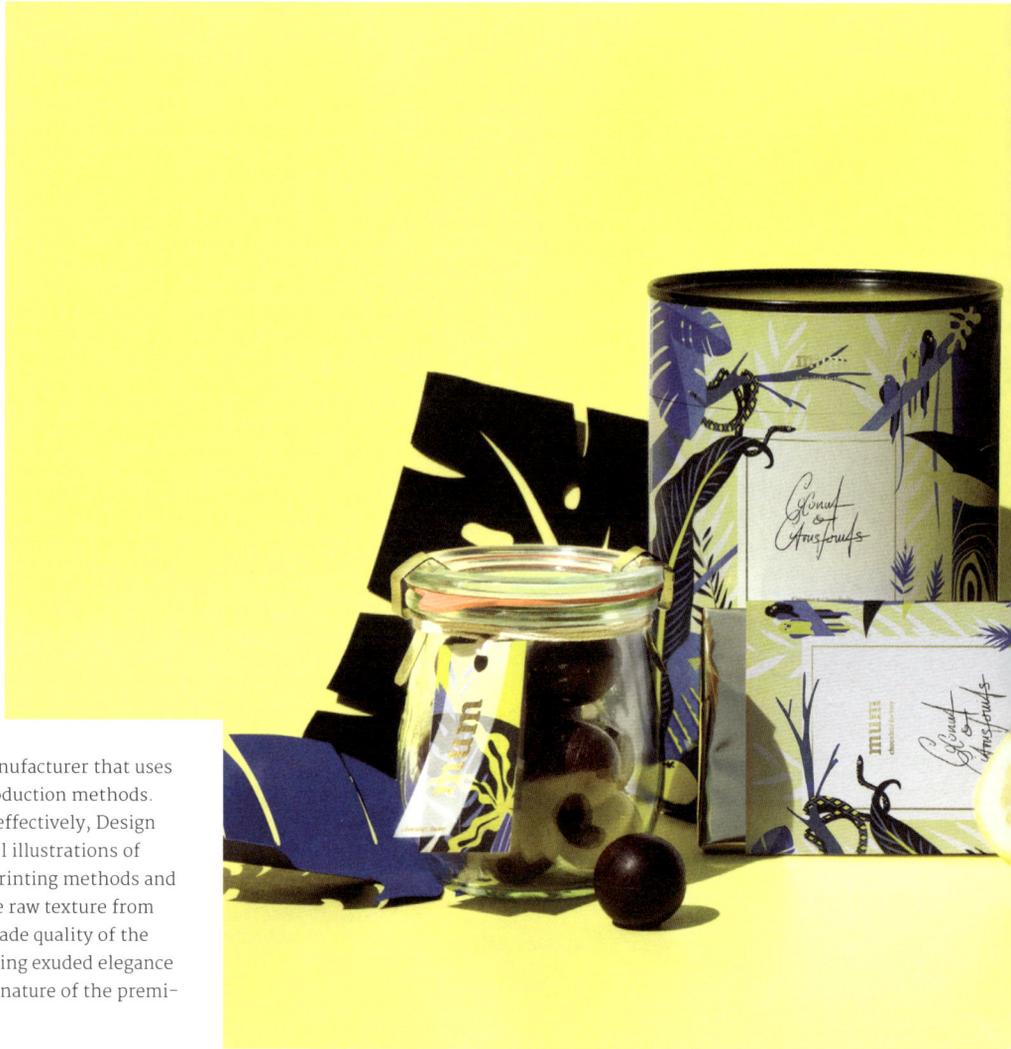

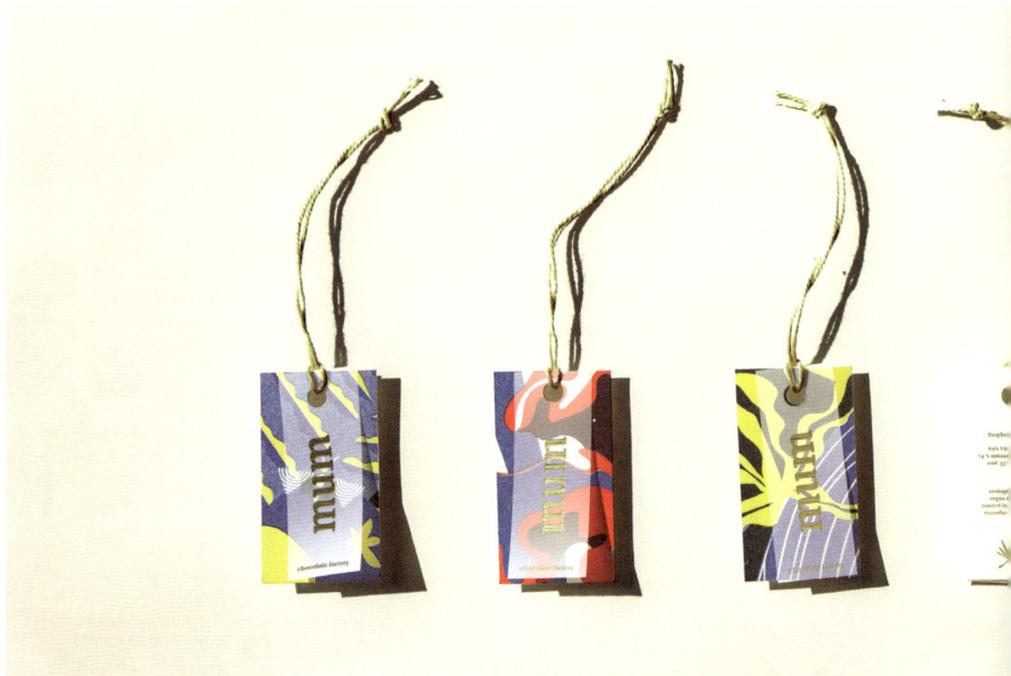

Design
Design Studio B.O.B.

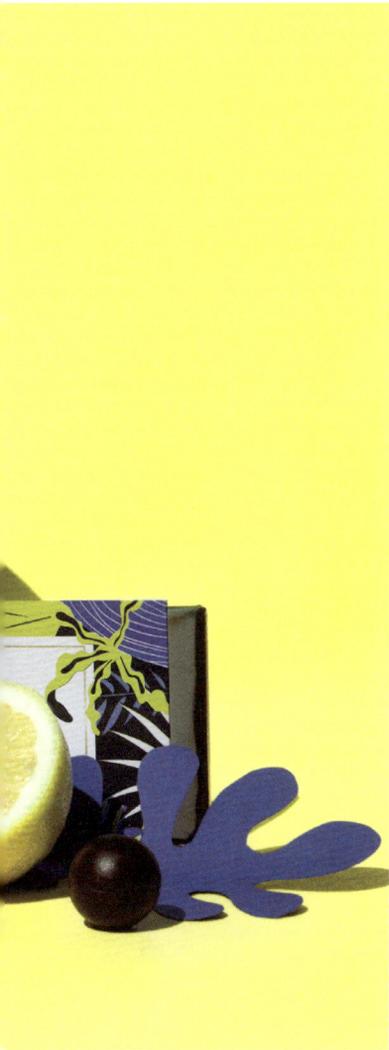

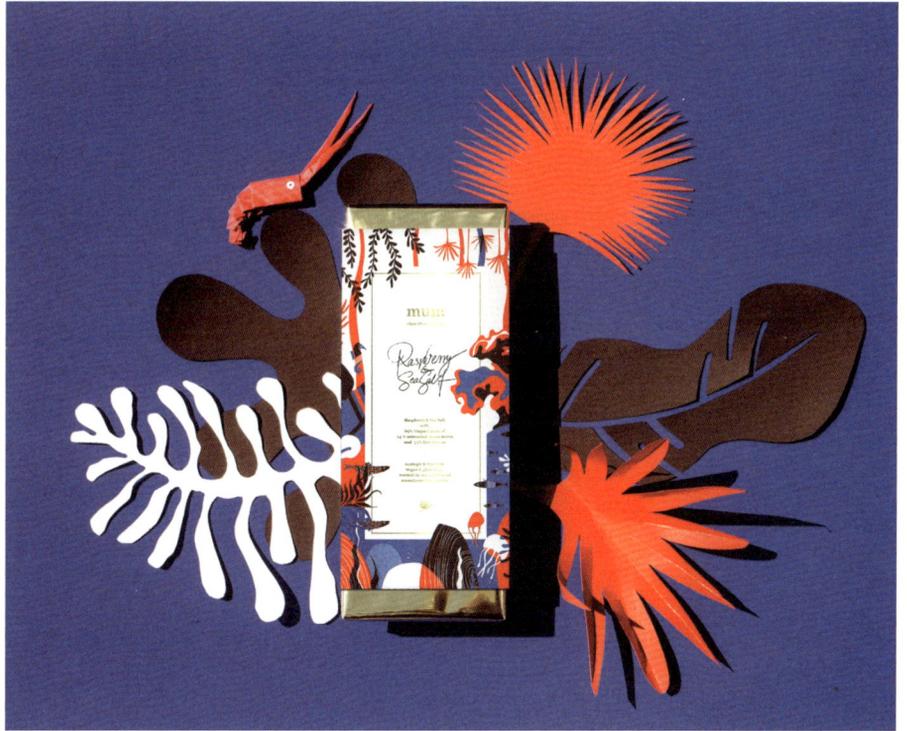

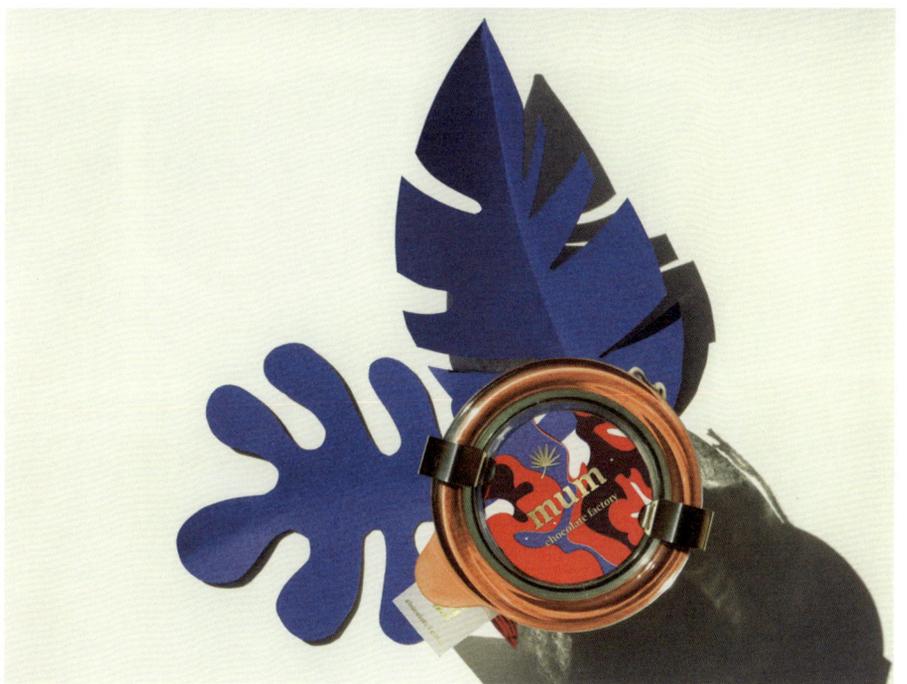

Design
Backbone Branding

Day & Night

Inspired by the brand's transition from restaurant to bar come sundown, Backbone Branding's visual identity work for Day & Night reflects the concept of duality through various design elements. The logo seamlessly combines the letters 'D' and 'N' to symbolise the earth's rotation and shift from day to night, while on product packaging, different animals are depicted in flesh and constellation forms to bring their idea to life.

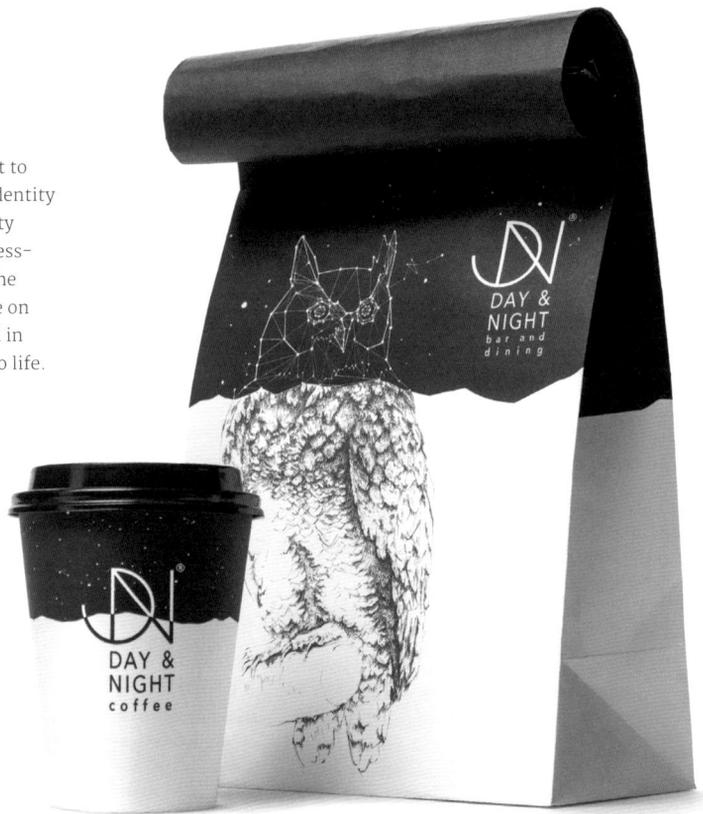

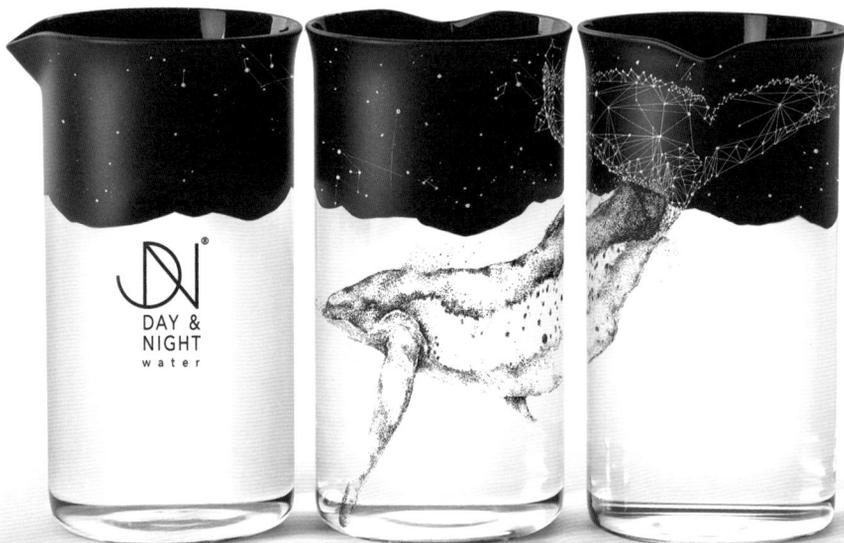

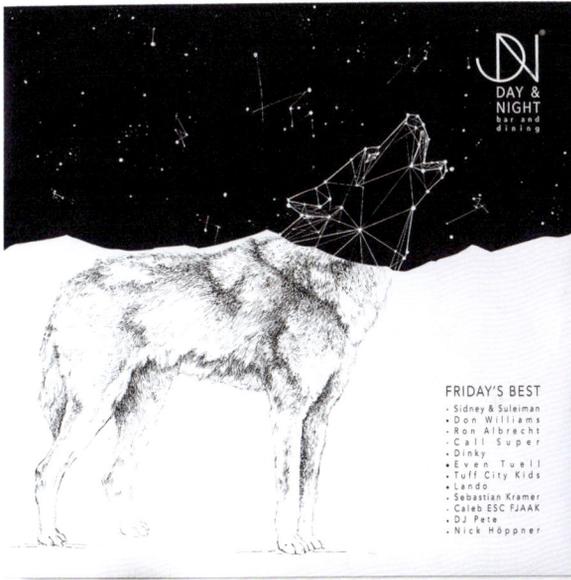

FRIDAY'S BEST
· Sidney & Suleiman
· Don Williams
· Ron Albrecht
· Call Super
· Dinky
· Even Tuell
· Tuff City Kids
· Lando
· Sebastian Kramer
· Caleb ESC FJAAK
· DJ Pete
· Nick Höppner

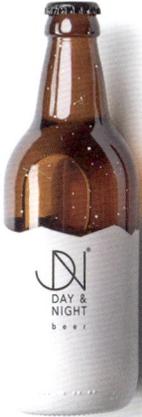

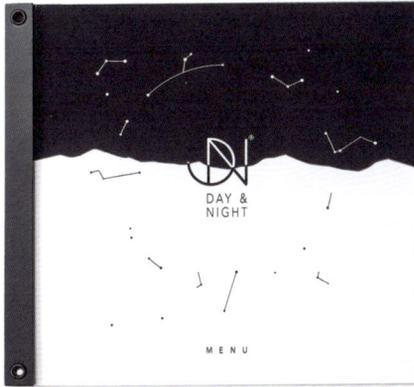

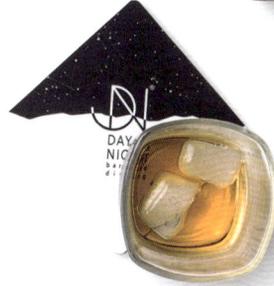

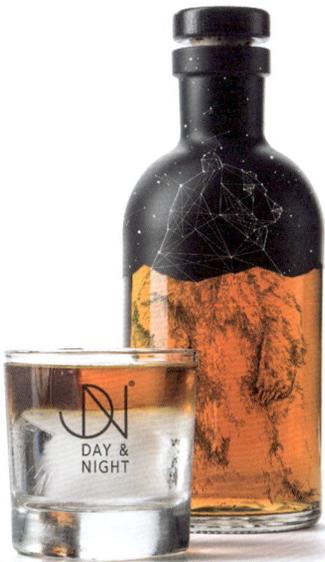

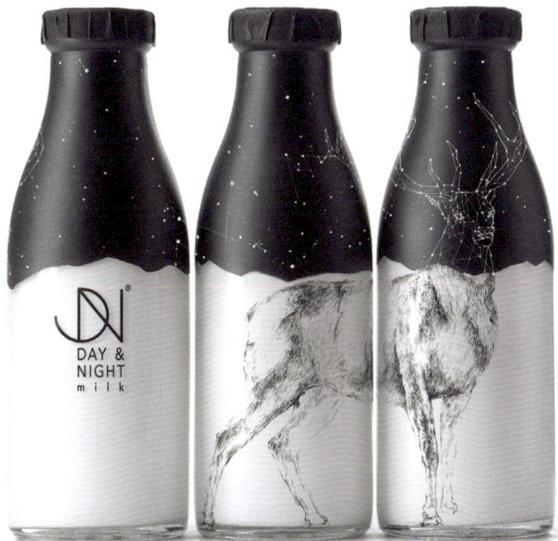

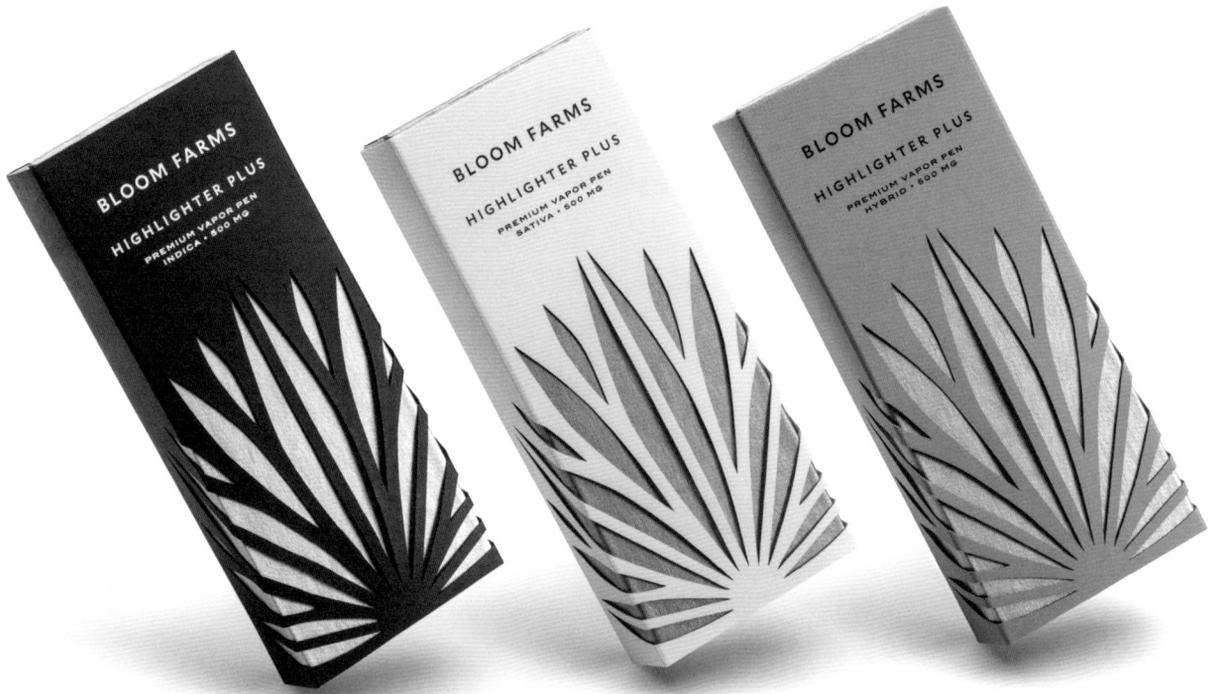

Bloom Farms
Highlighter Plus

Pavement's packaging design work for Bloom Farms Highlighter Plus products with advanced vaporisation technology combines elegant cut-outs of petals with a sophisticated silver palette. Through the textured sleeves, they successfully added a subtle layer of style, progress, and luxury to the product range to reflect the brand's spirit of innovation.

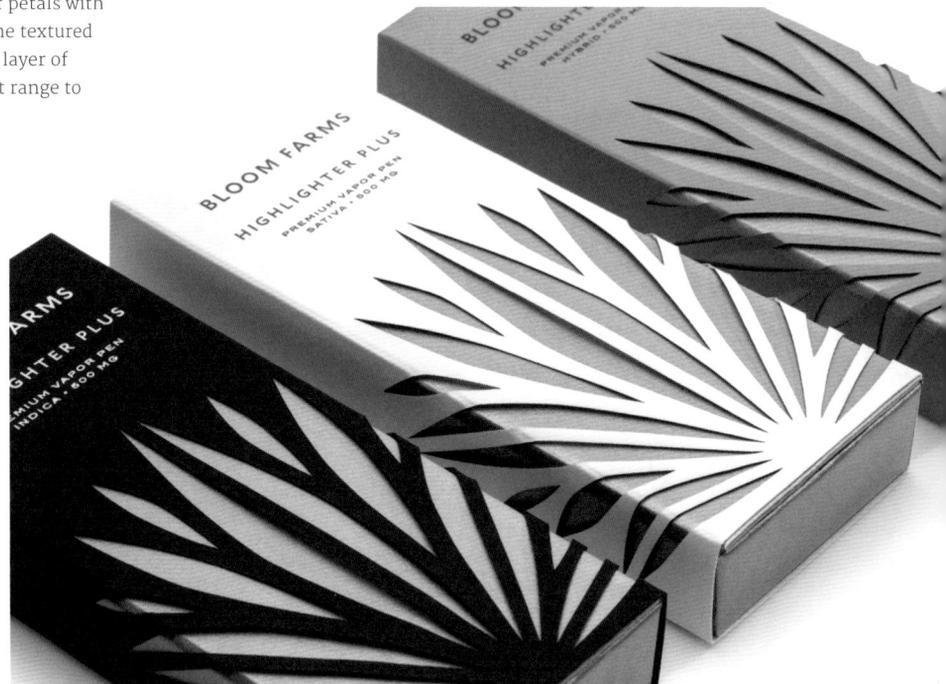

Design
Pavement

Client
Bloom Farms

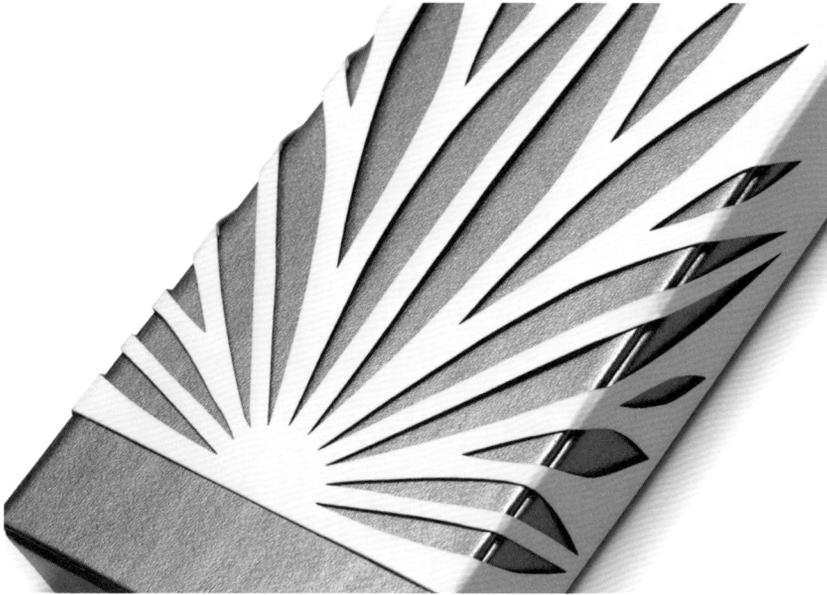

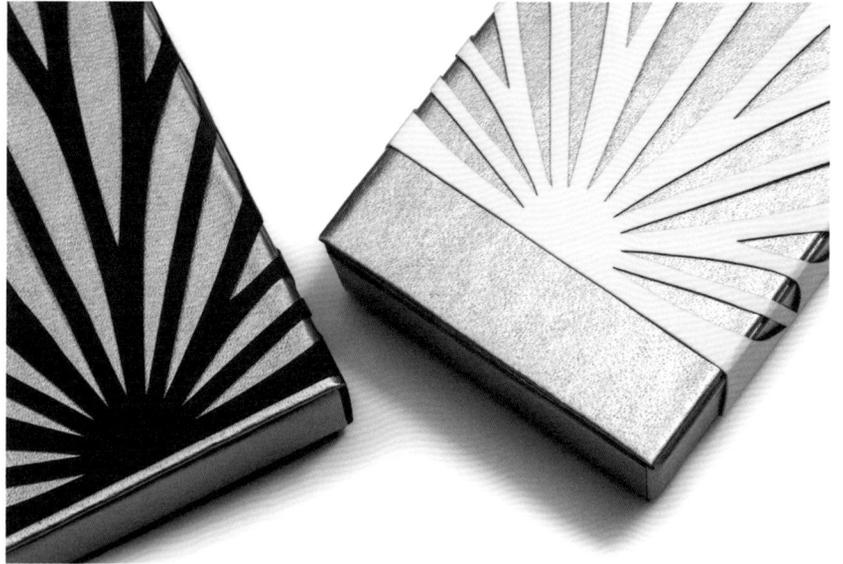

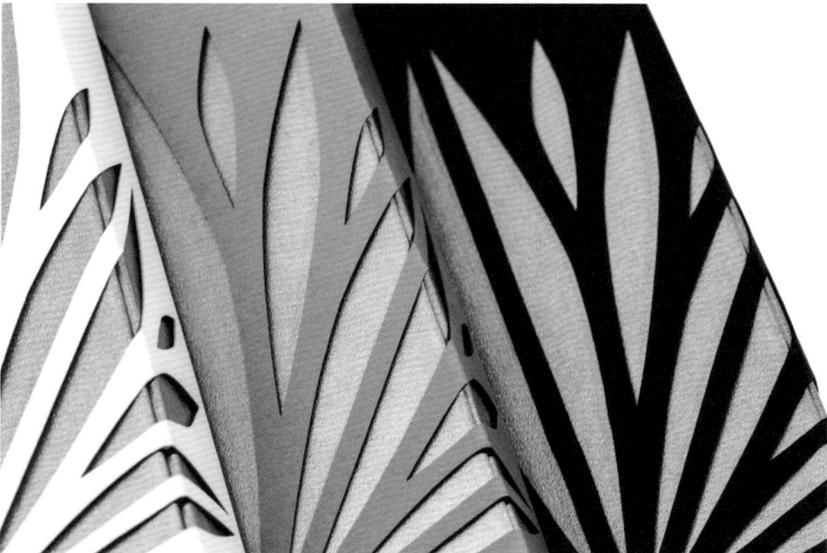

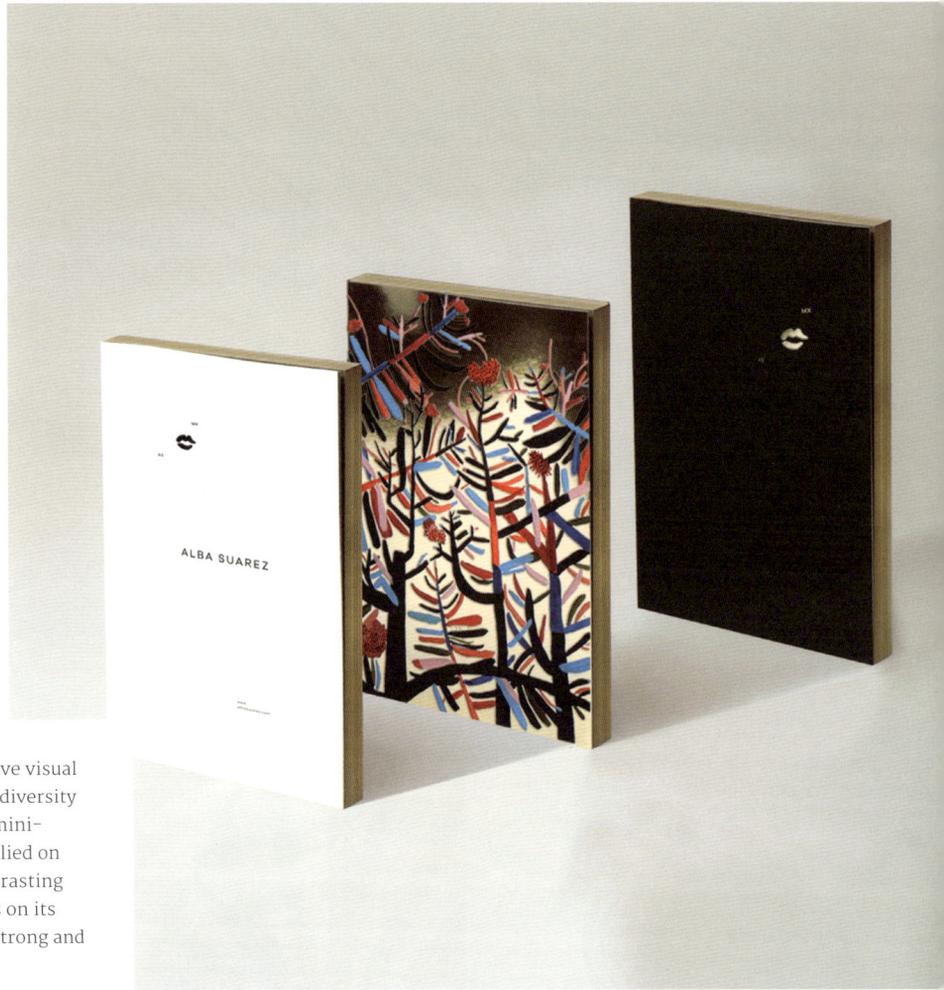

ALBA SUAREZ

Karla Heredia Marínez created a distinctive visual identity that cleverly communicates the diversity of ALBA SUAREZ's consumer base. The minimalistic typography and layout style applied on its branding suite complements the contrasting colourful and abstract floral illustrations on its packaging design to reflect the brand's strong and lively personality.

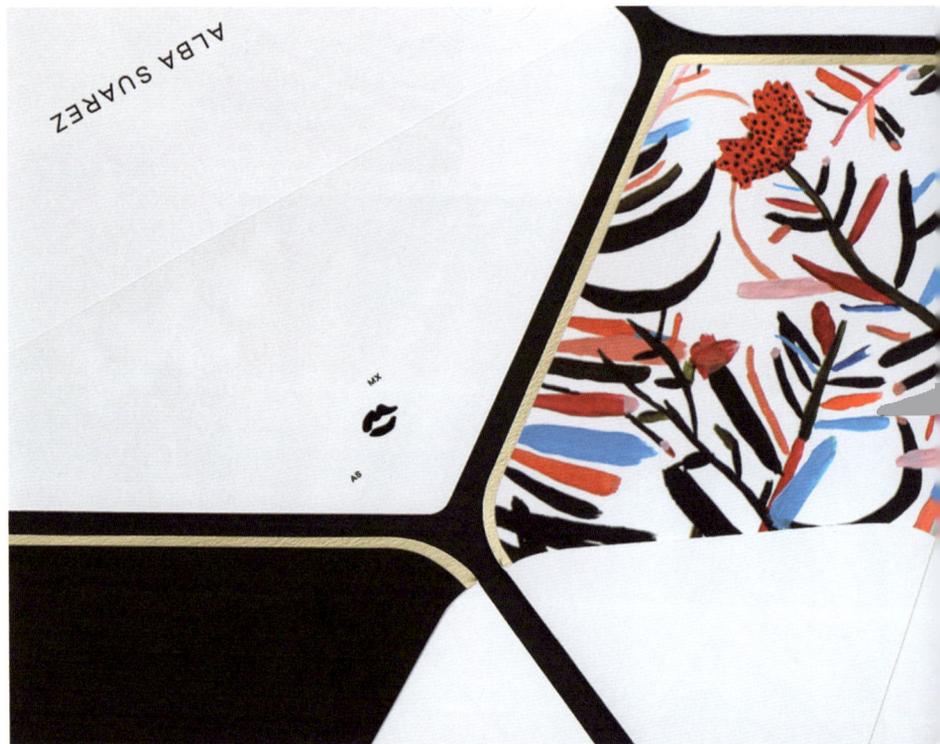

Design
Karla Heredia Martínez

Client
Alba Suárez

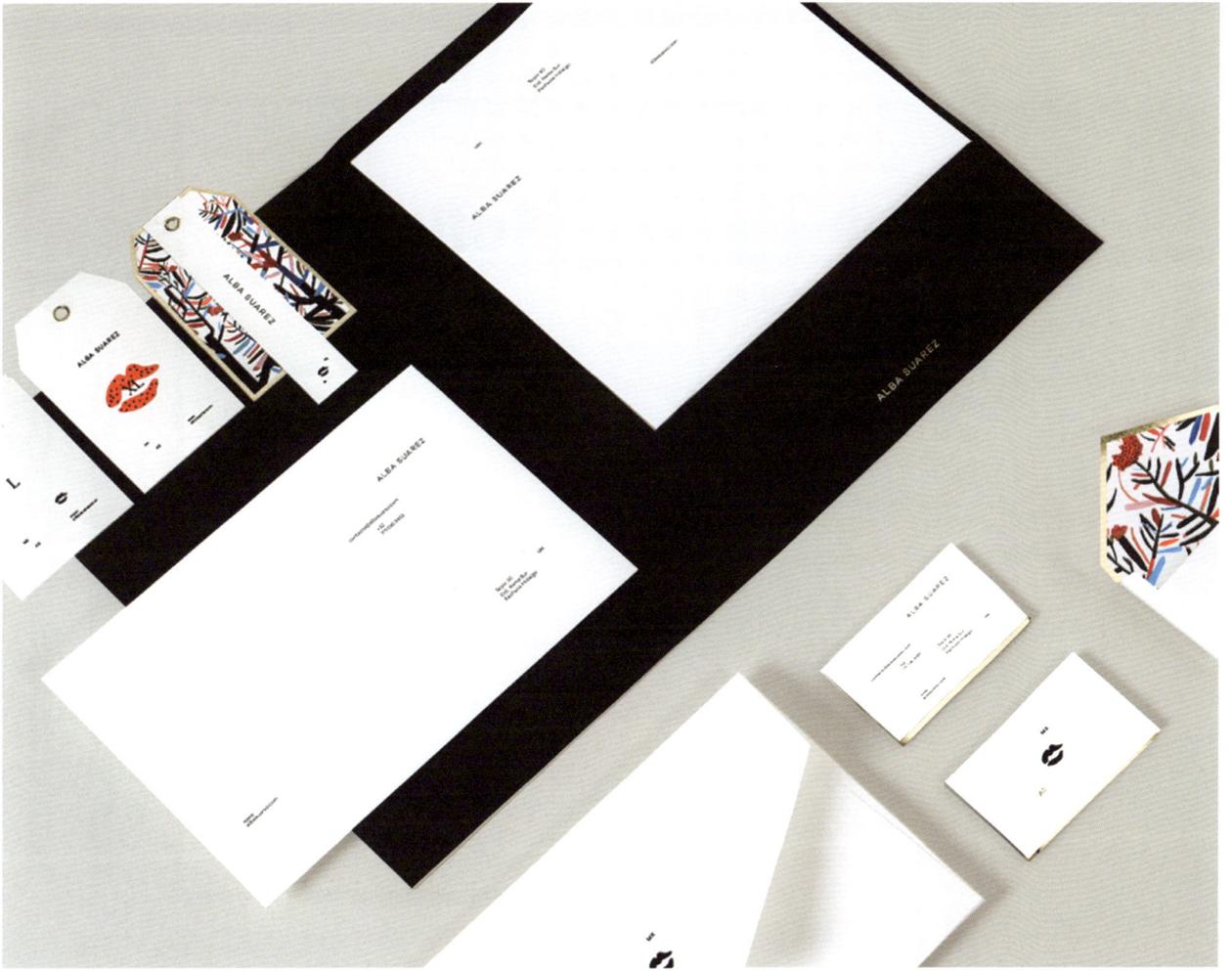

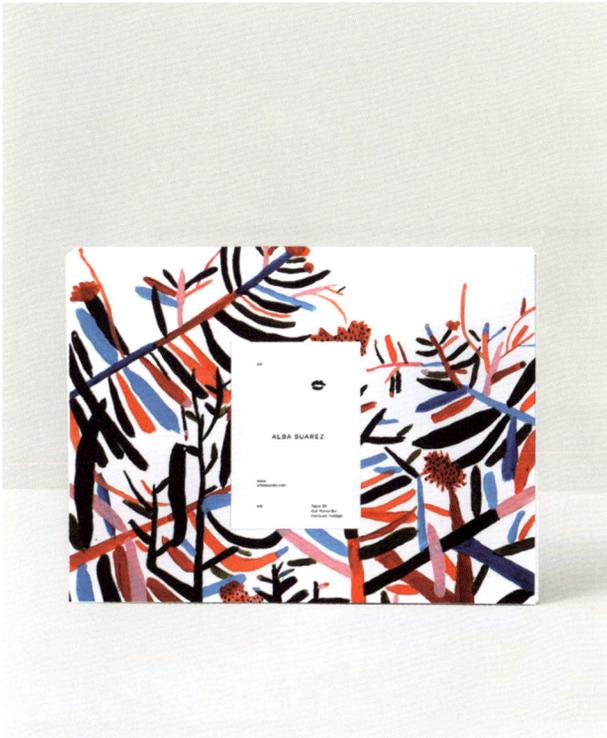

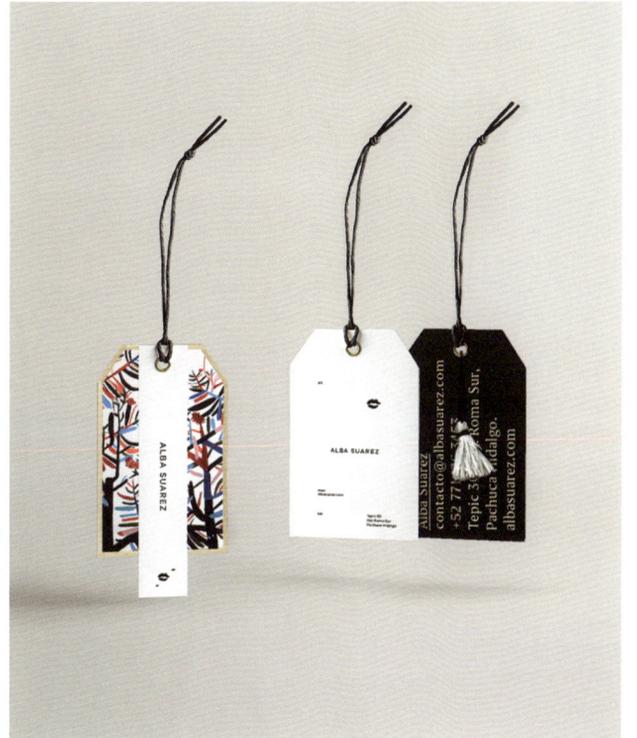

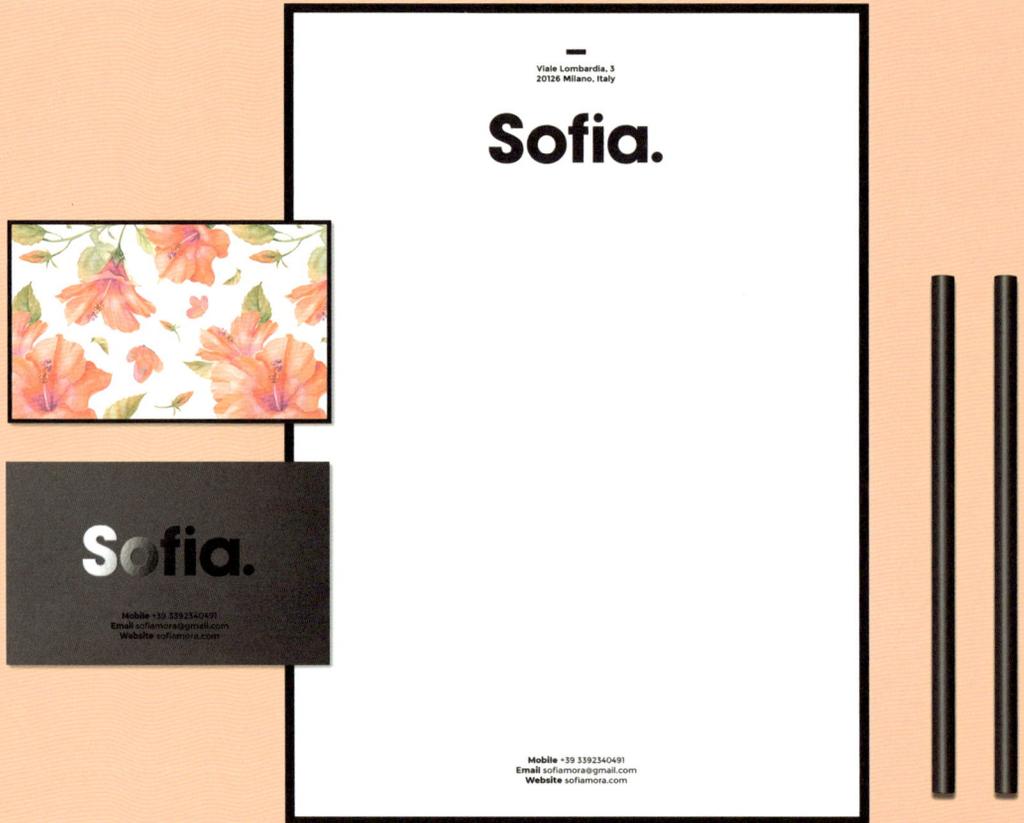

Sofia Mora

Floral patterns against a black backdrop may seem like an unexpected combination, but Davide Parere expertly integrated the two elements to create a seamless visual identity for Sofia Mora, an independent Italian fashion boutique. The memorable branding suite exudes both elegance and dark sophistication through his intricate illustrations and clever application of colours to reflect the originality and timelessness of the boutique's offerings.

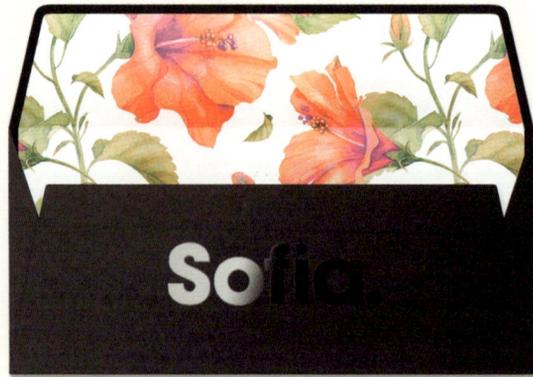

Design
Davide Parere

Client
Sofia Mora

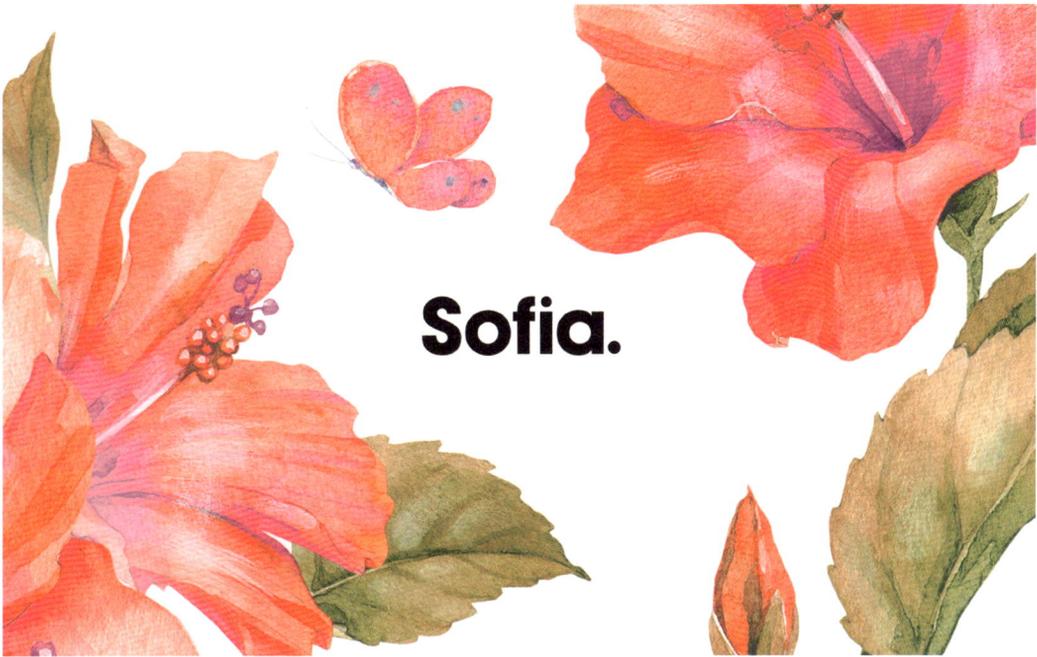

Sofia.

Sofia.

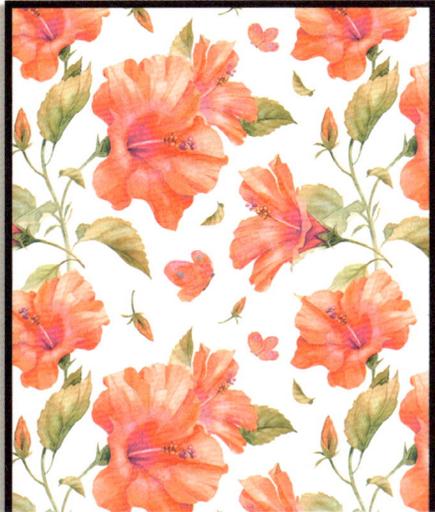

Viale Lombardia, 3
20126 Milano, Italy

Nu Ritual

A celebration of the artisan method of soap-making, Nu Ritual is a new line of soap bars inspired by French craftsmanship. To hint at the products' pure and natural ingredients while embodying the essence of the brand as a whole, Menta designed a visual identity that conjured images of antique apothecary jar labels in combination with modern botanical illustrations. Through their use of fine paper, advanced printing techniques, and detailed imagery, they crafted a distinctive, tactile, and luxurious visual language.

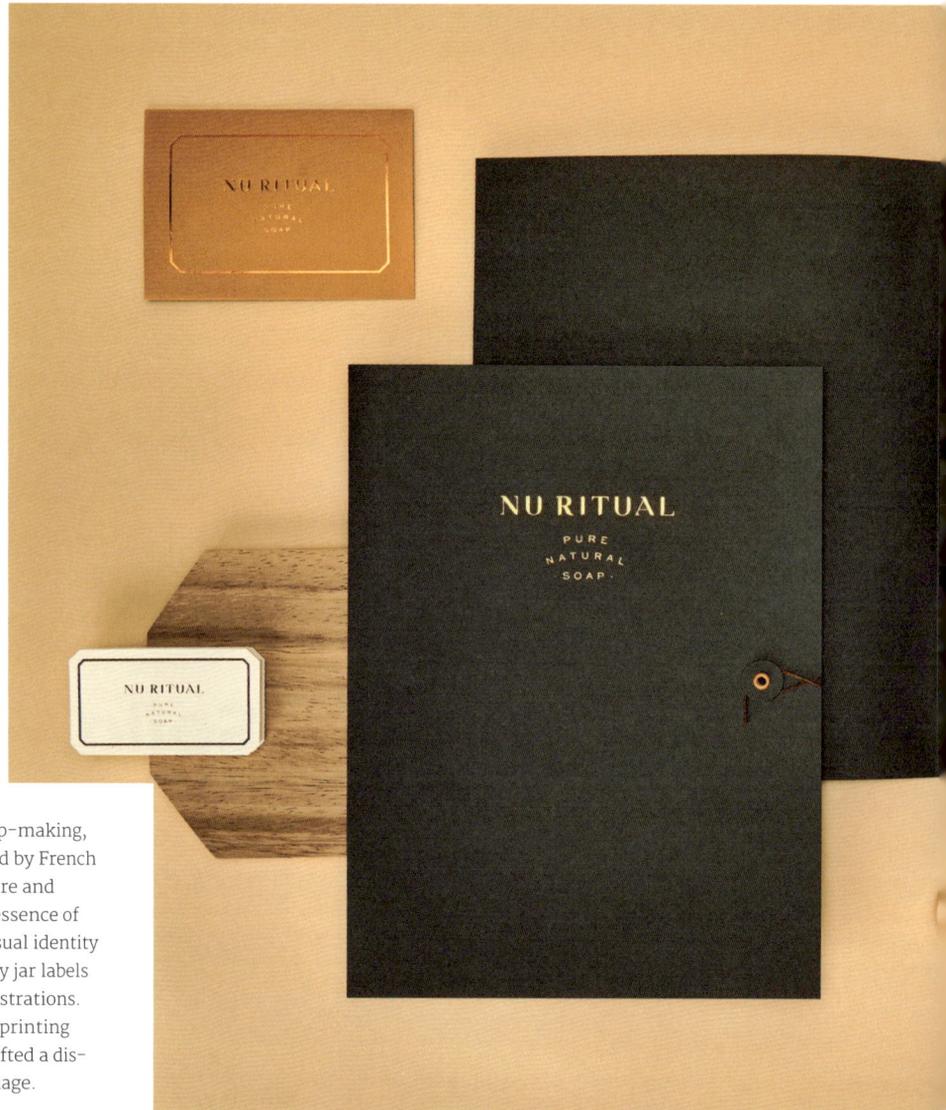

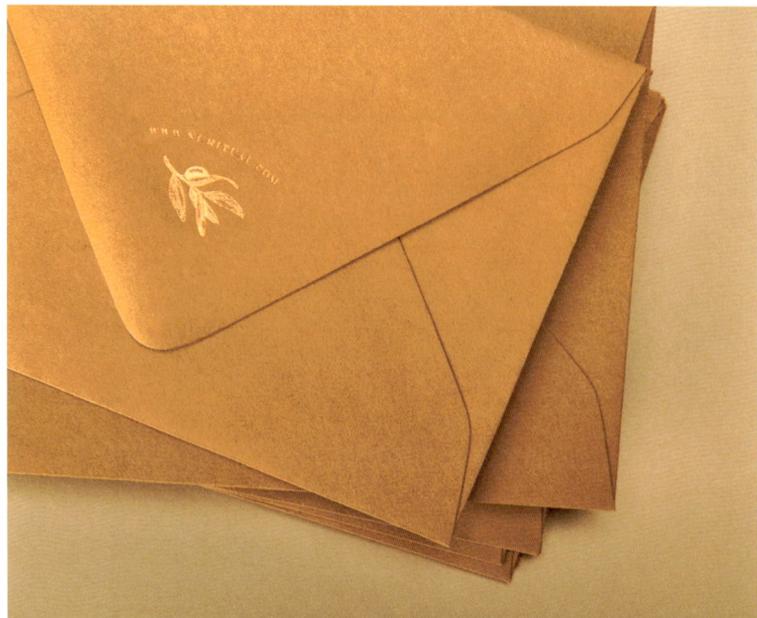

Design
Menta

Client
Charles Breidinger

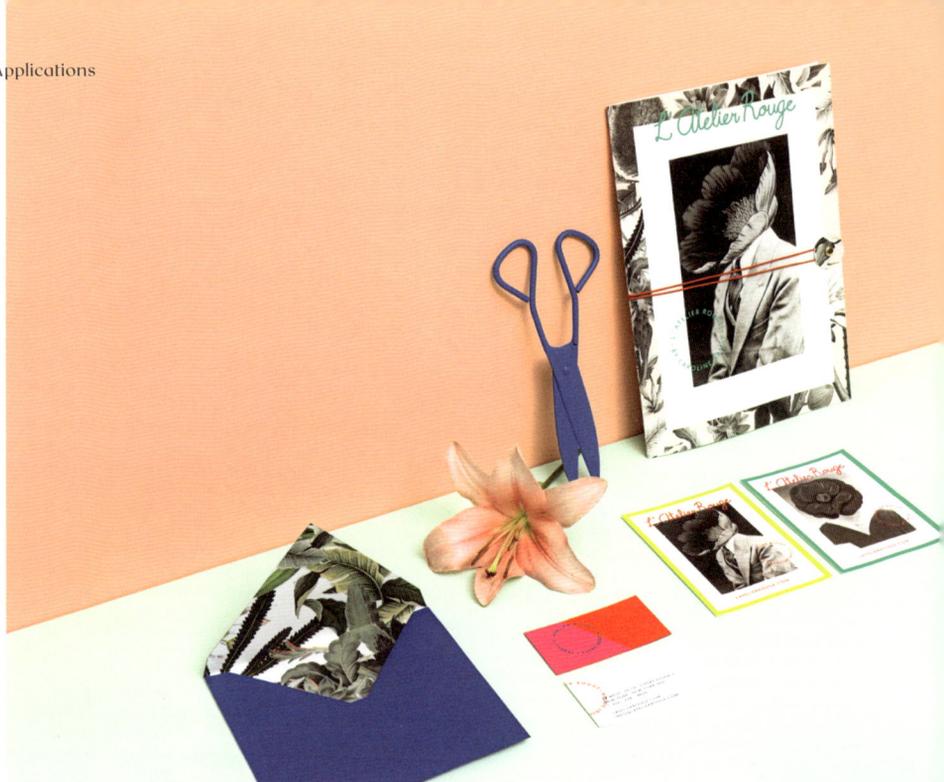

L'Atelier Rouge

In adding a contemporary and minimalist touch to the established 'floral punk' image of distinguished New York florist L'Atelier Rouge, Masquespacio Design utilised a clever combination of bold colours, intricate illustrations, and floral photography. They also applied flowers onto the heads of the L'Atelier Rouge team to create inventive and head-turning portraits. The resulting blend of concepts and styles balances the edgy character of the brand with its professional front perfectly.

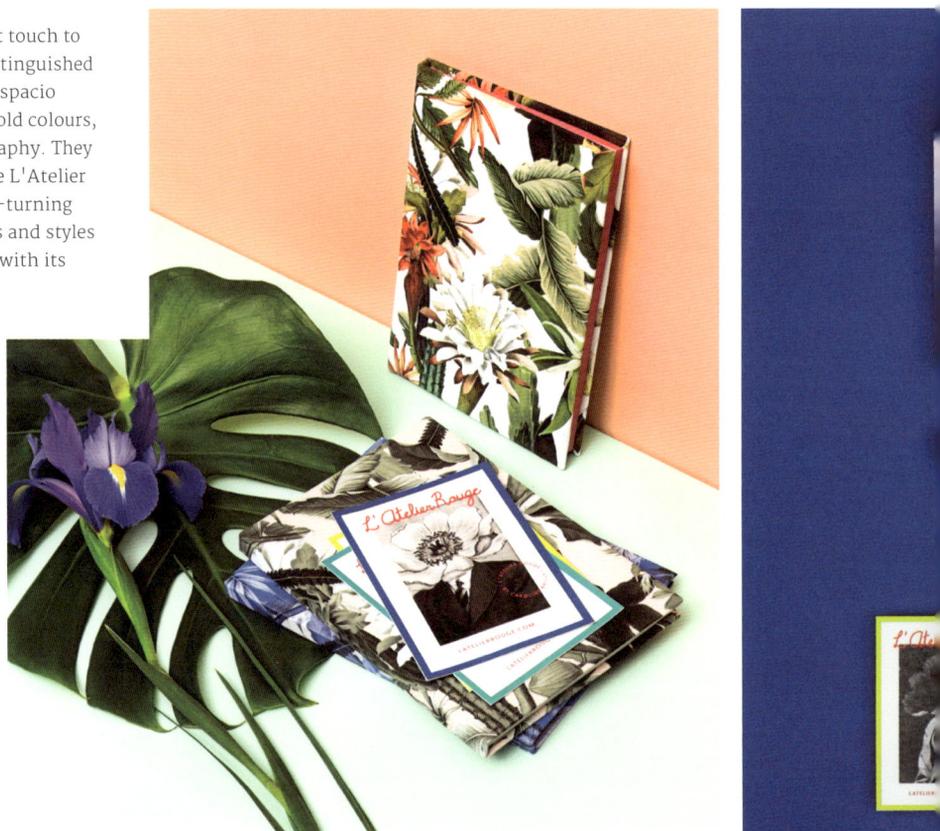

Design
Masquespacio

Client
L'Atelier Rouge

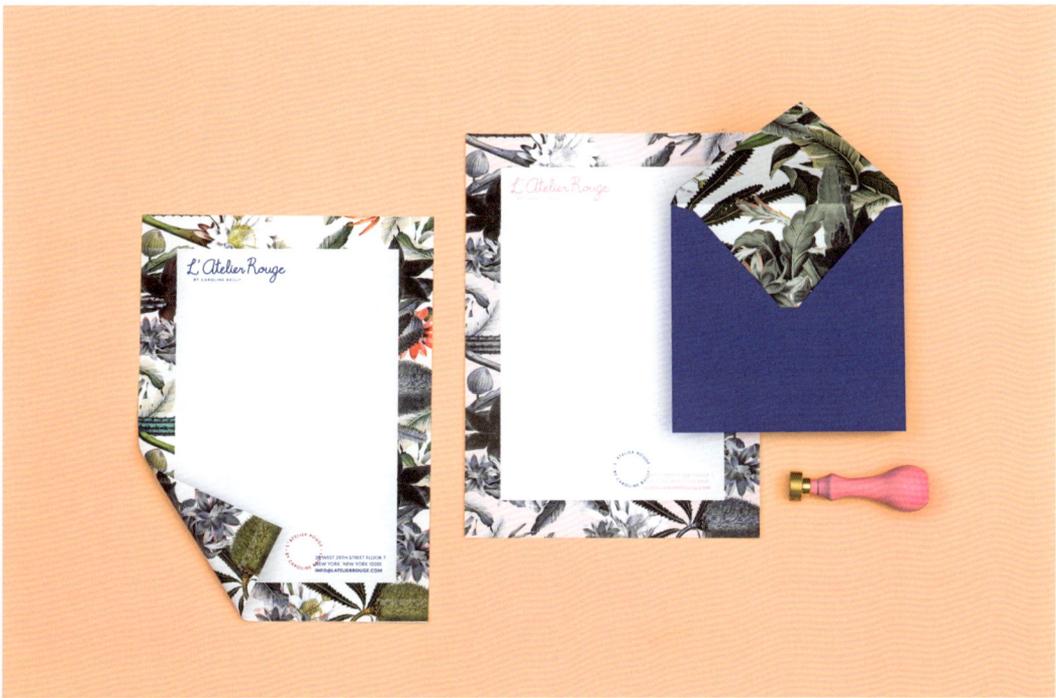

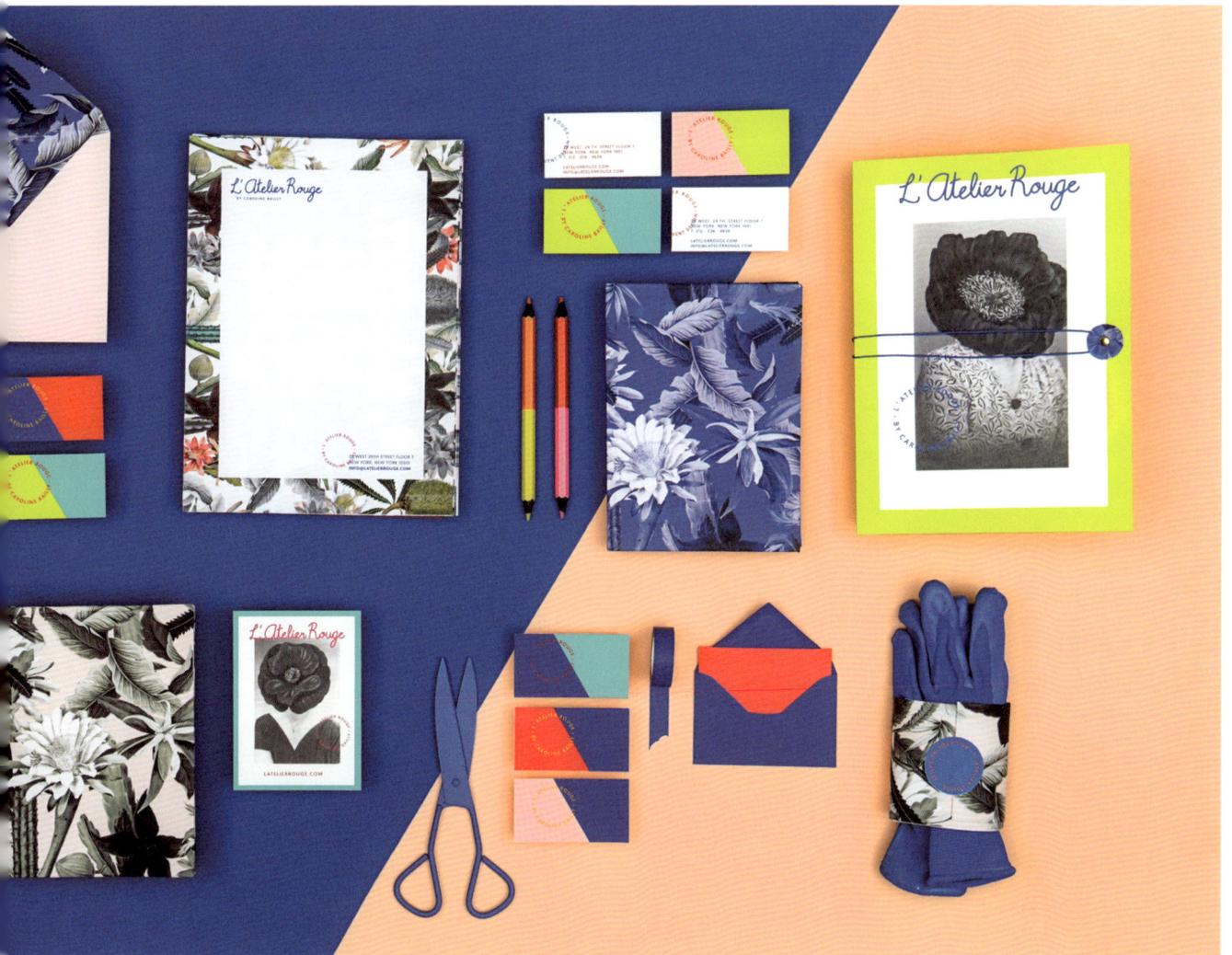

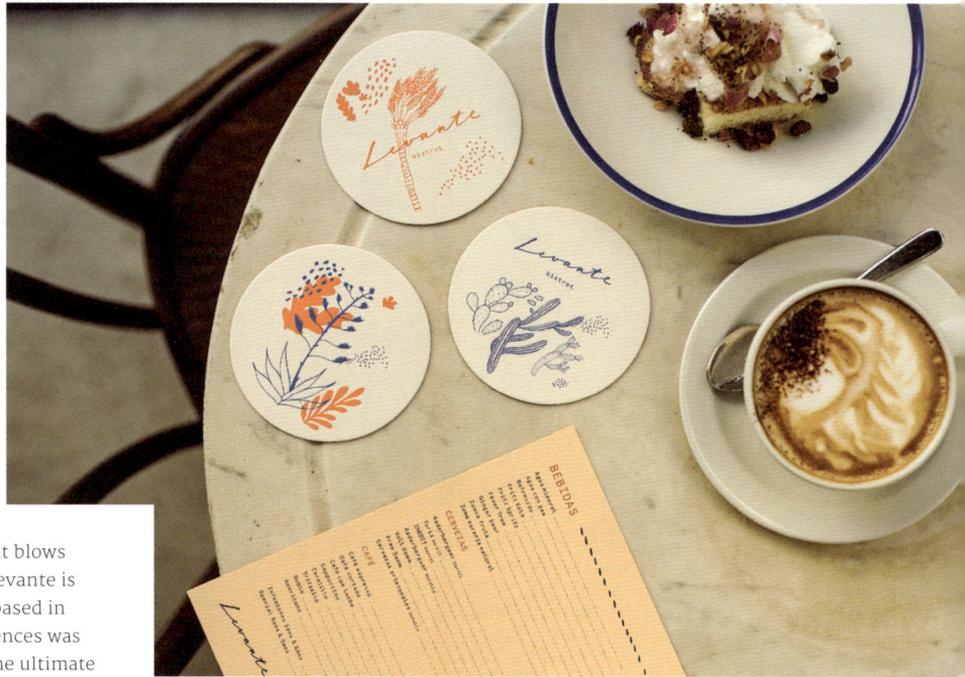

Levante

Sharing the name of an easterly wind that blows across the western Mediterranean Sea, Levante is a food bar owned by an Italian architect based in Barcelona. The merging of cultural influences was inspiration for studio NUR to celebrate the ultimate Mediterrinean lifestyle with a memorable visual identity. Through the slanted handwritten logo, illustrations of Mediterranean plants bending in the wind, and bright tones that echo those of a tropical sunset, they successfully captured the carefree essence of the word as well as the outlet.

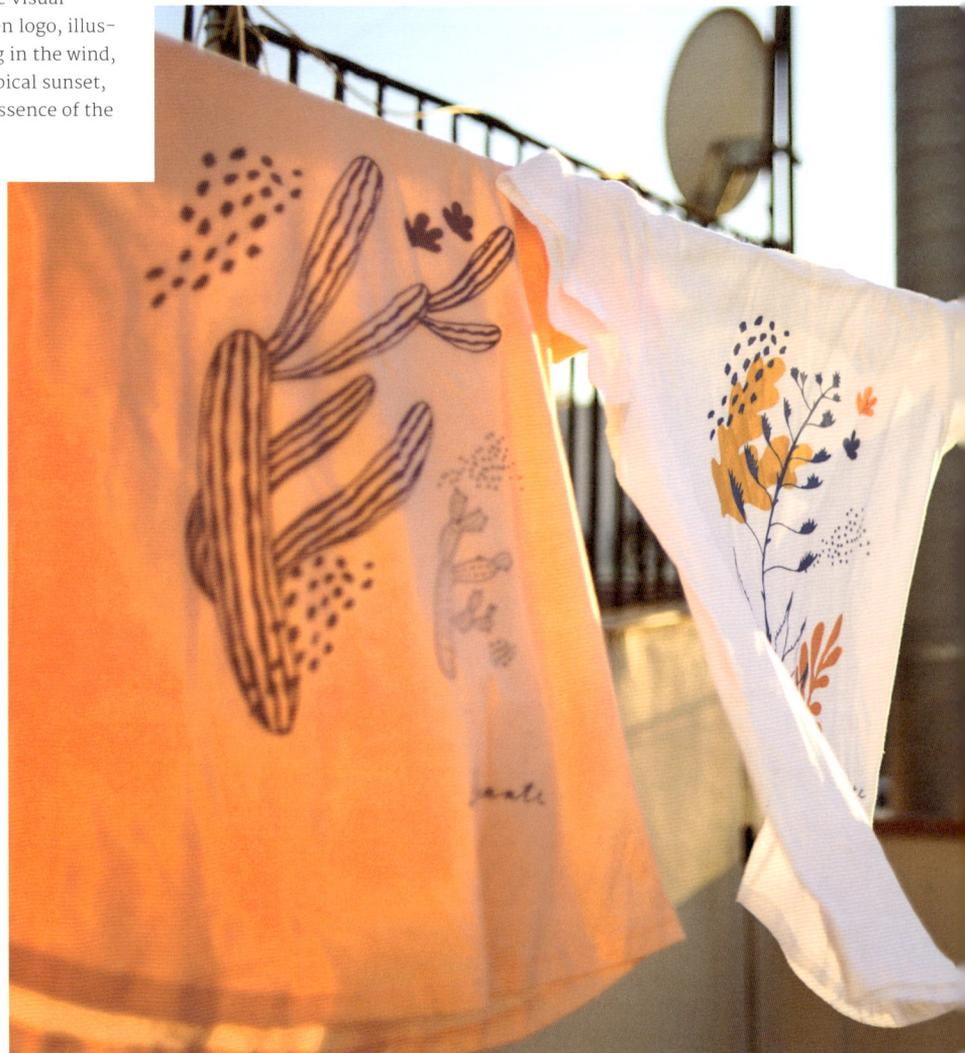

Design
studio NUR

Client
Levante

Photography
András Zoltai

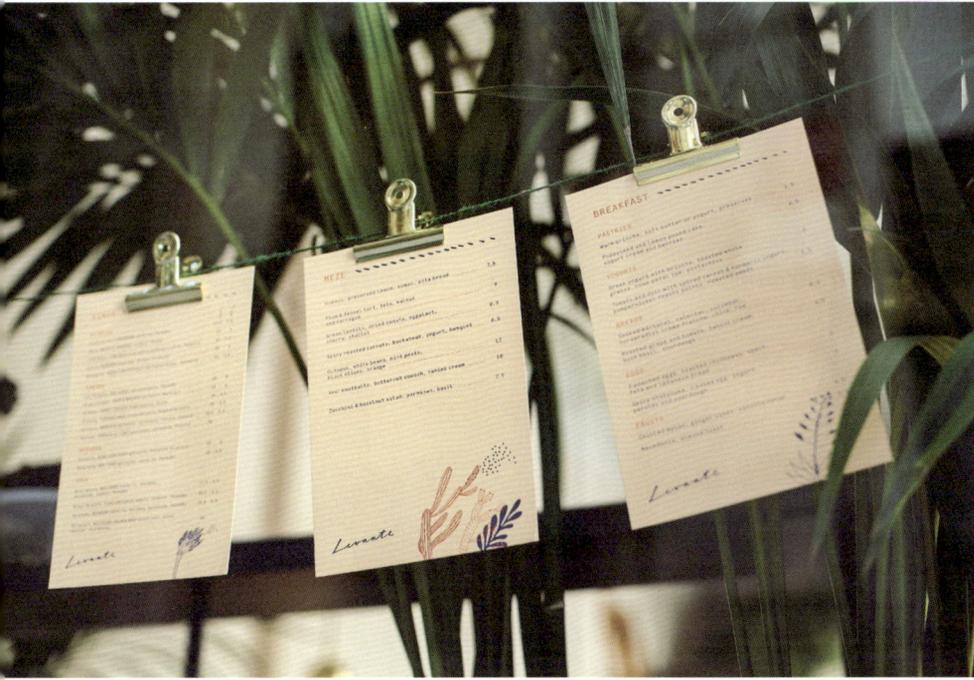

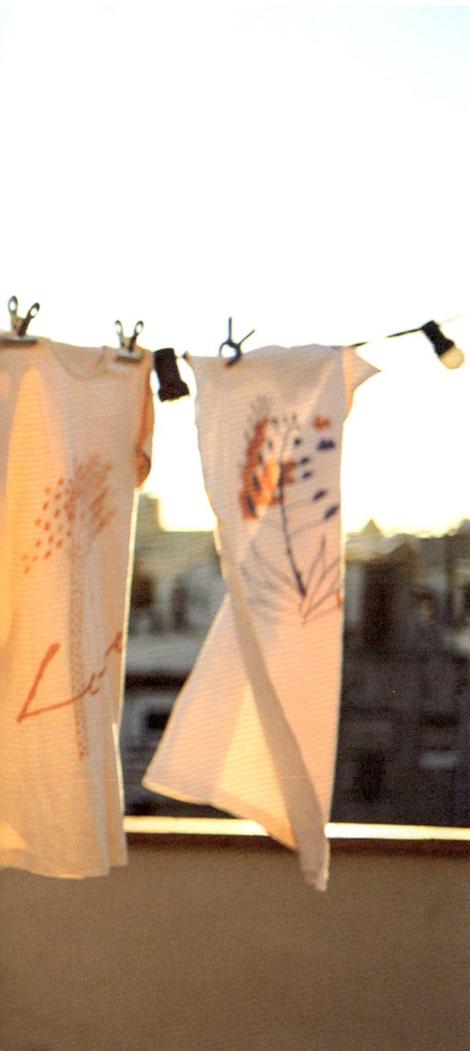

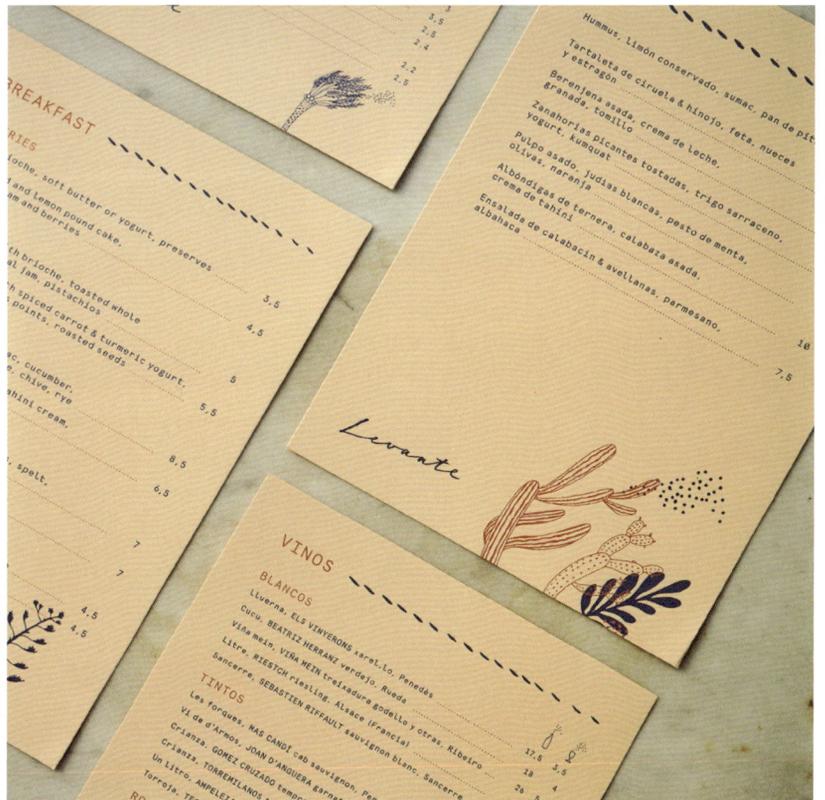

Nosh

Delicate illustrations of various leaves in subtle shades of green form the basis of the lush and luxurious visual identity for Nosh. Darling Visual Communications represented the bold, refined, but distinctively human character of the brand through the serif logotype stamped onto rich green fabric and timeless craft paper for an authentic and textured finish.

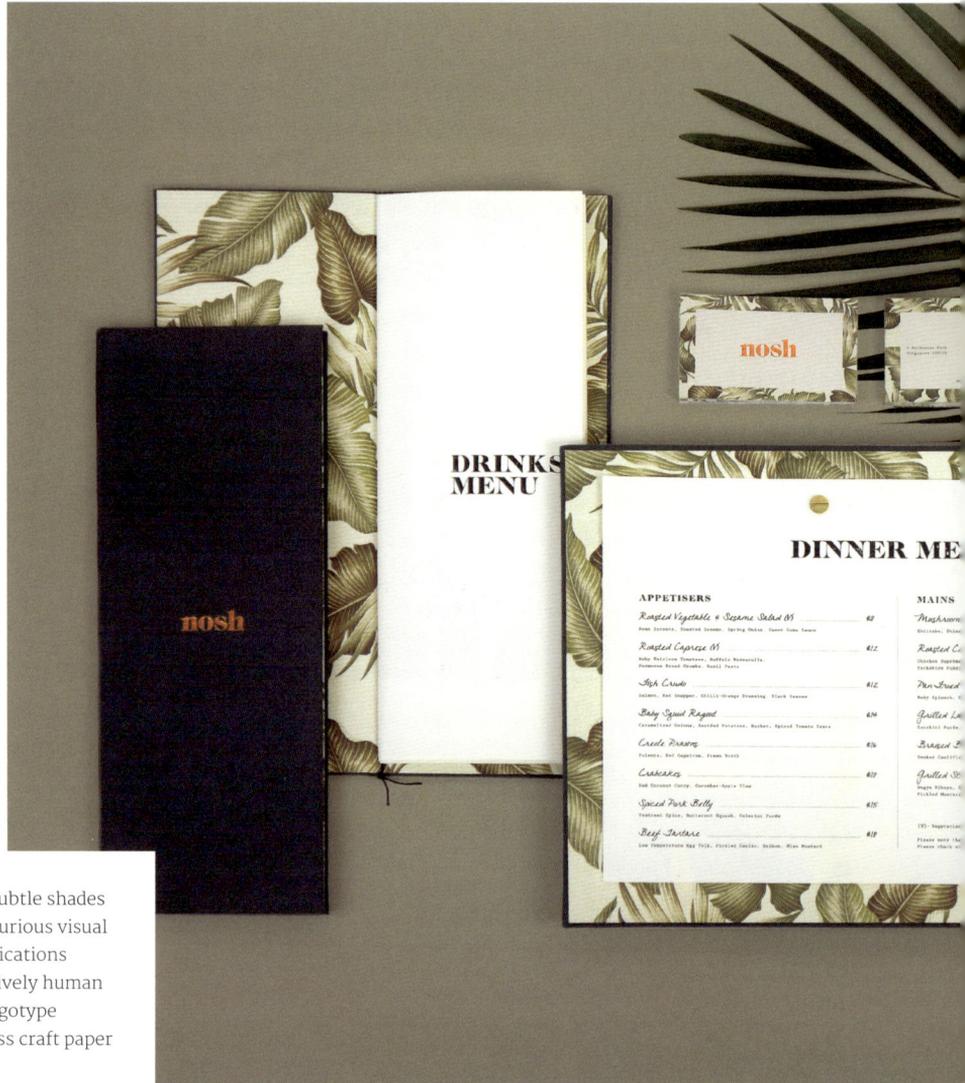

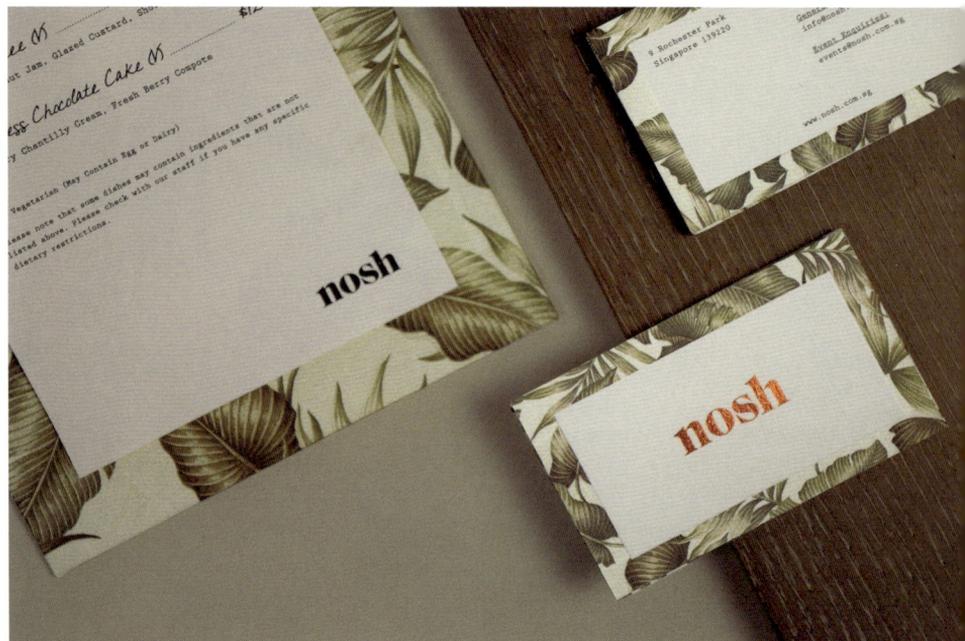

Design
Darling Visual Communications

Client
Nosh

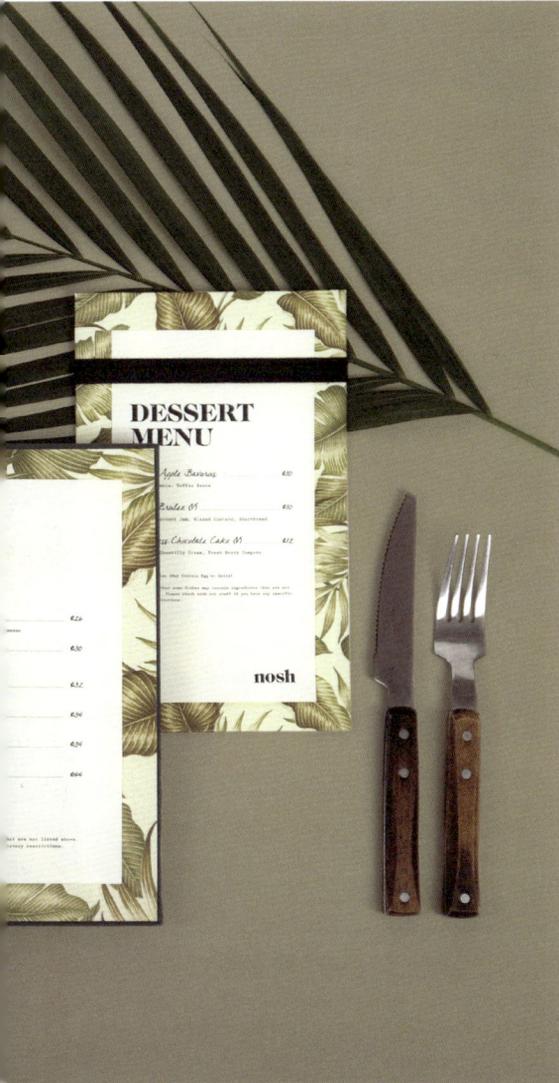

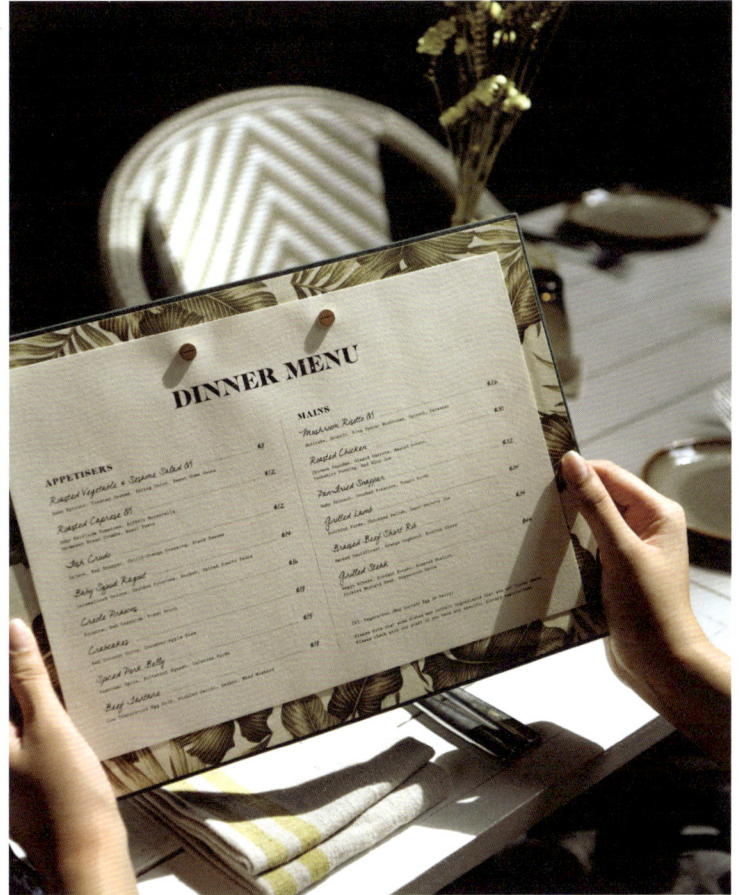

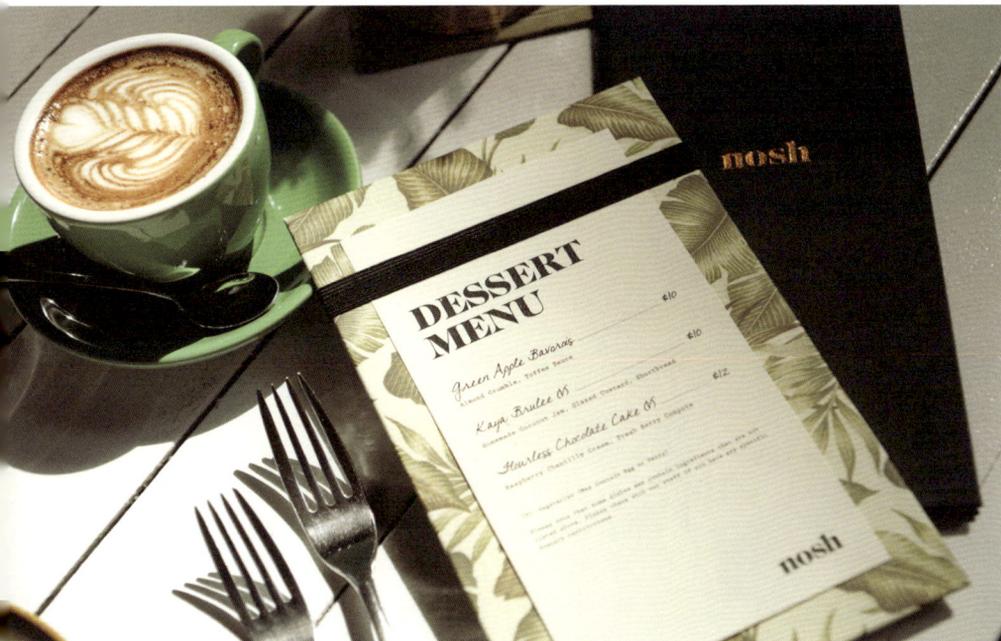

Bar Renard

A space free of labels, Bar Renard required a visual identity as impressive and progressive as the establishment itself. To accomplish this, Le Billyclub used leaf illustrations in intense colours to complement the simpler tones on different communication materials to create a truly classic brand identity that inspires curiosity and exudes elegance. The leaves also allude to the jungle – another place as diverse, abundant, and full of life as Bar Renard itself.

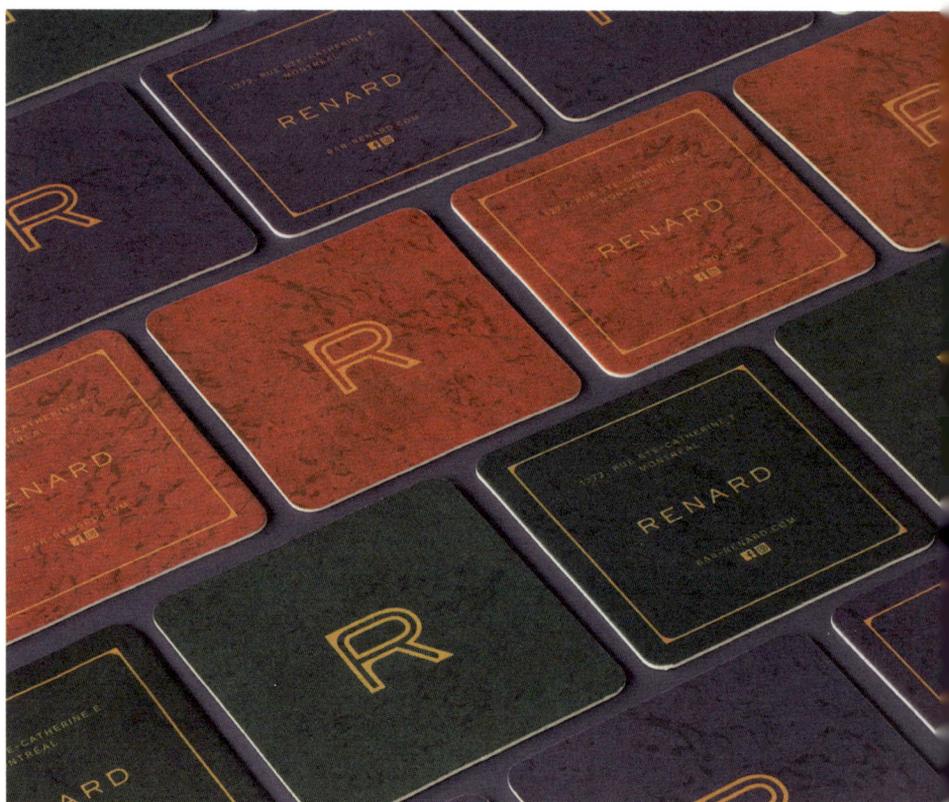

Design
Le Billyclub
Gabrielle Matte

Client
Marc-Antoine Coulombe
Isabelle Corriveau

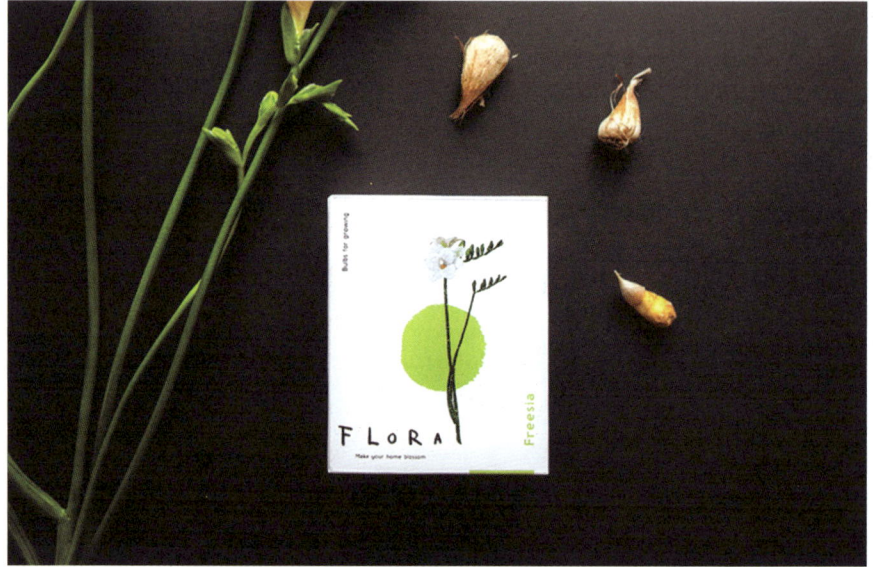

Flora

LOCO Studio were inspired by the concept that growing flowers can brighten any windowsill for Flora's packaging design. For the brand of indoor-germinating flower bulbs, they featured emotive illustrations of different flower types by themselves as well as various arrangements of potted plants in an intimate scene. Each box design hints at how its customers can make the world more beautiful, one blossoming windowsill at a time.

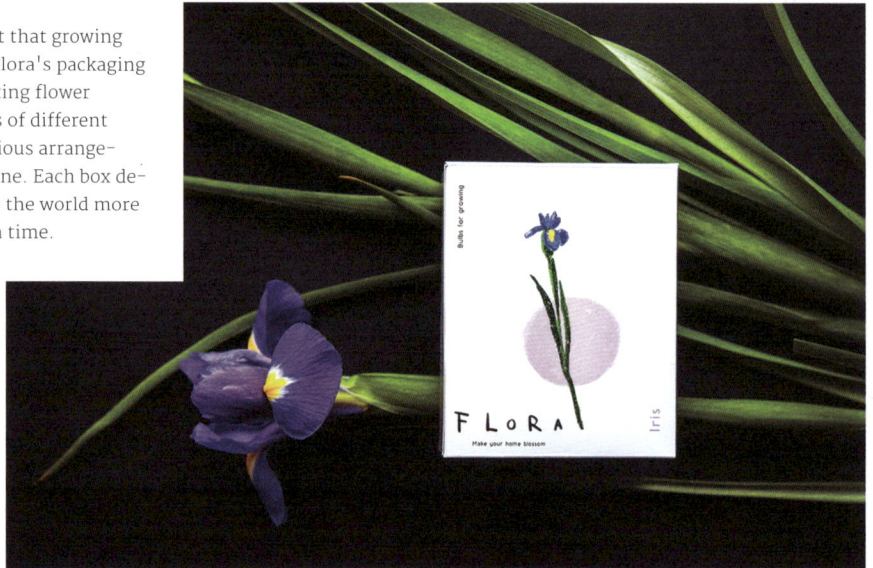

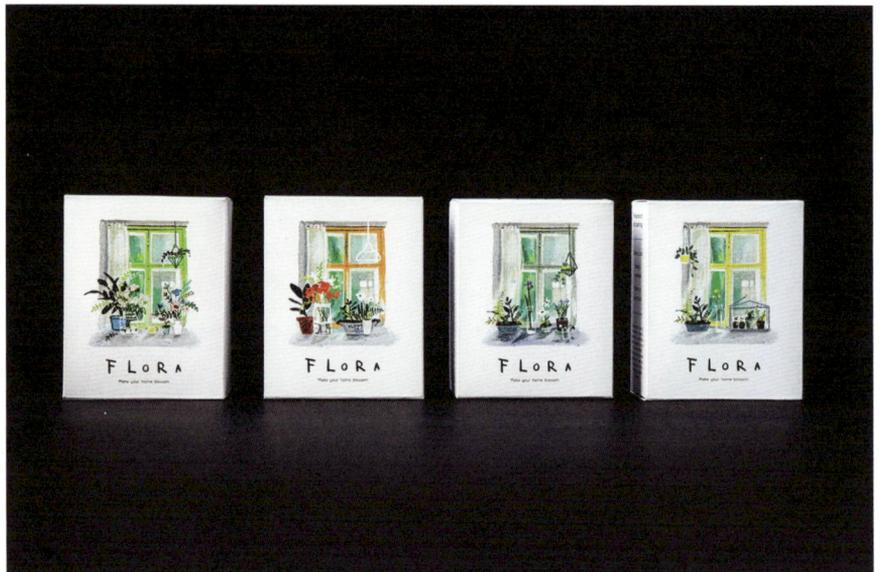

Design
LOCO Studio

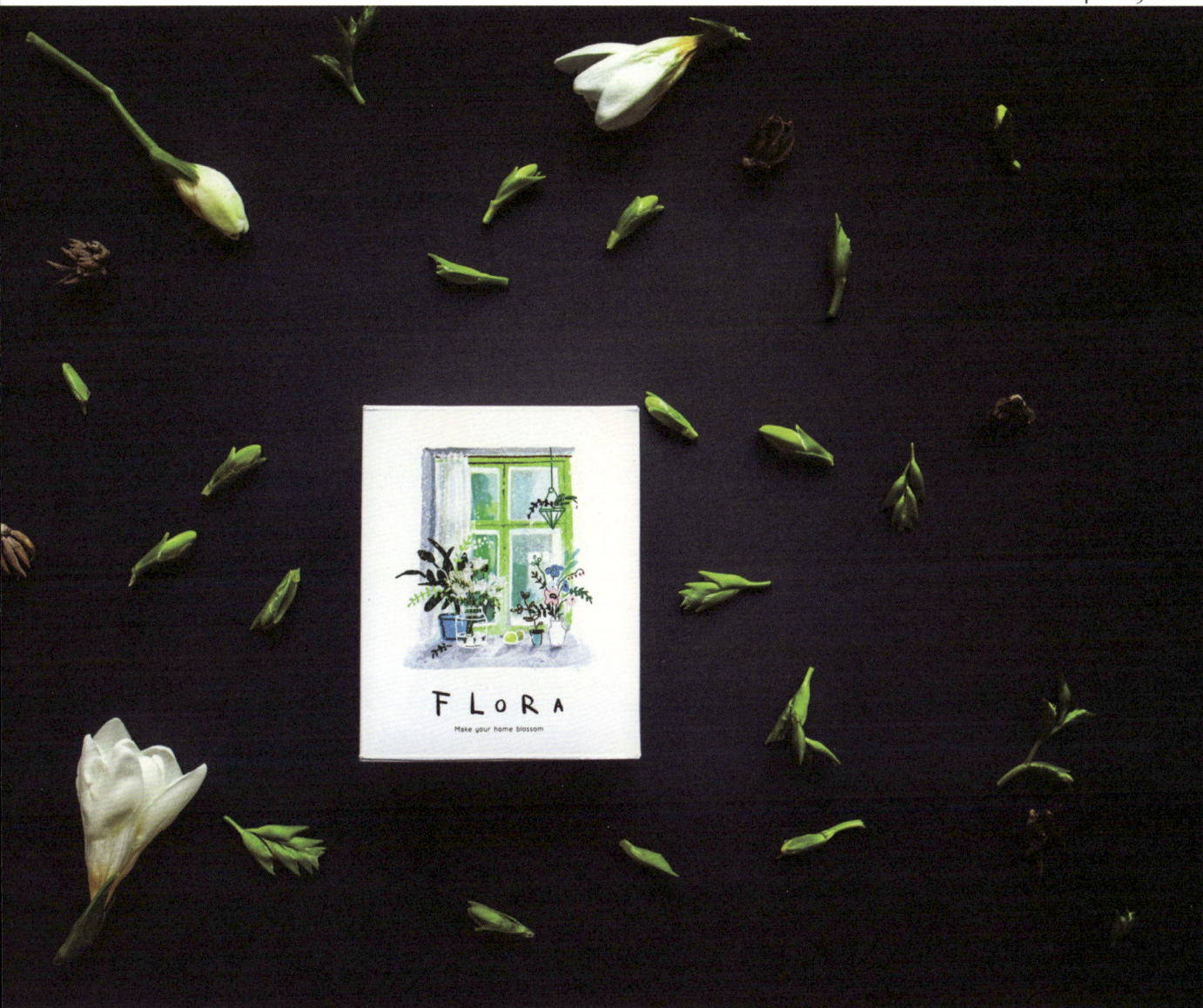

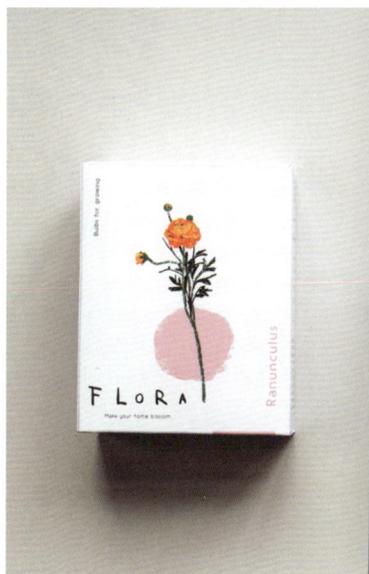

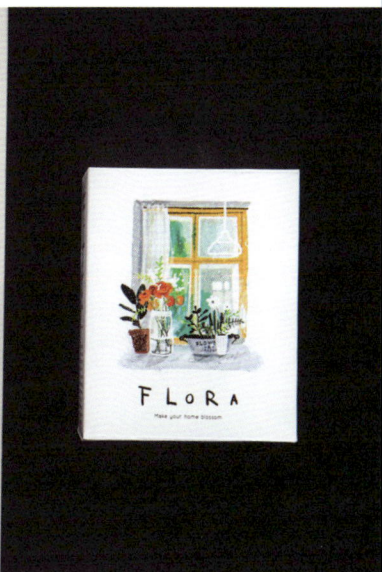

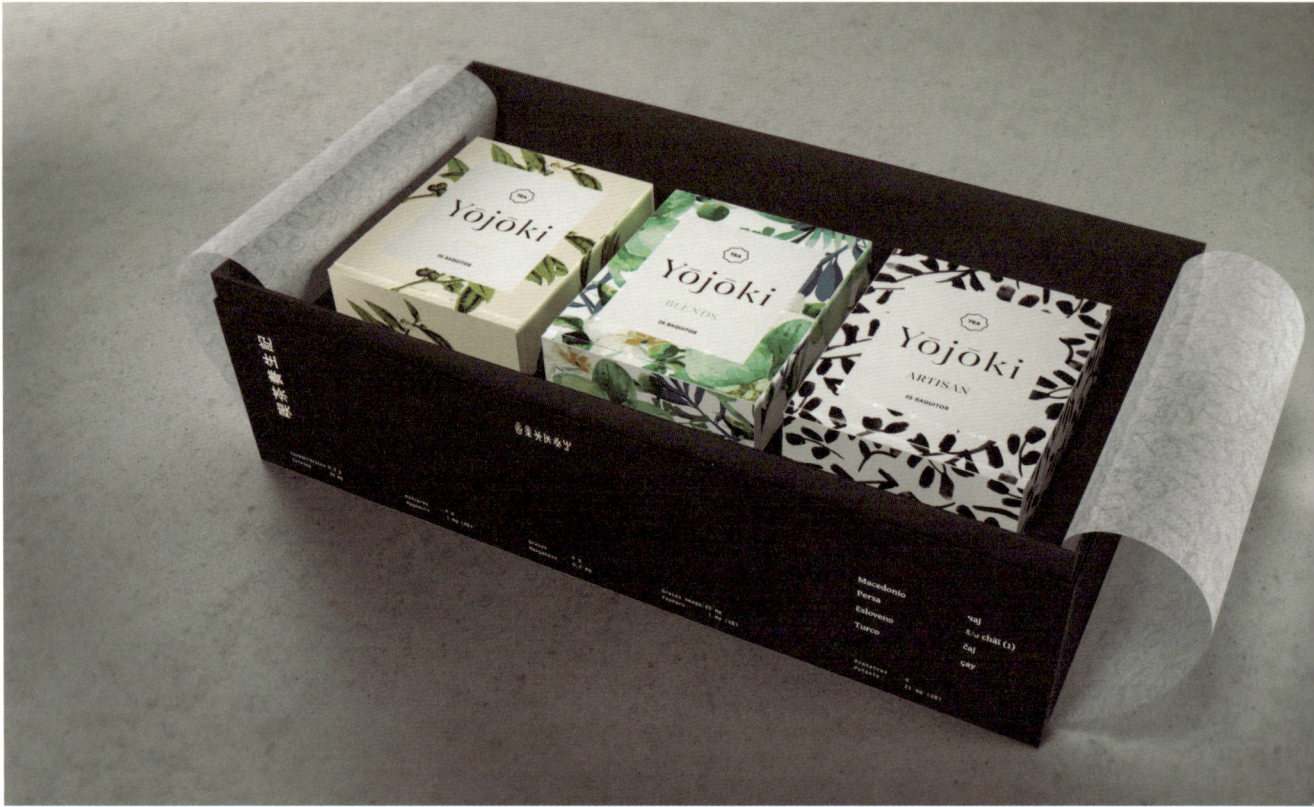

Yōjōki

While researching on ancient Asian tea culture, Twentyfive™ stumbled upon an old Japanese phrase: 'Be healthy through tea'. This phrase went on to inspire their visual identity work for Yōjōki Tea, which included its branding suite and packaging design. The logotype appears in many forms and is often accompanied by handmade textures, floral elements, subtle finishes, and high-quality materials – all working together to convey a feeling of luxury that is inherent to the brand.

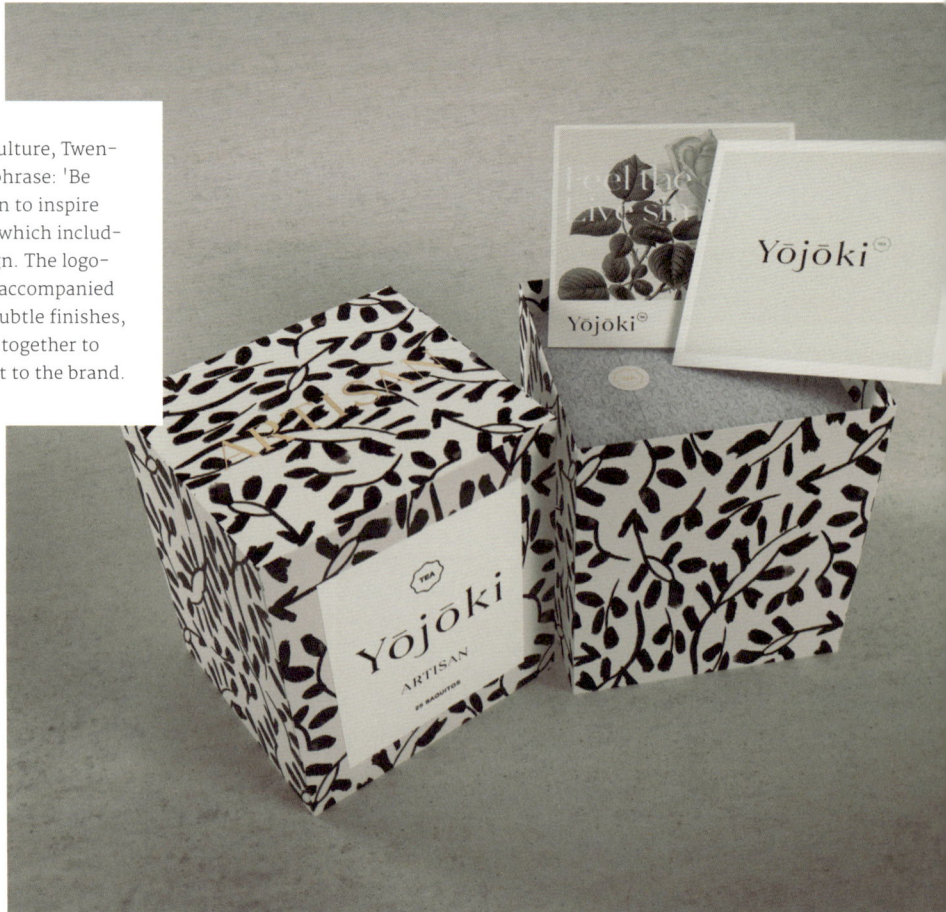

Design
Twentyfive™

Client
Yōjōki Tea

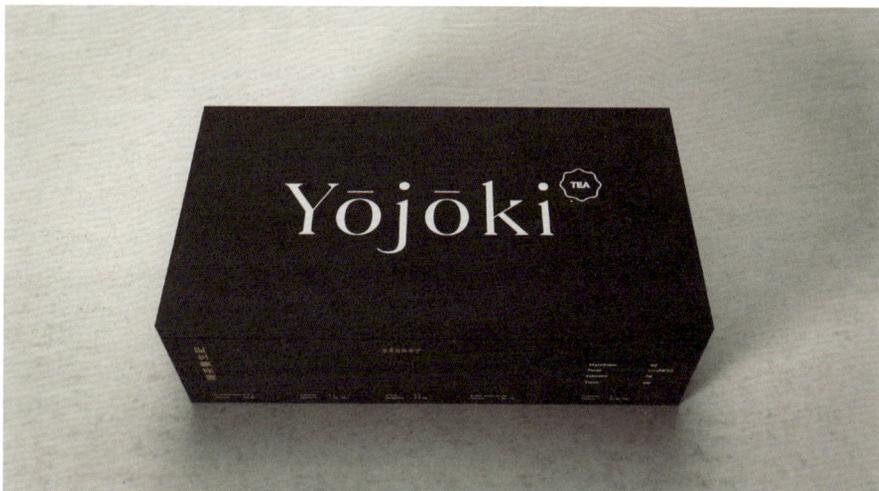

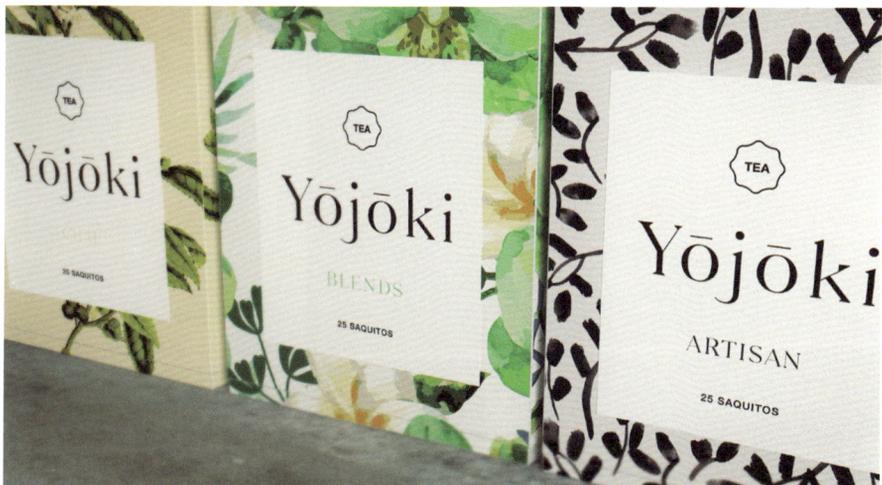

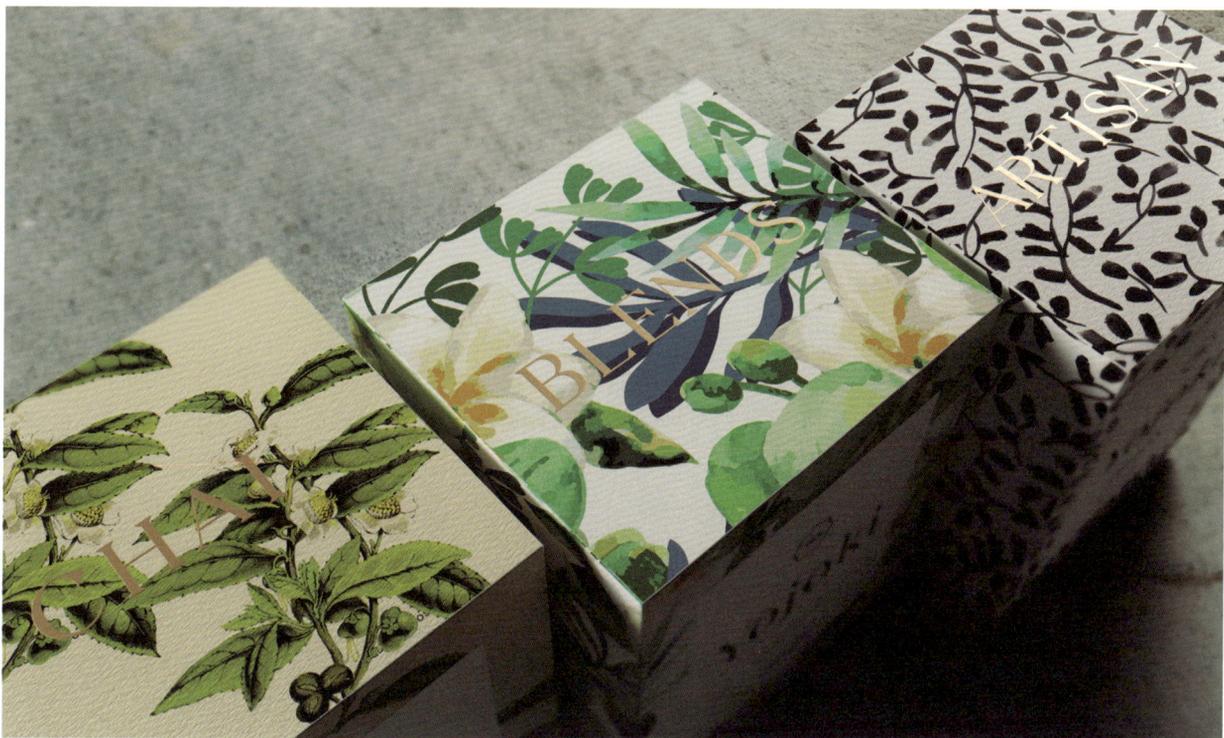

Redroaster

For Redroaster, a coffee roastery and cafe that serves as a sanctuary for the city dwellers of Brighton, Pop & Pac's design work was inspired by the 'botanical punk' concept. They juxtaposed lush leaves against a muted gridded backdrop with touches of brass to reference the plants and tiles found in the outlet. Through the bespoke illustrations and crafted type on the packaging design work, they introduced a luxurious new take on haute cuisine.

Design
Pop & Pac

Client
Redroaster

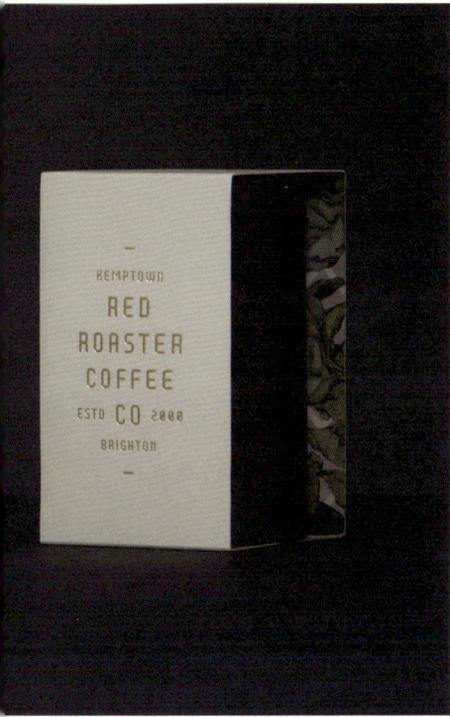

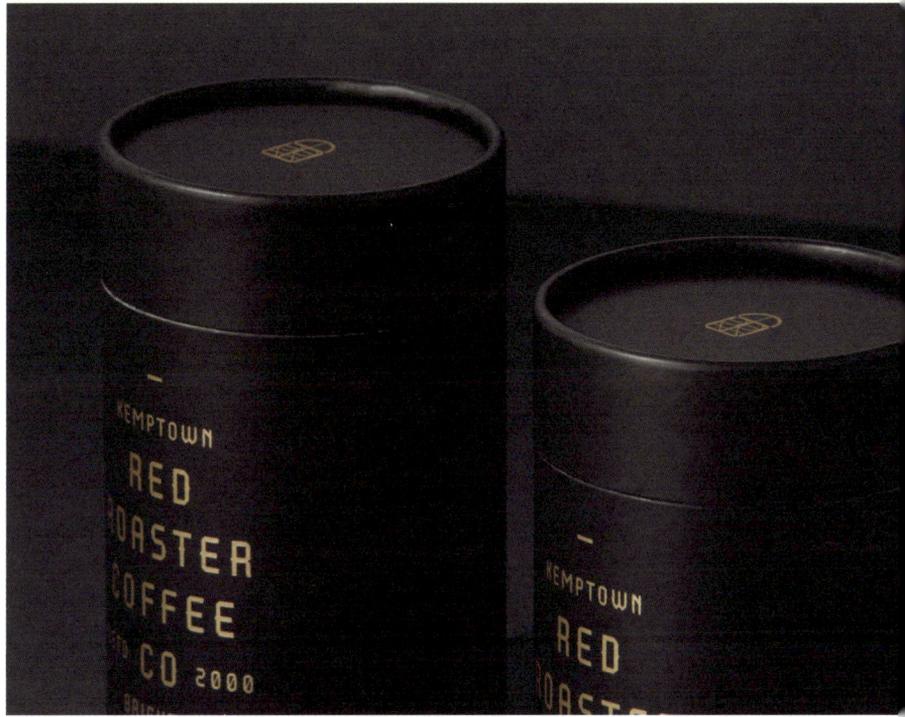

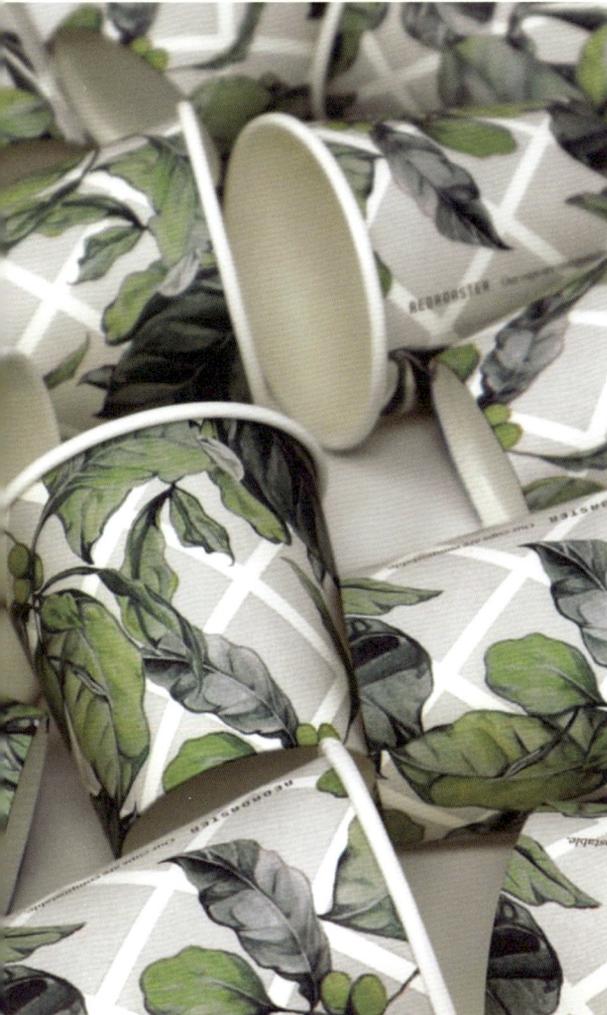

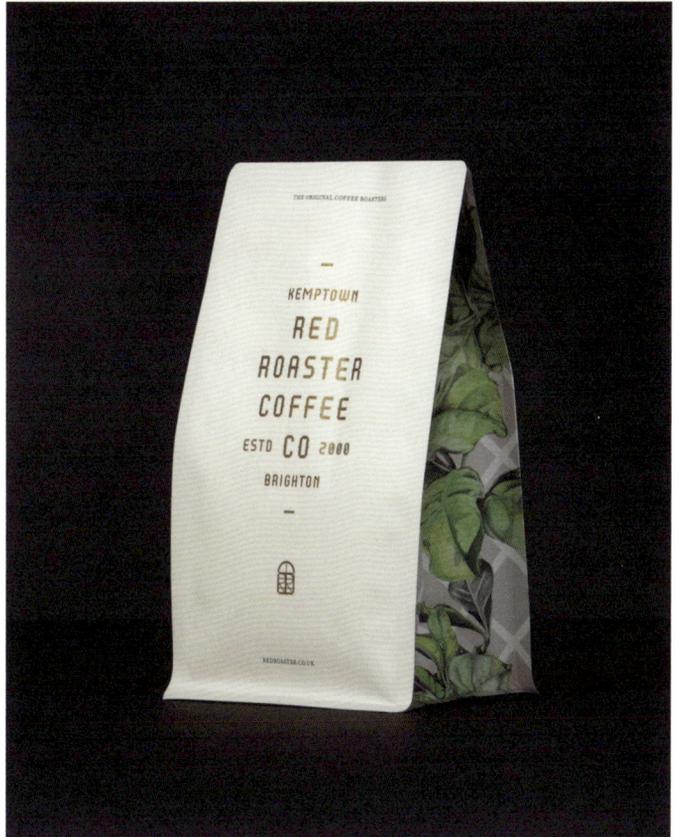

babyface
handmade dessert

With a predominantly pastel colour palette complemented by delicate linework and golden accents, babyface handmade dessert's visual identity reflects the company's ideals of achieving success and happiness through grounded living, giving, and hard work. By overlaying shiny bluebird and plant illustrations on muted backgrounds within vintage frames, 2TIGERS design studio's charming work evoked subtle hints of lavishness.

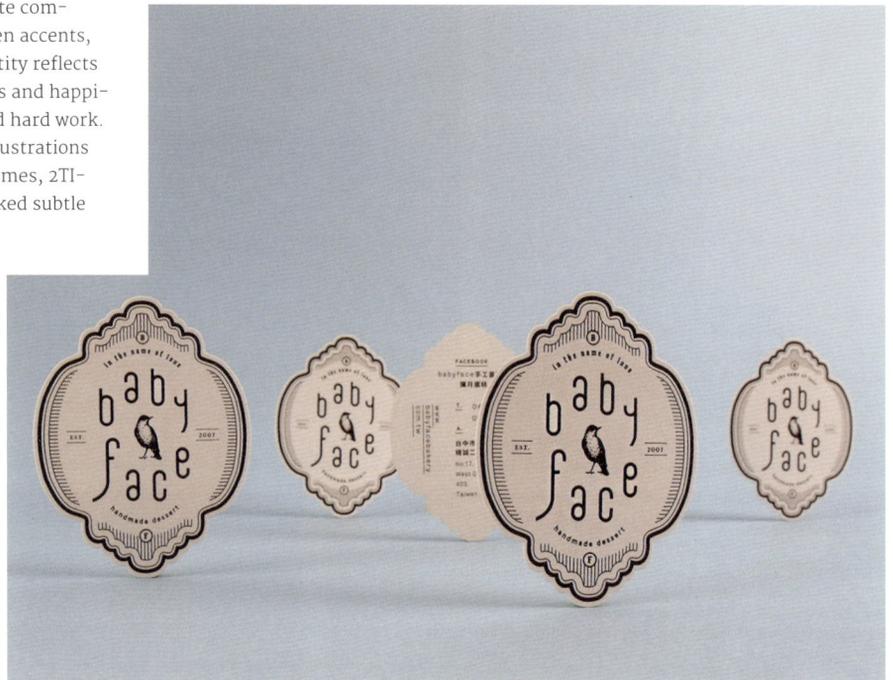

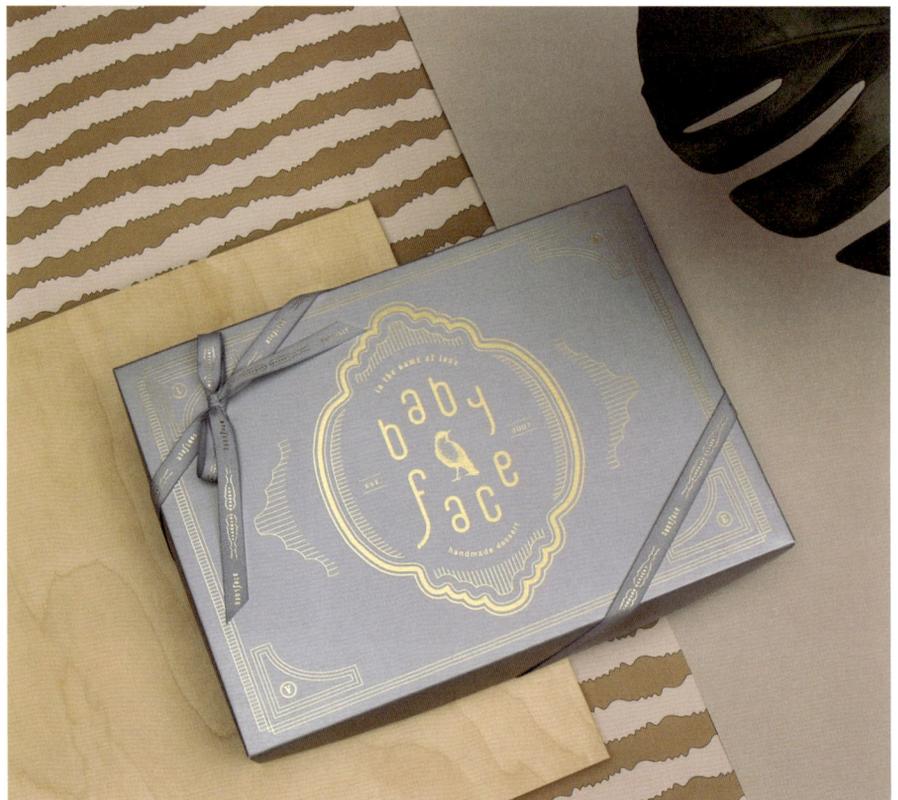

Design
2TIGERS design studio

Client
babyface handmade dessert

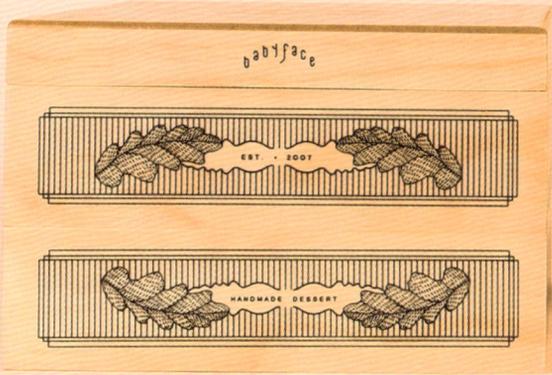

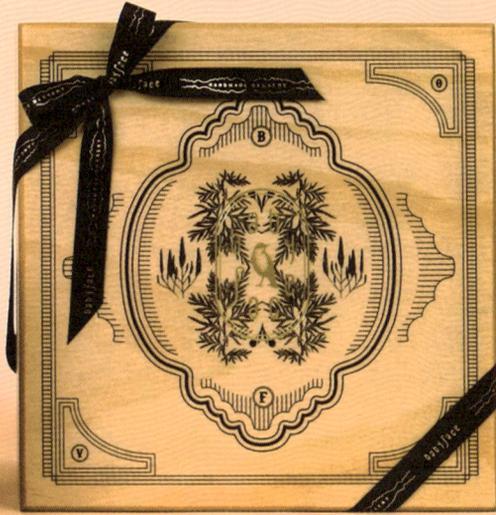

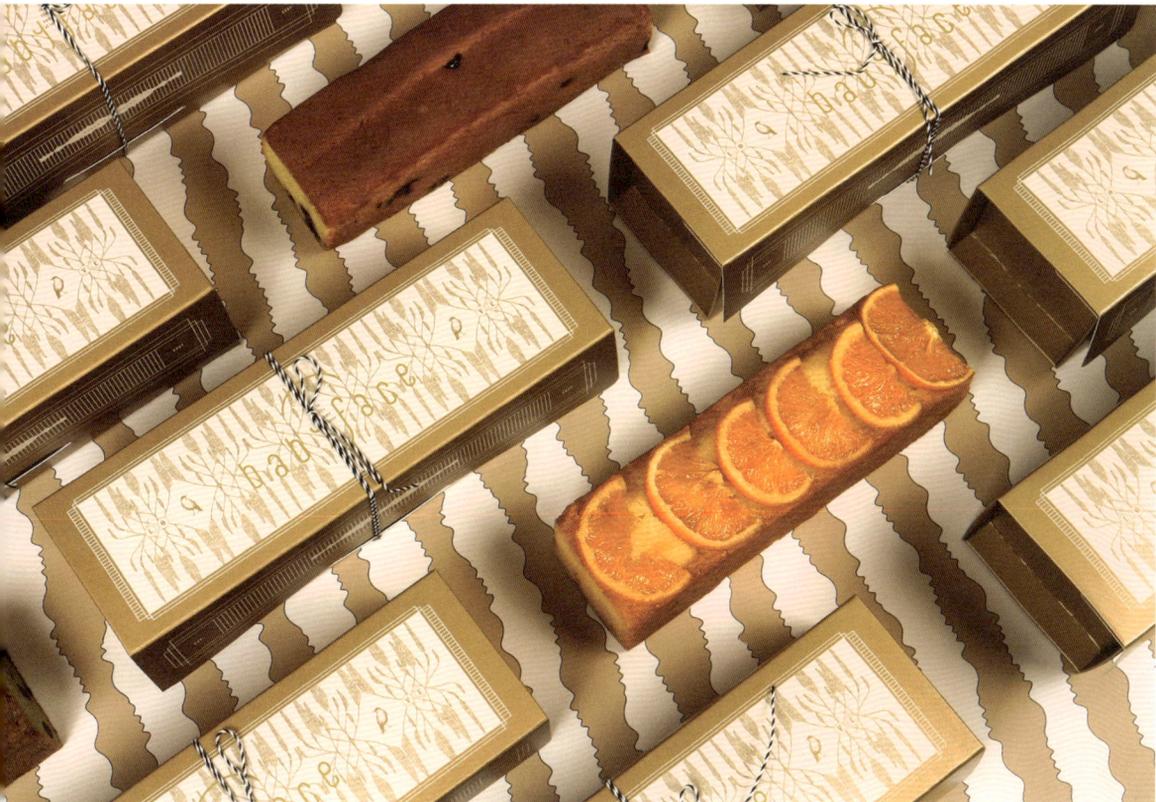

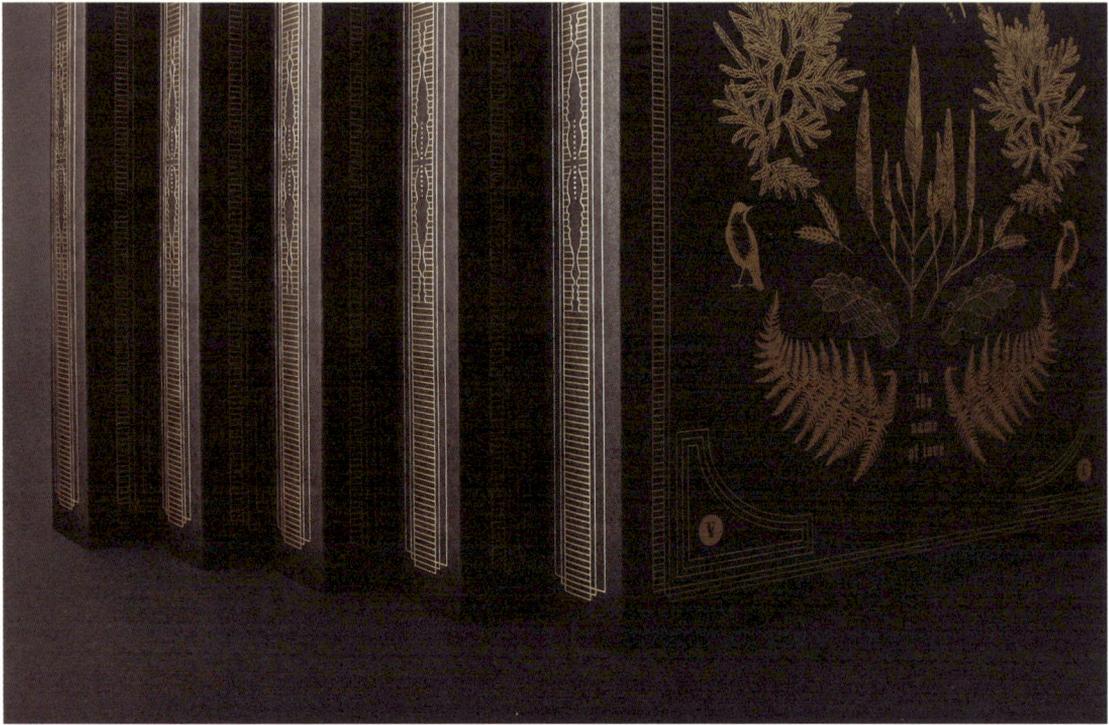

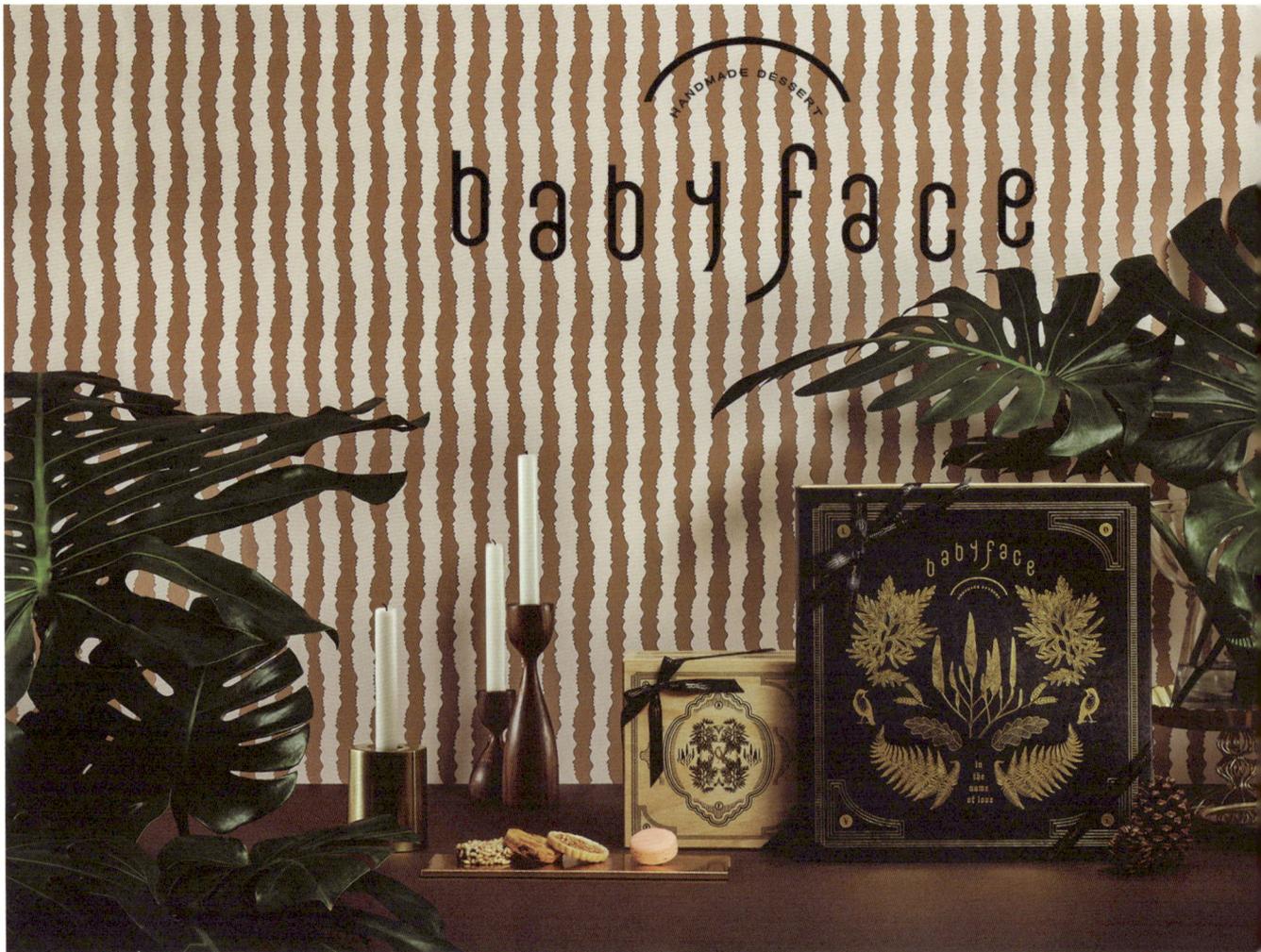

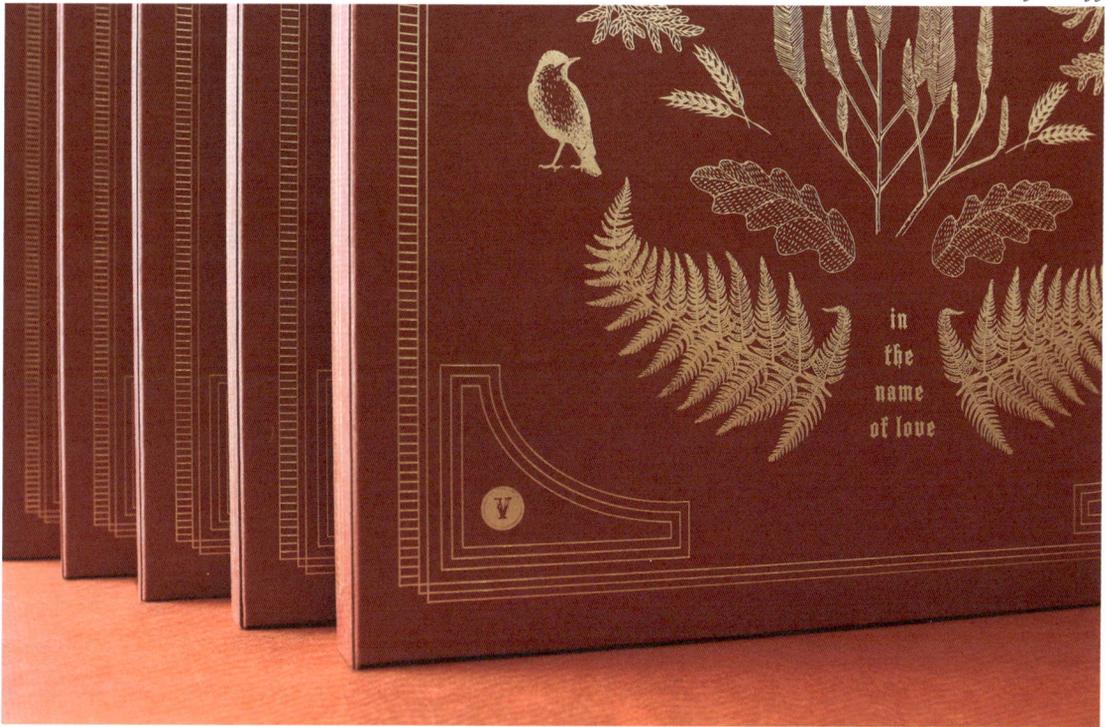

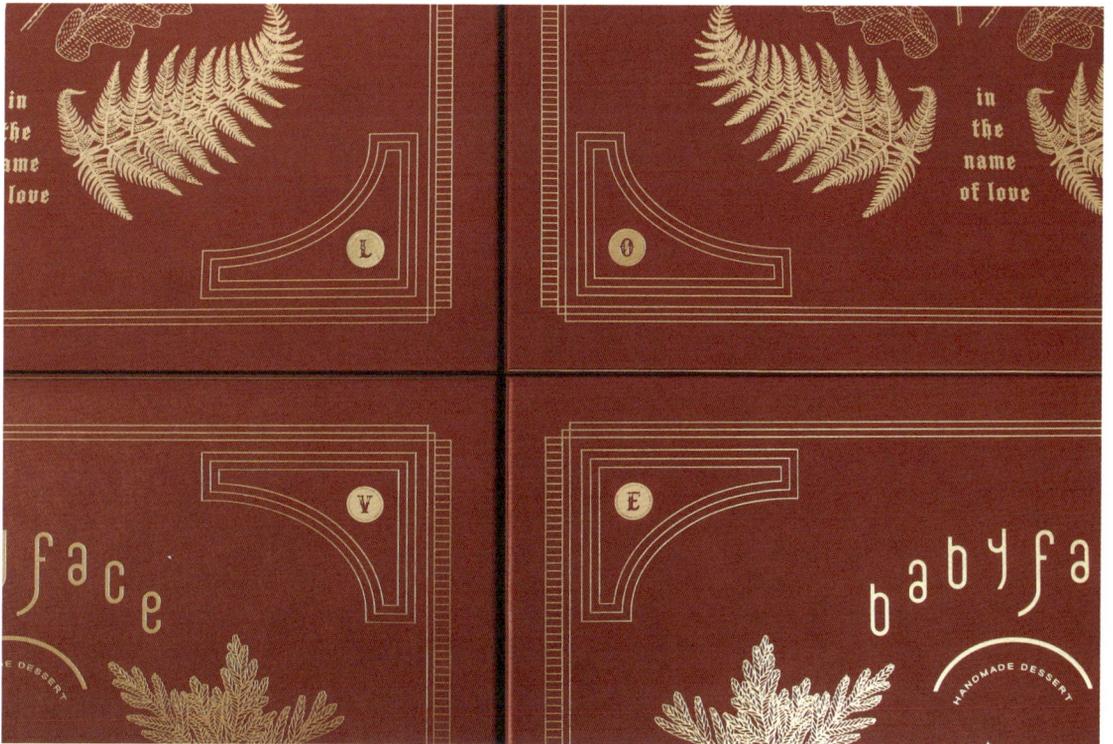

Design
Suisei

Client
LA CANDEUR

LA CANDEUR

A collision of worlds, cultures, and flavours, LA CANDEUR is a French patisserie helmed by a Japanese patissier in Senkawa, Tokyo. In creating its visual identity, Suisei strove to produce original work that fused Japanese and French tastes through the store's branded materials. The result is a testament to ingenuity, and reveals inspiration drawn from vintage French letters, printed materials, and traditional Japanese textiles.

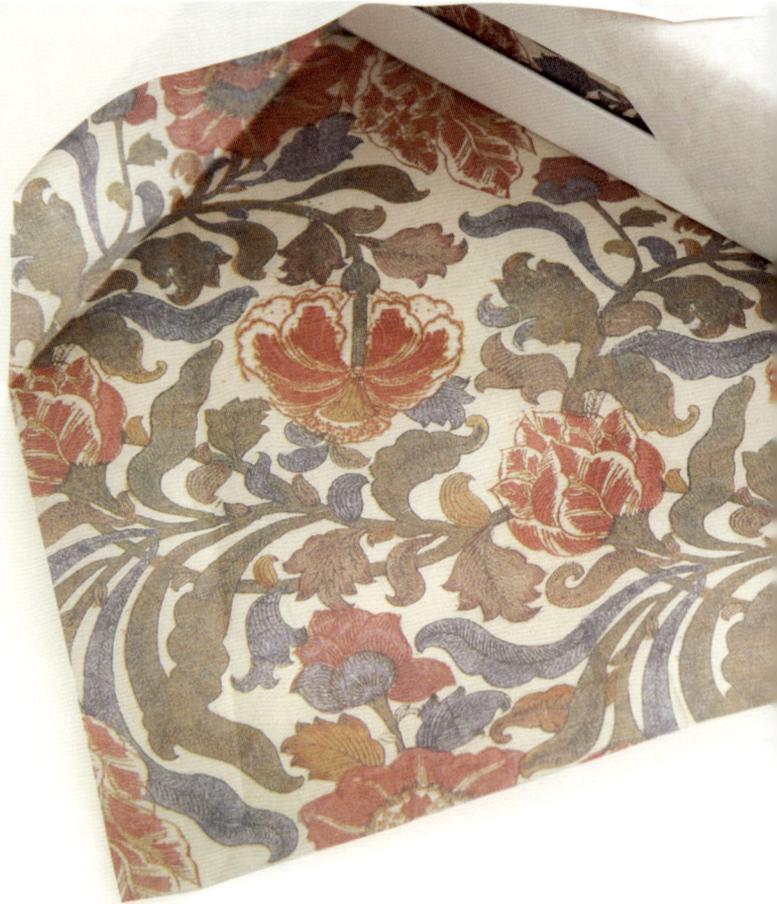

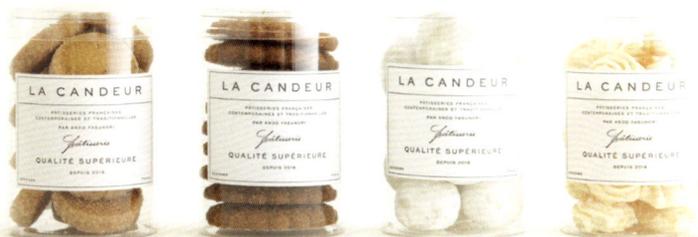

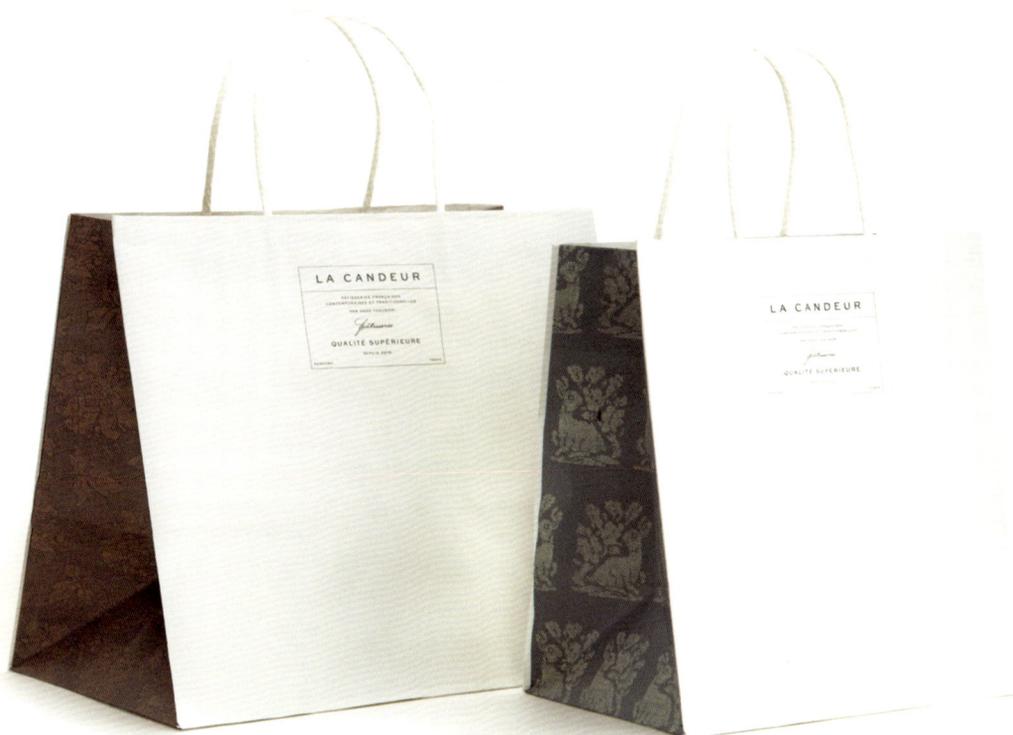

CANDEUR
PÂTISSERIES FRANÇAISES
TEMPORAINES ET TRADITIONNELLES
PAR ANDO YASUNORI
Pâtisserie
ALITÉ SUPÉRIEURE
DEPUIS 2016

Douceurs de Bourgogne
ブルゴーニュ地方のお菓子

LA CANDEUR
PÂTISSERIES FRANÇAISES
CONTEMPORAINES ET TRADITIONNELLES
PAR ANDO YASUNORI
Pâtisserie
QUALITÉ SUPÉRIEURE
DEPUIS 2016

Douceurs d' Alsace et de Lorraine
アルザスとロレーヌ地方のお菓子

LA CANDEUR
PÂTISSERIES FRANÇAISES
CONTEMPORAINES ET TRADITIONNELLES
PAR ANDO YASUNORI
Pâtisserie
QUALITÉ SUPÉRIEURE
DEPUIS 2016

Douceurs de Normandie
et de Bretagne
ノルマンディとブルターニュ地方のお菓子

Design
Studio Pros

Client
BAO Coffee Roasting Lab

Chinese Typography Design
Bohan Shih

BAO | Coffee Roasting Lab

Using Eastern-style window silhouettes to frame Western-style coffee branches, Studio Pros tastefully integrated the two cultural influences that shape the visual identity of BAO Coffee Roasting Lab. The inseparable nature of the frame and the view, as well as both the English text and a Chinese stamp, elegantly encapsulate the harmonious nature and unique spirit that the brand represents to coffee lovers.

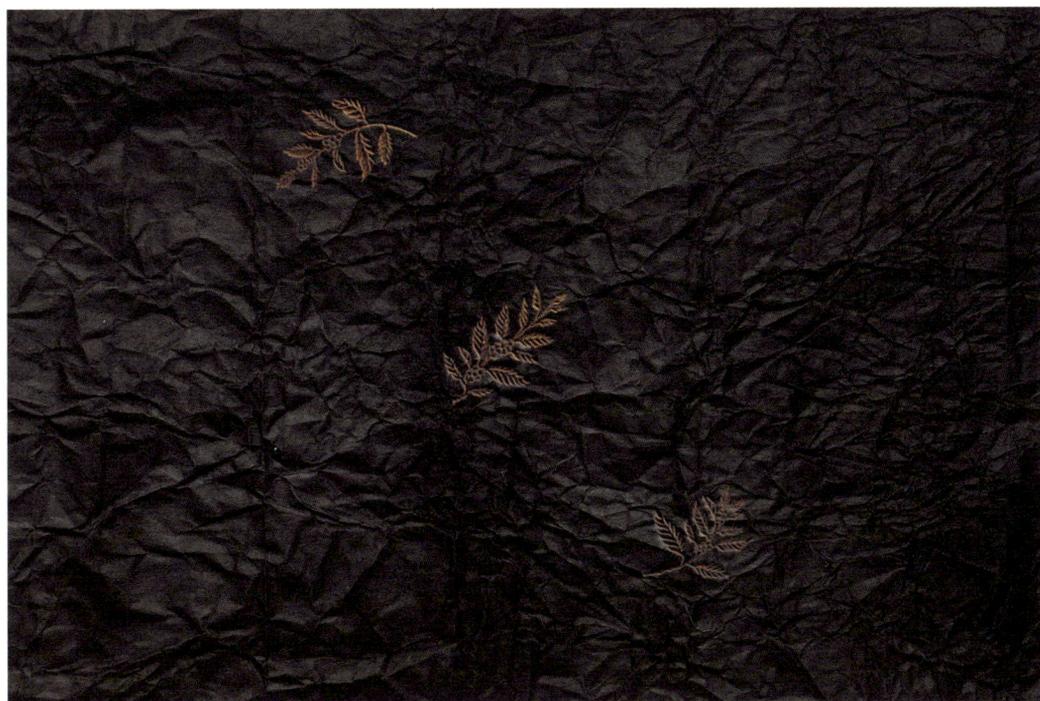

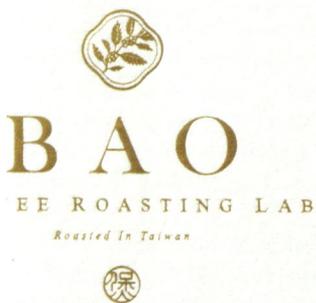

BAO | COFFEE ROASTIN

終身七折碼

- - - - - - - - - - - - - - - - - - - -

coffee

第　／500名

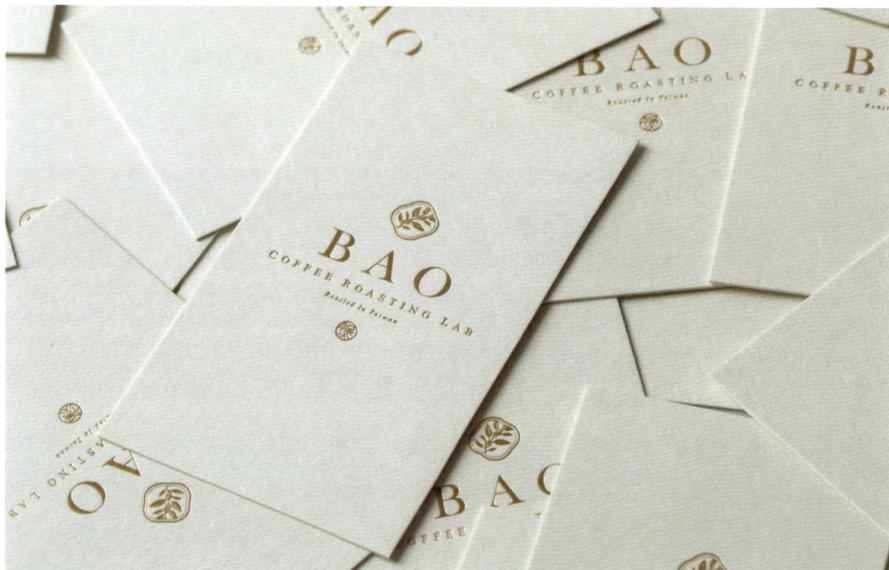

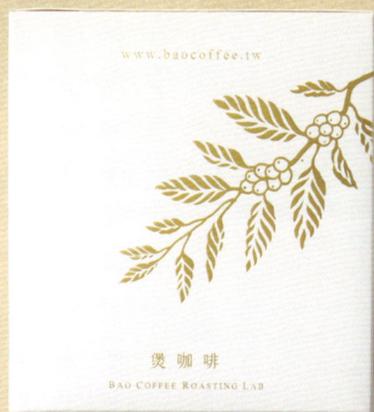

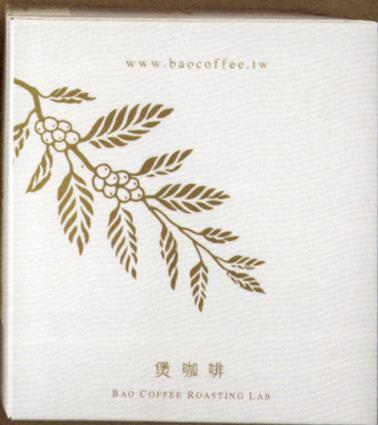
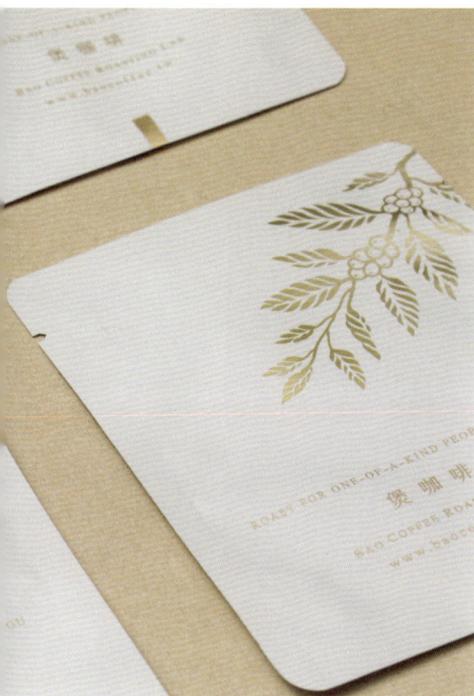
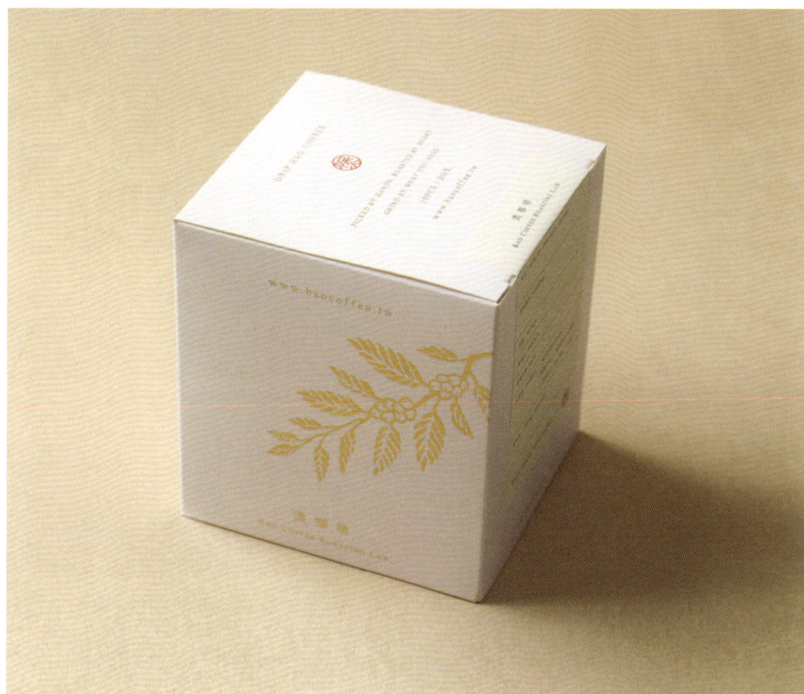

Mark Spencer Identity

Fieldwork Facility's innovative design concept for Mark Spencer Botanist embodies the niched field in which the latter operates. As a forensic botanist, Mark Spencer solves crimes using his vast botanical knowledge. To reflect the nature of his work, the logo depicts a skeletonised leaf to symbolise the observant eye that he often has to rely upon. The brand's business cards, tote bags, and stationery carry this logo in a rich green-and-white palette. Additionally, posters with intriguing slogans set against lush foliage were created to showcase both the forensics and the public-speaking, television-appearing sides of his unique practice.

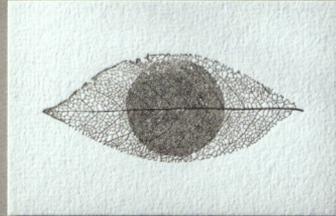

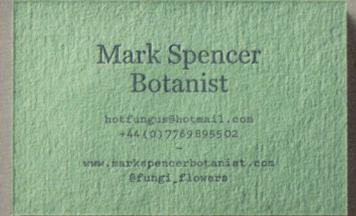

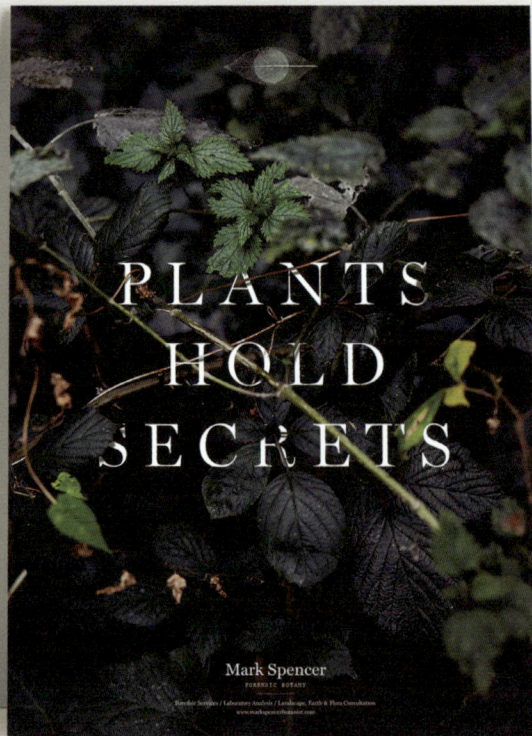

Design
Fieldwork Facility

Client
Mark Spencer

Photography
Robin Friend

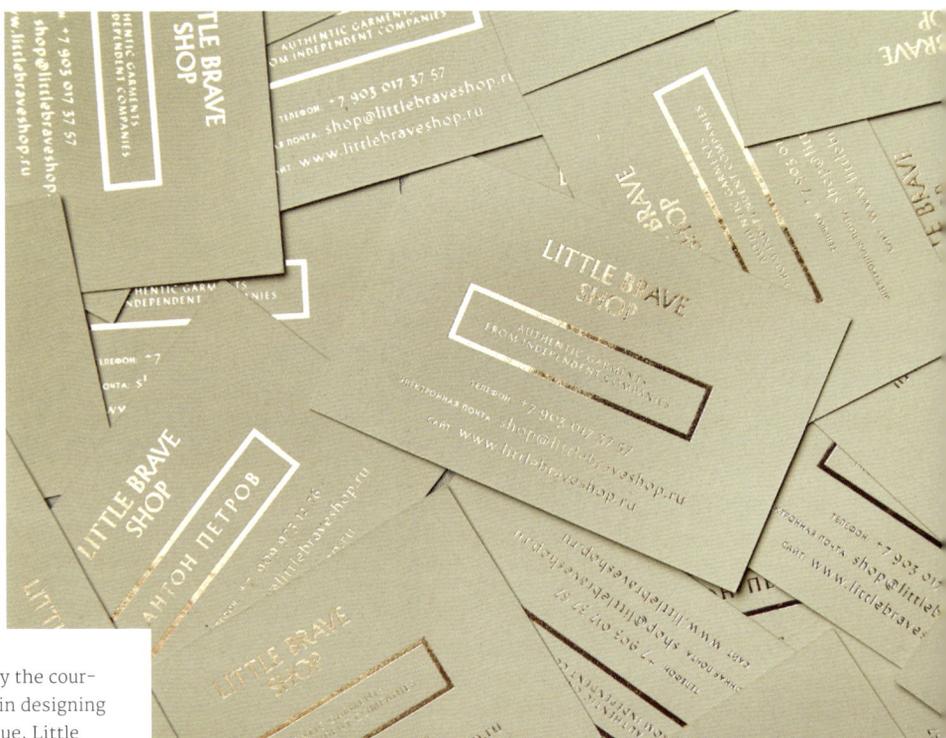

Little Brave Shop

The Bakery design studio were inspired by the courage it takes to open a new clothing store in designing the brand identity for the Moscow boutique, Little Brave Shop. Symbolising the store's fearless nature and ability to conquer the struggles of a competitive clothing market, they chose a mongoose as its mascot to embody the small animal's ability to fight and kill venomous snakes such as the cobra – a phenomenon that they reflected in the logo. Dressed as a preppy gentleman, the mongoose's outfit changes according to the seasons to reflect the merchandise being sold in the store.

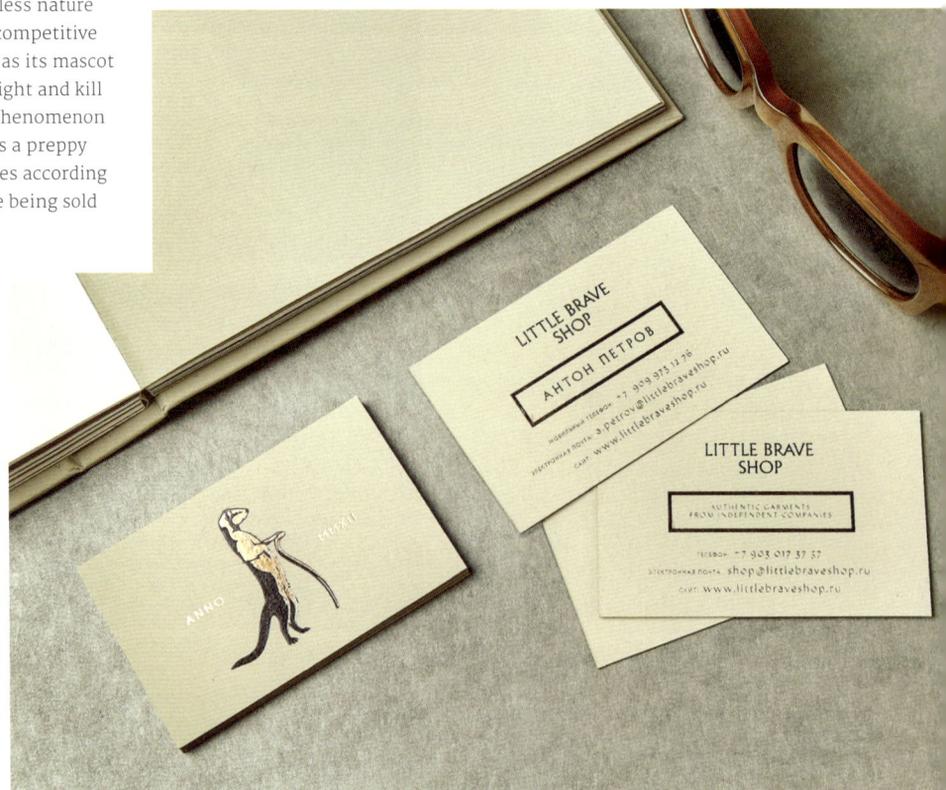

Design
The Bakery design studio

Client
Little Brave Shop

Photography
Olga Pogorelova

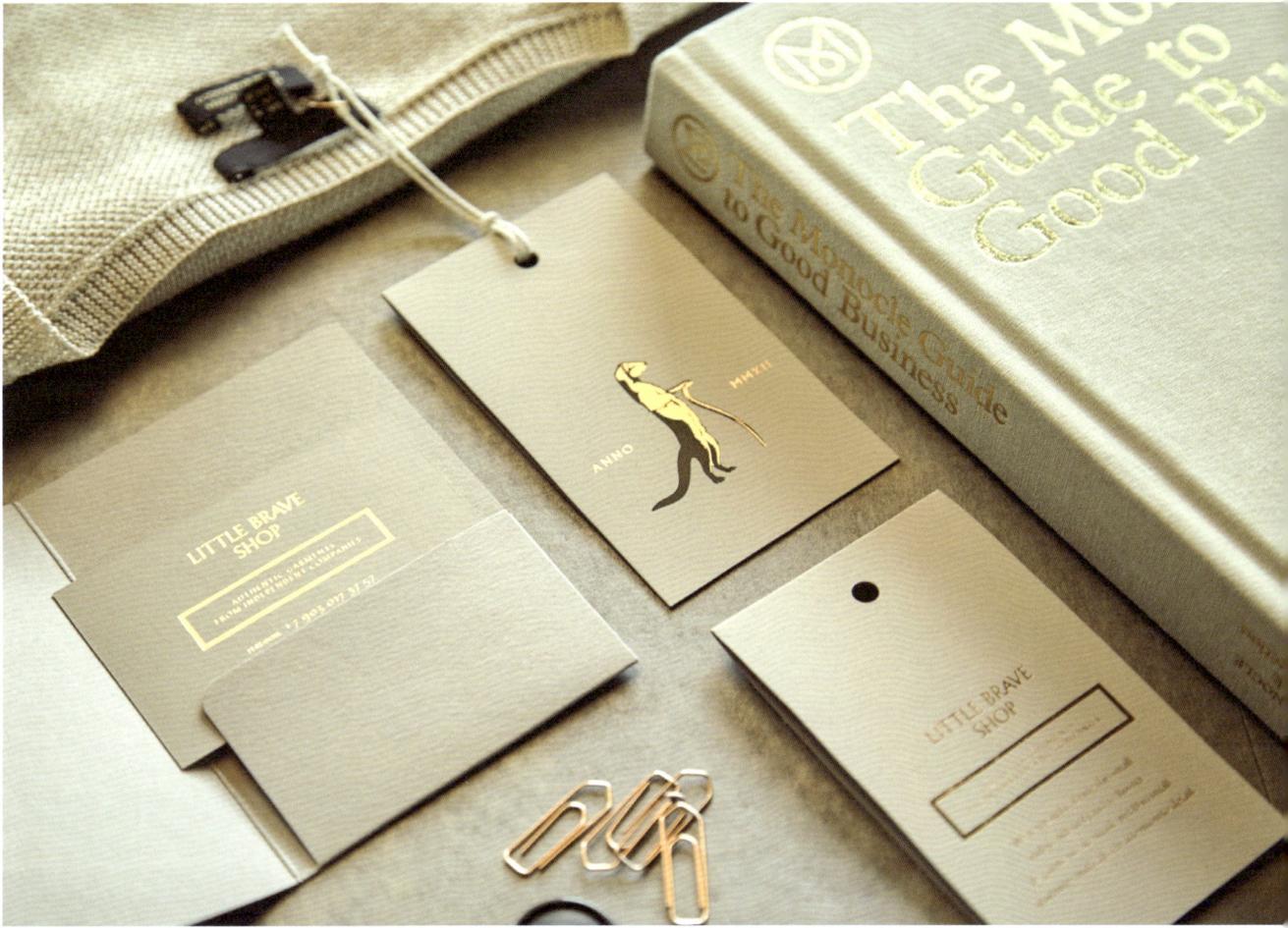

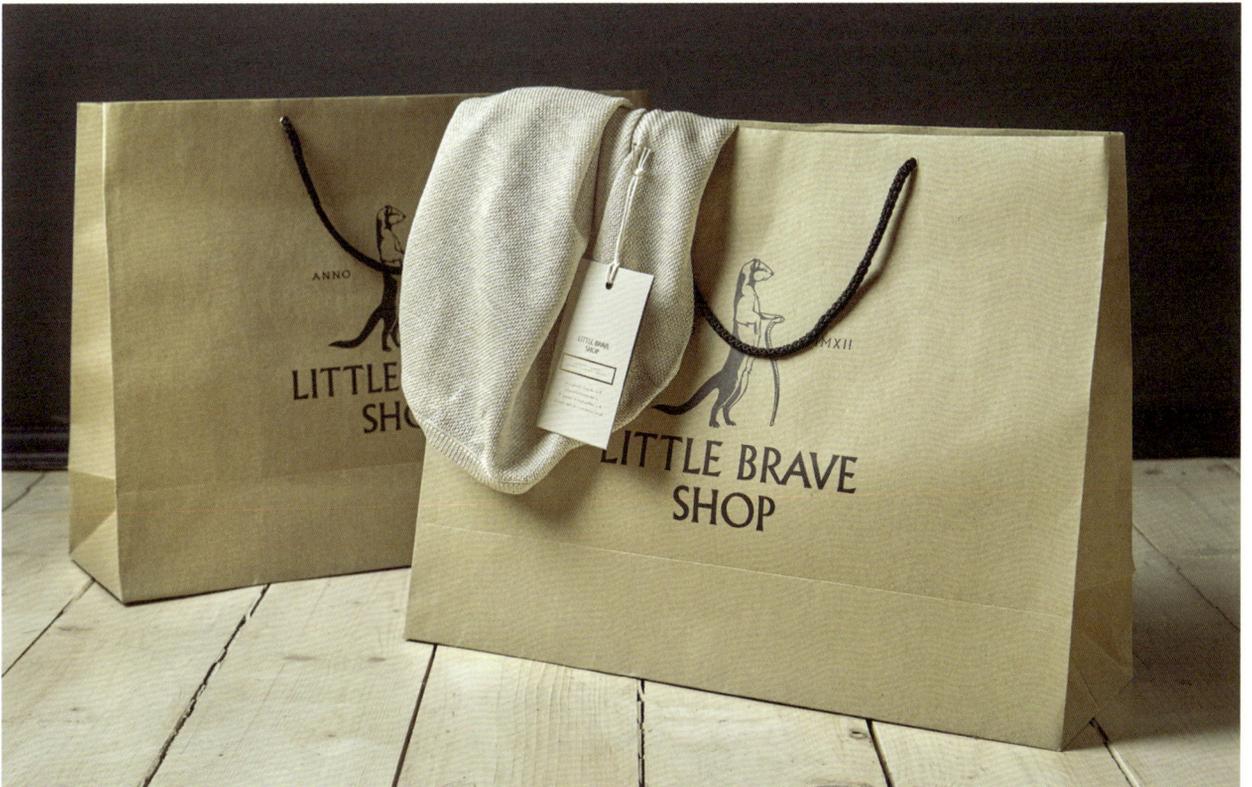

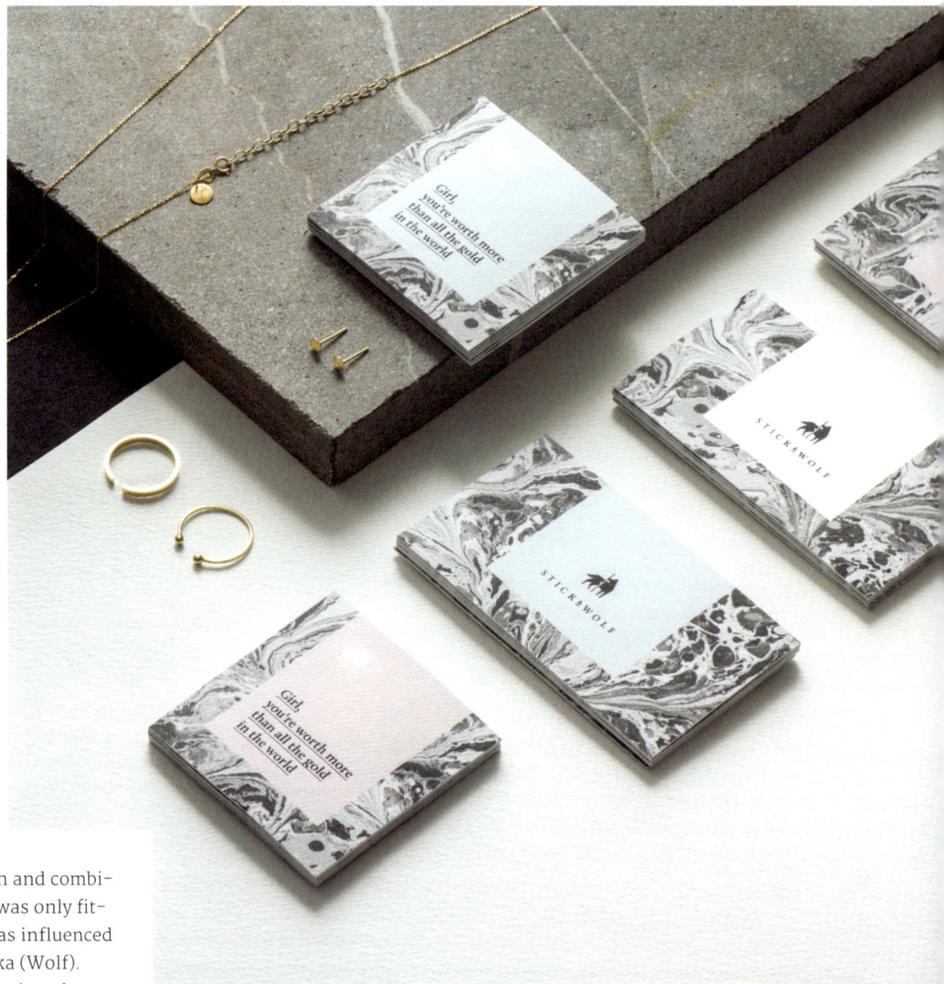

Stick & Wolf

With a name derived from the translation and combination of the co-founders' surnames, it was only fitting that Stick & Wolf's brand identity was influenced by Kasia Kijek (Stick) and Ania Wilczewska (Wolf). With their creative input, Motyf Studio designed a pattern for the minimalist and handcrafted jewellery brand that was inspired by the traditional Turkish art technique of aqueous surface design called Ebru, or paper marbling. The technique reflects simple designs of high quality just like its logo, which cleverly makes use of negative space.

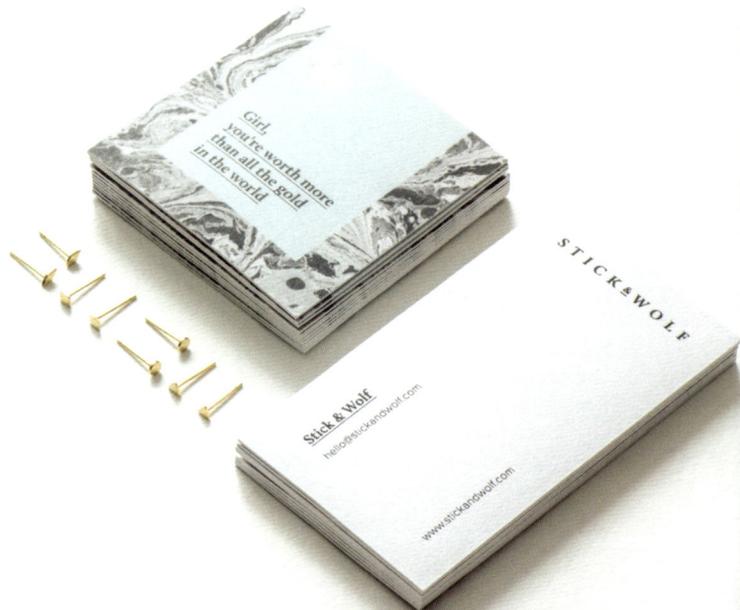

Design
Motyf Studio
Ollestudio

Client
Stick & Wolf

Photography
Yellowstudio

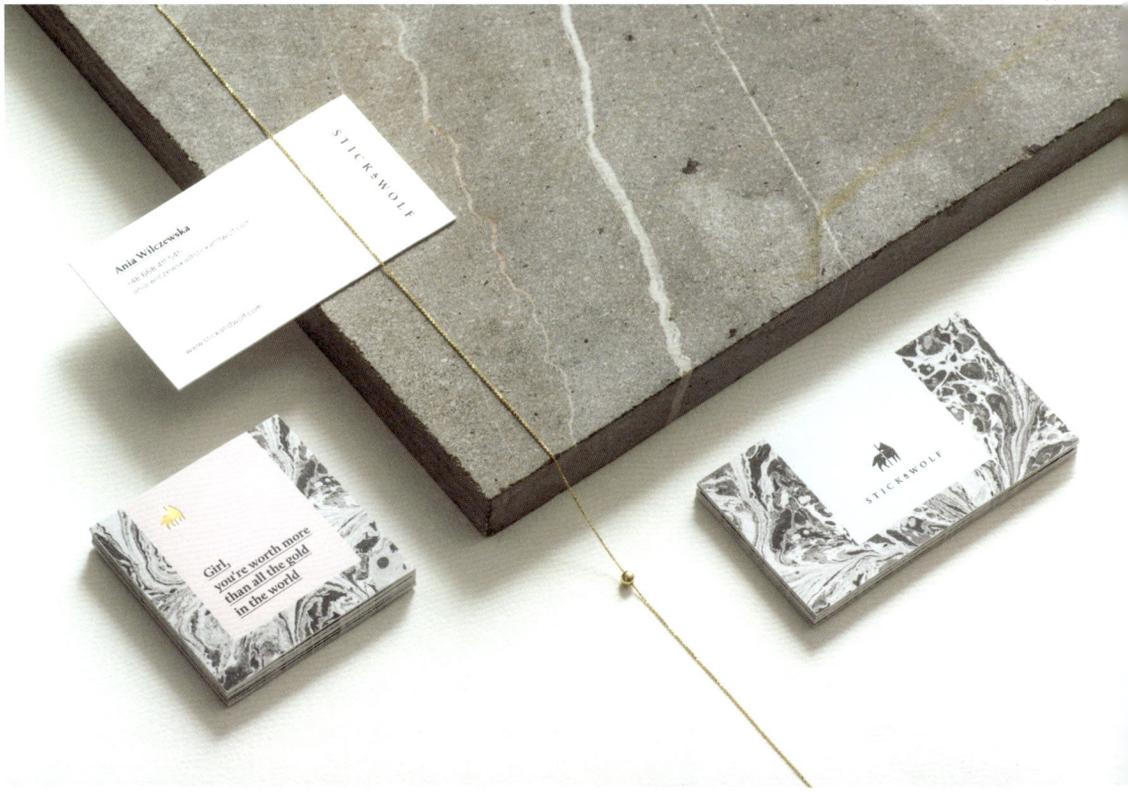

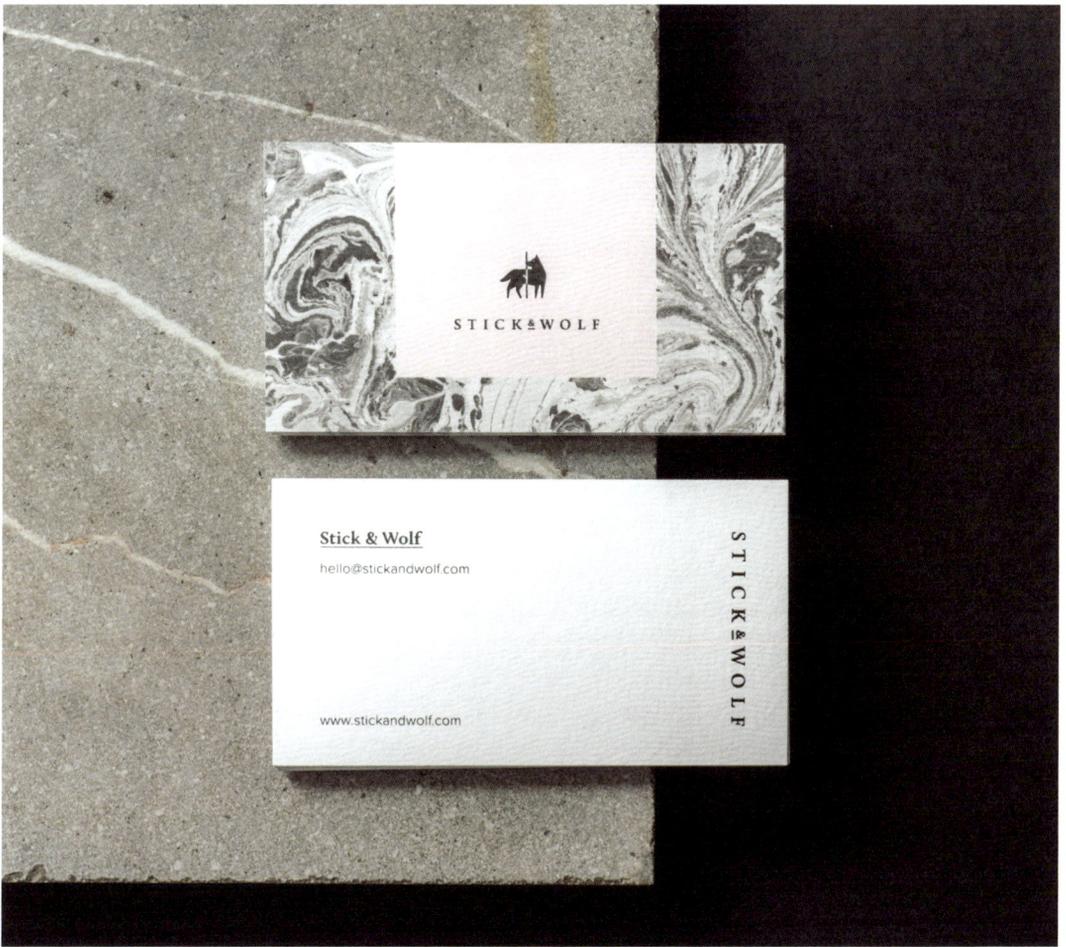

Chandra

Oddds developed a comprehensive visual identi-
ty for Chandra, a fashion and accessories brand in
Switzerland, revolving around the ideas of femininity
and style. The illustrated logo characterises the sense
of playfulness that is inherent in the label's target
audience, while the wordmark includes a gentler curl
in the letter 'R', which references the graceful tail of
a cat. A warm colour palette of light purple, salmon,
and terracotta tie the collaterals together in a modern
and memorable way.

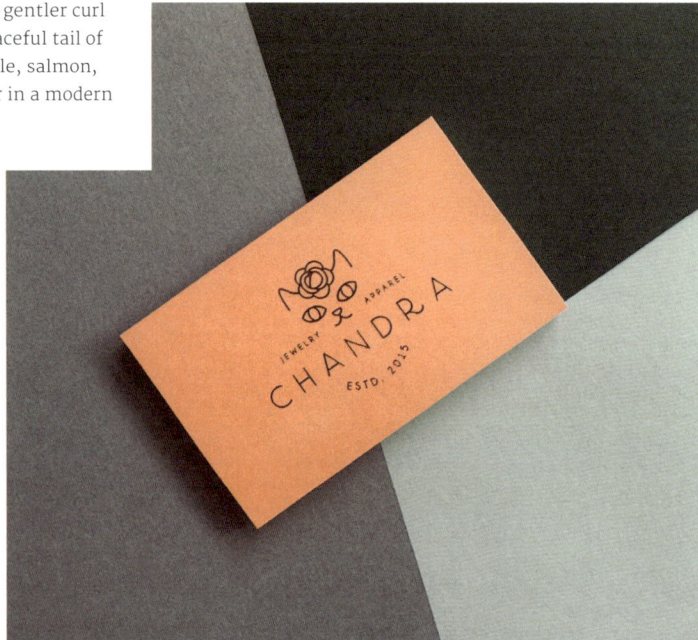

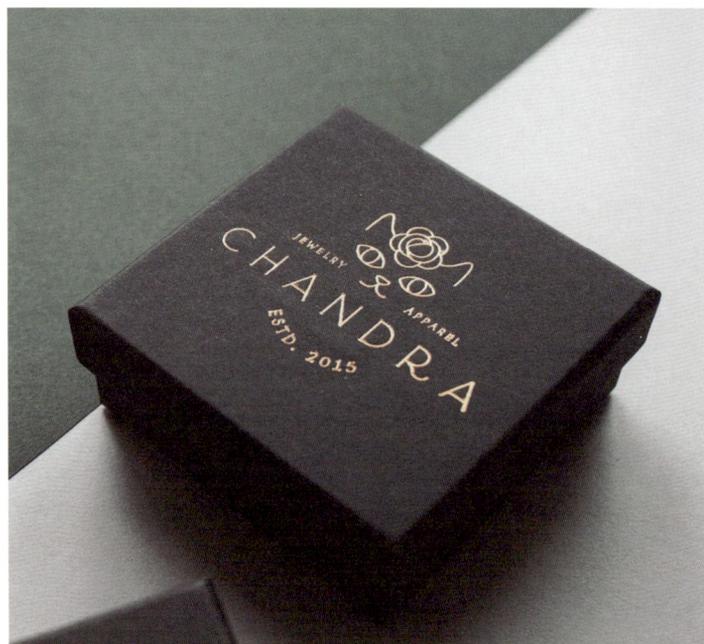

Design
Oddds

Client
Trang & Aurélien Spiegelberg,
Chandra

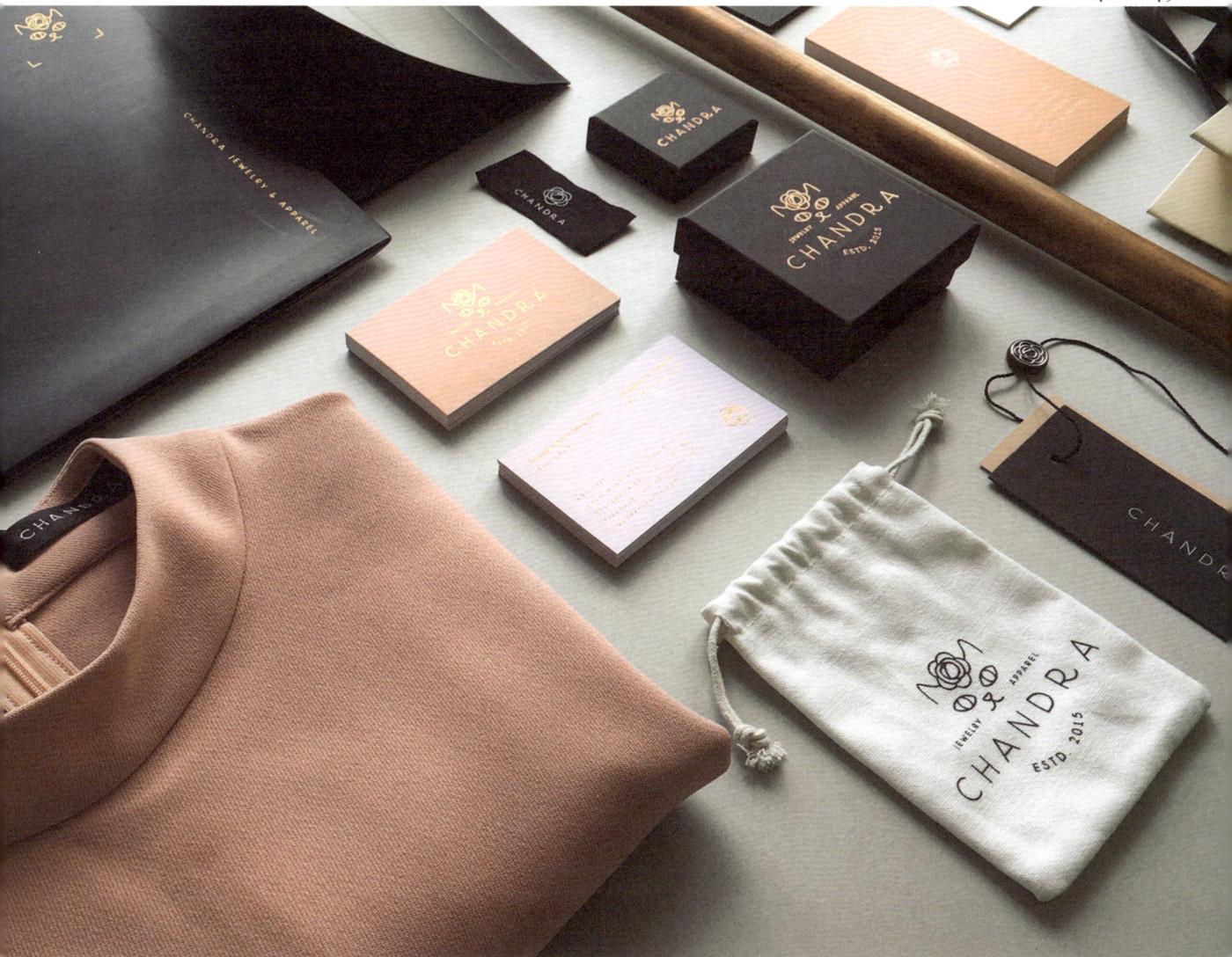

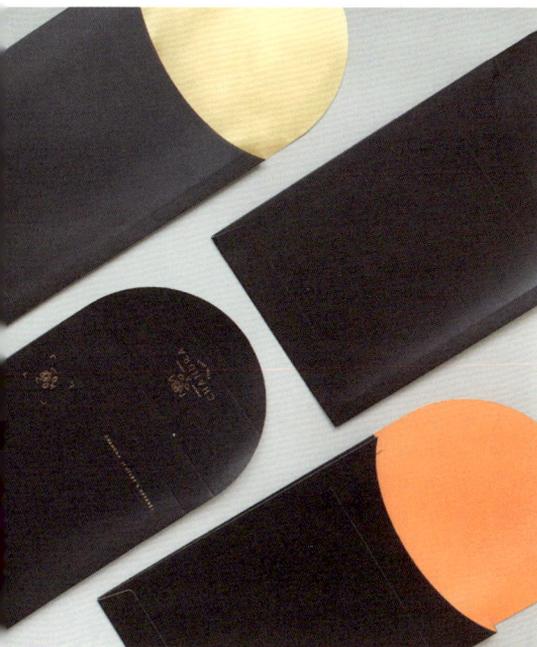

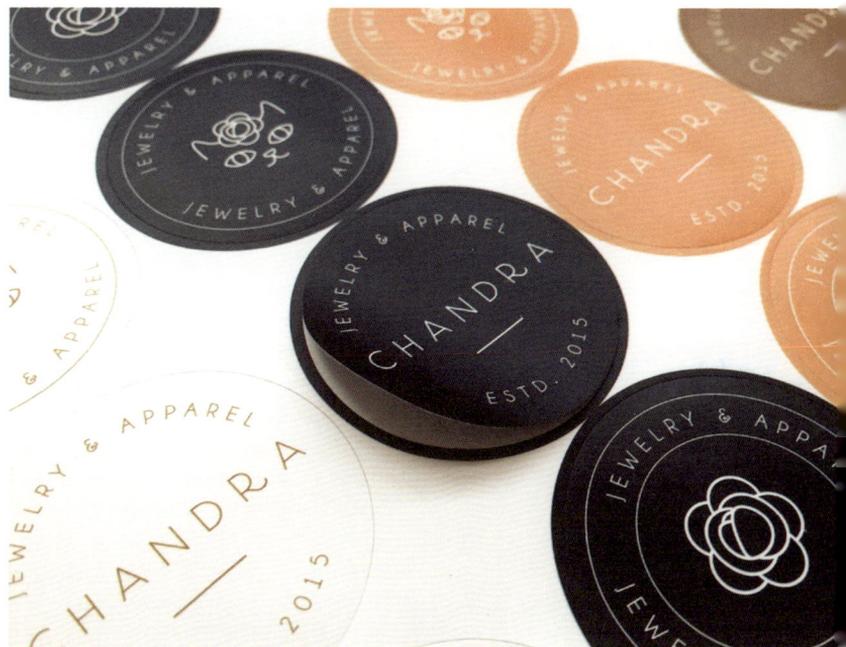

Design
Kobra Agency

Client
Förlaget Oy Ab

Photography
Niklas Sandström

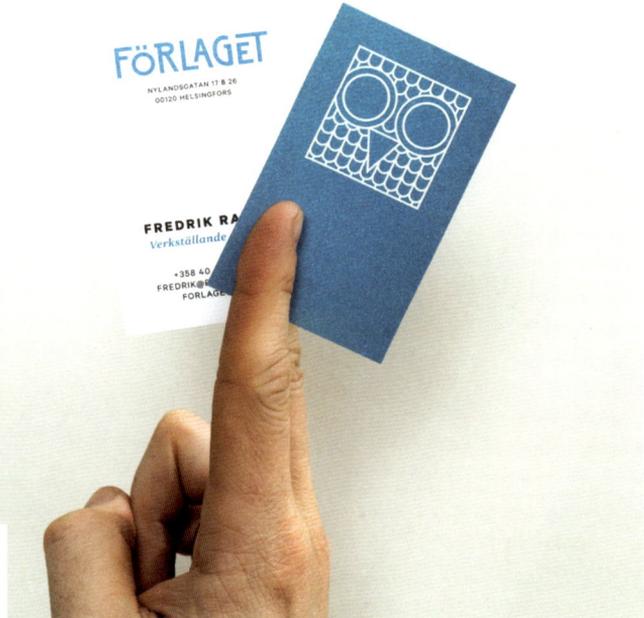

Förlaget

In creating a visual identity for the fledgling Förlaget publishing house, Kobra Agency were inspired by the owl. An animal that has long been utilised by the literary world as a mascot of sorts, it was transformed into a versatile, Art Nouveau-style graphic to reflect the publishing house's desire to celebrate its Finnish-Swedish cultural heritage. The resulting creative work served to connect classic texts from the past with modern publications in a bright and meaningful manner.

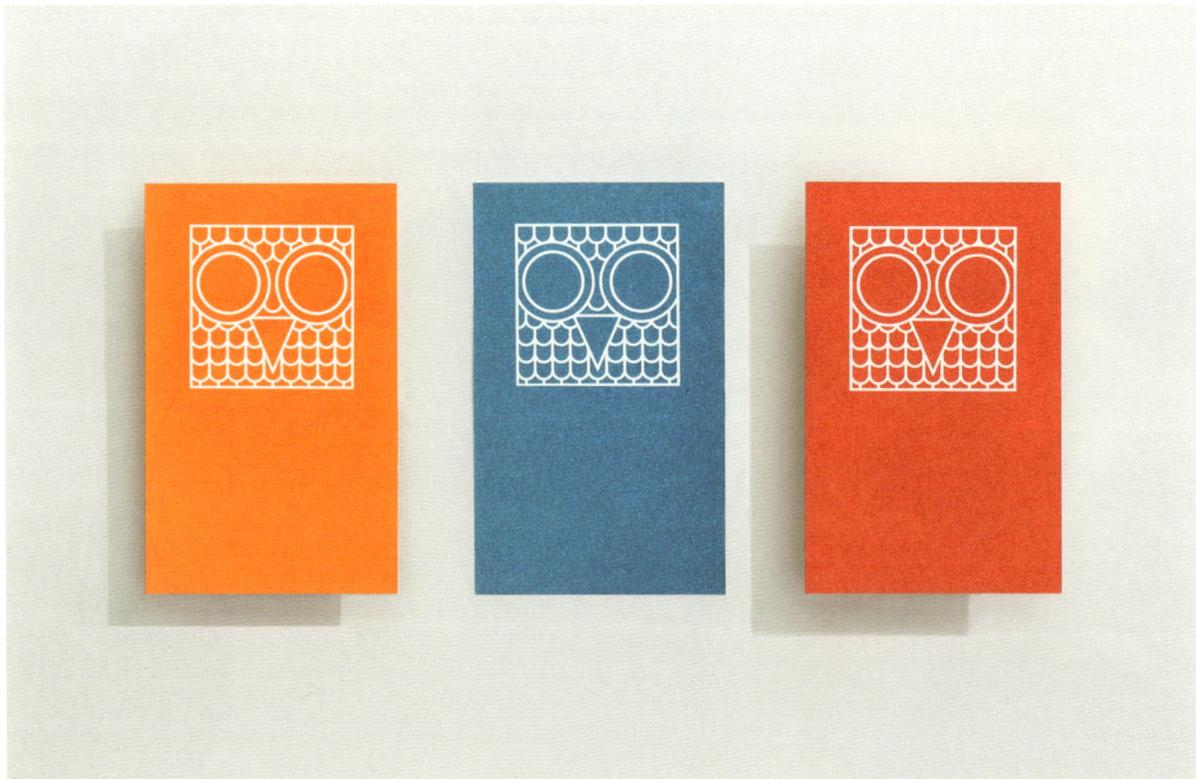

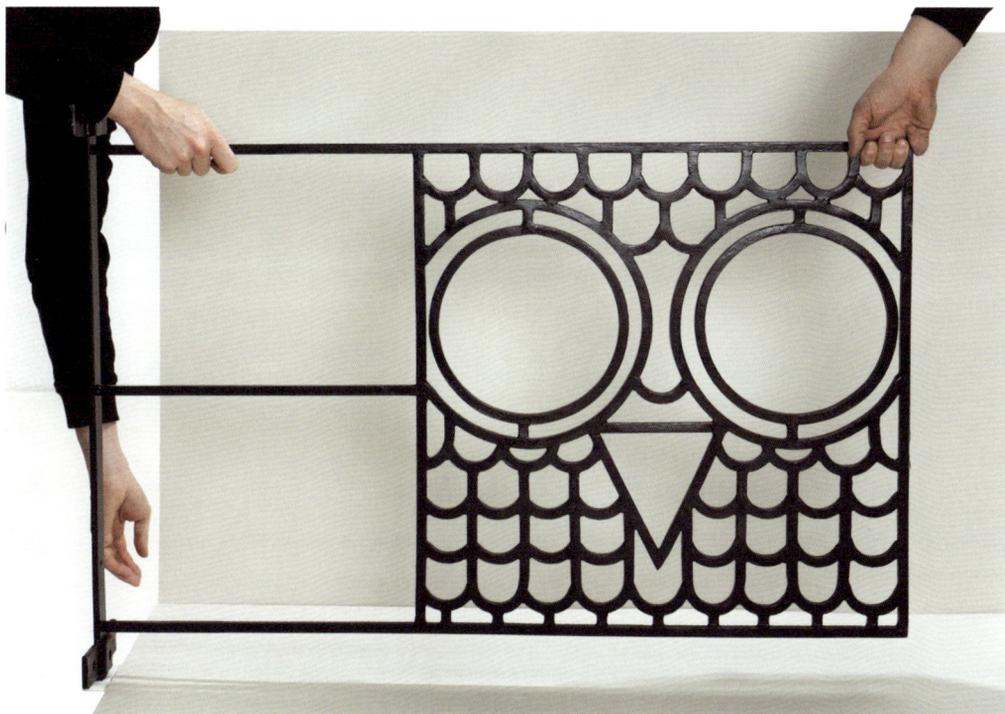

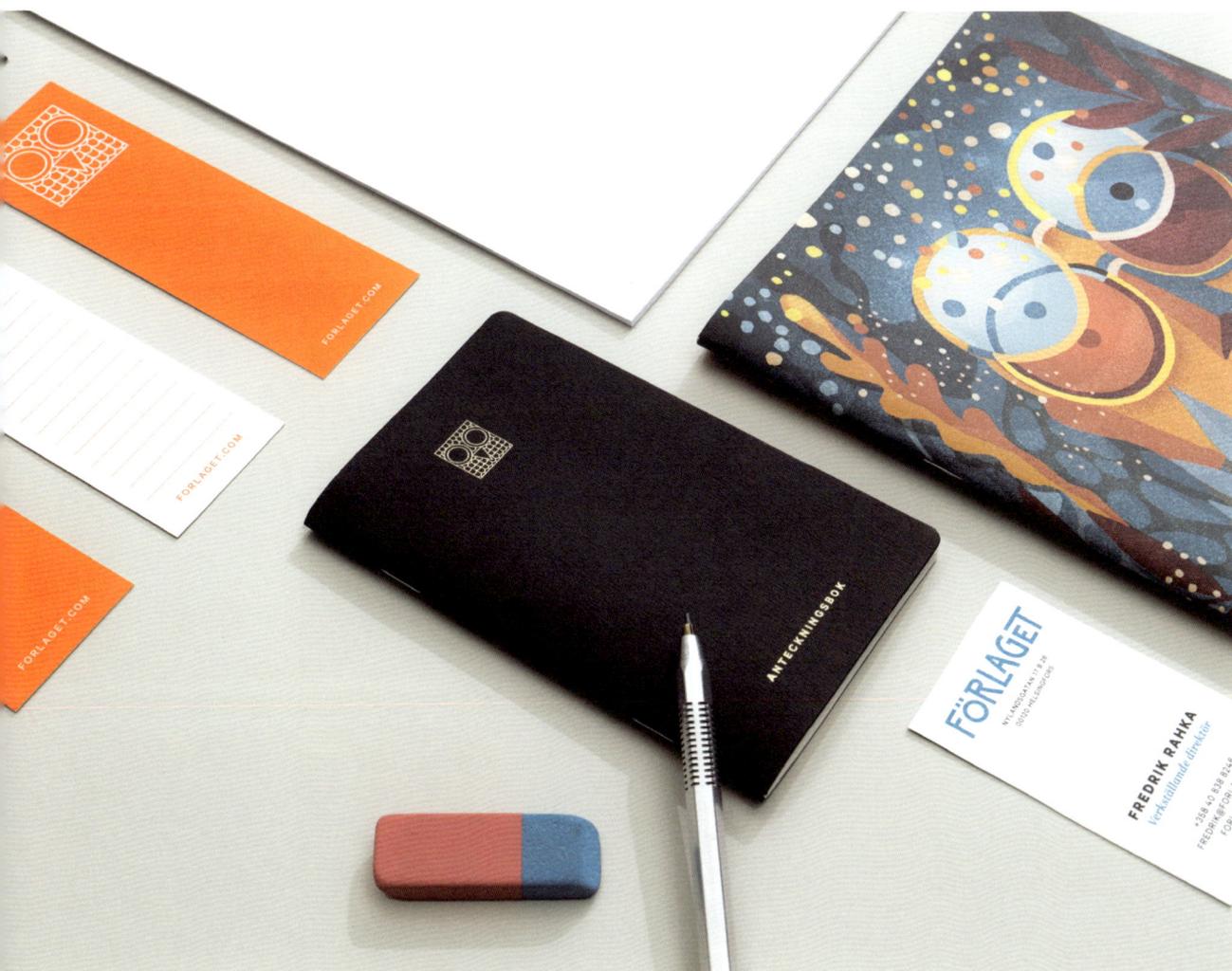

Hello Finch

For branding company Hello Finch, Studio Blackburn
created a visual identity that was both flexible and
distinctive. Drawing inspiration from its name, they
designed multiple vibrant versions of the bird – each
colour representing a company that it has helped to
transform. The geometric reinterpretations success-
fully represent Hello Finch's modern and innovative
mindset in the fast-paced digital age, while the varia-
tion of hues represents its ability to adapt, accommo-
date, and deliver according to its clients' needs.

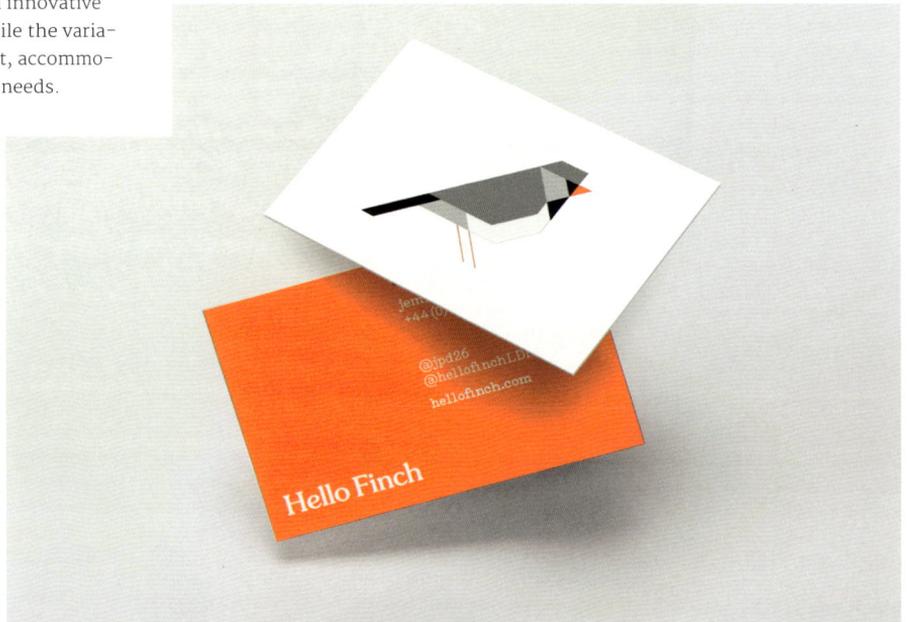

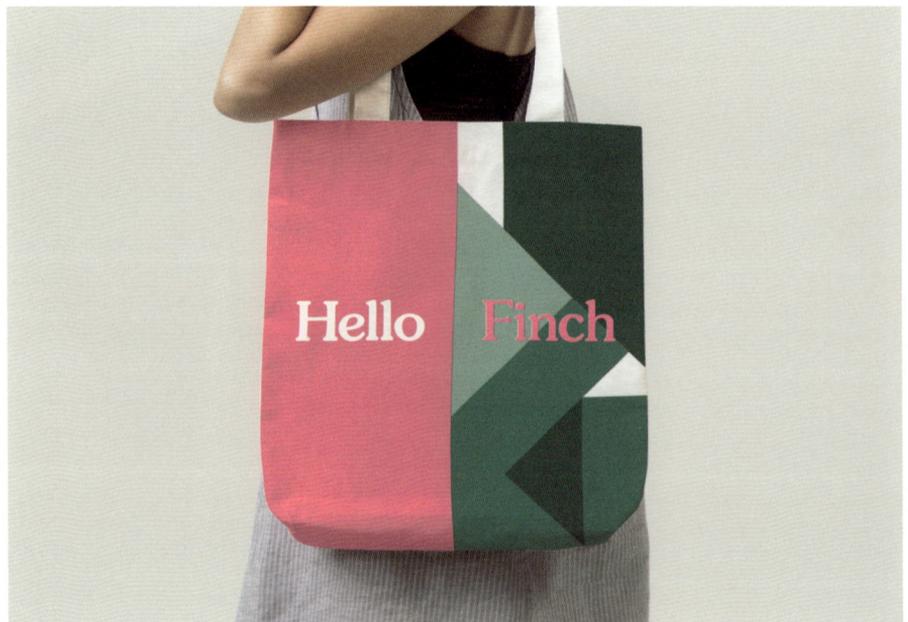

Design
Studio Blackburn

Client
Hello Finch

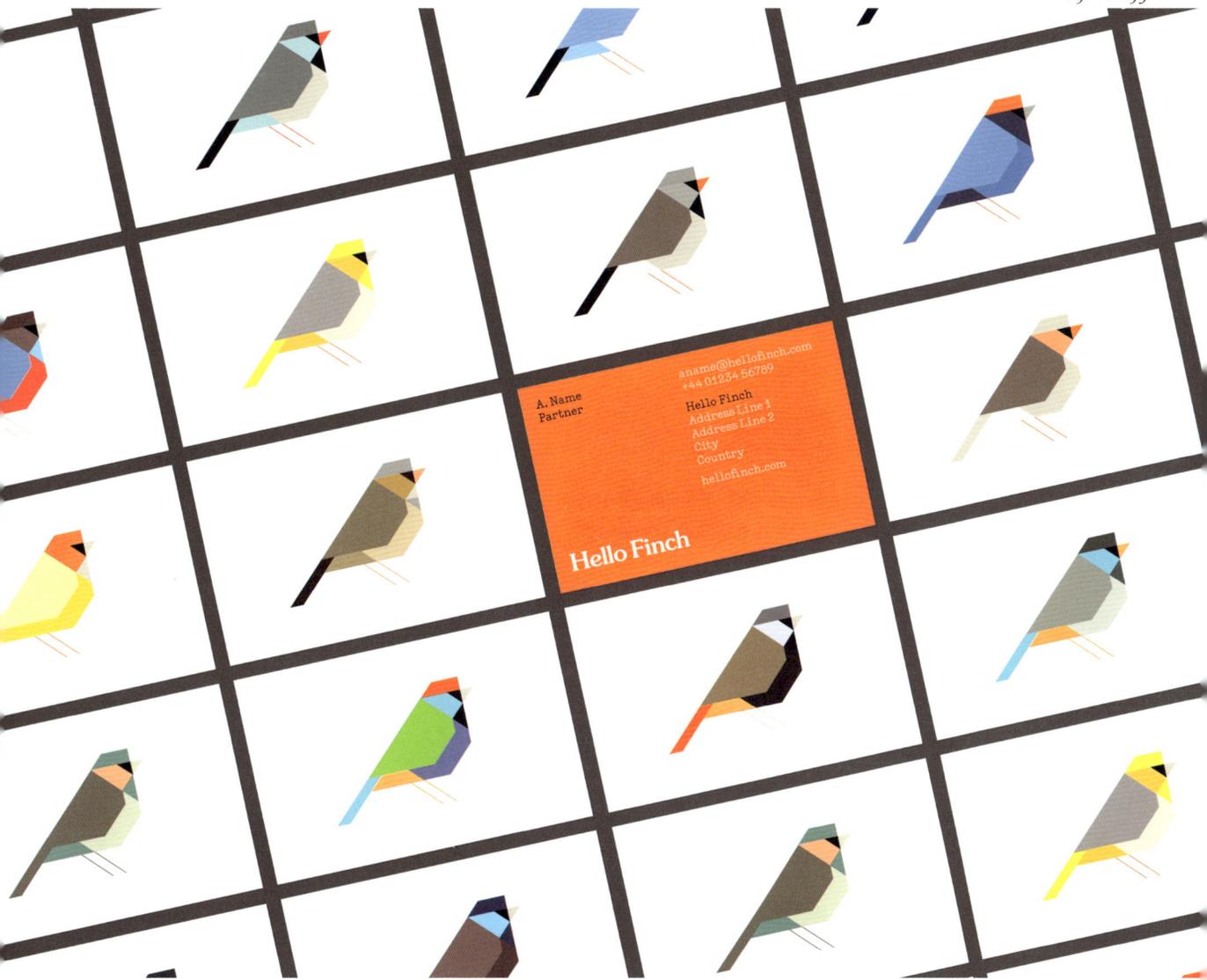

A. Name
Partner

aname@hellofinch.com
+44 01234 56789

Hello Finch
Address Line 1
Address Line 2
City
Country

hellofinch.com

Hello Finch

I stand
precisely
where
the doors
will part.
I am train.

trainline

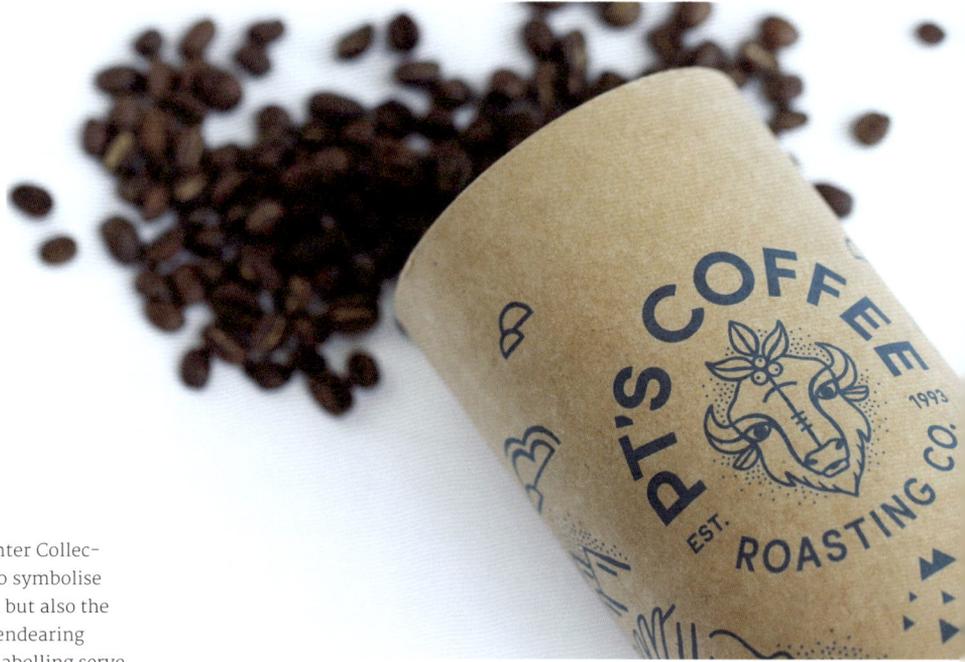

PT's Coffee

For the rebranding of PT's Coffee, Carpenter Collective featured a bison of the great plains to symbolise not only strength, unity, and abundance, but also the brand's roots in the Midwest. While the endearing illustrations in the logo, packaging, and labelling serve to reinforce the handcrafted nature of its products, the cohesive visual identity also accurately reflects its warm and welcoming personality throughout the customer journey.

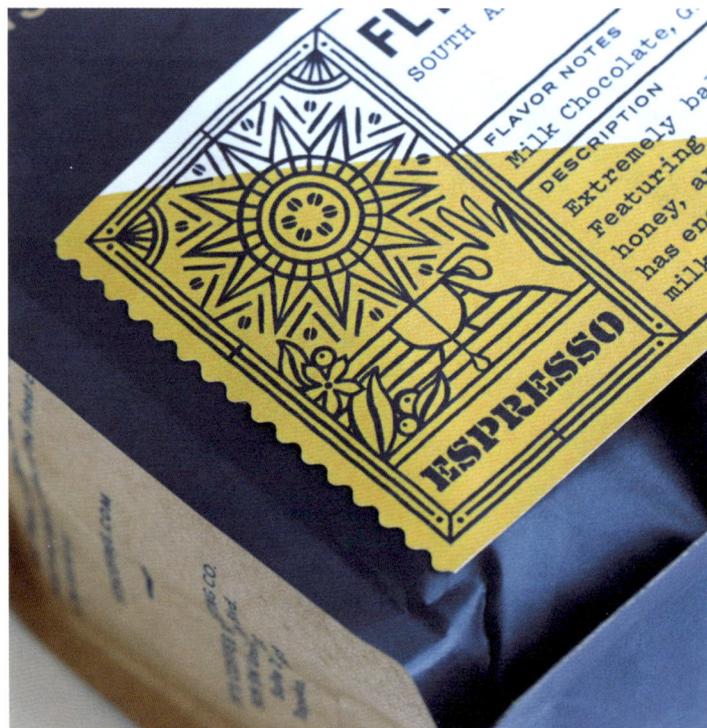

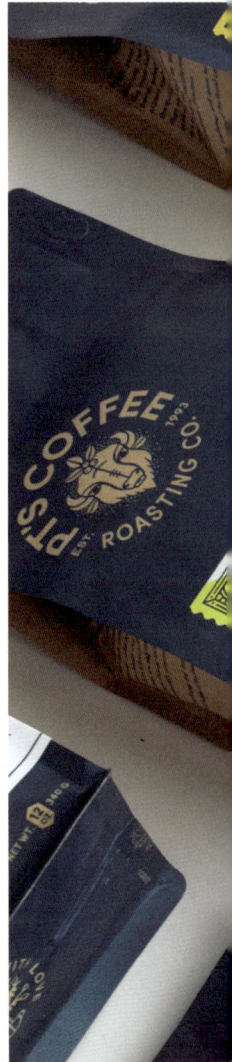

Design
Carpenter Collective

Client
PT's Coffee Roasting Co.

Photography
Bethany Hughes
Jessica Carpenter
Tad Carpenter

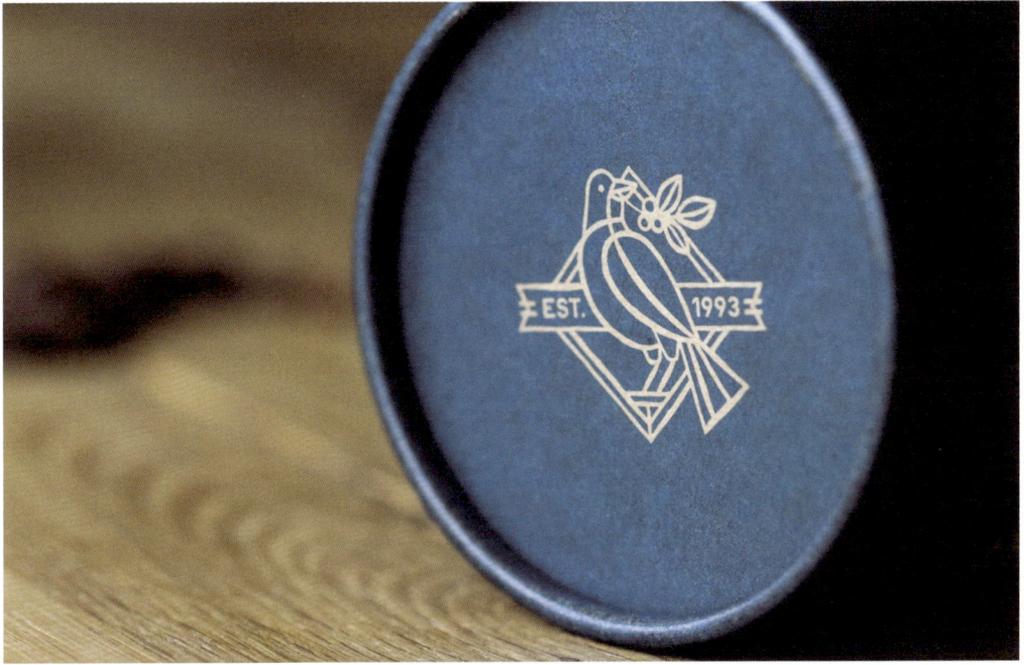

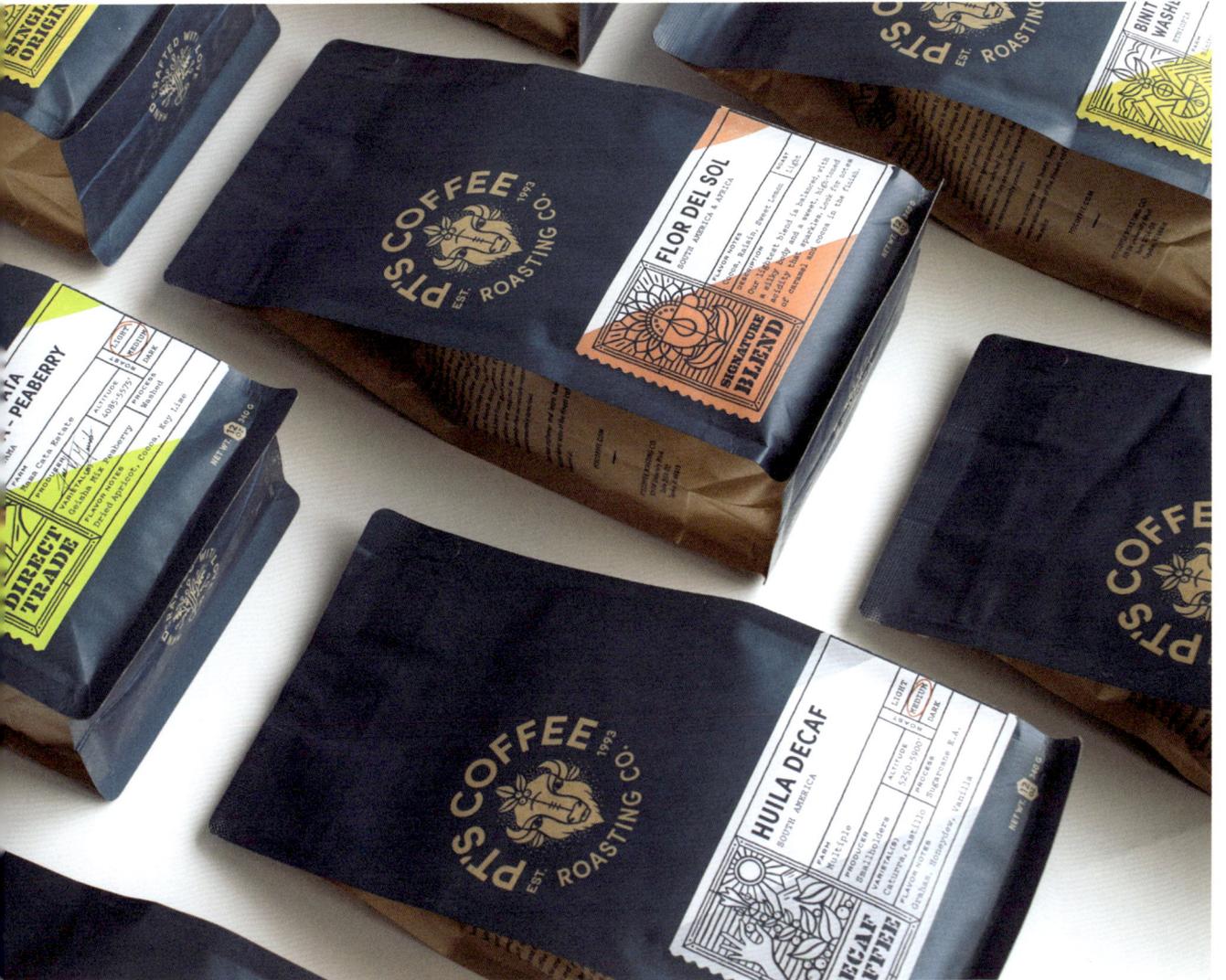

**TOMORROW MORNING NEVER
LOOKED SO GOOD!**

We put our heart and soul into this coffee—working with
the best producers in each growing region and meticulously
roasting at our facility in Topeka—with you in mind. We've
been doing this for 25 years and it's always exciting to
greet a new customer. We're glad you chose PT's!

Sincerely,

Jeff Taylor & Fred Polzin, Owners

PT'S COFFEE
ROASTING CO.

Enter coupon code 'roasted-to-order' at checkout
for 10% off your next coffee order!
(Valid for new user, not to be combined with other offers.)

LEAH SHINKLE
Head of Training and Education

EMAIL
leah@ptscoffee.com

OFFICE
785.862.5282

CELL
785.580.7074

PTSCOFFEE.COM

HAND-CRAFTED WITH LOVE

PT'S COFFEE
ROASTING CO.

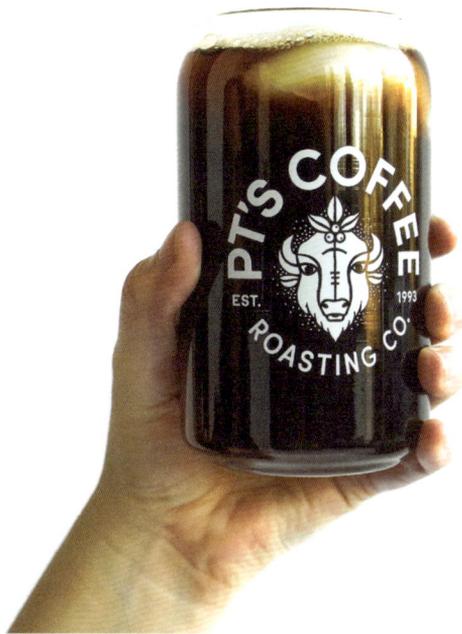

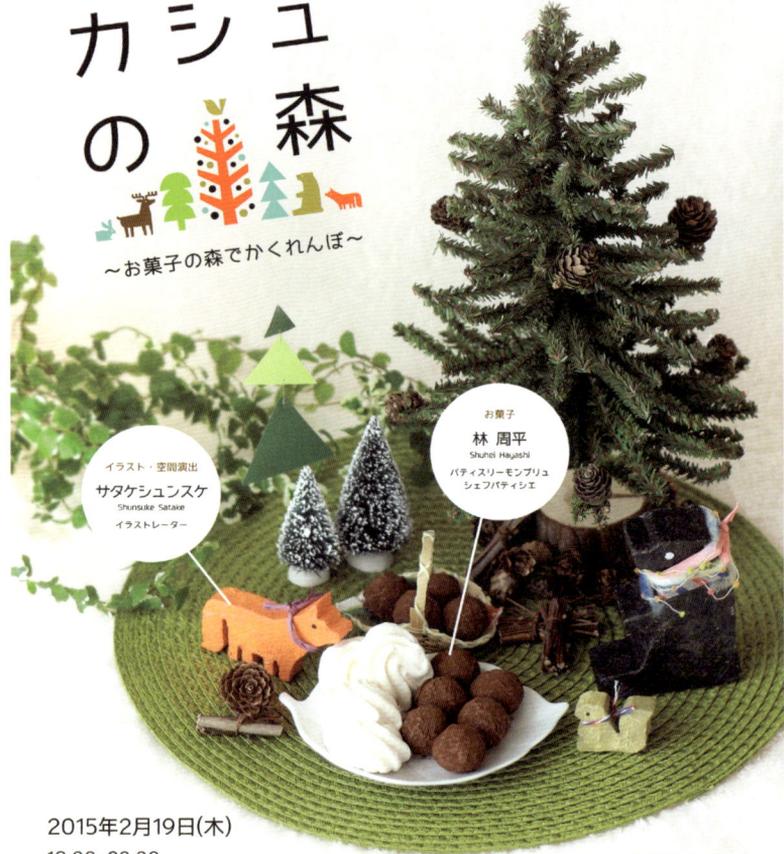

Forest of Cache Cache

Both a product and producer of collaboration, the Forest of Cache Cache was an interactive space that united parents and children through design and French sweets. Featuring simple and endearing illustrations of animals and plants from the forest in its visual identity, the one-time event was a result of the teamwork between chef Shuhei Hayashi and freelance illustrator Shunsuke Satake. Visitors to the Forest of Cache Cache could take part in a scavenger hunt full of cuddly creatures, elusive clues, and delectable treats.

Design
Shunsuke Satake

Client
Design and Creative Center Kobe
(KIITO)

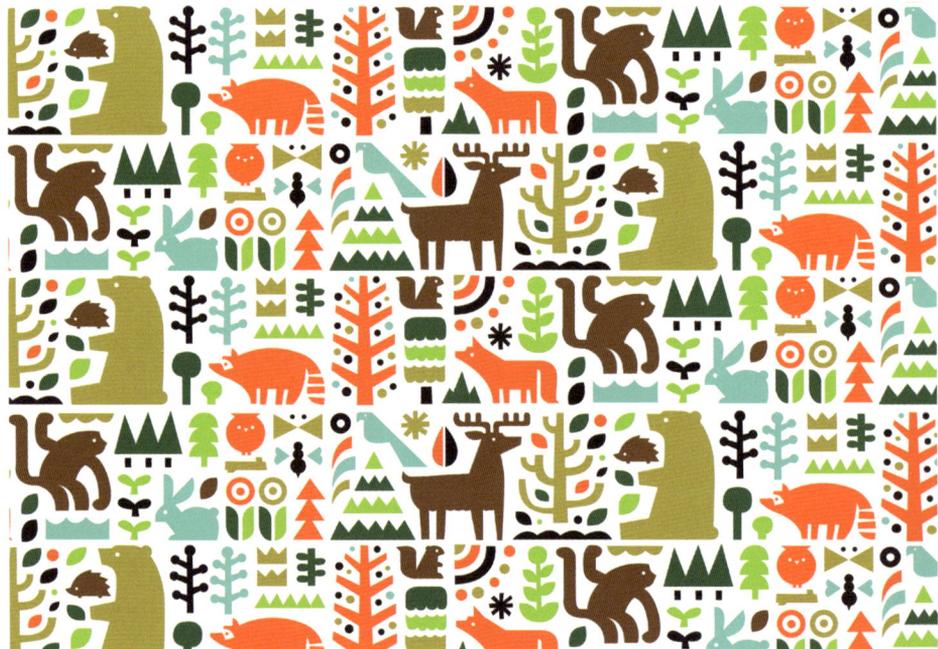

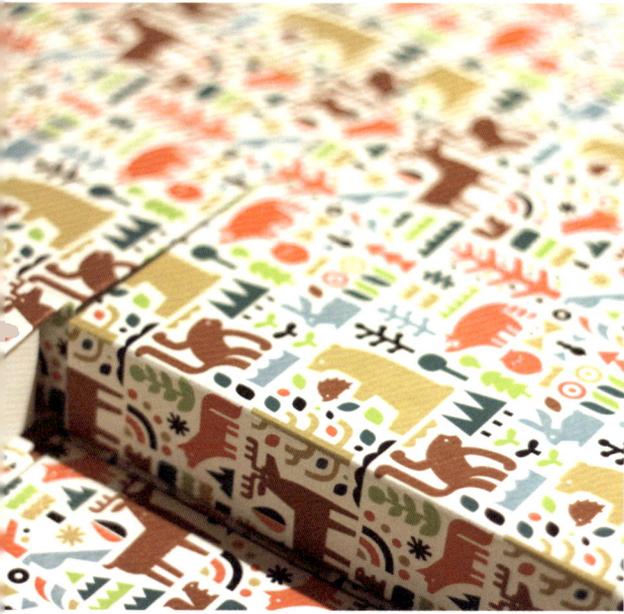

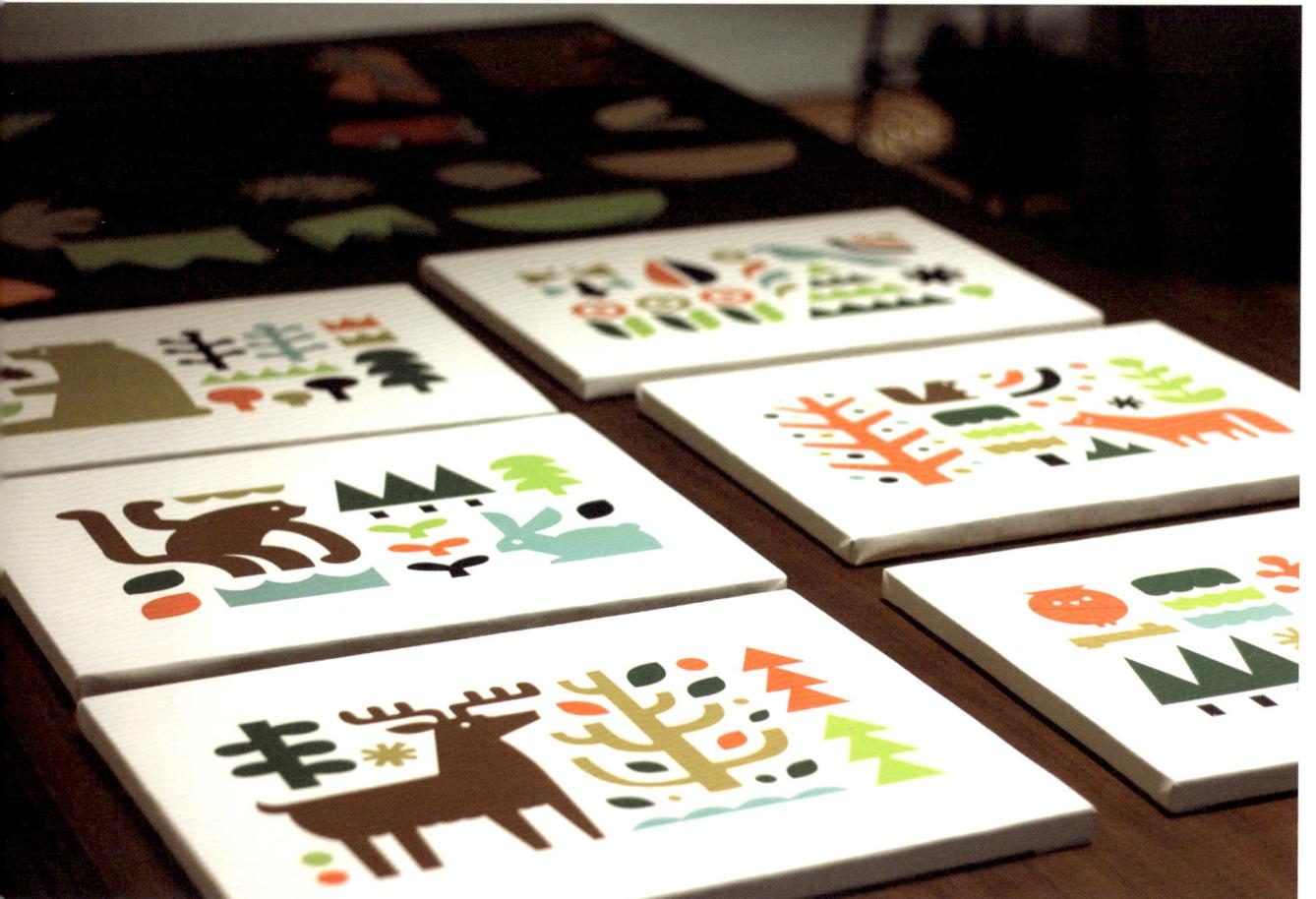

ekies - All Senses Resort

In designing for ekies, a boutique summer hotel with
a contemporary eco-friendly philosophy, Beetroot
Design Group drew attention to its unique natural set-
ting in Greece through illustrations of animals found
locally within the area. The project began in 2010 and
features almost 20 'family members' today, with a
new character popping up around the hotel grounds to
surprise guests every now and then.

Design
Beetroot Design Group

Client
ekies - All Senses Resort

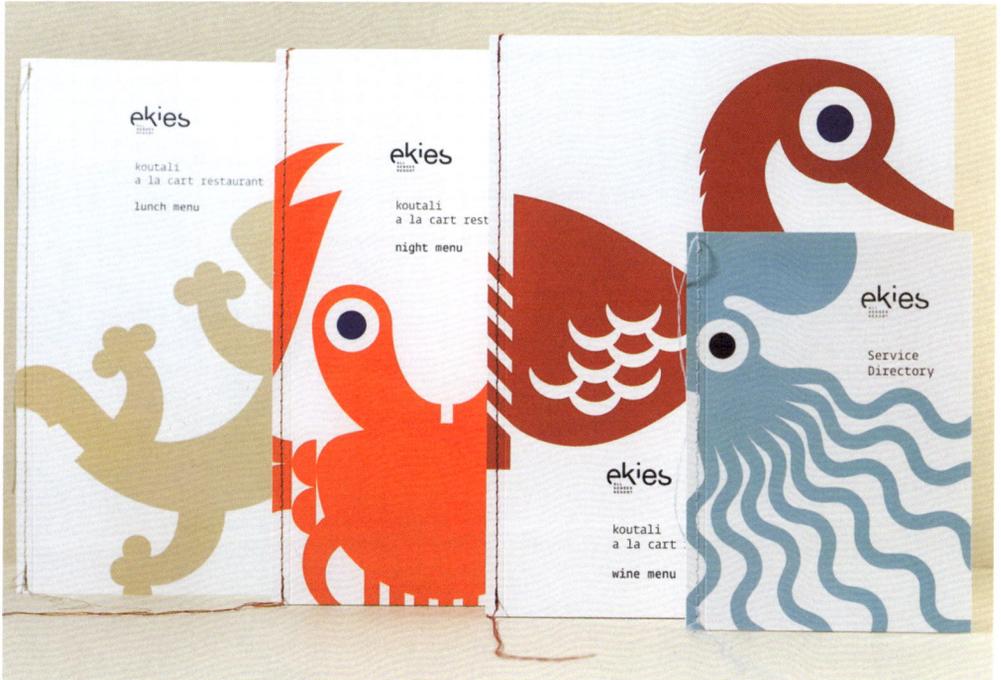

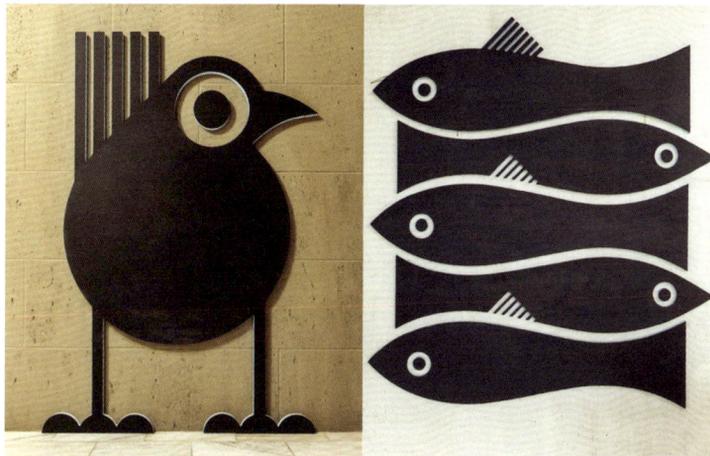

Design
Beetroot Design Group

Client
Ergon - Greek Deli & Cuisine

Yiayia and Friends

Partnering with Ergon, a company promoting Greek culture and gastronomy, Beetroot Design Group created a line of food products, tools, and objects that blended Greek traditions with contemporary customs. Yiayia (meaning 'granny' in Greek) and Friends was the resulting product—a multifaceted gastronomical project that uses vibrant and colourful characters with eyes illustrated in the same style, to remember, re-introduce, and re-imagine the practice of cooking and sharing food with others. Ultimately, the story of Yiayia is one about mankind's connection with nature, agriculture, produce, and creation.

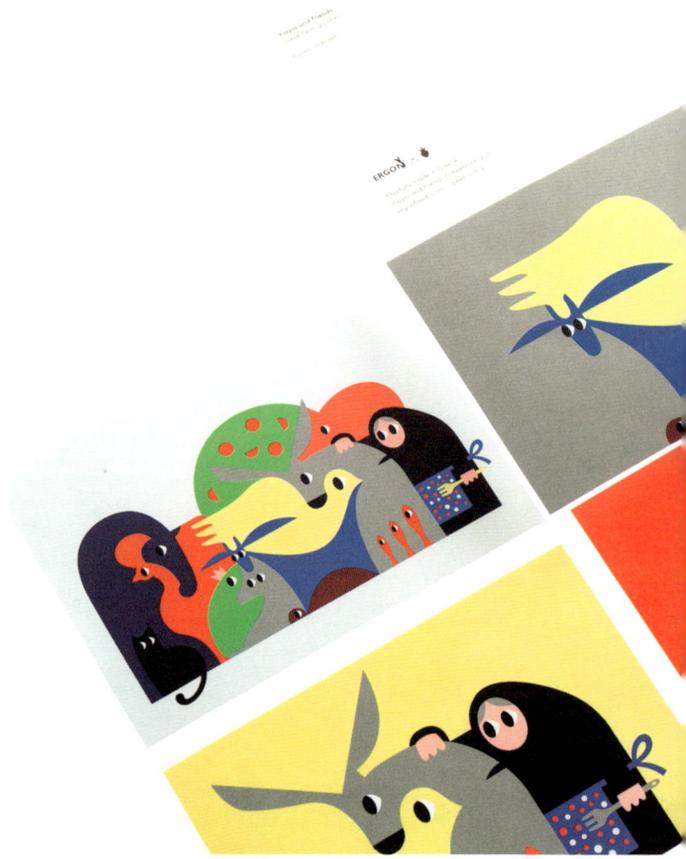

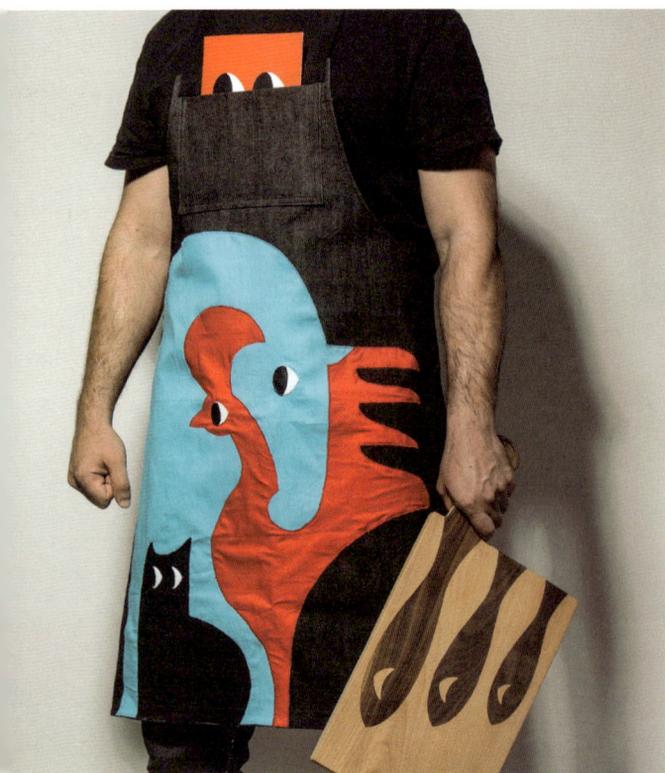

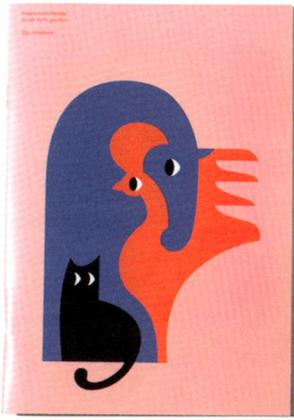 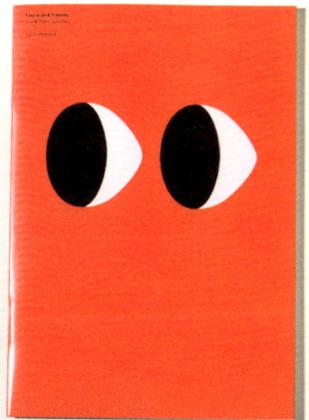

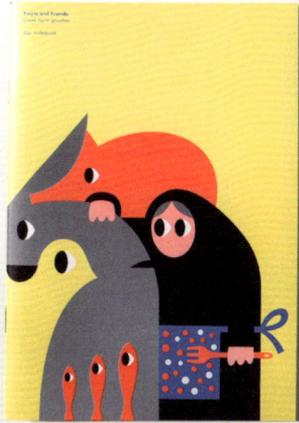 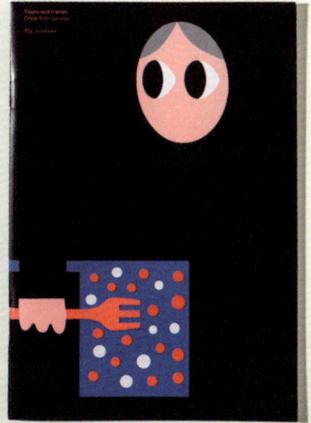

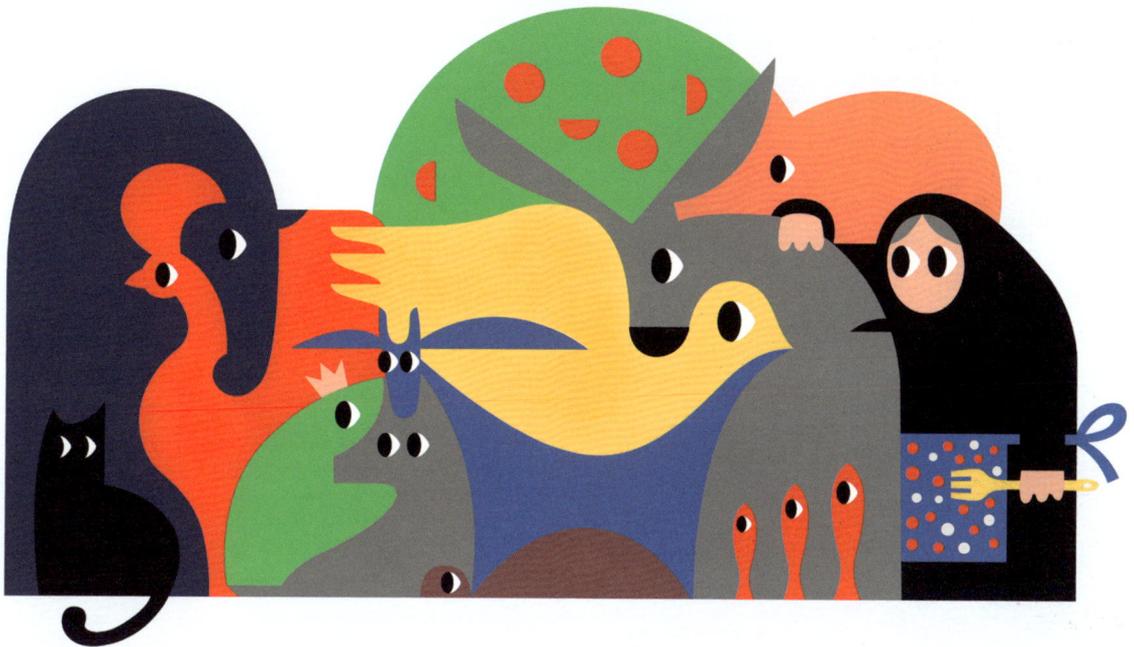

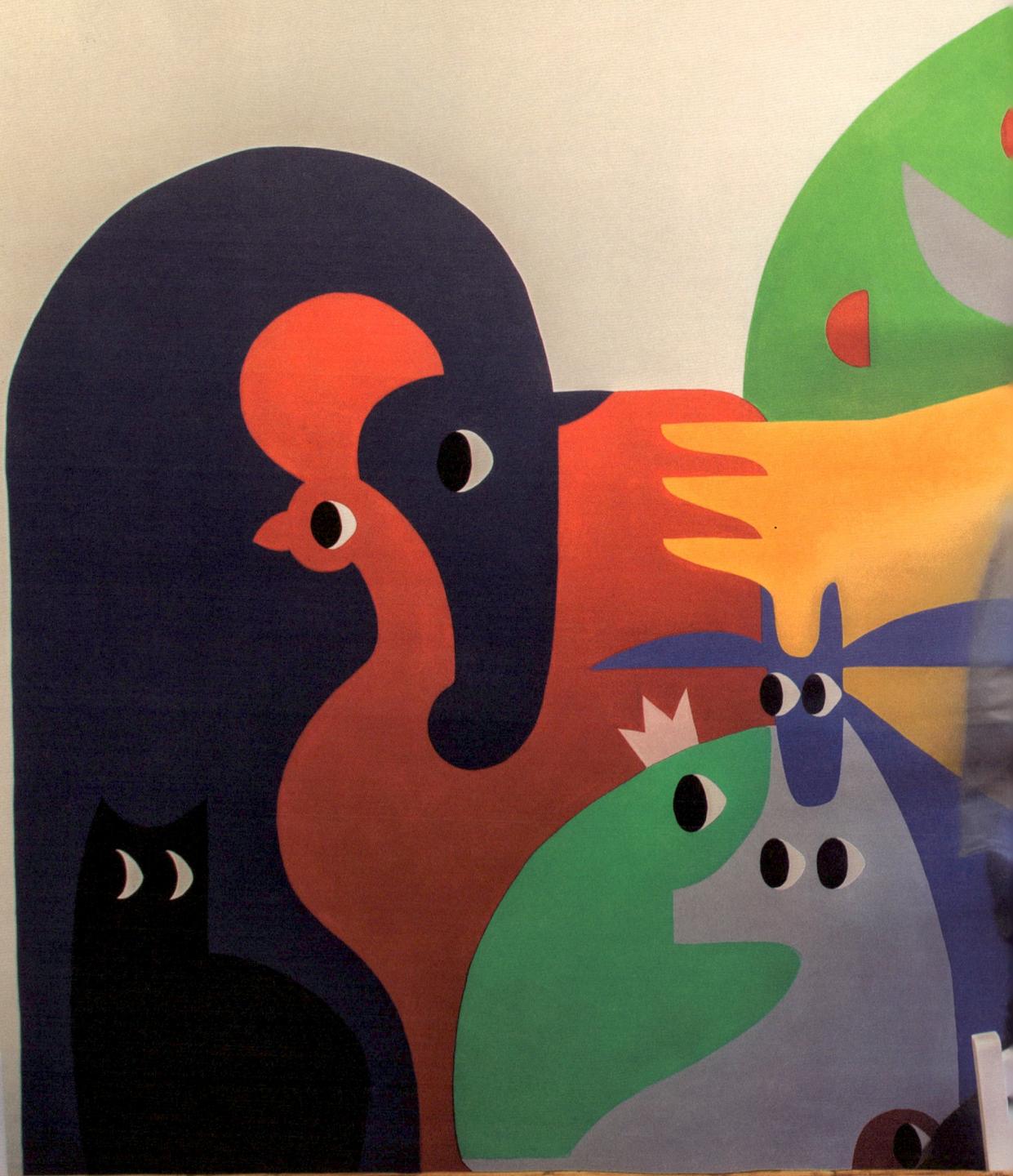

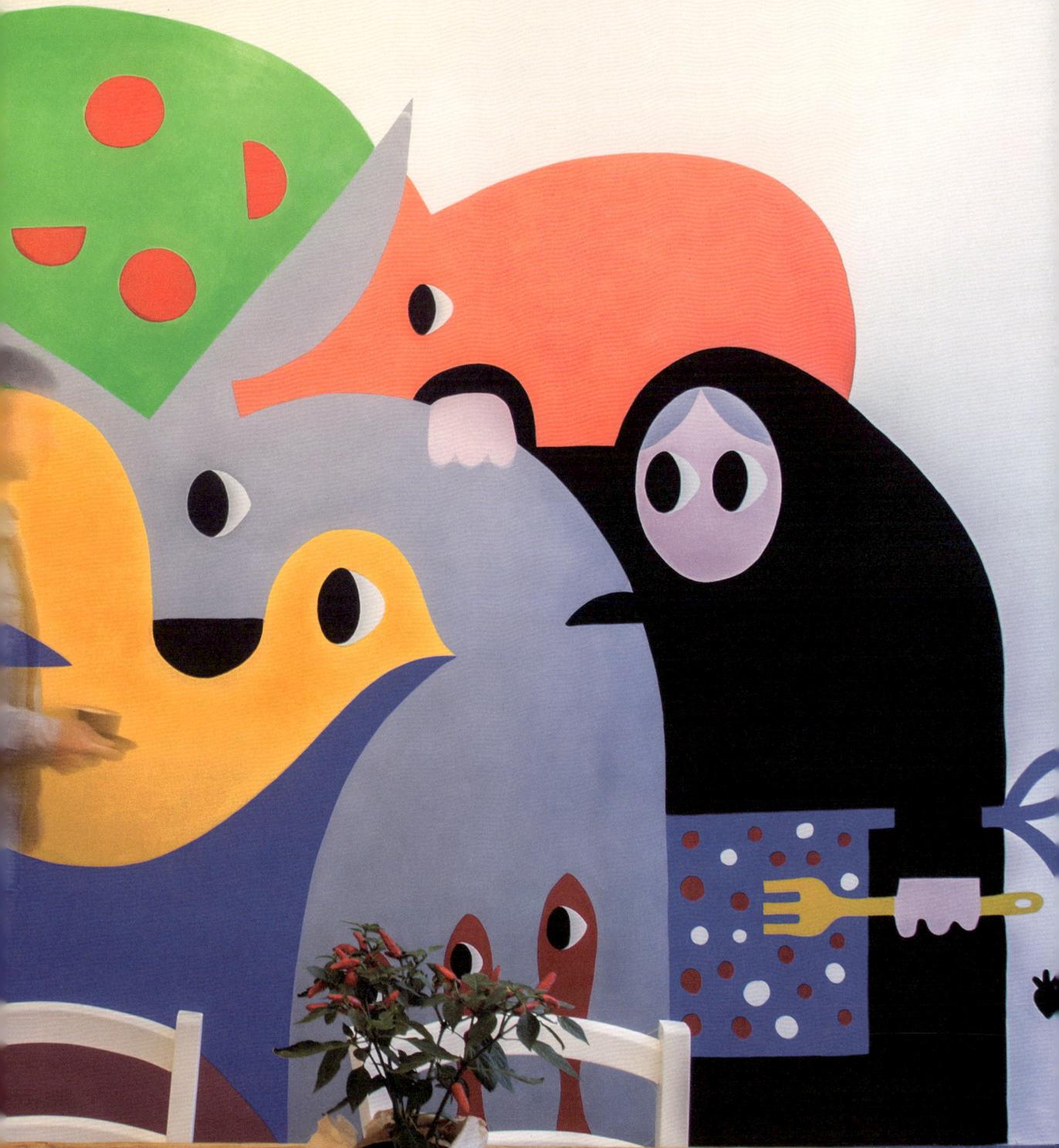

Music Album
by Sue Su

To capture the fantastical, magical, and raw creative energy of young music artist Sue Su, Magdalene Wong illustrated an eye-popping album cover depicting a wild and beautiful fantasy world. Standing out from most of the other album designs in the current market through its lack of commercial photography, this playful design is the result of a careful decision to go down a more non-traditional and unpredictable route of pure imagination, marvelous colours, and powerful personality.

Design
Magdalene Wong

Client
Bravo Music Inc

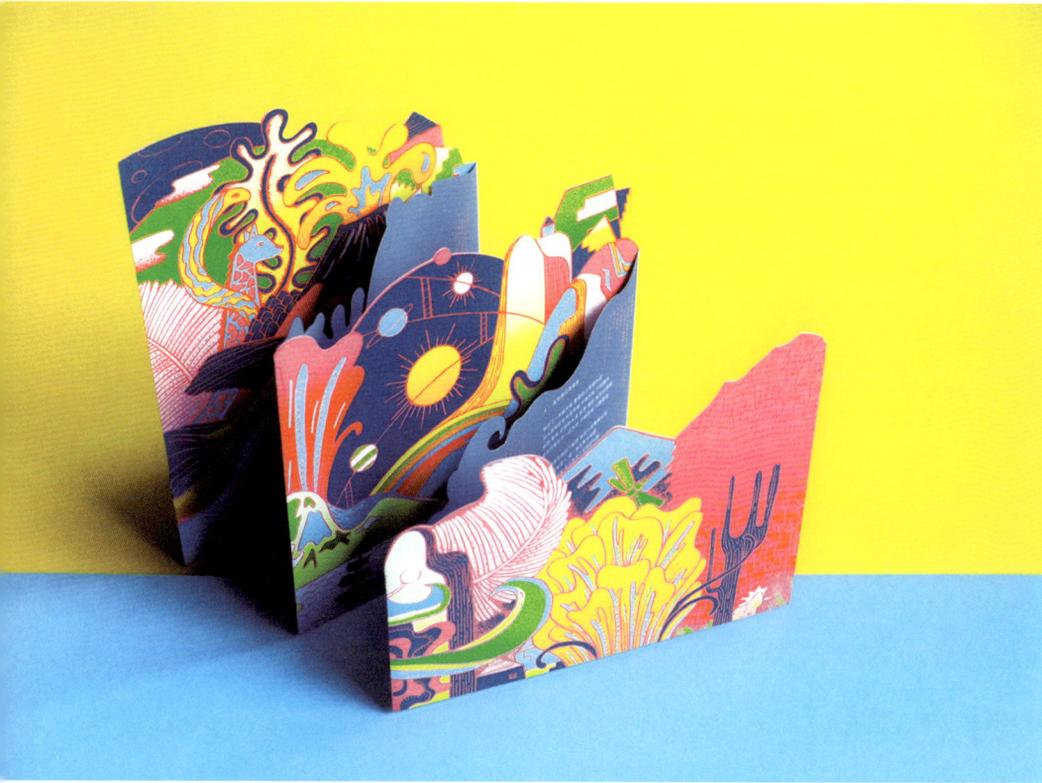

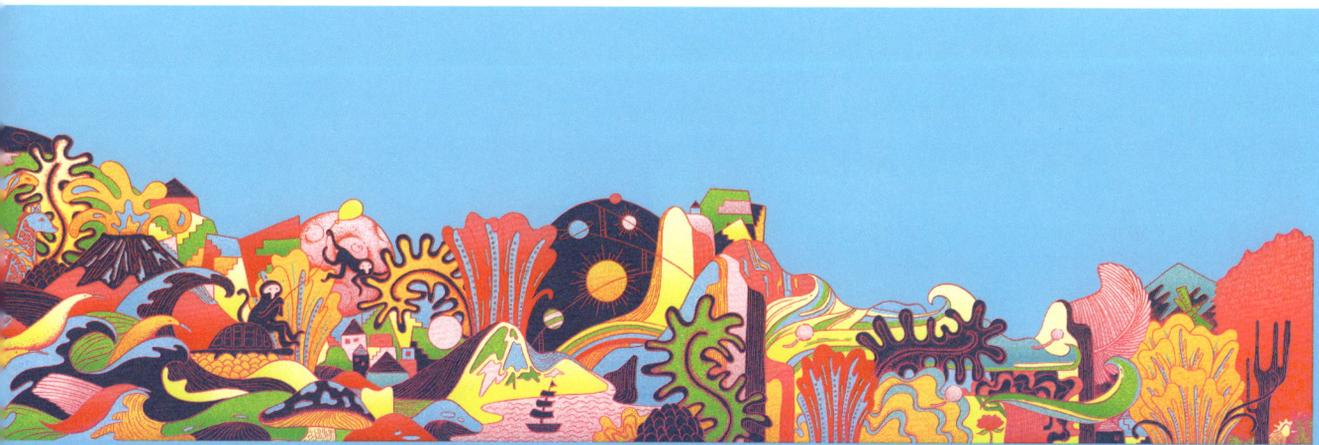

Design
studiowmw

Client
j&s printing ltd.

How do dogs see the world?

For 2018, the Year of the Dog, studiowmw designed a collection of red packets featuring different dogs in their 'homes' – housed within a bright yellow box. Sliding off the sleeve of the box revealed different pops of colours and patterns that depicted the different stories of each dog. Through hot-stamping, laser-cutting, and 3D embossing methods, they updated traditions with a contemporary and endearing twist to celebrate the new year.

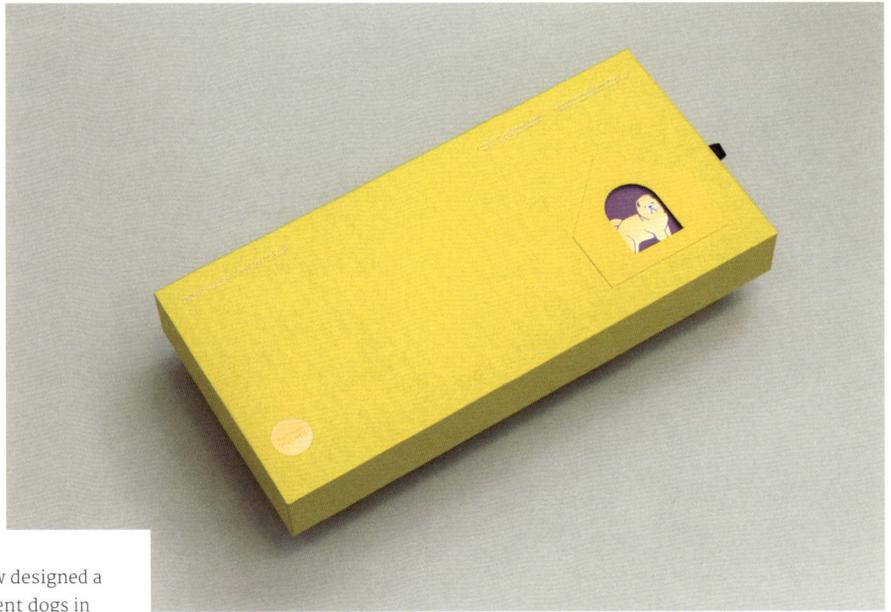

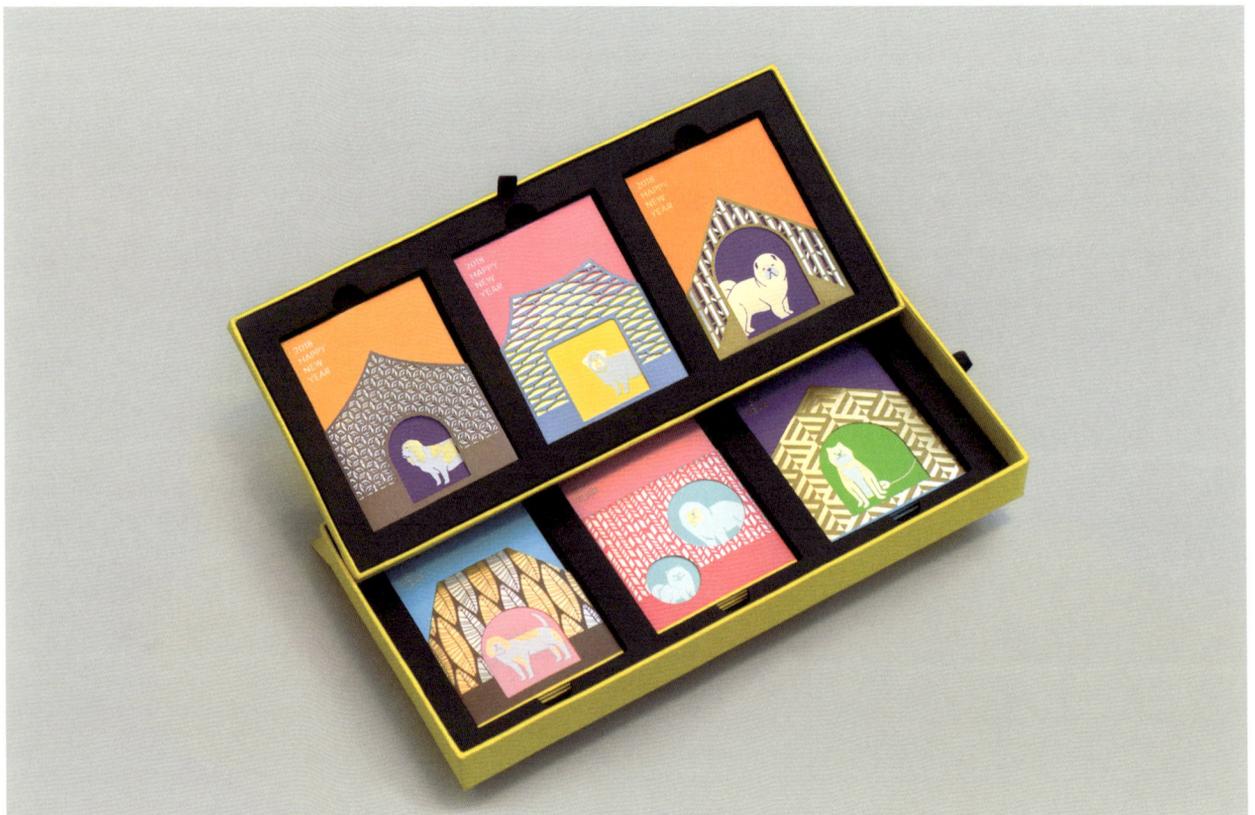

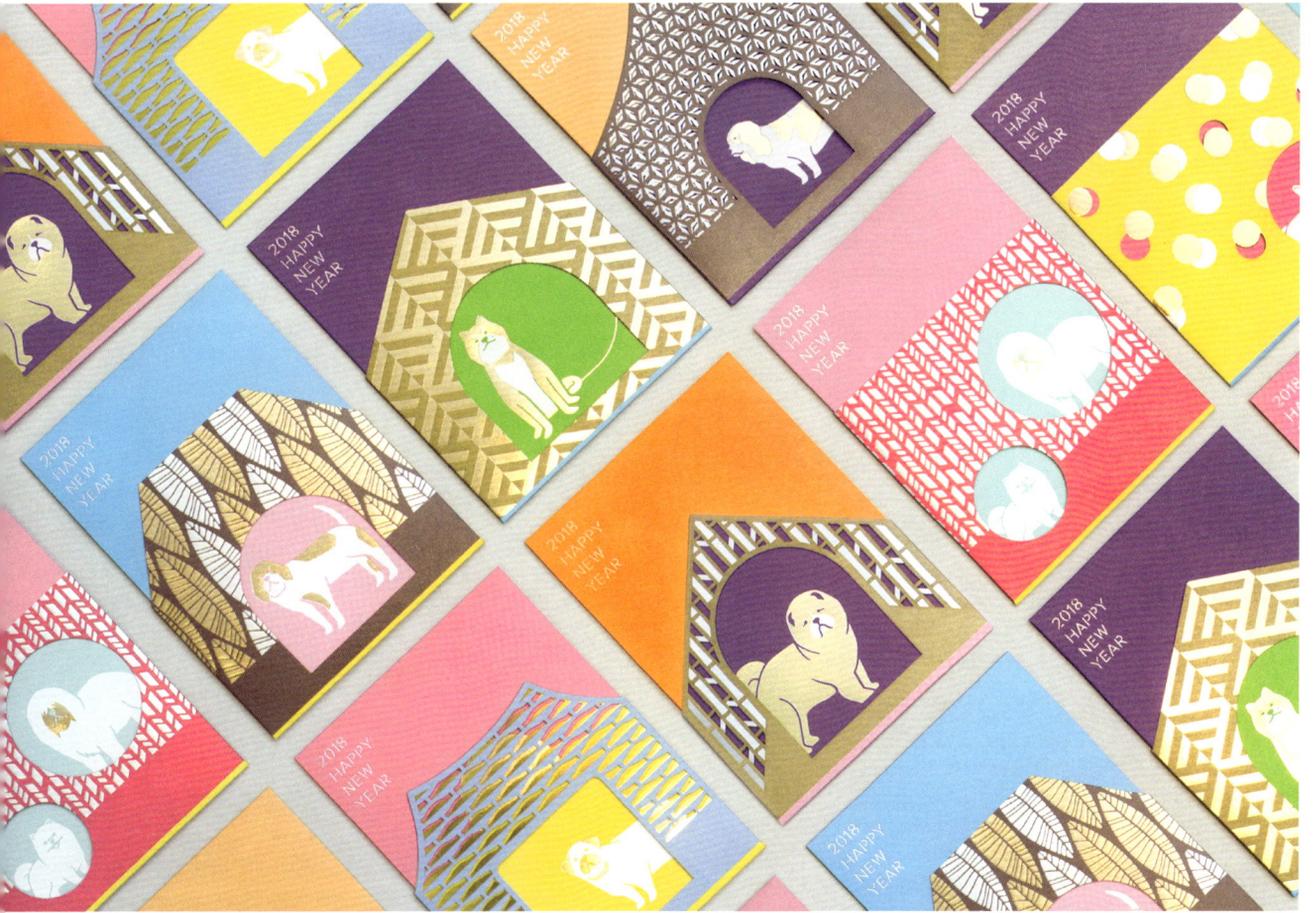

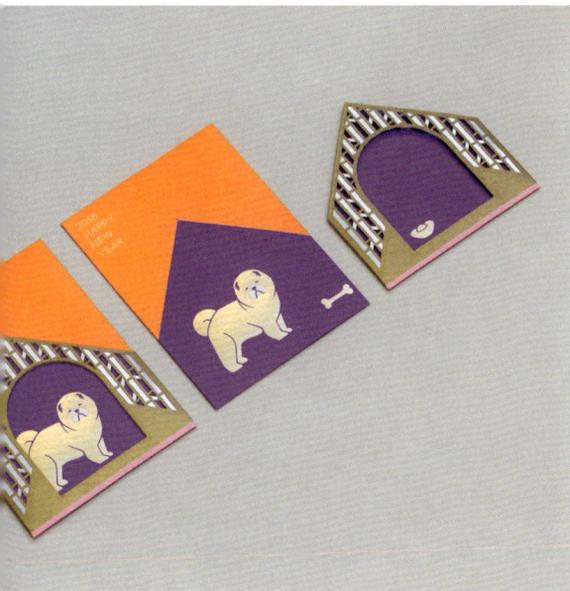

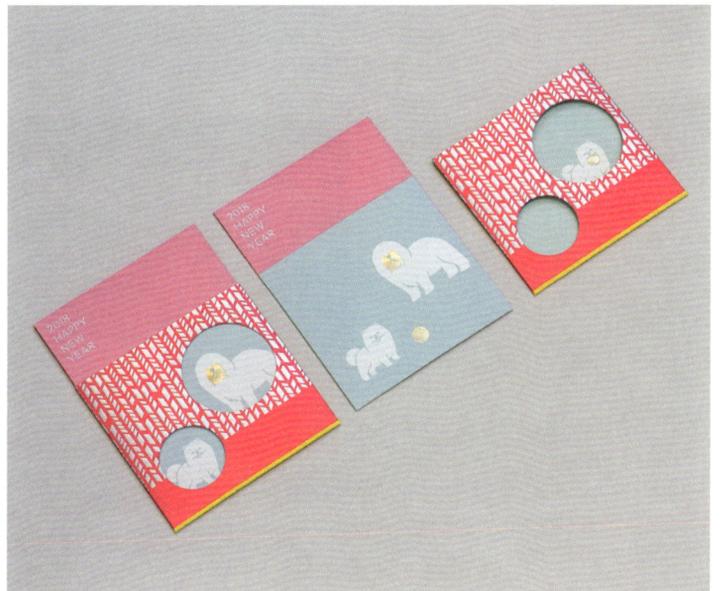

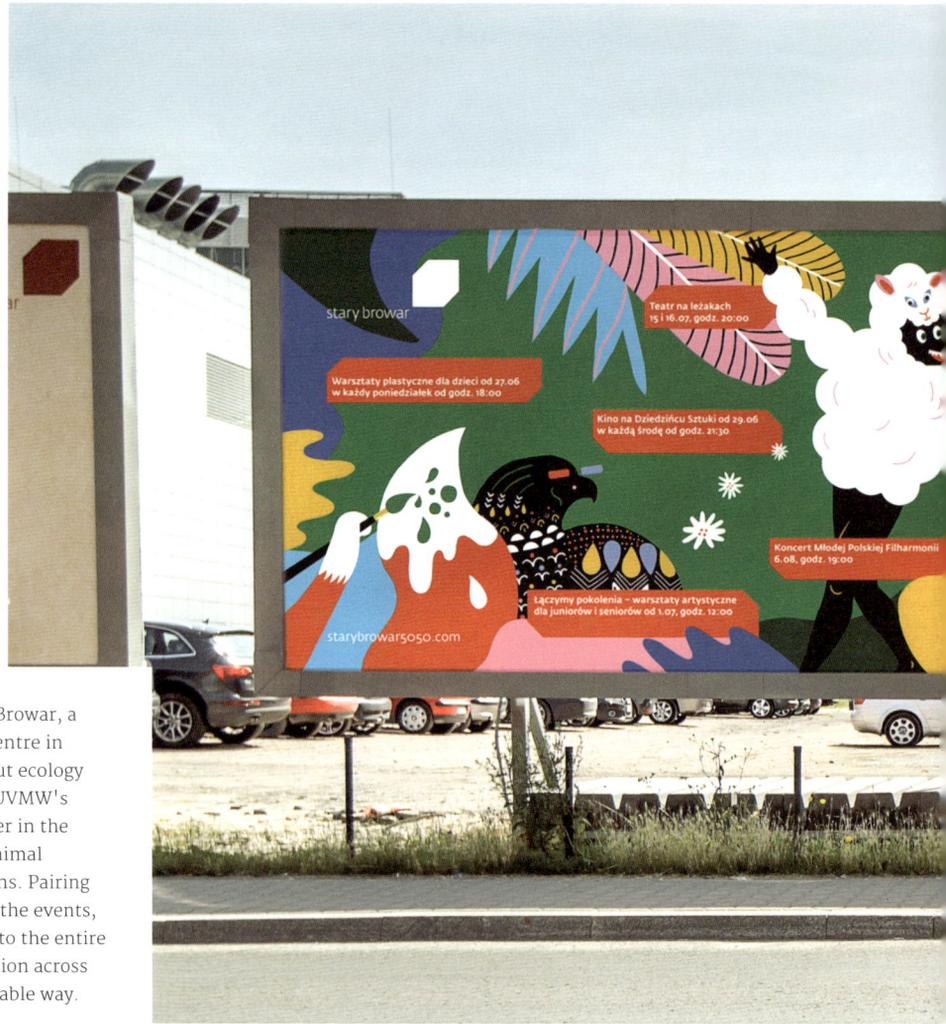

Summer in the City by Stary Browar 2016

To promote the summer events at Stary Browar, a premium shopping, arts, and business centre in Poznań, as well as promote learning about ecology and the protection of the environment, UVMW's visual identity design for its 2016 Summer in the City campaign featured various quirky animal illustrations in bright colour combinations. Pairing them with whimsical writing promoting the events, UVMW brought liveliness and optimism to the entire campaign, while disseminating information across mediums in an eye-catching and memorable way.

Design
UVMW

Client
Stary Browar

Illustration
Joanna Fidler-Wieruszewska

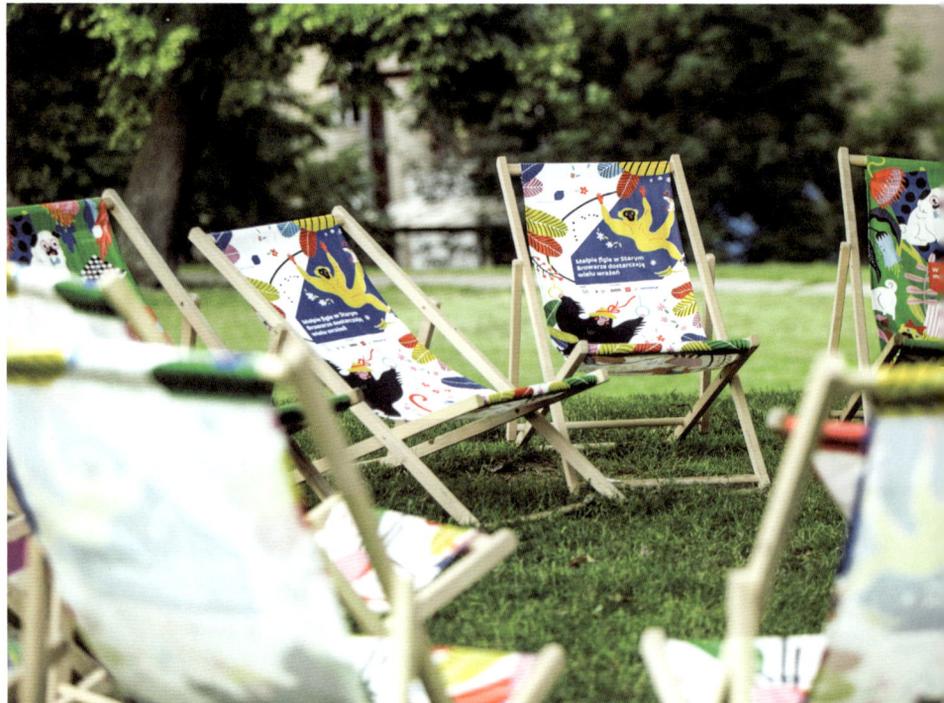

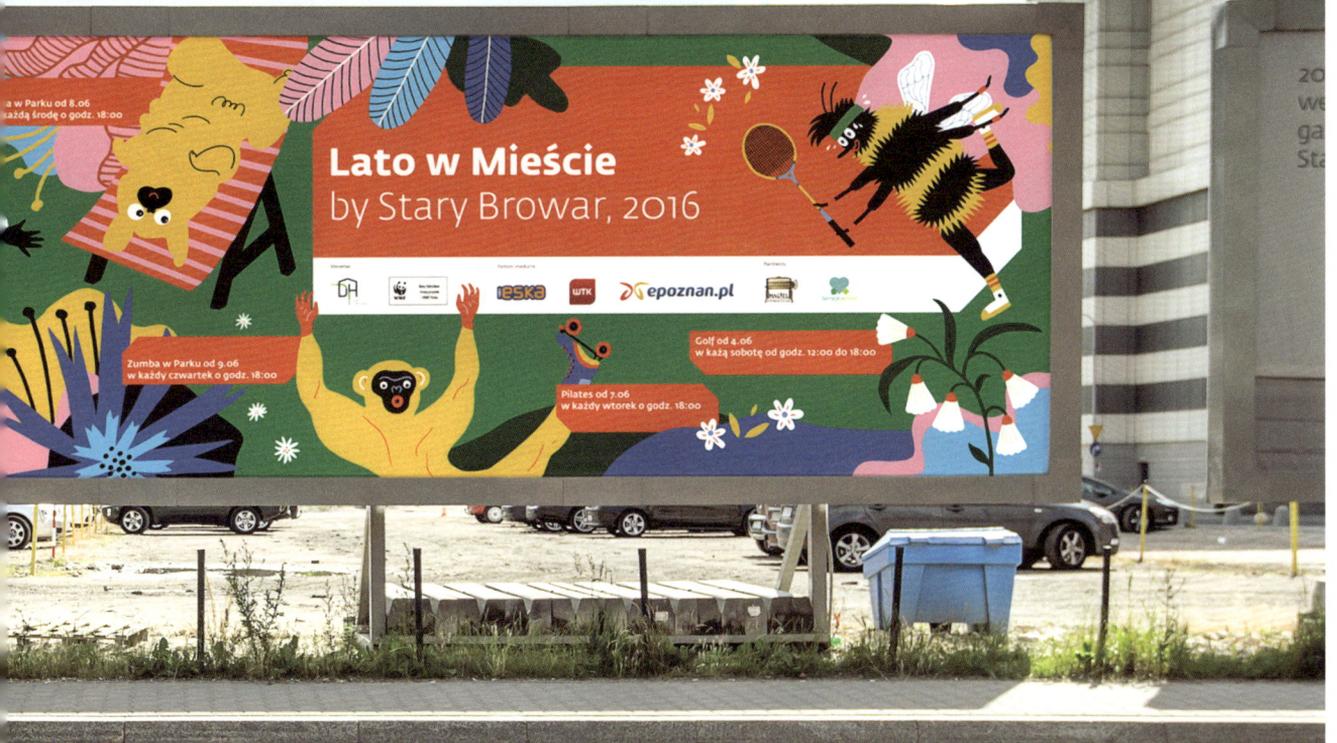

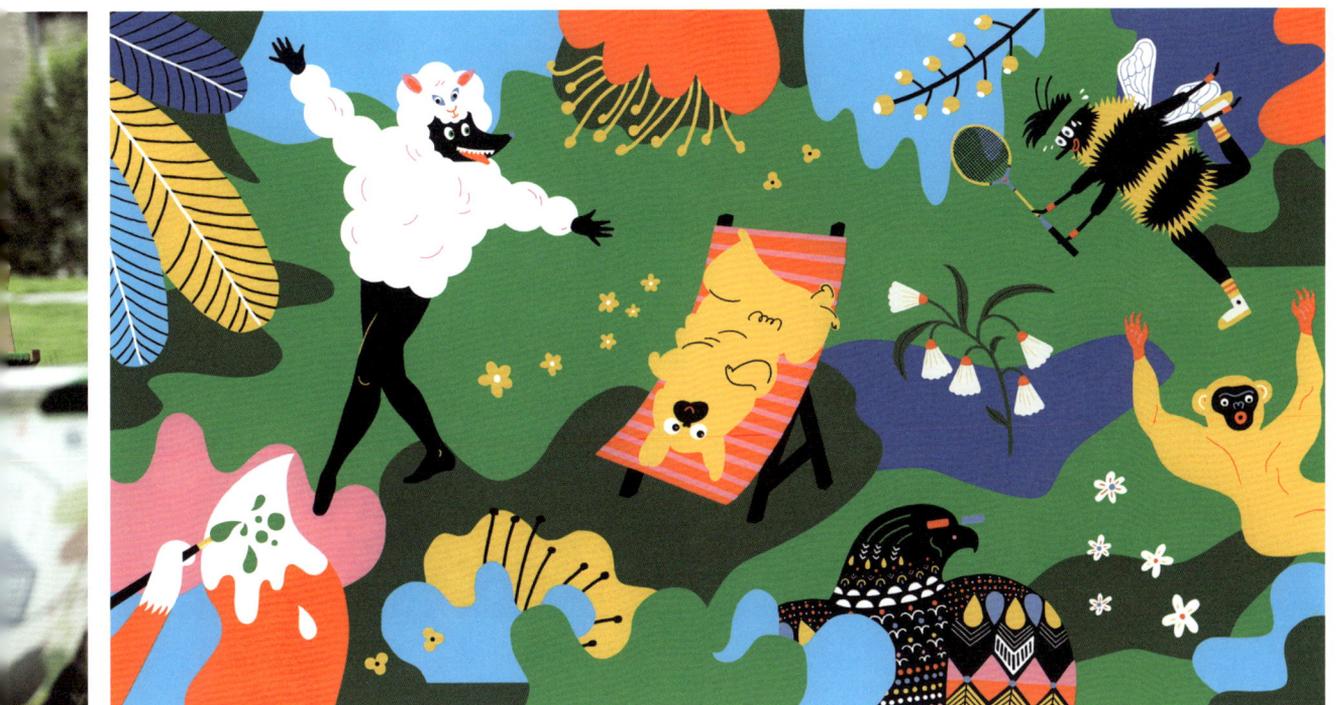

stary browar

**Farbowane lisy
w Starym Browarze
zwiastują wiele
plastycznych wydarzeń**

Zajęcia plastyczne z Młodym
Uniwersytetem Artystycznym
W każdy wakacyjny
poniedziałek o godz. 18:00
Park Starego Browaru,
a w razie niepogody Słodownia +1
Dla dzieci od lat 5

Wstęp wolny! Zapisy w Punktach Informacyjnych
jedności, e-mailem: edukacja@starybrowar5050.com
lub tel. 61 667 14 00 i 61 859 60 50

starybrowar5050.com

stary browar

**Wilki ubierają owcze odzienie,
bo w Starym Browarze
grają przedstawienie!**

Teatr Pijana Sypialnia
na leżakach w parku Starego Browaru°
15 lipca, piątek, godz. 20:00 - „Łojdyrydy"
16 lipca, sobota, godz. 20:00 - „Latarnik"

Wstęp wolny!
°W razie niepogody spektakle odbędą się
w przestrzeniach Starego Browaru

starybrowar5050.com

stary browar

**Małpie figle w Starym
Browarze dostarczają
wielu wrażeń°**

Pilates w parku z Magiel Fitness
Od 7 czerwca do 30 sierpnia
Wtorki, godz. 18:00

Joga w parku z Magiel Fitness
Od 8 czerwca do 31 sierpnia
Środy, godz. 18:00

Zumba w parku z Magiel Fitness
Od 9 czerwca do 25 sierpnia
Czwartki, godz. 18:00

Golf w parku z Domy Hybrydowe
Od 2 lipca do 27 sierpnia
Soboty, godz. 12:00–20:00

Wstęp wolny. Bez ograniczeń wiekowych.
°W razie niepogody zajęcia przenosimy
do Słodowni +1

starybrowar5050.com

stary browar

**Sokoły wzrok wytężają
gdy w Starym Browarze
filmy puszczają**

Kino na Dziedzińcu°
Od 29 czerwca do 31 sierpnia
Środy, godz. 21:30

29.06. Miś, 1980, reż. Stanisław Bareja
06.07. Człowiek słoń, 1980, reż. David Lynch
13.07. Psy, 1992, reż. Władysław Pasikowski
20.07. Młode wilki, 1995, reż. Jarosław Żamojda
27.07. Czarny kot, biały kot, 1998, reż. Emir Kusturica
03.08. Duże zwierzę, 2000, reż. Jerzy Stuhr
10.08. Jeździec wielorybów, 2002, reż. Niki Caro
17.08. Efekt motyla, 2004, reż. J. Mackye Gruber, Eric Bress
24.08. Barany. Islandzka opowieść, 2015, reż. Grímur Hákonarson
31.08. Moje córki krowy, 2015, reż. Kinga Dębska

°W razie niepogody seans odbędzie się na Szachownicy

starybrowar5050.com

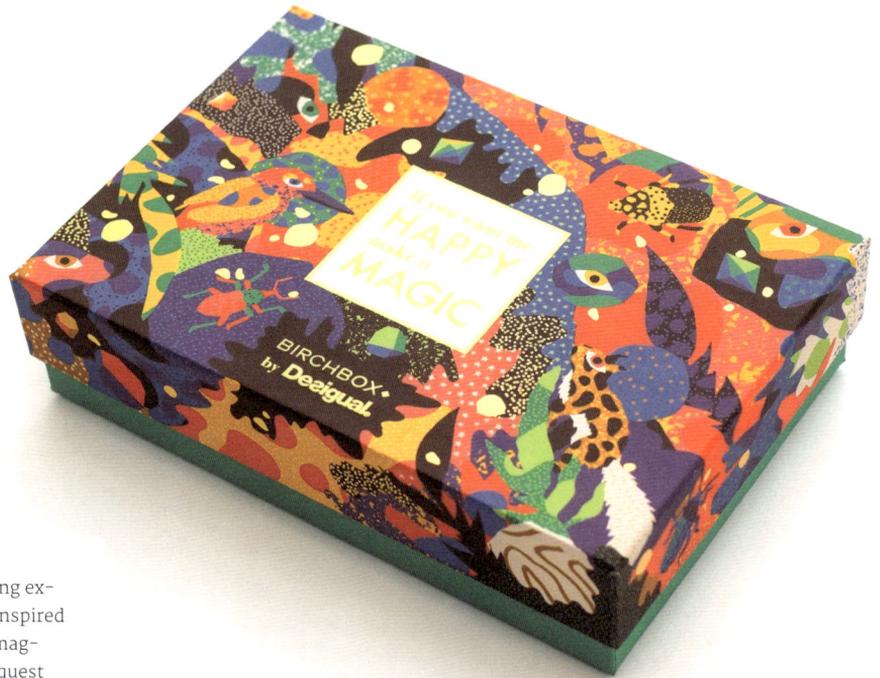

Desigual Holiday Packaging

For their annual Birchbox and holiday packaging exercise, Desigual requested something special inspired by the quote, 'If you want me happy, make it magical'. Nick Liefhebber delivered the brand's request with his imaginative designs of bags and boxes. His abstract, jungle-inspired prints came to life through the bursting colours and shimmering golden foil used to evoke a sense of fun and celebration.

Design
Nick Liefhebber

Client
Desigual

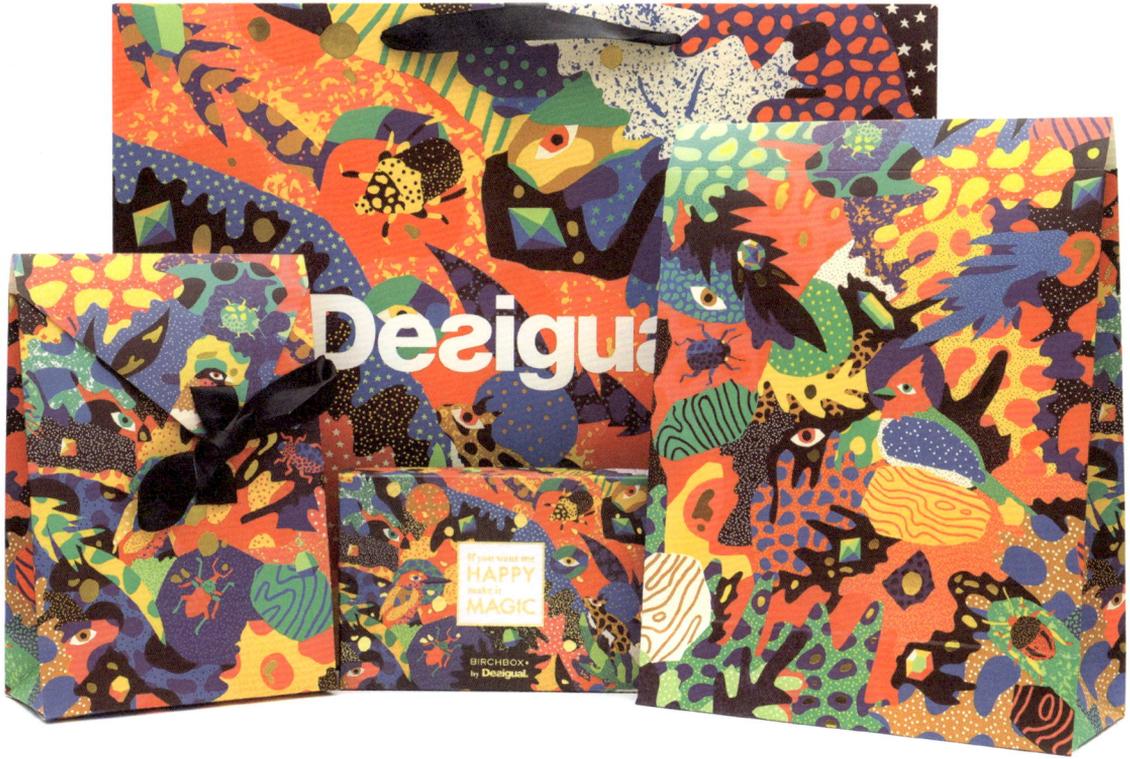

CAMEL & POLO
Dessert Giftbox

In designing the gift box packaging for CAMEL &
POLO, O.OO looked to the dessert brand's personality
— fast, ambitious, and accurate – for inspiration. To
avoid protraying the brand as too serious, they used
an abstract yet brightly-coloured illustration style for
the flowers featured; allowing them to pop against a
plain black background. The resulting work commu-
nicated the brand's lively spirit and edgier side in a
visually impactful way.

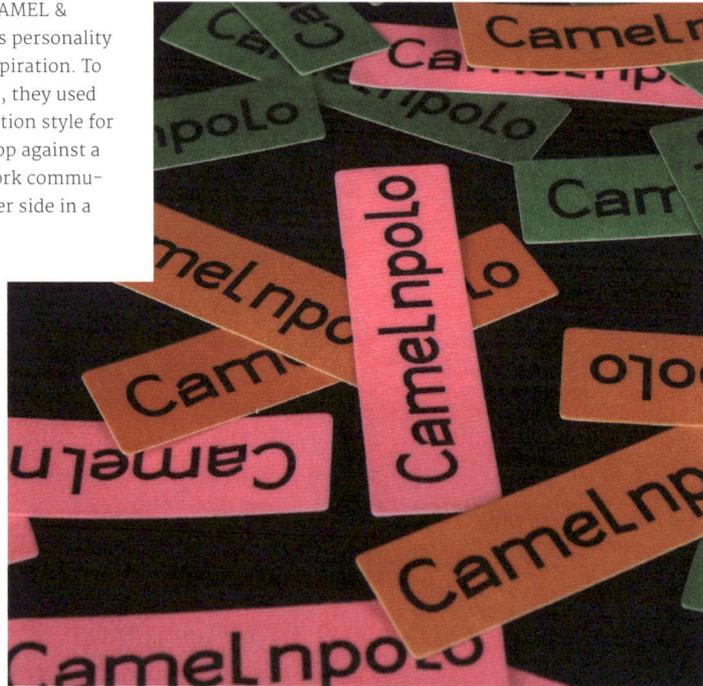

Design
O.OO Design & Risograph ROOM

Client
Camel & Polo

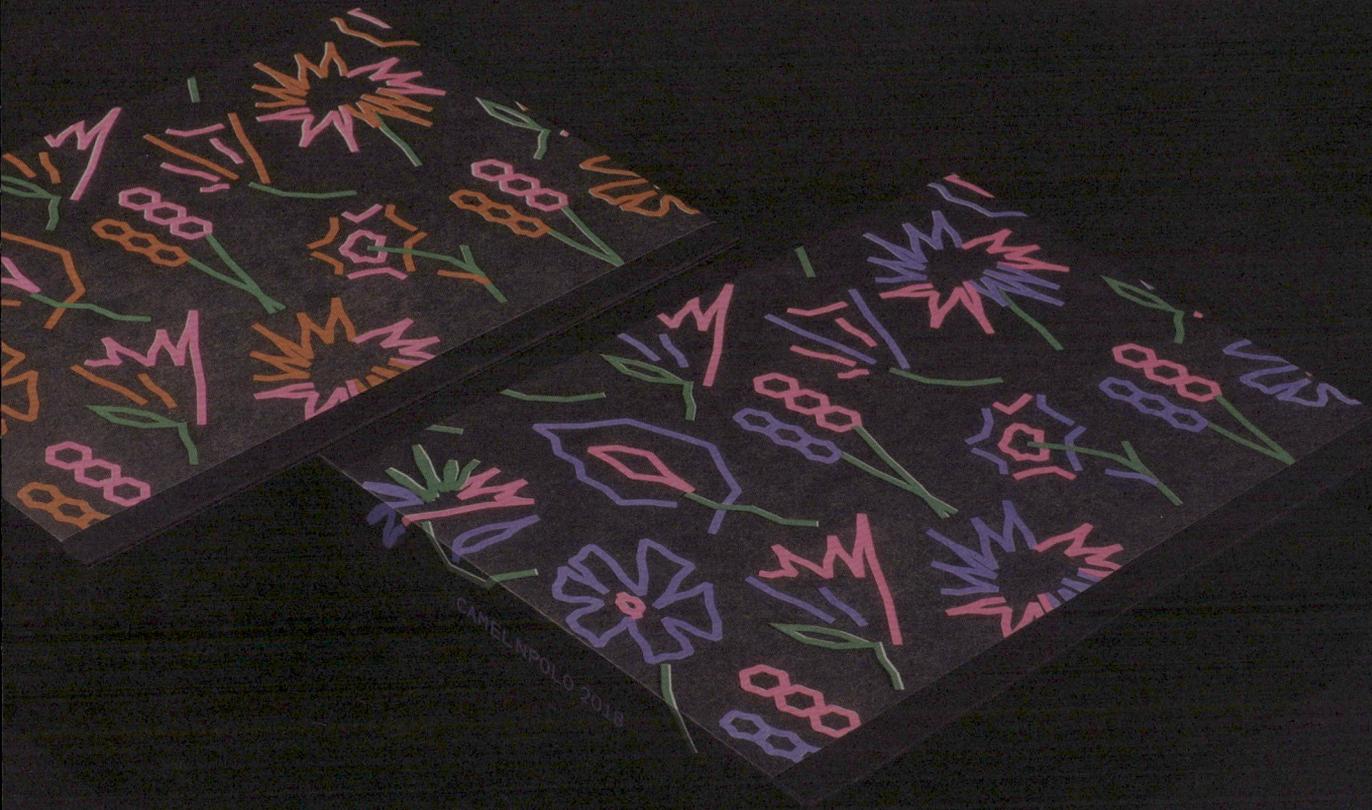

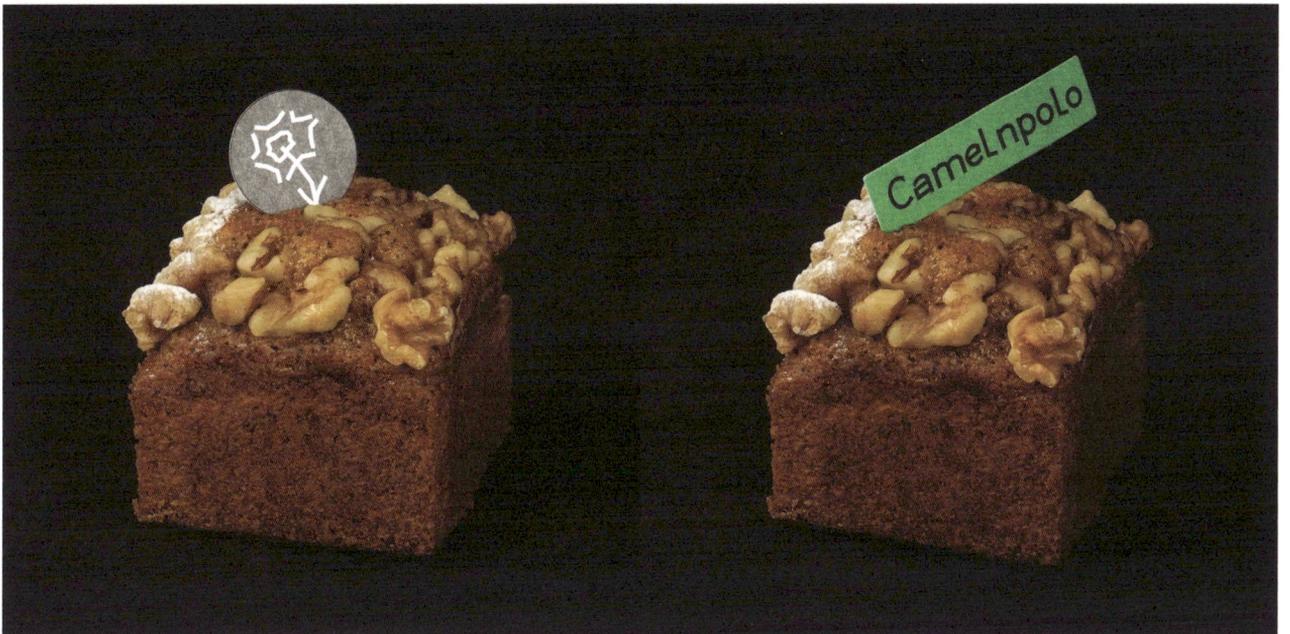

Liberty Feminine

In designing for Liberty Feminine Products, a company that delivers monthly organic, personal, feminine care packages to doorsteps, Carter Hales Design Lab knew they needed to produce a comprehensive brand identity and packaging design that would appeal to millennial women. The final product features animal wrapping paper in four bright colours telling the fictional story of an elemoose around a cardboard box covered in the brand logo. The tongue-in-cheek, crest-like logo design, consisting of a double rainbow, doves, and unicorns, perfectly reflects the fun nature of the project that aimed to capture the youthful energy of Liberty Feminine products.

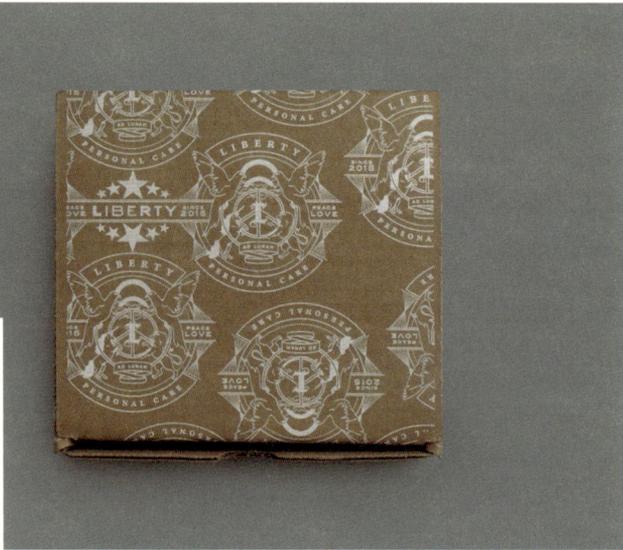

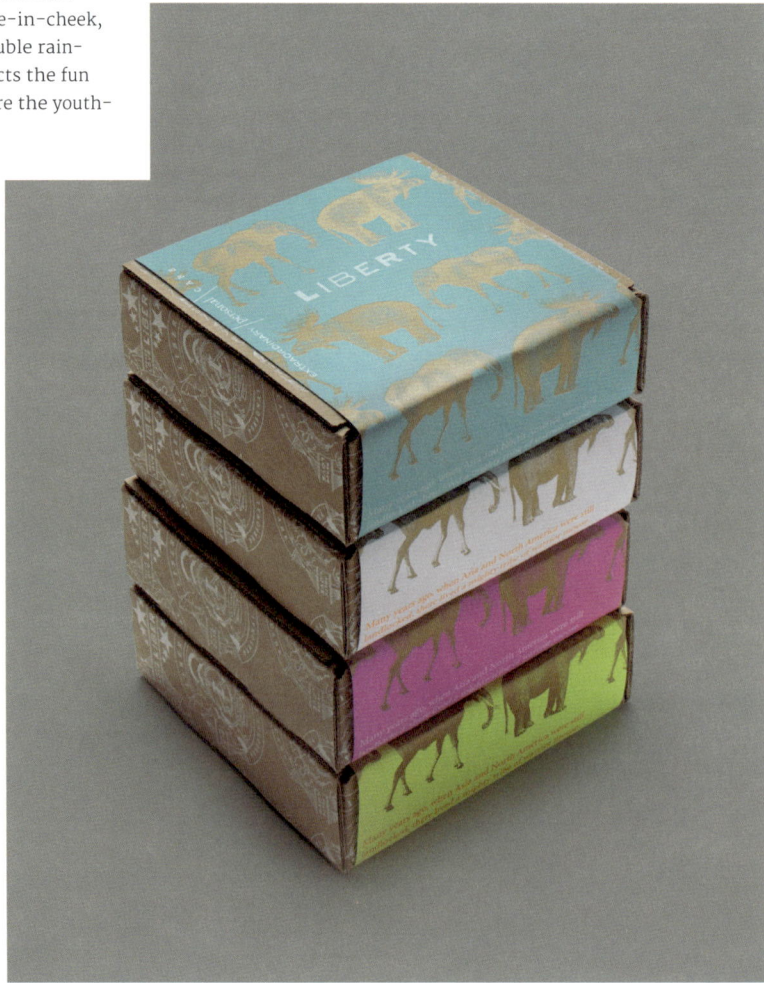

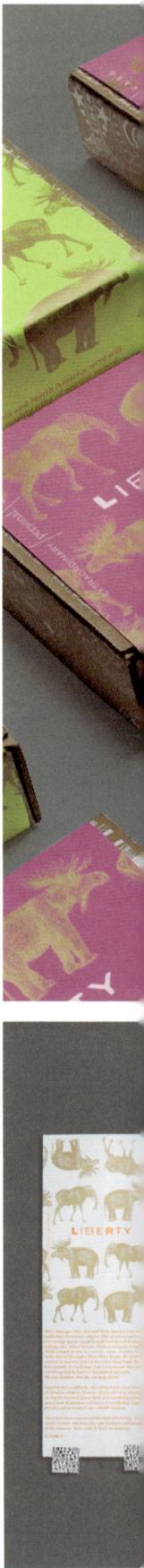

Design
Carter Hales Design Lab Inc.

Client
Liberty Feminine

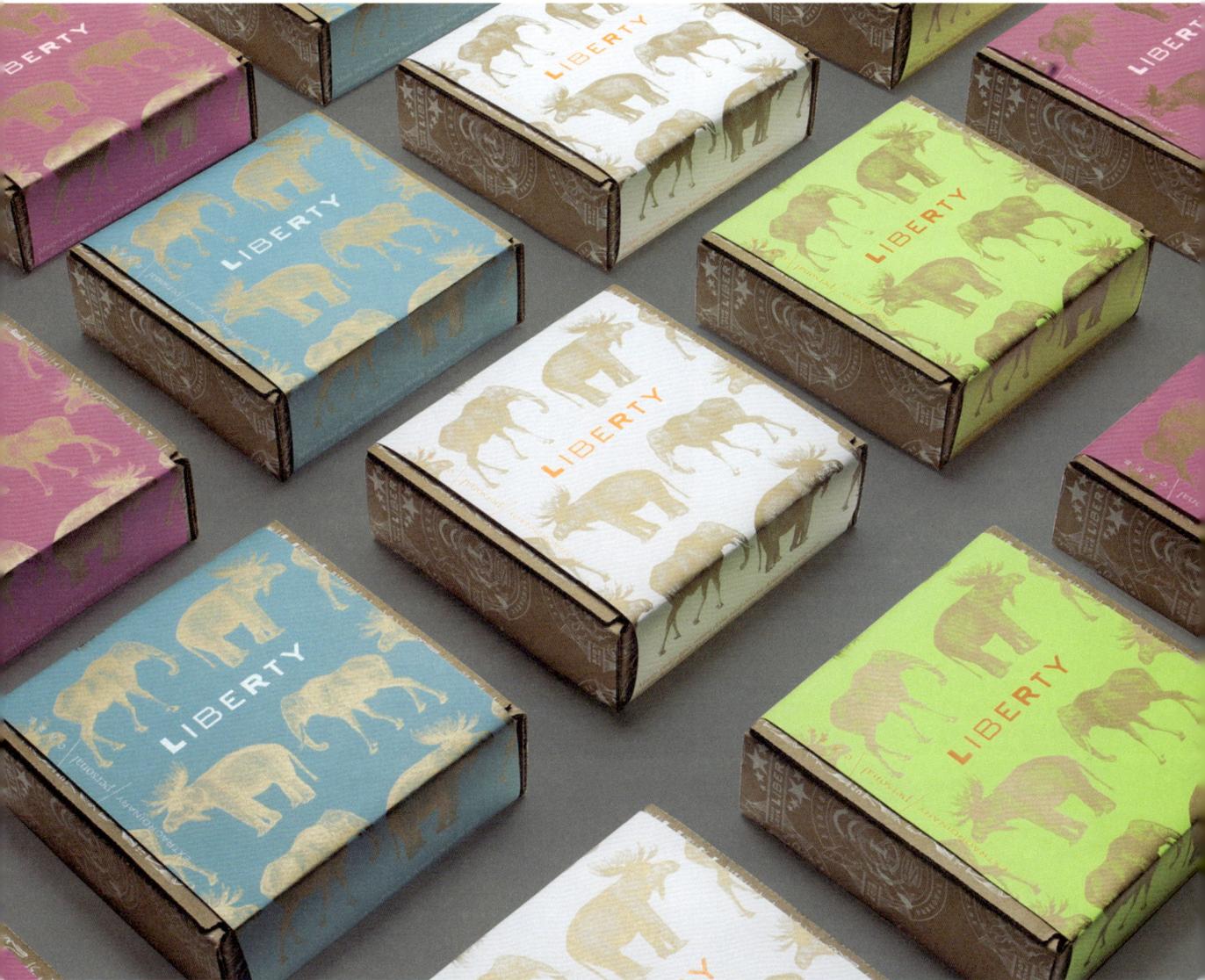

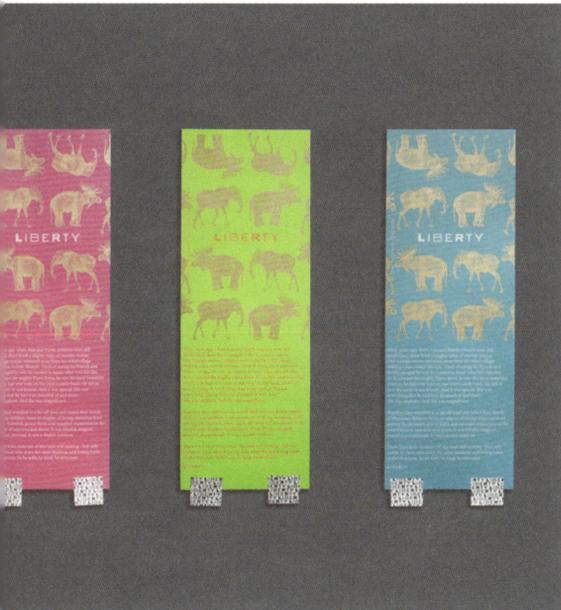

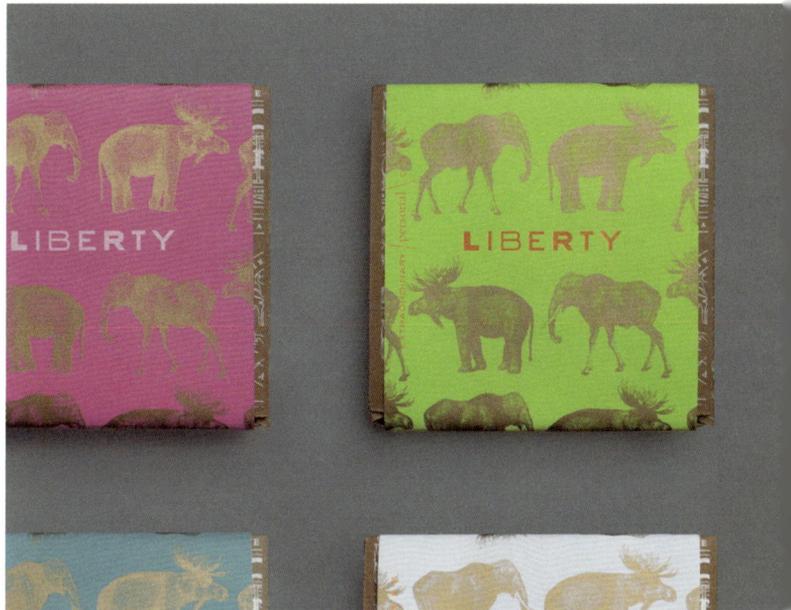

Design
Baillat. Studio

Illustration
Stéphane Poirier

WILD DESIGN

To celebrate their second anniversary, Baillat. Studio designed handmade posters that highlighted specially-commissioned illustrations by Stéphane Poirier using only two colours. The striking work featured a tiger and an eagle overlaid with text outlines to express their anticipation that the coming year would be a wild and exciting one.

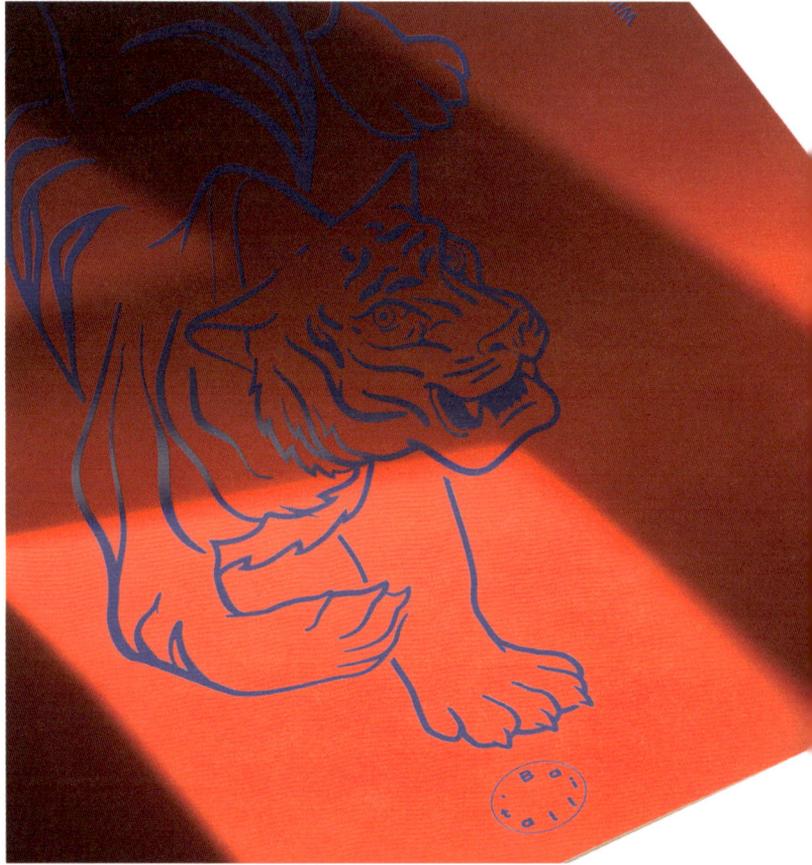

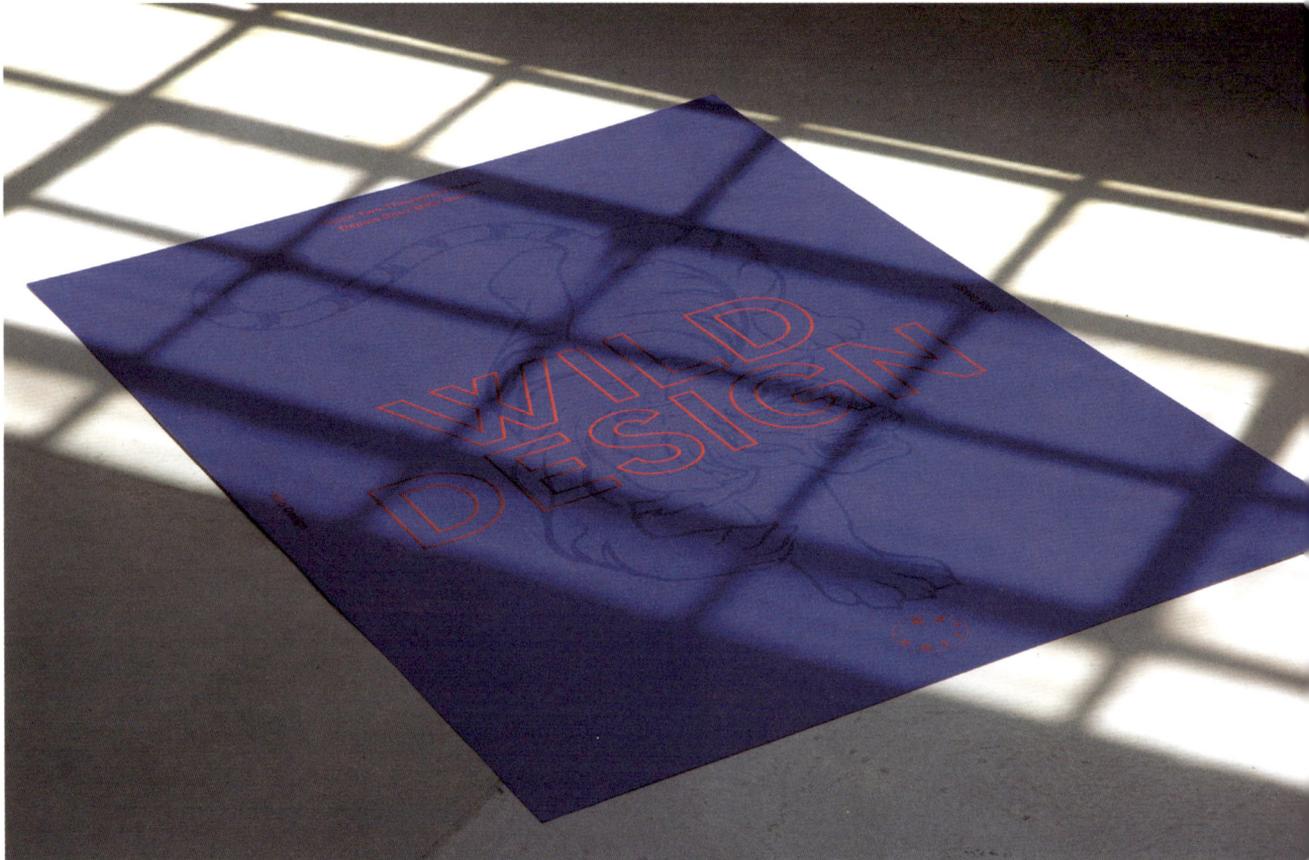

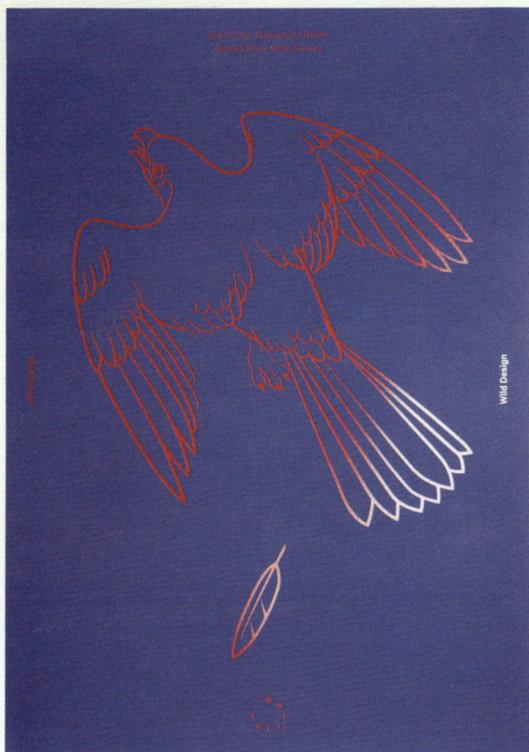
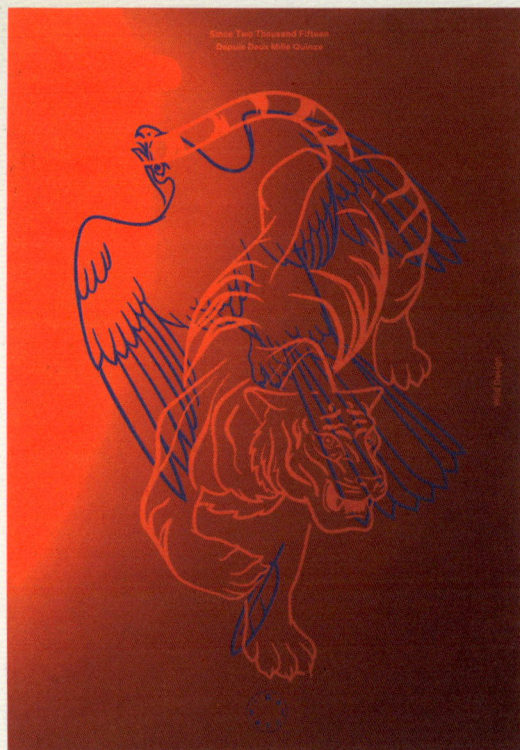
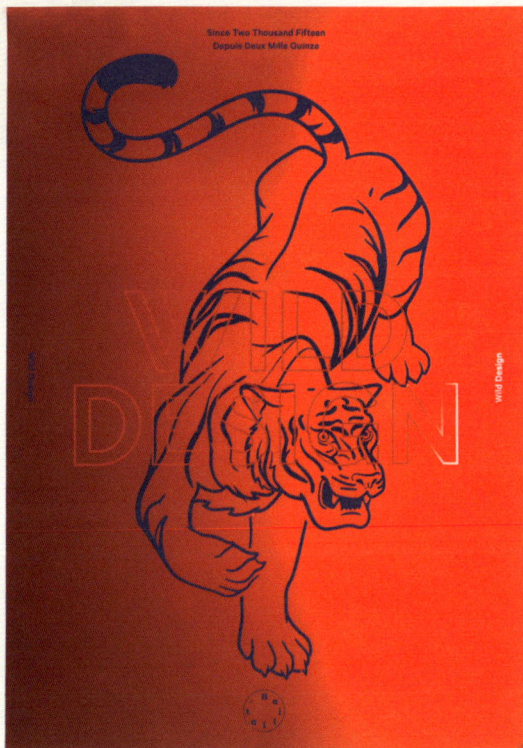
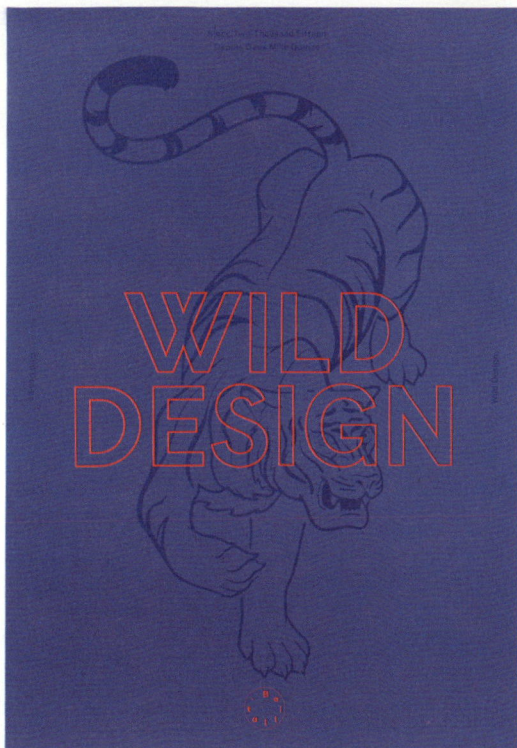

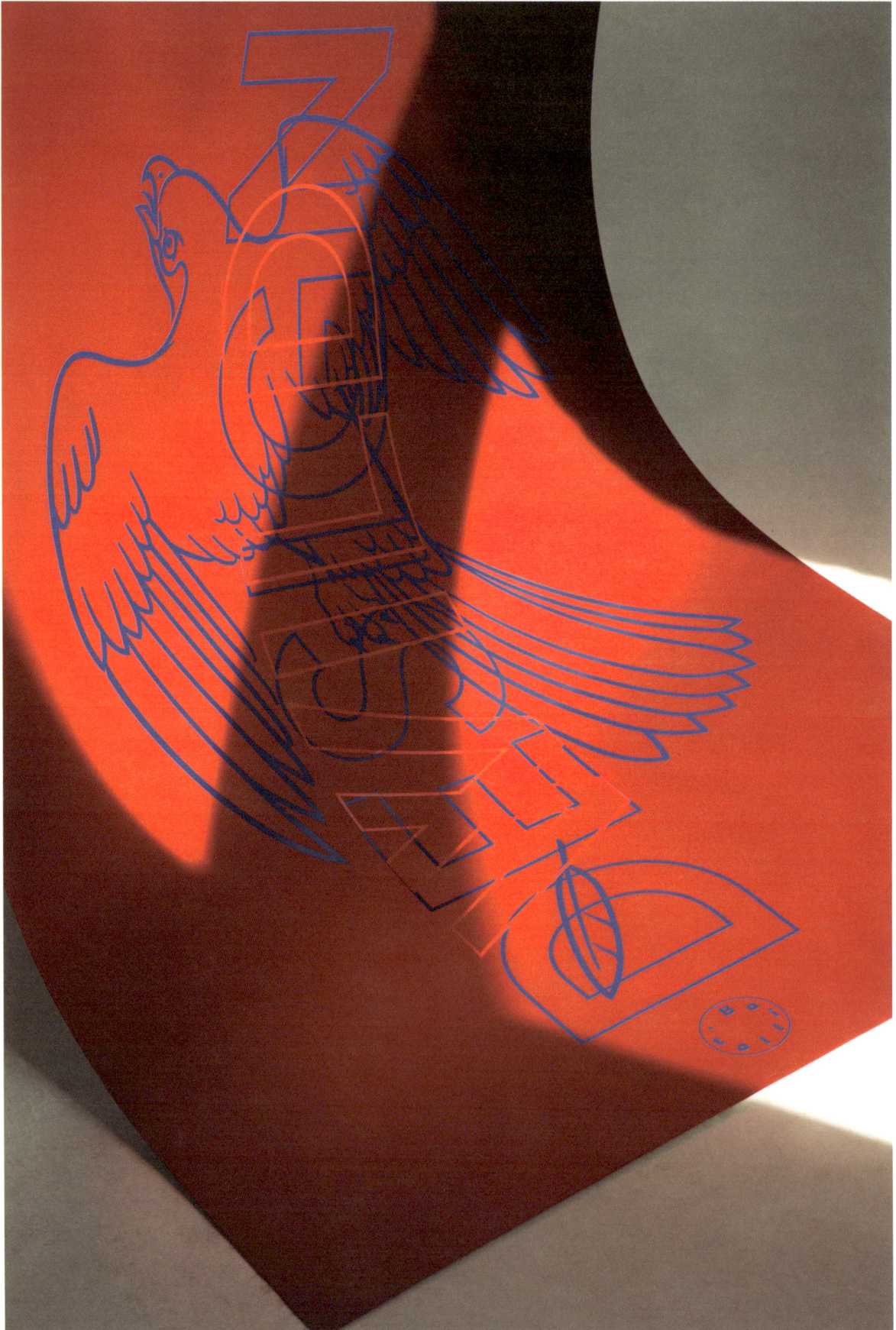

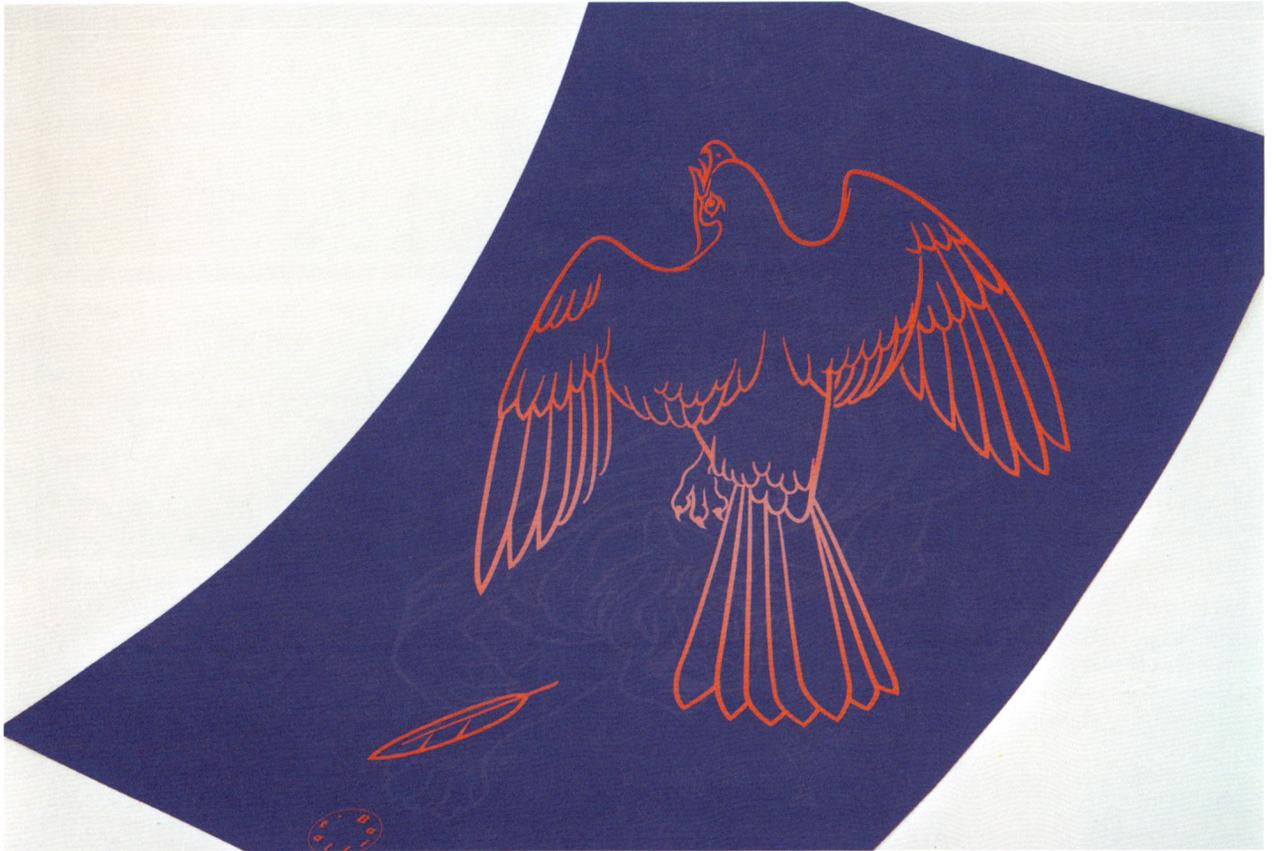

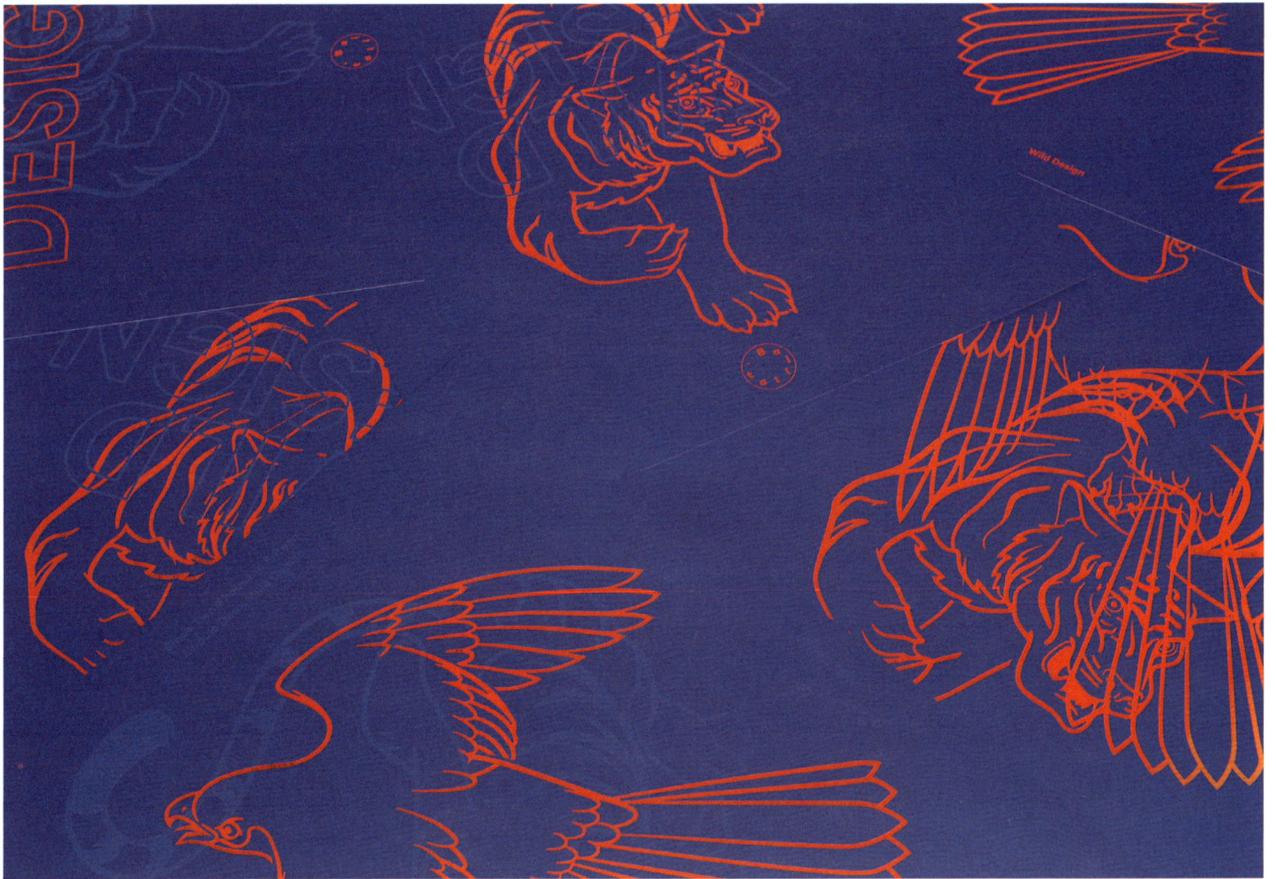

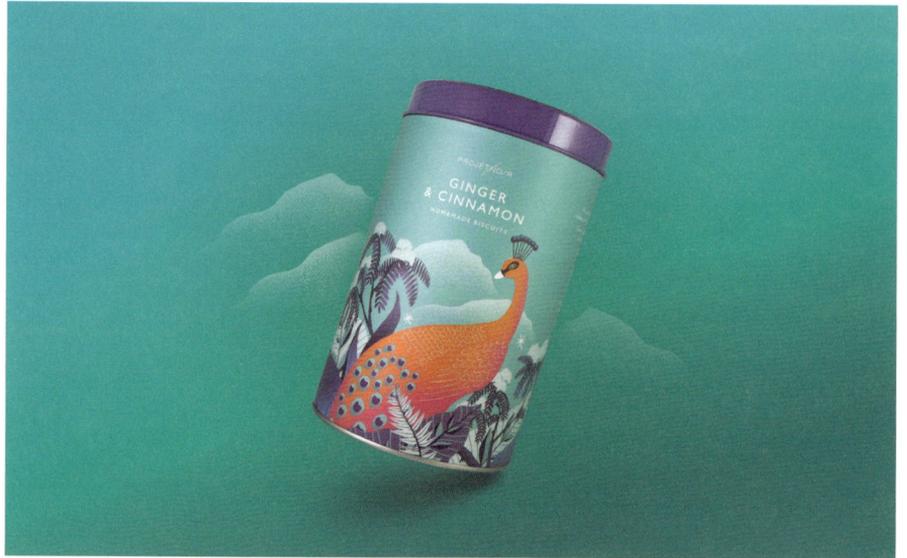

Exclusive Biscuit Tins

To accompany three distinct flavours, Projet Noir designed dreamy tin cans depicting three beautiful settings of wildlife on rich, Fedrigoni paper. The Cascade red fox, red deer, and Indian peafowl featured in idyllic versions of their natural habitats exude whimsicality and elegance – setting the packaging design apart from the typical ones of biscuits found on store shelves.

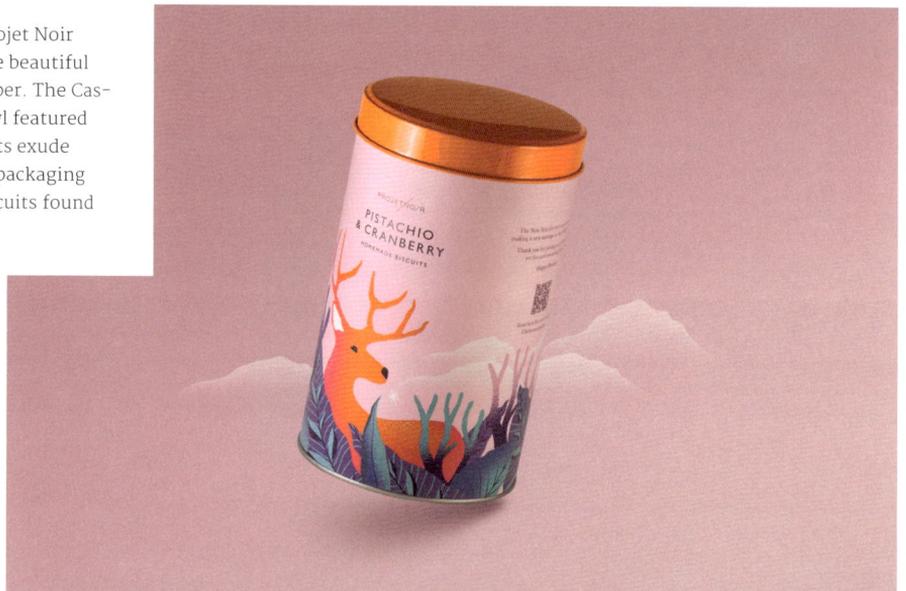

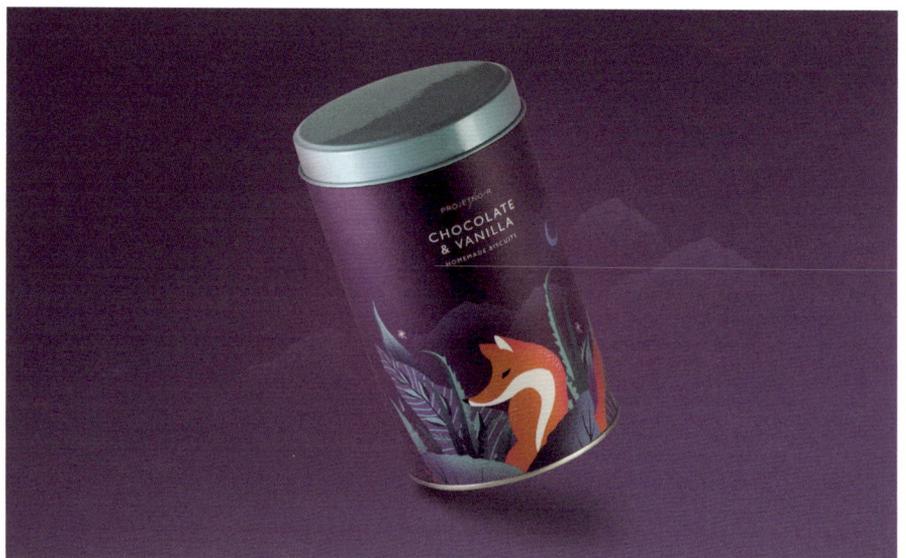

Design
Projet Noir

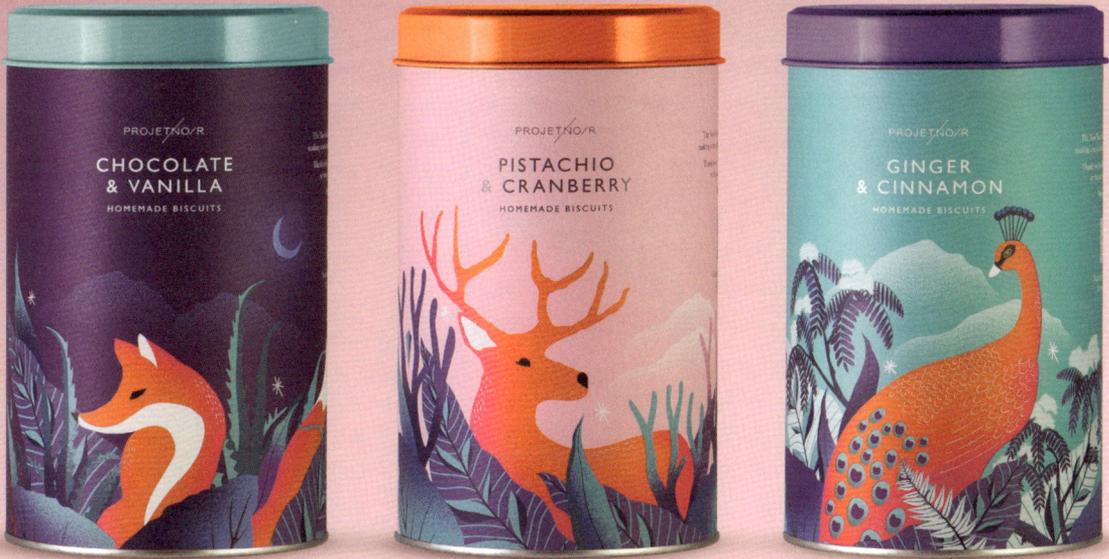

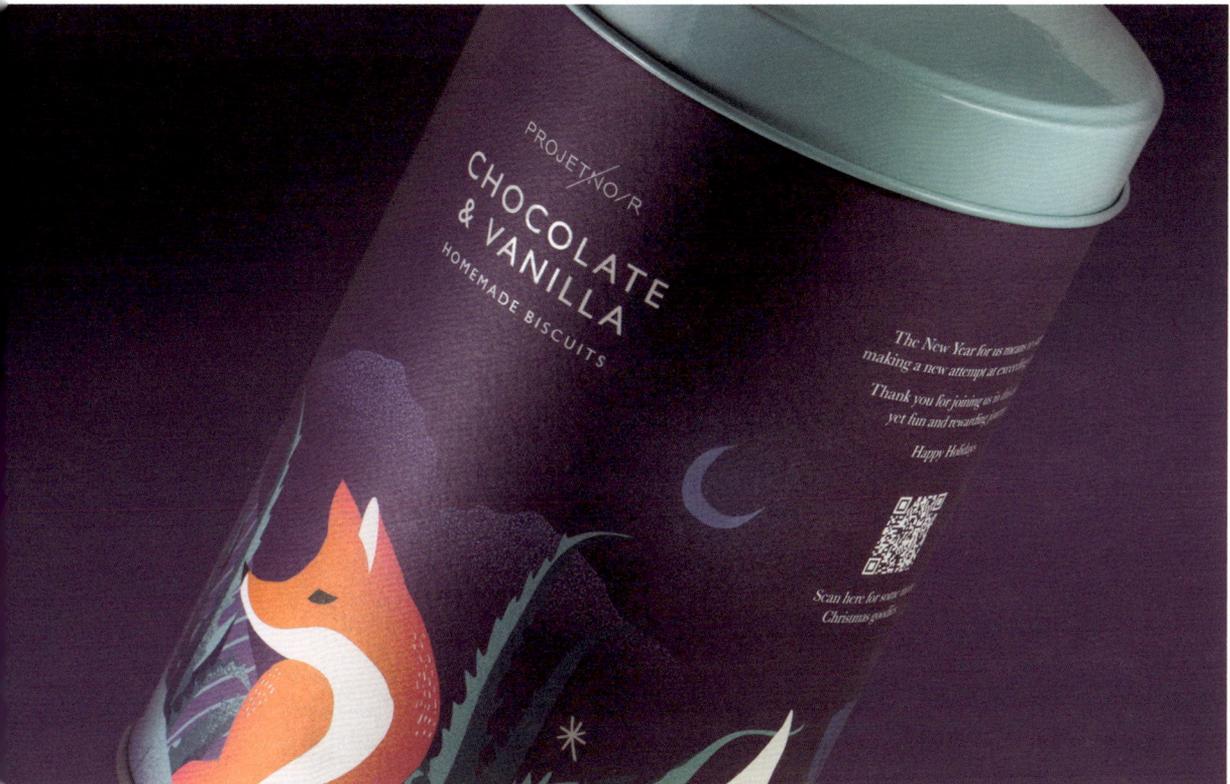

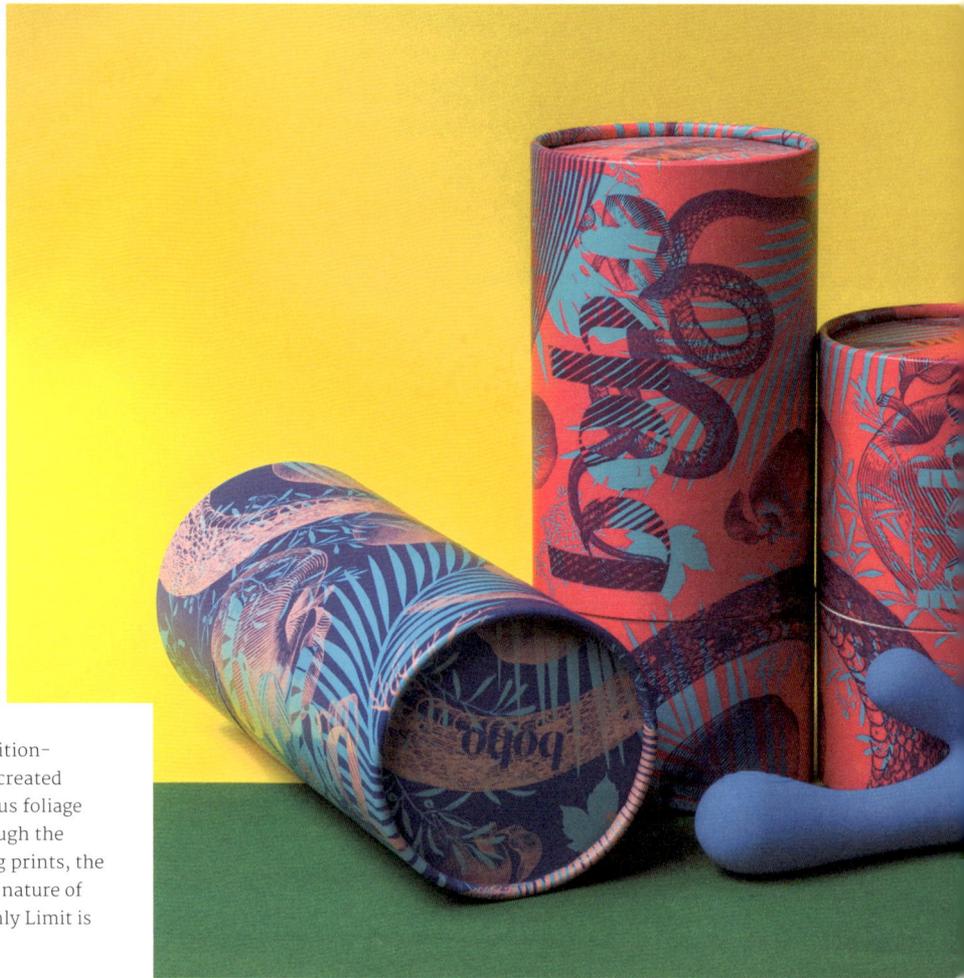

Boho –
The Only Limit Is
Your Imagination

Adding a modern twist of pop to the traditional imagery of Adam of Eve, Janar Siniloo created illustrations of snakes, apples, and various foliage in bright fuschia, cyan, and purple. Through the detailed, layered, and attention-grabbing prints, the packaging design reflected the luxurious nature of Boho products, which attest that 'The Only Limit is Your Imagination'.

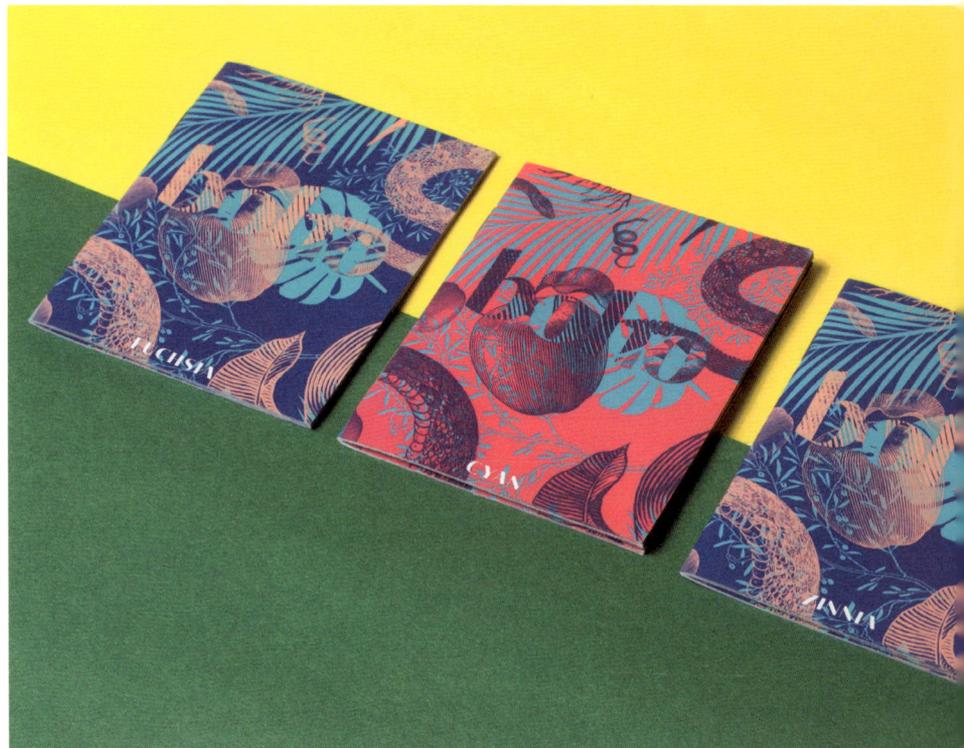

Design
Janar Siniloo

Client
AMORELIE

Toy/Industrial Designer
Tom Mudra

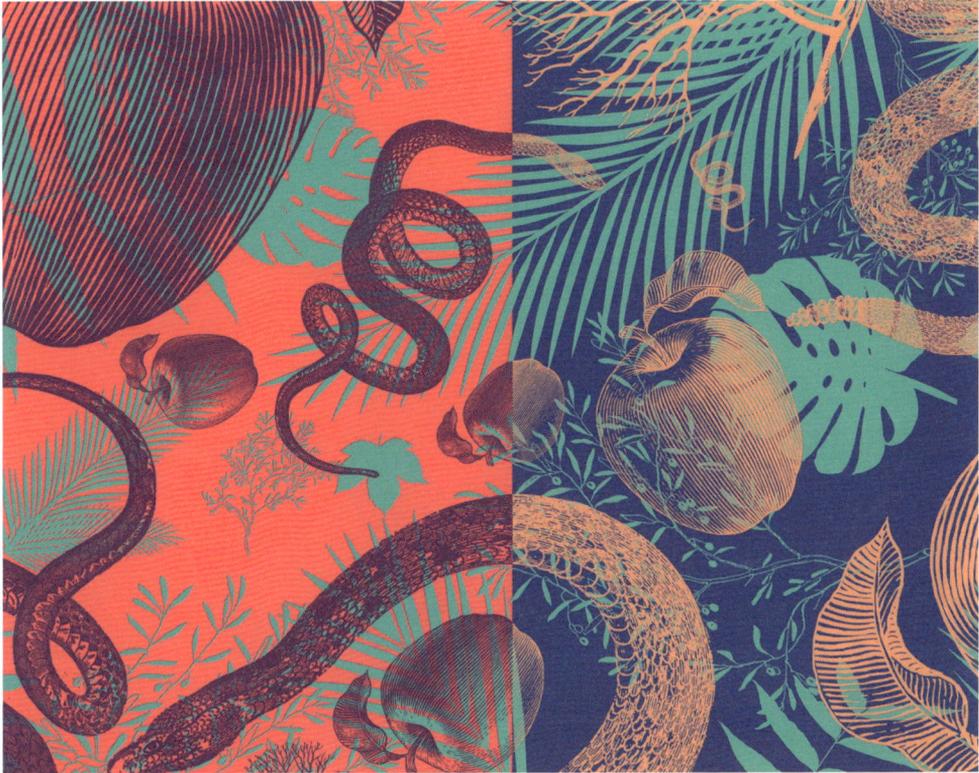

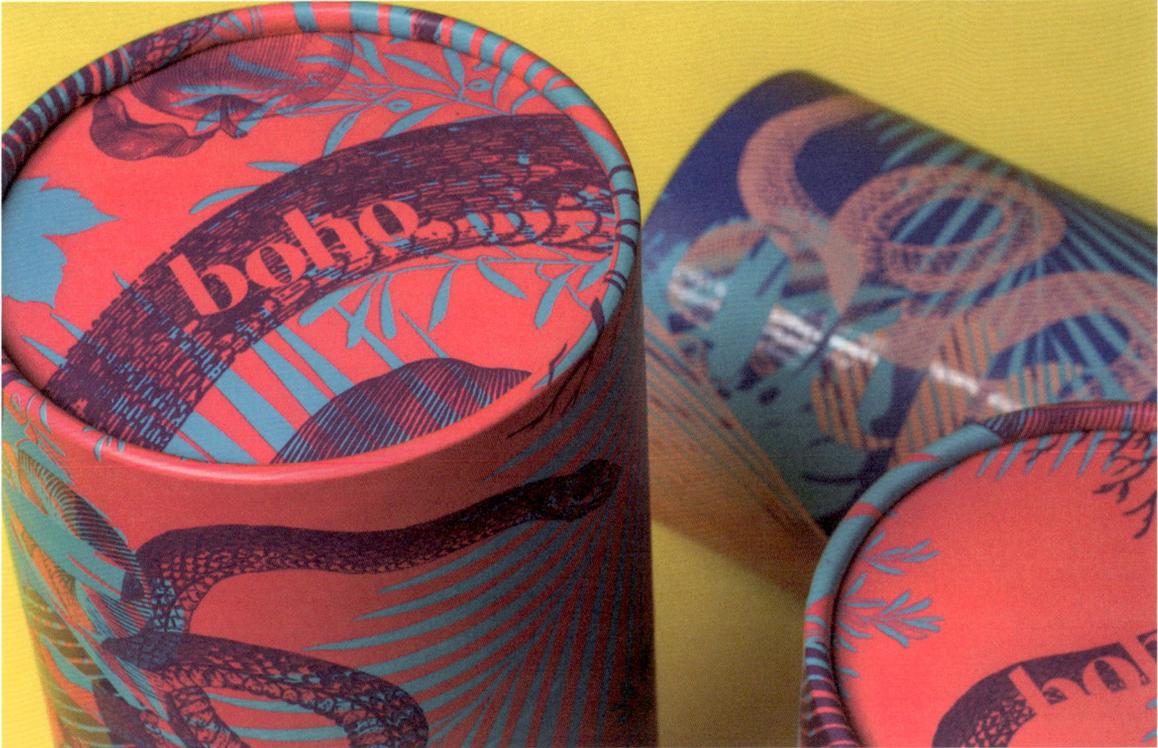

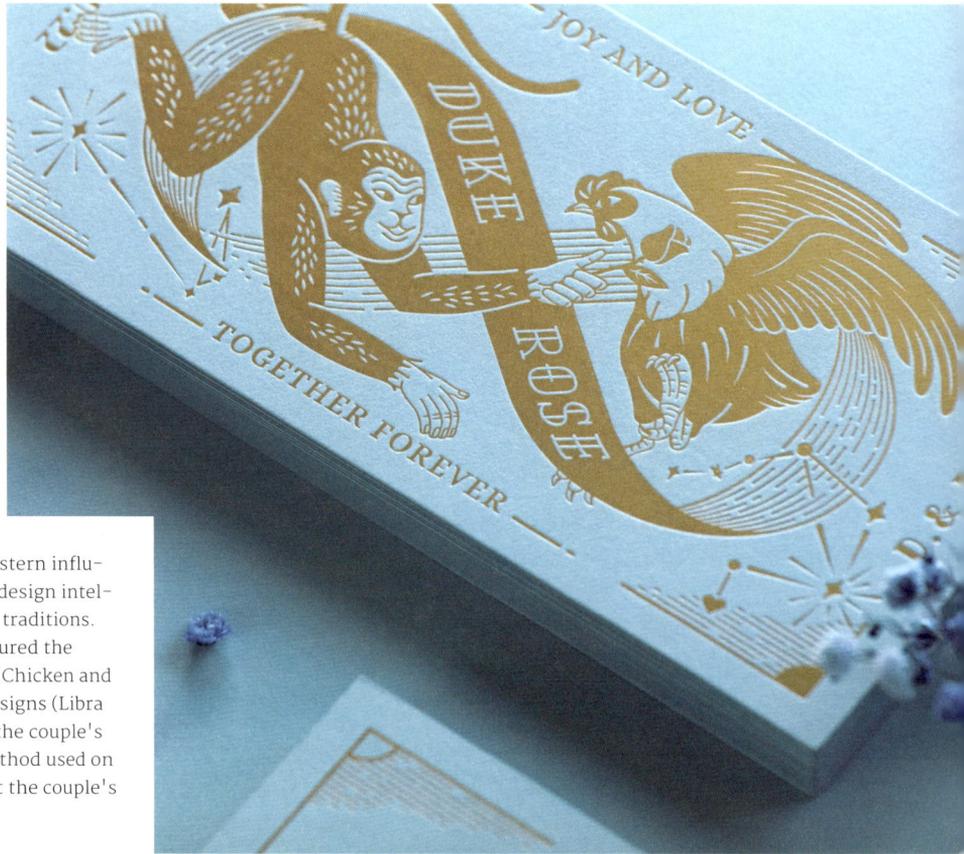

D&R
wedding card

A unique combination of Eastern and Western influences, Sean Huang's wedding invitation design intelligently incorporated symbols from both traditions. The retro-style graphic illustrations featured the bride and groom's Chinese Zodiac signs (Chicken and Monkey) as well as their Western Zodiac signs (Libra and Aries). An infinity sign represented the couple's eternal love, while the hot-stamping method used on the blue and yellow backgrounds brought the couple's sense of fun to life.

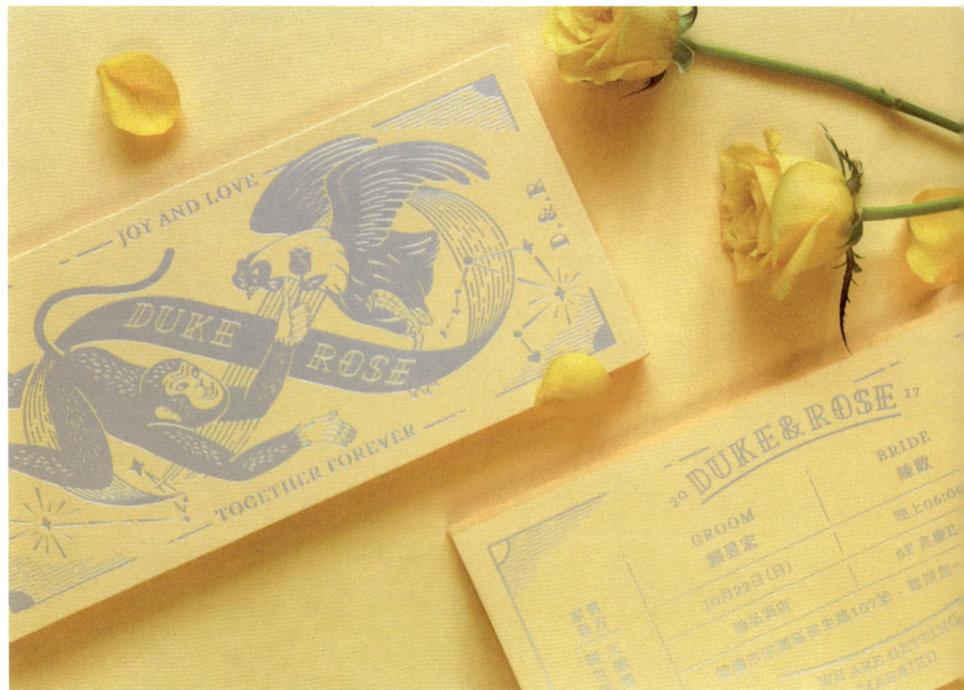

Design
Sean Huang

Client
Duke and Rose

Photography
Chris Yang

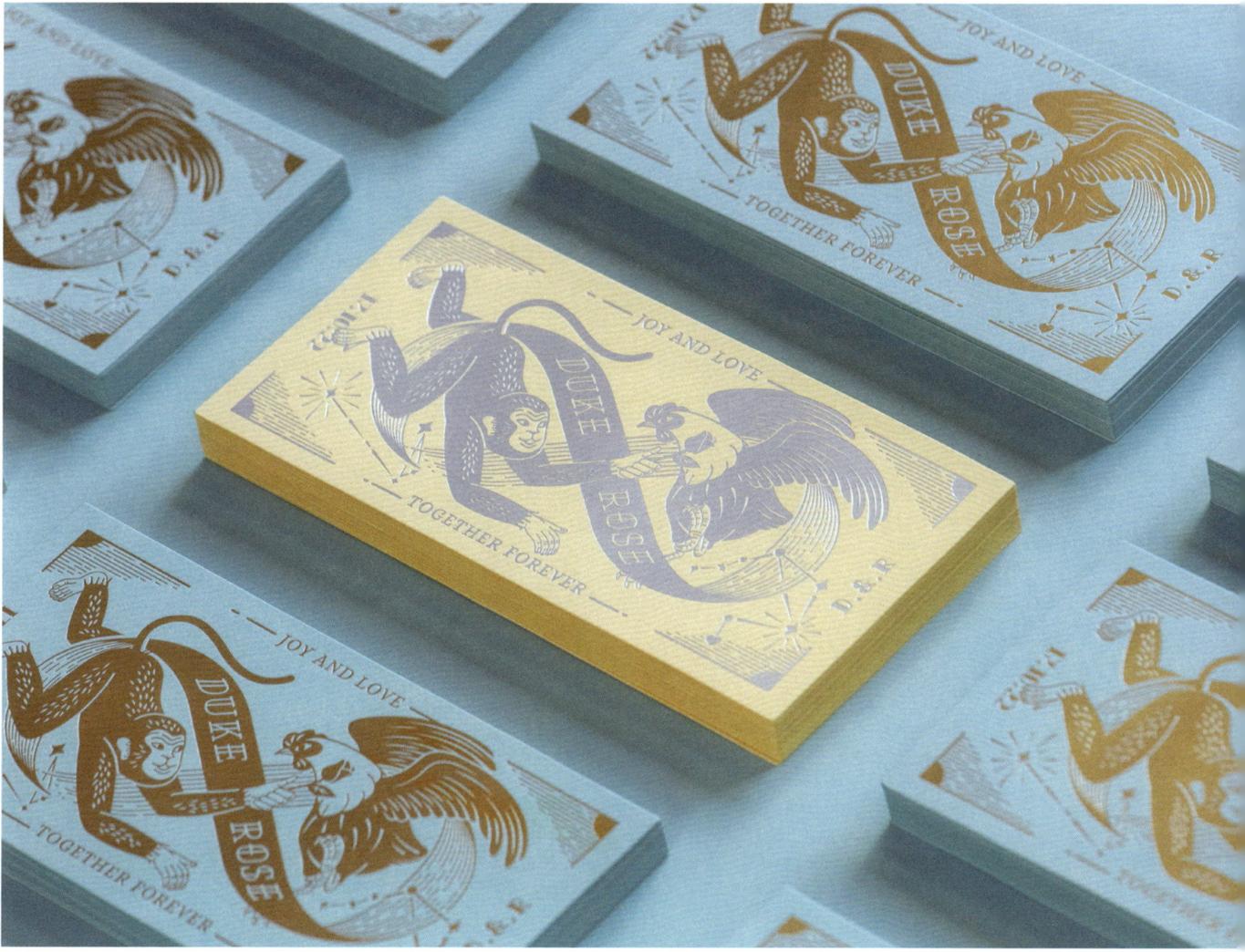

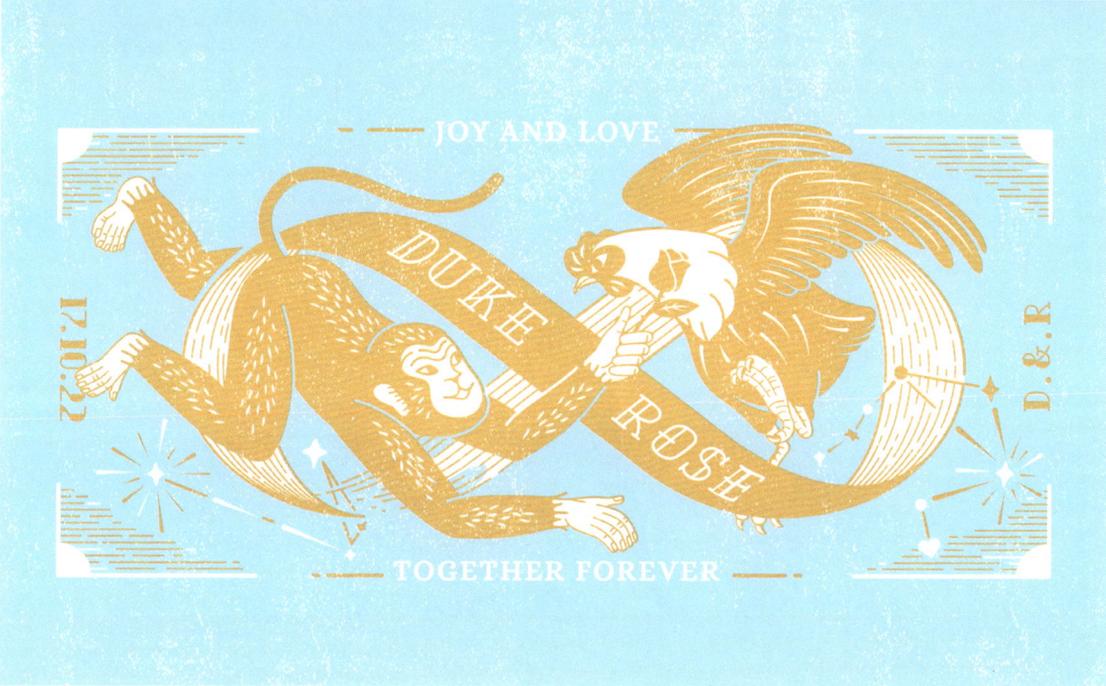

Making Sense of Dyslexia

Impact BBDO designed a series of posters to raise awareness about dyslexia, a relatively common learning disorder that creates difficulty in reading. In order to show how challenging it can be for people with the disorder to read even the simplest words, the posters featured jumbled animal names that only made sense when folded like origami. This interactive element also reflected how people with dyslexia often find it easier to grasp words when taught through visual, tactile, or spatial methods.

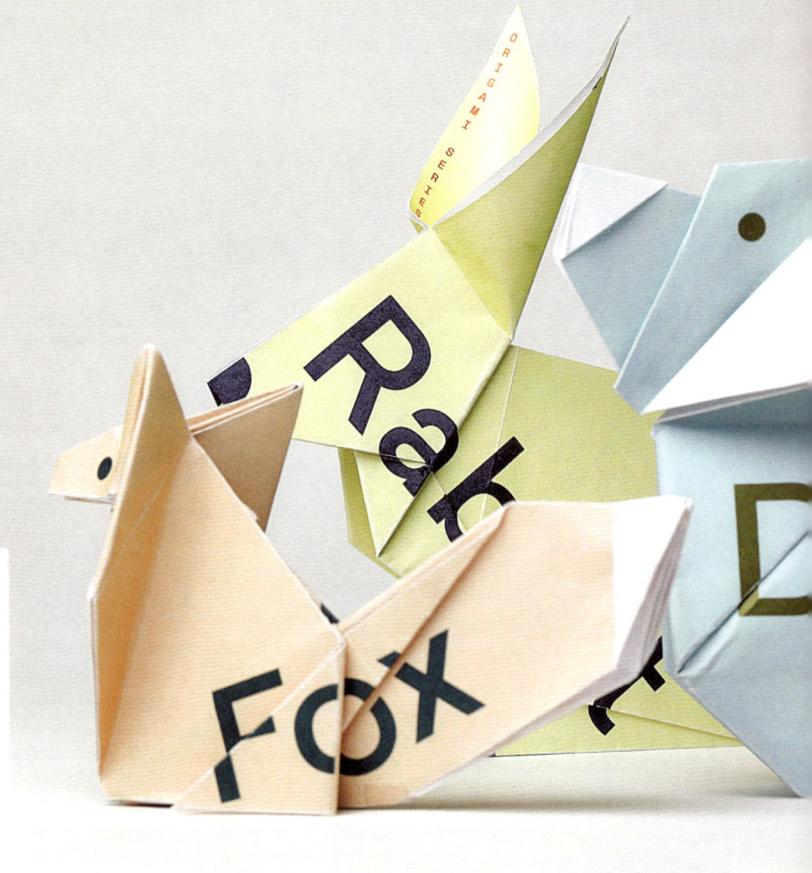

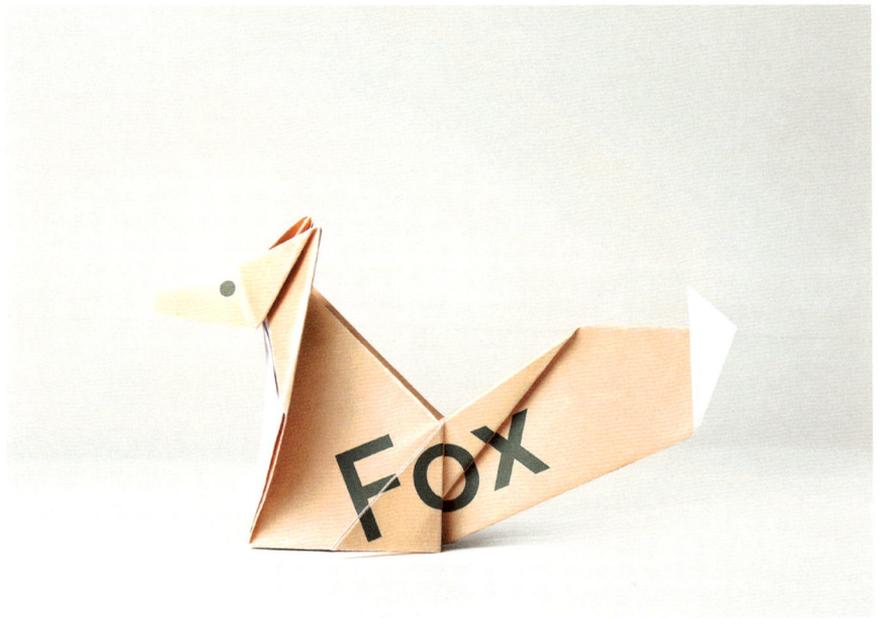

Design
Impact BBDO

Client
Sydlexia

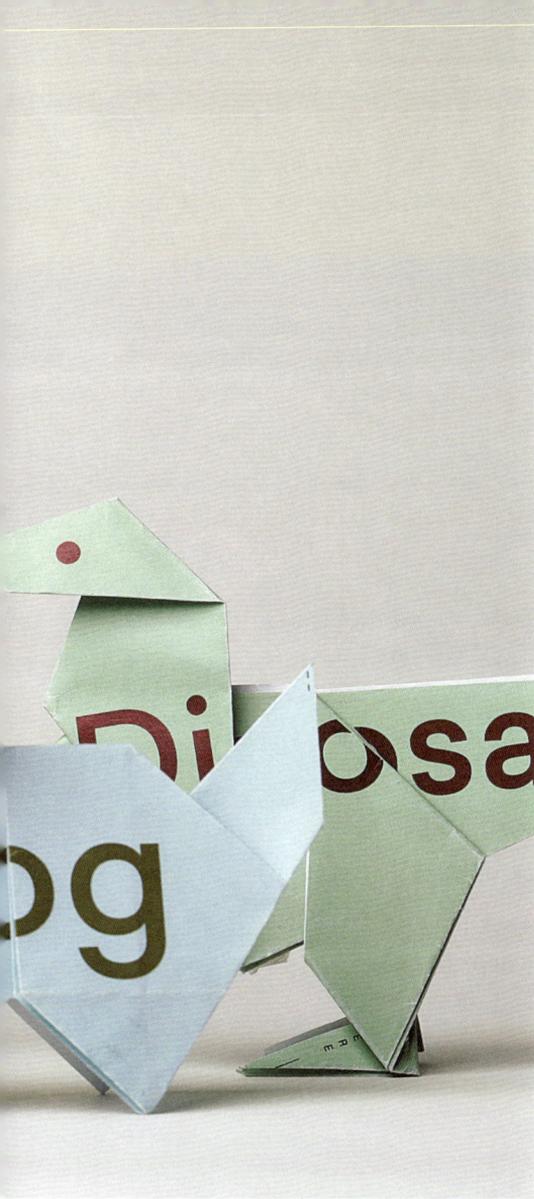

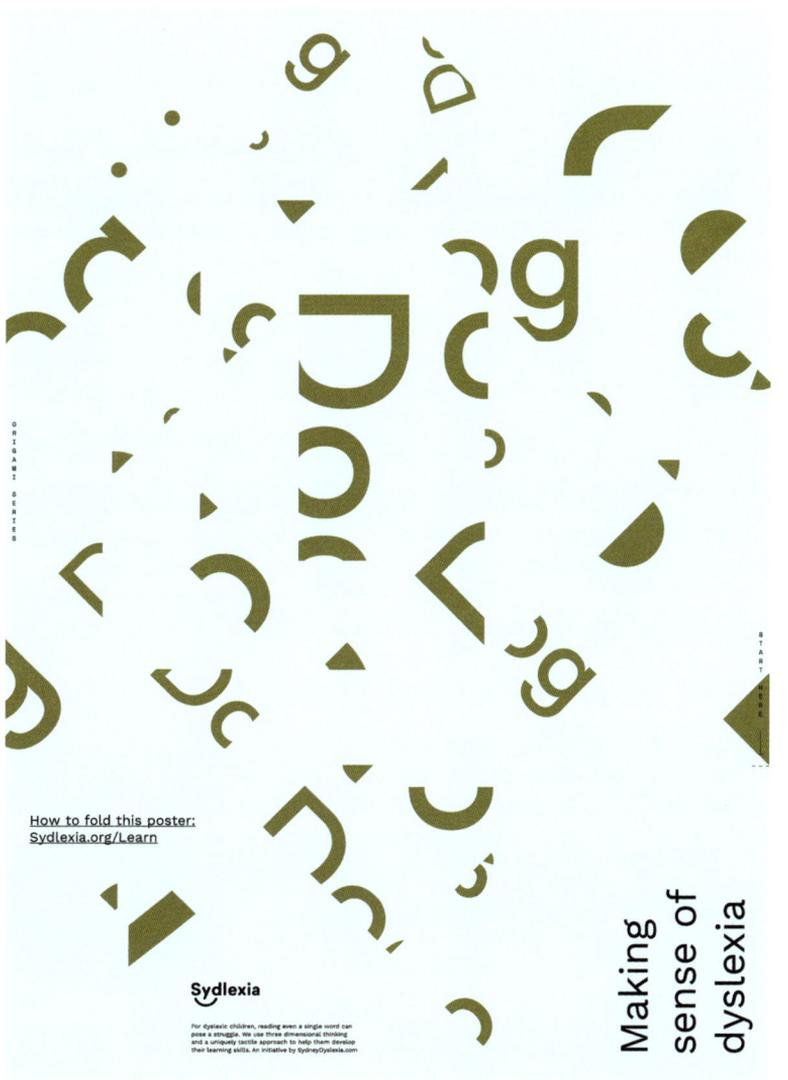

ORIGAMI SERIES

START HERE

How to fold this poster:
Sydlexia.org/Learn

Sydlexia

For dyslexic children, reading even a single word can
pose a struggle. We use three dimensional thinking
and a uniquely tactile approach to help them develop
their learning skills. An initiative by SydneyDyslexia.com

Making
sense of
dyslexia

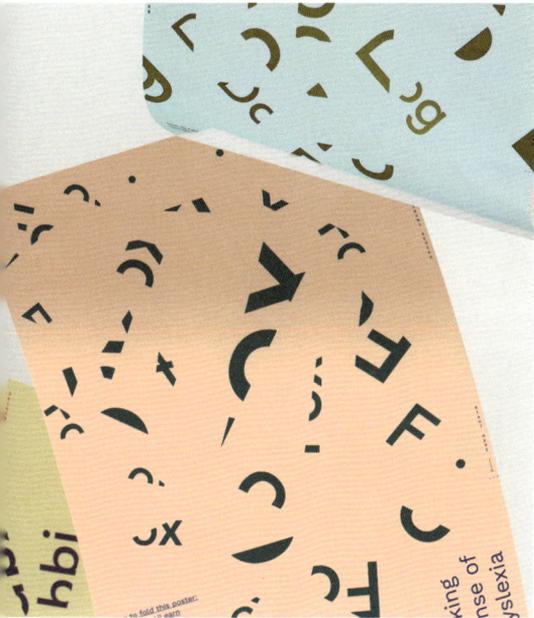

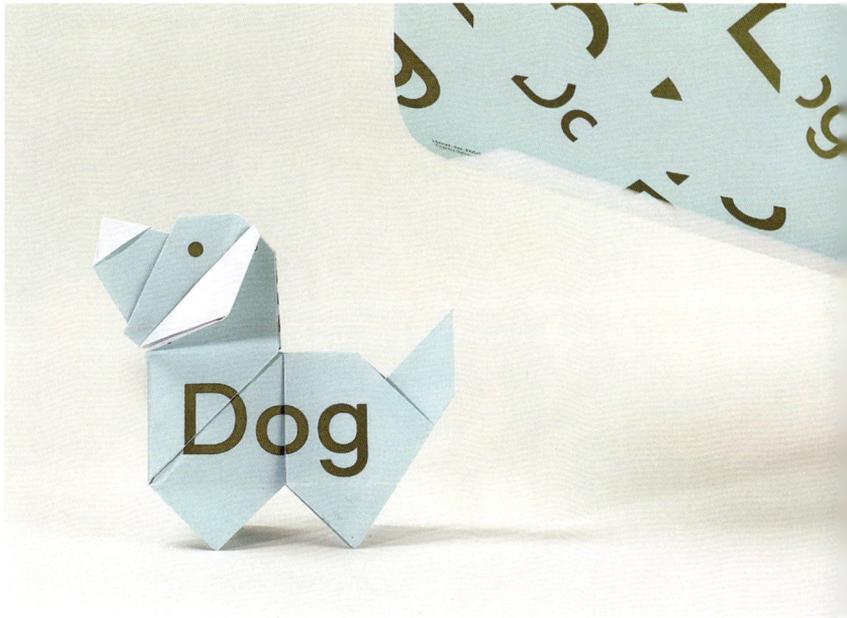

Design
SUBMACHINE

Client
Panka and Andris

Screen-printing
UNI Creative

Laser-cutting
TCN

Panka & Andris

To create a wedding invitation as unique as the re-
lationship between the soon-to-be-married couple,
SUBMACHINE designed a personalised interactive
card that let recipients build miniature figures of a
bunny to represent the bride, as well as a bear to rep-
resent the groom. The thick and durable card stock
allowed the built animals to stand on their own, while
the simple envelope held the clean visual language
together.

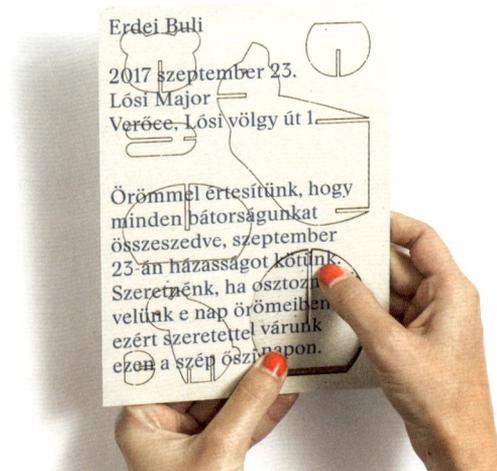

Design
Monograph&Co.

Delilah -
Limited Edition Teas

Delilah creates one-of-a-kind juice blends out of
seasonally handpicked flowers and locally sourced
fruits. For its floral juice bar, Monograph&Co. created
packaging that features flowers looking good enough
to eat. Their beautiful tea bag and bottle designs re-
flect the brand's delicate simplicity and lively beauty
– evoking the refreshing vibes of springtime.

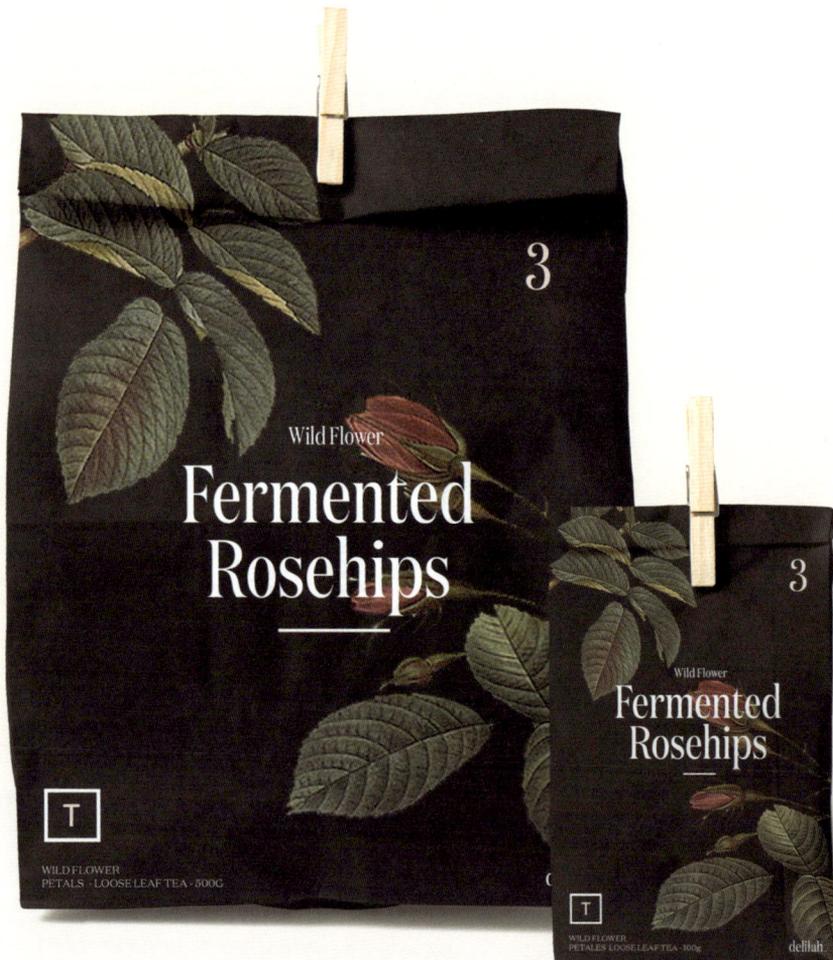

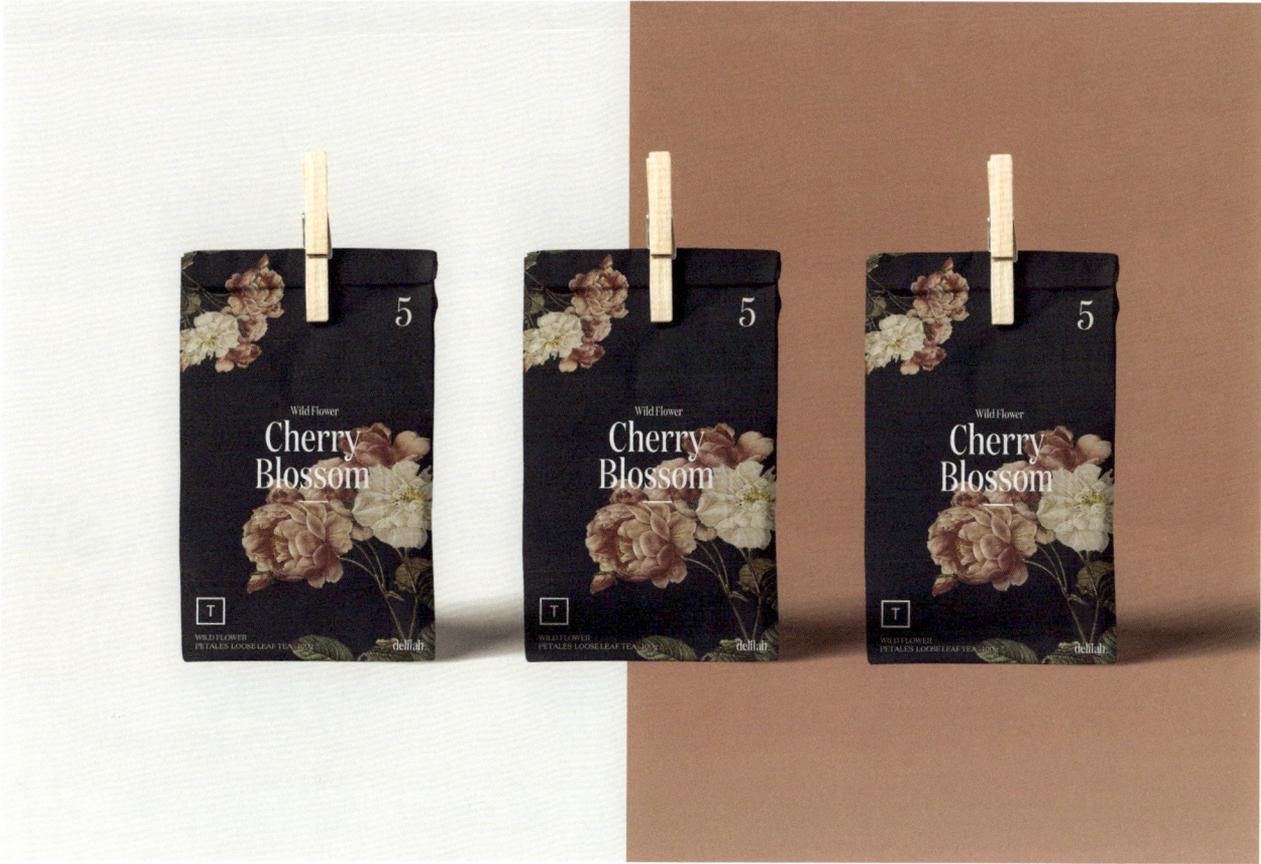

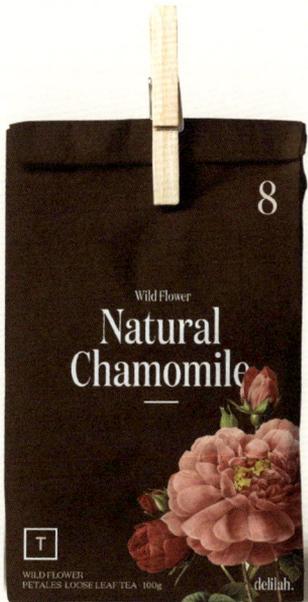

Smoor Chocolates

Blending aesthetic and strategic thinking, Anomaly Brands and Bloombox Brand Engineers developed a delectable visual identity for Smoor Chocolates that stands out from the conventional luxurious images used for similar products. They created memorable designs combining stunning fruits and vegetation with delicate typography to reflect where the chocolates came from and what they were made of – resulting in its delightful and vibrant packaging.

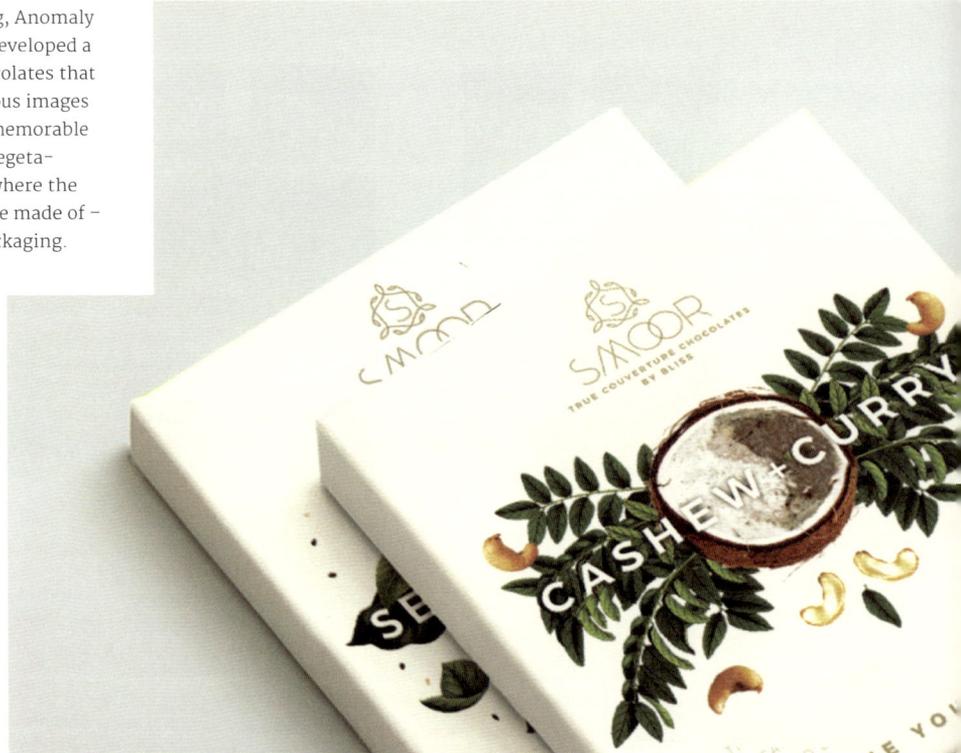

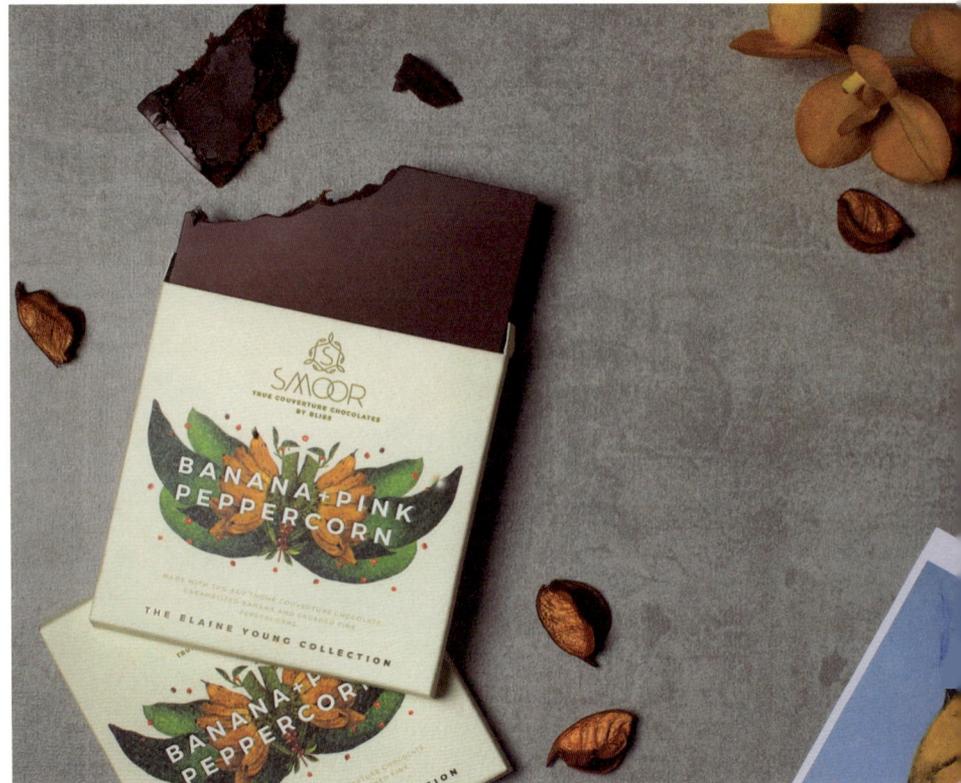

Design
Anomaly Brands
Bloombox Brands Engineers

Client
Bliss Chocolates

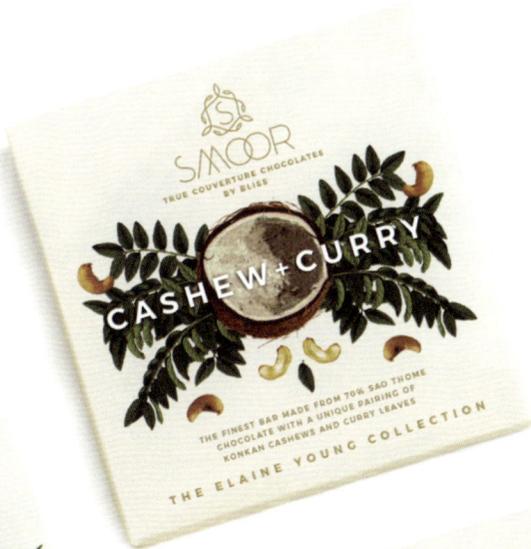

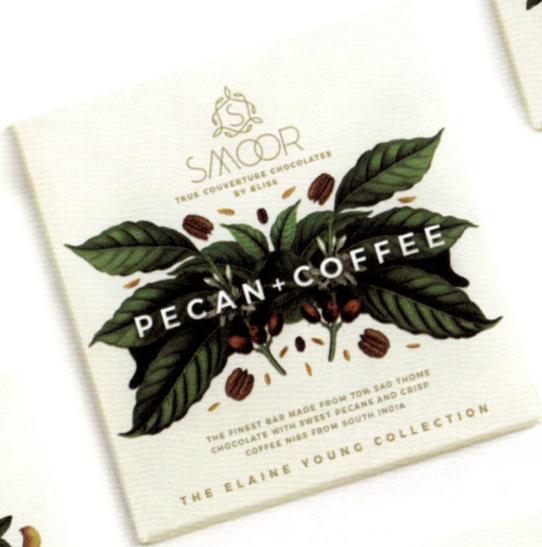

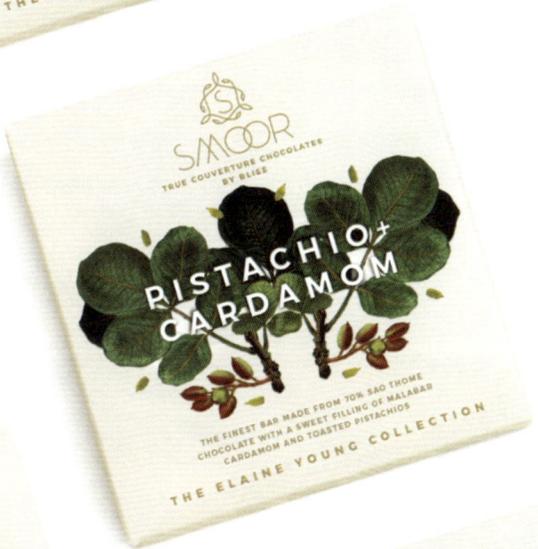

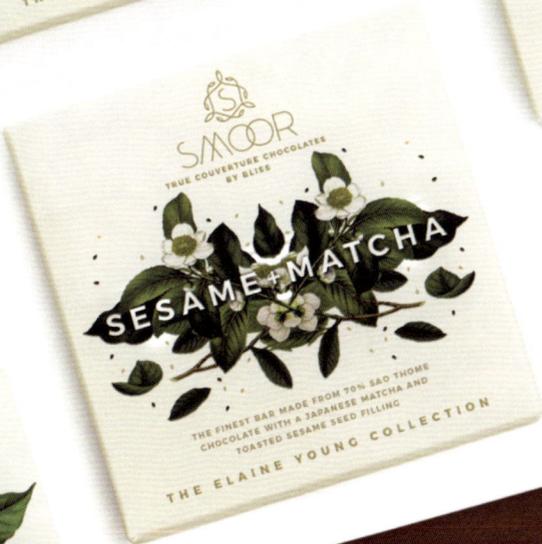

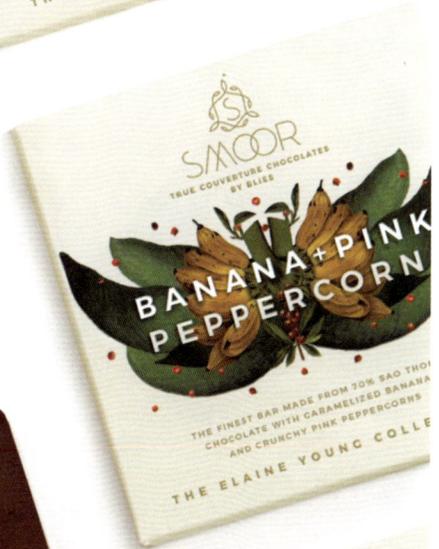

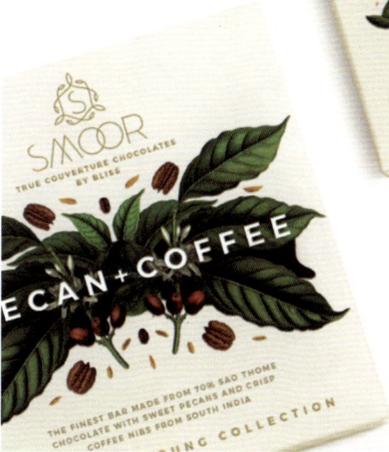

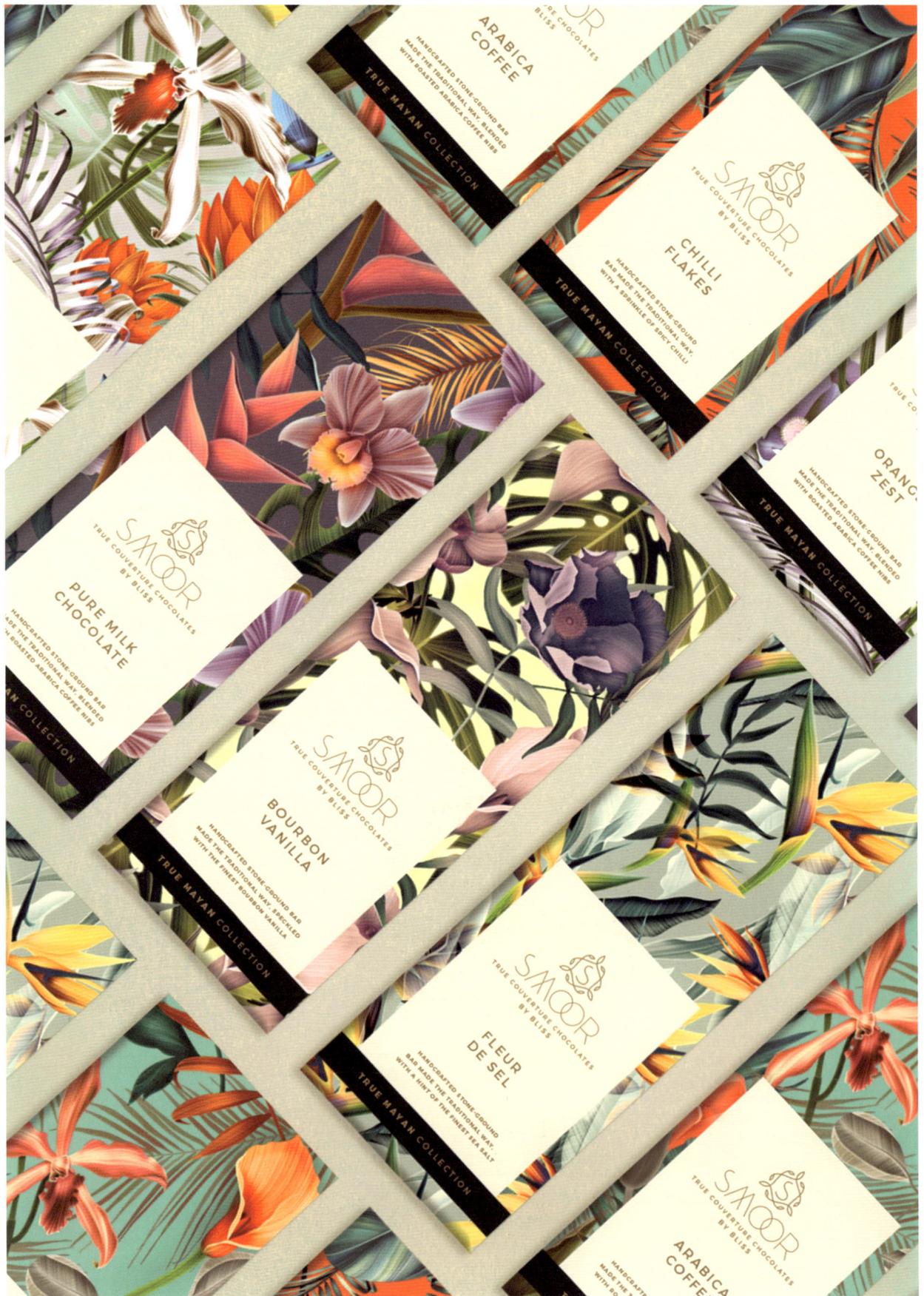

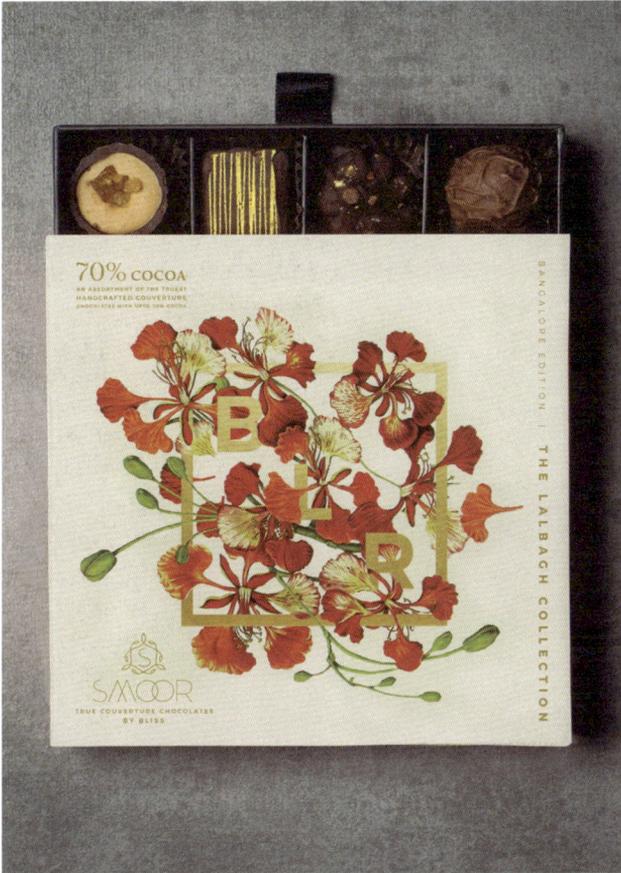

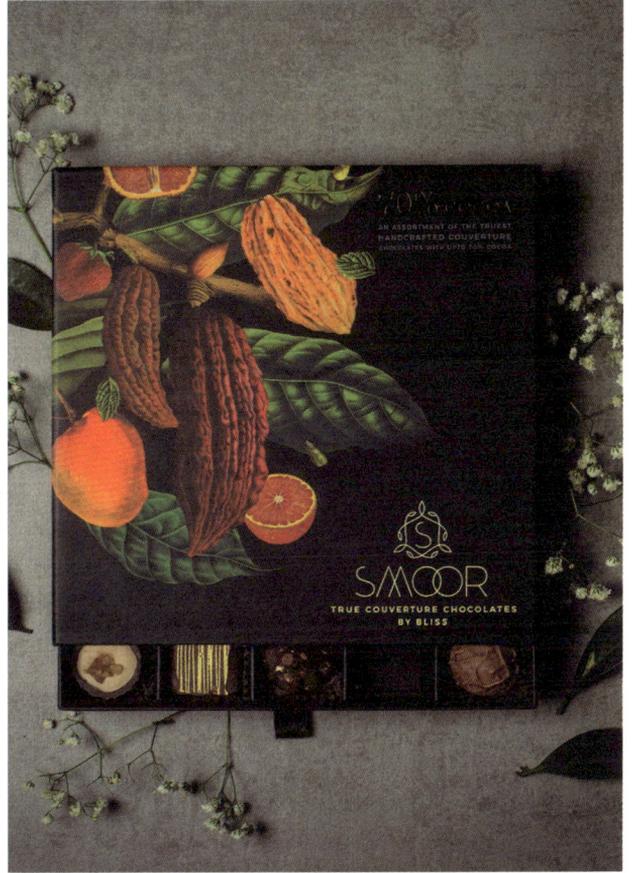

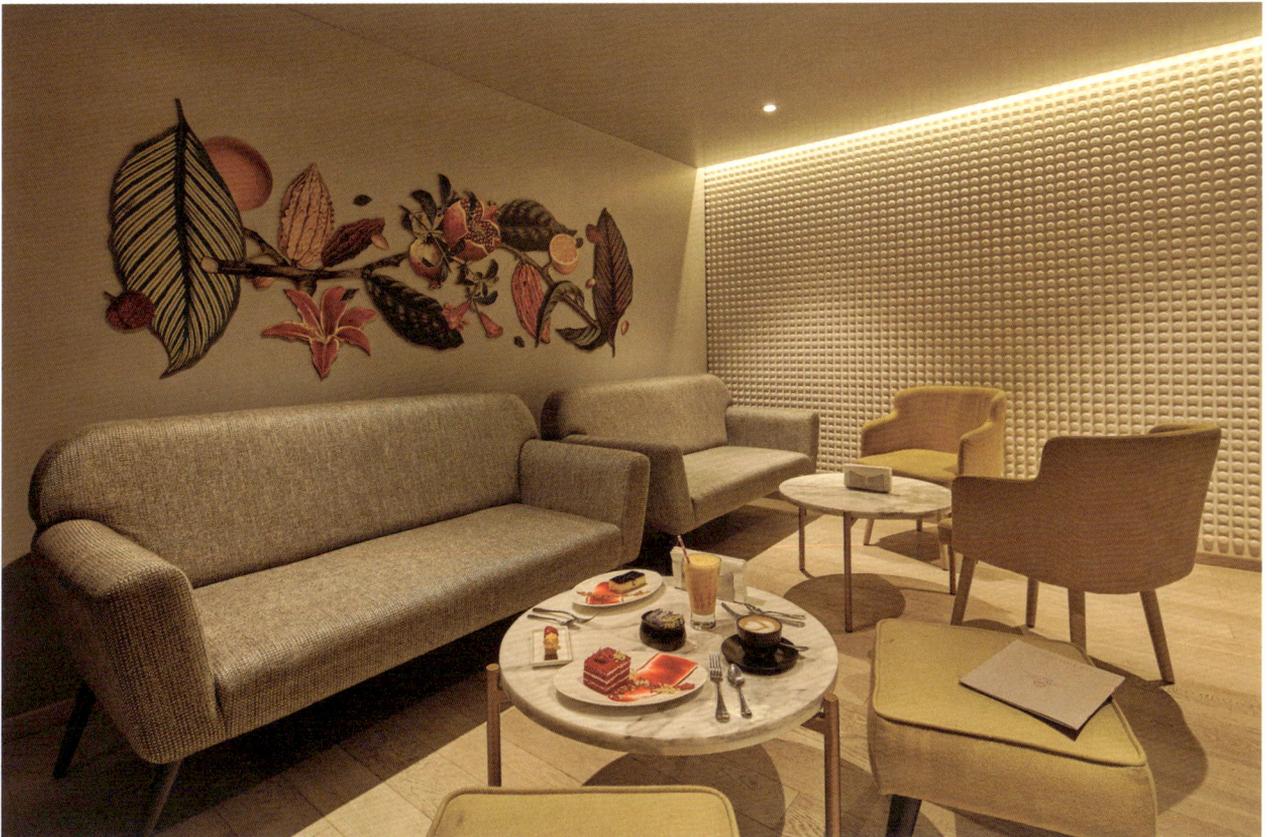

CS Light Bulbs

Armed with the knowledge that fireflies produce the most energy-efficient light known to man, Angelina Pischikova's packaging design work for CrazyService Belarus, the largest electrical company in Belarus, is original and thoughtful. Each light bulb is perfectly contained within various sketches of the insect to provide the brand with a fun and cohesive style without drawing attention away from the unique characteristics of the products.

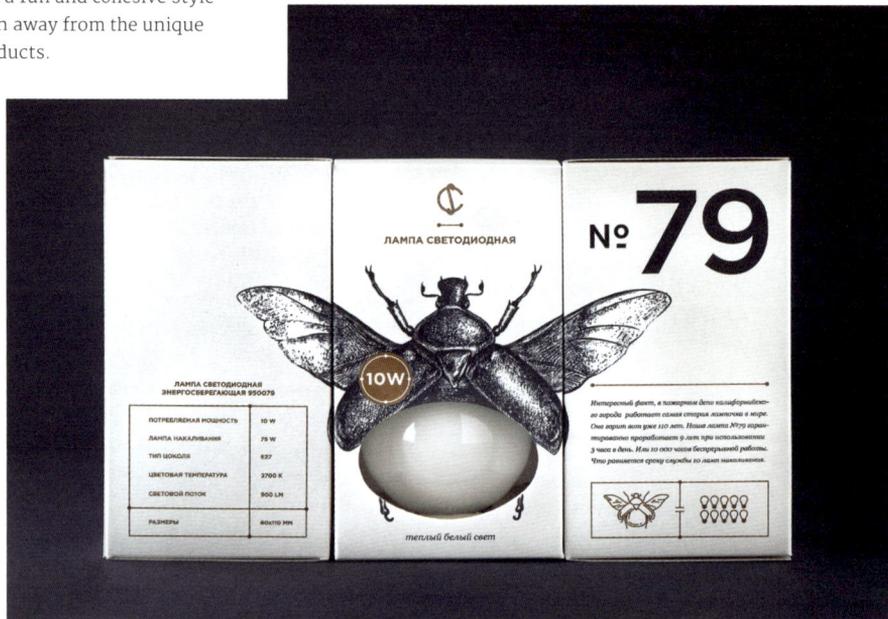

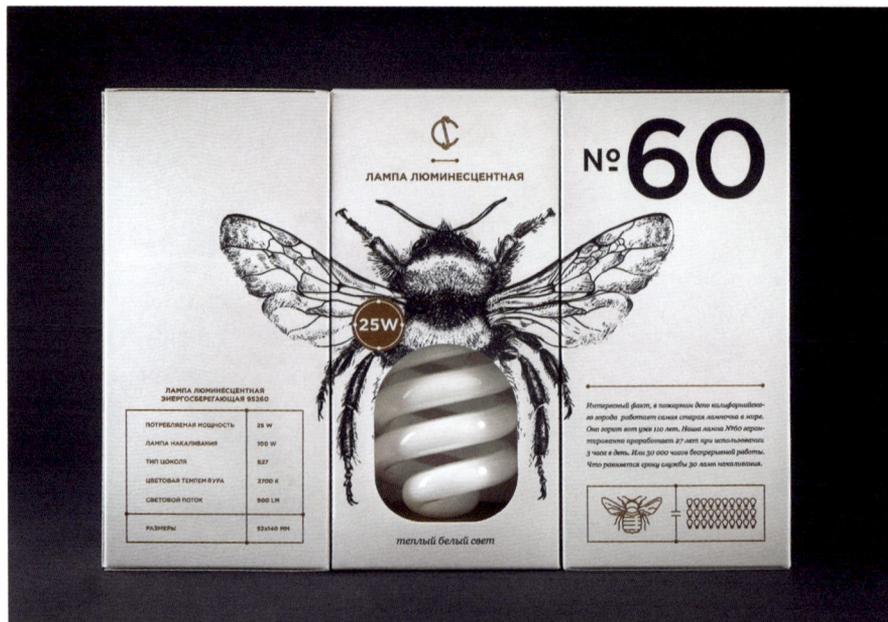

Design
Angelina Pischikova

Client
CrazyService Belarus

Photography & Post-production
Rodion Kovenkin

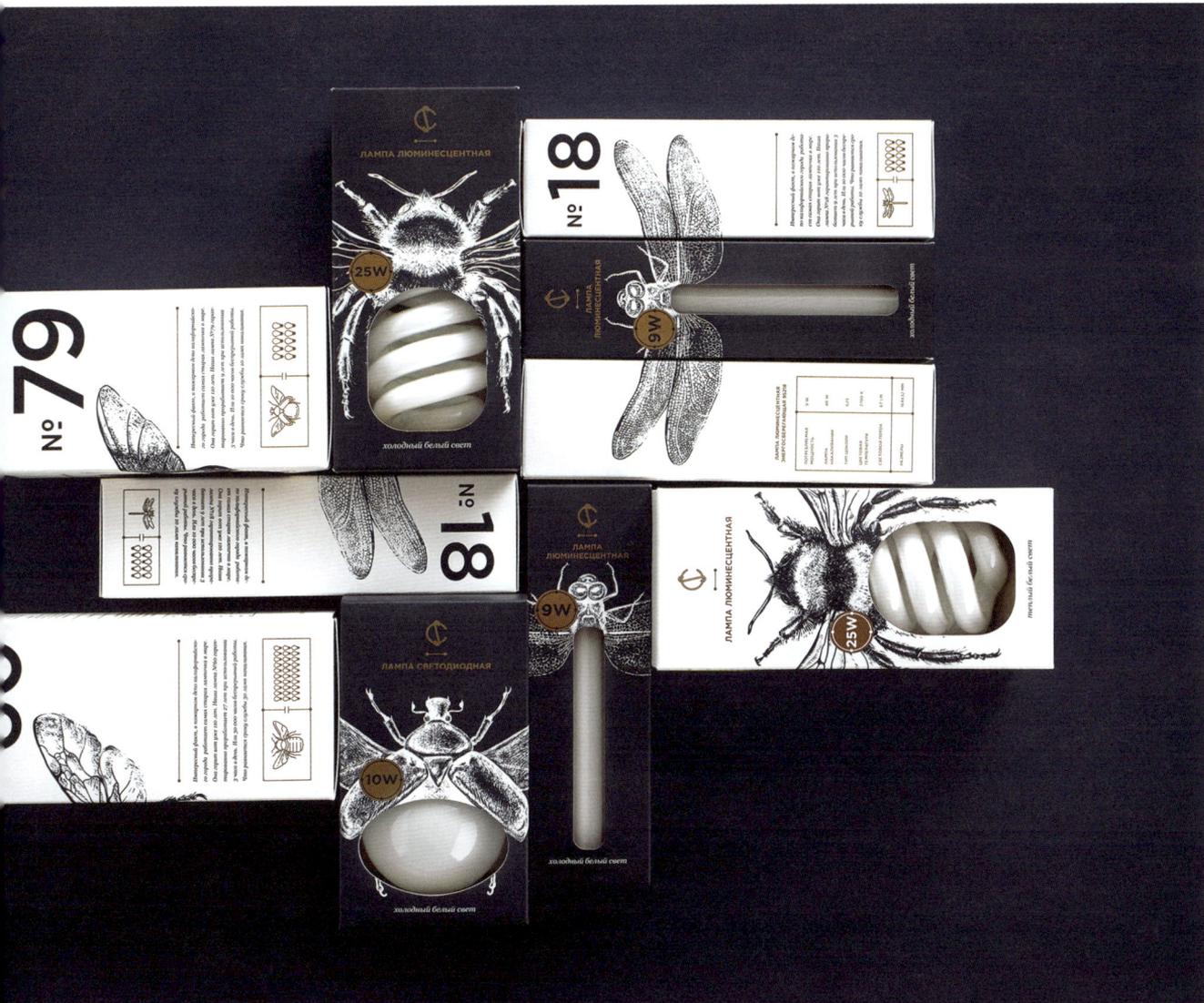

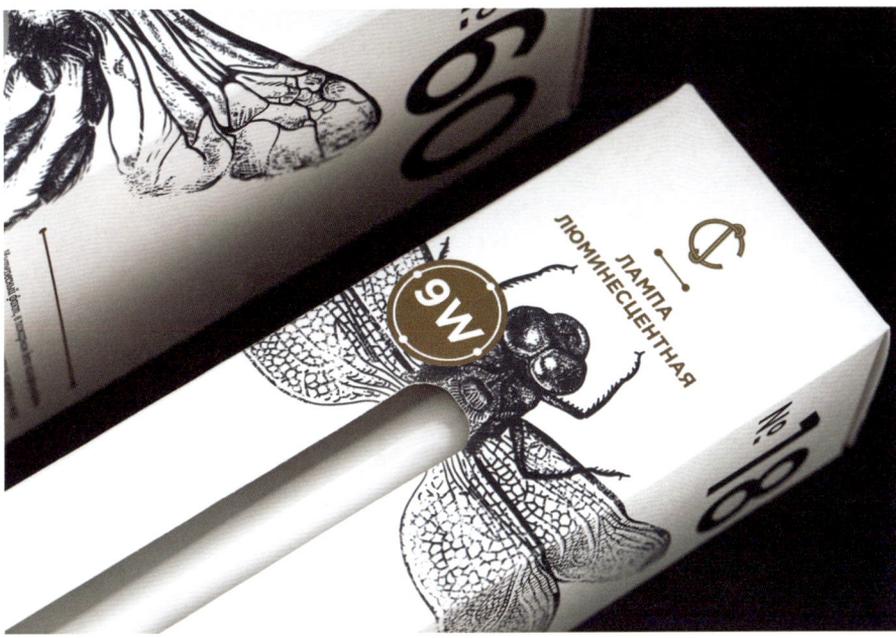

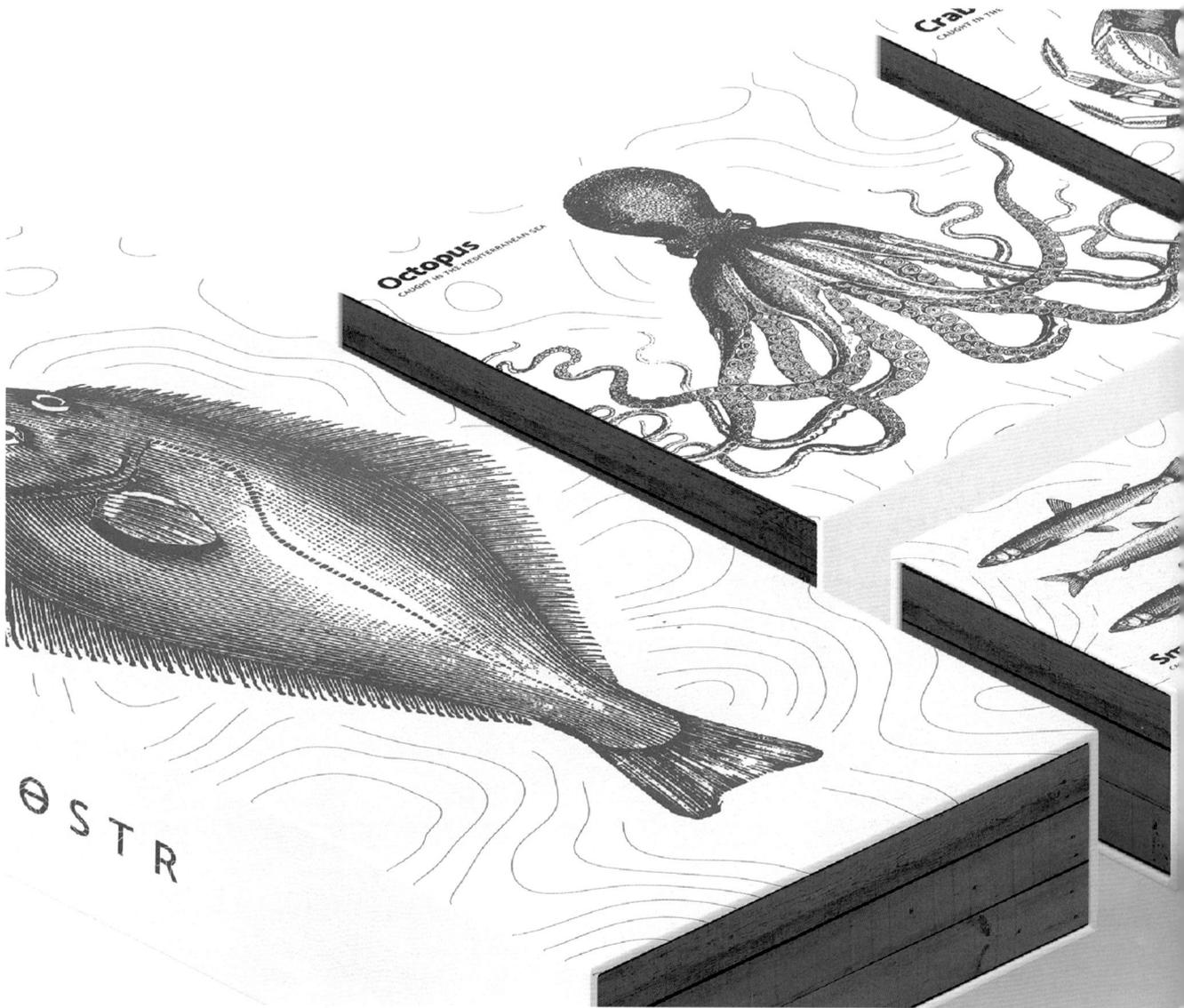

Octopus
CAUGHT IN THE MEDITERRANEAN SEA

Cra
CAUGHT IN THE

Sm
CA

Θ S T R

Kostr

Inspired by the products of Kostr, a fresh and nutritious seafood supplier that practices sustainable fishing techniques, Matt Ellis created a visual identity that features compelling and detailed sketches of sea creatures in a muted, deep blue ink. These illustrations adorn the minimalist, white packaging, while the same shade of blue appears across all the elements in the branding suite, such as the logo, aprons, and chef's uniforms.

Design
Matt Ellis

La Marimorena 2016

Aiming to preserve the La Marimorena personality while adding more sophistication and expression to the wine label, Estudio Maba's design work featured a vintage-inspired illustration of a fish. The detailed and eye-catching drawing was printed on highly textured cotton paper to create an elegant visual identity that brims with life.

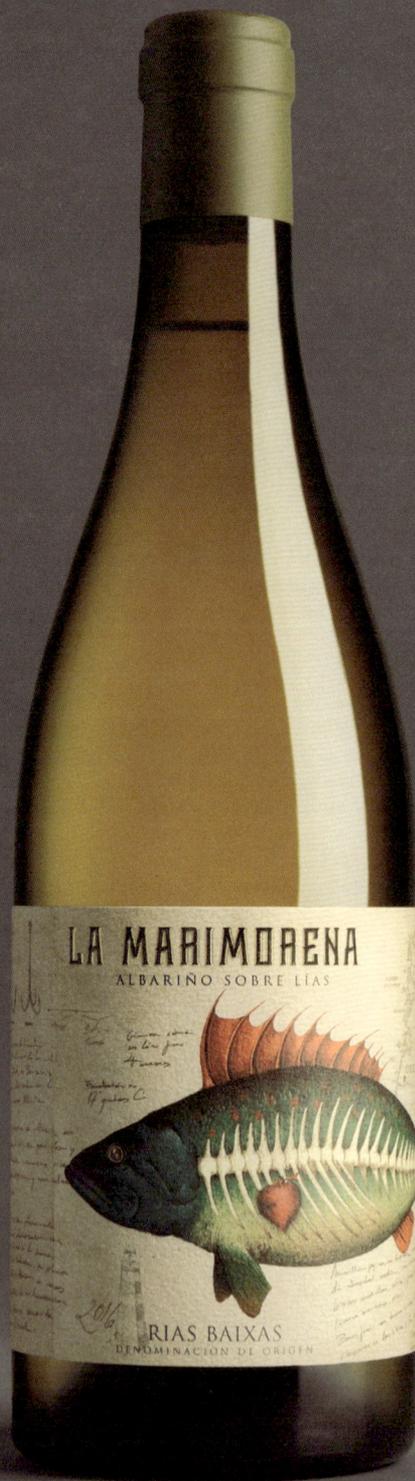

Design
Estudio Maba

Client
Casa Rojo

Photography
La Industrial

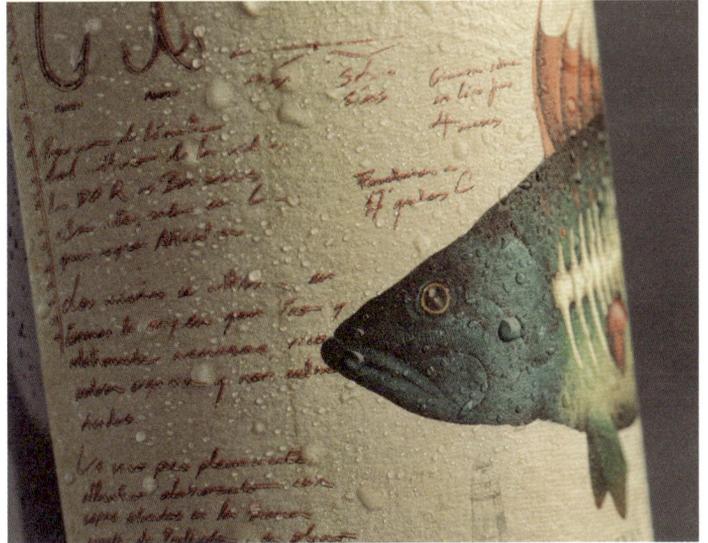

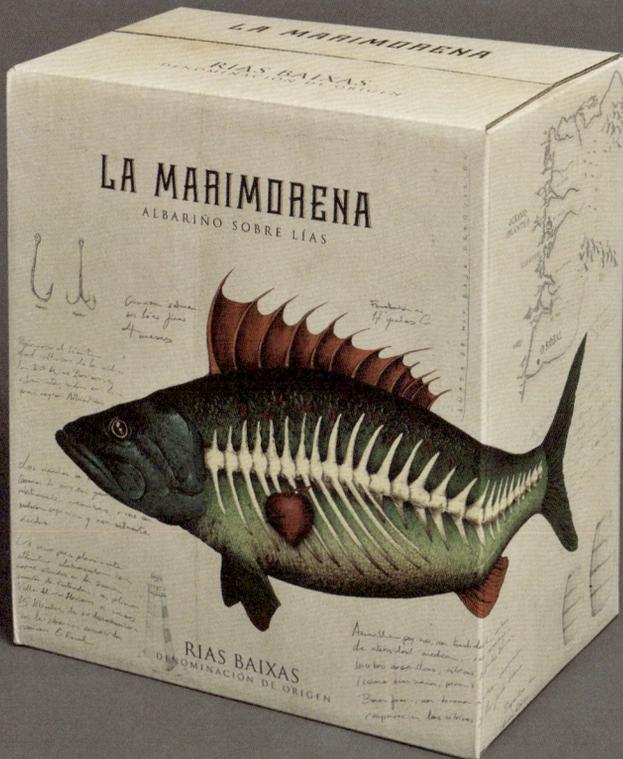

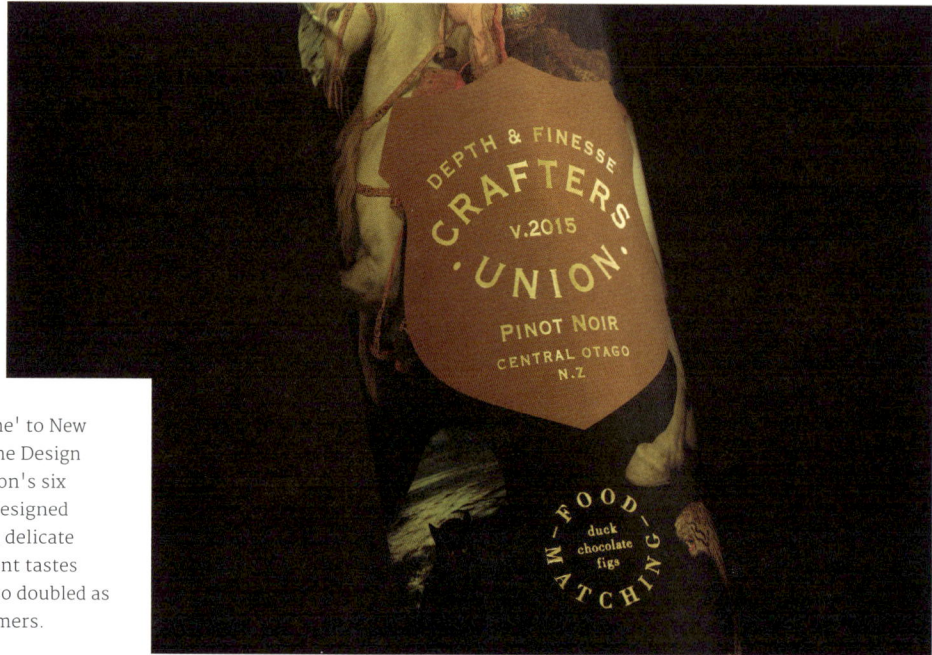

Crafters Union

To introduce the concept of 'wrapped wine' to New Zealand and Australia on a large scale, One Design created individual wraps for Crafters Union's six distinct everyday wines. Each wrap was designed to create a strong shelf presence through delicate illustrations, as well as reflect the different tastes and temperaments of the wines. They also doubled as beautiful gift-wrapping papers for customers.

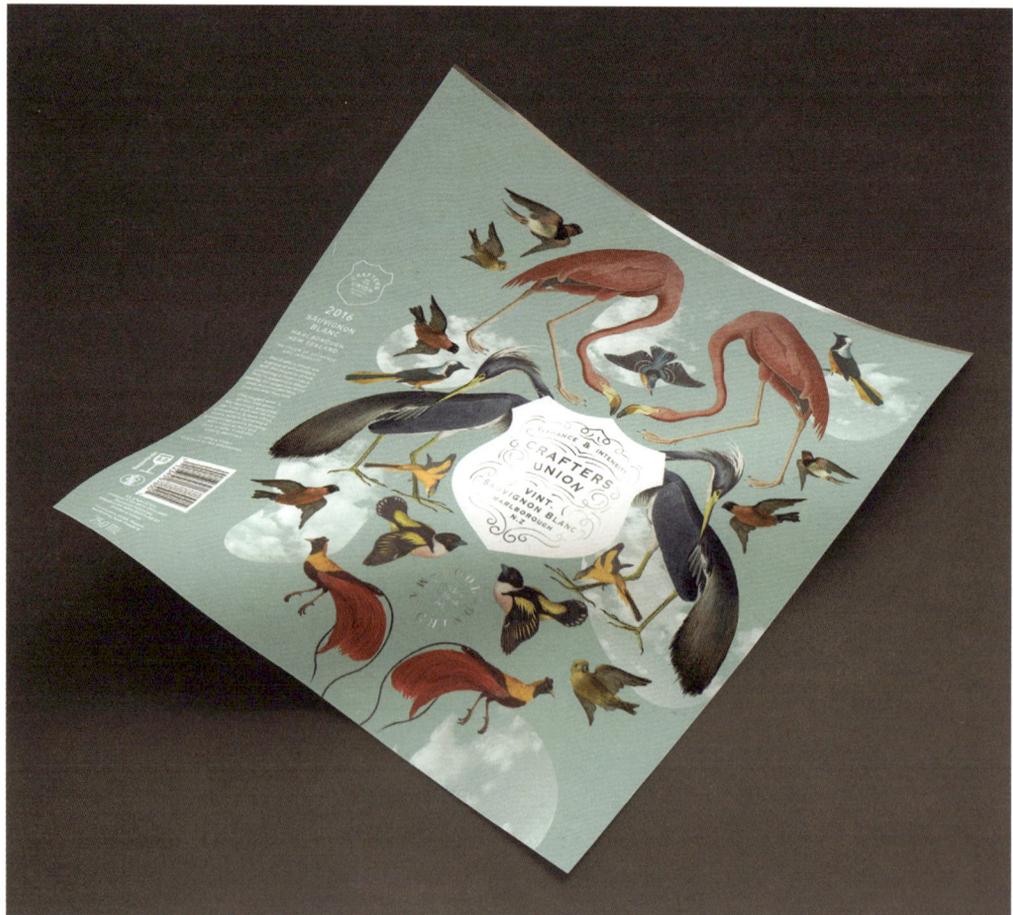

Design
One Design

Client
Constellation Brands (NZ)

Photography
Charles Howells

Illustration
Samuel Sakaria
Albert Ashok

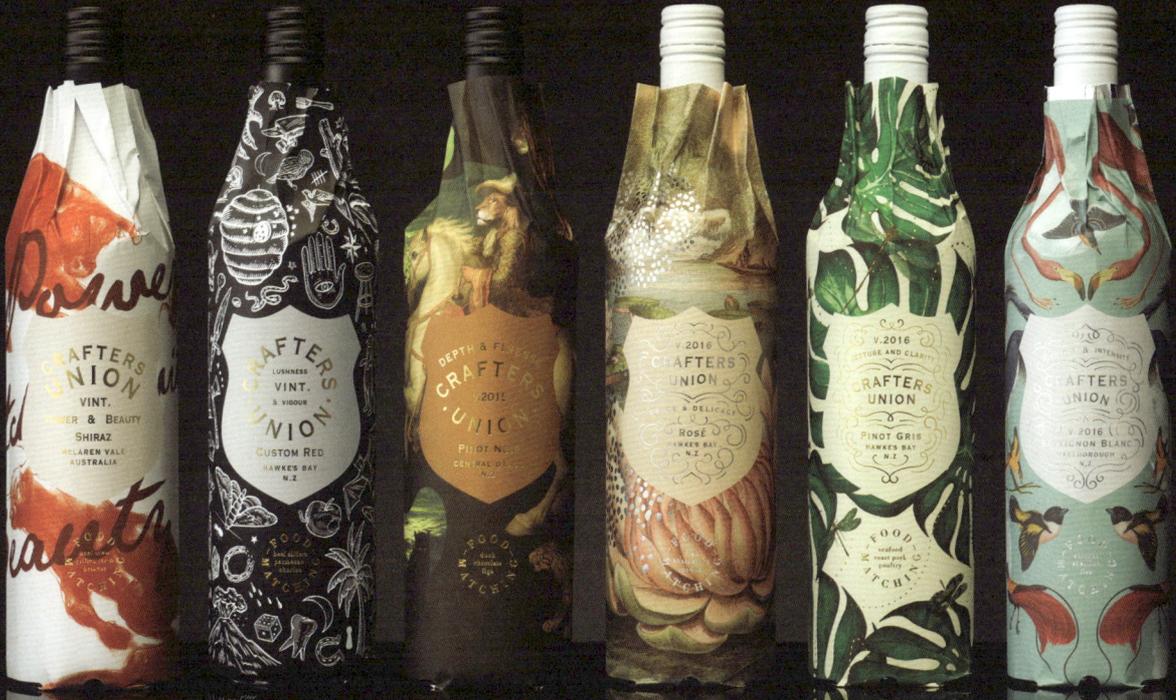

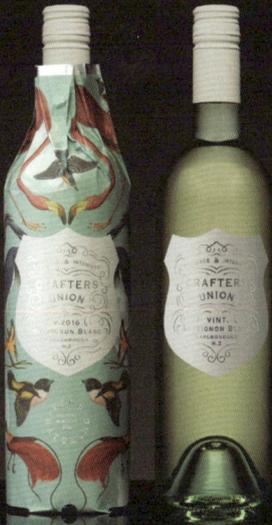

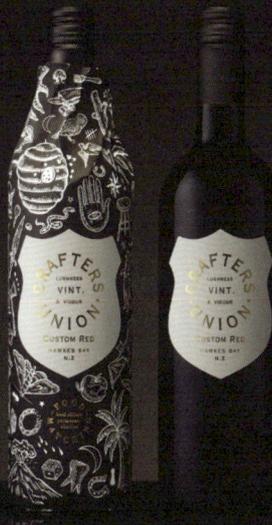

Provoca Wines

Exploring the relationship between man and nature, the label design for Provoca red wine features images inspired by scientific illustrations of carnivorous plants. To create a foreboding yet sensual visual language, Makers & Allies merged the plant stems' creeping tendrils with vintage-style typography to hint at the control man believes himself to have over nature – up until the moment the 'trap' swings shut!

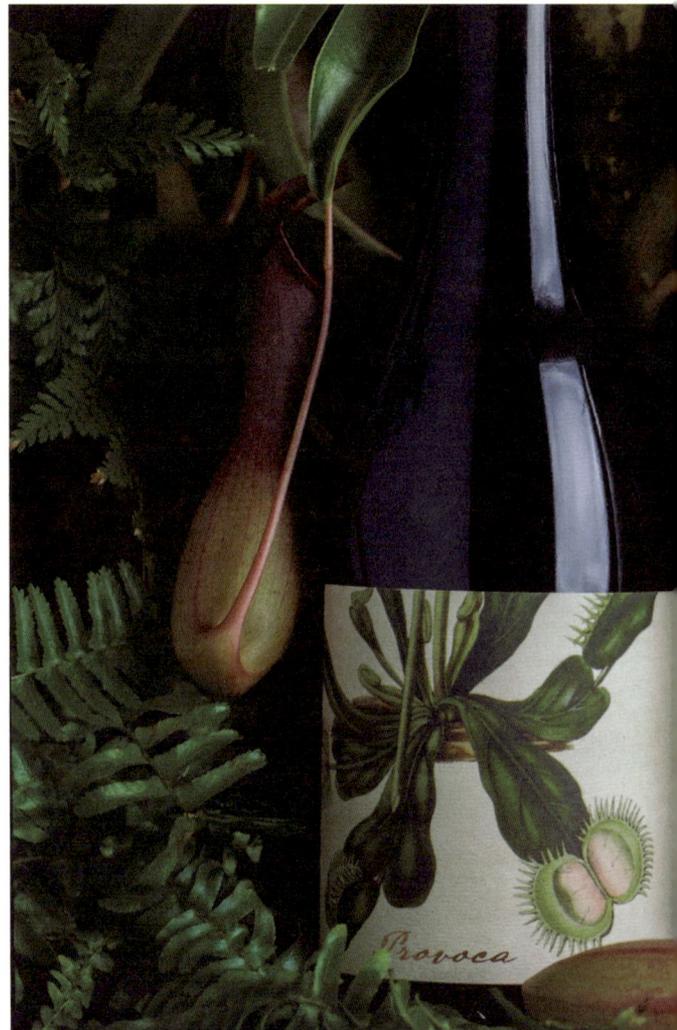

Design
Makers & Allies

Client
Provoca Wines

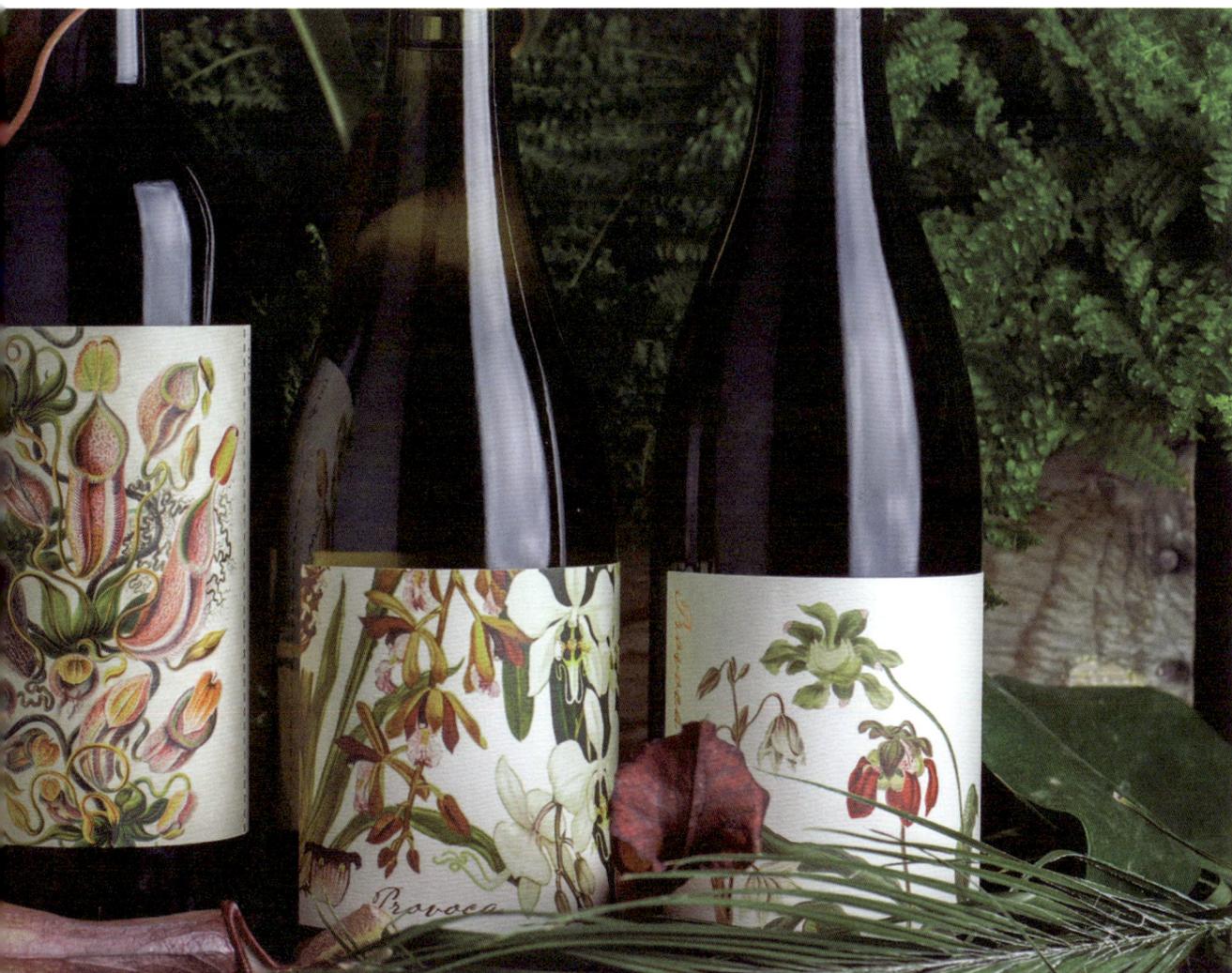

NATIVO

Candid Brands®' visual identity and packaging design work for NATIVO, one of the largest producers of organic native pork, was inspired by Charles Darwin's scientific theory of natural selection. To highlight the Cochinita Pibil, the brand's main product that is also an emblematic Yucatan pork dish, they incorporated delicate, vintage-looking illustrations and a logo in the form of the Mexican Creole hairless pig to complement the Yucatan gastronomical tradition.

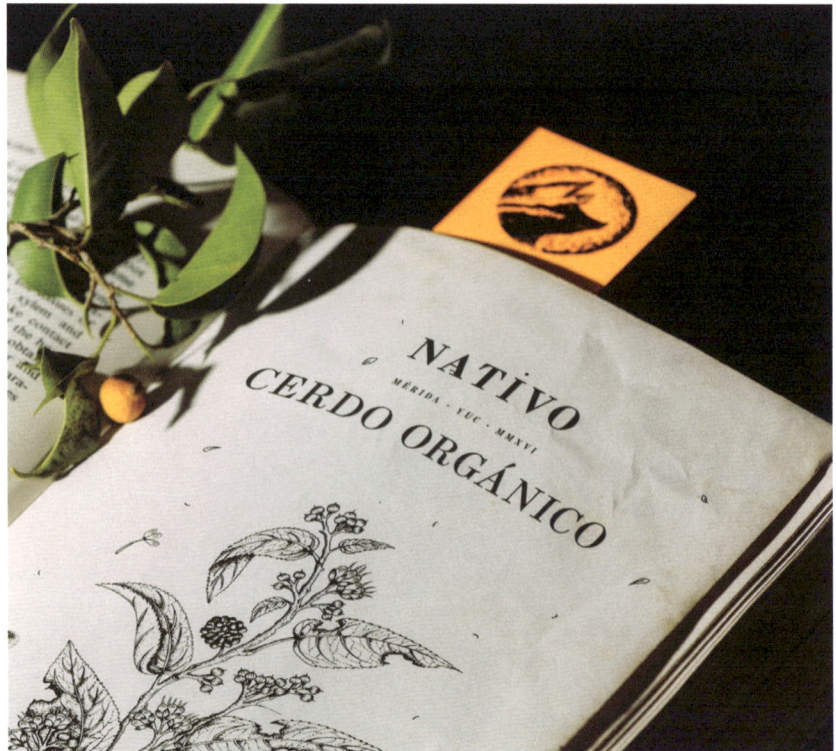

Design
Candid Brands®

Client
NATIVO

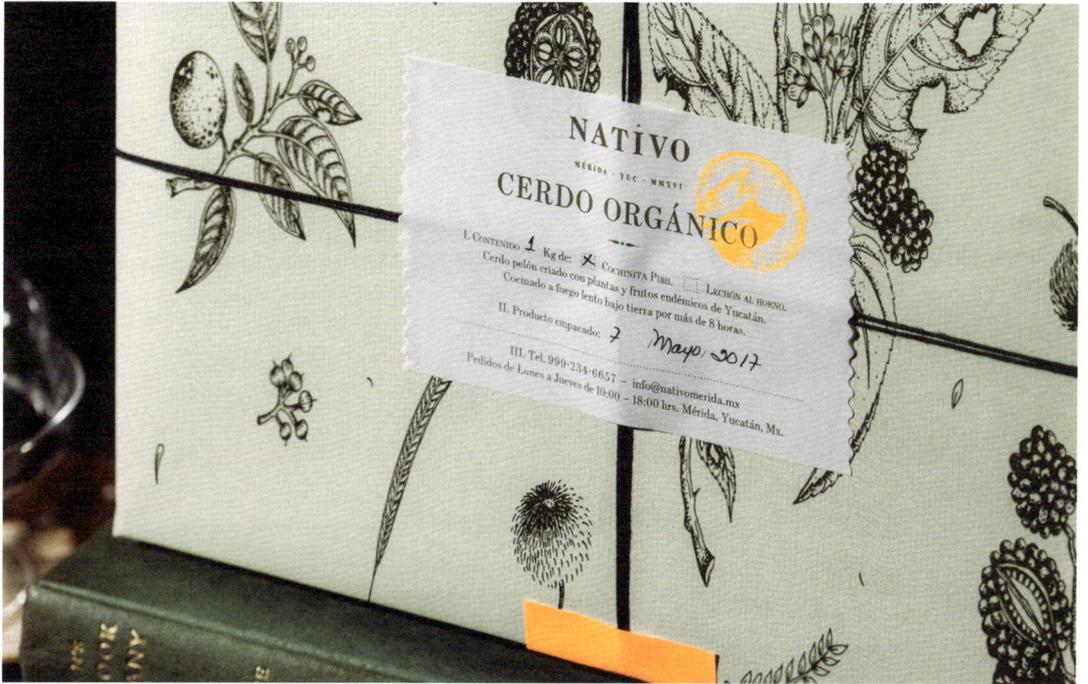

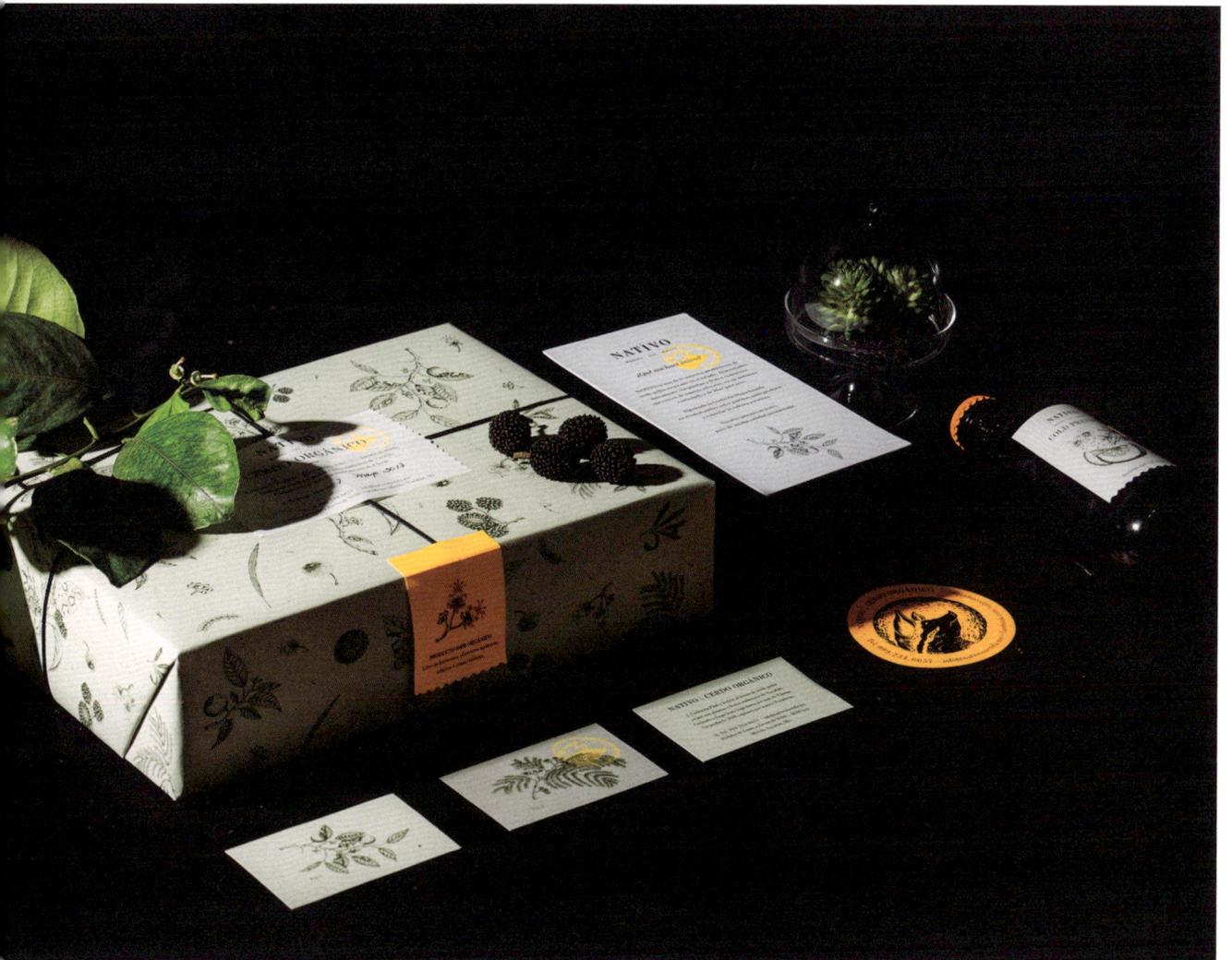

Soubois Restaurant

Emanating a mysterious and enchanting energy, Soubois Restaurant's visual identity is defined by deep forest greens and delicate golden highlights. Fitting for this local bistro, bar, and nightclub, Baillat. Studio's designs are dark, beautiful, and indicative of its location in an underground forest at the core of Montreal's downtown area. Detailed illustrations of various forest plants and animals are used throughout its collaterals that are all brought together by an eye-catching logo that resembles the cross-section view of a stem via a quasi-psychedelic pattern of dots.

Design
Baillat. Studio

Client
Soubois Restaurant

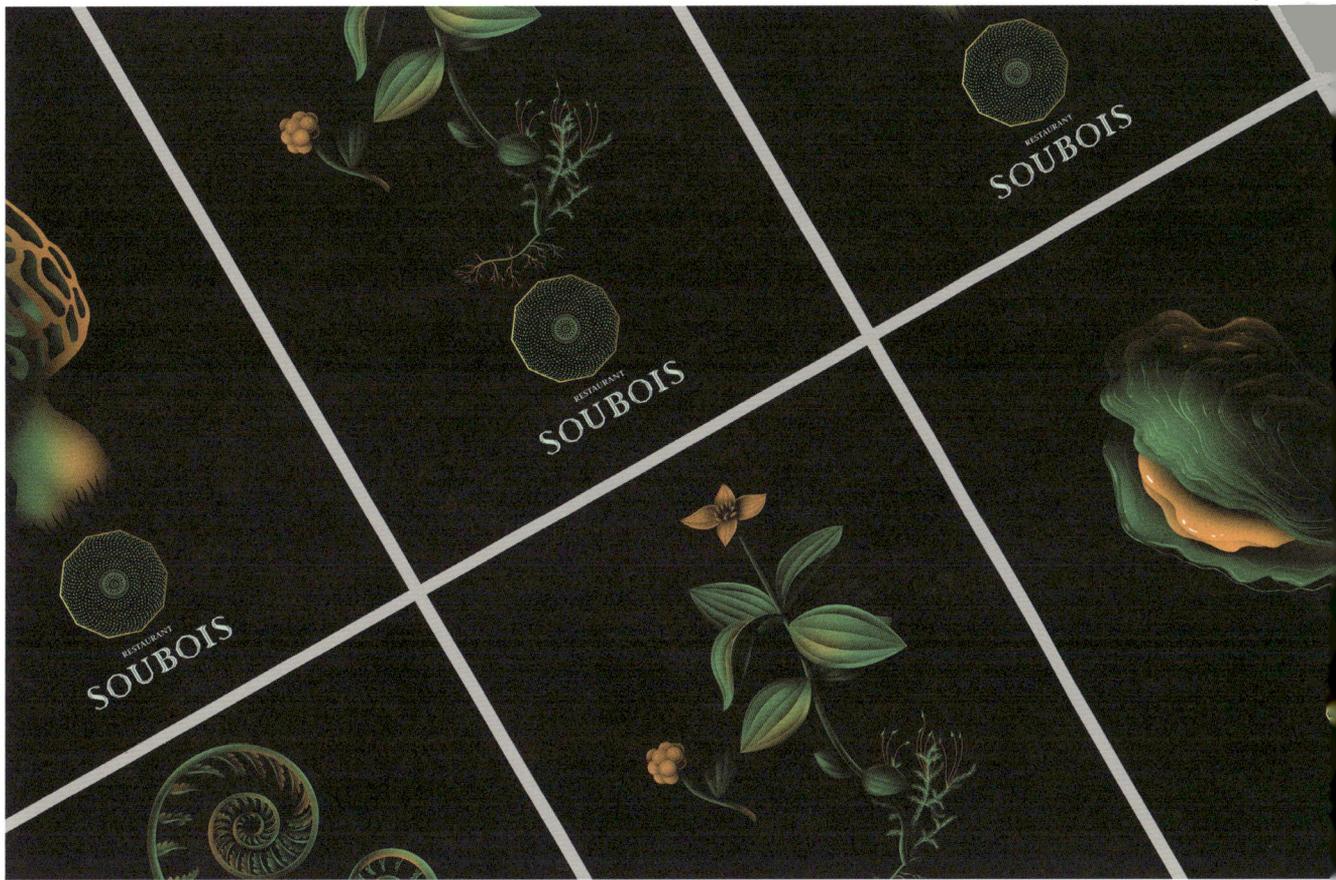

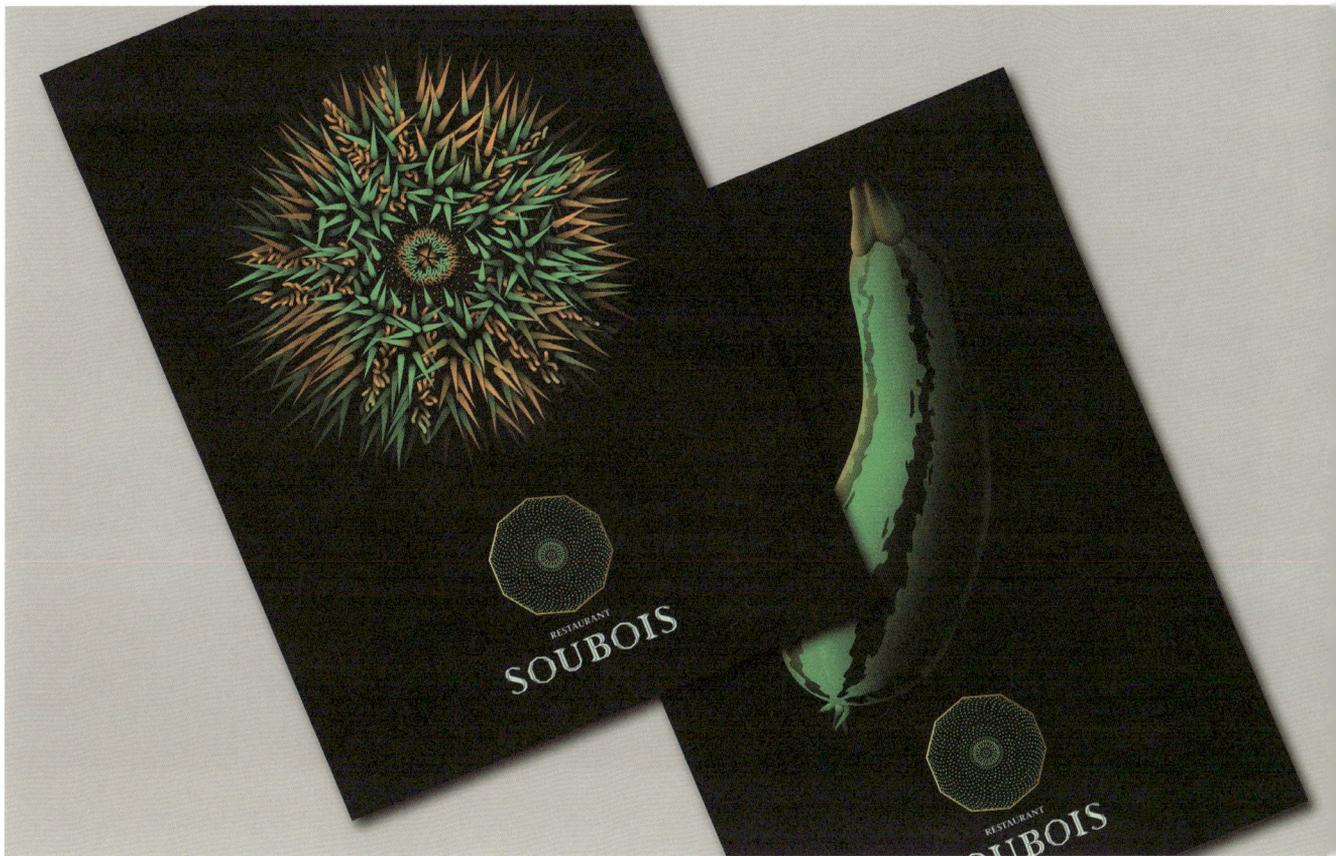

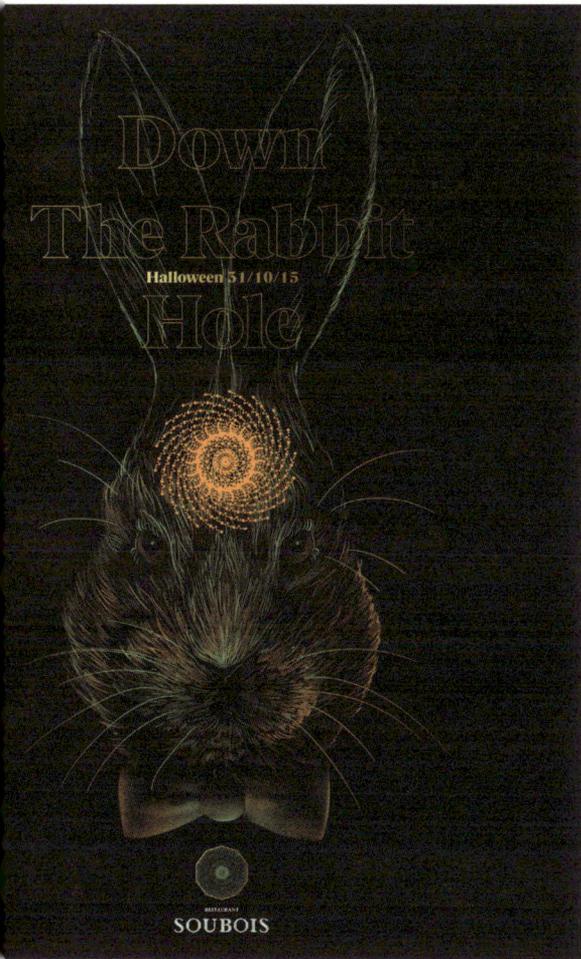

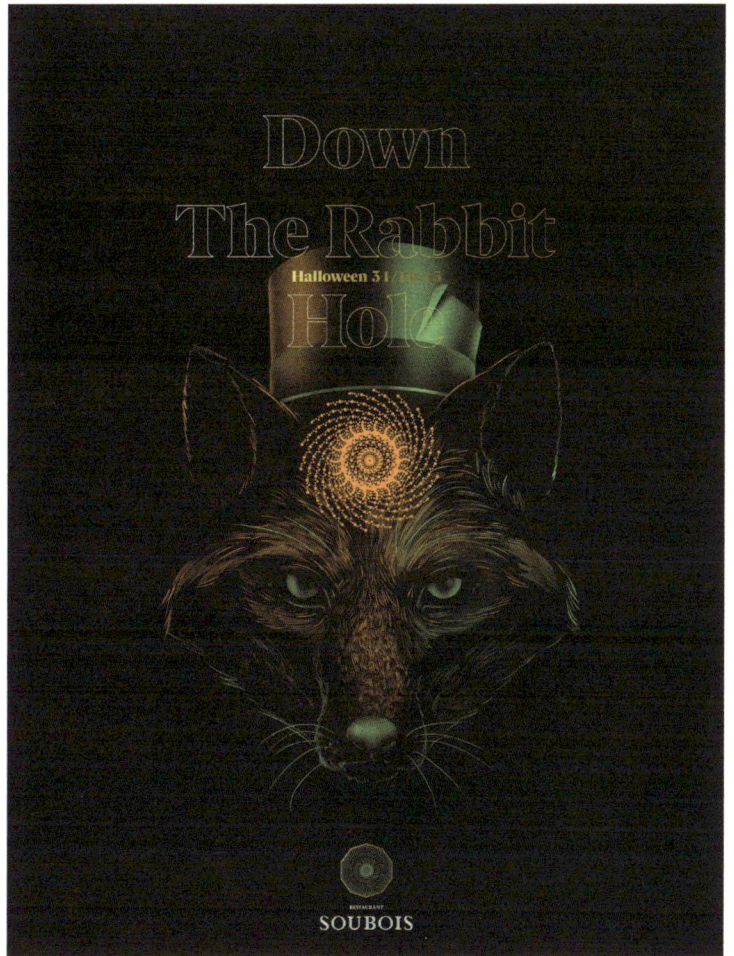

Mango Tree Café

Featured on the walls and menus of Mango Tree Café are images of Thailand's street life portrayed in a new light through people dressed in traditional garb while carrying massive bundles of leaves – resembling enchanted trees meandering through bustling Thai streets. Through these imaginary scenes combining classic Thailand with a contemporary twist, a familiar background becomes innovative: much like the restaurant's menu, which features Thai and Western fusion.

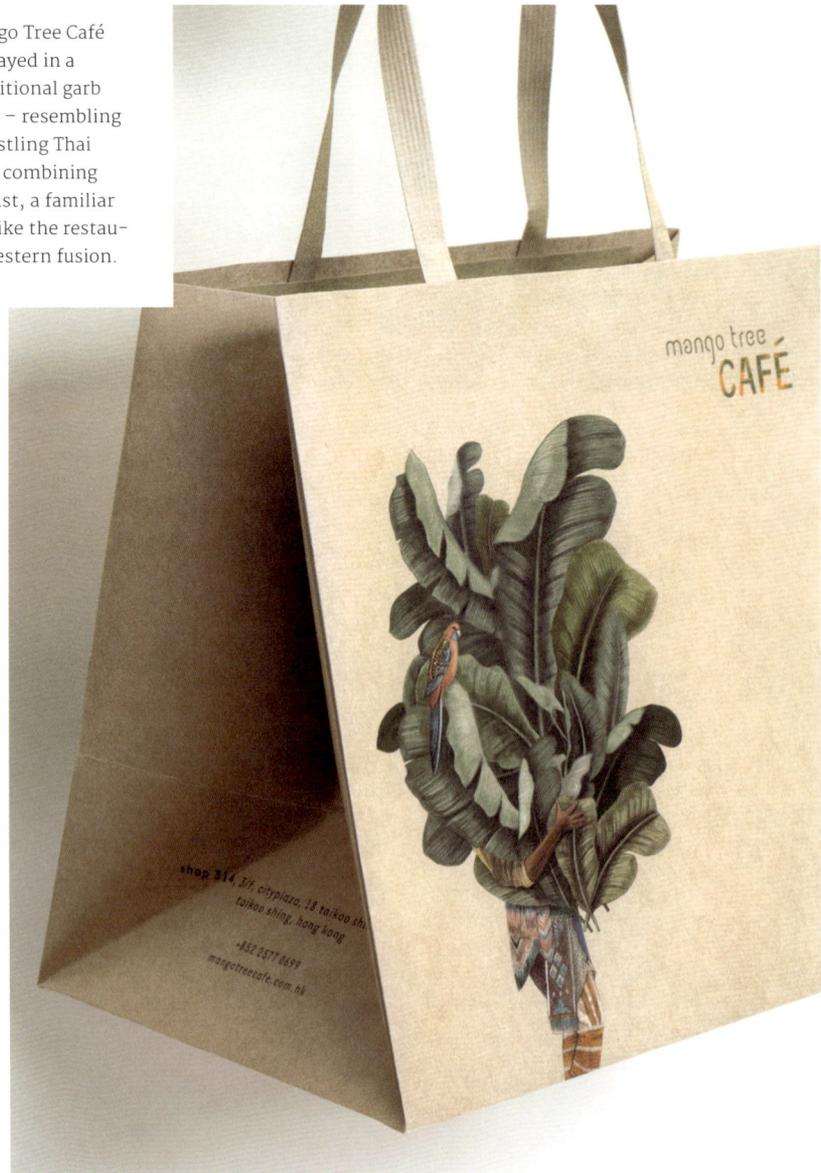

Design
A Work of Substance

Client
1957 & Co. Restaurant Group

Photography
Vita Mak

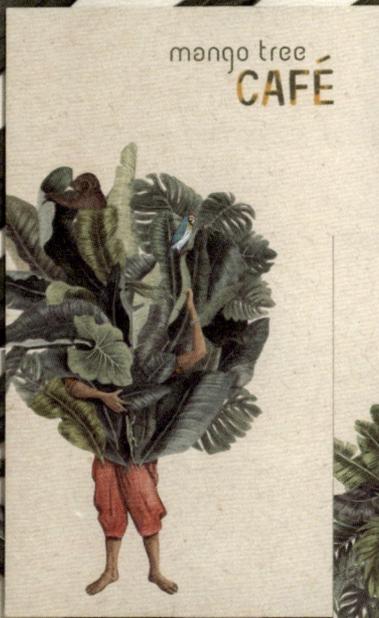

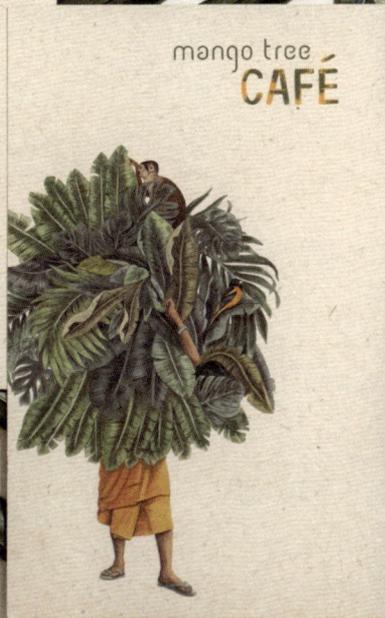

enquiry@mangotreecafe.com.hk
mangotreecafe.com.hk

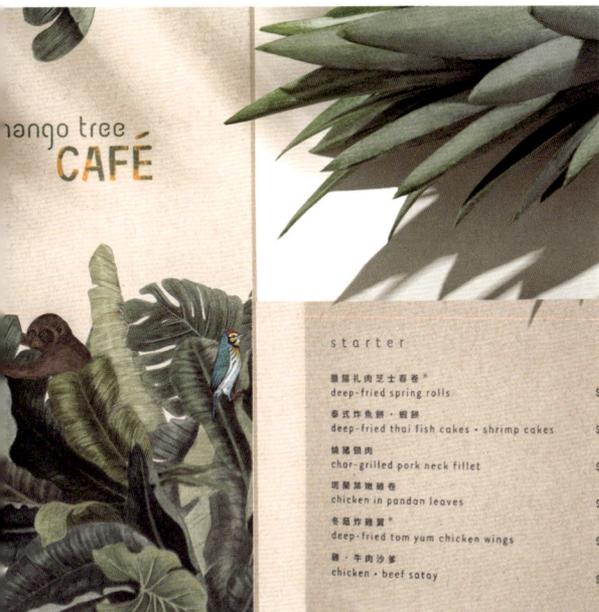

starter

豬膊扎肉芝士春卷 *
deep-fried spring rolls $

泰式炸魚餅・蝦餅
deep-fried thai fish cakes・shrimp cakes $

炭燒豬頸肉
char-grilled pork neck fillet $

斑蘭基慕斯卷
chicken in pandan leaves $

冬蔭炸雞翼
deep-fried tom yum chicken wings $

雞・牛肉沙爹
chicken・beef satay $

Coffee Jungle

At the intersection of an old-school location and tropical-style coffee lies Coffee Jungle in Samara, Russia. Natasha Nikulina designed a joyful, modern version of a forest for its visual identity, incorporating bright colours to reflect the store's sweet side where bagels and doughnuts can accompany every cuppa. The iconic pink and green leaves appear throughout the store on menus, napkins, wallpaper, business cards, plates, boxes, and cups – which also feature a friendly sloth.

Design
Natasha Nikulina

Client
OOO «Jungle»

Kitchen
Multi-Cuisine

MAMOOR

Seeking to embody the ambience of the mystical virgin forests, MAROG Creative Agency designed a brand identity for MAMOOR revolving around intricate illustrations. The ornamental Art Noveau-style drawings create an atmosphere of comfort and mystery at the same time, while the restaurant's logo represents the spirit of the deep forest. Stylised tree branches, a majestic bird, and uniquely shaped chocolate boxes form the other main graphic elements that define MAMOOR's timeless design language.

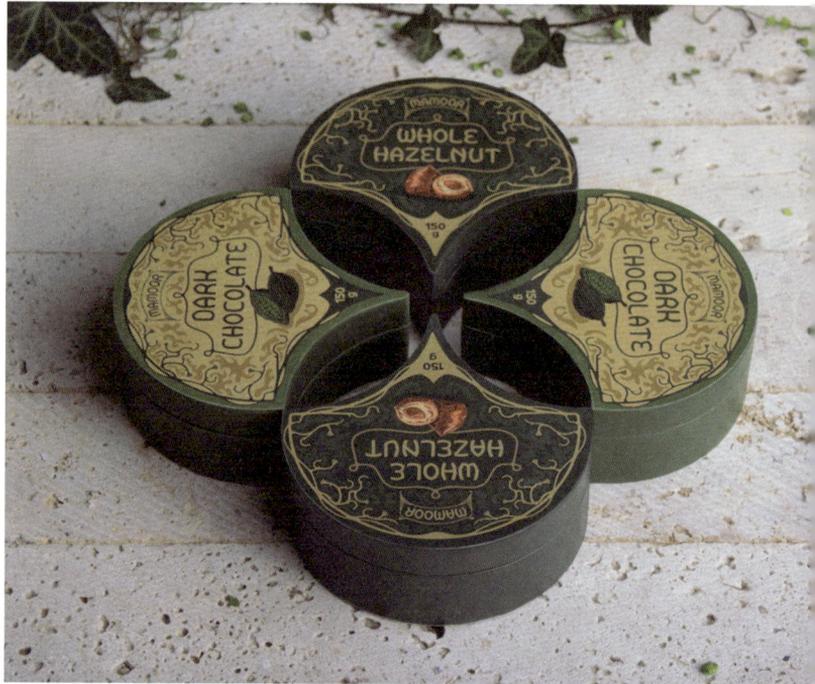

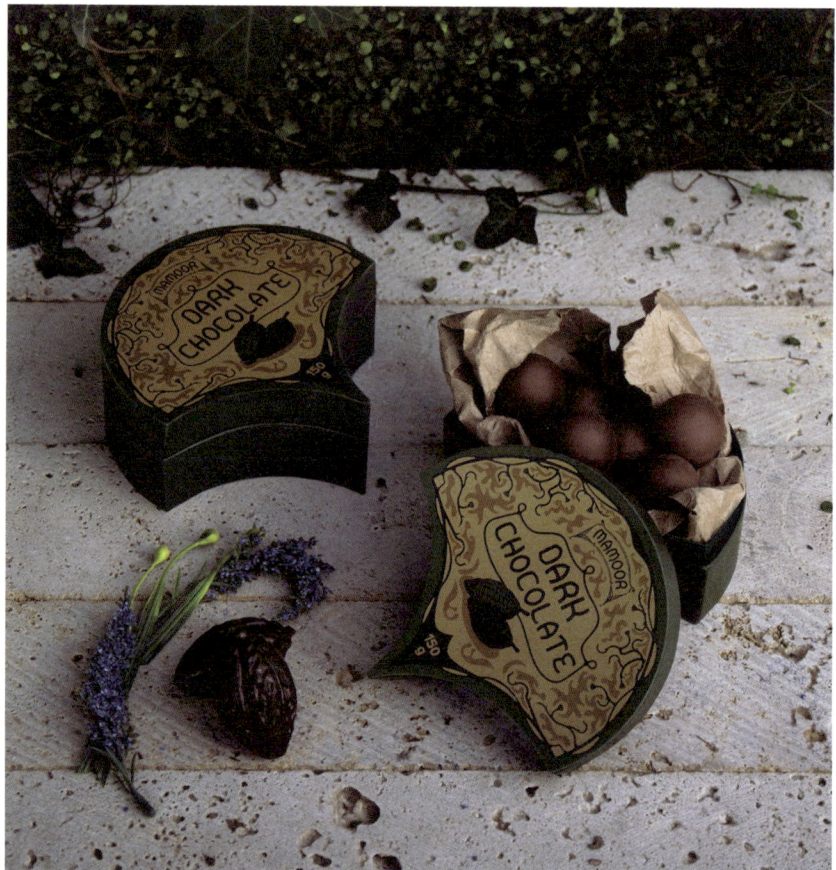

Design
MAROG Creative Agency

Client
MAMOOR

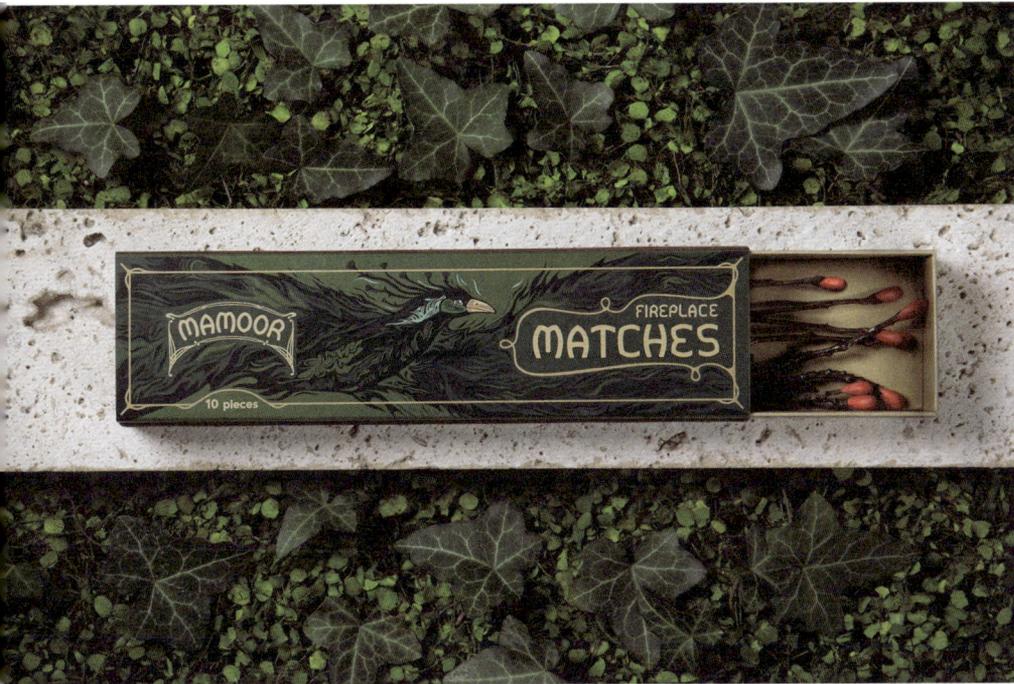

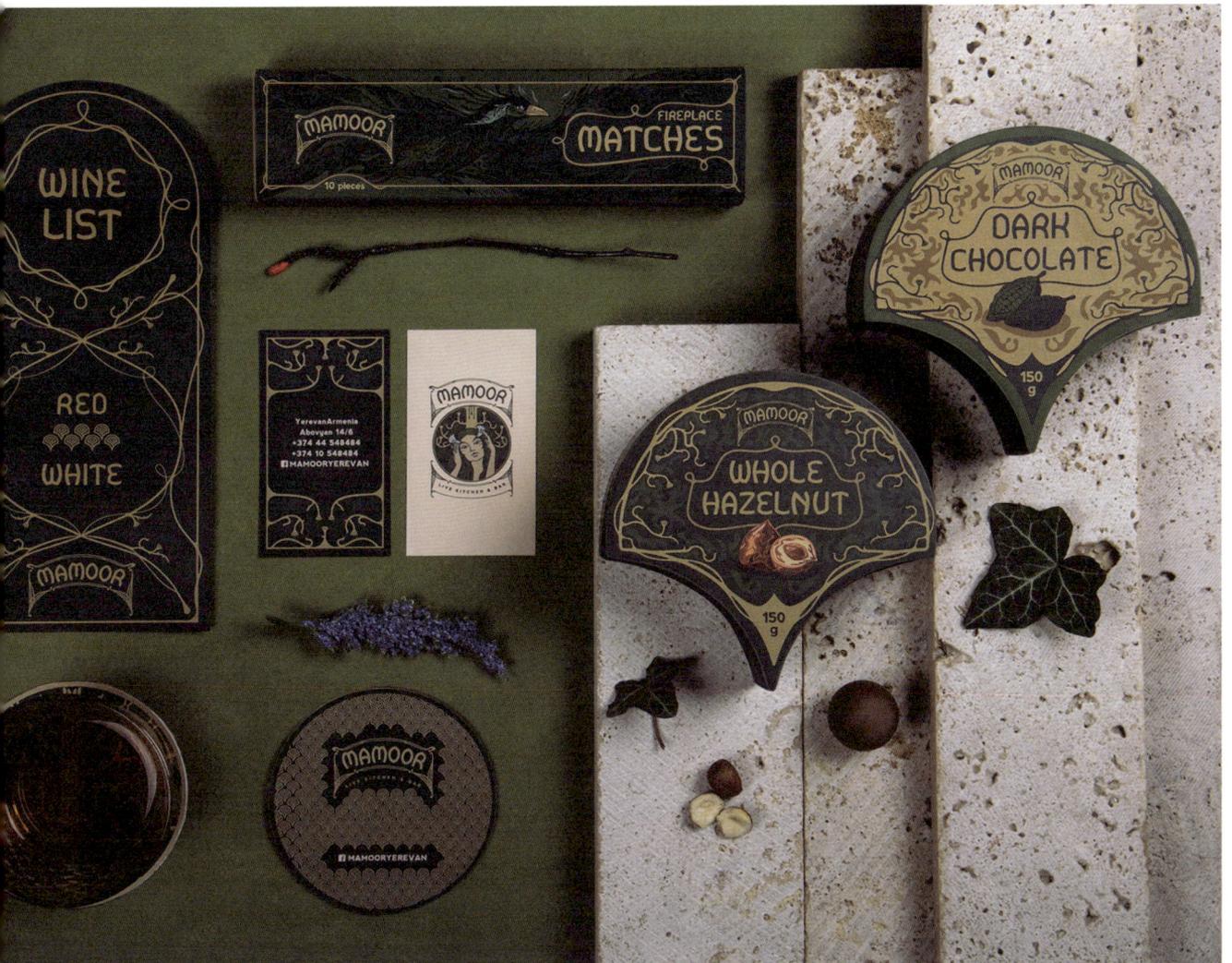

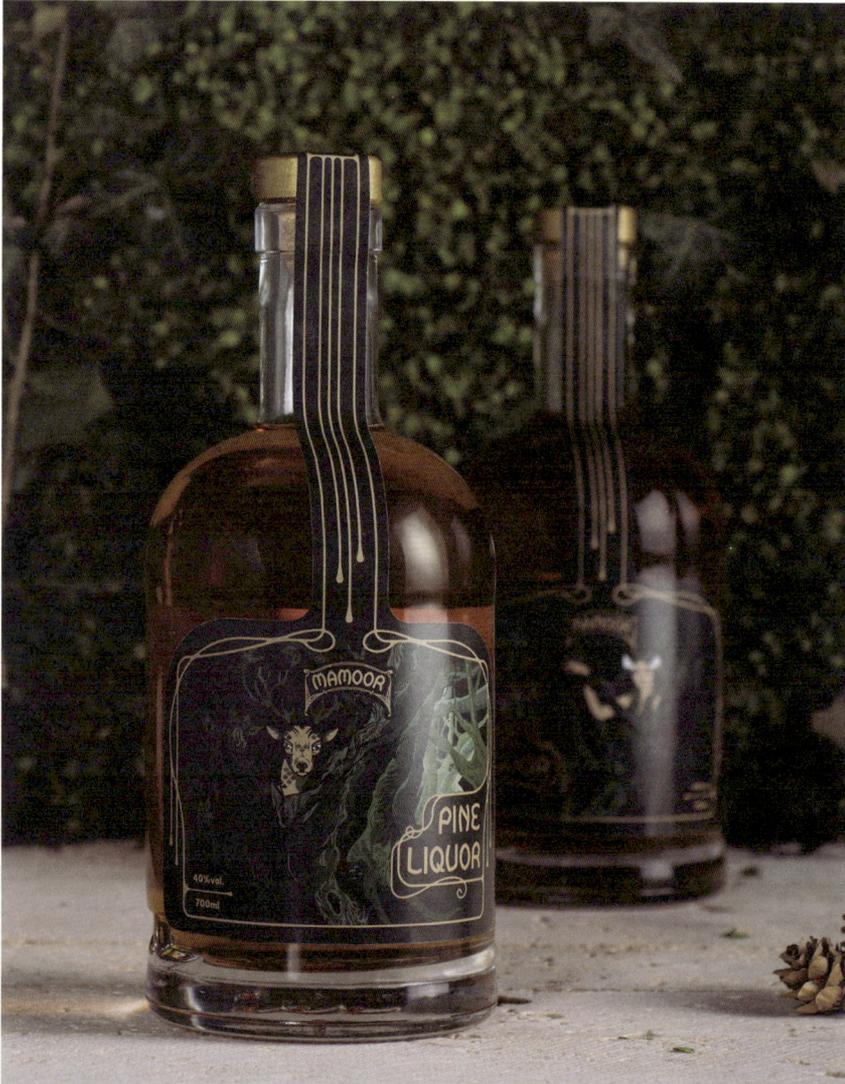

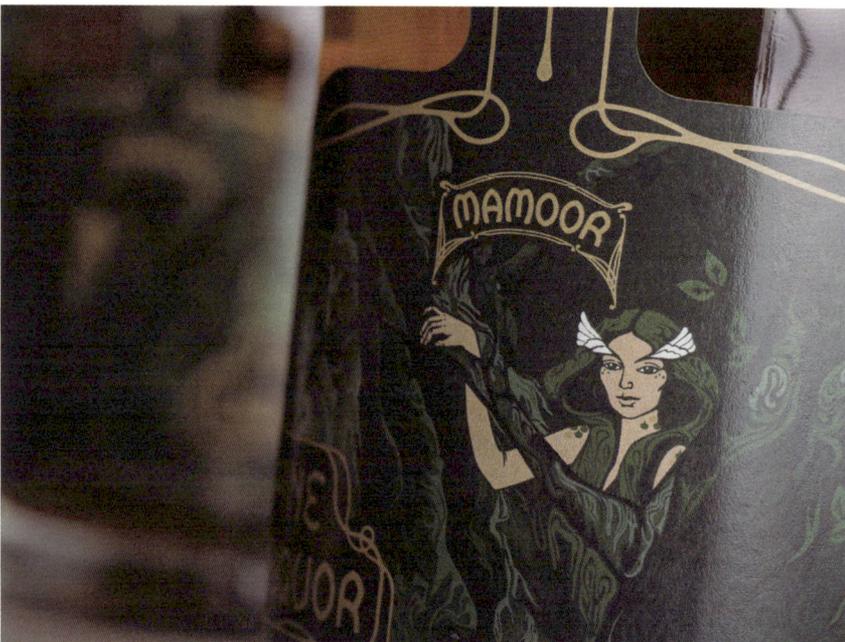

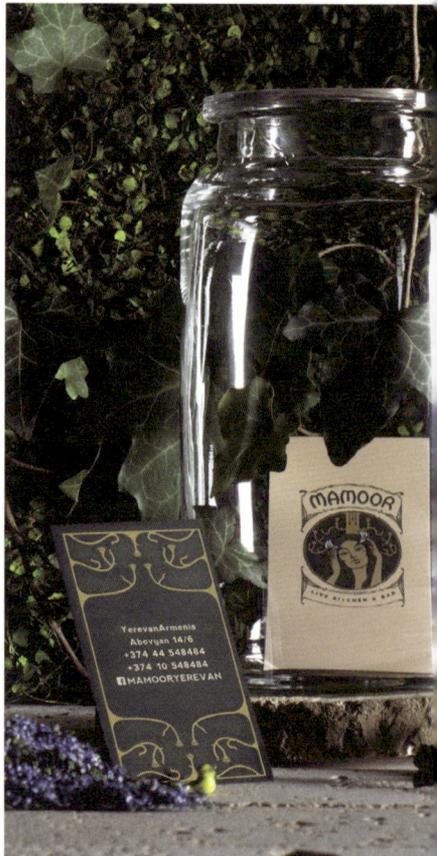

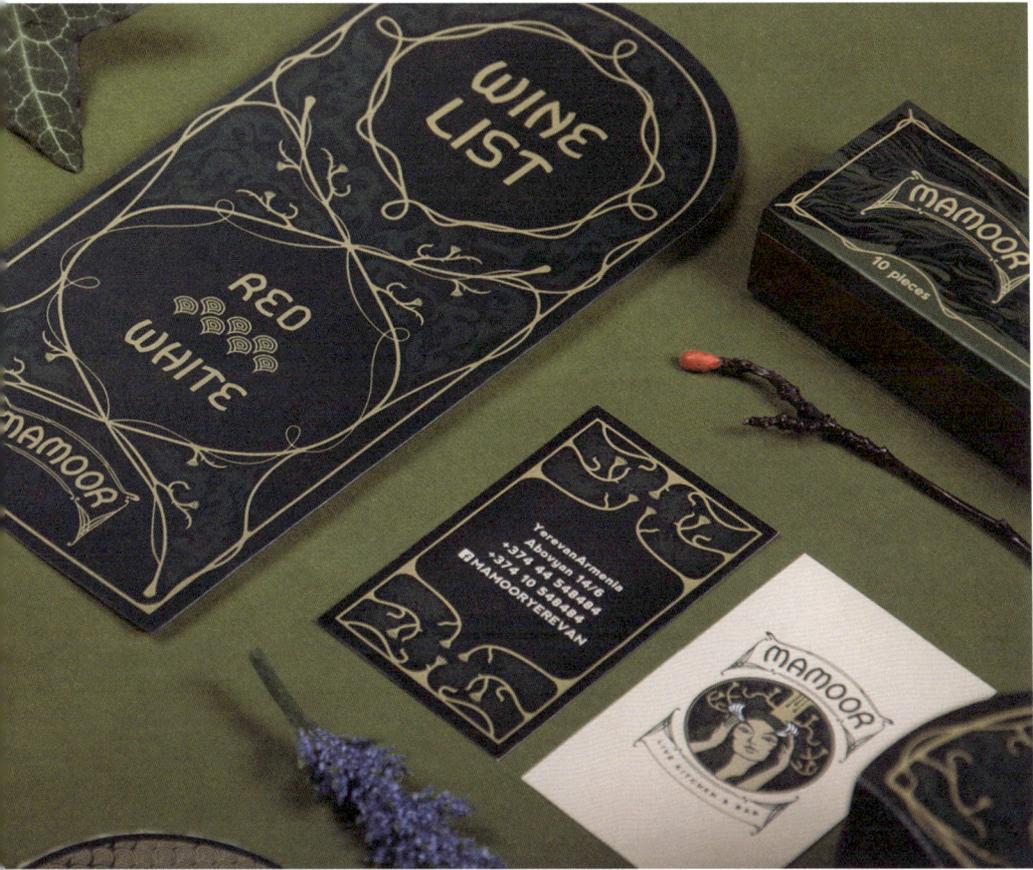

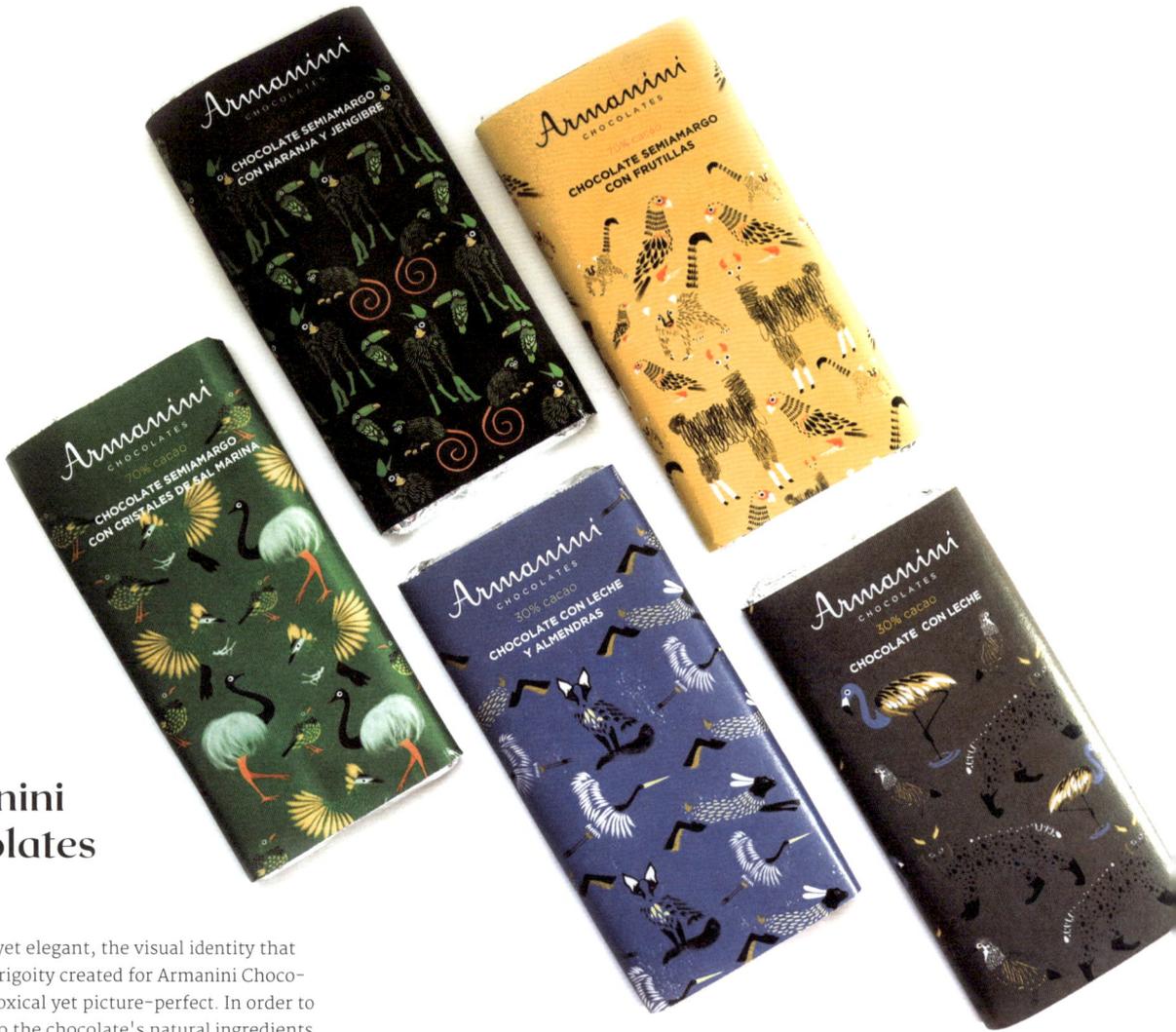

Armanini Chocolates

Raw, earthy, yet elegant, the visual identity that Natalia Elichirigoity created for Armanini Chocolates is paradoxical yet picture-perfect. In order to pay homage to the chocolate's natural ingredients and Argentine heritage, the packaging design for each of the five flavours of chocolate feature creative illustrations of the wildlife found in the different geographical regions of Argentina. The nature-inspired colour palette – yellow for the sun, brown for the soil, black for shades of the night, green for the grass and trees, as well as blue for the sky and water – add depth and meaning to the design. Through her creative work, Natalia was able to capture the chocolate's ties to its native land as well as the importance in feeling a sense of belonging.

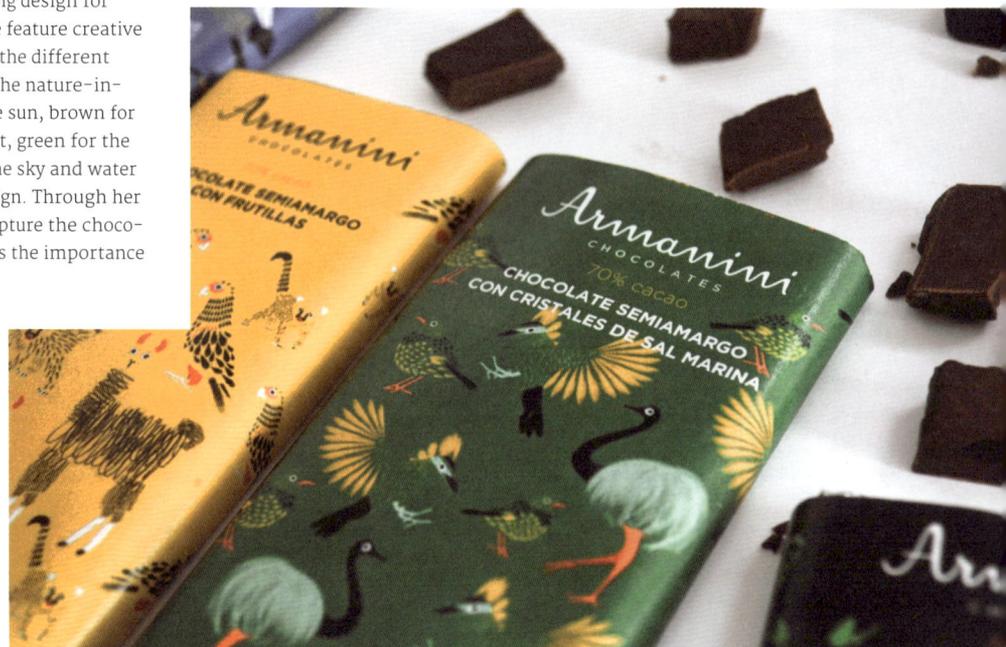

Design
Natalia Elichirigoity

Client
Armanini Chocolates

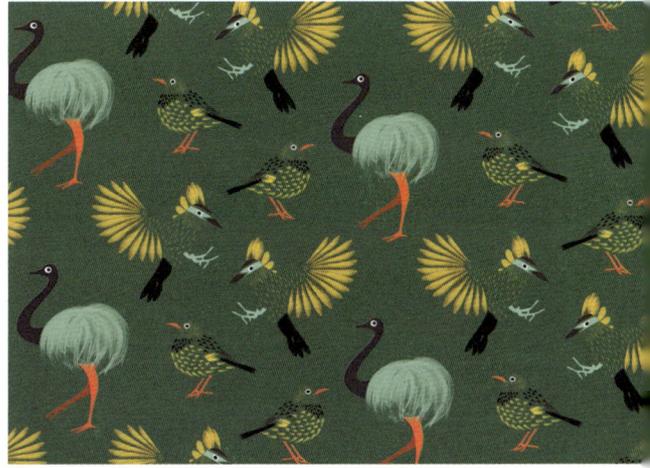

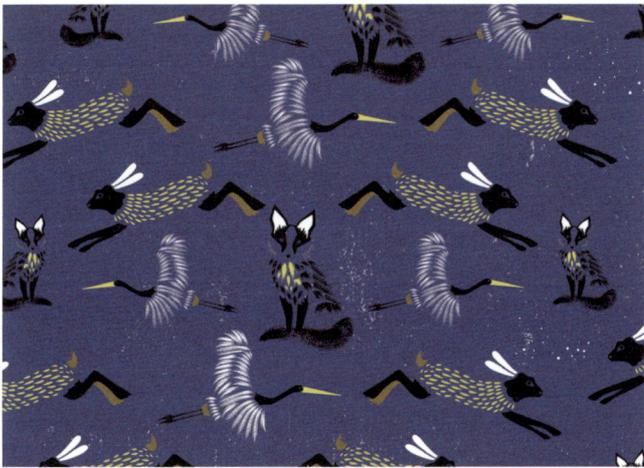

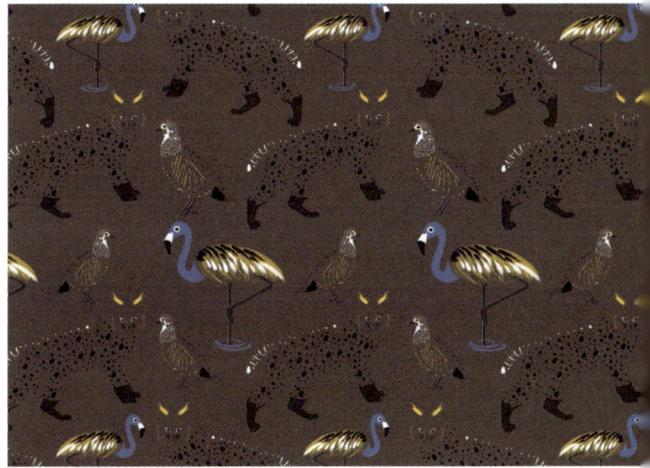

Oh! Chocolaterie

Using simple clean lines and coloured dots, Mundial created a vibrant visual language in the packaging design for Oh! Chocolaterie's products. They used a joyful orange and blue colour combination set against a plain white background to allow for the delicate illustrations to truly shine. Images of the Colombian jungle serve to reveal the story of the cocoa beans' origins, making the result not only beautiful, but also meaningful.

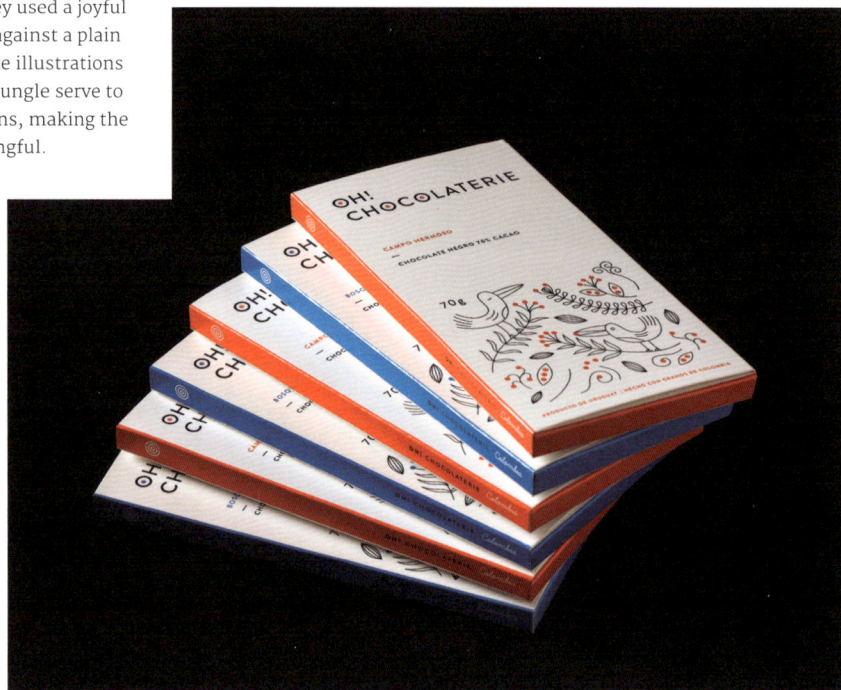

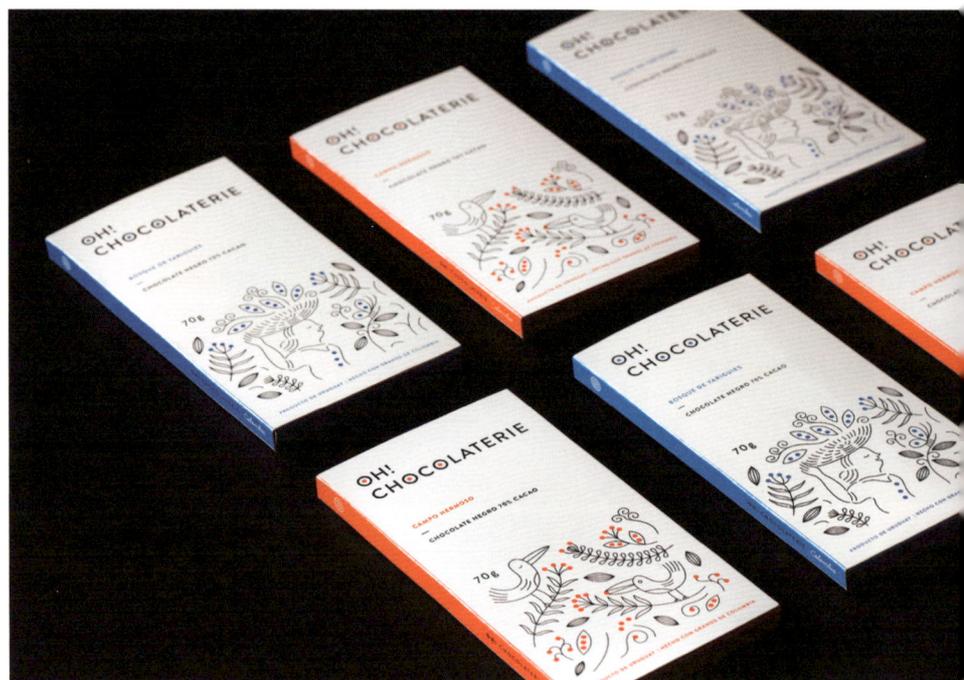

Design
Mundial

Client
Oh! Chocolaterie

Photography
Rafael Lejtreger
Aldo Giovinetti

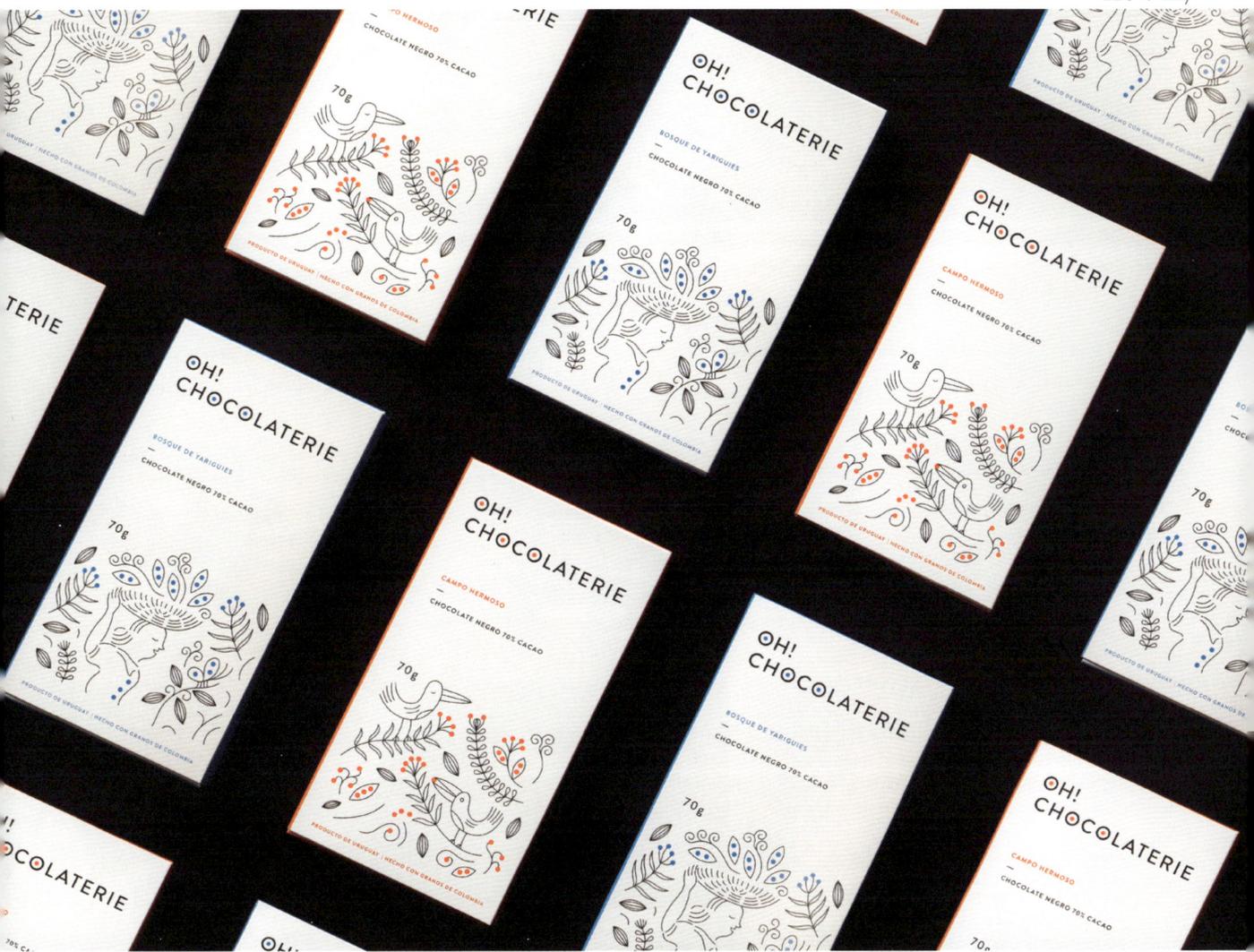

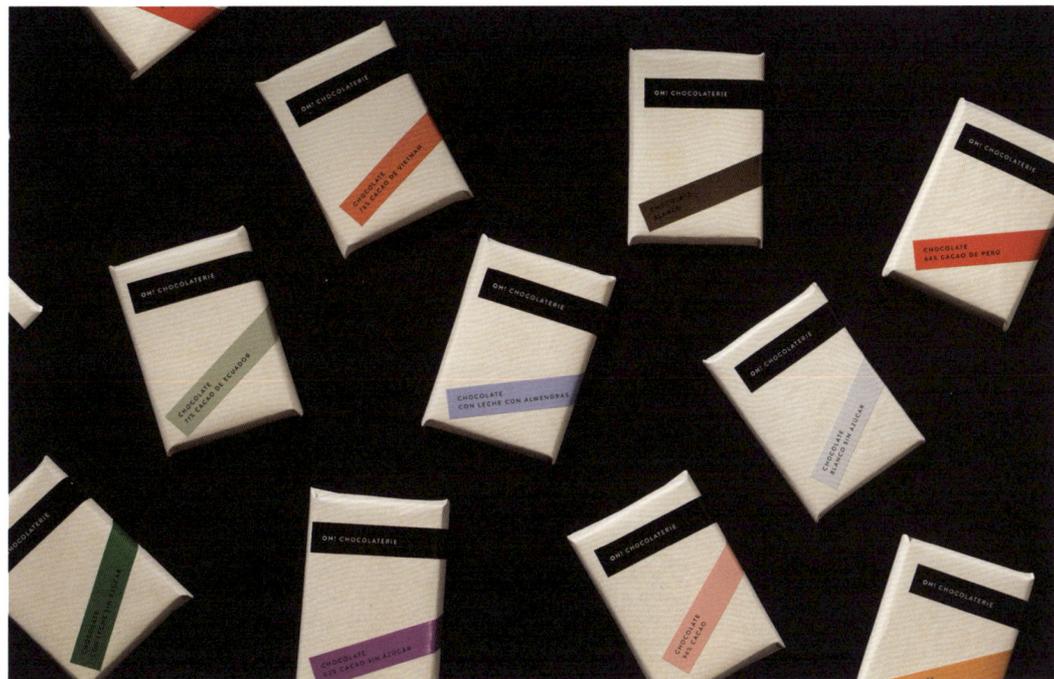

Gard'Ann
Patisserie

A clever portmanteau of the word 'garden' and the owner's name, Anne Marie, Gard'Ann is a patisserie featuring a tasteful colour palette in a French-Bohemian style. The pastel green and pink colour combination brings images of soft pastries and colourful macarons to mind, while the touches of gold further elevate the elegant atmosphere of its spacious interior. The exquisite wallpaper of various birds and leaves serves as a lively graphic addition in the space, which re-interprets the grand cafés of the early 20th century in a contemporary way.

Design
kissmiklos

Client
Gard'Ann Patisserie

Interior Photography
Bálint Jaks

Identity Photography
Eszter Sarah

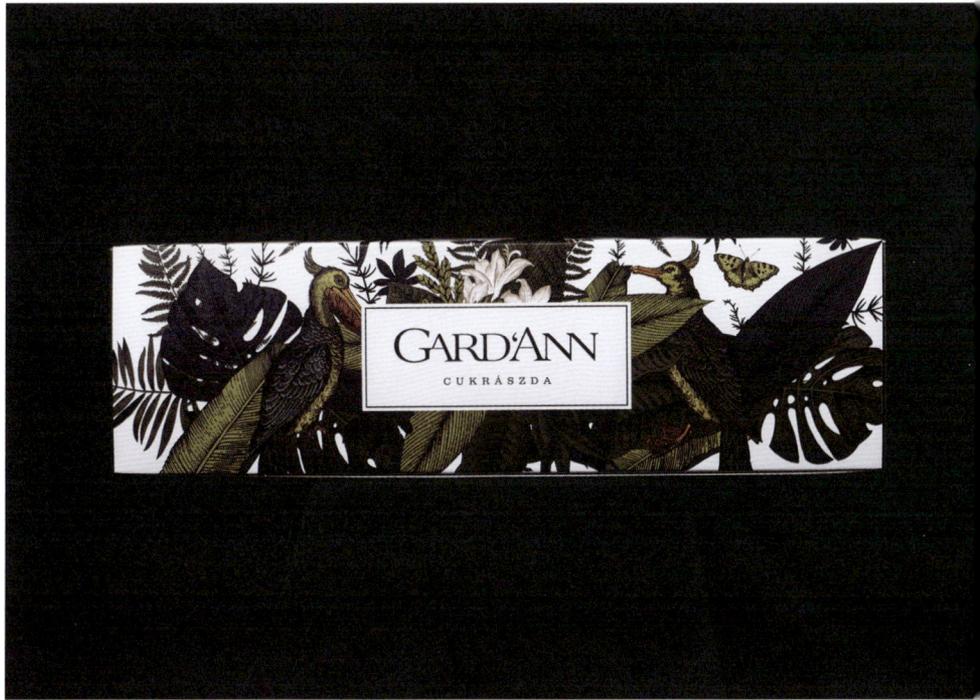

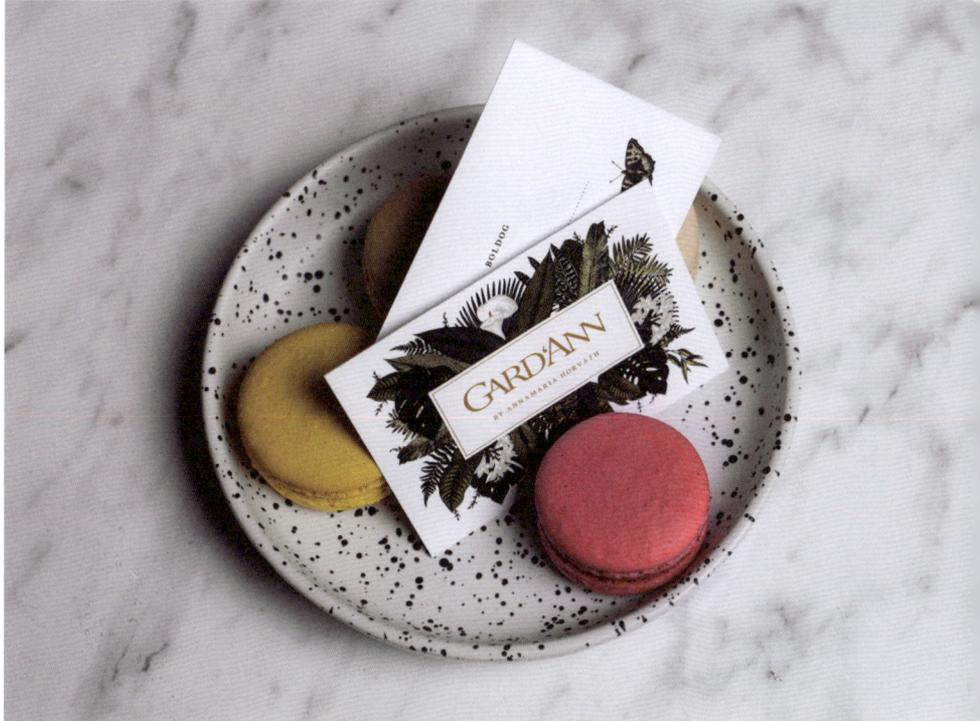

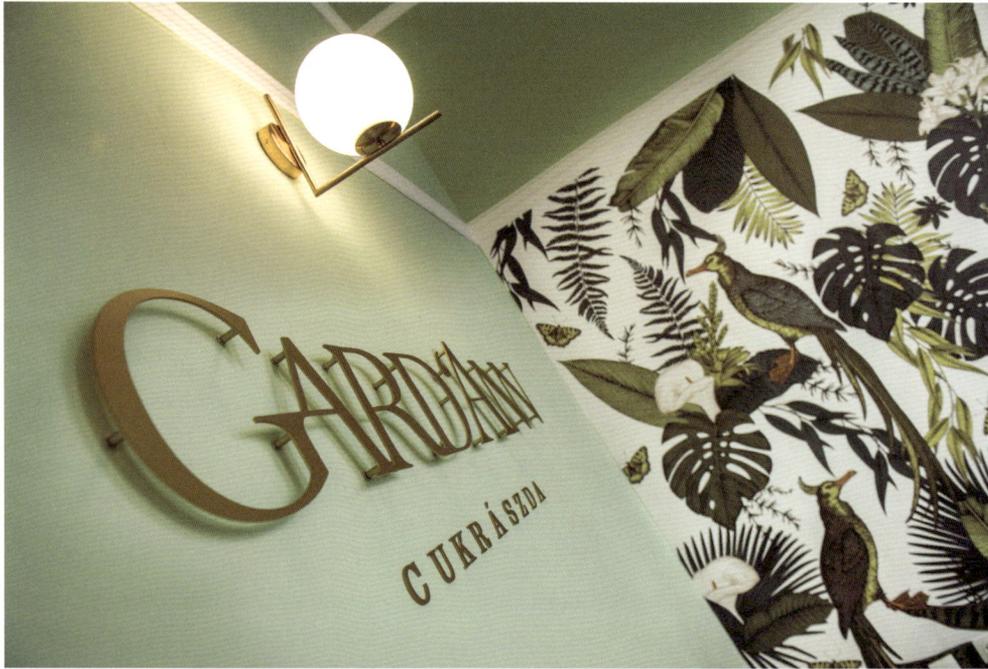

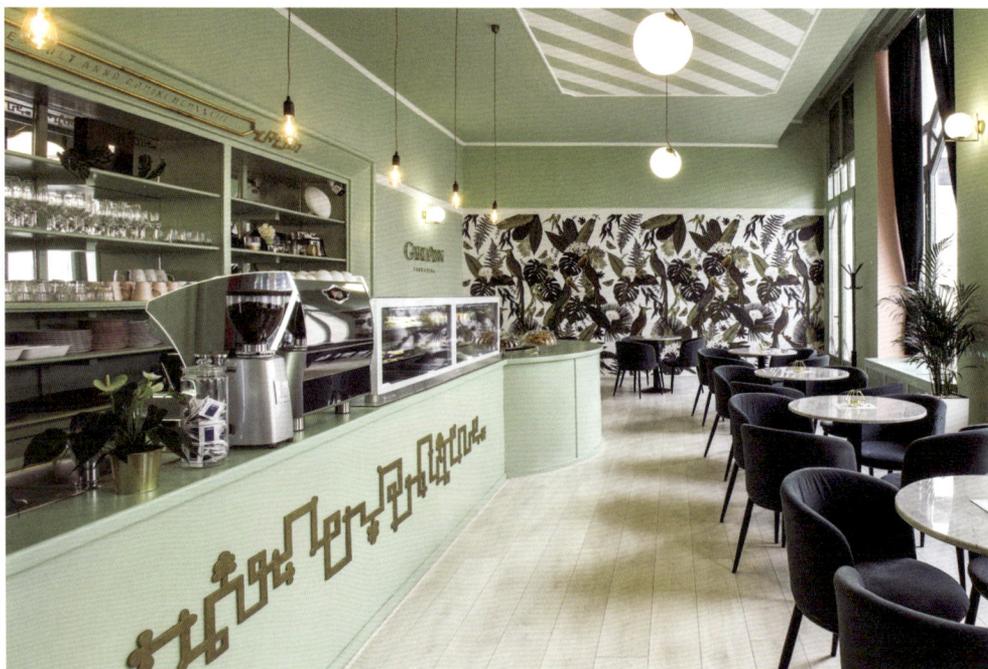

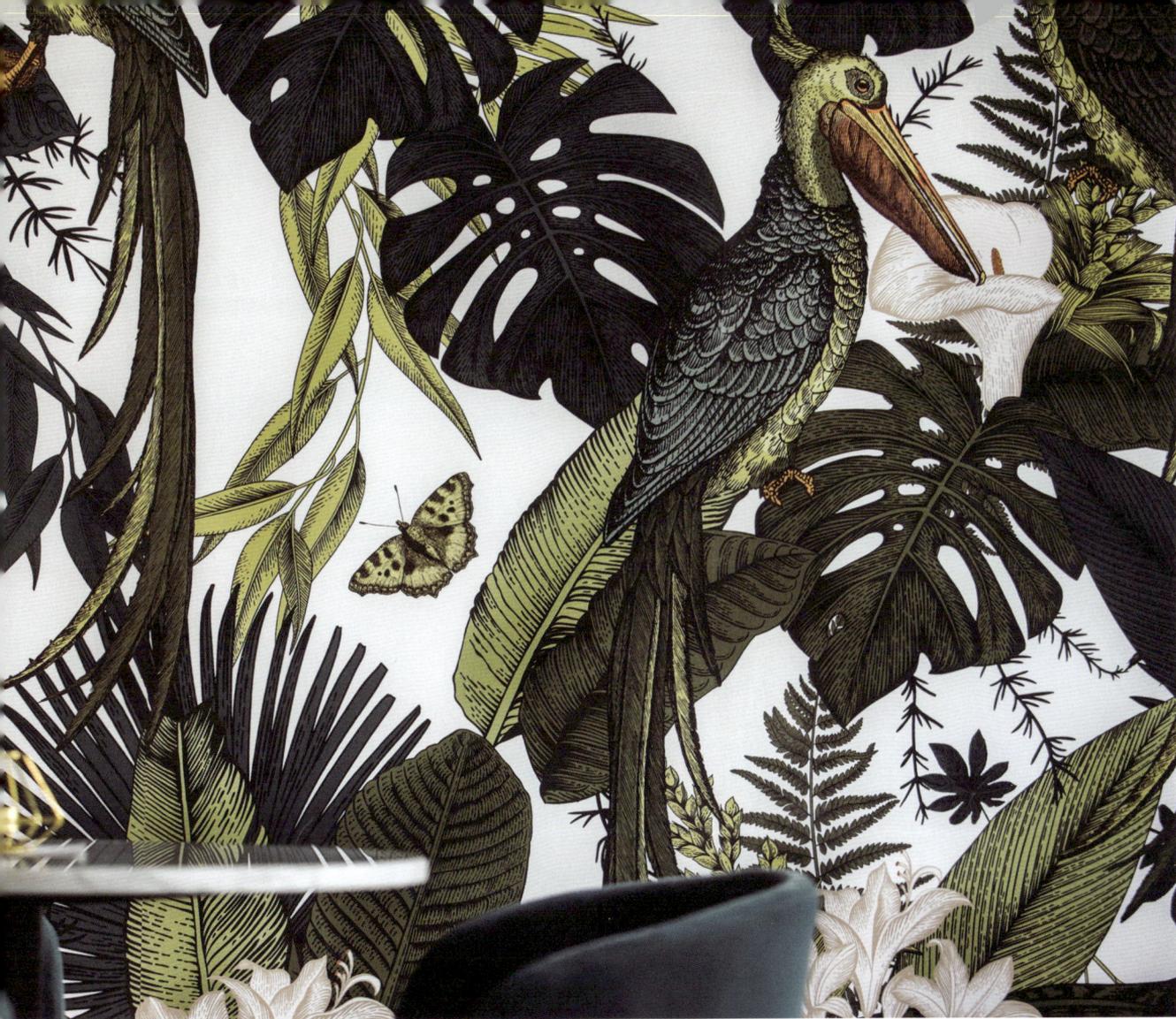

Feroz

Stylish restaurant by day, trendy club by night—Feroz is the place to be in Barcelona. In creating the visual identity for the establishment, Mucho drew inspiration from the powerful and mysterious creatures of the animal kingdom that roam the forests to create a strong and sensorial ambience. Juxtaposing the bright visages of various beasts with their habitats full of lush green foliage, the studio extended the raw and sensual qualities of their design work across multiple touchpoints in the venue.

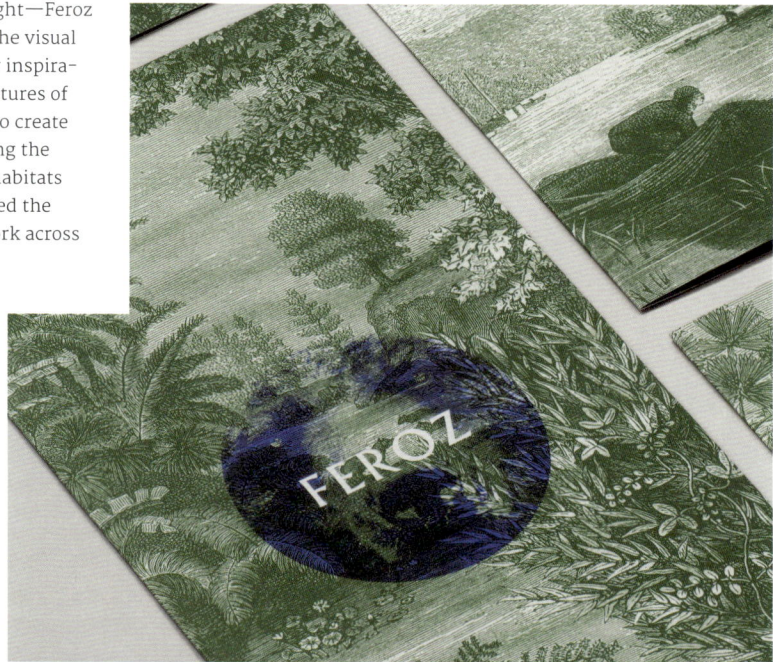

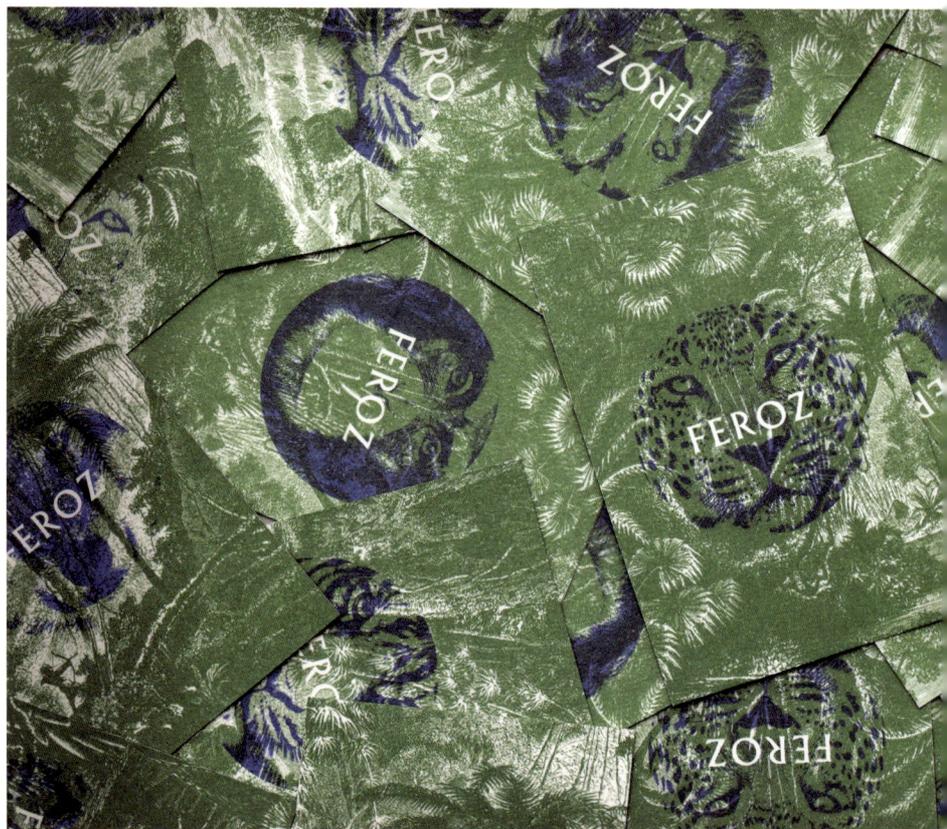

Design
Mucho

Client
Feroz Restaurant

Interior Design
Pablo Peyra Studio

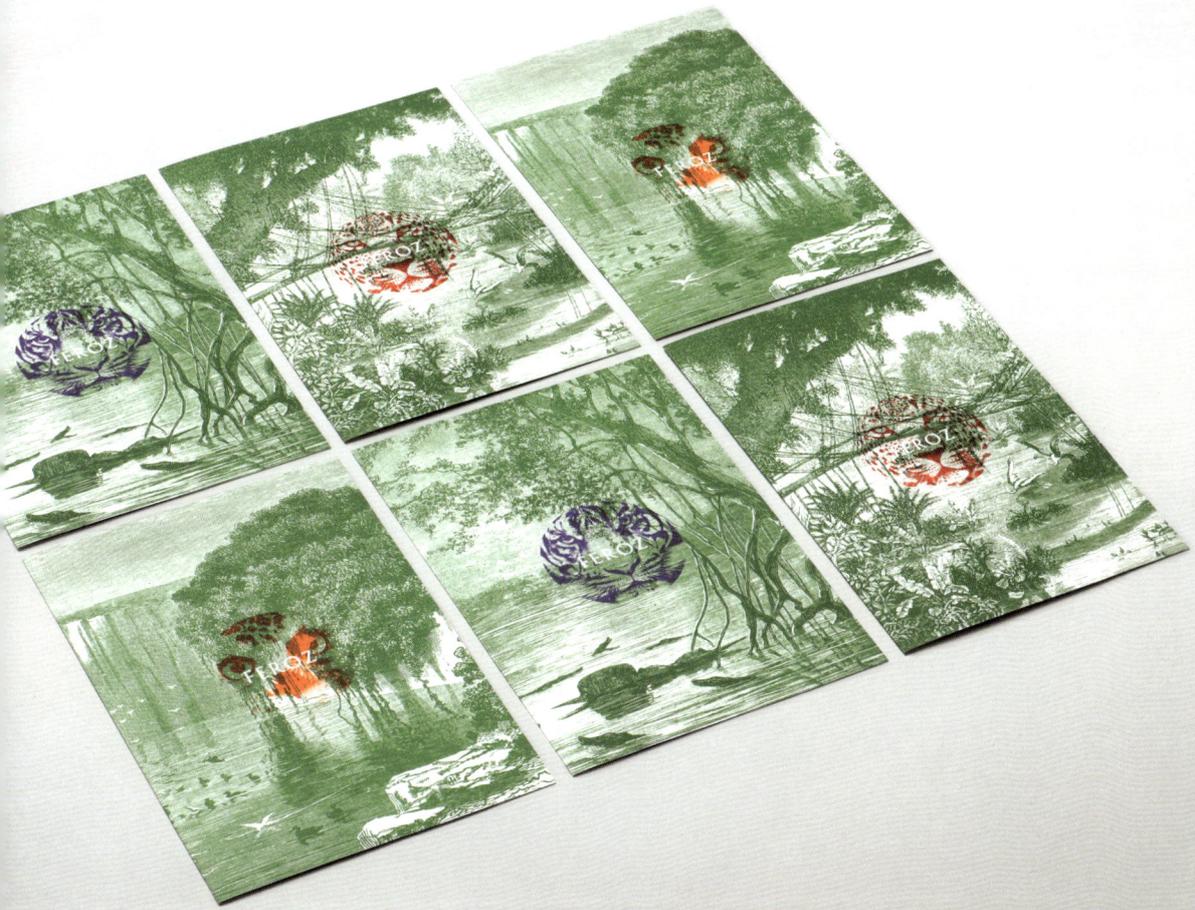

Ars Cameralis Festival 2015

For the 24th Ars Cameralis Festival, Marta Gawin sought to design a visual identity that was as distinctive as the collections of the organisers involved. The result of this goal was a fantastical collection of illustrations involving a unicorn, the legendary mythical animal of extreme rarity and appeal, as well as a rhinoceros, the modern-day equivalent of the unicorn that is similarly hunted and believed to have beneficial health effects. Basing these illustrations on famous historical sources, such as the 12th-century Aberdeen Bestiary manuscript and Albrecht Dürer's rhinoceros woodcut of 1515, Marta's designs presented a contemporary twist in their bold, graphic style resembling stained glass, accentuated by vivid colours, golden lettering, and expressive medieval-style typography. Her final work exuded a surreal, fairy-tale feeling that mirrored the qualities of the festival: ephemeral, mysterious, and beautiful.

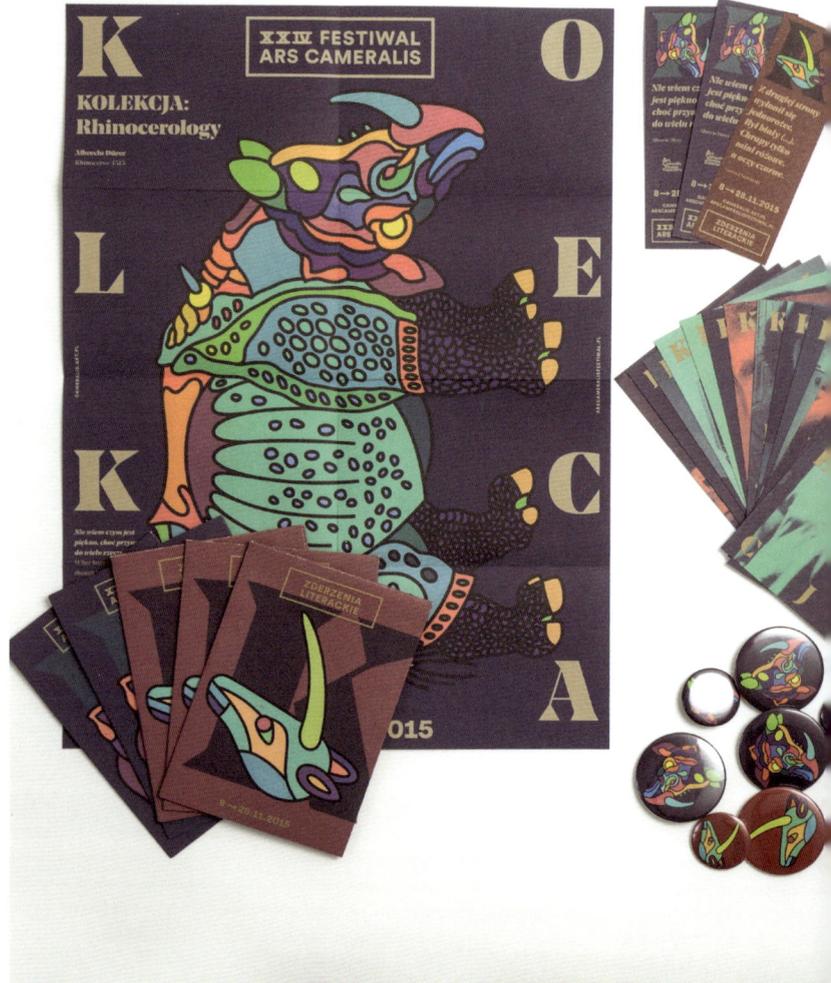

Design
Marta Gawin

Client
Ars Cameralis Silesiae Superioris

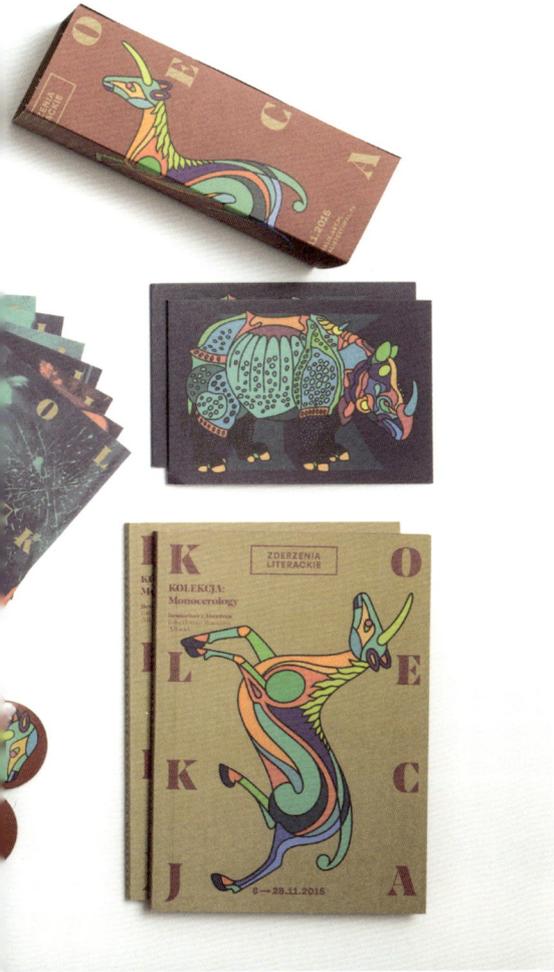

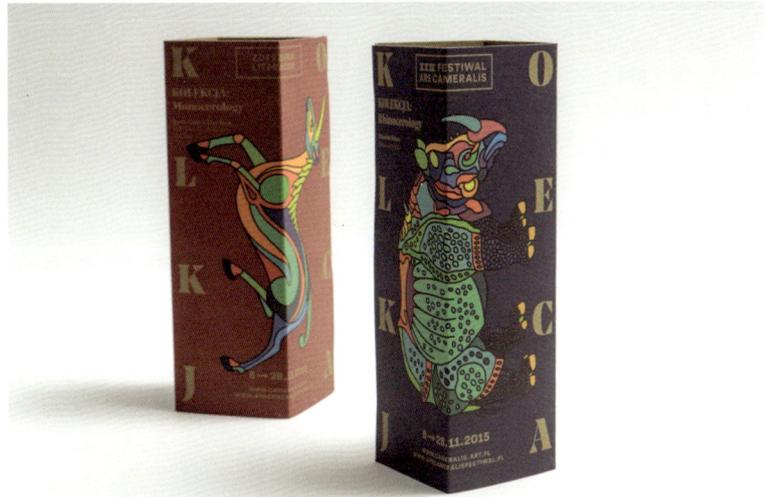

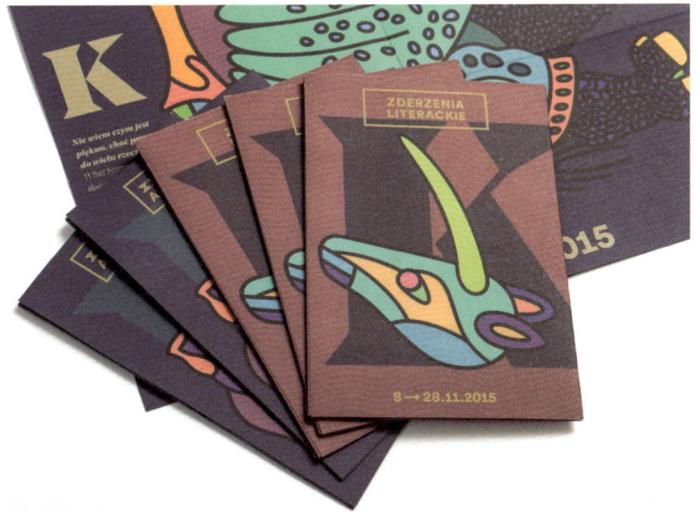

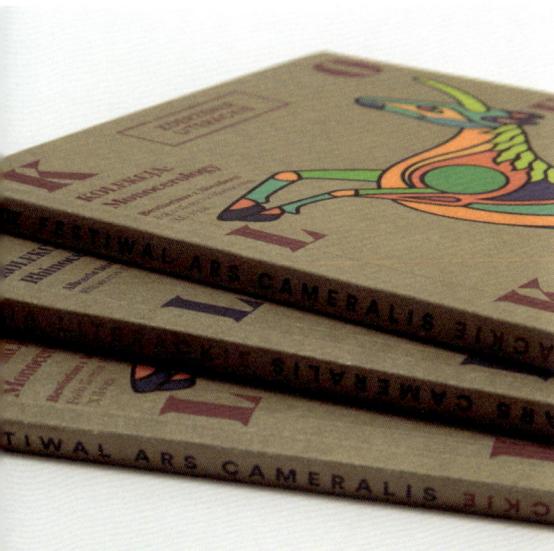

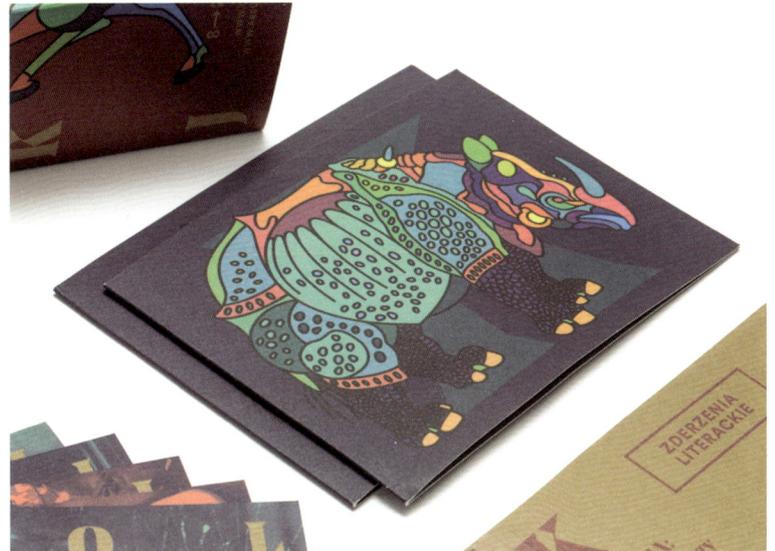

2016 Brand New Conference

Inspired by the music culture of Nashville, where the 2016 Brand New Conference was held, Under-Consideration designed a bright visual identity for the event that referenced the colours and patterns of country singers' outfits. Characterised by elaborate floral and botanical scenes punctuated by birds and butterflies, these illustrations accompanied hand-placed rhinestones on the event collaterals and souvenirs.

Design
UnderConsideration

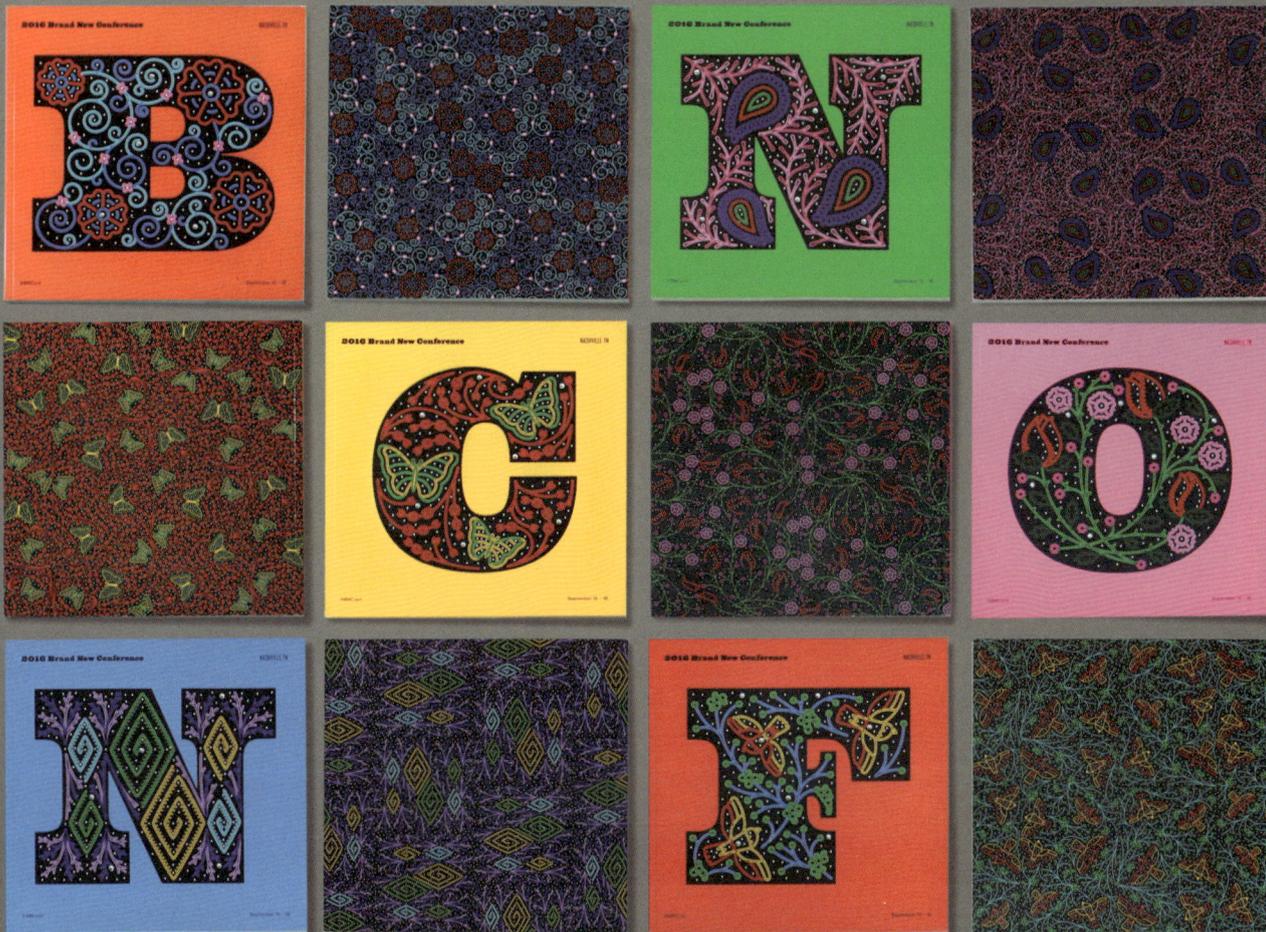

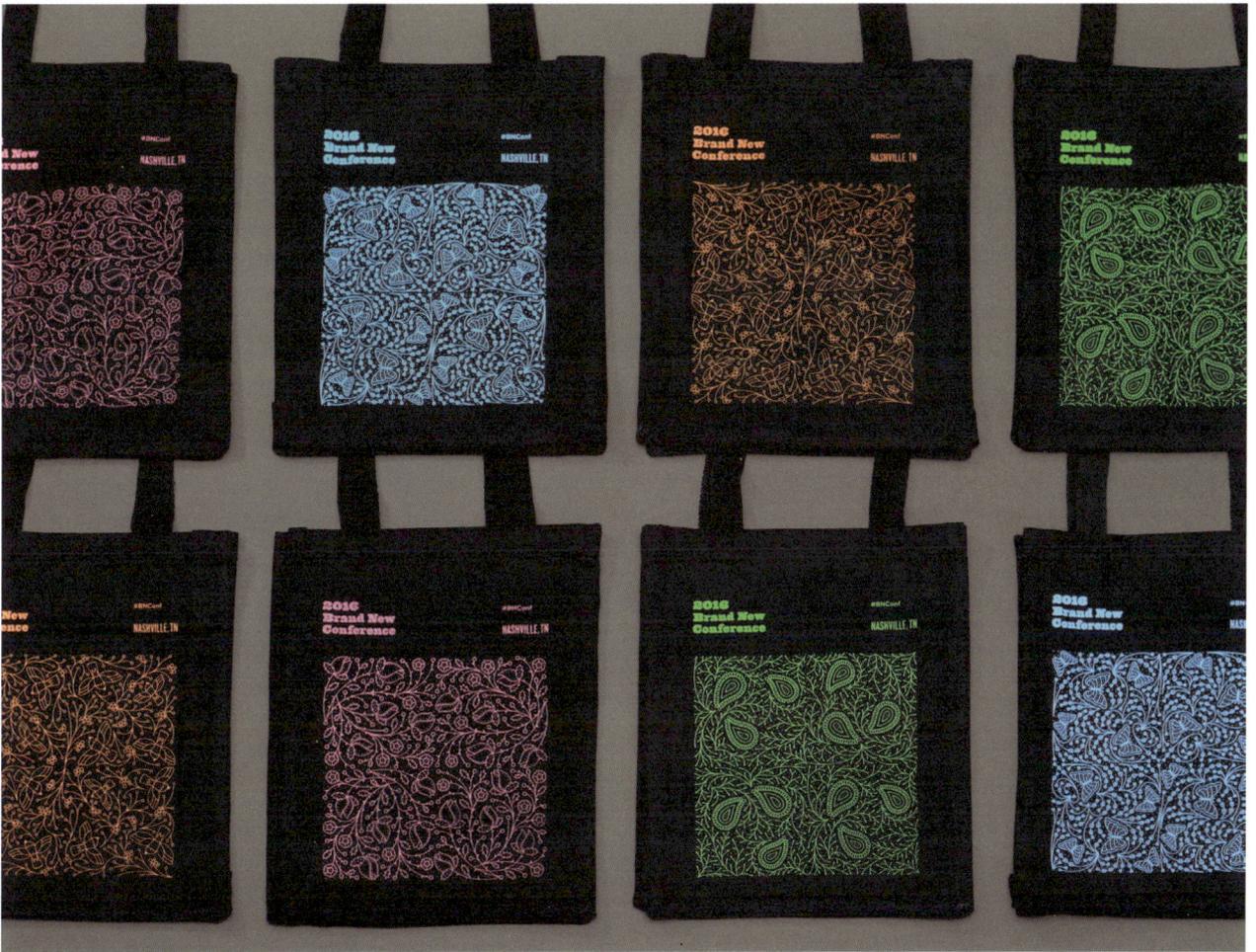

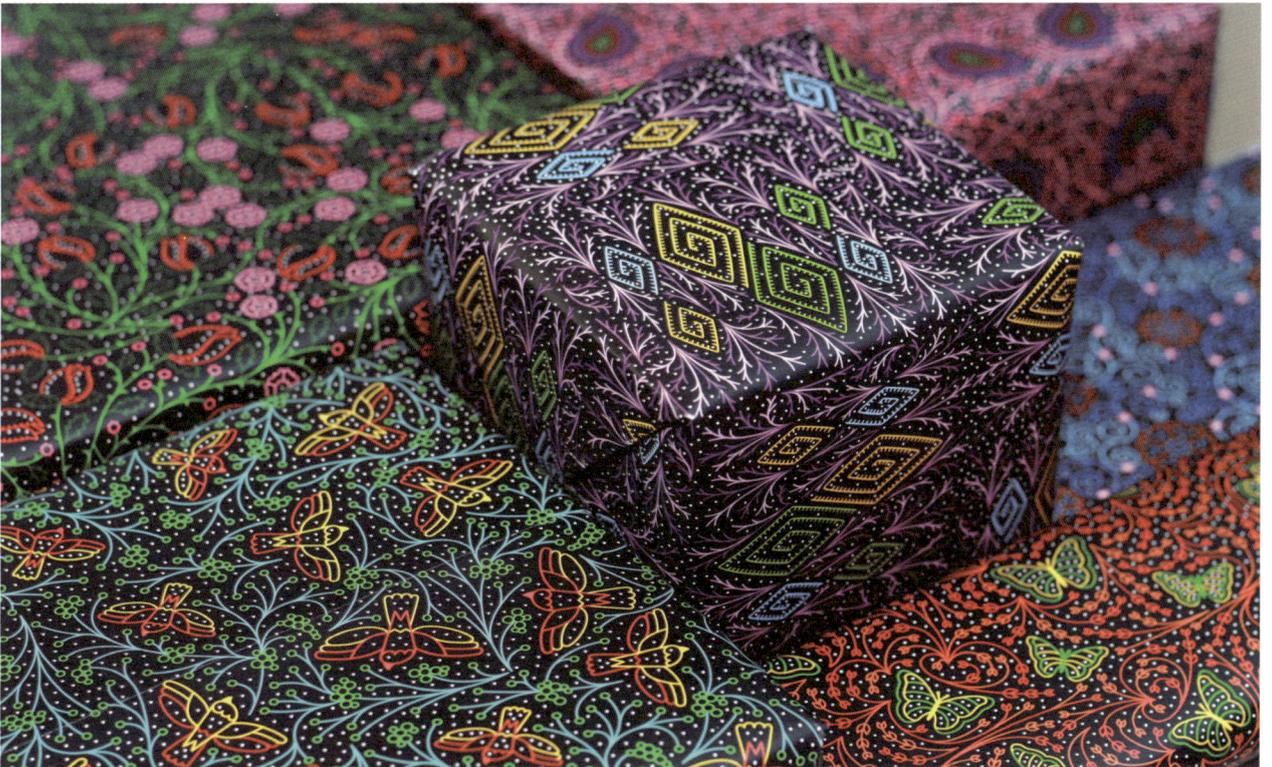

The BirdYard
Eatery and Bar

Epitomising the concept of balancing extremes, The BirdYard Eatery and Bar features entirely hand-painted murals extending from the floors to the ceilings of the venue – depicting colourful birds against lush foliage on a magnified scale. Besides being visually impactful, the immersive environ-ment serves to provide diners with an ant's-eye-view of a bird's world. The sleek logotype and simple typography used in its black-and-white branding suite perfectly juxtapose and complement the wild world created through the interiors.

Design
Atelier Olschinsky

Client
The Birdyard Eatery and Bar

Architectural Concept & Interior Design
Tzou Lubroth Architects

Wall Art
Saddo

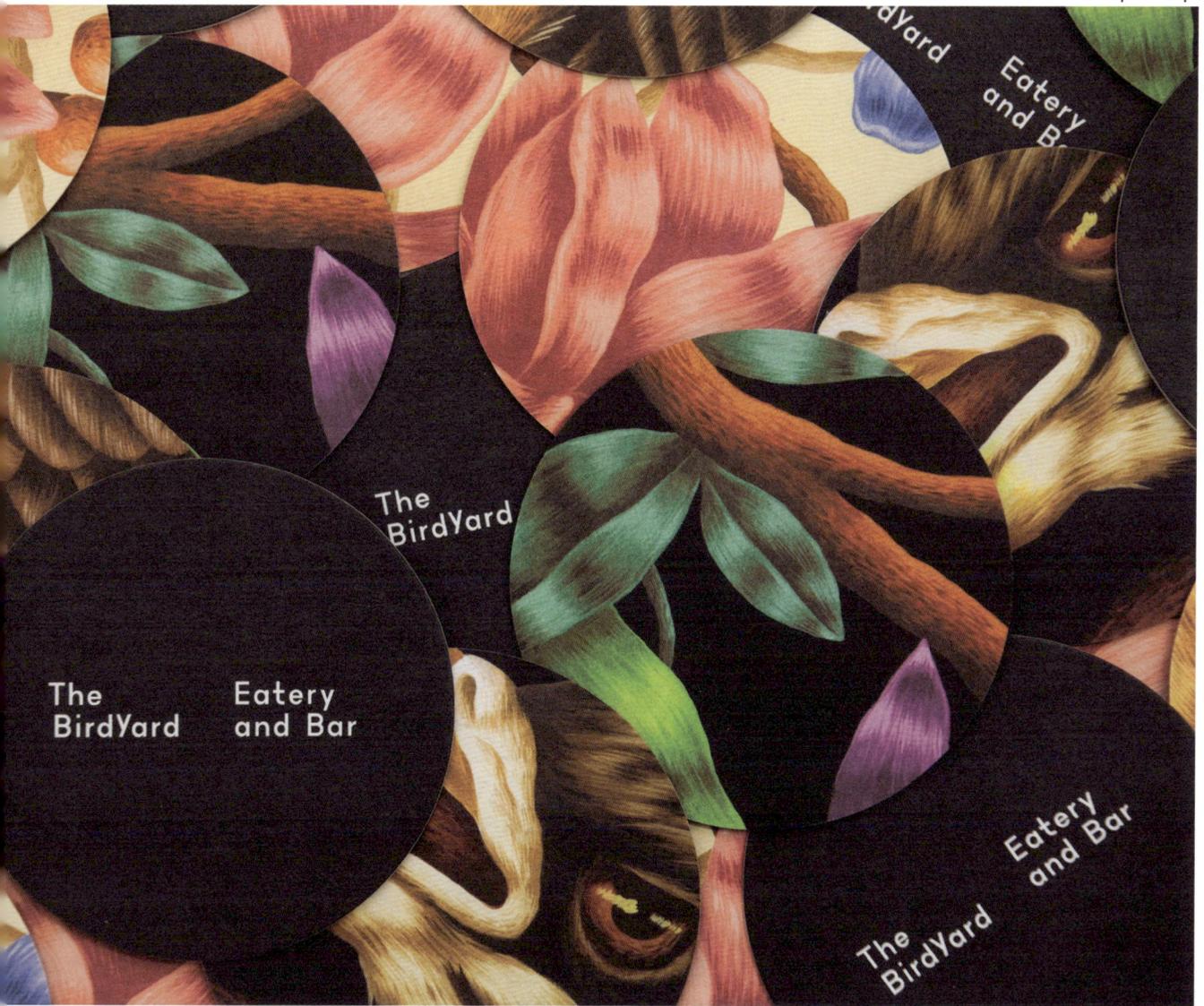

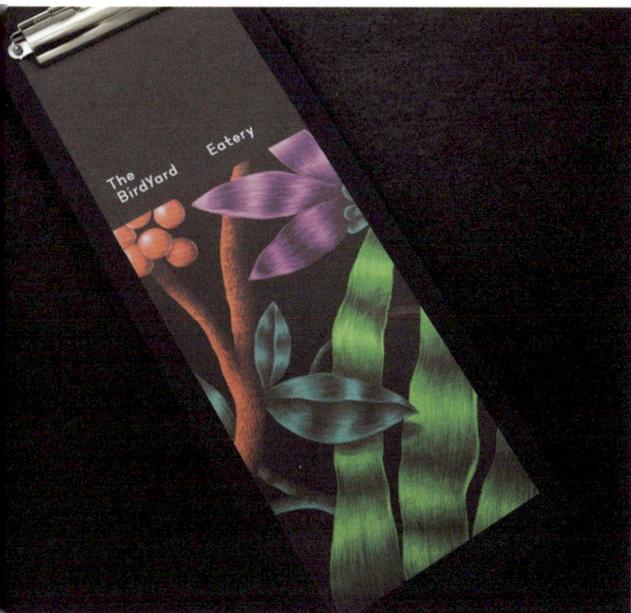

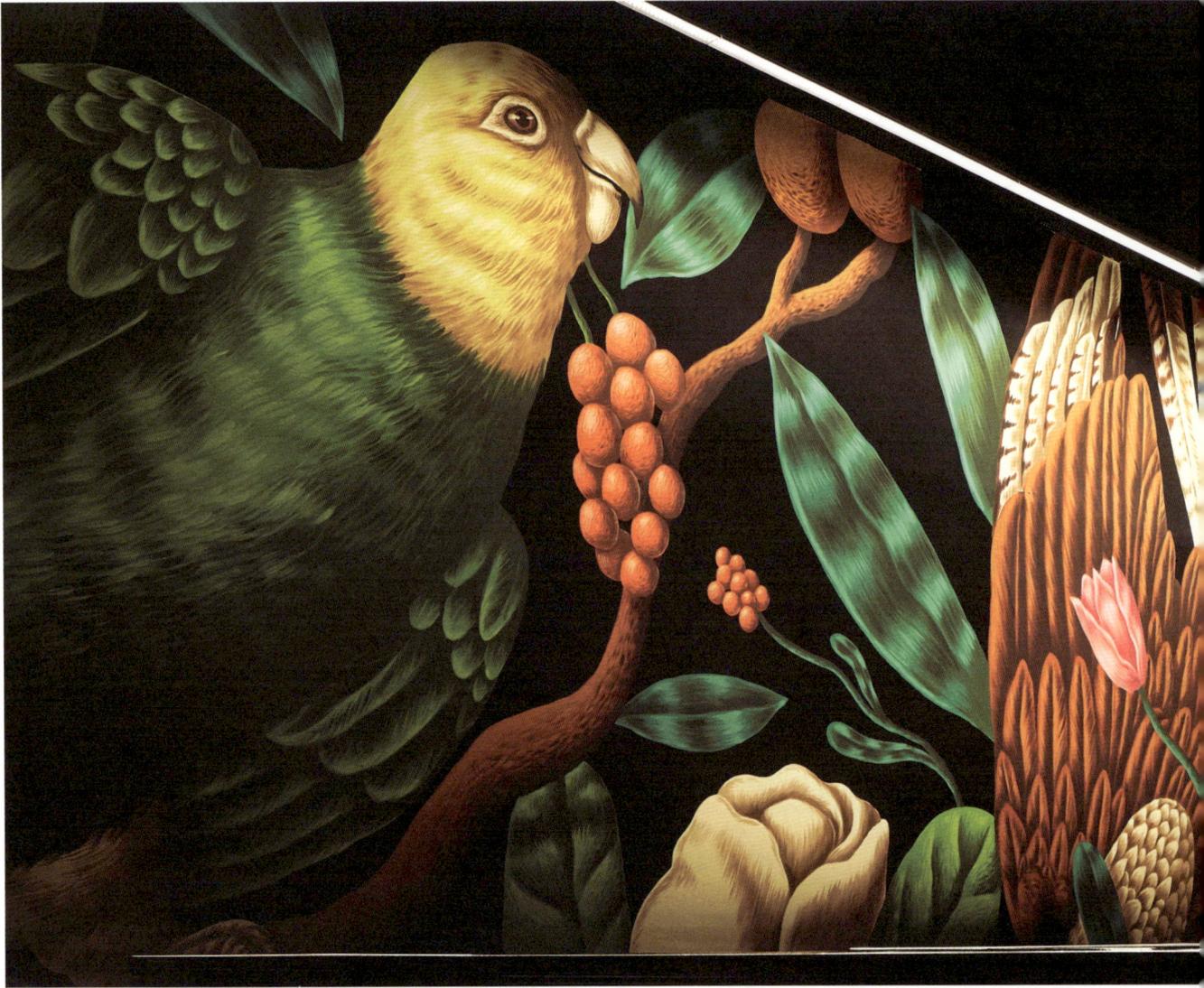

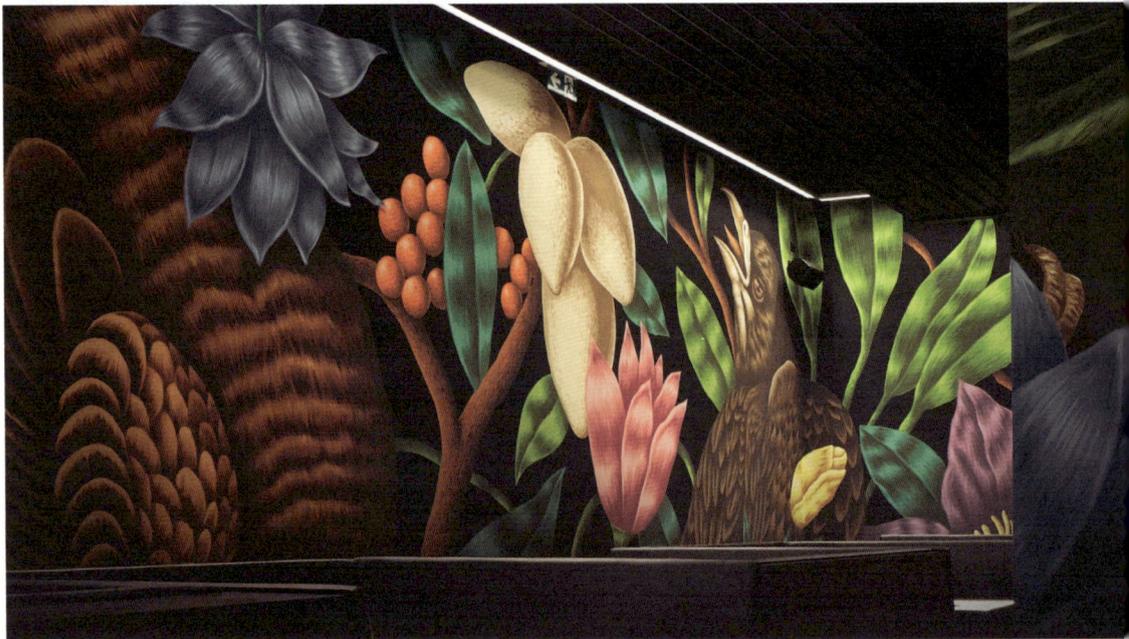

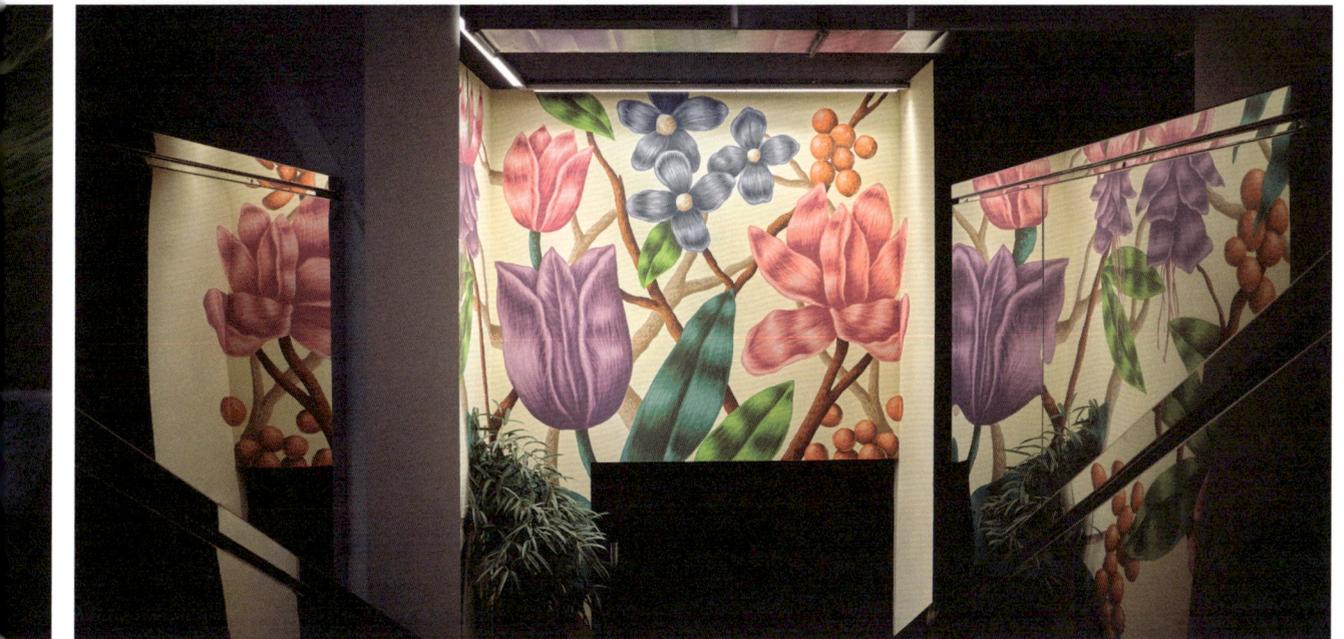

Iris & Cole

Reflecting the brand's mindful approach to life as well as its return to simplicity, Pata Studio's packaging designs for Iris & Cole's artisanal skincare line features a floral ampersand – composed entirely of various plants used in the products. Set against a velvety-black background, the modern yet natural feel of their delicate design work highlights the potency and effectiveness of the natural ingredients used in its innovative anti-aging blends.

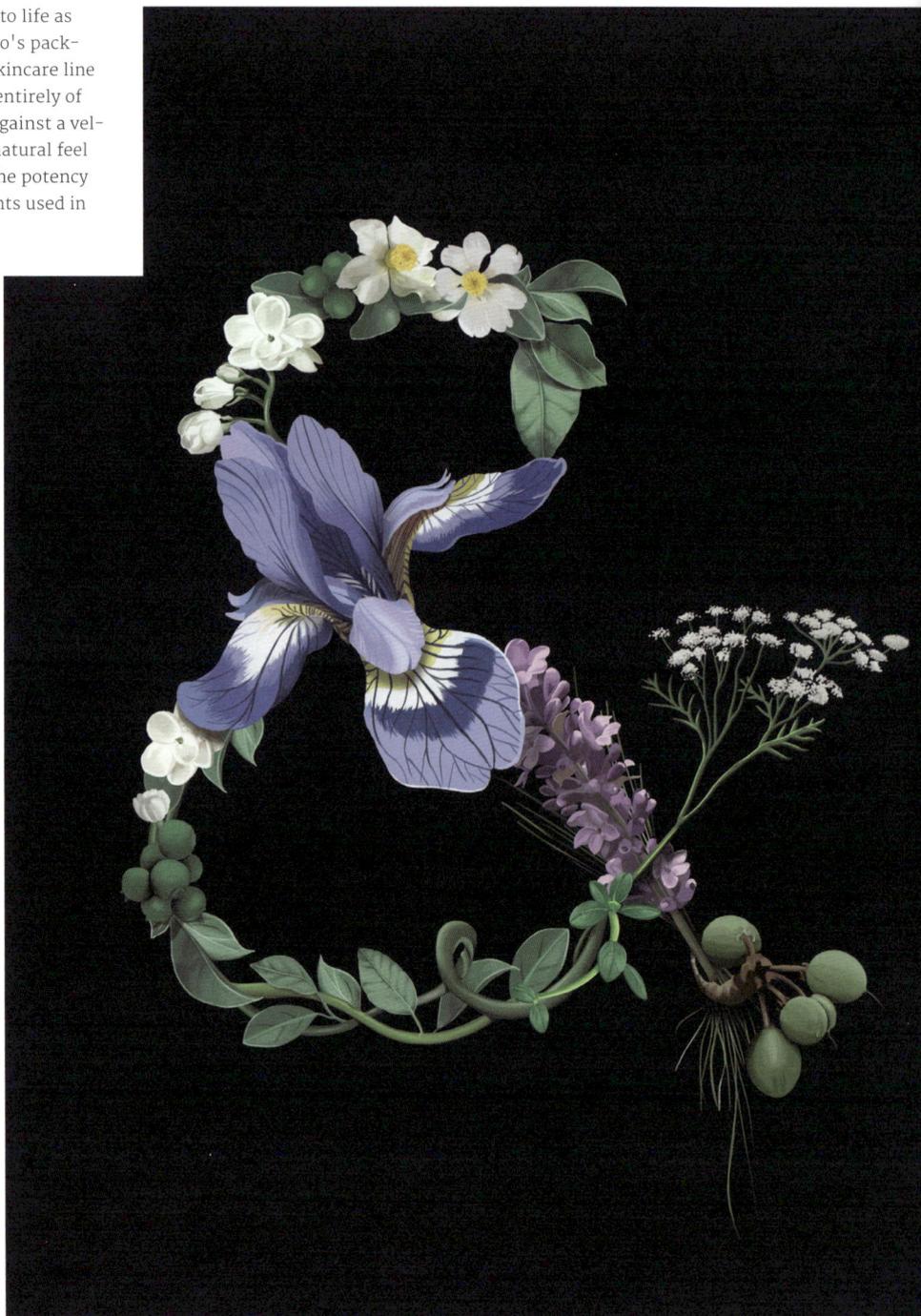

Design
Pata Studio

Client
Iris & Cole LTD / United Kingdom

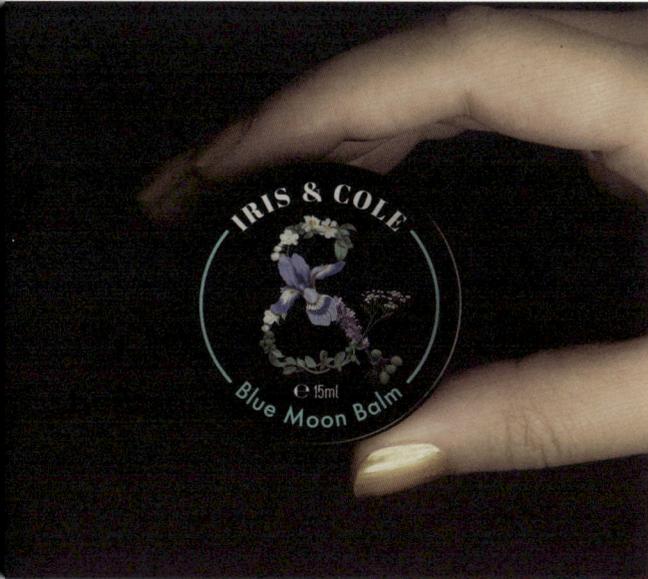

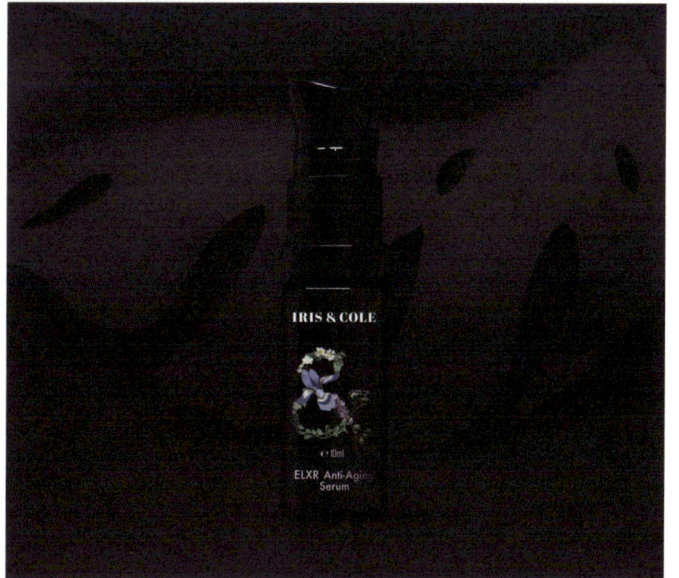

Takeo Calendar & Diary 2015 'Baa Baa Black Sheep'

Inspired by the age-old nursery rhyme, Shine Visual Lab used the 'Baa Baa Black Sheep' phrase and a sheep motif as the main visual elements in designing Takeo's annual gift set for clients in 2015. As it was the Year of the Sheep according to the Chinese Zodiac, the set consisted of a diary, a calendar and a set of Chinese New Year red packets with golden abstract patterns of the animal to convey the company's best wishes in a modern, bright, and fun way.

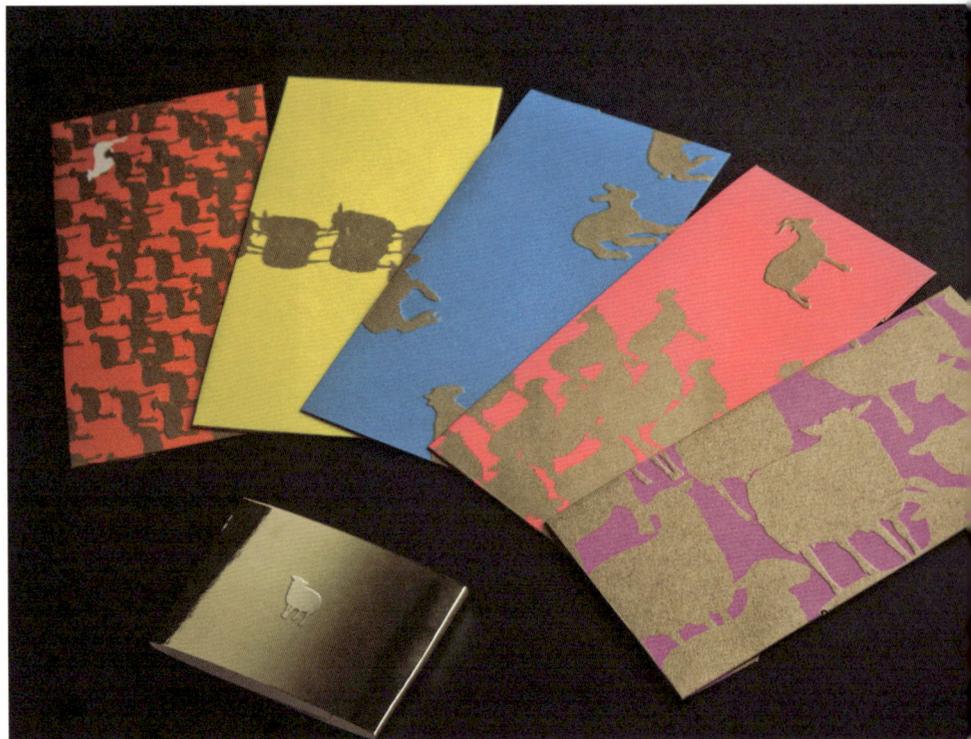

Design
Shine Visual Lab

Client
Fine Paper Takeo Sdn Bhd

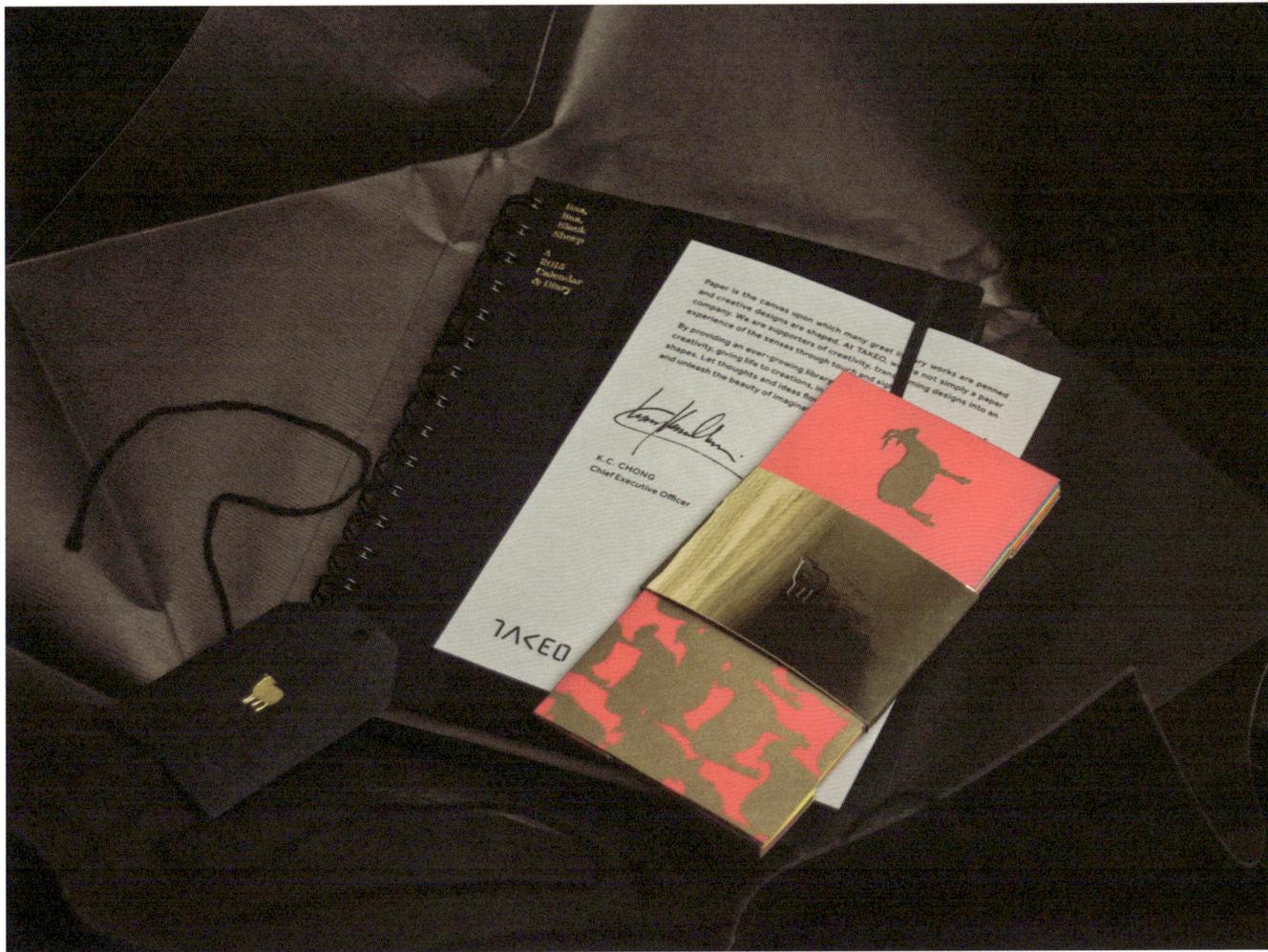

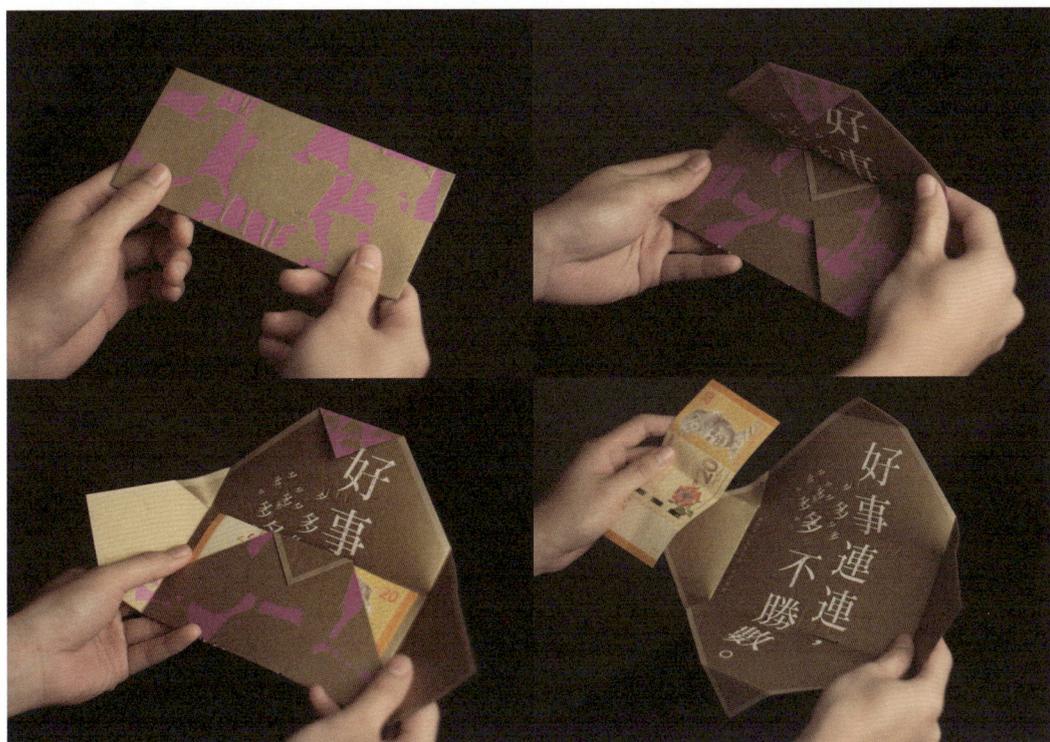

Index
for Symbolic Representations

Profiles
for Creative Applications

Believing in the power of design to make people feel, 2TIGERS design studio is a small multi-disciplinary studio based in Taichung. The studio strives to represent the spirit and value of each brand they work with by creating designs that are not only beautiful but also meaningful.

Operating at the epicentre of Hong Kong's design revolution, A Work of Substance is a design studio that aims to restore or rejuvenate culture. Their projects create works of substance that provide places for people to look to for inspiration. As their clientele expands in size and location, the studio continues to be daring and curious, venturing out into new industries such as furniture and lighting.

Keeping a great idea at the heart of everything she does, Angelina Pischikova is an award-winning graphic designer from Minsk. As a highly curious and organised worker, she always strives to provide her clients with creative designs of the highest calibre.

Working with the singular goal to make brands matter, Anomaly Brands is an independent brand transformation and invention company. Operating mainly across India and the Middle East, it aims to help every client become a relevant, distinct, and beloved brand to their consumers.

Producing work that is human minded and engineered, arithmetic is a creative agency whose work is constantly inspired by a personal passion for a healthy and happy lifestyle through artistic expression and wellness. Nature is often closely tied with their designs, woven into the essence of their work. The arithmetic team always immerses themselves into each brand they work with in order to convey their voice, story, and identity accurately.

Founded in 2001 by Shun Kawakami, artless Inc. is a global creative agency that creates art and design for the global marketplace. Based in Tokyo and Kyoto, the team works together and brings diverse perspectives to every new project they embark upon, whether in branding, graphic, interior, web, or other forms of design.

Based in Kobe, asatte is a design office founded in 2010 by Satoshi Kondo, an Osaka native and graduate of both Kobe University and Inter Medium Institute in Osaka. Satoshi Kondo is also a part-time lecturer at Kobe Design University and Kyoto University of Art and Design in addition to running the design office.

Based in Vienna, Atelier Olschinsky is a creative studio that was founded in 2002. The studio not only provides services in graphic design, illustration, photography, and art direction, but also runs several independent projects at the same time in order to develop and refine their work more often.

Believing in the power of design to bring brands to life, Backbone Branding is an independent branding studio that offers intelligent solutions to their clients. Serving as creative business partners, the studio team members thoroughly investigate each brand in order to fully understand and then accurately reflect them through design. Their goal is to leave each of their clients with an innovative brand identity that is both undeniably relevant and incredibly engaging.

Driven by a passion for the visual arts and the unknown, Baillat. Studio is a multi-disciplinary design and production studio that offers services in branding, advertising, videography, and graphic design. Based in Montreal, the studio has a worldwide reputation for its quality work and signature, almost-hypnotic style, which utilises repetition of form, boldness of colour, and sharpness of contrast to create lasting impressions on viewers.

Bardo Industries is an independent, multi-disciplinary, woman-owned design studio based in Brooklyn. With passion and commitment to all their clients, the studio creates long-lasting design solutions through conceptual thinking, research, and collaboration. Using this cultivated method, Bardo Industries has been behind numerous clear and transformative interactive brand experiences across various platforms.

Aiming to discover, develop, and utilise the true essence of every brand, product, or service they work with, Beetroot Design Group is an award-winning communication design office and think tank with a mission to help their clients grow and gain recognition, appreciation, and praise from all over the world. The Beetroot team consists of dedicated experts who use a wide and diverse range of creative skills to create design services and solutions.

The aptly named Candid Brands design studio holds a deep belief that every brand can be honest in a unique and interesting way. The studio is committed to making every project they embark on a pleasant experience for all parties involved and to revolutionise how the people they work with perceive design. Ultimately, Candid Brands wants to make a difference.

Carpenter Collective

Led by Jessica and Tad Carpenter, Carpenter Collective is a design and branding studio that utilises thoughtful strategy and strong visuals to tell the stories of brands. The pair have been collaborating for over a dozen years and, in that time, have earned themselves a reputation for their artistic, powerful, and often whimsical work.

Carter Hales Design Lab Inc.

Based in Canada but working all over the globe, Carter Hales Design Lab is an award-winning design firm that specialises in branding, packaging, and web design projects. The firm partners with ambitious clients to create intelligent solutions that produce engaging results.

Caterina Bianchini Studio

From its base in London, Caterina Bianchini Studio pushes the boundaries of design through experimentation, with a specialisation in graphic design and art direction. The award-winning studio develops original typographic layouts and carefully curated colour palettes for all projects, which are executed with compelling conceptual and strategic thinking.

CIRCLE Design + Direction

Founded by talented designers Alexander Sellas and Philipp Kral, CIRCLE is a multidisciplinary design practice that collaborates with a diverse range of clients on projects situated at the intersection of culture and commerce. The studio specialises in developing visual identities, art direction, and digital design, and their work is always guided by the pervading belief that less is more.

Constantin Bolimond

Working mainly in identity, packaging design, and motion design, Constantin Bolimond is a designer from Belarus. He studied communication design at Vitebsk State Technological University.

Darling Visual Communications

Working across the various fields of branding, print, typography, digital, spatial installations, and art, Darling Visual Communications is an award-winning interdisciplinary design consultancy firm that was founded in 2011 and based in Singapore. The firm works attentively and carefully to create meaningful, intelligent designs for all of their clients' diverse design needs.

Davide Parere

Using strategic thinking, considered concepts, and modern designs, Davide Parere is a freelance art director and designer who helps international brands grow. Focusing on design, art direction, and illustration in both print and digital environments, he has earned a reputation for his work with major names, such as Montblanc, Vanity Fair, GQ, Vogue, and more.

Design Studio B.O.B.

Co-founded in February 2018 by Alessia Sistori, Lilly Friedeberg, and Marc Oortman, Design Studio B.O.B. is a multidisciplinary design studio based in Düsseldorf. The studio offers services in branding, packaging design, illustration, and art direction, with a special focus on conscious and functional design.

Estudio Maba

Specialising in package design and strategic branding, Estudio Maba is a team of multidisciplinary designers that constantly seeks new horizons in the field. Working to provide their clients with effective communication solutions, the studio makes sure that the designs they produce convey the true essence of their clients' messages. The goal of their work is to reach who needs to be reached and to say what needs to be said.

Fieldwork Facility

Designing communications as well as experiences, Fieldwork Facility is an independent interdisciplinary design studio led by creative director and founder Robin Howie. The studio strives to incorporate emerging technologies into their work to allow for the creation of new connections and relationships between different fields.

FormNation LLC

With an impressive client list including adidas, KLM/Air France, and Kikkerland, FormNation LLC is an award-winning design studio with roots in European design. In collaborations with architects, engineers, photographers, and web designers, the studio deals in both conceptual and commercial work, constantly refining their reputation for clever and clean designs.

Happycentro

A group of professional problem-solvers, Happycentro is a small design, photo, and video workshop based in Italy. Devoted to both creativity and rationality, the group advises brands, plans strategies, designs advertisements, draws storyboards, directs commercials, and creates stop motions. Happycentro is also always eager to push boundaries, blend disciplines, and experiment with new techniques in order to tell every brand's story in a revolutionary and beautiful way.

HOUTH

Creating fresh narratives and clever solutions for its clients, HOUTH is a Taipei-based creative studio that integrates creativity, strategy, and abundant resources into all their designs. Bringing a unique perspective and an appreciation for the pure and simple, HOUTH aims to use real-life experiences to create designs that break the rules and transcend existing boundaries.

Hula Estudio

Hula Estudio is a Logroño-based studio that was founded by Sandra de Miguel and David Elorza. Specialising in packaging and visual identities to provide relevant, innovative, and high-quality work to help its clients communicate their values, it works with some of the best wineries in Rioja, one of the main wine regions in the world.

Impact BBDO

Part of the global BBDO network, Impact BBDO is a regional communications group that has been operating in the Middle East and North Africa regions for over 40 years. The group consists of over 1,000 employees dedicated to delivering comprehensive and integrate communication solutions.

IWANT Design

Formed in 2003, IWANT Design is a creative branding and communications agency based in East London. They work closely with all their clients to produce brands, naming, art direction, packaging, illustrations, and digital designs that they are proud of. In all of their projects, the studio practices principles of functional, beautiful design that engages and excites through quality concepts and undeniable dedication.

Mucho

Aiming to create intelligent, precise, and meaningful designs, Mucho is an international, collaborative studio with a process that involves transitioning from insight to idea to design. Through producing memorable work that is able to incite a response or reaction, the studio hopes to speak to both their clients' heads and hearts.

Mundial

Led by the belief that concepts start with and grow with people, Mundial is a small design studio that works personally with their clients in creative exchanges of ideas in order to create an experience or product that reaches its maximum potential. Working all over the world, the studio uses design and illustration to follow its greatest guide—the imagination.

Natalia Elichirigoity

Natalia Elichirigoity is a graphic designer who got her degree from the University of Buenos Aires and whose work is often characterised by simplicity in shapes and message. With work experience as an art director and many design workshops under her belt, Natalia Elichirigoity is an experienced designer who has a special interest in lettering and typography.

Natasha Nikulina

Founder and art director of HeyMoon Agency, Natasha Nikulina is an independent graphic designer based in Samara. She specialises in branding, packaging, and communication.

Nick Liefhebber

Nick Liefhebber is a graphic designer, illustrator, and artist from Utrecht who creates worlds. His bold, fun, detailed designs are inspired by patterns and rhythms found anywhere from art to nature; and while they often cannot be interpreted literally, they are always able to connect and converse with people in meaningful ways. He works for a diverse range of clients from all over the world and also creates self-initiated, limited-edition, hand-printed screen prints.

O.OO Design & Risograph ROOM

O.OO Design & Risograph ROOM is a design studio based in Taipei that is committed to experimentation. They have gained a reputation for their unique combination of Risograph printing and product design development, their characteristic style of work.

Oddds

Founded in 2013 and based in Singapore, Oddds is a creative and graphic design studio that creates aesthetic, relevant, and influential designs to tell the stories of their clients' brands. Working closely with their clients, the studio explores, develops, and connects brands to people, through the uniting power of design.

OlssønBarbieri

Exploring the boundaries of art and design, OlssønBarbieri is a design studio in pursuit of making change through brand strategy and identity. Surpassing traditional marketing thinking, the studio works with future-oriented premium brands to uncover new possibilities of meaning, purpose, and relevance.

One Design

Always thoughtful and often thought-provoking, One Design is an award-winning branding and packaging design studio based in Auckland. In order to give each project breadth and life, One Design uses crafted, bespoke, and detailed ideas, brand stories, and products.

Pata Studio

Specialising in branding, packaging, and illustration, Pata Studio is an independent design studio based in London. It is always in search of new, applicable approaches to redefine, redesign, and add value to the brands it works with.

Pavement

Pavement is a design and creative studio based in the San Francisco Bay Area. The studio specialises in crafting strategic packaging and brand identities, especially for wine, spirits, food, and other luxury goods.

Pop & Pac

With a passion for all things design, Pop & Pac is a studio based in Melbourne that works to make their clients' brands stand out. Using holistically experiential designs, the studio offers services in identity creation, strategy, print communications, signage, and web design.

Projet Noir

With a focus on branding and design, Projet Noir is a boutique creative agency based in Malta. Although small, it is able to produce award-winning work by handling only a select number of projects at one time. The team always puts full effort and dedication into every project; and thus, they are able to develop exceptional, timeless creations.

SanYe Design Associates

Based in Kaohsiung City, SanYe Design Associates is a studio that specialises in branding. Through visual expertise and experience, the studio is able to bring out the identity of each brand and translate it into products and packaging designs. In all of their work, SanYe Design Associates seeks to uphold their three core values of aesthetics, cultural significance, and the ability to move one's heart.

Sean Huang

Passionate about communication through visual language, Sean Huang is a visual designer, brand designer, and illustrator who graduated from China University of Technology with a degree in Visual Communication and Design. His usual practice involves the careful study and examination of each project, leading to a distinctive design style and identity.

Shine Visual Lab

With a heart grounded in the spirit of exploration, Shine Visual Lab is a brand and visual communications studio that unites creatives in an effort to channel passion into goals and solutions. Using a unique combination of finesse and surprise, it works to create effective communications for the distinctive brands with whom they work.

Shunsuke Satake
Pages 158-159

Creating work that is 'tailored for children, education, and families', Shunsuke Satake is a freelance illustrator based in Japan who specialises in advertisement and print illustrations. His fun, light-hearted illustration style is reminiscent of mid-century modern illustrations with a playful contemporary twist.

Studio Blackburn
Pages 152-153

Established in 2011, Studio Blackburn is a brand design consultancy based in London. The company values the relationships they create with the people they work with, who are often risk-takers and decision-makers. Together, the consultancy team is able to make a difference and produce creative work that is beautiful and effective in today's digital world.

studio NUR
Pages 118-119

Founded by Eszter Laki, studio NUR is a Budapest-based graphic design studio that creates brands based on manual gestures, often using custom typography and hand-drawn illustrations. Starting from scratch, the team creates complete, fresh concepts for their projects, ending in photo documentation. Their work ranges from product identity to editorial design, and they always complete it with great enthusiasm and full commitment.

Studio Pros
Pages 138-141

A passionate, dedicated, and award-winning designer, Yi-hsuan Li has worked with several international companies and events, such as Facebook, Shutterstock, and Helsinki Design Week. She is also the Art Director in Studio Pros, a design studio based in Taipei, that focuses on branding, typography, and packaging design.

studiowmw
Pages 168-169

Based in Hong Kong but working in the global marketplace, studiowmw is a new kind of design agency that specialises in brand-building through effective, captivating, and conceptual design solutions. The agency develops trusted relationships with its clients and works to deliver each brand's values to its audiences in the form of packaging products, identity, interior, and website design.

SUBMACHINE
Pages 192-193

SUBMACHINE is a studio based in Budapest, self-described as a graphic design collaboration between the two founders, Ági Rubik and Ákos Polgárdi. Working on everything from visual identities to museum exhibitions and publications, the powerhouse pair of designers have created an extensive portfolio and crafted an impressive design vision.

Suisei
Pages 134-137

Working primarily in design, branding, and identity, Suisei is a small design firm with a big goal of generating new value. The firm is led by two main focuses in their work: to create long-term enjoyment for people and to respect Japanese tradition and character through their designs. Its team brings this ambition and thoughtfulness to every project they work on with their clients.

The Bakery design studio
Pages 144-145

Specialising in all things creative, The Bakery design studio's services include art direction, strategy, way-finding, packaging, and more. Drawing on the expertise of an extensive network of collaborators allows the small studio to execute projects for both start-ups and established companies across the globe. These collaborations are always simple, functional, and unique; and the studio prides itself on its long-lasting relationships with clients and its ever-present quest for the unexpected.

Twentyfive™
Pages 126-127

A group of self-coined growth catalysts, Twentyfive™ is a modern creative branding agency that specialises in building strong brands through high-calibre work and innovative ideas. Approaching every project with strategy, quality, and creativity, the studio is an expert at creating emotional bonds between companies and people, offering meaningful market-oriented experiences for exceptional business-building results.

UnderConsideration
Pages 236-239

Run by Bryony Gomez-Palacio and Armin Vit in Indiana, UnderConsideration is a graphic design firm that takes on limited client work. The studio instead focuses the majority of its efforts and energy on its own projects, initiatives, and content, like the annual Brand New Conference they organise and execute regarding corporate and brand identity.

UVMW
Pages 170-173

Working to create brands anew, UVMW is a team of designers who specialise in creating unusual branding and visual communication projects. The studio, led by co-creative directors Robert Mendel and Jacek Walesiak, develops creative solutions for design problems of all types and magnitudes.

Xfacta
Pages 078-081

Determined to show that the unimaginable is possible, Xfacta is a bespoke strategic design, brand, and concept agency. The team works directly, honestly, and passionately with their clients, who in turn view the agency as their partners. Through effective collaboration, thought-provoking creativity, and solid strategic thinking, they are able to deliver exceptionally high-quality work in a variety of different brands in diverse fields.

Yao-ming Yan
Pages 056-059

Based in Beijing, Yao-ming Yan is a graphic designer who has a special appreciation for creating distinctive visual effects through the use of various materials. Yao-ming Yan's print, packaging, and branding designs have won numerous awards and have been featured in a number of domestic and international publications.

Acknowledgements

We would like to thank all the designers and companies who were involved in the production of this book. This project would not have been accomplished without their significant contribution to its compilation. We would also like to express our gratitude to all the producers for their invaluable opinions and assistance throughout this entire project. Its successful completion owes a great deal to many professionals in the creative industry who have given us precious insights and comments. And to the many others whose names are not credited but have made specific input in this book, we thank you for your continuous support the whole time.

Future Editions

If you wish to participate in viction:ary's future projects and publications, please send your website or portfolio to submit@victionary.com